THE
PARTNERSHIP

THE
PARTNERSHIP

Brecht, Weill, Three Women, and Germany on the Brink

Pamela Katz

NAN A. TALESE | DOUBLEDAY
New York London Toronto Sydney Auckland

All rights reserved. Published in the United States by Nan A. Talese /
Doubleday, a division of Random House LLC, New York, and in
Canada by Random House of Canada Limited, Toronto,
Penguin Random House companies.

www.nanatalese.com

DOUBLEDAY is a registered trademark of Random House LLC.
Nan A. Talese and the colophon are trademarks of Random House LLC.

Permission acknowledgments can be found on page 453.

Book design by Cassandra J. Pappas
Jacket design by John Fontana
Jacket collage illustration by Marty Blake

Portraits: (left to right, top to bottom) Bertolt Brecht, c. 1930s © Bettmann /
Corbis; Helene Weigel, Akademie der Künste, Berlin, Bertolt-Brecht-Archiv
FA 17/003, Foto: Osborne, Li / Zander & Labisch; Lotte Lenya, courtesy of
the Weill-Lenya Research Center, Kurt Weill Foundation for Music, New
York; Kurt Weill, c. 1930s. akg-images; Elisabeth Hauptmann, 1930. ullstein
bild / The Granger Collection, NYC.

Library of Congress Cataloging-in-Publication Data
 Katz, Pamela.
 The partnership : Brecht, Weill, three women, and Germany on the
 brink / by Pamela Katz.
 pages cm
 ISBN 978-0-385-53491-8 (hardcover)—ISBN 978-0-385-53492-5 (eBook)
 1. Weill, Kurt, 1900–1950. 2. Brecht, Bertolt, 1898–1956. 3. Weill,
 Kurt, 1900–1950—Relations with women. 4. Brecht, Bertolt,
 1898–1956—Relations with women. 5. Composers—Biography.
 6. Authors, German—20th century—Biography. 7. Dramatists,
 German—20th century—Biography. I. Title.
 ML410.W395K38 2015
 782.1092—dc23
 [B] 2014017458

MANUFACTURED IN THE UNITED STATES OF AMERICA
10 9 8 7 6 5 4 3 2 1
First Edition

To Florian, Rebecca, and Louisa

Contents

THE
PARTNERSHIP

The First Encounter

A man of precise habits, Kurt Weill always emerged early from behind the heavy piece of tapestry that divided the studio apartment in Berlin where he slept and worked. For a musical prodigy, he had conspicuously small ears, especially in comparison to the large dark eyes that dominated his face and were bursting with intelligence and warmth through his thick, wire-rimmed glasses. Wearing his perfectly ironed trousers and shirt, he sat down at eight in the morning and worked ceaselessly until late in the afternoon. He composed quietly. The large piano that filled most of the working half of his studio wasn't touched until he had heard the finished music in his head. Friends joked that he only used the elegant black instrument as a place to put his pipes. Weill's handwriting was immaculate, and he rarely changed a note once it had been written. With a perfectionist's rigor, he slowly and calmly captured, in his words, "the roaring hymns of the stars."[1] He was writing music the likes of which no one had ever heard before.

The twenty-seven-year-old composer had already impressed many of the cultural giants of his day, but that hardly satisfied the ambitious Weill. It wasn't enough to simply shake up the old institutions; he wanted to transform them by writing music that appealed not only to

the intelligence but also to the hearts and hips of a large audience. He dreamed of hearing his songs in the whistle of a taxi driver.

And he was a man who expected his dreams to come true, at least when it came to music.

On March 24, 1927, the nature-loving Weill probably would have been delighted by the unusually warm breeze coming in through the open window. He always reveled in the approach of spring, and that year it was arriving astoundingly early. It had been nearly seventy degrees the day before, a cause for celebration in the cold northern city of Berlin, but too warm for the butter he usually kept outside on the wide stone windowsill in winter. Before the rampant inflation had ended three years earlier, such commodities had been far more valuable than the ever-shifting currency. Weill had often calculated the price of his composition lessons in grams of butter.

On this particular day, he was excited to meet a writer who'd caught his attention and was eager to be finished with his work. Weill pursued literary talent with the determination of a hunter in the wild, and although the furnishings of his tiny room didn't belong to him, the dark ugly pictures of hunting dogs that adorned the walls seemed appropriate to his voracious artistic appetite. "I need poetry to set my imagination in motion; and my imagination is not a bird, it's an airplane," Weill wrote his brother when he was only nineteen years old. He'd been on the quest ever since.[2]

Before taking leave of his desk, Weill wrote a quick letter to his wife, who was out of town. Letter-writing was another of his devoutly observed rituals. In addition to maintaining a regular correspondence with a variety of friends and colleagues, he wrote almost daily to his brother, his publisher, and, when she wasn't at home, his wife. Letters punctuated his life every bit as much as musical notes, and he relished describing the details of his day to the love of his life, the savvy, sensual woman who had shocked his family, Lotte Lenya. "Last night I worked here until one o'clock, while outside the incessant demonstrations paraded by," he wrote. "That was something to warm my revolutionary heart. Today again I've been sitting at my desk since eight this morning . . . now I have to go see B. *Addio!* Be loved, *Schwämmi* (Little Mushroom)."[3] With the envelope sealed and stamped, Weill put on his fedora and dark formal coat in preparation for his journey across the

city. As he walked down the stairs of the Pension Hassforth where he lived, he passed the eclectic mix of tenants who also had rooms there. The rooms were rented mainly to working-class craftsmen, including the landlady's husband who was employed as a tool sharpener in a factory. The landlady had surely noticed the elegant clothes of the previous tenant, Georg Kaiser, who had graciously loaned his flat to Weill and Lenya, but she probably didn't know that he was the most successful playwright in Germany.[4] Kaiser's personal and professional friendship, which Weill had earned by brazenly approaching him at the age of twenty-four to collaborate on an opera project, was the strongest proof that the composer had conquered the literary elite. But such success didn't diminish his urgent desire for his music to engage the attention of Herr Hassforth and the other carpenters and electricians with whom he shared an address.

No one looking at Weill, a small, prematurely balding young man wearing conservative clothes and schoolboy spectacles, would believe that he had a "revolutionary" bone in his body. But judging the composer by his appearance would be a mistake. His calm exterior was there to protect the creativity that exploded within him. He had the talent and skill to compose an entirely new kind of music and he worked toward this goal every day without fail. He was a revolutionary artist in the precise sense of the word; he was *changing* what had come before. But his working methods were grounded in the conservative, even Prussian, traditions of punctuality, discipline, and rigor.

Crossing the inner courtyard and going through the dark hallway to the massive front door, the light would momentarily blind him before he could focus on the regal Schloss Charlottenburg across the street. Surrounded by its landscaped grounds, the palace instantly recalled the royalty that once ruled the land. It had only been eight years since Kaiser Wilhelm had abdicated and it would take some time before the stench, and the opulence, of the monarchy would entirely disappear.

In fact, the demonstrations Weill mentioned in his letter had been to rally support for a proposed law to confiscate all of the aristocratic properties in order to benefit the unemployed and the disabled veterans, both victims of the country's financial collapse.[5] Such demonstrations were still common, although times were astoundingly good compared to the postwar hyperinflation and poverty under which

Weill had suffered along with millions of other Germans. At the very least, everyone could take comfort in the fact that there hadn't been an armed uprising or political assassination in several years. When the citizens of Berlin peacefully demonstrated about the redistribution of wealth, it was considered a relatively docile event in the still-fragile Weimar Republic.

Weill's political sympathies were with the poor and the powerless, though he had been well treated by Duke Frederick II, who once ruled his hometown of Dessau. The royal family encouraged and supported his early signs of talent and, just as important, their warm relationship was emblematic of the acceptance of the Jewish community to which Weill belonged. Weill's father was the cantor at the prominent local synagogue and the musical prodigy moved easily between it and the local palace. But despite his friendship with the duke and his sons, the war had changed everything. Given the grave errors of Kaiser Wilhelm, who was largely responsible for the country's bitter defeat in the First World War, it was impossible for Weill to be nostalgic about the bygone days of royalty. In fact, when the composer witnessed the collapse of the monarchy, he rejoiced in the breakdown of class divisions and polarizing customs that had existed for hundreds of years. He was in favor of democracy and equality, although his pacifist beliefs were at odds with the violent nature of the many revolutionaries who tried to take charge of the new society.

The ground had finally shifted in Germany, in all of Europe, and Communists, Socialists, and Conservatives were rushing to fill the void caused by the abdication of the Kaiser. Governments were declared by both bullets and words, and they ended in the same way. In Berlin, the left had been ruthlessly persecuted until the extreme right factions had, in their turn, been quelled. By 1927, the improving economy had begun to soothe the bloody political disagreements, and as was so clear in Weill's pension, people who never knew of each other's existence lived harmoniously side by side. But how long could this last?

It would have taken about an hour to walk from Weill's apartment to the meeting with the up-and-coming young writer. Like most of his working-class neighbors, Weill couldn't yet afford to own a car. He had barely survived the inflation years and was only just beginning to enjoy the better times. Weill was not only hoping to hear his songs in

the whistle of a taxi driver; he was probably also wishing he'd soon be able to afford to ride as a passenger.

It had already been three long years since he'd landed a major contract with Universal Edition, the greatest music publisher in all of Europe. But although he was on the same roster with such legendary composers as Gustav Mahler and Arnold Schoenberg, Weill had yet to make a comfortable living. And even if it had been quite some time since he had given composition lessons in exchange for butter, he still needed to make frequent requests for more money and support from his publisher. His editor often replied with a stern reminder that "not one of your works has so far covered even the printing costs, let alone earned a penny in profit . . . We are in no way complaining about the fact that . . . we have on the one hand helped you with advances . . . but we must find it regrettable that we never hear anything but expressions of your dissatisfaction."[6]

Weill knew his worth and never missed a day at his desk. He was justifiably irritated that despite his enormous output in the last six years—including two operas, one cantata, two string quartets, a cello sonata, a violin concerto, and two song cycles—he still had to write reviews and articles for the German radio journal in order to pay the rent. He hated to be robbed of precious time when he was, as he wrote his brother, "going through the years in which an artist is always sitting on a powder keg, when unused energy has to be discharged explosively, when a heightened oversensitivity produces a constant state of suspense, of excitement."[7]

A more generous advance from his publisher would also provide Weill with not only time but also the possibility to indulge his appreciation for good food. He had known hunger during the war years and had no romantic illusions about the lifestyle of a starving artist. When he gave concerts as a young prodigy, coffee, cake, and champagne had accompanied his enthusiasm for his music. He had a very practical and positive attitude about money that distinguished him from other radical young artists of the time. Money would simply give him more time to compose and increase his ability to live well. It would not transform him into the stereotypical greedy German industrialist so often caricatured by fellow artists like George Grosz.

Fortunately he loved walking, and the unusually warm day, the

broad sidewalks of Berlin, and the bulbs poking up in the Tiergarten made for a pleasurable stroll across town. As he headed down the boulevard that swept majestically from the Schloss Charlottenburg to the center of the city, he crossed streets filled with buses, cars, those enviable taxis, as well as horse-drawn carts, bicycles, and pushcarts. His pace quickened with every step as he headed toward the man he had publicly proclaimed as "a true poet"—no small compliment from a composer who had already worked with Kaiser and set to music poems by Rilke.[8] But Weill was certain that his latest discovery, Bertolt Brecht, deserved the compliment.

On that day, he might have realized that his need for cash was fortuitous, since it was his job as a radio critic that had brought the gifted writer to his attention. It gave Weill the opportunity to hear a radio preview of Brecht's controversial play *A Man's a Man*.[9] The play was aggressively modern, and its language, violence, and sexuality had led to misunderstandings, mixed reviews, and a short theatrical run in the small city of Darmstadt. Because of the scandal, no theater in Berlin would mount a production, and the radio broadcast had been the play's second chance to reach an audience. Brecht was lucky to have gotten that. The story is about a dockworker who is paid to impersonate a missing soldier. A simple man, he soon forgets his former identity. The whims of kings and politicians, the play implies, forced the worker to be taken apart and reassembled as a soldier. It had been nine years since the Armistice, and although an abundance of postwar anger had already made its way onto the stage, Brecht's use of comedy to portray military violence was shockingly original.

It was a war that was hard to forget, and not only because of its devastating financial consequences. For years afterward, Berlin was filled with maimed veterans whose pain haunted everyone they passed. Between the Schloss Charlottenburg and Brecht's neighborhood, the composer would have seen many of the four million crippled soldiers still filling the sidewalks. The advent of air bombing, machine guns, and sophisticated cannons led to an unprecedented number of casualties. The trench soldiers who survived the sweeping attacks came back with hideous wounds, severed limbs, or, equally debilitating, the new phenomenon known as shell shock. The twenty veterans' shelters in Berlin didn't have enough beds to house them all, and the sight

of a crippled or blind World War I soldier begging on street corners remained a common occurrence.[10]

Brecht's sharp satire delivered an unforgiving reflection on German society and its wartime folly. His pitch-perfect vernacular of the common man further enhanced the mocking tone of the play's blunt social critique. The tales of the scandal caused by Brecht's play had filled the newspapers and sparked Weill's interest. The radio version surpassed Weill's high expectations, and a week before his meeting he had already published an enthusiastic preview of the broadcast in the radio journal, calling it "the most original and powerful theater play of our time . . . Brecht's comedy is original in every way: its characters, the speech style and the structure."[11] Weill was immediately tantalized by the "whip-driven rhythms of his sentences" that offered just the type of lyrics for which he'd been yearning.[12] The play was broadcast for the public a week later, and Weill had recently finished an even more enthusiastic review for the next edition. He extended Brecht his highest compliment, calling him "a poet, a true poet . . . with a bold grasp and wonderful empathetic power."[13] Brecht had done what no one had done before: He had caught the sound of everyday speech without sacrificing the power of great poetry. Weill's metaphorical airplane took off immediately.

The provocative and supremely confident poet and playwright had enjoyed Weill's praise and agreed with pleasure to meet the composer. At twenty-nine, Brecht was used to causing scandals, and he relished the proliferation of champions and enemies that often followed in their wake.

Like Weill, Brecht also began work early in the morning and labored for many uninterrupted hours each and every day. But unlike the solitary composer, Brecht thrived on discussion. His tiny apartment, with its views of the rooftops of Berlin, was usually filled with three or four co-workers at any given time. Whether it was directors, scenic designers, writers, or sometimes even a boxing champion, they all climbed the five flights of stairs, ventured across the narrow catwalk, and opened the massive iron door to reach Brecht's studio, eager to participate in his many projects. He conversed with everyone in a

soft voice, rolling his Bavarian *r*, well aware that his intelligence was obvious even in a whisper.

Brecht was not handsome in a conventional way. Medium height and skinny, his slight body was anchored by dark and deep-set eyes that seemed to devour everything he could see. His nose sat prominently on a narrow, angular face, and depending on the angle, his thin mouth offered either a smile or a smirk. The smile was marked by several dentures, an unusual sight in such a young man, and caused by his failure to clean his teeth properly. By the age of twenty-three, several of them had already rotted away. Brecht's legendary attractiveness stemmed not from his looks but instead from his potential to be a powerfully flattering mirror. He focused on people with intensity; not a word was missed, not a gesture unseen. His penetrating expression could offer a warm and yet enticingly illicit stamp of approval. Receiving his coveted approval charmed and even bewitched people—especially, but not only, women.

Brecht's workroom had one long table near the window, which was covered with folders, newspaper clippings, and sketches. An upright piano, which he couldn't play, stood in the corner. A typewriter was always ready for work. It had been five years since one of the greatest critics in the country, Herbert Jhering, announced that Brecht's early work had "changed the German literary landscape overnight,"[14] and the young man's growing collective of collaborators had been working tirelessly ever since. On that day in March when Brecht left for his meeting with the eager composer, he was confident that the ideas he was exploring would continue to be investigated in his absence. That's how it had to be if the poet and playwright's enormous output—five plays, a prizewinning story, a book of poetry, and several screenplays so far—was to continue.

Also like Weill, Brecht lived rent-free, thanks to his girlfriend, Helene Weigel, a smart young actress from Vienna. She had moved out of her studio a few months after their son was born and let Brecht keep it for himself. She knew that he needed room to work and breathe. Not to mention room "to spit," a concept he'd tried to make his first wife understand, but she was neither as strong nor as accommodating as the liberated Weigel.[15] Weigel defied her family's objections to a life on the stage, and by the age of twenty-four, she had already forged a solid

career as an actress in the theaters of Frankfurt and Berlin. "Helli," as Brecht began to call her early on, as well as "Hellitier" (Helli-animal), didn't make a fuss about his being married, nor about his having two other children with two different women, all of whom needed financial support. Nor, finally, did she object when Brecht's most important collaborator, Elisabeth Hauptmann, not only worked closely with him in that same studio but often slept there with him as well. Many women loved Brecht, and he loved them all in return. Weigel, however, was determined to be the partner that lasted. She enjoyed the challenge.

As actress and writer, Weigel and Hauptmann were both intimately involved in Brecht's plays and poetry. In fact, whether they were friends, lovers, or colleagues, Brecht was incapable of having a profound relationship with anyone who wasn't actively engaged in his desire to revolutionize the theater.

Even Brecht's clothes were a uniform that suited his artistic and political preferences. The leather jacket, tie, and cap, the smelly cigar and unshaven face, the steel-rimmed glasses of "a civil servant or schoolmaster" were often ridiculed as the pretensions of a member of the bourgeoisie masquerading as a proletarian.[16] But that criticism was misguided. His appearance was a frank display of his admiration for the worker. It signaled his firm belief in the proletarian movement, and his commitment to writing plays that appealed to the working class. And it was this absolute sincerity that attracted people to him. For when it came to his belief in himself and his ability to change the world, Brecht was supremely convincing.

Like the composer he was about to meet, the young firebrand had been honing his skills since he was a boy. Brecht had been certain of his talent early on, as he stated clearly in his journal when he was eighteen. "I can write," he insisted. "I can write plays which are better than Hebbel's and wilder than Wedekind's."[17] And write he did, every day, alone and with others. He also read avidly, and the eager co-workers of his ever-growing collective researched, revised, and scouted for materials. But despite the approval of many influential luminaries of the theater, his reputation as a brilliant poet and playwright wasn't always enough to balance the scandals and unrest his plays had caused so far. Also like Weill, he had yet to earn much money. He had waged a number of cultural battles in conservative Munich and moved on

to the edgier Berlin in the hopes of finding a warmer welcome for his rebellious voice. He was joining the many left-leaning artists who had migrated north after Hitler's attempted putsch in Bavaria in 1922. Although it had failed, and Hitler had been banned from public speaking for the past three years, the Brownshirts had begun taking up residence in the southern part of the country. Their presence, along with Brecht's decaying early marriage, motivated him to head north to Berlin, the newly crowned cultural capital of Germany.

Berlin was far more fast-paced and urban than Munich, and it should have been the natural habitat for the poet who had famously written, "In the asphalt city I'm at home."[18] He loved cars, boxing, movies, and cabaret, as well as newspapers and tobacco. But walking in the crowded streets of the city was a different story, and Brecht's intense dislike for strolling in what he came to call the asphalt "jungle" revealed his provincial roots. In fact, not very many Germans were accustomed to the intensely urban way of life that so rapidly took over the country. The sudden surge in city populations was a direct result of the monarch's abdication, which had in turn forced the feudal system to collapse. Since the agrarian way of life had severely limited the poor's chances for upward mobility and had especially restricted the lives of women, it wasn't surprising that so many people seized the opportunity to flee the economic and social barriers of the "idyllic" countryside. They flocked to cities to enjoy their modern conveniences as well as a more liberated society. With its wide variety of professional possibilities, not to mention the indoor plumbing, department stores, radio, films, theater, and perhaps (once unthinkable for a woman) a room of one's own, cities were presumed to be the obvious choice for free citizens.

Brecht's profession naturally led him to the cultural center of the country, but the adjustment was not easy for him. He had grown up in Augsburg, a small town near Munich, and he missed the luxury of open spaces, clean air, and, most of all, the Black Forest, which he immortalized in his poetry.[19] From the age of sixteen until well into his twenties, Brecht loved to walk and play the guitar, roaming along the banks of the Lech River with a loyal band of friends. There, walking was a chance to think, reflect, and often write on small sheets of thin typing paper folded to fit in his leather notebook. Many of his early

poems were written as ballads for the guitar, and he would sing them in his thin, light voice. "I walk for hours to the sound of falling chestnuts all round me . . . not one word (is written) in an enclosed space."[20]

Brecht's writing had always been engaged with his love of music. Those musical riverbank strolls continued in the living rooms of his teenage friends, and evolved later into his active participation in professional cabarets in Munich. His powerful presence as a performer quickly made a splash upon his arrival in Berlin. "When he picked up his guitar, the murmur of conversation stopped . . . Everyone squatted on the floor around him, charmed by his spell . . . His singing was raw and abrasive, often crude like a street-singer or a music-hall minstrel, with an unmistakable Augsburg accent, sometimes almost beautiful, soaring without any vibrato."[21]

In noisy Berlin, where the sound of chestnuts falling could hardly compete with the clamor of city traffic, his affection for walking was drastically altered. And since it was useless for his work, he did as little of it as possible. It was no coincidence that he had asked Weill to meet him a short five blocks from his attic studio at Spichernstrasse 16. Brecht rarely had to travel very far to meet people, since his centrally located and affordable neighborhood of Wilmersdorf was filled with many of the greatest writers and painters in Berlin. The density of talent in so few streets was living proof of the city's magnetism for artists from all over Europe. A preliminary count of those within a stone's throw of Brecht's residence would have included Heinrich Mann, Anna Seghers, Walter Benjamin, Kurt Tucholsky, Erich Kästner, George Grosz, and Alfred Döblin, the author of the novel *Berlin Alexanderplatz*. In a typical hallway in any one of these buildings, the walls would vibrate with the sound of typewriters, the air would smell of paint, and the rooms would be filled with passionate conversation. Brecht admired some and disdained others, but he fervently shared their belief that the burning questions of his generation would be answered by art.

Brecht was an avid reader of the newspapers, and he had certainly heard about the composer's short opera *The Protagonist*. The press hailed this work by Kaiser and Weill as "leading the way to a new kind of opera."[22] Brecht would have been intrigued by the word "new," since for him, opera was an outdated and elite form of art, one in dire need of transformation. Weill's invitation to meet was well timed, since

the main element Brecht was missing in his devoted collective was an intelligent composer who could help him transform the fundamental role of music in the theater.

The composer's keen ear instantly recognized that Brecht was a gifted lyricist. And just as Brecht captured the rhythmic force of authentic speech, whether it was in the fairgrounds, sporting halls, dockyards, or the soldiers' barracks, Weill similarly had begun to lace his music with the sounds of contemporary life, incorporating phonograph recordings, the honk of a car horn, and popular dance music such as a fox-trot or tango. Brecht had developed his unique language after mastering such diverse traditions as the German expressionism of Frank Wedekind and Georg Büchner, the rapturous rebellion of Arthur Rimbaud and Paul Verlaine, and, finally, the icy wit of contemporary cabaret. On a parallel track, Weill had also been mastering a wide variety of musical styles. His early compositions combined elements of late romanticism, Schoenberg's twelve-tone method, and Mahler's groundbreaking modernism. In the "intensely idiosyncratic" composer's broad range of skills and dramatic flair, he could be compared to Stravinsky, whose *L'histoire du soldat* he greatly admired.[23] As Weill and Brecht walked toward each other on the hectic Berlin streets, they were not only about to collide in person but also to discover the artistic potential of fusing their rich cultural backgrounds.

Weill's work with Kaiser was successful within the limited sphere of the operagoing public, but he sensed that a young playwright like Brecht could catapult him out of the opera house and into the theater. In turn, since Brecht's scandals were still limiting his exposure, the composer believed his style of music would broaden the playwright's appeal. In strikingly similar language, both had written in the Berlin newspapers about their hopes for reaching a wider audience. Brecht had insisted that theater must achieve the same level of popularity as sporting events. "Make no bones about it, we have our eye on those huge stadiums filled with 15,000 men and women of every variety of class and physiognomy, the fairest and shrewdest audience in the world . . . Against that the traditional theater is nowadays quite lacking in character . . . A theater which makes no contact with the public is a nonsense. Our theater is accordingly a nonsense."[24] Weill was equally impatient with modern composers who "continue to work

toward the solution of aesthetic problems as if behind closed doors."[25] In addition to their enormous output of plays, poetry, and music, both men expounded on their artistic beliefs in newspaper articles, radio interviews, essays, and reviews.

What was so critically important about accessible art? Why did Brecht and Weill, and so many artists of their generation, believe in the power of music, theater, and painting to help understand the chaos that had been gnawing at society's roots ever since the end of the war? In a world wiped clean by destruction, Weill and Brecht would have answered, artists were essential in rebuilding their country's identity. Education, especially in the form of accessible culture, was the only means by which to transform subjects into citizens, a monarchy into a true democracy. Creating equal access to all forms of culture was one of the most important ways to obliterate the boundaries of class and wealth. Because they both believed that Germany's true strength was its rich artistic heritage, they were allied with the extreme opposition to rearmament. But this view was hardly shared by everyone. Rebuilding a strong German army was a goal still held dear by many powerful conservatives, and this elemental split between artistic and military pride informed much of the turmoil that divided the Weimar Republic. Weill's and Brecht's sense of urgency was fueled by the belief that they, as supremely talented artists, were especially obliged to demonstrate as quickly as possible that the pen, the paintbrush, and the baton are all mightier than the sword.[26]

The fractious opinions still swirling around the war were firmly divided by political affiliation. Those on the right believed the war could have been won and that defeat had been the result of betrayal from within their own country. On the left, they believed the war was a mistake from the start and blamed the Kaiser, an argument convincing enough to force his abdication. These differences had many subdivisions, and, remarkably, there were six major and eight minor parties under the broad headings of Socialists, Communists, and Conservatives. There had been seven different governments in the past nine years.

On all sides, everyone was crushed by the humiliation at Versailles, where the Allies insisted that the price tag, psychologically and financially, was made as painful as possible for Germany. Ever since the

treaty had been enacted, not a sentence was uttered or an argument debated without mention of the ruinous cost of the reparations. They were indeed steep, and Germany's debt led to the savage inflation that, toward the end of 1923, made one dollar worth 4.2 trillion marks. Paper money decreased in value every second, and people literally raced to stores and restaurants after being paid. Five minutes meant the difference of thousands of marks for a loaf of bread. The resourceful Weill had been quite clever to measure his fees in grams of butter.

But whether they embraced the new freedoms of the Weimar Republic or despised the very essence of a free culture and democracy, everyone was affected by the war reparations. The haunting debt, and the dire poverty it had caused, was a constant reminder of the country's deep divide over the First World War. This was an open wound for the entire German population. The anger was festering even as the country was getting back on its feet.

After the German economy nearly collapsed, American officials offered hefty loans to abate the catastrophe. Germany had no choice but to accept, agreeing to a payment plan that would last until the mid-1980s. The loans had certainly fostered economic stability and this was directly responsible for the cash that was flowing into the arts. It was not only intellectuals and radical young artists like Brecht and Weill who believed in the healing power of culture but also a number of wealthy industrialists. Influenced by the contagious atmosphere of prosperity, some of the more modern businessmen invested their own money in theater productions. Even more significant was the very active Ministry of Culture, which was determined to wipe out the imperial past in one fell swoop. The arts, they insisted, were no longer focused on entertaining the lords and ladies of the court. Elite institutions had no place in a society trying to eradicate divisions based on class and wealth.

Brecht and Weill understood and appreciated that art funded by state institutions must appeal to as many citizens as possible, and they each declared the urgent need for the renewal of opera and theater in almost identical terms: "When one sees that our world of today no longer fits into a drama," Brecht proclaimed, "then drama does not fit into the world."[27] Weill famously mirrored this sentiment: "If the bounds of opera cannot accommodate . . . the theater of the times

(*Zeittheater*), then its bounds must be broken."[28] Berlin took this obligation most seriously of all. A city of just over four million people, it was home to more than fifty theaters and three major opera houses, all generously subsidized by the government.

There was undoubtedly an artistic revolution going on, and it was a subsidized revolution at that. Let the conservatives wallow in anger over who had been to blame for the defeat and the raw deal at Versailles—forward-thinking artists and businessmen would focus on making sure that the kings and lords and corrupt politicians would never victimize the people again. Democracy and freedom were the answer, and this would be reflected in the classroom and the factory, as well as in every note of music, every inch of a painter's canvas, and every word uttered on the stage.

Rebellion was expected of intelligent men.

Given their thorough exploration of Berlin's cultural landscape, it would have been almost impossible for Brecht and Weill not to meet in person at some point. But before their paths had a chance to converge, the radio demonstrated the power of technology to bring people together. Their particular circumstance was emblematic of the invention's pervasive presence in German life. This groundbreaking machine, which had begun with one Berlin station in 1923 with two hundred listeners using cumbersome headsets, had grown to almost two million people by the time Brecht's play had been broadcast.[29] The radio's rapid infiltration of the home made it a powerful equalizer for the new democratic society, and it was not only defining but also mobilizing the public. Weill quickly realized the implications of this phenomenon: "So revolutionary an institution as radio also demands an entirely new attitude toward art and the economics of art . . . perhaps the broad masses to whom radio belongs could form the basis for a whole new direction in music."[30] Weill wanted his music to blow open the doors of the elite concert hall. The universal access of the radio was helping to bring this about as rapidly as possible.

Brecht was also fascinated by the potential of radio to make culture available to the broad population. In his introduction to the radio version of *A Man's a Man,* he said, "The theater has too long been the property of a small elite that claims to be the nation. It is no accident that today, when this elite clearly *no longer* represents the nation, the

theater is in decline and that an invention like the radio . . . is simply attending to the art that was previously the theater's obligation . . . Usually the masses are considered to be too stupid. They are not stupid. It is probably that only a small minority of the masses understand, say, the theory of relativity. But does that mean it should be communicated only to a few?"[31] A case in point was Brecht's latest play, where his "non-fashionable, wild, strong, colorful language" was still considered shocking on the stage, simply because it was "not something read in books, but heard from the people."[32] In contrast, his dialogue was perfectly fitting and in fact essential for the radio.

Brecht not only spoke the language of the masses; he also made them the subject of his plays. In a world ruined by war and controlled by industrialists, as *A Man's a Man* had shown, boys were transformed into soldiers because of the political and economic conditions. They didn't go into battle of their own free will; heroism was a myth foisted onto young men by the ruling elite. It had become impossible, as far as Brecht was concerned, for a modern man to determine his own destiny. In order for contemporary drama to remain relevant, it had to abandon the concept of the individual and instead focus on the situation of the masses of men. And such masses are utterly formed by the needs of their society. And since there were no more individuals in the world, they had to be thrown off the stage as well.

It had been little more than a week since Weill had heard the poet's radio play when the composer was approaching the door of Schlichter's restaurant. This popular theater haunt was situated on the corner of Lutherstrasse and Ansbacherstrasse in the heart of Brecht's literary mecca of Wilmersdorf.

Weill walked briskly on this balmy winter day, and as he came inside, the crowded, bustling interior was far warmer than the outside air. His glasses would have fogged, obscuring his view of the large, inviting rooms filled with directors and actors, writers and artists, editors and publishers. The restaurant would have been humming, as always, with the heated conversations about theater and art and politics. Opinions loudly expressed on the stage generated an outcry from all corners of the city. Critics attacked and praised artists and artistic movements in

uncompromising, even brutal language. Political analysts never failed to weigh in as if theaters were presenting government policy instead of plays. These discussions would take place in many languages, as well as in a mixture of accents as foreigners attempted to speak German. In the words of Hans Heinsheimer, Weill's editor at Universal Edition, the people who filled the city and flocked to restaurants like Schlichter's were increasingly difficult to define except by acknowledging the sudden and cataclysmic shift toward diversity. The "air of Berlin" had changed "slow moving Austrians and sun-spoiled Italians, Russians and Poles, Frenchmen and Hungarians, and the Germans from all four corners of their land and made them into Berliners."[33]

This vibrant restaurant was owned by Max Schlichter, the older brother of the artist Rudolf Schlichter, whose paintings covered the walls and whose political activities defined the locale as much as the cold buffet and good hot coffee for which the place was known. Rudolf Schlichter had been a member of the German Communist Party for many years and was the leader of a collection of artists known as the Novembergruppe. He had banded together with Grosz and Otto Dix to issue a manifesto declaring that in order for art to create a new and better society, artists must support the plight of the working man.

Brecht and Weill had both belonged to the November Group but didn't cross paths in this context.[34] Weill had joined the original November Group, along with other politically moderate musicians, because he shared its initial intention to create art for the people. But when Schlichter and his group split off to heighten their proletarian goals, Weill did not follow. He was interested in composing accessible and, in that sense, socially relevant music, but unlike Schlichter, Weill didn't want to become directly involved in the political struggles of the day.

In addition to writing manifestos and organizing exhibitions, Schlichter also painted portraits of artists whose politics he supported. His pictures of patrons covered the walls as their discussions about the meaning of art filled the air, as if the portraits themselves were joining the conversation. This was Schlichter's radical Hall of Mirrors, revealing the search for utopia that everyone in the Weimar Republic was seeking.

While the painter's radical approach had disenchanted the com-

poser, it was a powerful attraction for the playwright. Schlichter was therefore delighted to paint the very left-wing Brecht's portrait, which hung prominently on the wall of his brother's restaurant. When Weill wiped his steamy glasses and put them back on, the painting was likely one of the first things to catch his eye.

Not far from his portrait, Brecht was sitting at his favorite table, where he enjoyed reading the many Berlin newspapers that were draped over long wooden holders. News couldn't be current enough in a town that worshipped the present tense, and Brecht was hardly alone in his fascination with the news. In addition to the three flagship papers, which came out four times a day, there were also at least thirty smaller papers and thirty even smaller neighborhood-based dailies.

Despite the warmth of the room, Brecht's dark, weathered leather jacket would be fastened and his hat pulled low on his forehead. He hated to be cold and was vulnerable to drafts. The small composer was not particularly athletic, but his solid, compact build and rosy cheeks made him seem like the picture of health compared to the skinny, scruffy man he was about to meet.

As he crossed the crowded, colorful room, one thing must have been clear to the observant Weill: The artist who had killed the "individual" on the stage was in no way prepared to eliminate one very particular individual in the real world—that is, Brecht himself. This man's singular confidence was as powerful as the stench from his cigar, whose smoke swirled up toward his portrait on the wall.

In his quiet way, Weill was equally self-assured. Both men were emboldened not only by their talent but also by their strong sense of purpose. They had come of age on the despoiled cultural plain of post-war Germany and began their careers believing they had an essential role to play in the fate of their country.

As he approached Brecht's table, Weill passed patrons from many social and cultural backgrounds and nearly everyone was discussing the same thing: how to understand and fulfill the demands of democratic art. "It was a time of youth and a city of youth," Heinsheimer aptly described the atmosphere. "The old empire had vanished, the old conceptions, the old conventions, the old traditions, and the old people . . . The young soldiers, back from the war, met under huge banners, proclaiming 'Nie wieder Krieg'—'Never again war.' The young

musicians, looking into a new, exciting future . . . proclaimed '*Nie wieder Grieg.*'"[35]

Brecht had taken an obligatory glance at the changes going on at the old Court Theater of the Kaiser Wilhelm, but he was disappointed by the attempts of the newly named State Theater. Although this theater devoted itself to discovering the contemporary relevance of plays from Shakespeare to Schiller, Brecht believed it hadn't yet succeeded in departing from past traditions. When it came to reinterpreting the classics, Brecht had been far more fascinated by the great Max Reinhardt, and upon his arrival in Berlin, he immediately began working as a dramaturg for the groundbreaking impresario. Reinhardt's gigantic productions routinely attracted more than five thousand spectators and could almost compete with the magnetic sporting events so admired by Brecht. By the time he was about to meet Weill, Brecht had become even more interested in the radical direction being pursued by Erwin Piscator. An "older" director at thirty-four, Piscator was committed to revolutionary drama and had begun his theatrical career staging plays in the beer halls and community centers of working-class neighborhoods. It was typical for open-minded Berlin that a wealthy businessman, the husband of an actress devoted to Piscator, agreed to subsidize the Communist director's largest proletarian theater to date. Tickets were cheap, the plays were radical, and Brecht was impressed by Piscator's efforts to achieve a true "art for the masses." The young playwright eagerly participated in Piscator's experiments, ravenously consuming their innovations and figuring out how to surpass them in the future. Brecht was producer, dramaturg, playwright, and poet. He was the only theater man in Berlin who could do it all.

While Brecht had been investigating every worthwhile theater he could find, Weill had actively searched for the places, and the artists, that would inspire drama and music to intersect in an entirely new way. The composer saw that even the most modern institutions—the renamed and well-funded "State" and "City" operas—weren't keeping pace with the seismic changes in society. It wasn't enough to compose a new style of music; the stories and characters that musical drama addressed had to change as well. The romantic foibles of lords and ladies that had once entertained the monarchs had to be replaced by ideas and circumstances that the broader public could recognize and

care about. That's why Weill impatiently pursued writers who could help him create a new kind of musical theater, an opera "for the times" (*Zeitoper*) that was as radical as the *Zeittheater*. He had his eye on a third opera house that was quickly gaining prominence in Berlin. This was run by Otto Klemperer, a famous German conductor and the man who was most likely to comprehend and facilitate Weill's revolutionary ideas. If Weill was right about Brecht, a project that would capture the attention of this modern maestro might soon be on the horizon.

Although Weill and Brecht had swiftly found footholds within the institutions that were flowering all over Berlin, neither man would have been satisfied by working in any single genre. They were both keenly aware that art for the "people" was an embryonic concept, and each new work must evolve along with a world that changed every day. Weill and Brecht were devoted students who wanted to learn from everyone, but as emerging masters, they would not become followers of anyone. That was something else they had in common.

When Brecht realized that the formally dressed little man moving toward his table was the modern composer he awaited, he too must have taken his appearance as a sign of character. Clearly the composer didn't need clothes to help bolster his image as a radical, forward-thinking artist. Weill's dark suit was similar to one Brecht's father might own. Although there were only two years between the artists, they looked as if they came from different generations.

Brecht would have put the paper down and stood up to greet Weill. For all his attempts to overturn the conventions of the past, the playwright had been well-raised and was as famous for his polite demeanor in private as he was for shouting down his adversaries in the theater. At five feet nine inches, he would tower over Weill, a good six inches shorter. As he shook Brecht's hand, Weill must also have been grateful for the pungent smell of the cigar smoke. It was far more pleasant than the pronounced body odor wafting from the playwright. The composer was also spared the bad breath caused by Brecht's chronic renal condition.

As they introduced themselves, their voices enhanced their drastically contrasting appearances: Brecht's rhythmic Bavarian dialect clashed with Weill's Anhaltinische, a distinctive version of "high" German comparable to Oxford English, but one that has a flat, parsed

sound, notably lacking in intonation.[36] As if to put an official seal on the differences between them, Weill would have lit an elegant pipe to contrast with Brecht's thick, stubby cigar.

Both men were famous for being good listeners. Like Brecht, Weill was in the habit of fixing his eyes on the person speaking and offering his full attention. When two such listeners meet, there must be a good deal of silence at the start. Neither was one to share personal details at a first encounter; each would have politely waited for the other to begin.

Since Weill had insisted on meeting the writer who had mastered the poetry of everyday speech, it's likely that the composer was the first to speak. The gracious Weill wouldn't have hesitated to reiterate his compliments in person. For Brecht, professional appreciation was always a welcome icebreaker. Once it came to sharing ideas, both men were equally known for their intellectual excitement, their ability to articulate their ideas eloquently, and, perhaps most important, their impatience. They were in a hurry to shatter the conventions of the theater, the concert hall, and the opera house. Once this common quality was discovered, no doubt their mutual energy and enthusiasm gave way to an exhilarating afternoon.

They also shared a fascination with America, whose sights and sounds were arriving rapidly from across the ocean. Whether it was Charlie Chaplin's *The Gold Rush*, which Brecht adored, or the popular melodies Weill was absorbing, each had a sensory engagement with a country they had never been able to visit. Brecht had published ballads about a fictional desert town in the American West, a whiskey-drenched place where people spent their days gambling, drinking, and whoring. Although these ballads were as yet unknown to the composer, the strands of fox-trot and jazz rhythms that Weill had woven into his operatic scores had already begun to capture the sounds that Brecht's ironic "paradise" evoked. The cultural breeze from the west had wafted over both men, and the seeds of modernity had sprouted in their classically educated European minds. This was another important quality they shared. They didn't toss away their cultural heritage like many radical young artists; instead, they combined old and new, domestic and international, high and low. Whether from the past or the present, not a word had been spoken or a note played—on the

stage or in the street or, for that matter, blasting over the radio—that hadn't found a foothold somewhere in the words and music of Brecht and Weill.

Once the spark between them ignited, Weill told Brecht about his commission from the famous modern music festival in Baden-Baden. He had been searching for something he could adapt into a short, modern opera, but it had to work with his increasingly populist dreams. He had already impressed the refined festival crowd, Weill informed Brecht, and now he wanted to shake them up. Weill was thrilled to learn that Brecht's first book of poetry would be coming out in the next few weeks, and from what he could tell, the poems might suit his needs perfectly. Brecht had already published twenty-five special editions a year earlier, and he probably had a copy on hand the day he met Weill. The collection was called the *Manual of Piety*, but its blasphemous parody of religion was hardly pious.

Weill couldn't have failed to smile when he saw that the *Manual* looked just like a traditional prayer book. Bound in black leather, the poems were organized into double columns and printed on the same type of paper as the Bible. This was fitting for a poet who provocatively claimed that his most important influence had been Luther's Bible. The equally irreligious Jewish composer would have no problem with Brecht's playful religious parody. Weill was certainly influenced by many kinds of sacred music, from his Jewish heritage—his cantor father had written some religious music of his own—as well as compositions by Beethoven, Bach, Haydn, and Handel. The two men could now add religion to the potent blend of influences they shared. Both clearly enjoyed profaning all things sacred.

Weill's appetite never failed him, and he would have been incapable of meeting in a restaurant without ordering something to eat. Brecht's kidney problems caused him to suffer a nearly constant metallic taste in his mouth. This severely dampened his appetite, and forced him to be increasingly sparing with alcohol. He would have envied and enjoyed the composer's evident lust for food. There was an amusing contrast between Weill's passion for music, theater, and most certainly a good meal, and his soft voice, old-fashioned polite manner, and conventional clothes. Weill looked like a professor of rebellion rather than a rebel. Brecht was increasingly intrigued by this revolutionary in disguise.

Weill hardly considered his comfortable, well-pressed clothes to be a disguise. It was Brecht's "uniform" of the working class that the composer would regard as a kind of costume. He had instantly recognized the poet's education and intelligence, an original voice to be sure, but one coming from an upper-class family and background. But if Brecht dressed that way to indicate his solidarity with the people, or if he charmed women with his proletarian image, it was of no consequence for Weill. He wanted Brecht's poetry, and for him, that black leather-bound book was far more intriguing than the poet's leather jacket and tie. Weill wanted to read it immediately.

They saw through each other's surface appearances and liked what they found. In essence, they believed they weren't so different: each was a highly intelligent, hardworking, accomplished young man. Their quick understanding was akin to the mutual admiration that arises between skilled athletes. When a ball is thrown and caught with an obvious facility, or a player displays speed and precision, eyes meet across the court or field and the connection is instant. The creative chemistry between two artists is just as obvious, and just as powerful.

Weill and Brecht were less of an anomaly than might be supposed, given the aura of debauchery that surrounds the myth of the golden twenties. Even if they are extreme examples, their work ethic wasn't particularly out of place in a city that had such a rich abundance of cultural institutions. The variety of original productions was proof that hundreds of writers, musicians, actors, directors, and conductors were hard at work every day. If many artists stayed out late in theaters, concert halls, and opera houses, they still got up early the following morning. "That was the kind of Germany that I wish more people knew," lamented one of Weill's early students, the conductor Maurice Abravanel. "People are convinced . . . [the Weimar Republic] was just a cesspool of vice and nobody did anything except . . . the most lurid things, which is not true."[37]

The composer and playwright by no means learned everything about each other in that one meeting. Weill would not yet have known that Brecht had an ever-growing collective of talented theater professionals utterly devoted to his work. They included his boyhood friend Caspar Neher, also from Augsburg. Neher was Brecht's visual counterpart; he was literally redesigning the stage from the curtain to the

scenery and the lighting. Not a single word or idea of Brecht's was complete before it was pushed through Neher's painterly imagination. Brecht's girlfriend, Weigel, was an actress with a distinctive style and speaking voice. And although Weill might not yet have seen her on the stage, he'd surely heard her in the radio performance of *A Man's a Man*. The composer hadn't singled her out in his own review, but others had, describing her voice as a unifying force between the two opposing elements of her character. She had managed to embody a typically Brechtian combination of barmaid and philosopher.[38]

Of all the *Mitarbeiter* (co-workers) who were researching, editing, and writing Brecht's many projects at that time, the most important one was Elisabeth Hauptmann. She had been directly involved in the last three years of revisions for *A Man's a Man* and also had written some of the poems that Brecht published under his name in the *Manual*. In her letters to him, she also omitted her actual name, signing them—in English—as "Chiefgirl." This was a play on both the images of the Wild West that gripped her and Brecht's imaginations and, as he well knew, a clear indication of the place she hoped to occupy in his life. As people flocked to and from his attic studio on Spichernstrasse at all hours of the day and night to fulfill his perpetual need for discussion, she was his most constant collaborator. With her help, he perpetually revised his work whenever an interesting suggestion came his way. Brecht was undoubtedly in command of the creative process, but Hauptmann's intelligent presence behind the typewriter was the engine that kept the vehicle speeding confidently down the road. For the past three years, she'd been a full-time *Mitarbeiter* but only a part-time lover. She accepted that.

There was also much that Brecht didn't know about Weill. The most glaring contrast between them was that Weill required solitude and silence to compose. It would have surprised Brecht to learn that even the sound of a piano disturbed Weill, let alone the company of other people. He only allowed one person into his inner world of musical creation, and even she didn't have unlimited access. That was, of course, his talented and streetwise wife, Lotte Lenya. She was powerful enough to hold her own with Brecht's expanding group of unusual women, even and especially since she lacked a formal education or a

comfortable upbringing. She had known hunger, poverty, and brutality, and her experiences reverberated through her performances as a dancer and actress. And although she also had no musical training, Weill was transfixed by the sound of her distinctive Viennese voice. She had the innate rhythmic talent that Brecht displayed in his writing, and she understood the workers and washerwomen they hoped to attract to the front row of the theater. The composer sensed right away that an introduction to his wife should take place quickly. She, and perhaps she alone, would be able to form an essential bridge between himself and Brecht.

Other than his muse Lenya, Weill came to Brecht as an independent and solitary artist. But this didn't mean, as Brecht readily assumed, that the composer wanted to join the playwright's collective. He was not there to take a place at the table alongside the designers, co-writers, and actresses, all of whom offered their talents for Brecht to use as he pleased.

Indeed, the composer saw things quite differently. He assumed Brecht would be eager to have his plays and poetry transformed into songs and works of musical theater and opera. That is, he intended to work, as he always had, side by side with the writer as they developed a piece, but of course any musical production had to be finalized in a composer's hand.

Even if they had known how differently they viewed the idea of working together, Brecht and Weill were too electrified by each other to attend to such conventional issues about control. In the new era, it was logical that the collaborative way of working would be redefined; both men believed they were entirely open to new approaches. How else would they discover the unknown vistas they craved? They were determined to break down all the old-fashioned barriers, including the famous hierarchical battle between music and words. Such outdated categories smacked of the past, of aristocratic notions about opera, where the composer ruled imperiously over the librettist. Together, they would create a new approach to musical drama, one that would mirror the transformation of politics and society. In a democracy where all citizens are equal, it followed that all artistic elements, whether words, music, stage design, or performance, would be equal as well. For a

composer and a writer to attempt working together in this way was the cultural equivalent of overthrowing the monarchy. They were both convinced that hierarchy itself had to abdicate its role in the arts.

And even if Weill had known that Brecht was fascinated by Marxism and was closer to the part of the November Group that had split off to strengthen its politics, the composer would hardly have minded. There was a difference between pursuing intellectual ideas and joining the Communist Party, and Brecht had so far shown no interest in becoming a member. Weill was sure that Brecht was first and foremost an artist, who, like him, wanted to capture the attention of the common man. In order to attract their ideal audience, they would naturally have to present stories that reflected their reality, ones that raised all the relevant social issues of the day. Therefore Weill was right to assume, at that point in time, that Marxism mainly provided a philosophical perspective for Brecht: a way to analyze the world he lived in. In 1927, Brecht certainly believed that theater had to reflect contemporary times, but he had as yet shown no signs of believing that it could be used as an effective tool for changing social or political structures. In this precise sense, Weill was further correct in his first impression of Brecht as a "true poet," an idealist who believed, as the composer so fervently agreed, that only great art could make a lasting difference to the human condition. That afternoon, united by high ideals and expectations, they were two equals on the road to reinvention, likeminded rebels in search of revolution, even if one looked the part far more than the other.

Weill's large and Brecht's small, deep-set eyes met in celebration of the spark between them. The contrast of the composer's properly ironed shirt and the poet's creased leather jacket had faded early on in their encounter. Surface appearances were nothing compared to the artistic alliance they so quickly forged. And yet, even in the electric city of Berlin, no one could have predicted the high voltage of their encounter, the complementary nature of their talents, or the harmony of their creative goals. How did the son of a cantor from an established Jewish family and the Protestant scion of a businessman from Bavaria arrive by such different paths in precisely the same artistic place at the same time? Who were they before this fortunate collision?

Coming of Age

At first glance, the unshaven Brecht, with his sly grin and dirty leather jacket, looked like he'd once been the playground bully. In fact, he was far more similar to the fragile Proust. Born on February 10, 1898, the young Eugen Berthold Friedrich Brecht was pale, skinny, and frequently sick. As other boys his age were running freely down the tree-lined streets of Augsburg or swimming in its famous rivers, the frail boy was usually tucked into a warm bed in his large attic room. His Protestant mother, Wilhelmine Friederike Sophie Brezing, was also chronically ill, and she would read Luther's Bible to him for hours at a time. Sophie was more devout than her Catholic husband, Berthold Brecht Sr., and she insisted on raising both sons in her faith. Often frustrated with his semi-invalid wife, Brecht Sr. agreed to her wishes in part because attending to the children's religious education was one of the few activities that would get their mother out of bed. Sophie and her beloved Eugen both spent a lot of time resting in sanatoriums, either sharing a room or, if they were separated, placing their beds against the same wall so that he could knock if he needed her. In the days before antibiotics, complications from an untreated strep infection had weakened his heart. Until well into his teenage years, Eugen would awaken to hear his heart pounding so loudly that he feared he might die in the night. He suffered a heart attack when he was thirteen,

and doctors "diagnosed" him as a nervous boy.[1] This was, however, the effect, not the cause, of his actual ailment of the heart.[2]

During those long winter days when mother and son huddled together through their many illnesses, Sophie marveled at the quick mind of her sensitive Eugen. He read and wrote with much enthusiasm, and when his father became gravely ill, the young boy discovered that writing poetry also soothed his anxiety. He feared his one healthy parent slipping away and took metaphorical charge of his father's illness. By writing a series of poems located in the hospital room, he gave himself a childish but effective illusion of control. Staying calm was a medical necessity for the tender boy, and writing became nearly as essential to him as oxygen.

Brecht's father was a hardworking, disciplined, cheerful man, who despite the limits of his elementary-school education had become a manager of the prominent Haindl paper factory. He enjoyed music and performed with a singing club, but he never imagined that he would sire a poet, nor did he encourage his son to pursue a literary profession. As far as he was concerned, making and selling paper was a business. Writing words on it was a hobby.

The factory provided Brecht's family with a house just outside the medieval walls of the industrial city. The contrast between the picturesque ramparts and the bland Haindl buildings offered a telling illustration of Augsburg's rich history. Its location at the confluence of two rivers had given it a strategic trade and military function during the Holy Roman Empire, and its importance continued, if more prosaically, into the twentieth century, when it became a center of the textile and paper industry. The Brechts' home was large but not distinctive—it was one of several in a row of identical two-story houses with matching gardens in the back. Haindl also provided apartments for many of the three hundred employees living in the same neighborhood, and Eugen grew up surrounded by the laborers who worked for his father. He wrote humorously, if critically, of his upper-middle-class upbringing as the scion of a factory boss, a boy who observed the lives of its workers from his privileged window: "I grew up the son / of well-to-do people. My parents / tied a collar around me, and brought me up / In the habits of being waited on / And instructed me in the art of commanding."[3]

Eugen's quiet, intellectual upbringing was formative for the young boy, and he was deeply influenced by traditional German culture and values. But because he missed a lot of school, spent time in hospitals and sanatoriums, and was more often indoors with his mother than outdoors with other boys, he also experienced early life from a marginal perspective. When Eugen read about the adventures of his boyhood heroes, most often in Karl May's Wild West novels, he was usually lying in bed with the shutters closed.

Eugen's younger sibling, Walter, was sturdier and more conventional. But although he admired Eugen's intelligence, Walter was often embarrassed by his nervous, chess-playing, bookworm of a brother who was frequently teased by the other boys. Walter described the precious Eugen as "a nervous child. He could only sleep if he had a candle burning on his night table . . . He spoke little and read all the time."[4] Walter could have clinched that damning description of his odd brother with the fact that he almost never bathed. With so much time spent under thick blankets, Eugen was especially sensitive to the cold, and the damp chill he felt after leaving the tub was unbearable. As a child with an impressive brain and a weak heart, he was quite adept at talking his way out of washing.

Eugen ultimately learned that words could be as powerful as muscles, and he used his persuasive verbal skills to attract a small group of friends who were also interested in literature and art. Everything changed when he began working on his school's literary magazine. His talent—his poems, stories, and his first play, appropriately titled *The Bible*—instantly established him as an intellectual leader. He set up his room as the center of artistic operations in Augsburg and aptly dubbed it his *Kraal*. An Afrikaans term for a cattle's corral, the *Kraal* was the place Eugen corralled his ideas.[5] His first truly good friend and comrade was Rudolf Caspar Neher, a tall, good-looking boy who was a year older. Neher was as precocious a visual artist as Eugen was a writer, and they quickly declared themselves "brothers in arte."[6]

The nervous pale boy overcame the constraints of his fragile constitution and grew into a highly confident teenager. Dismissing his body altogether in favor of his more impressive assets, Eugen began to emulate his new heroes—rebellious poets such as Verlaine and Rimbaud—and to his pious mother's dismay, he stopped bathing, brushing his

teeth, or wearing clean clothes. By the time he was sixteen, the brave new Eugen had begun to lead a band of friends on his riverbank walks. As he played the guitar and sung ballads inspired by the town's local minstrels, he became the literary pied piper of Augsburg—singing the songs of the barkers he came to know on his frequent visits to the fairgrounds. Eugen drew much of his early inspiration from these lively fairs, and his imagination blossomed during his promenades beneath the magnificent chestnut trees of his beautiful hometown.

Eugen was proud of his superior intelligence and certain of his artistic judgments, and he enjoyed the currency of these qualities when it came to attracting girls. His weak heart no longer hindered his popularity or power, and it may also have saved his life. He was declared unfit for military service after the war broke out in 1914.

Like Eugen, the bespectacled diminutive Weill also spent much of his early childhood indoors. But despite many hours of piano practice and composing, the young Kurt Julian Weill, born in Dessau on March 2, 1900, was a rosy-cheeked, robust little boy with a healthy heart. He adored his two elder brothers, Nathan and Hans, and was affectionately protective of his younger sister, Ruth. The Weills were sophisticated in every way, including their belief in a vegetarian diet, which had become quite popular among health-conscious people in late nineteenth-century Germany. Kurt's family believed in good food, fresh air, and long walks for the body; music, literature, and art for the soul. They adhered to religious and cultural traditions but maintained a progressive attitude toward contemporary social mores. This was clearly reflected in their decision to give Kurt a middle name. This was not a traditional practice in Jewish culture, and using one was a nod to the social norms of secular Germany. His mother, Emma Ackermann Weill, took the even more unusual step of giving Kurt a literary middle name, Julian, after the character in Stendhal's *The Red and the Black*. Another nod to modernity was the young boy's use of K, rather than the old-fashioned C that was on his birth certificate, for his first name. These minor freedoms were emblematic of his family's hybrid identity.

Compared to Eugen's early years convalescing in his quiet attic

bedroom, Kurt grew up in a happy, bright, and noisy household. Nathan and Hans were more active than their studious little brother, and the family lived very close together in a modest ground-floor apartment next to the synagogue.[7] While Eugen's early language was influenced by hearing Luther's Bible in his mother's voice, Kurt's earliest musical experiences were hearing his mother play the piano. She was an amateur, but she knew enough about music to recognize that her son was undoubtedly a prodigy. Kurt's father, Albert, was a cantor and both parents were delighted at the discovery of their son's musical ability. Kurt's talent was especially treasured by his mother. She was convinced that, of all her children, it would be her youngest son who carried on the proud cultural legacy of her family. Kurt was no less a mama's boy than Eugen, but with a significant difference: In the Weill household, the mother was the dominant parent. Eugen appreciated his ailing mother's loving support, but Emma's approval gave Kurt a privileged position in the household.

The Weills were an established Orthodox Jewish family with German roots going back to the fourteenth century. They were just as German as they were Jewish, but although they were open-minded, they were too religious to ally themselves with assimilated and secular Jews. Alongside their traditional German education, all the children studied the Jewish faith, the Hebrew language, and biblical history. Emma and Albert both descended from a long line of prominent rabbis, and Albert's decision to become a cantor indicated not only his love of music but also a certain lack of ambition. Given the stature of her father and brother, who were both rabbis, Emma especially welcomed the discipline and promise of her youngest son.[8]

It hadn't always been possible for religious Jews to maintain a national German identity, but Dessau was a particularly glowing example of tolerance. Since the early eighteenth century, it had been one of the most enlightened cities in Germany, with a Jewish gymnasium and a synagogue where some of the first German-language sermons of the Jewish faith were heard.[9] One of the city's most famous residents was Moses Mendelssohn, the Jewish philosopher (and grandfather of the composer Felix) whose work helped to establish the friendly cohabitation of Jewish traditions and European culture. At the time Kurt was born, the reigning Duke of Dessau was a liberal man who enthusiasti-

cally continued the warm relationship with the Jewish community. He built a new synagogue in 1908 and promoted Albert to first cantor. In addition to his open religious attitude, the duke was devoted to the arts, and determined to uphold Richard Wagner's coveted description of Dessau as the "Bayreuth of North Germany." The cultivated Weill family was extremely well regarded in this atmosphere, but they hardly took such acceptance for granted. The mutual respect between Germans and Jews was particularly strong in Dessau, but as in all of Europe, the division was still there.

The duke was fond of the musical son of the cantor, and he gave Kurt free admission to all the theatrical and musical performances. The Weills' finances were modest, and these complimentary tickets opened vistas otherwise unavailable to the young boy. The duke also hired Kurt to give his youngest daughter piano lessons, and from a very young age, Kurt was at home in two quite different environments: his Orthodox Jewish family and the ducal palace. He developed a natural ability to deal with authority figures that later would ease his way in the hierarchical world of opera and classical musical establishments. Kurt began his artistic life dependent upon the kindness of royalty, and this created his outwardly modest and humble personality. Even when he became certain of his talent, this aura of humility remained.

In contrast, the young Eugen, the son of the most privileged family on the block, only had to be concerned with his health and the cultivation of his literary gifts. He wanted the respect of his peers, but he didn't need anyone outside his family to provide him with the opportunity. He never learned how to be diplomatic and even came to view this skill with a certain suspicion.

Both Kurt and Eugen reveled in their aura as the family artists, heightening the drama by creating a poetic garret in the attics of their homes. Eugen had his *Kraal,* and Kurt was called the *Dachstubenkomponist* (attic composer) because he would "disappear for long stretches at a time into the privacy of his tiny room under the rooftop to scribble down music."[10] He filled countless pages of his composition notebook and had already written a short opera by the age of eleven. "While most of us went off to play ball after school," a friend remembered, "Kurt would practice the piano or the organ for three to four hours almost every afternoon."[11] But Kurt's musical preoccupation didn't transform

him into a pale loner who rarely socialized. For many years, the daily afternoon strolls where the boys and girls would meet in town were equally as important as his hours at the piano. "Kurt never missed it," Ruth remembered. "He would jump up, wash his face and hands, slick back his hair and take off with Hans, who was the real lady-killer in the family."[12] The Jewish community center was also a very social place and friends would often gather there. Together with his siblings, Kurt would stage plays and concerts and was, of course, in charge of the music. The Weills were all in some way musical, and there was no more exalted and revered occupation than that of composer.

When the war began, Kurt was only fourteen and therefore out of danger in the initial years. But his brothers were drafted right away. To express both his patriotism and his solidarity with his siblings, Kurt joined the German equivalent of the Boy Scouts and proudly donned his uniform.[13] He composed several war songs, including one called "Für Uns" (For us).

Kurt's and Eugen's mothers were relieved that their exceptionally gifted sons wouldn't have to face the dangers of war. But even if the boys were convinced of their talents early on, they nevertheless felt uneasy standing by as their friends and brothers were sent off to battle. Kurt was too young. Eugen was unfit. That would change for both of them as the war dragged on and the "fitness" standards for soldiers were lowered along with the minimum age.

A young man strolling along the Lech River in Augsburg was a rare sight after war was declared. It was a bitter time for sixteen-year-old Eugen, who had finally come into his own. His friends' lives were in danger, and although Eugen's weak constitution kept him safe, it was a blow to his ego. Eventually, his younger brother, Walter, was also called up, which exacerbated his embarrassment.[14] He consoled himself by focusing on his writing, as well as on the local girls with whom he had become especially popular even before most of the competition had been drafted. But he longed for the time when he could lure his friends back into the *Kraal* where he reigned supreme.

In 1914, the most influential man in Germany had, unlike Eugen, never recovered from the humiliation caused by his poor health. Kai-

ser Wilhelm II, born with a crippled arm and a troubled disposition, was neglected at birth by his English mother (the daughter of Queen Victoria). He became Kaiser at the age of thirty due to the early death of his far more confident and liberal father, and he used his power to build up the military might of Germany. A cowardly bully, Wilhelm II destroyed what had long been solid relationships with all his European and Russian friends, but he could not conquer enough territory or gain enough power to cure his inferiority complex. He whipped up the pride and fear of his German subjects and managed to parlay his personal weakness into a national malady. The war would unify all Germans, he promised, far more than the political unification of 1871.[15] If territory and precious natural resources were gained, there would be power for the aristocrats, profits for the industrialists, and jobs for the unemployed. Among the many complications plaguing Europe at the time, one strong motivation for going to war was that the Kaiser wanted to be taken seriously by the rest of the world. When Wilhelm II declared war on France and Russia in 1914, he was involving the country in an adolescent identity crisis of catastrophic proportions.

The war initially inspired patriotic fervor all over Germany, and the young Eugen was swept up in the national mood. He even penned a few nationalistic poems in the same spirit as Kurt's songs, as well as writing many patriotic articles for the local newspaper, praising the war and encouraging his peers to sacrifice for a great cause. But as soon as the illusion of a quick victory began to fray, so did the allegiance of many Germans, including the bright young poet. In 1915, soon after his eighteen-year-old friend Caspar Neher enlisted and was sent to the front, Eugen wrote a school essay expressing the country's disenchantment. "Only blockheads could think of death lightly," he wrote scornfully.[16] As one of the few students left in the classroom, such rebellion hardly went unnoticed, and he was nearly expelled.

Most painful for Eugen was the loss of Caspar—Cas, as he called his dear friend—whose pictures covered his bedroom walls, and with whom he shared burning hopes of an artistic future. He corresponded intensely with his friend, who became a gunner in a Bavarian field artillery, reminding him of their dreams. "We mustn't let anyone talk us into believing that art is a hoax. *Life* is a hoax," he wrote.[17] Throughout Caspar's army duty, Eugen demanded that his friend con-

tinue drawing. Once again marginalized, Eugen had no choice but to insist that interpreting world events through writing and painting was more important than direct experience. The horrors Cas was living through would be useless unless he documented them. He wrote to Cas: "I fervently hope you're keeping a diary. It would be shameful not to. You must write down the important things. Philosophy, people, marches, the dead, guns. When a notebook is full please send it to me. To keep it from falling apart, use as thin ones as possible."[18] In addition to these professorial instructions, Eugen also sent other more adolescent—and utterly tactless—letters describing his evenings out with lovely young girls. Eugen's frequent bouts of bragging along with his stern list of artistic assignments were all attempts to camouflage the shame of being left behind. But he revered Cas, and his love always burst through his pride: "I am praying that you won't be demoralized. And you won't. I need you . . . I like winners more than winning/victors more than victory."[19] He also wrote: "If you get shot dead I shall be an ordinary singular of people. So please *don't!*"[20]

The worst almost came to pass in April 1917 when Caspar's battalion defended a strategically vital area on the western front. The French attack took place on the Chemin des Dames ridge, located in the *département* of Aisne, which had been a stone quarry for centuries. Its underground caves and tunnels offered the German soldiers protection from the bombardment, but the hard rock of the surrounding territory also made it impossible to dig large trenches. Cas fought from holes often no more than eighteen inches to two feet wide, and was unusually vulnerable to highly explosive shells. Buried alive when his narrow pit caved in on top of him, Cas was badly injured and suffered most of all from acute shock. But despite the severity of his condition, he was sent, just a few months later, into yet another perilous battle at the front.

Eugen wrote a wickedly ironic poem that expressed his outrage over Caspar's traumatic experiences. "The Legend of the Dead Soldier," an allegory for the cruel treatment of his friend, portrays a dead soldier as he is pulled out of the grave and sent back to war: "And since the soldier stinks a mile, / A priest limps on before, / Waving an incense burner over him, / So he should stink no more."[21]

Eugen's deeply personal poem captured the national mood of dis-

illusionment. For although he was likely unaware of a 1917 sketch by the revolutionary Berlin artist George Grosz, it had rendered precisely the same accusation. Titled *The Faith Healers*, the drawing shows army doctors declaring a skeleton fit for military service. Life was indeed a hoax, and a cruel one, and like the war itself, the furious reception of this poem would haunt Eugen for a long time to come.

Eugen was careful to hide the fact that the poem was inspired by Cas, and long after it was published and became famous, few people were aware of its heartfelt origin. He dedicated it to a presumably imaginary "Christian Grumbeis," born on April 11, 1897. This was Caspar's actual birthday and served as a clue that would be easy for his "brother in art" to discover.[22] Eugen didn't share his true feelings with very many people, but in those days, he rarely hid anything from Caspar.

Due to the war, Eugen was given an emergency gymnasium diploma and went off to university to study literature and philosophy. He soon switched to medicine, a change calculated to keep him from the front in the likely event that even the weakest of men were to be drafted. In the final year of the war, he was called in for an examination, and although he drank an enormous amount of coffee right before his physical, he was, like Grosz's skeleton, judged fit for service.[23] His father's influence and his medical studies helped him gain a place as an orderly in a military hospital.

Before reporting for duty, Eugen hurried to finish his first professional play. Titled *Baal*, it is about a poet "of the streets and the cities." Named for the lustful deity of insatiability, Baal is a Christian symbol of evil and not so different from the lusty young Eugen himself.[24] The play was written as a direct response to Hanns Johst's *The Lonely One*. But where Johst's work admires the unhappy poet he portrays, Brecht's *Baal* contradicts the traditional German reverence for the poet as a lonely visionary. Instead of exerting a moral and aesthetic influence on mankind, Baal is a rogue poet and a sinner who exemplifies man's weakness.[25] "No brandy, no poetry," Baal declares. He continues: "The Lord God, who sufficiently declared his true nature once and for all in combining the sexual organ with the urinary tract." *Baal* is a loosely structured play that follows the deceitful young poet on his destructive journey. He causes a woman to take her life, kills his

best friend, and neither redemption nor punishment is offered for the profligate poet. *Baal* is best described by a beggar in the play: "Tales that can be understood are just badly told."[26] The play often has the tone of a locker room guffaw—a schoolboy's exploration of his crude sexuality. But Eugen's budding genius is everywhere apparent. His first play effectively captures the spirit of expressionist drama, and yet the passion of the poet and his plight is simultaneously lampooned by the crudeness of his sensibility. By merging the idiomatic language of the marketplaces and fairs he attended as a boy with the rhythmic beauty of the poets and playwrights he had mastered, Eugen created an entirely new language for the stage. A few months shy of his eighteenth birthday, he extended his new speech style to his name. He was no longer Eugen Berthold Friedrich Brecht, but simply Bert Brecht. The poet and playwright had come into his own just moments before he donned the uniform of the German army.

Brecht, as he had begun to refer to himself, trained for three weeks and was then sent to an emergency military hospital in his hometown. The clinic was little more than a series of hastily erected unheated wooden huts built on the playground of an Augsburg school. His duties were relatively light, and he was even allowed to sleep at his family home. After a few weeks of assisting with operations and amputations, he was placed in Ward D, the unit treating officers with venereal disease. This was unpleasant, but shielded him from the far more grotesque experiences helping the many soldiers who lost their limbs, and often their sanity, during the war.

His assignment certainly didn't interfere with his intense but sporadic love affair with a local girl, Paula Banholzer. By the time the war ended in November 1918, the sweet, smart Catholic daughter of a doctor, nicknamed "Bi," was pregnant. Her parents were adamantly against their daughter marrying her troublesome poet boyfriend, and he was overwhelmed by both the responsibility and the romance of the debacle. One of the many rhapsodic letters he wrote her was typically laced with his self-mocking humor, as he compares himself to the Holy Ghost: "Maybe our child will see the first light of day from a farmhouse room and hear as his first noise the soft bleating of the sheep and the dark moo of a motherly cow—like the little Jew in Bethlehem, only then an even more holy spirit than I was the guilty one."[27]

No matter how the situation was handled, Brecht would have to make the irrevocable step from son to father just in the moment when the entire country was undergoing the same transformation. The "sons," who had trusted the monarch, obeyed the generals, and helped the nation's industrialists make a fortune off the war, were traumatized by the unnecessary slaughter of their brothers. The burden of rebuilding the ruined nation was on their youthful and inexperienced shoulders, and they were grappling with its weight. Brecht was to become a parent in a world where the fathers had so bitterly failed.

Kurt's family also suffered from the misfortune the war had wrought on all of Germany. As the youngest son, fourteen-year-old Kurt may not have feared being drafted when the war began, but his father's salary was slashed, and food and clothing were scarce for the first time in their lives. He was perhaps equally surprised by his parents' refusal to ask for help. His sister "remembered taking hikes with Kurt to small villages trying to find food, without success."[28] His eldest brother, Nathan, was soon drafted and, like Brecht, served as a medical orderly. But instead of the safety of a makeshift clinic in his schoolyard where Brecht was lucky enough to be placed, Nathan was unfortunately sent to the front. Hans was drafted the following year but was ultimately rejected because two of his fingers had been fused since birth. The Weills were hardly the only family in Dessau to suffer. Kurt wrote Hans about his rapidly disappearing classmates as the war escalated: "Now we're only filling just one single bench; . . . this seems somewhat eerie."[29]

The war also made the concept of "singing for your supper" even more appealing to the young prodigy. He had already been welcomed into the palace to instruct the duke's daughter, and he would soon find favor with the conductor and musical director of the court theater. Albert Bing was the first Jew to have such a prominent position at the palace, a fact young Kurt certainly noticed. Bing instantly recognized the boy's talent, and he not only extended the duke's invitations to the theater rehearsals and performances but also taught Kurt composition, piano, orchestration, and conducting. Since so many trained musicians had been drafted, Bing was also able to employ his

seventeen-year-old student as an accompanist and opera coach. The Bings introduced Kurt to the sophisticated world of cosmopolitan Jews "who sought religiosity in music and literature rather than ritual."[30] In contrast to the assimilated Bings, Kurt still strongly identified with his traditional Jewish upbringing. His letters are rich with Jewish expressions and the occasional Hebrew word, illustrating that his religious background was just as important to him as music. With Bing, he worshipped Beethoven and Haydn and Verdi—and with his family, he celebrated the Sabbath and the High Holy Days.

Far from the horrors of the front, Kurt learned and practiced his craft in the haunted atmosphere of a war-torn country. Classrooms, theaters, and concert halls were nearly empty, and inside the palace Kurt experienced a musical education whose intensity surpassed the finest of conservatories. He had daily piano lessons, and if he wasn't weakened by hunger, he practiced for many additional hours.

The richness of Kurt's musical life was in sharp contrast to the scarcity of food. His sister, Ruth, remembered that "Kurt frequently fainted from hunger and eagerly looked forward to any invitation where there was some good, solid food to be had."[31] His enthusiasm for a great meal even outweighed the young composer's usual diplomacy. If Brecht cruelly wrote Cas at the front about his success with the lonely women left behind, Kurt was equally shameless when he described one of his rare moments of culinary satisfaction to Nathan and Hans: "You ask how I like my present food situation. Well: better than ever. Firstly: as many potatoes as the heart desires. Secondly, always wonderful and sometimes some fancy tidbits and now, thirdly, all day long those terrific pears, with which I fill my pockets every morning and afternoon, eating one right after the other. That way one can really keep going."[32] Every time Kurt had a joyful encounter with food, he saw fit to share it with Hans: "Yesterday we went to the country and at some rich person's house we had marvelous cake and country bread with snow white butter and Swiss cheese."[33] The food shortage in Germany reached its peak in the "Turnip Winter" of 1918. This bland root vegetable, preferable only to starvation, was the main staple of the German diet for many months. By comparison, potatoes were a delicacy that Kurt treasured all his life.

Toward the end of the war, Kurt began to worry that the mini-

mum age requirements for soldiers would be altered in the increasingly hopeless war. Just in case he was drafted, Kurt bought a cheap trumpet and began taking lessons in the hopes of being assigned to the military band. The night before his medical examination, he swallowed a hundred aspirins, and Ruth stayed by his side until dawn. His heart was pounding so rapidly that he was, unlike the caffeine-stoked Brecht, judged unfit for service.[34] Finally, the eighteen-year-old was unburdened by the ever-present threat of becoming cannon fodder, and soon afterward, Kurt was accepted to the prestigious music conservatory in Berlin. He arrived in the city with no money but confident that his talent and impressive musical skills would help him survive.

Weill found a tiny, unheated room and began his studies with the great composer Engelbert Humperdinck, whom he managed to impress within a few short weeks. But despite the celebrity of his teacher, Weill felt he was ready to move on after the first year of his studies. He yearned to study with Arnold Schoenberg, but the famous composer was in Vienna and private studies were expensive. And although Weill thought Schoenberg was the most compelling and original composer of his day, he was not eager to leave the cultural center of Germany. He slept to the sound of the nearby streetcar and survived on a student stipend and a small salary from the synagogue where he conducted the choir. But far more transforming than the musical education Weill received was the opportunity for him to watch the entire nation go down in flames.

By the fall of 1918, the political chaos generated by the Kaiser's abdication—which in turn spurred many competing revolutionary groups into action—dominated the entire country. Berlin was at the center of the explosion. Tens of thousands of people were congregating all over the city, the royalty was on the run, and everyone with a following was proclaiming their own republic. Weill wrote to Hans with great excitement, "The great revolution broke out with such elemental force and such fabulous speed . . . On Saturday I stayed close to the Reichstag all day and saw them force their way into the barracks and form the workers' and soldiers' councils. I witnessed the parades, the speeches of Liebknecht . . . and finally the fierce fighting that night in

front of the royal stables . . . I was also present at the pitched battle at the Reichstag . . . I could fill volumes. But I'm too tired!"[35] Weill was not at all conservative, but he was still hesitant to embrace the "dictatorship of the Proletariat," which Spartacists (a radical Socialist group) like Rosa Luxemburg and Karl Liebknecht favored. But when these two idealistic leaders were summarily murdered by the menacing Freikorps—a military force consisting of former imperial officers from the war—Weill's ideological concerns about the left-wing activists were soon replaced by an abject horror of the violent right.[36] As he witnessed his country having a violent nervous breakdown, the conservatory training Weill had longed for became a mere backdrop for far more important events. After waging a long war against most of the world, Germans were now killing each other.

The young composer heard an entirely new sound in the demonstrations ringing through the city and longed "to write down uninterruptedly everything that makes my head practically burst, and hear only music and be only music. Oh yes, the kind of things one dreams about."[37] Weill's artistic vision was being wrought as the German citizens battled their way to a new political identity. The war was crashing to its hotly debated end, and the music of the future had to appreciate and accompany the shouts of rage echoing off the asphalt. Weill was determined to be one of the first composers to discover its melody.

In Augsburg, Brecht's *Kraal* once again became the postwar gathering place for his "brothers in arte." His floor was permanently littered with books, newspaper cuttings, and Neher's drawings of Nietzsche, Napoleon, Wedekind, and, of course, Baal. His guitar hung ceremoniously over his bed. Whenever his friends were on leave, and later when they had returned from the war, they intensively discussed *Baal* and Brecht's poetry. This first literary collective was formative. Brecht discovered and cultivated his need for the constant company of devoted collaborators.

Just like Weill in the north, Brecht was ideally placed to observe and capture the cataclysmic ending of the Great War in the south.[38] The country that had hoped to be united by fighting its neighbors was soon divided, not only by political party but even more bitterly by regional pride. The rivalry between Prussia (Berlin) and Bavaria (Munich) ironically had its roots in the traditional monarchies of the past. The

royals had lost their power in the wake of the Kaiser's abdication, but the local identity of their subjects was not easily abandoned. Only two months after the Social Democratic Weimar Republic was declared in Berlin, Kurt Eisner proclaimed the Revolutionary Republic of Bavaria in Munich. Equally as important as their political differences was the fact that Brecht's fellow Bavarians refused to be ruled by the government in the north. The anger over the brutal double assassination of "Red Rosa" Luxemburg and Karl Liebknecht provoked Eisner and the left-wing Socialists to seize the day in Bavaria. The lethal mixture of geography and politics was tearing the country apart.

Brecht participated directly, if somewhat coincidentally, in Eisner's brief reign. Workers' councils, inspired by the Russian revolution, were formed by laborers, sailors, soldiers, and farmers to support the new republic. As a medical orderly, Brecht was chosen for his eloquence, not his commitment to the cause, and he became the leader of his military hospital's council. But shortly after the left took power, Eisner was assassinated in 1919 by a young, right-wing aristocrat. The murderer was a misguided boy acting alone, but the assassination became a lightning rod for the postwar fury and confusion of the German people. Even those who disliked Eisner and Socialism were horrified to see Germans killing each other in the wake of their international defeat. And yet some conservatives were grateful that the Socialist Republic was so short-lived and were willing to accept murder as a necessary evil. One of Brecht's good friends, Hanns Otto Münsterer, describes the reaction to Eisner's fate: "In the following stormy night in Augsburg we were present at the street fighting and helped to carry away the dead and wounded, but Brecht experienced the events in Munich. He stayed there in appallingly middle-class student digs full of plush-covered furniture, and wrote, in three days, a new play called *Spartacus*." The title was a clear reference to the bloody Socialist uprising in Berlin that resulted in the assassination of Luxemburg and Liebknecht.[39] The play also drew an implicit connection between the murders perpetrated by the extreme right in Berlin and Eisner's fate in Munich.

Spartacus proved that Brecht was already able to render the fractured political state of his country on the theatrical stage. This was a remarkable feat for anyone living in the middle of a prolonged and bloody version of a civil war, let alone such a young playwright. He

wanted to illuminate the country's chaos in his work and devoted himself full time to writing plays that were as revolutionary in style as they were in content. By observing and writing, rather than engaging in the street protests and local politics, Brecht was actually reflecting the spirit of the Weimar Republic itself. Weimar was the birthplace of Goethe and Schiller, and the hope was that naming the republic after this illustrious city would evoke the country's cultural pride. Military and political attempts at unity had failed—and despite its divisive beginnings, the citizens of the Weimar Republic in Berlin still pinned their hopes on great poets to quell the fury that was exploding all over the country. War had failed—art must prevail.

In *Spartacus,* the soldier Kragler returns home only to be ridiculed for having gone to war at all. Rejected by his fiancée and her family, Kragler becomes a symbol of all that Germans would prefer to forget. But Kragler doesn't even react to the injustice of his plight as a veteran. Since there are no more heroes or heroic solutions, he doesn't join any of the left-wing revolutions or any other political group. "Every man for himself," he declares. The war has taught him one thing only: how to survive. "I am a swine," he brags, and Brecht's spirited and youthful play insists that this is the only useful identity in the swinish jungle of a world he inhabits.[40]

Brecht had enough confidence in his two plays to approach the successful Jewish playwright, author, and dramaturg Lion Feuchtwanger.[41] They met a month after Eisner's assassination when tempers in Munich were still ablaze. Feuchtwanger, then thirty-four years old, was surprised to find such a cool head and acerbic tone in a "slight, badly shaven, shabbily dressed" young man.[42] Feuchtwanger was impressed not only by Brecht's astute social observations but also by his original language, and the influential writer quickly introduced him to the luminaries of the Munich theatrical world. The career of the twenty-year-old Brecht was launched.

Brecht was concerned about the very pregnant Bi, but he was far more preoccupied with what he believed were his obligations as a poet. As a very young man about to become a father, these creative obligations also included a wide variety of life experiences. He spent many wild evenings with his friends, sometimes visiting brothels, a habit that once landed him in jail.[43] Convinced that writing was also the

only way he could make a living, he saw no conflict between his artistic yearnings and paternal responsibilities. If his father had told him to get a paying job, he would have replied that he was doing exactly that by peddling his plays and poetry. He wrote to Bi proudly that Feuchtwanger, "who's very important and writes good plays himself, finds *Spartacus* very nice. He'll do something for it and we'll get some money . . . It was written for you . . . I love you, girl, I kiss you always on the knee, secretly, in the evening. When can one come to you?"[44]

As quick as he was, Brecht's writing could hardly keep up with the continuing political violence. In 1919, just a month after he finished *Spartacus*, a Russian Communist named Eugen Leviné declared the Bavarian Soviet Republic. His "dictatorship of the Proletariat" promised apartments to the homeless and factories to the workers, but he was soon accused of brutally murdering eight right-wing spies. The vulnerable Weimar Republic, still hoping to unify the entire country, sent in the Freikorps. They killed more than seven hundred civilian men and women, eight thousand Red Army soldiers, and they shot Leviné as well. Only two months after Eisner's proclamation and murder, the Communists were once again infuriated by the unholy alliance between the centrist Social Democrats in Berlin and the right-wing military corps on the far right. To Brecht's great disappointment, his brother Walter volunteered for the Freikorps. Like many good bourgeois sons, Walter feared the Soviet threat and believed that restoring order was the first priority, even if it meant joining the conservative military forces. Neher's father also wanted his son to join in this "anti-Red" maneuver, but the artist flatly refused. Both Neher and Brecht understood that working with the former imperial officers who had aided and abetted the Kaiser's war was a deal with the devil. If neither artist was completely in league with either Communists or Socialists, they certainly leaned heavily to the left. Brecht did hide a Spartacist leader in his Augsburg bedroom, but purely out of friendship.

Shortly after Leviné's assassination, a group of right-wing soldiers conducted a surprise search of Feuchtwanger's house and found a copy of *Spartacus* in his desk drawer. Its incendiary content might well have provoked them to execute him on the spot, but by sheer chance, some of the soldiers had seen Feuchtwanger's plays and read his books. They

listened dutifully when the "Professor Doctor" explained that the manuscript was not propaganda material.[45]

In the summer of 1919, Brecht and Bi's son was born. They named him Frank, after one of Brecht's favorite playwrights, Wedekind, and for the time being, he was sent to a family of farmers in the country. Since Bi was Catholic, they baptized Frank a month later, naming Neher as a godparent. It was a scandalous out-of-wedlock birth, but the christening was celebrated at a proper bourgeois luncheon with friends and family. This combination of formality and rebellion defined the enigmatic Brecht—not yet twenty-one—as a poet who rejected the traditions of the past but who was still under their influence. He disdained religion, but he loved the Bible; he required artistic freedom to transform the literary future, but he also needed a paycheck to fulfill his obligations to his son. He was sufficiently worried about his parents' reaction that he waited two months before telling them he had become a father.

With two plays completed, a book of poetry on the way, a job as a critic for the local newspaper, and, thanks to Feuchtwanger, increasing interest in his work, Brecht settled down to write with great intensity. He hoped to fulfill his roles as father and artist, but just two months after Frank's birth, he met a beautiful opera singer named Marianne Zoff. He still adored Bi, but he fell passionately and uncontrollably in love with "Mar." Brecht's emotional life became dramatically more complicated, and yet he still managed to produce enough material to be regarded as a wunderkind by the theatrical establishment. He could no sooner stop himself from absorbing the zeitgeist into his work than he could resist Mar's spell. Brecht believed he could and must experience life as intensely as possible and on all fronts, and he didn't even try to resist. He captured this quite precisely in his journal: "I am seized with a wish to have the whole world delivered to me: I wish all things to be handed over to *me*, along with power over all animals; and my grounds for this demand are that I shall exist only *once*."[46] Perhaps his grandiose hauteur also stemmed from the fact not only that he was a brilliant observer but also that he was documenting a transformative era in the history of Germany. His plays, as he saw it, were as necessary to the country as brick and mortar. This made him feel powerful.

The internal combustion of Weill's and Brecht's prodigious talents were further inflamed by the bloody battles for power on the streets of Berlin and Munich. Coming of age as men and artists against the backdrop of these seething political divisions, it's significant that both of them refused to narrow their focus to a particular party. But there was a very great difference between the two artists' responses to the chaos, one that reveals their starkly contrasting backgrounds and personalities. Brecht was far more eager to attack established bourgeois society. In its depiction of a soldier's humiliating betrayal, *Spartacus* exposed the hypocrisy not only of the government but also of a society determined to erase its own complicity in the war. Brecht mocked his class with abandon—which meant he had no fear of losing his place.

It was quite a different matter for the Jewish composer. Weill's first response to the uprising was concern for its effect on the Jews. Unlike Brecht, Weill closed ranks with his people. In the heat of the November revolutions, he wrote Hans: "It would all be fine were it not for one fear: that in place of a dictatorship of the aristocracy we could get a dictatorship of the proletariat . . . (And then) . . . we can expect Russian conditions—and pogroms . . . Jews are being used by every party that feels oppressed as a means of deflection . . . The mob is just waiting for the call to revolt and pillage, and their favorite target will be the Jews."[47]

Just as Brecht led the council of his military hospital, Weill participated in the student council at his university in Berlin. But once again, his only activism was on behalf of the Jews. He remarked that he accepted a place in order to "fight the *Risches*."[48] But outside their minor roles in these councils, it is significant that neither Brecht nor Weill participated directly in the struggle for political power. Holding fast to pens and batons in this time cannot have been easy, and it proves both men realized that, for them, the only meaningful shout of protest would be through the medium of words and music.

In the summer of 1919, the conscientious Weill was called home from Berlin to help his family. Everything had been shaken up in Dessau—the duke was no longer in control, and sources of funding for the arts as well as religious organizations had been slashed. The synagogue in Dessau was nearly out of money, and Weill's father had lost his job. Nathan had returned safely from the front but was away studying med-

icine. Hans was a merchant's apprentice in another town. Although he was the youngest, Weill was the only one who was able to earn a salary right away. Once again, his mother had the opportunity to admire her capable and disciplined son, who took on the responsibilities his father was unable to meet. Weill first went back to work as an opera coach for his old mentor Bing, but he quickly found a more satisfying job as a conductor in the small town of Lüdenscheid. Although Weill was not happy to leave Berlin or to stop his studies, this job influenced him in a profound way. It was here that he first fell in love with musical theater. He told his sister that writing music for the dramatic stage would "probably turn out to be my life's work."[49] He certainly received a trial by fire, conducting everything from *Die Fledermaus* to *Cavalleria rusticana* to *The Flying Dutchman*. He was nineteen years old.

As soon as his father found a job at a boy's orphanage in Leipzig, Weill went racing back to the city of his dreams. Brecht was still firmly rooted in Bavaria, even though he knew that in order to fundamentally renew the cultural and spiritual life of Germany, Berlin was the place to be.

Brecht had, with his first two plays, forcibly taken poets and soldiers off their exalted pedestals and revealed their simple, wretched humanity. These plays had impressed Feuchtwanger—who not only was a celebrated writer but also worked for a publisher and as the dramaturg of the Munich Kammerspiele. These connections, in addition to the support he would receive from Herbert Jhering, one of the most influential drama critics in Germany, and the subsequent admiration and attention from playwrights such as Arnolt Bronnen, made it clear that Brecht would soon be produced and published. But his father could only see a rebellious son who had gotten a girl into "trouble," and who had no degree, no job, and no interest in the paper business. Brecht Sr. had a more dutiful child in Walter, who had fought bravely in the war and planned to follow in his father's professional footsteps. When Brecht's devoted mother died of breast cancer in 1920, he was devastated to lose not only the gentle parent he had loved but also the person whose faith in him was the foundation of all that he strived to become. He deeply regretted the fact that his rebellious behavior had driven a wedge between them in her last few years. Although he was too upset to attend her funeral, and watch her coffin being lowered

into the ground, Brecht characteristically wrote about it with mock bravado in his journal: "Why watch what is self-evident." He would, however, visit her grave regularly after the "earth covered her over."[50]

Brecht now craved his father's approval more than ever. This is most poignantly shown in a letter he wrote begging his father, who had already paid the family in the country to care for Frank, to take his son into his home: "I've gone back and forth in my mind about what to do with my child, and if I give up this last desperate way out then I don't know any more what to do, and wait with a pounding heart for your decision. I know of course, that it's a huge favor to ask, to take my child with you to live, and I am very grateful that you didn't say no right away—but it would be so good for the child, when he had a home, and a real upbringing."[51] Brecht swore to his father that he would marry Bi as soon as he had enough money. But he was worried about what would happen to Frank during these formative years. As he wrote to his brother Walter: "At our house, it's the best care that could be had. It is now the years where speaking and thinking are learned, and the impressions now are the most important."[52] Despite Brecht's penchant for assaulting the bourgeoisie, these letters reveal just how much regard the twenty-two-year-old Brecht had for his class and education. Although his plays and poetry were singing the song of the common man, Brecht nevertheless feared that Frank would grow up to be like the simple farm people who were raising him. His expectation that his family should take responsibility for his mistakes highlights not only his self-centered nature but also his upper-class sense of entitlement. Perhaps he also hoped his father would want to take on at least a fraction of his adoring mother's role in his life.

Brecht's father had no interest in maintaining his late wife's total acceptance of their eldest son's folly, and although he contributed financially, he refused to let Frank live with him. The poet wouldn't starve, but he received little in the way of encouragement. A few months after his mother's death, Brecht describes an argument with his father in his journal: "He'd like to know what I've done for the community so far . . . My literary achievements in his personal view amount to nothing at all . . . What's a poem worth? Four shirts, a loaf of bread, half a cow?"[53] The prospect of unconditional love from a parent had died

with his mother, but Brecht ardently hoped that his ability to transform the culture of Germany would ultimately earn his father's respect.

The need for artistic transformation was dire, and Brecht wrote scathing theater reviews in the Augsburg newspaper. In his letters to Neher, he declared that "the theaters should be closed on artistic grounds. There won't be any art until the last theatergoer hangs himself with the bowels of the last actor."[54] He believed that the seeds of the future were in Germany's folk culture, and when Brecht wrote *Baal* and *Spartacus,* he invoked the street ballads and speech patterns found at his beloved Augsburg fairgrounds. As far as he was concerned, cabaret was the only form of existing theater that was worthwhile. Brecht attended cabarets all over Munich and even managed to perform in one of the best, Karl Valentin's famous Laughing Cellar.[55] Valentin was the Chaplin of Germany, and his act included Brecht on the clarinet, a show girl, a straight man, and a clown. Combining slapstick antics and edgy satire, the top-hatted Valentin's act was intelligent but also had a broad comic appeal.

Brecht's immersion in the cabaret and theater life of Munich kept him very busy, but it was hard to ignore the increasingly loud siren call from the north. Berlin was rapidly becoming the gathering place for the left, the liberal, and the artistic, but most of all, for anyone connected to the theater and publishing. And since Brecht had so far been unable to find a theater willing to take his provocative play *Baal,* he tried to cultivate the important Berlin publishers and theaters by taking short trips to Berlin. But the cold and unfriendly city, with its "every man for himself" atmosphere, was not yet a place he could imagine living. After one of his prolonged visits, he wrote in his diary, "Nobody has yet described the big city as a jungle. Where are its heroes, its colonizers, its victims? The hostility of the big city, its malignant stony consistency, its Babylonian confusion of language . . . its poetry has not yet been created."[56] It was Brecht's innocence that allowed him to see Berlin's asphalt cruelty. His naïveté, which was as strong as his literary sophistication, gave him the ability to recognize the many faces of modernity—simultaneously fertile and inhumane—reflected in the city's pavement. The sharp-tongued poet was still a wide-eyed boy from Bavaria, lingering in the shade of Augsburg's leafy chestnut

trees and enjoying the elegance of Munich's literary elite. Berlin was a beguiling city full of temptation, but still foreign to his soul.

Brecht was at home in the Bavarian landscape—he liked breathing its fresh air, swimming in its rivers, and enjoying its southern sense of humor. He occasionally saw his son in the country and still hoped that his father would relent and take Frank in. Throughout the early years of his passionate courtship of Mar, he continued to be sincerely and romantically involved with Bi. In turn, Bi had bouts of impatience and engaged in other relationships. Her "infidelity" aroused Brecht's ferocious jealousy, even as he was openly struggling with his passion for Mar. Mar, too, had another lover with whom Brecht constantly tangled. Brecht could control Bi up to a point; conversely, Mar's erratic behavior sent him into paroxysms of anger, despair, and possessiveness. He was, like many young men, unsure how to recognize true love. Was it the comfort and peace of your first teenage sweetheart, or the overpowering lust and fascination of a great beauty? Two elements made Brecht's situation very different from most: He already had a son whom he couldn't afford to support, and he would soon have a daughter with Mar. Unlike Bi, she demanded marriage, and he agreed with very mixed feelings.[57] His letters to both of them reveal a mixture of confusion, desperation, youthful bravado, and fear. His affection for both was so intertwined that he even convinced Mar to take care of Frank for several months. The warmhearted poet was indeed coldly practical when it came to his career, and he was unwilling to abandon his talent and ambition, no matter how much he loved the women in his life. And it is only possible to understand Brecht by accepting that he loved them both very much and expected each to love him in return, regardless of his flagrant infidelity. Brecht would have dismissed an accusation that he was a heartless womanizer. He sincerely wanted to make everyone happy, including himself, and he was grandiose enough to believe that he could. The only limitation he accepted was "I shall exist only *once*."

Brecht may have been anchored in Munich by women and children, and the landscape, but he only remained there so long because it was still the place where his artistic gifts were most noticed. And although *Baal* remained unproduced, his second play, *Spartacus*, now renamed *Drums in the Night* to soften its political provocation, premiered

to great success in September 1922 at the Munich Kammerspiele. The
director Otto Falckenberg, whom Brecht had already impressed as
a dramaturg for his theater, was gratified not only by the praise his
bold and risky young playwright received but also the opportunity to
bask in the glow of Brecht's success. Jhering declared that *Drums* had
"changed the literary landscape overnight," and in his review credited
the courageous director for mounting the play: "Falckenberg and the
Munich Kammerspiele . . . have done more for the German drama
with this production of Bert Brecht than has Berlin in recent days with
all its theaters put together."[58]

Although Brecht was only twenty-four when *Drums* premiered, this
recognition seemed long overdue to the ambitious playwright. His
belief in himself and his need for control was everywhere apparent,
and he had constantly intervened in the rehearsals. If the text wasn't
working, he rewrote it immediately and demanded that the actor learn
it on the spot. He also hounded the director mercilessly. Brecht's impo-
lite manner and unpleasant appearance took their toll. Mar remem-
bered "that many of his colleagues and the actors suffered because
of his flawed approach to his bodily hygiene, and about that there
were even conflicts . . . I tried to change his unkempt appearance . . . I
washed him."[59] Brecht's theatrical skills were mighty and never failed
to impress, but by the time his play premiered, he had earned, to put it
mildly, a reputation for being difficult.

He didn't care. He knew he was among the best young writers in
Germany. And he was sincerely, and just a bit belligerently, certain that
his country needed him in return. His plays would find an audience.

Weill returned to Berlin in the fall of 1920 to find the city that had
survived war and revolution undergoing yet another transformation.
The Weimar Republic had merged many separate districts, urban and
rural, to form "Greater Berlin," a city of more than 3.5 million people.
It was now a truly cultural metropolis, and this time, Weill was in
a far better position to take advantage of what the city had to offer.
Although he still wore threadbare shirts and his coat was too thin for
the northern winters, he was grateful for the fifty marks a month he
was receiving from a generous uncle.[60] Even more exciting, he had

been accepted into a master class with the renowned composer Ferruccio Busoni.[61] Busoni wanted to "renew the opera" and, like Weill, compose music that dealt with political, social, and philosophical issues. Weill had found the perfect mentor, as brilliant as he was encouraging, and accepted the compliment of being the youngest member of the master class with great humility. He wrote Busoni, "Let me assist you in the future for whatever you might need me for . . . I'll be there for your work and for your life with everything I have."[62] Weill's sincere appreciation makes a stark contrast with Brecht's demanding posturing during his first production. The playwright felt entitled to the attention and insisted upon his authority. The composer's equal confidence had the opposite effect: He was eager to express his gratitude. Busoni adored his pupil in return and dubbed him, with sincere affection, "a very fine little Jew."[63] During his years with the "master," Weill was very productive. He composed a string quartet, a song cycle, a concerto, and a children's ballet. But although he was developing his classical skills, his liberal idealism quickly found its way into his work. He made no secret of his ambitions to reach a broad audience and dedicated his first orchestral piece to workers, farmers, and soldiers.[64] "What do you want to become, a Verdi of the poor?" Busoni asked him with a hint of disdain. Weill's answer was ready: "Is that so bad?"[65] Weill was poor enough himself at the time—he traveled all over the city to give lessons in order to eke out a living. Food came first, and he spent the rest of his money on music.

It was in the middle of his studies with Busoni that Weill became an official member of the November Group, so named for the month of revolutions during which the monarchy collapsed and the fledgling democracy was born. Weill was completely in league with the group's goal of creating "art for the people," but it wasn't long before he found their political ambitions difficult to support. Weill believed that both the subject matter and the music for his compositions must engage and entertain the broader public, but he definitively parted ways with the artists who insisted that art should promote a particular political structure, or a "society of workers," as their proclamation read.[66]

Up to this point, he was on exactly the same path as Brecht. For both young men, the very act of liberating culture from its elitist jail cell was revolutionary enough. And since they were aiming for works

that would bring in a crowd, neither was eager to replace the court snobbery with the equally limiting demands of didactic political ideas. "People are always telling us that we mustn't simply produce what the public demands," Brecht wrote. "But I believe that an artist, even if he sits in strictest seclusion in the traditional garret working for future generations, is unlikely to produce anything without some wind in his sails . . . (Once one has a wind one can naturally sail against it; the only impossibility is to sail with no wind at all.)"[67] Without appealing to a broad audience, no crusade for the *people* would take place.

But even if they didn't believe in the social obligations of art, it would have been impossible for any artist to shut the door of his studio and ignore the ongoing calamity of contemporary events. Weill had to work several jobs in order to eat and study with Busoni, but the poverty and privation in Germany had reached a truly alarming state by the beginning of 1923. Ever since the war had ended, the punishing reparations had been impossible to maintain. When Germany defaulted on its payments, conflicts with France and Belgium forced the government to take the even more disastrous step of simply printing money, unbacked by any precious metals. Whether a citizen was buying a loaf of bread with a wheelbarrow full of money or giving music lessons in exchange for butter, no one was immune to the rampant bankruptcy and starvation. In order for music and theater to communicate with a society that was in a perpetual state of emergency, it had to utterly disown the dishonorable imperial past. Even the most abstract of cultural controversies—such as the Austrian Schoenberg's twelve-tone method of composition introduced that same catastrophic year—can be viewed as a reaction to the crisis acutely affecting Germany and rippling throughout Europe. The Kaiser's war had brought the country to the brink of ruin, and the transition from monarchy to democracy was essential to its survival. However apolitical Schoenberg might have been, his proposal that all tones are inherently equal must still be seen as a pungent political metaphor.

In these turbulent times, Weill hoped that romance would provide a sanctuary of peace and tranquillity. If Brecht craved the sexual and emotional drama that was part and parcel of his complicated love life, Weill's needs were just as extreme in the spiritual direction. "What I require of a woman," Weill wrote to his brother Hans, "what every-

one, we artists perhaps the most, needs of a woman—not only in the sensual but also in the psychological and spiritual aspects—is what Goethe raised to its highest incarnation with his 'ewig Weibliche' [the eternal Feminine], the very thing that one rarely finds in intelligent girls."[68] Weill's devotion to his music overshadowed and sometimes even extinguished his sexual and romantic urges. Brecht, however, seemed unable to work or even breathe without his constantly shifting and ever more intense passions.

When Weill met his distant cousin Nelly Frank at Hans's wedding, he found an intelligent woman who could be a source of affection and comfort. She was a sophisticated married woman and, once again in contrast to Bi and Mar, she was unlikely to become too attached or accidentally pregnant. Their relationship was loving and warm, and she was wealthy enough to take him to Italy to see the cultural sights in the winter of 1924. They enjoyed the work of Michelangelo, Raphael, and Leonardo da Vinci—he dedicated a song cycle to her called *Frauentanz* (Women's Dance)—and Frank seemed to offer a glimpse of the "eternal feminine" he was seeking. They did not let the affair get out of hand, and it ended amicably after three years.

In contrast, Brecht was incapable of ending any of his relationships. He always found something irreplaceable in the successive women he loved—to him, they were all "ideal" in their own way—and he wanted to keep all of them. Weill was an entirely different kind of romantic, always certain that there was only one "ideal," even if its definition shifted over time. He made fun of his shifting ideas about the "perfect woman" in a letter to Ruth: "My terms: extremely pretty, very stupid, unmusical, with a dowry of a million marks."[69]

During the rehearsals for his children's pantomime, Weill briefly encountered a woman who asked him to play "The Blue Danube" for her audition. But she was so much the opposite of his "ideal"—not pretty, quite poor, and rather musical—that he failed to notice her at all. He didn't even catch her name, one he would come to know so well: Lotte Lenya. The show was aptly titled *The Magic Night,* and it proved most enchanting for the young composer. For although he had long been trying to camouflage the complexity of his compositions—to achieve what Busoni called "Oneness"—this was the first time he had actually succeeded in achieving the kind of simplicity for which he was

striving. Weill was certain that composing for an audience of children had been the decisive force. The ballet was, appropriately enough, the first time he used popular dance music on the stage, but he also incorporated parts of his earlier string quartets, as well as marching music in the style of Mahler. He combined these disparate elements and distilled them into a hauntingly magical score.

Sitting in the audience was the famous playwright Georg Kaiser, who not only would jump-start Weill's stage career but would also offer him a second chance to meet the woman of his life. It would be several years before this momentous encounter would come to pass, and in the meantime, Weill continued studying, composing, teaching, and, above all, searching for the elusive, and as yet unwritten, melody of his generation.

As Weill was thoughtfully wading in the musical waters of Berlin, Brecht was plunging himself into the deep end of the Munich Theater. After *Drums in the Night* had been so well received, he began enthusiastically writing *In the Jungle of Cities*. The title was a direct reference to Upton Sinclair's *The Jungle*, but was mainly inspired by Johannes V. Jensen's Danish novel *Hjulet* (The Wheel). But while Jensen admired American industry and the tough Chicago atmosphere, Brecht viewed it as a "jungle," fraught with powerful businessmen and gangsters and, of course, slaughterhouses. Brecht was simultaneously co-writing an adaptation of *King Edward II* with Feuchtwanger, and yet he still found time to cultivate his most important admirers. His biggest champion so far was Jhering, who had nominated him for the prestigious Kleist Prize, given to the most talented young playwright in Germany.

By the time Hanne, his daughter with Mar, was born, the young father was frantically busy and had no time, patience, or nerves for a wailing baby, however much he loved her and admired her spirit. "There's so little one can do with children, except be photographed with them, even when they're of such superior quality as my daughter . . . (like me) she's inexhaustible and insatiable."[70]

The same month Hanne was born, Brecht was writing a short film for his beloved Valentin. It was for this project that the twenty-four-year-old playwright ensnared one of the most prominent directors in Germany, Erich Engel.[71] Utterly convinced by Brecht's literary gifts, Engel immediately agreed to direct *In the Jungle of Cities*. Since the criti-

cal success of *Drums,* Brecht had the power to insist that Neher be hired as the scenic designer. A powerful trio was born.

The year of Hanne's birth, 1923, was one of the worst for Germany as a whole, and especially for Munich. If the Weimar Republic had been far too conservative for the Socialists and Communists in 1919, four years later it was much too liberal for the Brownshirts. Hitler tapped into the anger of the right-wing Bavarians and staged a putsch. In connection with this attempt to seize power, Brecht discovered that his poem "The Legend of the Dead Soldier" placed him high on Hitler's list of enemies. And even though the putsch failed and Hitler was imprisoned for his actions, it was clear that National Socialism had taken root in Bavaria. The events leading to hyperinflation and poverty fanned the flames of bitterness toward the liberal Weimar democracy that was, in the National Socialists' eyes, destroying all that was great about Germany.

Brecht's Munich production of *Jungle,* with its brutal depiction of men, morals, and sex, was interrupted when a Nazi sympathizer threw a gas bomb into the audience. The conservative local authorities declined to bring charges against him, and instead announced that further performances were canceled due to "public resistance" to the play.[72] In that same year, Brownshirts had already thrown stones at the Jewish Feuchtwanger's windows. If Brecht was eager to have an excuse to flee his domestic problems in the south, Munich's increasingly right-wing population also gave him a concrete reason. Along with so many others, Neher and Engel were already up north enjoying the cultural freedoms in Berlin, and the director had swiftly arranged a job offer for Brecht as dramaturg for Max Reinhardt's theater.

On his earlier trips to Berlin, Brecht had already met a woman as charming as Mar, as kind as Bi, and smarter and stronger than either of them. Helene Weigel was an actress who understood the importance of his work and was charmed by him as a man. They'd corresponded, and Brecht had seen her many times before moving to Berlin permanently in the fall of 1924. Although Weigel was about to give birth to Brecht's third child, he still didn't realize what a hugely important role this beguiling actress would play in his life.

The Women

It was a glorious Sunday afternoon in 1924 as Kurt Weill, dressed in his only presentable suit, gazed out at the Peetzsee—one of the many lakes that form a chain around the city of Berlin. The young composer breathed in the fresh air, amazed that this idyllic scene was only an hour's train ride from his cramped studio in the city. It was a short walk from the rural train station to the tiny dock where Georg Kaiser, the most successful playwright in Germany, had told him to wait for a ride to his house. The powerful scent of pine trees went straight to Weill's head, contributing to the magic of his auspicious invitation. Knowing that Kaiser had refused every other opera composer who'd come his way, Weill still couldn't believe his luck. The forty-six-year-old celebrity had expressed his admiration for Weill's music, but Kaiser was actually far more impressed by the young composer's nerve. No one as young, or as relatively inexperienced, had ever dared to approach the eminent dramatist before.

Weill hadn't been waiting long when he saw a rowboat approaching the dock. The rays of the bright sun cast the rower's back in silhouette as the boat moved slowly and steadily toward him. It was certainly an unusual way to be picked up—pure Kaiser—as was the exceptional woman who leaped nimbly onto the dock. Her sensuous mouth and piercing eyes dominated her strong face, but every feature seemed to

demand an audience of its own: the pronounced nose, large teeth, and short, dark hair she clearly cut herself.

The formally dressed composer and the bold young woman with a stripe of dark red lipstick looked comically out of place standing on the dock with the glittering lake behind them—two such distinctly urban people alone in the wilderness. They didn't appear at all similar, except that both were quite sturdy and extremely short—she was five feet two and a half inches, and he was only an inch taller. They looked at each other for a moment. She was taking in his blue suit and matching tie, smiling as she remembered that Kaiser had told her all musicians looked alike—he had even predicted Weill's broad-brimmed hat. The composer was trying to figure out where he had seen her striking face before.

"Are you Mr. Weill?" she asked politely, although the hat had already given her the answer. He nodded, hearing her voice more clearly than the words. "Would you mind stepping into that boat?" she continued. "That's our transportation."[1] It was hard for Weill to imagine that this tiny woman would row them all the way across the large lake, but all his senses were activated at once as the boat glided easily in her capable hands. He was most entranced by the lilt of her Viennese accent. She introduced herself as Lotte Lenya, an actress and dancer who was working—temporarily, she stressed—as a nanny for Kaiser's children. Her dialect betrayed a lower-class background that contrasted with her precise articulation and sophisticated wit. When she spoke about herself, it was as if she were a character in a play she had analyzed perfectly.

Lenya was born in 1898 as Karoline Wilhelmine Charlotte Blamauer. She quickly proved to be the smartest child in her family, and also the most gifted in her impoverished neighborhood. Her father was a coachman and a drunk, her mother an uneducated laundress who suffered her husband's abuse in silence. Lenya had two brothers and one sister, but most important was the ever-present ghost of yet another sibling who had died at the age of four. Lenya's father had adored this firstborn girl, especially because she had been blessed with a beautiful singing voice. He loved her voice as much as he despised Lenya's attempts to imitate it: "I had to learn to stay out of his way as much as

I could in that crowded one room and kitchen we lived in until I left home for good . . . It was always me who was dragged out of bed when he came home drunk . . . I would sing for him the most stupid song he knew . . . One night he got so furious at me for not remembering all the lines that he picked up the petroleum lamp and threw it at me as I stood trembling in the corner. The impact put the flame out and I was saved from burning to death."[2] Lenya's mother tried to protect her, but from a very early age the young girl learned to look out for herself.

Despite admission to the best public high school in Vienna, she was forced to leave after the eighth grade because her parents wanted her to be an apprentice in a hat factory. When an invitation to visit her aunt in Zurich came her way, Lenya jumped at the opportunity to get away from her dreary life. "Be smart, Linnerl, and don't come back if you can help it," her mother offered as a farewell.[3] Lenya worked in exchange for dancing lessons, until the Swiss director Richard Revy noticed the scrappy but highly talented girl. He taught her Goethe, Schiller, Strindberg, Ibsen, and Chekhov, and he encouraged her to develop her precocious dramatic abilities. Revy, a "pudgy moonfaced man," was much older than his sixteen-year-old protégé, but the helpful coach soon became her lover as well. She called him "Uncle Vanya," and he was in turn inspired to dub her "Lenya" after "Yelena" from Chekhov's play.[4] Her way of speaking was certainly affected by this crash course in Western drama, and by the time she was rowing Weill across the lake, her expressive range reflected a unique blend of influences from her poor neighborhood in Vienna, the sophisticated stages of Zurich, and the streets of Berlin. She had an uncanny memory for lines from all the plays she had read. Weill was captivated, and he was grateful that the lake was large and that her rowing slowed as she spoke with increasing animation.

It was in Zurich that Karoline Blamauer became Lotte Lenya. She not only changed her name but also tried to bury the poverty and violence of her past. She fought her way to a future with everything she had. But it was hard for the teenager to study, perform in the ballet and the theater, and earn her keep by cooking and cleaning. When an older Czech baron came to the rescue, she accepted his love and enjoyed the expensive dinners and luxurious life. He was kind to her,

but she yearned for a career on the stage. Lenya ultimately stole the baron's jewelry so she could afford to go to Berlin with her lover and coach. The moonfaced Revy insisted that they both try their luck in the theatrical mecca up north.

Soon after she sold the last of her valuable trinkets, Lenya did manage to land a few roles in a suburban Shakespeare theater near Berlin. But this was during the height of inflation, and although her salary climbed into the billions, she still couldn't support herself from her earnings. When Revy brought Kaiser to the theater to see her, Lenya's feisty personality and evident street smarts attracted the great playwright right away. A few days later, Kaiser arrived at her rooming house and was further touched by the picture of Nijinsky she kept above her rust-stained sink. He gave her a suitcase filled with money and told her if she hurried it would be enough to buy a train ticket to Grünheide. The invitation was for the weekend, but Lenya was a big hit with the family and ended up staying for a year.[5]

Lenya was an enthusiastic storyteller and often had to stop rowing altogether in order to gesticulate with her hands. Weill was mesmerized as the boat drifted idly on the lake, the sun warming his back. At some point, Lenya became so involved in acting out one of her anecdotes that she accidentally knocked Weill's glasses right off his nose and into the water. He was very nearsighted, and Lenya often claimed that in this moment of near blindness, he asked her to marry him.[6] Literal truth was not Lenya's specialty, but there's no doubt he was smitten before the boat reached the shore.

Many luminaries came to visit the great Kaiser, and Lenya had as much time to make an impression as it took her to row across the Peetzsee. This was just the sort of high-wire act that she had learned very early in life. It was in the tiny circus that set up shop in an abandoned field beneath her window in Vienna where she first learned how to entertain a crowd. There were "dancing acrobats, a tightrope, and clowns," she remembered. "Among that audience was a little wide-eyed girl of five who was never asked for a nickel. Instead, she was asked whether she would like to learn how to dance and walk the tightrope."[7] This was the best training an actress can have, she often declared. "A slip can mean disaster . . . You cannot cheat or lie when you are on a

tightrope."[8] When the twenty-six-year-old Lenya rowed Weill across the lake, it was the best, and most important, audition of her life.

They pulled up to the shore, and Lenya held the boat steady as the nearsighted Weill gingerly stepped onto the dock. Kaiser's piercing blue eyes—the color of a child's marble, as Lenya described them—could be seen from quite a distance, even before Weill put on his spare glasses. Kaiser greeted Weill warmly, eager as always to entertain an interesting guest. Weill, who didn't know about the precarious nature of Kaiser's finances, was impressed by the array of small boats tied to the dock (sailing was one of the playwright's many passions), and the comfortable family house nestled between the trees. Kaiser had just recently bought the villa by the Peetzsee, but he had been so broke he needed his publisher to co-sign the mortgage. As it turned out, Lenya wasn't the only ex-thief standing on the dock that day, and the publisher probably granted this financial favor in the hopes of keeping the tempestuous playwright out of trouble. Just four years earlier, Kaiser had borrowed a summer house from a friend and proceeded to pawn the owner's paintings and jewelry in order to keep up his lavish lifestyle. He was sentenced to a year in prison; his wife, Margarethe, was arrested, and their three children were temporarily placed in a poorhouse. But true to the transformative spirit of the Weimar Republic, Kaiser (who transacted a good deal of business from his cell) became the most honored and frequently performed playwright in Germany only three years after getting out of jail in 1921.[9] And as to the enviably happy family that greeted Weill on the front lawn, that, too, was somewhat of an illusion. Kaiser's long affair with an actress had only recently ended, and the betrayal still hovered in the air. Margarethe was indeed lovely and cultivated, but her forbearance outshone all these other qualities. She had put up with quite a lot of scandal, hardship, and humiliation, not least the ruin of her family's fortune.

Kaiser treated the composer like a son and fellow artist from the beginning. The timing of this new relationship was fortunate for Weill since his first substitute father figure, Busoni, was gravely ill and would soon die. Weill was used to the support of his parents and siblings and sought their replacement wherever he went. Even if the brash Kaiser hardly resembled Weill's stable parents, the composer's bond with the

playwright and his family was immediate and permanent—equally as important as their creative partnership.

Anything seemed possible on that bright day in Grünheide. As Weill shook Kaiser's hand, he finally realized where he had met Lenya before. She had auditioned for *The Magic Night*—the children's panto-mime where Kaiser had first heard Weill's music. It was Lenya who had impulsively called down to the pit and asked the unseen composer to play "The Blue Danube." She never laid eyes on Weill after the audition—he was, she'd been informed, too busy to meet her. He later told her that he had been changing his pants under the stage because the dressing rooms were full of children.[10] Their fateful meeting was thus delayed for two years. The rowboat was an essential prop for their fairy-tale beginning.

In Lenya, Weill discovered a strong woman hardened by a rough childhood and yet in dire need of his protection. In Weill, Lenya found the most gentle and protective man she had ever met. He was also the only one confident enough to accept and adore her just as she was: "I desire nothing more passionately than to be allowed to be endlessly good to you," he wrote to Lenya. "I know that ugliness must disappear from your life for you to be able to believe that a very kind hand might wipe the pain away."[11] She found Weill's rhapsodic courtship irresist-ible. "I have one destiny: to sink into you, to disappear into your life, to drown in your blood towards a new existence. I see myself within you—and for the first time I sense what I am, because I am allowed to be within you, like a reflection in a spring."[12] Weill's rapture was cer-tainly influenced by Lenya's overwhelming sensuality. He had never met a woman like her before.

Their passion is frankly illustrated by the suggestive nicknames he used in his letters, frequently signing "Your devoted monkey tail" or "Your highly erect monkey tail."[13] But Weill wrote his most passion-ate letters about her voice: "When I feel this longing for you, I think most of all of the sound of your voice, which I love like a very force of nature, like an element. For me all of you is contained within this sound; everything else is only a part of you; and when I envelop myself in your voice, then you are with me in every way."[14]

Soon after his first visit, Weill was offered the opportunity to live in

Kaiser's rented rooms at the Pension Hassforth. Lenya moved in with Weill shortly thereafter, sliding easily into the single bed tucked behind the tapestry that divided the room. Weill's piano was on one side, and Lenya on the other. And although Weill insisted that he wanted nothing more than to be her "'pleasure boy,' more than a friend but less than a husband," they nevertheless married in January 1928, eighteen months after the encounter in the rowboat.[15] He was the only member of his family to marry outside the Jewish faith, and, significantly, he decided not to invite his family to their civil ceremony.

They wed at the marriage bureau in the Berlin neighborhood of Charlottenburg. In the photo, Lenya smiles broadly, wearing a black-and-white checkerboard coat and clutching her flowers. Weill wears his long dark overcoat, a bow tie, and his broad-brimmed "musician's hat." He holds a package of herring for the afternoon celebration. They couldn't afford anything more.[16]

Did Weill care that Lenya wasn't Jewish? Certainly not. Did he care that his parents cared? Perhaps so, and his decision to marry rather quickly could have been to prove that the relationship with Lenya was permanent. "The family was violently against me. My God!" Lenya exclaimed. "They didn't talk to me until they saw me for the first time on stage. Later on I became their favorite daughter-in-law."[17] The problem probably wasn't resolved as simply as she described—the Weills cared more about their son's evident happiness than her talents as an actress. Weill certainly thought this was the case, and he frequently wrote his parents about the pleasure of living with his new wife: "I have become noticeably more independent, more confident, happier, and less tense. Of course, living with Lenya accounts for much of this. It has helped me tremendously . . . How long will this last? I hope a long time."[18] Lenya was a surprising but utterly satisfying answer to Weill's quest for the feminine ideal. In her and her alone Weill saw himself as he wanted to be: a romantic and devoted protector, with the unexpected pleasure of being an amorous "pleasure boy."

The stark contrast between the chronically unfaithful poet and the composer was made clear in one of Brecht's early poems. The poet described himself with glaring honesty: "Here you have someone on whom you can't rely."[19] Fortunately for Brecht, he discovered a par-

ticularly capable woman who found this declaration quite intriguing. She preferred a genius to a devoted gentleman, and she was certain she would never find both qualities in one man.

On one of his early trips to Berlin, Brecht decided he needed to meet an actress. A good friend told him about a woman who lived nearby, and before a proper introduction could be made, Brecht rushed over to pay a spontaneous call. He walked eagerly up five steep flights of stairs, and he liked the feel of the cold, heavy iron door he had to pry open in order to reach her studio. He already had a fondness for attics, and the eccentricity of the narrow hallway, no wider than a catwalk above a theater stage, also appealed to him. He had yet to meet the actress, but he liked where she lived.

The woman who opened the large door confirmed his optimism. Helene Weigel was only five feet three inches, but she was a powerhouse of a woman. In his first play, *Baal,* Brecht's renegade poet renounces his vision of women as being only "cascades of bodies," and insists, "Now I want a face."[20] In Weigel, he certainly found an impressive one. She had a broad forehead and prominent cheekbones, her hair was pulled tightly back, and her dark eyes dominated an angular face. Until the smile formed, and the two deep dimples warmed her expression, her appearance was severe and forbidding. Although he had come over uninvited, Weigel knew who he was right away. Brecht was unaware that he had met her before, but she remembered seeing him in rehearsals more than a year earlier for the Berlin performance of *Drums in the Night.* She had played two small, unnamed roles but was too far in the background for him to remember. Unlike Weill's encounter with Lenya, Brecht didn't even have a flash of recognition as he introduced himself.

Weigel was happy to meet Brecht and found the great poet to be as charismatic and sharply intelligent as his reputation had promised. She was also very different from the women he had met before. Weigel wasn't the type to leap without looking, and she rightly sensed the need for caution when it came to this impatient man. The twenty-five-year-old married charmer, who already had two children and too many relationships, quickly discovered that he would have to alter his

usual expectations with this resolute young woman. Weigel wrote him a challenging letter that revealed her sharp understanding of the man who had frustrated and confused so many other women. "I feel foolish for having said no . . . but I was also surprised by your newly revitalized interest, why, only because of the no? . . . It seems like you cannot and don't want a state sanctioned marriage, you never wanted that and I never asked for it, which I'd like to say is that I would never ask for that, because I see that it wouldn't work for you, but then I see that you do give in to the demands of another woman who does want that from you . . . And then you completely disappear, silent for three weeks, you change your mind again (regarding your attitude towards marriage), and that's a particularly painful blow to me. I'm not insensitive, if that's the life you want to have, I can't be part of it."[21] With this letter, Weigel laid down the only terms she could abide: She'd take Brecht as is, but he must treat her with equal respect. Even if she chooses to accept his inability to commit officially to a relationship with her, she will not tolerate his decision to suddenly surrender his principles in order to please another woman. And when things become uncomfortable, her letter announced, avoiding her was not an option.

Brecht had no intention of avoiding Weigel. By the time he made his tenth trip to Berlin in September 1924, he had arrived to stay. Since meeting the woman he came to call "Helli," the man who climbed those narrow stairs had changed his appearance completely. Eugen Berthold Friedrich Brecht had died with his mother, and along with his name, he left the rest of his identity as an upper-class brooding poet behind in Augsburg. He shed his provincial wool suit and white shirts and donned the black leather jacket and tie and the signature cap. He was Bert Brecht from then on. With Helli at his side, he became a "man of the people," finally at home in the asphalt jungle.

Like Lenya, Brecht knew that changing a name goes a long way toward burying the past. In his case, he still hoped to escape his father's continuing disapproval of his profession. His brother Walter—the better son—was studying for a PhD in paper manufacturing at a technical university. The black sheep Brecht was still only writing words on the commodity his father valued so highly.[22] He had to leave the shadow of his conservative family in order to follow his talent.

By then, Brecht was bursting with more confidence than ever. He

didn't yet have the financial security that would command his father's respect, but with four completed plays under his belt and one on the way, several important productions behind him and more on the horizon, as well as a book of poems to finish, he had certainly earned a solid reputation as a scandalously modern writer. On an earlier trip to Berlin, he managed to sign two separate publishing contracts for *Baal* even before it had been performed. Despite the controversy his plays had generated, the prominent Berlin critic Herbert Jhering had remained a faithful ally. "This is a language that you feel in your tongue, your palate, your ears, your spine," he wrote. "It is brutally sensual and melancholically tender."[23] And ever since the well-established Engel had directed *In the Jungle of Cities*, theaters all over Germany were becoming increasingly interested in Brecht's work.

Weigel eagerly anticipated Brecht's frequent visits. She listened impatiently for the squeak of the heavy iron door at the end of the corridor and came running with particular joy on the day he had come to Berlin for good. She loved her Bert, and her beautiful wide smile greeted his long-awaited arrival. Although he hadn't yet moved into Weigel's studio permanently, it was looking more and more like his Augsburg *Kraal* every day. He had shortened his name and changed his clothes, but he still needed an exact replica of his boyhood room in order to do his work. As the toughest yet the most accommodating woman he had ever met, Weigel understood his needs and helped him to set up shop in her tiny apartment. It was already filled with his usual array of articles, manuscripts, and notes, and Caspar Neher's pictures had begun to cover the walls. Brecht was thrilled to feel at home so quickly, and his boyish enthusiasm burst through when he was being interviewed by a Berlin newspaper. In describing the style of acting he was developing for his new form of theater, Brecht merged his praise for Weigel as an actress with his distinctly Brechtian esteem for her as a woman: "Her voice is rich and dark and whether in sharpness or a scream, it's always pleasant. Her movements are definite and soft. What kind of person is she? She is good-natured, gruff, courageous, and reliable: She is unpopular."[24]

Weigel had insisted that Brecht fight harder and longer for her affection than he was accustomed to doing, but after she succumbed

to his charms, she became pregnant by him just as quickly as the others. By the time he arrived in Berlin to stay, the twenty-four-year-old actress was carrying his third child. Although becoming a mother would make it even harder for her to support herself, and having a child with someone else's husband was hardly ideal, Weigel decided she could face the challenges ahead. He admired, and was relieved by, her strength. No one had ever understood him so quickly or taken such good care of him. No one, except his mother, had ever offered him such valuable, and such unconditional, love.

It wasn't as though Weigel had nothing else to do. Her career as an actress was in full swing. She had only played small roles so far, but she'd performed in works by Shakespeare, Schiller, Kleist, Strindberg, and Ibsen, as well as Wedekind and Kaiser. She always made a strong impression. One typically positive review declared: "Helene Weigel's fiercely energetic performance takes command of the stage. Her shouting, howling, and sobbing come from deep within. A small volcano about to burst."[25]

Brecht had found a woman as loving as his long-suffering, physically weak, and devoted mother—but since Weigel was also a burning artist, and a rebellious daughter, she couldn't have been more different from Sophie Brecht. The strong actress was far more powerful than his mother had been, but Weigel nevertheless made Brecht feel like the center of her universe. Incredibly, she even agreed to Brecht's request that she travel to Augsburg to convince Bi to abandon her wedding and move to Berlin with Brecht's son, Frank. The ever-jealous Brecht was certain that Bi was making a mistake in marrying a local man, but knowing that she wouldn't listen to him, he had sent Weigel to make his case. Bi naturally refused the offer and was amused to see that Brecht had managed to convince a woman like Weigel to do his bidding. But Bi didn't understand that the shrewd Weigel was helping out for her own sake as well. She assumed Brecht was most interested in having Frank nearby, and it was in the new mother's interests to encourage his paternal instincts. Weigel could see that Brecht adored his children but that he was worried by the financial burdens placed upon him, as well as being unable to care for them on a daily basis. Weigel was no less in love with the poet than Bi or Mar had been—she

was just smart enough not to let this cloud her cool judgment of him as a man. She saw his weaknesses clearly and knew how to compensate for them.

Weigel had been unwittingly preparing herself for this modern, independent relationship all her life. She was born on May 12, 1900, into a secular Jewish family in Vienna. Her father was a manager in a textile factory and her mother owned a toy store. They enjoyed a cosmopolitan, upper-class life—worlds away from the poor Viennese neighborhood where Lenya had grown up—but despite their assimilation, the family was forced to confront a persistently anti-Semitic undercurrent in the local school. This unpleasant fact resulted in one of the most fortunate events in Weigel's young life: She was sent to a progressive school run by Eugenie Schwarzwald, an innovative Jewish educator. Weigel received an unusually liberal education and enjoyed a faculty that included such luminaries as Oskar Kokoschka and Arnold Schoenberg. In Schwarzwald's salons, Weigel met Käthe Kollwitz and Rainer Maria Rilke, and the bright teenager was also permanently influenced by Schwarzwald's social conscience. In addition to running her school, Schwarzwald often organized soup kitchens and homeless shelters. By the time she graduated, Weigel's artistic and political interests had been inextricably fused. She learned the classics and performed in a wide range of plays, but understood immediately that theater must appeal to the whole of society. Like Brecht and Weill, she believed that art could and must improve the world.

Despite Schwarzwald's encouragement, Weigel's family hadn't approved of the acting profession, and her father had cut her off when she insisted on pursuing it without their blessing. Once she'd been successful, her family slowly began to respect her decision, and their personal and financial support had recently returned. If they knew she had become pregnant by a married man with a notorious reputation, she would lose all that she had gained with her family. She didn't tell them about their grandchild for a very long time.

Brecht and Weigel were typical twentieth-century children of privilege. Their fathers were managers profiting from industrial commodities and factory laborers, and their families had enjoyed the higher education and opportunities of the upper classes. Other than Weigel being Jewish, which for the moment meant very little to her, they were

both rebelling against the same upper-class strictures. Their mutual devotion to the theater, their unusual relationship, and the potential scandal of her out-of-wedlock pregnancy signaled their identity as a couple eager to escape the conventional values of their bourgeois background.

Without the safety of the new *Kraal* that his Helli provided, moving to Berlin permanently would have been much harder for Brecht. There was no question that his profession required him to live in the theatrical center of Germany, but he couldn't function without an equally strong domestic anchor. Weigel found just the kind of long worktable that Brecht loved, and she placed it in front of the large window from which he could look out over the city he planned to conquer. Weigel's belief in him infused the air and the pleasant aroma of her excellent Viennese cooking also offered him a warm welcome to the city he'd once found so cold and uninviting. Strong and self-assured on the outside, the sensitive and once sickly poet knew he could rely on Weigel to keep his life in order. She had already realized that once her baby was born, she would have to move out in order to ensure that Brecht could continue his work in peace. It wasn't so easy to find a new apartment in Berlin at that time, but the resourceful Weigel figured out a way. She waited until the very end of her pregnancy before going to the city office to plead her case. The small woman with a large stomach presented an emotional case, complete with tears the skillful actress could easily summon. The housing department sympathized with her plight, and Weigel proudly equated her bureaucratic success with a standing ovation in the theater.[26]

Brecht was twenty-six when his third child, Stefan Weigel, was born on November 3, 1924.[27] Coincidentally, this was the precise date of the second anniversary of his marriage to Marianne Zoff. Three months later, Weigel moved and the attic studio became Brecht's permanent home and place of work. Every day at two o'clock, he took the ten-minute walk to Weigel's apartment and ate a delicious, lovingly prepared lunch with her and Stefan. He frequently, but by no means always, spent the night there as well. They settled into a routine that worked for both of them. Brecht was free to pursue his career; Weigel had enough room for herself, her child, and a housekeeper. Brecht always got up early to work, and when Weigel was performing, she

came home late at night. Their arrangement ensured that no one's precious sleep was disturbed.

The degree to which young people took advantage of new freedoms in postwar German cities varied considerably, even among the small group of friends and colleagues surrounding Brecht and Weill. Brecht's beliefs and, perhaps more important, his personal needs required a total rejection of all the rules that had governed his social class. In contrast, Brecht's good friend Neher had fallen in love and married Erika Tornquist, the sister of a fellow student. A month before Stefan was born, the Nehers had a son named Georg. Although Neher had a similar background to Brecht and was working in the same atmosphere of radical Berlin theater, he had as yet no need to rebel against the norms of marriage and family life. Given the choice, both Neher and Weill chose to maintain some of the conventions of their parents. Fortunately for Brecht, Weigel also believed that a woman's freedom was impossible to achieve without a total rejection of bourgeois morality. She wasn't at all concerned about getting married, at least not yet.

Weigel was the least beautiful of Brecht's women so far, but she was certainly the most attractive partner. She soon began to help take care of his other son, Frank, and often took his daughter, Hanne, on vacations with Stefan. She cooked Brecht's meals and paid for his apartment as well as her own. This meant she had to go back to work rather quickly. A few months after Stefan's birth, she was back on the stage in Berlin and Munich.

During Stefan's first year, Brecht began to coach Weigel in the various roles she accepted. With his help, she soon had the biggest theatrical success of her career playing Klara in Christian Friedrich Hebbel's *Maria Magdalena*.[28] After working so well together, Brecht began to insist on Weigel's participation in his productions, which pleased her very much. She was as attracted to Brecht's genius as she was to the man, and she wouldn't have accepted being part of his domestic life alone. She also recognized, perhaps even before Brecht himself, that he deeply enjoyed being with a woman who was embedded in every aspect of his life. Their identity as a private couple as well as an artistic duo quickly became a crucial part of their relationship, one that ensured her sense of being Brecht's only irreplaceable woman. But this

confidence in her position was put to the test only a few weeks after Stefan's birth.

A newborn does wreak havoc with regular mealtimes, and Brecht was a strict creature of habit. One day while Weigel was occupied with the baby, Brecht showed up around two o'clock at the apartment of an old female friend, perhaps hoping to be served lunch. He'd once had a passing interest in the woman who greeted him, but on that cold and rainy day in late November, he was instantly distracted by her roommate. Elisabeth Hauptmann was a pretty and extremely intelligent woman with a modest disposition. Brecht was intrigued by the quiet presence of a born listener, not realizing that her silence was also caused by a very bad cold.

Hauptmann was well aware of Brecht's brilliant but scandalous reputation, but she hadn't read any of his plays. She had heard the rumors and read the reviews and articles about the controversial premieres of *Drums* and *Jungle* in Munich, and more recently of the explosion *Baal* had caused in Leipzig. By the end of 1923, Brecht had finally found a theater in Leipzig willing to risk mounting his provocative first play. Because of its rude language and Baal's irredeemable amoral character, one local critic called it a "mudbath." A far more graphic description was offered by Alfred Kerr, the most prominent reviewer in Germany: "Liquor, liquor, liquor, naked, naked, naked women."[29] His article, however, simultaneously increased ticket sales as well as the demand to close the show. Under pressure from all sides, the mayor of Leipzig shut the play down as quickly as possible.[30]

Usually Hauptmann would have been fascinated to meet such a rebellious man of the theater, but because she was ill, she left the room without saying goodbye. Brecht called her the following morning. "Brecht here," he informed her curtly. "I was never dismissed in such an unfriendly way before!"[31] Hauptmann humorously insisted that what first attracted Brecht to her was that she had hardly spoken a word. They went for a walk the same day he called, and Brecht quickly saw that Hauptmann would be the ideal *Mitarbeiter* (collaborator) for him. She could speak English and French, knew a lot about his beloved America, was musical and literary, and, finally, she was funny and attractive. Hauptmann never admitted that he appreciated

her humor, but given the satirical spark of her writing, it is impossible to imagine that she didn't impress him with her wit. She would be every inch the painstaking, detail-oriented secretary and researcher that he required—but she had the ironic perspective and quickness without which one could not work with Brecht. He went to his publisher, Kiepenheuer, right away and asked them to hire Hauptmann to work exclusively with him. He insisted that this would be the only way he could finish his book of poetry, as well as his new play, *A Man's a Man*. Nervous about their "bête noire" author and his difficulty with deadlines, Kiepenheuer agreed right away. Hauptmann became the first member of his Berlin collective.

Brecht was elated. He had come of age in a collective setting where people were always available to him for commentary and discussion, and he couldn't work without an exchange of ideas. In Augsburg, he had relied heavily on the input of Neher and other literary friends—all male. In Munich, he had worked with Lion Feuchtwanger and later with Emil Hesse-Burri, another *Mitarbeiter*. But Hauptmann was the first woman to be involved directly in his writing process, and this preference for female collaborators was a clear result of modern Berlin life. Hauptmann was equally thrilled when Brecht gave her the first artistic job she had ever been offered.

Bess, as Brecht soon began to call her, was a country girl. Born Elisabeth Flora Hauptmann on June 20, 1897, she grew up in the small village of Peckelsheim in the northwestern part of Germany. Her father was a doctor; her mother was an American who worked as a pharmacist.[32] Like Brecht, her father was Catholic, but she was raised in her mother's Protestant faith. She attended a tiny one-room schoolhouse for the few Protestant children in the village, but her mother made sure to enhance her education in literature and music. At some point, her mother hoped that her gifted daughter would become a concert pianist, but Hauptmann's skills were elsewhere. Her English was perfect, she had a talent for both languages and translation, and she loved to read. Girls weren't permitted to take the final school exams in her small country town and Hauptmann was thus ineligible for university. The best option was to become a private tutor for wealthy families, but this meant obeying the old-fashioned rule to remain unmarried and celibate. For the adventurous and educated Hauptmann, her position

with such a family was doomed from the start. Even if the provincial families in the country refused to recognize the new face of the post-war world, she had already read far too much to resist the vista of freedom looming in the big city.

She fell in love with the cousin of one of her private pupils and followed him to Berlin. She scandalized her father and the family that had employed her, and she had no choice but to remain in the city she in any case adored.[33] Hauptmann may have hoped to marry her lover—she may indeed have hoped to marry in general—but she also wanted to become a writer. Her American-born mother probably had something to do with that ambition, but her father angrily refused to support her in any way. She worked as a secretary at various firms until she was hired by Kiepenheuer. Her life was far from luxurious, but it was far better than her suffocating existence in the provinces. In nineteenth-century terms, she was ruined; in twentieth-century Berlin, she was a modern woman who could pursue a profession, socialize with artists and writers, and become engaged in politics. She could also go to cafés, theaters, and concert halls without an escort.

Hauptmann told almost no one about the passionate affair that first brought her to Berlin, and people often mistook her for a virginal schoolteacher navigating the dangers of the big city. She did little to correct their impressions because she found it fascinating to play the role of a naïve ingenue in her daily life. This was a fictional type that intrigued her, and pretending to be the innocent girl from the country had much to offer this sophisticated author who wanted to write about women entering modern society. By performing the part of the wide-eyed girl, she was able to generate the raw material for her short stories. She wrote about the person she pretended to be, traversing the tenuous border between her actual and fictional selves. Sometimes, of course, the line between the two became blurred. "I'm not an important movie star, not a famous writer," Hauptmann wrote during her early Berlin years. "I can't compete in a world champion tennis match and haven't swum the Channel, and yet I believe that I must draw my picture here. So that you can really see that I don't look so bad. So you don't think: what a poor person she is who can't find a man." The mixture of satire about a woman's chances and her own self-parody are quintessentially Hauptmann. "Where does it say that I can't find

a man? I have one big problem, I don't have much money . . . (so) it must be a Prince." Men, she wrote with sharp irony, "are the only way for a woman to move up in life."[34] Hauptmann wrote about the power of men in a satirical way, but even her own relatively independent life was still inextricably controlled by them. Brecht was giving her what she perceived as her first chance to realize her artistic dreams, but he was still a man.

Hauptmann's new life began by walking up five flights of stairs to the Spichernstrasse *Kraal*. For her, it was the fairy-tale version of a poet's garret with its cast-iron stove, bare floors, and long, heavy, cluttered table, where a big black typewriter beckoned. Brecht shared the contemporary fascination for newspapers, and he often drew inspiration from current events or by reading about foreign lands that set his imagination in motion. He saved anything that struck his eye, and news clippings were everywhere. Brecht was eager for Hauptmann to add articles from American papers and magazines, and he was thrilled to have a native English speaker by his side. She was also the only other person there. "It was urgent that he find someone to sit with him in the morning," Hauptmann realized. Brecht openly admitted to her that "it was boring to sit like this all alone with a play."[35] He was happy for the company, and Hauptmann was delighted by Brecht's appreciation of her literary talent. It's hard to know if she fell in love with the man right away, but she certainly fell in love with her new life. She was working with a prizewinning writer who was admired, produced, published, and ambitious, and who was instantly dependent on her for help. That was as intoxicating as any other part of their relationship. Even when they began sleeping together, it didn't matter that he was married to Mar, stayed often with Weigel, and already had three children. She was in Berlin to pursue a more exciting and artistic life. The life of a woman seeking a husband was what she had left behind.

There was much to do, but Kiepenheuer's main concern was the completion of Brecht's play. It was tentatively called *Galy Gay* but would soon become the comedy that first attracted Weill's attention on the radio—*A Man's a Man*. Brecht reveled in the exotic names and places that Hauptmann's translation skills brought to him, and her first critical contribution to his work was her ability to read and translate Rudyard Kipling. This process goes to the heart of Brecht's

collective approach to writing. He worked with those who could contribute ideas and information that he didn't have, and he freely borrowed from published works as well.[36] Hauptmann's language skills, her dramaturgical precision, her gift for organization, and, not least, her ability to type were all essential to the development of *A Man's a Man*. There are those who point to the influence of Kipling, as well as to the many direct imitations of his stories and songs, as "proof" of her early contributions to his writing, but the nature of their collaboration was already far more complex than that. She had the stamina to go over structural issues in a way that the "big picture" writer was too impatient to pursue. Brecht, conversely, had great confidence in the value of his ideas. He would make sure the broad strokes were in place and soon trusted Hauptmann to attend to the details. And because she was truly the ironic and witty woman her early fiction revealed, as well as the dutiful and detail-oriented secretary of her public persona, she was uniquely able to understand Brecht's genius and take care of the practical issues. Hauptmann was dramaturg, researcher, and co-writer, as well as human spell-checker and administrative assistant, all rolled into one. And she was thrilled to have found the best place in all of Germany to ply her trade. After the first year of working for him on her own, more and more people came to his studio, hoping to participate in Brecht's collective. This confirmed Hauptmann's sense of privilege in being one of the selected few to work for the increasingly magnetic Brecht: "We profited immensely from it—I have to say, had we looked, or placed an ad, or asked the best people—nobody would have thought of telling us: go to Brecht, if you need to learn how to write. But that's what we had."[37]

One year later, *A Man's a Man* was completed. Brecht bound a copy in red leather and gave it to Hauptmann with the following inscription: "At the end of 1925, I give this as a present from me to Bess Hauptmann, who worked with me the entire year without compensation. It was a difficult play, and even the compilation of the manuscript from twenty pounds of paper was hard work. It took me two days, half a bottle of cognac, four bottles of sparkling water, eight to ten cigars, and all my patience. And it was the only thing that I did on my own."[38]

It is odd that Brecht wrote "without compensation," and this was a point that Hauptmann was at pains to correct. An essential part of

her identity was as a working woman who supported herself. Kiepen-heuer paid her to help Brecht, and only when the work was completed did her salary end. She continued to work for him but took on extra translating, helped Brecht write and sell his short stories, and, most important, began publishing some of her own work as well. Her diary entry on April 26, 1926, reads: "From Brecht, 100 marks for a coat and hat."[39] Such was the form of erratic payment she received after the contract ended, but she was a proud and resourceful earner who earnestly endeavored not to become financially dependent on Brecht.

The second year of her relationship with Brecht was marked by two competing elements: a strong desire to pursue her writing, and the realization that she had fallen completely in love with Brecht. Unable to separate her life—or her time—from Brecht's needs, she couldn't stop herself from giving his work priority over her own. As a sarcastic and sophisticated female author, Hauptmann must often have been frustrated by her utter subservience to a man. She had to console her-self by insisting that Brecht was not just any man—he was a brilliant poet who believed in her and from whom she could learn so much. Brecht, in contrast, found nothing unusual in Hauptmann's total com-mitment to him. He was not only becoming accustomed to women like her and Weigel playing multiple roles in his life—he had also become virtually unable to love a woman who wasn't utterly devoted to his work. He required total engagement on all levels. This was a Berlin innovation—the purely domestic relationships with Bi and Mar were now a thing of the past.

By the middle of 1926, Hauptmann had published a poem and a short story in well-known magazines, a real feat for a woman at that time.[40] Her story, ironically called "Juliet Without Romeo," was about the young Mabel, whose parents forbid her to marry the man she loves. Mabel threatens to jump off the roof if they don't consent. The father relents, but the mother doesn't. When Mabel jumps, she's caught in a fireman's net and lives. But her young man is so frightened by her erratic behavior that he decides not to marry her after all. This story displays just the sort of ironic "Brechtian" humor that Hauptmann herself possessed. In writing a story about a woman willing to die for a man who is subsequently repelled by his fiancée's passionate nature, the courageous self-parody in Hauptmann's fiction is striking.

The most fascinating aspect of Hauptmann's first short story is that she published it under the pseudonym "Catherine Ux." Since this was not done to hide the author's gender, it must be seen as an attempt to hide Hauptmann herself. Perhaps by using another name, she was better able to see her fictional self—the naïve girl she pretended to be in everyday life—with the distance of an author's perspective. This is a clue as to why she was also comfortable working for Brecht. When she wrote for and with him, they always published under his more famous name. There were practical reasons for this—it was easier to sell his stories, and indeed they managed to sell fourteen in one year. But she also clearly preferred to publish under another name, whether it was his or the fictitious Ux. She was powerfully drawn to anonymity, and Brecht was more than happy to provide her with a great deal of that.

As an author, she often wished she had enough time for her own work. As a woman, she frequently worried that she didn't have enough of Brecht's attention. She wrote in her diary: "Yesterday I was sick. Fever. He didn't think it was necessary to inquire, only when he needed to deal with an announcement in the newspaper, did he call me."[41] The author and the woman in Hauptmann both understood all too well that she was under Brecht's spell and had freely allowed his work to dominate her own: "Brecht told me that the worst consequence of my laziness is that I don't always write down everything he says . . . Otherwise I would have an arsenal of material: plans, fables, ideas, phrases, suggestions, changes, and so on that we could successively work on."[42] This confusion of identity came naturally to Hauptmann, who so often saw herself as a sophisticated woman writing autobiographically about a naïve girl. Her behavior was not necessarily pathological, but it was definitely due to an extremely creative disposition. She may have even confused herself at times, so convincing was her performance as Brecht's "devoted shadow" sitting dutifully behind a typewriter.[43] Most people overlooked the hidden mischief in Hauptmann's eyes.

Their confusion was understandable. Hauptmann's principal desire in those early years was to be known mainly to Brecht. No magazine audience, publisher, or editor meant more to her than he did. She signed her letters proudly as "Chiefgirl"—happy to be his girl, hoping to be the one in charge of all the others.

Brecht was consistently engaged in various forms of triangulation. He had children with three different women, and in the case of his lovers, he formed one point of a triangle with Weigel and Hauptmann. But there was also a third and very different triangle to which he and Hauptmann belonged, along with what they called *"die dritte Sache"* (the third thing). This was politics, and it began with an intense interest in Karl Marx. In Marx, they found the first illuminating analysis of the postwar world, with its mass society, technological modernization, and capitalism. The intense revisions for *A Man's a Man* were greatly influenced by Brecht's enthusiastic reading of *Das Kapital*. The journey of the main character became increasingly emblematic of the political and economic circumstances of the colonial war depicted in the play.

A Man's a Man is set in a fictional India. A dockworker is cajoled and then forced into taking on the name, rank, and serial number of a soldier who has disappeared. He does it first for money, but ultimately he assumes his new personality completely. He forgets his former self, and in a climactic scene, he reads a eulogy over an empty box at a mock funeral for the man he once was. The play's metaphor exposes the way in which peaceful boys are transformed into violent soldiers. It was intended as a black comedy about the tragedy of World War I, with the colonial war as a symbolic mirror for the young soldiers who were forced to surrender their individual identities in order to serve the needs of monarchs, businessmen, and politicians. Nine years after the end of the war, this was still a searing commentary.

Although stories about a confusion of identity had been the source of comedy for hundreds of years, Brecht's play was one of the first to suggest that the confusion itself is based on a fallacy. If all men are composed of interchangeable parts, an individual identity does not exist. In this, he anticipated notions of the "mass man"—a term that hadn't yet permeated the common language of the people.[44]

Brecht's and Hauptmann's developing interest in art and politics in general, and Marxism in particular, hardly existed in isolation. The connection between art and the workers had been the direct result of the 1919 revolutions, and it was the motivating ideology of the November Group. The obligation of artists to society had rapidly led to the movement called New Objectivity (Neue Sachlichkeit). This was defined as a functional form of art—one that was concerned with

the impact of technology on modern life—for the laborers and for the industrialists profiting from their work. Like its name, the movement embraced cool objectivity over the kind of individual subjectivity that mass culture was rapidly forcing into irrelevance. The passions of the noble hero, and his individual destiny, were a thing of the past—the modern man's character and fate were utterly determined by the external conditions of their society. In embracing the concept of objectivity, artists were gripped by the realistic effects of film, photography, and radio, as well as George Grosz's political caricatures, Max Beckmann's paintings, Bauhaus architecture, and all forms of newsprint and magazine images. When it was finally produced in Darmstadt just before the Berlin radio broadcast, *A Man's a Man* became the premier theatrical representative of New Objectivity. It was one of the first plays to fully magnify the idea of modern man's similarity to a machine: an entity defined not by a human soul but by the circumstances of contemporary society.

Ever since Brecht's father had criticized him for failing to contribute to society with his work, the angry son felt driven to prove that his writing was as valuable as a "loaf of bread," or as useful as the paper upon which it was written.[45] With the advent of New Objectivity, artists would no longer be seen as bohemian dreamers but instead as construction workers helping to build a better world. Art must deal with the problems of the age and have a direct, practical influence on contemporary life.

Hauptmann was fully convinced of "the third thing" and believed that Marx could lead the way. She was Brecht's most important partner when it came to creating a theater that would fulfill these lofty goals. The Berlin collective, of which she was the first and most constant member, also became a more exciting atmosphere as Brecht's work began to attract intellectual Marxists like Fritz Sternberg, a radical economist and Socialist whom Brecht called his "first teacher," and Karl Korsch, a Marxist philosopher and professor whose lectures Brecht attended.[46] How could Hauptmann care about the triangle with Weigel, when she was involved in a much more holy trinity?

They were certainly a modern, artistic, and political couple. But that didn't prevent Hauptmann from fulfilling Brecht's requests to help him buy a car, correct and type his manuscripts, handle his contracts,

and, finally, find an affordable apartment for Mar and Hanne in Berlin. She was well aware of Brecht's turbulent relationship with Mar and discounted it as a youthful error on his part. She behaved as if she were certain he preferred the relationships he had with both her and Weigel, and only revealed her insecurity in her journal. "Oh, [Mar] wasn't dumb. But she was getting dumber," Hauptmann lamented. It was always "A woman's war . . . She saw that other women came. Everything was ten times harder for her than the other women," Hauptmann confessed in private. She regretted to see that she was locked into "a competition to be the essential one."[47] And yet she fervently hoped that she would prevail.

Weigel saw no competition, so certain was she about being the only essential woman in Brecht's life. But by the time it became clear that Brecht was becoming entangled in far more than just a professional relationship with Hauptmann, any shrill objections would have been beneath Weigel's dignity. Even worse, they would have shattered her dreams of what a modern relationship could be. As far as Weigel was concerned, the apparently modest Hauptmann was respectful of Brecht's Berlin family life, she was extremely helpful professionally, she didn't get pregnant, and she didn't have periodic fits of jealousy. As lovers go, she was a good one. The indignant wife, Mar, was a different story—the drama between her and Brecht was distracting him from his work, and that could not continue.

Mar soon realized that Brecht had set himself up very well in Berlin. She knew he had an actress girlfriend who was a very good cook, as well as a talented *Mitarbeiter,* and she had also heard about his third child. Brecht reacted to her accusations with blatant lies about both women. He dismissed Hauptmann as a typist sent by Kiepenheuer, insisting that he was "as friendly with her as Kiepenheuer himself." About Weigel he assured Mar, "I don't have another woman besides you and won't have one. I know very well that you are superior to all women, and I like you the most."[48] When her accusations became ever more bold, his denials heated up accordingly. "It's of course false what you write," he fumed. "I am not getting used to another child other than Hanne and will not be used to another, never!"[49] At this point, Stefan was already seven months old.

Why was Brecht fighting for Mar when he'd found a far more suit-

able kind of "wife" in Weigel—one who understood that the mixture of love and work had become essential? He lied with abandon to Mar during this time, but he could hardly have wanted to return to his marriage. And he was far too dependent on both Weigel and Hauptmann to contemplate giving them up.

Brecht didn't want to lose Mar—but he was in no way prepared to actually get her back. If she had believed his lies, things would have become unbearably difficult for him. The twenty-eight-year-old poet's desperate entreaties to her can only be read as the product of his most dominant emotional characteristic: He could not bear to end relationships, no matter how many new ones he began. It was a personality type as powerfully compulsive as a gambler or alcoholic. But it shows no signs of being a purely sexual addiction—his relationships with women like Weigel and Hauptmann were intensely intellectual and emotional as well. He was warm and affectionate and genuinely concerned with their welfare. He adored his children, and this created another level of permanent attachment to their mothers.

Mar belonged to Brecht's past, and although she didn't fulfill his new requirement of being involved in his work, she was still his wife, the mother of his child, and the first woman who had overwhelmed him with physical passion. It was as if giving her up would erase the emotions she had once invoked in the burning poet. Brecht clung to his women as if they were the repositories of his most important memories—he feared their loss with irrational terror.

Mar wisely found herself a more devoted partner. The comic actor Theo Lingen fell madly in love with her and also adored Hanne. Brecht exploded with jealousy. Although her relationship with Lingen began long after Stefan was born, he insisted that Mar's infidelity with Lingen had destroyed their marriage. "Of course I'm an idiot. I regret the time I've given you. It's significant that the only person who I've ever trusted other than my mother was such a ridiculous and ordinary phony. Most likely, you won't understand . . . Go to the devil."[50] After such eruptions, Brecht often reversed his tone upon receiving an answer from her. "I now have your letter. I thank you again, I'm in your debt for the rest of my life . . . I never wanted to leave you, or you to leave me. I have no attachment to anyone else."[51]

Brecht's jealousy knew no bounds: He insisted that Lingen was

a danger to Hanne. "I will do everything I can to protect my child from that fellow . . . Your crime is monstrous."[52] His suspicions grew increasingly grave with each letter: "Think how tender and observant and easily influenced children are! . . . I am sure, dear Marianne, that you are burning and a little blind . . . but try hard to think about the important things and know that you would never forgive yourself such a mistake."[53] No evidence of sexual abuse has ever surfaced about Lingen, but for more than a year—Stefan's second year of life—Brecht was possessed by worry and suspicion about Mar's lover: "Hanne is in the society of a man who hates me and who is (himself) suspicious and with whom you sleep . . . which is no atmosphere for a small girl. Think, if your mother had done that!"[54] Brecht's onslaught of anger and accusations only ended when he had to face the impossibility of keeping Mar in his life. He was devoted to Hanne, however, and she spent many vacations with Weigel and Stefan in the following years.

There is much to be reconciled in the passionately jealous and judgmental correspondence with Mar. Brecht openly lied about his relationships with Weigel and Hauptmann, as well as about Stefan. The facile interpretation is that he was a neglectful father and a deceitful Casanova who liked to keep all his options open. But it doesn't quite wash. It's entirely possible that he denied Stefan's existence because Weigel hadn't yet informed her parents, and he was protecting her secret. And perhaps his affair with Hauptmann might have endangered her job at Kiepenheuer. Certainly both Berlin women knew about each other, and he hadn't even tried to lie to either of them. Since up until this point, Mar was the woman to whom he lied most often, it's possible that he might have feared her indiscretion. His wild accusations about Lingen were a clear indication of his inability to control his emotions when it came to his wife. Brecht didn't "believe" in jealousy—he wanted to be more modern than that (in fact, his women were required to be more modern than that)—and it is interesting to observe how starkly his emotions and his convictions were in conflict. In these letters to Mar, we see Brecht as he is, rather than as he wanted to be. In a flash of recognition about his problem, Brecht once wrote to Weigel, "If I had two selves, I'd murder one of them."[55]

When Marieluise Fleisser, a young protégée of Feuchtwanger, came to Berlin in 1926 to get her play produced, Brecht's battle with

Mar was in a particularly explosive stage. It hardly seemed possible, even for Brecht, to engage in a dalliance with yet another woman. But he admired Fleisser's work and wanted not only to help her produce it but also to pursue his increasing desire to direct. He poured a lot of passion into her play, *Purgatory in Ingolstadt,* and fought for it as if it were his own. The energy Brecht summoned for the theater was fused with erotic tension, and it compelled him—or so he seemed to feel—to have an intense affair with his latest female discovery. At the same time, he also insisted on giving Weigel a part, even if it would mean her witnessing his romance with Fleisser. Typically, Weigel showed no indications of jealousy. When the play ended, she immediately took a job out of town, and in a display of extreme confidence, she even allowed Fleisser to stay in her apartment. Weigel likely saw that the flame between the two writers would soon go out after the show had closed. Fleisser, after all, had no intention of joining Brecht's collective, nor of devoting her talents to his plays. Without the common thread of work, Weigel knew the affair couldn't last. Fleisser lacked the one central feature of Brecht's women: Her own writing was more important to her than Brecht. And he could not tolerate a relationship with a woman who put herself first in any way.

Interpreting Brecht's behavior as weakness—rather than the signs of a rampantly cruel nature—is in no way forgiveness or absolution. But it's the only way to reconcile his true affection with his unequivocal deceit. He was actually, as Weigel described him, "a very faithful man—unfortunately to too many people."[56] The common denominator for all the women who remained loyal to him was that they understood and forgave this incurable aspect of his character.

Weigel knew Brecht best of all. She understood that he needed everything in excess—women, children, work, and love—but she also had surmised that of all these elements, his domestic life was paramount. "At heart, Brecht was a family man," Lenya sharply observed, "with two trees at Christmastime."[57] Weigel not only took care of Stefan but knew that Brecht needed to cultivate a strong connection to all his children—one that she was responsible for facilitating.[58] She remained essential to Brecht not only because she watched out for all his children, and for all practical purposes was his wife, but also because she was an ambitious and politically committed artist.

She made it possible for Brecht to have it all—the security of family affection along with the freedoms of the sexual and cultural revolutions. That's what it took to remain at the center of his complicated life. When Rudolf Schlichter painted Weigel's portrait—once again confirming her importance as an actress who was respected by the radical artists in Berlin—she hung it boldly in Brecht's attic *Kraal*. If women, including Hauptmann, wanted to sleep with Brecht, they would do so under her portrait. Weigel didn't lack a sense of humor.

Brecht obviously enjoyed being with intelligent and funny women. There was no doubt that he would have a powerful attraction to Lenya—although she was the least likely to accept his lopsided deal with women. She didn't have an upper-class upbringing against which she could rebel, nor did her father represent the kind of bourgeois values that Brecht's trio was escaping. She wasn't sexually loyal to Weill, but she would be the first to insist that this was a personal, not a philosophical, choice.

In contrast to Weigel, Lenya was escaping her brutal father's violence as well as her dismal future as a hatmaker. Her journey out of poverty had thus taken her in the opposite direction from Weigel, who was from the wealthy side of the tracks in Vienna, and had traded the comfortable life of an upper-middle-class family for the hardships of a struggling actress. And unlike Lenya, who learned her trade by the seat of her pants, Weigel was privileged to begin her stage career armed with a great education and exposure to the prominent artists who taught in her school. But both women were profoundly affected by the freedoms of modernity. If the times hadn't changed, it might have been much harder for even an educated woman to live alone in Frankfurt without her family's support. Since the "new" woman could now smoke and curse and pay her way, not to mention vote, neither Weigel nor Lenya had to keep their famously distinct voices suppressed.[59] They could display their ferocity with impunity, and it served them well on the stage and off.

Hauptmann, the supposedly shy literary woman from the country set loose in the big city, also owed her actual and fictional identities to the changing times. The new freedoms allowed her to see herself

as part of a larger female migration to the cities, and to analyze, satirize, and, most important, survive her naïve flight following a lover to Berlin. As a writer, she didn't have to succumb to despair, and she was able to view her misfortune as a chance to play the leading role in the new society. Hauptmann, Weigel, and Lenya would have been outcasts, but in the Weimar Republic, they had the chance to become artists instead.

Brecht's and Weill's relationships with very different women, each from utterly disparate worlds, said much about the breakdown of class divisions and gender inequality in postwar Berlin.[60] There were far more independent women working, living, and making love in Berlin than had ever been imaginable before. The modern woman was slender and athletic, and she might have a variety of lovers. She certainly had a job, and she had access to contraception—even if this was one opportunity most of Brecht's women failed to exploit.

Weigel and Hauptmann were from social and economic backgrounds that were similar to Brecht's, whereas Lenya's impoverished upbringing provided Weill with a point of view about both life and art that was entirely different from anything he had known before. She was his guide to the underground clubs in Berlin and a new set of ears with which to hear the popular songs of the day. She was smart and bursting with talent, and he craved her "uneducated" but sharp opinion of the short opera he was writing with Kaiser, especially since it was not the kind of music she normally enjoyed. His love for her voice, a "force of nature," enthralled him, but in a significant contrast with Brecht's women, she had no direct professional role in his life in their first years together. "Kurt always sat down at his desk at 9:00, completely absorbed and working like a happy child," Lenya reported. "At that time I didn't have much to do at the theater. I sat at the table, Weill came downstairs for breakfast, and then he went back to his music . . . 'This is a terrible life for me,'" she told him. "'I only see you at mealtimes.' He looked at me through his thick glasses and said, 'But Lenya, you know that you come right after my music.'"[61] When Weill dedicated his first opera to her, it was because she was his muse, not his partner.

But despite the difficulty of living with a workaholic, Lenya was thrilled to see her name on the dedication page of *The Protagonist*.

There she was, Karoline Blamauer from the slums of Vienna, now Lotte Lenya, a promising young actress who inspired a great composer's imagination and his first real success. This was the kind of class mobility that had been unimaginable for someone like her in the years before the war.

The composer's relationship with Lenya had changed his life, and so would the success of his first opera. Up until then, Weill was living hand to mouth, giving lessons and writing reviews, along with his tiny stipend from Universal Edition. "We were so poor that Kurt had to borrow a tuxedo to appear at the opening," Lenya remembered.[62] Weill and Kaiser sat in a bar across the street during the premiere. This was surely the experienced playwright's preference, one to which the outwardly confident young composer quickly agreed. Lenya, however, insisted on witnessing the premiere of the opera that was dedicated to her.

The Protagonist takes place in what the libretto calls "Shakespeare's England" and appropriately makes use of the play-within-a-play structure. The story focuses on an intensely talented actor who can no longer tell the difference between art and life. His confusion ultimately causes him to murder his sister while they are performing together. Weill boldly employs late-romantic and neoclassical music to distinguish the "real" from the "theatrical" aspects of the opera, heightening the literary characterization of both worlds. The full score encompasses a broad range of musical styles that rivals Mahler's symphonic sweep—covering the spectrum from Richard Strauss to Alban Berg—yet it is not only the variety itself but also Weill's skillful use of contrast that enhances the dramatic experience. This is most evident at the end of the opera. Just as the audience became impatient with the harmonically unresolved music, Weill shocked them with a sudden shift to a climactic finale in D major. This sudden jolt was perfectly timed, and it quite literally brought the audience to their feet. Lenya, who had been visibly shaking until it was clear that everyone approved, joined the rousing applause. Felix Joachimson, a composer and friend of Weill, remembered, "The audience hadn't heard a major chord for three-quarters of an hour" and they were "tremendously relieved."[63] Oskar Bie, a famous critic who was also present that evening, wrote that the contrasting musical styles gave the opera its "double soul."[64] There

were forty curtain calls and a twenty-minute standing ovation. Some-one ran across the street to convince Kaiser and Weill to take a bow for the enthusiastic public. From that moment on, Weill's ability to use provocative and beguiling combinations in order to illuminate a narrative became his distinct signature.

If Weill had been nervous enough to let the trembling Lenya do the worrying for him, the composer certainly leaped upon his success. He wrote his publishers right away: "It is already apparent that the extraordinary public success of *The Protagonist* is developing into a decided critical success as well . . . Everyone recognizes my pronounced talent for the stage . . . Everything depends on your exploiting the success in order to bring about further acceptances."[65] Soon dissatisfied, as he often was, with his publisher's efforts, he wrote them again a few weeks later: "We're happily at the point where impartial musicians have begun to notice your silence regarding *Der Protagonist*. I must confess that this really upsets me . . . Everyone who was there can confirm that there has never been such a successful first opera by a 25-year-old."[66] The loyal, quiet, dignified manner of the composer, with his monogamous tendencies and desire for a legal marriage, might have given the impression that he was milder than the provocative Brecht. But when it came to contracts and the promotion of his own career, Weill had a steely, sharp, unforgiving stance. Even before he had earned his publishers a nickel, he expected to be treated as though he was their most successful client. Brecht also played several publishers against one another—just as he usually had more than one woman at a time—but the writer was no stronger or stricter than the composer when it came to demanding respect, recognition, and money.

Both men were also equally stubborn, if in opposing ways, about the role of women in their art. For the composer, the division was still absolute: He went so far as to say that no composer should marry a woman who can read music. Hauptmann and Weigel, in contrast, contributed labor and inspiration in equal part, and Brecht urgently insisted that all of them share in his work.

Weill understood that his solitary devotion to composing made him a very unsuitable husband. And although he had quickly realized that Lenya would be incapable of being sexually faithful to him, he nevertheless believed that her behavior was no worse than his. He

confided to a friend, "People like us shouldn't get married. They are already married to their work. They commit bigamy if they marry a woman."[67] The composer believed that they had a great marriage— each tolerating the other's penchant for their particular version of infidelity. He was certain that the crossroads of his professional and personal life should be limited to Lenya's clearly defined and much appreciated role as his muse. She inspired him—for two years. But the mixture of art and love and collaboration rarely remains so pure. Lenya was a performer. And soon after meeting Brecht, Weill began writing a song he could only hear in her voice.

The step from muse to performer is never uncomplicated— especially when it's being taken by your wife. The romantic composer warmly encouraged Lenya to take this step, and was convinced it would be a short, fun collaboration. But he was about to delve into waters long inhabited by Brecht—that fateful combination of love and work and sex. The difference was that Brecht thrived on complications. Weill didn't.

Moon of Alabama

T he first meeting between Bertolt Brecht and Kurt Weill in the spring of 1927 had quickly assumed the aura of the inevitable. By the time they parted ways outside Schlichter's restaurant, they regarded each other as the missing link in their artistic evolution. The composer gripped Brecht's poetry collection, *Manual of Piety*, and hurried home in a state of keen anticipation. Weill hadn't been this excited since he had begun working with Kaiser. As he sat down to devour the small book, bound in biblical black leather, the air of suspense was palpable. He was hoping that the poetry in his hands would live up to the compelling ideas about musical theater they had so passionately discussed all afternoon.

Weill had high hopes for a collaboration with Brecht in general, but he was particularly eager to see if the poems would be suitable for the commission he had been offered by the renowned music festival in the city of Baden-Baden. The composer had recently abandoned his plan to submit the second opera he was writing with Kaiser. The opera was titled *The Czar Has His Photograph Taken*, and although it was more modern than anything he had done before—it featured a gramophone playing a record with a tango written by Weill—it had become too long and complex for the festival's program.[1] Weill excused this change of heart by declaring to his publishers that he was happy not to

"waste the work on the snobbishness of the music festival," revealing his strong critical stance toward the elite venue.[2] He had been ready to turn down the entire commission, but after meeting Brecht, his desire to shake up the audience in Baden-Baden was renewed. For although Kaiser was a brilliant dramatist, his interest in writing the text for an opera began and ended with Weill. Brecht's literary gifts were, by contrast, inextricably connected to his love for music and his ear for rhythm, and this convinced the composer that together, the two of them would create something that could both please and provoke the "snobs."

Weill sat back in his chair and leaned his head against the baby grand piano that was squeezed into the corner directly behind his worktable. His eyes fell upon the first page of Brecht's imitation "Bible." The poet offered firm instructions about how the book should be read: "This *Manual of Piety* is intended for the readers' use," Brecht wrote. "It should not be senselessly wolfed down. The First Lesson (Supplications) is directed straight at the readers' feelings . . . The Second Lesson (Spiritual Exercises) is addressed more to the intellect. It is advantageous to read it slowly . . . The Third Lesson (Chronicles) should be leafed through at times when Nature is showing her naked powers . . . Smoking is recommended." The Fourth Lesson was particularly intriguing, not least because it was already conceived as a musical section. The "Mahagonny Songs"—as the lesson was titled—are "the right thing for hours of wealth, for fleshly awareness, for presumption."[3] Weill glanced up at one of his landlady's hunting pictures of bloodthirsty dogs chasing deer and smiled. "Fleshly awareness" would be deliciously out of place at the high-toned music festival. A short opera infused with flagrant sensuality would come as a surprise to the elite intellectuals who were still in the habit of separating high art from the realm of earthy delights.

Since Weill was more familiar with the Torah than with the Lutheran Bible, he might not have been aware that Brecht's *Manual of Piety* was a parody of Martin Luther's 1527 *Book of Piety*, a collection of homilies and interpretations of biblical texts and sermons. And since the Lutheran Bible had permanently influenced Brecht's language, this impertinence was a humorous acknowledgment of both his creative debt and his critical stance.[4] And yet the satirical tone of the poetry

collection extends beyond conventional religion to include all forms of piety. Obedience to an omniscient higher authority, the poems proclaim, was a relic of the past. It was not only gods and kings but also the voices of previously exalted poets who must relinquish their power once and for all. In a truly democratic society, no one had the right to preach from on high. When Brecht wrote the specific instructions for how the poems should be read and "used," he was invoking the reader as an equal player in the game of poetry.

The section of poems titled "Mahagonny Songs" caused Weill's imagination—his "airplane" as he had written to his brother—to soar. This feeling propelled him out of his chair and onto his feet. As so often when he was absorbed in thought, Weill would walk back and forth between the window and the door, unconsciously pressing his right index finger to the side of his nose as the concept of the town called Mahagonny pulsed through him with the force of an electrical current.[5] The name itself—Mahagonny—was intriguingly mysterious. It sounded just like the German word for mahogany, but it was spelled differently and bore no obvious relation to the subject of the poems. The raw atmosphere of the town that the poems described, however, was as compelling as the title was enigmatic. The composer was entranced by the place long before he understood Brecht's reasons for its name. Over the course of five poems (or "ballad texts" as Brecht called them) the poet depicts a parody of a utopian town—a place where the only sin is running out of money. Weill began formulating an idea for a short opera about Mahagonny as soon as he read the last page of the book. Two of the five "songs" were in English, and he was particularly drawn to the beguiling rhythm of the "Alabama Song." Because Brecht wrote and sang ballads himself, the cadence of all his poetry had a naturally musical quality, and this was precisely what had captured Weill's attention the very first time he heard the poet's work on the radio. When the composer finally sat back down, he glanced at the musical notation that Brecht had included for all of the songs.[6] And although he was impressed by Brecht's sense of timing, he was not at all interested in the poet's specifications about the melody.[7] The composer understood that the melodies Brecht had published in the book, and his musical suggestions in general, "adhered to the totally personal and inimitable manner of singing with which

Brecht performs his songs." But Weill distinguished this from the actual act of composing: "This is nothing more than a notation of the speech-rhythm and completely useless as music."[8] With these words, the composer expressed his ardent admiration for Brecht's lyrical sensibility, while simultaneously staking out his artistic territory. The composer reveled in the musical potential of the Fourth Lesson, but he knew that the Mahagonny poems were not yet the "songs" their title promised. He was, however, passionate about their potential to be adapted into a one-act opera.

Moments after he finished the book of poetry, Weill began his typically intense composition process, rarely sleeping or eating for the ensuing hours and days, and from Lenya's point of view, he totally ignored her. As usual, she kept busy with auditions as much as she could, but she hated being alone. When Weill retreated into his composing cave, Lenya was compelled to seek the company of others. Weill knew that she often strayed during these times, but instead of becoming angry he would feel guilty about his own behavior. He once told a friend: "It isn't easy being married to me . . . It's hard on Lenya . . . I wouldn't blame her," he added, in a frank admission of her infidelity.[9] But Weill was also gratified by their unique understanding of and tolerance for each other's needs, and he believed this arrangement was proof of their deep and abiding love. He wrote proudly to Lenya about their ability to solve "the question of living together, which is so terribly difficult for us, in a very beautiful and proper way."[10]

Lenya and Weill had been living together for almost two years by the time he began working with Brecht. In addition to being happily in love, Weill also felt grateful on a purely professional level that she was in his life. Thanks to her, he had been exposed to a broader range of popular music and had learned about a variety of nightclubs and performers he had never seen before. The composer had enjoyed the influence of Lenya's popular tastes, and he freely absorbed them into his continually emerging blend of musical styles. But she longed for the stage, and her restlessness filled their tiny room just as powerfully as her voice began to haunt Weill's first attempt to set Brecht's lyrics to music. Lenya just wasn't the type to remain the silent inspiration behind her man—her days as a muse were clearly numbered.

When Weill began to set Brecht's poetry to music, he began with

the "Alabama Song." He may have appeared to be ignoring her, but in fact Lenya's presence suddenly began to seep into his work in an altogether new way. The profoundly sensual passion he felt for her had become inextricably entwined with his composing. "When I envelop myself in your voice," as he had written to her, "then you are with me in every way."[11] As he began to set the first Brechtian song, her voice, which he had dubbed "a force of nature," no longer overpowered him from the outside alone—it exploded within the deepest part of his creative self. Lenya's voice sprung from his soul. And since she had helped bring the "Alabama Song" into the world, he asked her to be the first one to sing it. She was thrilled.

When Lenya took her position by the piano and he played the opening bars, it must have been a tender and frightening moment. Was she all that he sensed she could be? Would her own soaring hopes be crushed?

But soon after she sang the first few lines, it was clear to both of them that she was born to sing that song. Lenya had an untrained but naturally pure soprano voice that contrasted with her direct, forceful, and even menacing performance style. Weill had been right about his muse—she infused his music and Brecht's lyrics with just the right blend of tragedy and humor. "Oh, show us the way to the next whiskey-bar / Oh, don't ask why, oh, don't ask why."[12] The "Alabama Song" had clearly been written under Lenya's spell and it lived best of all in her voice.

After hearing her sing, Weill was ready to invite Brecht over to hear the "Alabama Song." Weill was confident about the song and only hoped that it was as obvious to Brecht, as it was to him, that no one could sing it better than Lenya. The composer also hoped that the rebellious poet would particularly enjoy casting an unprofessional singer in an opera for a highbrow music festival.

As Lenya and Weill waited with great anticipation for Brecht to arrive, the poet was ambling leisurely down the street toward their pension on the Luisenplatz. Turning the final corner, he would probably have been delighted by the magnificent Schloss Charlottenburg across the street. There were many remnants of the monarchy in German archi-

tecture, and Brecht enjoyed these frequent reminders of the emperor's demise. He also would have admired the expansive park that surrounded the castle. Brecht had come to like Berlin, but he still missed the open spaces and fresh air of his Bavarian hometown. The river running behind Weill's building recalled the days and nights Brecht spent roaming the banks of the Lech in Augsburg, playing his guitar and singing. Weill's neighborhood had wider boulevards and more trees than Brecht's, and the nature-loving writer was grateful for the chance to see a bit more of the sky. The poet from the Black Forest, as he liked to call himself, would have enjoyed gazing at the winding canal before heading upstairs to Weill's apartment at the back of the building.

The *Manual of Piety* that had inspired the composer had actually prompted an angry rupture between Brecht and his publisher, Kiepenheuer. Once again, his poem "The Legend of the Dead Soldier" had gotten him into trouble. Kiepenheuer had recently acquired new backers, and they refused to include Brecht's antiwar poem in the collection. As a favor to Brecht, Kiepenheuer had put out twenty-five special copies that did include the controversial poem, but this edition was intended for private use only. They then insisted that the official publication adhere to the censorship demands of their financiers.[13] Brecht happily accepted the twenty-five free books—ignoring the "private use" mandate by offering them to potential colleagues like Weill— and as soon as he found a more courageous publisher, he proceeded to rip up his contract with the acquiescent Kiepenheuer.[14] The new publisher produced a handsome edition, but one that offered a milder version of the religious satire that the Bible look-alike had emphasized. The cover, by Caspar Neher, portrayed a monster with a rosary and a derby hat.[15]

Brecht was determined to keep the controversial poem about the dead soldier in the collection not only because he liked to have his way but also because its critique of society was crucial to the *Manual*'s artistic goals. By 1927, the widespread commitment to a democratic culture had permeated every aspect of the arts. The eradication of elite traditions meant that all forms of culture had to be relevant and entertaining for ordinary citizens. But the concept went even further than that to demand that all art serve a specifically useful function in

society. Music, for example, should be an integral part of daily life, not a temporary and transporting amusement. Young composers like Weill no longer wanted "concerts that release listeners *from* life, but music-making that redeems the listener *in* life."[16] The Bauhaus school of design created a form of art that was directly useful—their chairs were meant to be sat upon—and their buildings provided beauty and shelter in equal measure. As far as Brecht was concerned, a poem criticizing the war was but one example of how literary activity could be "useful." In the case of "The Legend of the Dead Soldier," he believed that his poem could function as a clear argument against a potential war in the future. This was not at all a vague sentiment against violence in general. It was a specific protest against the dangerous threat of rearmament in Germany. Bitterness over the humiliating surrender in World War I was still strong, and dreams of revenge festered in powerful quarters. It was imperative to remind everyone of the vile hypocrisy of the Great War in order to thwart the dangerous military impulses in their midst. Brecht was certain that the social and political impact of his poem was as necessary as a "loaf of bread." Poetry, he claimed, "should not be an outlet of private emotions . . . It should be judged solely by its social usefulness."[17] That's why in the *Manual*, each poem is designed for use in a certain situation. Just as the roguish Baal of his first play transformed the romantic image of the visionary poet into a crudely realistic and sinful man, so Brecht's *Manual* was intended to establish a new understanding of what poetry could accomplish in the world.

When the controversy over his poem led to the severing of his contract with Kiepenheuer, Hauptmann was also directly affected. Since the publisher had been paying her, in part, to help him finish the poetry collection he had taken away from them, she lost her job. But she stayed on with Brecht and was already deeply involved in his next play. By then, they were developing a number of projects together, and although Hauptmann would have to find a new way to earn reliable money, she didn't hesitate for a moment. "The third thing" defined the purpose of all her creative work with and for Brecht.

By the time the book of poetry had switched publishers, Hauptmann had already played a crucial role in its completion, one that was still known only to Brecht and herself. If Weill and Lenya had realized

that Hauptmann was the only one who could actually speak or read English, they might have had a clue as to who was the true author of the "Alabama Song." Then again, given Brecht and Hauptmann's way of working, the notion of "true authorship" is far from simple. Hauptmann wrote the precise words, but the poem could never have been written without her profoundly symbiotic relationship with Brecht. It was Brecht's overall concept of the *Manual of Piety* that had inspired Hauptmann to write the song. The poem's dual genesis resonated powerfully enough to inspire the creation of yet another significant collaboration between Weill and Lenya. There was a good deal of passion in this single song—the love lives of four people were inextricably woven into its creation.

Brecht arrived at Weill's pension attired in his usual way. His unshaven cheeks and the stump of a cigar perched in the corner of his mouth did little to improve his habitually disheveled appearance. When she answered the bell, the landlady, Frau Hassforth, mistook him for a beggar and shouted, "We don't want anything today!" as she slammed the door in his face. Weill heard the commotion in the courtyard and went running down many flights of stairs to inform his landlady that Brecht was his guest.

Brecht probably didn't yet know that the polite composer had a wife, let alone such a surprising one as Lenya. He was taken with her before he knew she could act or had any intention of singing the "Alabama Song" for him. Lenya never tried to gloss over her background, and in her direct manner and blunt speech, Brecht would have seen right away that she had grown up among the lower-class society he was so eager to understand. One particular coincidence was uncanny: When *Baal* had its first Berlin performance at the experimental Junge Bühne (Young Stage)—a theater without a permanent building or reliable funding—Brecht and Hauptmann decided that the play would attract more attention if they pretended the story was based on a real person. Together, they invented a mechanic named Josef K., a laborer who became, like the character of Baal, a poet of the streets and cities. Brecht wrote a newspaper-style article for a popular magazine with the added detail of Josef K. being the illegitimate son of a washerwoman.[18] Baal's fake autobiography cloaked him in working-class authenticity, just as Brecht's leather jacket gave him the appearance of a common

man. As the playwright was introduced to Lenya, who actually was the daughter of a barely literate laundress, he was thrilled to meet just the sort of character he wanted to create for the stage. His fictional plays and his life were blending, which is just what he wanted.

As Weill predicted, Brecht was delighted to hear Lenya perform, and especially because she had no formal musical training. When she began to sing, she was on her familiar tightrope again—the high-wire act where she knew that one slip can mean disaster—and the tension was perfectly suited to the "Alabama Song." When she sang in her high, sweet voice, which simultaneously embodied everything that was not sweet—"Oh Moon of Alabama / We now must say goodbye / We've lost our good old mamma / And must have whiskey / Oh you know why"—the desperation of an unhappy five-year-old girl came ringing through the lyrics. The public admiration of the circus audience had helped her to survive the oil lamp, and the abuse, that had been hurled at her in private. But because she didn't have a shred of self-pity, the adult Lenya would have denied her need for applause to soothe the pain of her past. Such denial made her performance especially poignant. Lenya refused to consider herself a victim, but she could certainly sing a convincing song about lost innocence. And yet, even the raw emotion she so powerfully displayed would not have been enough for the composer or the poet if she didn't also have the musical talent to match. As it turned out, she had an extraordinary ear, as well as an equally natural gift for rhythm. Since Brecht had sung and played guitar for most of his life, and had admired the fairground barkers and local balladeers in Augsburg, he could certainly appreciate the singular quality of Lenya's untrained voice. He was impressed from the very first line. When Weill played the piano and Lenya sang, the poet realized that his words and the composer's music were having a magical encounter in the voice of Lotte Lenya.

The song describes a quest for whiskey first, pretty boys second, and, finally, dollars. The song is melodic, jazzy, and lighthearted on the surface, but it is also rich with a melancholic undertone. The music, like the words, captures both the excitement and the disillusionment of life in a cold, uncaring city. In a world without values, only vice can nourish the soul. The town of Mahagonny may offer freedom from conventional morals, but—the ironic tone implies—that doesn't

necessarily lead to happiness. The cheerful melody underscored the harshness of the lyrics, playing skillfully with the listener's emotions on both levels. As the lyrics bitterly proclaim "For if we don't find the next little dollar / I tell you we must die," the music simultaneously taunts with its merry rhythm.[19] This contrast forces the audience to enjoy the humor and suffer the pathos all at once. There is freedom to do what one wants in Mahagonny, but the song warns that this version of paradise is not for everyone. The song is a specific parody of bourgeois values as well as a universal send-up of man's relationship to sin. Lenya's style was perfect—she blended tragedy and whimsy with ease as she delivered the song with her entire body. She used her large eyes and red lips, and, until Brecht stopped her, she also tried to frame the music with her expressive hands as well.

"When I sang the 'Alabama Song' for him the first time," Lenya remembered, "with my good solid ballet school training, I started and evidently made a few gestures which he considered too balletic, and he told me, 'Lenya darling, don't be so Egyptian,' and with a slight touch he just turned my hand round, and it became a famous gesture of mine . . . This was his way of just touching you, and, without taking away anything of your personality, he brought out whatever was there."[20] The perceptive poet must have sensed that what was "there" in Lenya was the depth and power of her painful past. Her way of moving and singing was infused with her brutal childhood, and he knew that no amount of "solid ballet school training" could or should smother it. Instead, he encouraged her to "pour out her sorrow to the moon."[21] "He listened with that deep courtesy and patience that I was to learn never failed him with women and actors," Lenya said, accurately sizing up the rogue genius who so skillfully guided her performance.[22] She realized quickly that Brecht's talents—his acuity, instincts, and charm—were as well suited to the art of theater as to the art of seduction.

When Brecht took Lenya's hand and turned it over, she was sensing not only his tenderness but also his force of will. He knew precisely how he wanted his performers to look and sound, and although he had interfered loudly in nearly all the rehearsals of his prior productions, he was getting better at communicating his demands. His close

relationship to Weigel might have helped him understand that speaking gently with actors was more productive than shouting at them, as he had during *Drums in the Night* and *In the Jungle of Cities*. Brecht was always frustrated when people had trouble making changes as quickly as he did. In past rehearsals, he had asked actors to memorize and interpret text that he had revised on the spot. He refused to tolerate objections or hesitations from anyone, even directors and producers. This—just as much as the rebellious content of his plays—had earned him a reputation as a troublemaker. Prominent actors often exercised their power over the young playwright, and some even quit if their authority wasn't instantly acknowledged. If Lenya perceived Brecht as deeply courteous and patient, this meant he had come a long way since his first experiences in the theater. Perhaps he had finally realized he should find a way to win over his actors as successfully as he charmed women. It's also quite possible that Brecht was as perceptive about the composer's wife as she was about him. He hadn't taken three steps into the room before he realized that it would be almost impossible to intimidate a woman like Lenya.

Lenya, Brecht, and Weill were all equally ecstatic about the first song. They were also all equally unable to understand much English.[23] This probably added to their innocent pleasure of the way the words interacted with the melody to create a fantasy impression of America. Although they were certainly familiar with the simple vocabulary— whiskey, mammas, pretty girls, dollars, and perhaps even the whole sentence "Oh, moon of Alabama / We now must say goodbye"—the most important word in the song had initially been chosen without anyone realizing that it was the name of a state. Not even Hauptmann knew much about the actual geography of her mother's native land. Brecht and she had simply liked the way "Alabama" rhymed with "mamma"—that is, if you pronounced the state name so that this rhyme would work. The mythical city of Mahagonny could have been located almost anywhere from the Gold Coast of Florida to Alaska— saloons, whiskey, and dollars were all meant to invoke the generic symbols of America. The entire conception was a testament to the obsession with the country that bewitched so many Berlin artists.[24] They read the American newspapers and were captivated by the dan-

gerous Al Capone, the Florida hurricanes, Jack London, and Tin Pan Alley. Anything extreme, violent, or uncontrollable in both humans and nature signified America.[25]

The atmosphere of the "Mahagonny Songs" was inspired by Brecht's and Hauptmann's imagination of what America might be like. It was partly based on information they read in the newspapers but ultimately had little to do with the particular reality of an actual place. In this same spirit, as Weill had noticed right away, the very title was a made-up word. The similar German word, spelled *Mahagoni,* refers, like the similar-sounding English word *mahogany,* to the dark wood of tropical trees, but the connection between the trees and the mock utopia was hardly self-evident. Deciphering the meaning of Brecht's invented word is like putting together a jigsaw puzzle he invented for his own amusement. The mystery underscored the metaphorical nature of the town Brecht had invented, and it also provoked the audience to consider the various possibilities for its origin.

Brecht never deigned to give a complete explanation, but there are three interlocking theories that attempt to solve the mystery. The most common one was offered by a friend who was with Brecht when he first saw the Brownshirts marching in Munich in 1923. The poet apparently likened the color of their uniforms to that of the dark wood and remarked grimly, "If Mahagonny is coming, I'm leaving."[26] Another theory is that the name comes from the biblical city Magog, a city of sin that makes Babylon look tame.[27] Given Brecht's penchant for playing with biblical references, it's likely that this thought came to mind at some point, even if it didn't spark the idea itself.

Finally, and most intriguing on many levels, there was a German song that came out in 1922—the year Brecht first mentioned the name "Mahagonny" in his poetry—called "Komm nach Mahagonne" ("Come to Mahagonne"). This song was actually a cakewalk, but it was misleadingly subtitled as an African shimmy and was a big hit all over the country.[28] Brecht had certainly heard at least one of the two popular recordings.[29] Both the song's subtitle and its rhythmic genre were emblematic of the interest in the culture of black people that went hand in hand with Germany's interest in America. Sounds and images from Harlem were just as tantalizing as those colorful Chicago gangsters and Wild West cowboys. The hit song and Brecht's poem used

extremely similar language and references to invoke the European fascination with the freewheeling country across the ocean.

The most telling evidence for Brecht's familiarity with the hit tune is contained in a special feature of its lyrics. In the original song, the use of a repeating syllable was employed in the case of the word *Ziehharmonika* (accordion). When sung, the first syllable, *zieh* (meaning "pull"), is sung several times before the word is completed. The word-play of *"zieh-zieh-Ziehharmonika"* mimics the action of the accompanying accordion that is being pulled out as far as possible before being pushed in again. The physical movement of the accordion creates the music that is heard, which is in turn described by the lyrics themselves. Brecht made use of this entertaining mirroring device in a darkly comic way. In the first ballad of the lesson titled "Off to Mahagonny," he uses the repeating first syllable for the word *Zivilisation* (civilization). *Zi, zi, zi* is repeated, and because it sounds like the beginning of the German (and English) word for *syphilis*—*sy*—the lyric is clearly playing with the connection between so-called "civilized" society and venereal disease.[30] The third stanza of his poem reads: "Off to Mahagonny! / Our good ship is unmoored / And there our ci-ci-civiliz- / ation will soon be cured."[31] The bitter irony of the lyrics also stems from Brecht's unpleasant stint as a medical intern in Ward D during World War I, when he attended to the officers who were suffering from this malady.

There are too many coincidences to deny a relationship between the original song and Brecht's poem.[32] But this was surely but one of many influences on his fictional utopia. The notion of multiple origins for the "Mahagonny Songs" is especially intriguing with regard to the light it sheds on Brecht's artistic process. Whenever he was inspired by the work of another, it was always in part because it had captured an essential aspect of the zeitgeist. Brecht's poetry collection as a whole, and the "Mahagonny Songs" in particular, is an excellent example of how the poet literally absorbed the contemporary times into his work. He borrowed freely from real people and events, as well as from the creativity of others. The association with the song doesn't rule out the importance of his unpleasant confrontation with the Brownshirts. Their uniforms reminded him of the color of mahogany, and this contributed perhaps to many of the other negative aspects of his made-up town. America was wild as well as greedy, a place where dollars ruled

the day. Hitler's emerging party was diabolical and dangerous—a lightning rod for the frightening military and industrial interests. Greed leads to violence in the town of Mahagonny, thus combining images of an imaginary America with Brecht's fears about the rabidly right-wing elements in Germany. The name Mahagonny is a play on the color, geography, and culture that it calls to mind, and it's unlikely that there is a single source for the Fourth Lesson of his poetry collection. Everything was fair game when Brecht went to work. As far as he was concerned, even the "Alabama Song" was neither borrowed nor stolen but instead freely given. On the day the song was truly born, he probably saw no reason to inform Weill and Lenya that the English lyrics had been penned by Hauptmann.

The poet, composer, and newly christened performer worked on the "Alabama Song" in a state of great excitement. Brecht needed to walk around as he worked, and he must have traversed Weill's tiny room many times before they were finished for the day. Lenya stood in front of the piano and felt increasingly confident of her ability to realize the vision of both the astute writer and her husband. Weill sat at the piano, listening and watching—and likely smiling to himself about his and Lenya's shared success—but he would have waited until he was alone before making any permanent revisions. Both men were thrilled to discover that they not only had similar ideas but also were a good match in terms of talent, energy, taste, and, just as important, speed. They both liked working quickly and required the same level of velocity to keep their creative engines running. Brecht agreed to Weill's suggestion of rearranging the poems to suit the needs of a short opera, and they plunged into a mutually inspiring and intense exchange of ideas for the rest of the afternoon. The three of them went to Schlichter's— the restaurant where it all began—to celebrate what promised to be a great partnership.

Weill and Brecht were celebrating not only their creative connection but also the prestigious commission from Baden-Baden. For despite the long list of achievements each of them could boast by the middle of 1927, neither of them had much money, and every opportunity to publicize their talents was welcome. Brecht's poems were published but hardly lucrative—and although he had several publishers vying for his theatrical works, he could barely support himself, let alone his

growing number of dependents. Brecht made his situation very clear in a letter he wrote to the German internal revenue service: "I have received another summons to file a tax return and wish to explain to you why I regard myself as tax-exempt. I write plays and . . . live exclusively on publisher's advances, which are paid to me in the form of loans. Since *for the present* I earn next to nothing with my plays, I am up to my ears in debt to my publishers. I am living in a small studio in Spichernstrasse and, should you suspect the presence of wealth, invite you to call on me."[33]

Weill was in the same financial position as Brecht, minus the many dependents. His first opera was a critical success and had been performed at fifteen opera houses in Germany, but he was still not earning enough to live comfortably. Most of his income came from teaching private students, but he spent far too many hours on his own work to adequately devote himself to his pupils. By April of that year, he had lost most of them, and he was finding it hard to survive by writing reviews and from his meager monthly advance from his publisher. He pressed them to give him a better stipend so that he could concentrate on his real work. He increasingly resented having to write for the radio journal, complaining that it "costs me my best working hours, and as it is, the pace of my composing is very exhausting for me . . . I believe, that . . . since I have worked uninterruptedly for an entire year, you are obliged to improve my financial position."[34] He truly believed—and in fact demanded—that Universal Edition's faith in him should override all else. He wrote directly to Emil Hertzka, the head of the company: "The recent severe deterioration of my financial situation demands a fundamental change . . . In my present situation, it is quite impossible to begin work on . . . any of my compositional plans if you don't pay me quite a bit more than before (and according to my increased productivity)."[35] Weill naïvely insisted that idealism must trump commercial concerns. Did he truly expect a publisher to agree, or were these challenging letters a shrewd calculation? Perhaps the music-loving publishers of Mahler and Schoenberg were willing to give Weill more money in order to maintain their cultured and prestigious reputation. Surely, Weill was suggesting in a provocative tone, they cared more about their artists than they did about turning a profit?

As Brecht, Weill, and Lenya were celebrating the birth of the "Ala-

bama Song" at Schlichter's, patrons at other tables were hotly debating Fritz Lang's incendiary film *Metropolis*. The film was a metaphorical but searing portrayal of contemporary divisions of class and wealth in Germany, and it exposed the violence that was simmering just below the surface of polite society.[36] Artists like Lang, and Brecht and Weill, were eager to bridge the gap between businessmen and workers, between rich and poor, and they believed in the communicative powers of film and theater and music to help unify the country. Weigel was proud to have played the role of a worker in Lang's important film.

Although it had been three years since hyperinflation had been brought under control, and the number of unemployed had dropped significantly, the financial hardship of Brecht and Weill in 1927 mirrored the persistently fragile condition of Germany itself. German citizens had yet to fully recover from the dire postwar poverty; and the lingering economic insecurity fueled the psychological effects of the internal violence that tore the country apart in the wake of World War I. From 1922 to 1924, there had been three hundred politically motivated assassinations in Germany, and old wounds had yet to heal.[37] Political violence perpetuated the financial insecurity, and the same month that Weill and Brecht began working together, the German equity market collapsed due to a steep and sudden decline in prices. May 13, 1927, was dubbed "Black Friday," reminding everyone that despite the dramatic improvements the year had witnessed, the country's finances were still quite precarious. Germany was deeply in debt and dependent upon American loans, and its citizens knew all too well that economic turmoil could unravel democracy faster than Penelope could undo her shroud.

Brecht and Hauptmann's latest idea for a play, which took place against the backdrop of the international wheat market, became increasingly relevant after Black Friday. The working titled was *Joe Fleischhacker*—Joe Meatchopper, a humorous way of referring to a butcher—and Hauptmann enthusiastically researched the idea. This was their first direct attempt to develop the kind of theater that illuminated social and economic subject matter. "When I read *Das Kapital* of Marx, I understood my own pieces," Brecht wrote. "I did not of course discover that I had unconsciously written a whole batch of Marxist plays; but this Karl Marx was the only spectator of my pieces

I have ever seen. For to a man with such interests, these pieces must have been of interest, not because of their intelligence, but because of his."[38] Where the "Mahagonny" poems had been a playful parody of a greedy bourgeois society, *Joe Fleischhacker* was an attempt to present a specifically Marxist perspective in the context of a dramatic narrative.

Brecht's growing interest in the Marxist worldview made him particularly receptive to another offer that Weill received just after they began work on their one-act opera for the music festival. The city council of Essen asked the composer to write something that would commemorate the industrial complex of the Ruhr district, an important region in Germany.[39] Eager to maximize the potential of a multimedia presentation, Brecht and Weill engaged Carl Koch, a photographer and filmmaker, to work with them. The initial idea was to create an "industrial opera" that would satisfy the politicians and business leaders who hired them and also appeal to the miners and factory workers. And unlike the music festival, where artists worked for the honor alone, this job would do more than just spread their name. If it worked out, this would be a paid commission.

The Ruhr invoked bitter memories of Germany's postwar agony. The financial hardship that began at the end of the war continued for many years, and the German government was paying hefty reparations in a currency whose value was decreasing by the hour. By 1923, the Allies finally refused to accept German paper money and instead demanded commodities such as gold, wood, and coal. Germany resisted as long as possible, hoping to avoid handing over their sorely needed material goods. France and Belgium were outraged and invaded the Ruhr to seize its key assets: the coal mines and steel mills. The German workers refused to work for the occupying countries and went on strike. The government supported their resistance but had to print money in order to survive. That caused the hyperinflation, and in less than a year, the dollar was worth a surreal 4.2 trillion marks.[40] Since most of Germany was dependent on the Ruhr industries, everyone immediately felt the impact of the strike. The poverty that followed crushed what little strength the German civilians had left after the long, destructive war. As such, the Ruhr symbolized the humiliation of defeat for the entire country. This hadn't been forgotten in the four short years since the invasion, and a musical drama about

this area would speak not only to the workers who had been directly involved but also to the whole of the angry nation.

The *Ruhrepos* (Ruhr Epic), as it was titled, was the ideal project for Brecht and Weill, who were eager to rip the opera out of its elitist shell and offer it up to the workers.[41] In June, only three months after their first meeting, they went down to explore the area together. One of the most exciting aspects was the opportunity to take an airplane, and Weill wrote enthusiastically to Lenya about the trip: "The flight was magnificent. One actually feels amazingly safe, and much less nervous than on a train. The most beautiful moment is when the airplane very slowly lifts itself into the air." From the bright and brilliant trip in the sky, Weill, Brecht, and Koch soon descended into the dark reality of industrial laborers. Weill continued his letter to Lenya in a more somber tone: "The next day by noon we again emerged from the mines into daylight; then it became clear—the terrible horror down there, the boundless injustice that human beings have to endure . . . just so that Krupp can add another 5 million to their 200 million a year—this needs to be said, and in such a way, indeed, that no one will ever forget it. (But it will have to come as a surprise, otherwise they'll shut our mouths!)"[42] Brecht, Weill, and Koch had begun the project with every confidence that they could please industrialists and workers alike. But when confronted with the actual conditions of the miners, they became increasingly critical of the politicians who were financing this homage to the great industry of the Ruhr. The plight of the laborers was impossible to ignore, and the three men resolved, as Weill wrote, to sear their reality into the minds of all Germans.

After an initially favorable response to their written treatment for the project, the culture minister of Essen, the capital city of the Ruhr, suddenly expressed his concerns about the cost of *Ruhrepos*. Brecht responded quickly with a promise to reduce the budget, but his letter was met with stony silence.[43] Although there was no reason to think that the authorities had gotten wind of the artists' antagonistic stance toward big industry, it certainly would have explained the switch from enthusiasm to indifference. But even if this had crossed their minds, Brecht and Weill were under pressure to complete the *Mahagonny* opera and they didn't have much time to deal with the brewing difficulties in Essen. The situation might even have brought a brief, bittersweet smile

to their lips as they reflected on the similarity between Essen and the inhabitants of their fictional Mahagonny, both plagued by that need for dollars. Art that captured the spirit of the times was merging with reality once again.

During that superbly fertile spring of 1927, Weill and Lenya had become quite familiar with the steep stairs of Brecht's fifth-floor attic studio on Spichernstrasse. The married couple observed the spare space with a smile. They too lived simply in their small room divided by a piece of tapestry, but they had at least managed the rug and curtains that Brecht either disdained or couldn't afford. The staunchly bohemian atmosphere was intriguing but definitely not congenial to the composer or his wife. There was a lot of paper "flying messily around," as Lenya observed, a huge couch sitting on a bare floor, Hauptmann's typewriter on the long table, and of course Brecht's guitar hanging on the wall. Weigel had also bought an old upright piano for Brecht, which Hauptmann knew how to play, and he was also learning the banjo. Weill had heard Brecht's love for music in the rhythm of his words, but in this instrument-filled studio, the composer also saw that this passion overpowered every corner and crevice of the room.

When a strong breeze rattled the loose windowpanes, the cold would leak in through the gaps and even the large iron stove wasn't able to heat the room adequately. But on almost any given day, one could rely on the intense intellectual activity to warm Brecht's studio. Lenya and Weill inevitably found Brecht surrounded by Hauptmann and several disciples, or, as he called them, collaborators, "getting ideas, reactions, a word here, a thought there, his ear constantly on the alert, freely, ruthlessly, everyone else sitting while Brecht walked leisurely around the room . . . On a large easel, which was also standard equipment in Brecht's room, would be the inevitable charcoal drawing by Caspar Neher, [with] ideas of décor, costume, or character."[44]

Weill formed an immediate connection with Neher. These two quiet men were far more similar to each other than either one was to Brecht, and both felt the potential for a deep friendship alongside their professional relationship. This was fortunate for everyone, since it was impossible to work with Brecht without appreciating Neher's

ideas. The visual impact of Brecht's plays was inextricably intertwined with the designer's artistic perspective.

It was at Spichernstrasse that Lenya first encountered Hauptmann, and where she first dubbed her the "devoted shadow." "She still had the neatness of a schoolteacher at that time, despite her conscious effort to be a Brecht-type woman. [She was] rosy-cheeked, with slightly popping brown eyes, plumpish with a Rubens-type behind and the most servile imitation of Brecht's mannerisms of gesture and speech."[45] If Weill and Lenya had known that Hauptmann was the writer not only of the "Alabama Song" but also one of the other poems included in the "Mahagonny Songs" section, they both might have guessed at the independent spirit brewing within the outwardly mild assistant. But they might also have been curious as to how these poems came to be in a collection with only Brecht's name on it, and thus wondered at his facile ability to subsume the work of others.[46] But Hauptmann viewed her English songs as a small contribution that she had only been able to make in the context of Brecht's inspiring collection of poetry. Lenya would have found it especially hard to comprehend Hauptmann's yearning for anonymity since her own desires ran in the opposite direction. She was already suspicious of the atmosphere of intense devotion to Brecht that hung in the air of his studio just as thickly as the smoke of his cigar.

Hauptmann would have countered that she was far more devoted to "the third thing"—to politics and the collective style of working it entailed—than she was to Brecht. This was certainly what the author in Hauptmann wanted to believe, even if she didn't always fulfill her goals of independence. And even if someone like Lenya couldn't understand this attraction to group creativity, Hauptmann would have been encouraged by the many Berlin artists who worked in a similar way. They were all hoping to smash hierarchy and elitism with the mighty hammer of equality and democracy. "I believe that the collective attitude [requires] a certain absence of vanity," Hauptmann said proudly, "or absence of a need for recognition . . . It really needs to all be focused on a 'third thing' ('*dritte Sache*') . . . And I think that's how it was, there was no rivalry." "No rivalry" was a claim the idealistic Hauptmann often made, but she was clearly only indicating that the people in the circle around Brecht did not compete with him. She

freely acknowledged that Brecht's spectacular talent, along with his strong personality, set him apart. He was the undisputed authority in this staunchly egalitarian collective. "That was the inherent acceptance of the 'primus inter pares' . . . which was Brecht," Hauptmann said, describing this paradox without apology. "He knew that, we all knew that . . . He knew and understood so much more than all of us, of course. That goes without saying."[47]

It was clear, however, from the very first visit that Weill would never be part of this particular configuration. Brecht perhaps sensed this resistance to his way of working but must have found the competition with the composer to be just as inspiring as the devotion of his collective. Since Weill was an equal player who could not be easily absorbed, Brecht was spurred to keep vying for the kind of creative dominance to which he had become accustomed. This was an unusual and even daunting feeling for the magnetic poet who so easily drew people into his constellation, and it provoked him on a profound level. Brecht rarely met someone he considered close to being his match. Few were accorded the status of Neher, his artistic brother.

Brecht's need for discussion was as necessary to him as silence was to Weill, but the composer nevertheless enjoyed the lively intellectual atmosphere at the studio. "Brecht often had extremely primitive ideas for a song," Lenya observed. "A few bars of music which he had previously picked out on his guitar. Kurt always took these with a smile, saying yes, he would try to work them in. Naturally, they were forgotten at once."[48] Hauptmann, who had studied piano quite intensively as a child, took Brecht's ideas about music more seriously. She and Brecht often played music together and "during the mornings, we created endless song texts, also melodies," Hauptmann remembered happily.[49] Weill noticed the difference between his and Brecht's way of working, but as far as he was concerned, the poet was a gifted writer who was free to create however and with whomever he pleased. And the highly educated Weill was certainly not musically threatened by someone who had written an occasional ballad. He enjoyed Brecht's sensitivity to rhythm and love for music, but knew that had nothing to do with real composing. Weill assumed that Brecht was smart enough to know that as well.

True talent is rare, and two truly compatible talents is an even rarer

phenomenon. Composers are always on the hunt for literature—and then librettos—that give them the opportunity to write great music. Discovering the prodigious, prolific, and intensely talented Brecht was a dream for a composer of Weill's ambition. Since Brecht was certain that stage music was in as much need of transformation as drama itself—and since his poetry was infused with a musical cadence—he was equally thrilled to have found a composer whose devotion to literature, and whose conceptual ideas of musical theater, were in the same league as his own. As musicologist and Weill expert David Drew eloquently writes, they had "two such dissimilar yet strikingly complementary minds," and the creative results were both fast and furiously satisfying.[50] They acknowledged each other as equals, but both were accustomed to having the final word, and the balance of power was the as yet unspoken question in the room.

Brecht and Weill had noticed the personal differences between them from the very first moment of meeting. They had each smiled wryly at their contrasting ways of dressing and speaking, but were soon overwhelmed by their mutual artistic vision. But after a few months of working together, it had become clear that while there was a lot of heat, there was not much affection between the competitive Brecht and Weill. If Kaiser and Weill were like father and son, the writer and composer weren't even cousins. But in those first heady months, that wouldn't have mattered at all. Their creative connection was so exciting that the lack of friendship was unimportant by comparison. They continued to use the formal *Sie* and both were comfortable with the linguistic and personal distance between them.[51] Neither Brecht nor Weill offered the informal "you" lightly—and certainly not to each other.

Brecht therefore often found it necessary to depart from his circle in order to work with Weill, and before they began in earnest, he would send everyone away except Hauptmann. They completed *Mahagonny* in just two weeks—small wonder that their artistic harmony far outshone their glaring differences of personality. For Brecht and Weill, the creative result mattered more than anything else. When they began to discuss the visual concept with Neher, they were more excited than ever.

Lenya was the only one to foresee a contest of wills between these

two strong men, and she wondered how the writer's personality would mesh with her equally confident and entirely independent composer husband. In contrast, Weigel and Hauptmann would have been unable to imagine anyone competing for power or primacy with Brecht. They felt privileged to be part of his collective and were certain the new composer would feel the same way.

The festival in Baden-Baden prided itself on being an important venue for modern music in Germany. Although the composer certainly hoped a number of prominent people in attendance would take serious notice of his musical achievement, both men looked forward to puncturing the festival's lofty sense of its own importance. With their lusty portrait of a whiskey-soaked utopia populated by gamblers and whores, they hoped to change the cool and pristine trappings of "modern" opera forever. All would be transformed in Mahagonny, a place where man's devotion to money is so powerful that even the moon is green.

Off to Mahagonny

B recht was no stranger to the spa atmosphere of Baden-Baden. As he and Weill strolled across the landscaped grounds toward the concert hall and heard the musicians tuning their instruments, the smells and sounds would have taken him back to those long summer days when he was still Eugen, the boy with a weak heart. He had spent a lot of time in elegant sanatoriums, and since the healing power of music had always played an important role in the German *Kurhaus,* Brecht was exposed very early to the joys of Beethoven, Mozart, and Haydn.[1] Presenting operas and concerts in a therapeutic spa seemed quite appropriate to Brecht, but to Hans Heinsheimer, Weill's editor at Universal Edition, this tourist haven seemed a strange venue for avant-garde musicians to present their work. As Heinsheimer ambled along the promenade underneath the Corinthian columns of the covered walkway and observed the pleasure-seeking patrons of the famous summer resort, he wondered, "What [is] a modern music festival doing here?"[2] The year 1927 was the first time that the German Chamber Music Festival was taking place in Baden-Baden, and his surprise was shared by many. The festival had begun six years earlier, not only in a different location but, in many ways, in a different world.

The festival had its origins, like most of the arts in pre–World War I Germany, as an act of royal generosity. Prince von Fürstenberg's fam-

ily had long presided over Donaueschingen, a picturesque town in the foothills of the Black Forest, nestled between two rivers that flow into the Danube. Although royal patronage had been largely shunned after the emperor's abdication, the prince had a sincere interest in culture, and he maintained a close relationship with his progressive musical director, Heinrich Burkard. In 1921, Burkard urged the prince to start a modern music festival on the castle grounds, assuring him that this event would promote a sense of community as strongly as it supported the advancement of art. The gracious invitation to stroll freely through the lovely gardens of Prince von Fürstenberg's estate, and to enjoy concerts that would both educate and amuse his former subjects, would surely be appreciated. The festival's sophisticated aura of modernity quickly attracted many prominent musicians, critics, and intellectuals from all over Europe, and the citizens of Donaueschingen were proud to see their village become an important cultural landmark. Arnold Schoenberg, the esteemed modern composer, was welcomed there in 1924,[3] and shortly after his visit, he wrote a letter to the prince praising the atmosphere: "This enterprise . . . is reminiscent of the fairest, alas bygone, days of art when a prince stood as a protector before an artist, showing the rabble that art, a matter for princes, is beyond the judgment of common people."[4] His music might have defined the avant-garde, but Schoenberg's words clearly betrayed his archaic nineteenth-century vision of the relationship between art and the people.

Paul Hindemith, a younger composer who had been discovered at the very first Donaueschingen Festival, entirely disagreed with Schoenberg's attitude. Hindemith, too, was a modern composer, but he was also an ardent believer in the artist's responsibility to society. After his celebrated debut, his career soared, and he joined forces with the original festival director, Burkard. Together they were determined to replace "the isolationism of the Schönberg school with social usefulness."[5] Hindemith was a great proponent of *Gebrauchsmusik*, which translates to "music for use." This concept grew out of an opposition to "art for art's sake," and the goal was to make music an integral part of everyday life. There were many places where such "usefulness" could be realized, including the mass mediums of radio and film, as well as political events, dance halls, and schools. The partner concept

of *Gemeinschaftsmusik* (community music) was equally as important. This referred to music that was simple enough to be both played and enjoyed by amateur musicians. These two movements confirmed every citizen's right to become both the producer and the consumer of art. Music was no longer a gift to be accepted from the monarchs; it had to be reclaimed by the people.

Hindemith was very close in spirit to Parisian composers such as Darius Milhaud, and because the French had incorporated jazz and fox-trot since the early 1920s, the sounds of America came blowing through the Fürstenberg estate as powerfully as those famous hurricanes had been blasting through Florida throughout the decade. American rhythms and melodies had arrived in Paris before they reached the more isolated northern city of Berlin, and the French had quickly recognized that these exciting new influences would enhance the broad appeal of their European music. Hindemith, Weill, and other German composers were quick to follow their lead.[6] The wind from foreign lands brought another groundbreaking composer with it: the cosmopolitan genius Igor Stravinsky. The festival became an important center of his influence on other German musicians.

The prince might have been somewhat dismayed by the aggressively modern atmosphere of his festival. He began to realize that the composers he had commissioned were far more determined to expunge, rather than disseminate, the elite aspects of classical music he had prided himself on sharing with the people Schoenberg called "the rabble." Over the course of five years, the prince's festival had increasingly come to symbolize a rebellion against itself, and he stopped hosting it on his estate. Fortunately the town of Baden-Baden was eager to add such a prestigious and international cultural event to the allure of its summer resort. Mirroring the social and political transformation of the entire nation, the cultural life of Germany had shifted from a palace to a town square.

Legendary for more than a thousand years, Baden-Baden had been hugely popular with the Romans. Since the nineteenth century, it was a place where European nobility and celebrities had come to recuperate in the mineral-rich hot springs, as well as to gamble in the famous casino and enjoy the renowned horse races. Other than the fact that it had been the residence of Johannes Brahms, a fact that few of the

wealthy tourists even knew, nothing about the luxurious summer resort town inspired a cerebral appreciation of modern music.[7] But the festival directors were eager for a new home, and the elegant concert hall located in the main hotel, along with the generous invitation from the city officials, had been more than enough to entice them. The grounds were just as lovely as the prince's estate, and the tourists who came for other reasons could enjoy the chance to succor not only their bodies, but also their souls. The edifying power of music had certainly soothed Brecht when he was a young and sickly boy.

With its new location came a new name: The princely Donaueschingen Festival became the German Chamber Music Festival. Since the twentieth-century citizen was no longer interested in fairy tales about knights and lords, nor able to afford the expensive tickets, the first event in Baden-Baden commissioned four short, accessible pieces that would reinvent the form in a way that appealed to a broad audience. The works to be performed were produced on a lower budget with smaller orchestras and simple settings, utterly divesting themselves of the grand imperial trappings of traditional opera. Every decision had political and cultural significance; composing an opera that only requires ten musicians was not just a stylistic choice but also a contribution to democratic art.

Hindemith was five years older than Weill, and they had been toiling in the same populist waters ever since the end of the war. With his stellar music credentials, the critical success of his opera with Kaiser (*The Protagonist*), as well as his clear ability to combine classical music, popular melodies, and jazz rhythms in his compositions, Weill was certainly an obvious choice for the forward-looking festival. On a professional level, Burkard and Hindemith couldn't have avoided inviting him even if they wanted to. But did Hindemith want to? The fact was that Hindemith and Brecht had been discussing potential projects since 1924, and none of them had yet been realized. He must have wondered why Brecht seemed to be so much more electrified by the younger composer. Had Hindemith also heard that Weill thought of the festival as a den of snobbishness?

Brecht and Weill had certainly intended to make a splash in Baden-Baden. But they were rebelling against Burkard and Hindemith, who were themselves radically opposed to the traditions of the musical past.

They were both, Hindemith could have insisted, against Schoenberg's insistence on the princely domain of art, and theoretically all innovations were welcome. Would *Mahagonny* be able to send shock waves through this already progressive venue?

Weill, Brecht, and Lenya approached the grand neoclassical *Kurhaus* with excitement. They settled themselves on the broad stone steps and, along with their cast and the festival director, posed for a photo. As they leaned back and smiled for the camera, their excitement was as palpable as it was different for each of them. Since Weill had the most to gain from a success in this environment and therefore the most to lose if they failed, his adrenaline probably ran the highest of all. The experience was more of a lark for Brecht—a way to develop his new relationship with Weill, as well as to hear what the best modern composers in Germany and France were doing. Lenya was thoroughly delighted to be in such a place for the first time in her life, and she steadfastly denied any anxiety about her singing debut. All three of them were under thirty, thrilled with their opera, confident of their talents, and, of course, bursting with mischievous energy.

The tall, blond, rugged Neher hadn't stopped to pose for that particular photo on the *Kurhaus* steps, but as the scenic designer, he was as necessary to the opera as Brecht and Weill. And he was just as excited to join in the fun. He moved slowly but had a quick sense of humor, enormous confidence, and impeccable taste. An avid reader of Brecht's work since he was a teenager, Neher had been involved with the *Manual of Piety* from the very beginning, and he and Brecht needed very few words to communicate their thoughts. Neher's ideas for stage design were also, Lenya remarked, "the perfect match for Kurt's music," and the two new friends were eager to begin their first project together.[8] Neher was the artistic equal of both Weill and Brecht, and, just as important, he got along equally well with each of them. The creative fire between the composer and the writer was still feverish, but they had far warmer personal feelings for Neher than they had for each other.

Since the festival attracted the power brokers of the musical world, Lenya's presence was also an acknowledgment of how important this performance was for her husband. She probably would have been there even without a part in the show. In contrast, neither of Brecht's

women attended. Despite Hauptmann's involvement as the author of lyrics for two of the songs—and this would have been the first time she could have heard her poems performed with music—both she and Brecht clearly felt it was far more important for her to keep developing their current projects in Berlin. She was mainly working on *Joe Fleischhacker* but was also running every aspect of Brecht's business. While Hauptmann supervised his publications and handled his professional correspondence, Weigel was covering the home front. Although she was quite busy onstage—in that year alone, she had roles in plays by George Bernard Shaw, Molière, and Ernst Toller—she took care of Stefan, as well as dealing with Hanne and Frank whenever necessary.

Unlike Lenya, Brecht's women were far too busy with their careers—and with his concerns—to make it down to Baden-Baden for the short performance. And even if they had, their attendance at the event wasn't important enough to them, or to Brecht, for them to buy an expensive train ticket from Berlin. Neither Weill's nor Brecht's bank accounts were keeping pace with their rising fame. Perhaps both men hoped a succès d'estime or, even better, a scandal in these precious waters would generate just a bit more income. The composer certainly was hoping that would be the case.

Of all the people attending the festival, no one could have advanced Weill's career more powerfully than the famous conductor Otto Klemperer.[9] At six foot six inches, Klemperer loomed large in every way, and when his imposing figure paused in the doorway of an opera house or concert hall, the hearts of many a composer began to beat just a bit harder. Klemperer's approval meant a chance at being produced at the Kroll Opera House in Berlin—the most radical, and the most respected, modern opera house in Germany. Weill had tried to no avail to get him to attend a performance of *The Protagonist*, and persistently requested the help of Universal Edition in getting Klemperer's attention. But by May of that year, Weill was tired of waiting for his publisher to help him, and he impetuously wrote the conductor on his own.[10] When Weill saw Klemperer lingering on the *Kurhaus* steps, his blood pressure must have increased. Weill was the youngest and least-established composer on the program, and this was his chance.

It was Lenya's chance as well, even if she tried to ignore the pressure. She was the only untrained singer in the cast, and as the wife

of the composer, she had to prove herself worthy of the role. She had come too far on her own to allow anyone to suspect that she didn't deserve the part. She played Jessie; the other woman, Bessie, was to be sung by a famous coloratura, Irene Eden. The four men in the show were all trained opera singers as well.

The *Songspiel* consisted of six songs, with connective musical interludes between them. *Mahagonny* had no logical plot, nor any characters that undergo a traditional dramatic journey. Their names on the program were used to distinguish one from the other, but besides the quality of their singing voices and their gender, there was little to distinguish them as individuals. There is no dialogue to complement the songs. The performer's role was to sing songs that described the utopia called Mahagonny, and hence the *Songspiel* was more about a place than it was about its inhabitants. If there's a story at all, the town of Mahagonny—not any one person—is the main character. And it is the attitude toward the town that undergoes a dramatic change. Mahagonny begins as a place where everyone wants to go. It ends as a city everyone is desperate to leave.

During the first orchestra rehearsal, Lenya watched as "the other five singers stood there with their partiturs and sang. Irene Eden told me to look at the score. I said, 'It doesn't mean much to me to look. I don't read music.' But I was the only one who didn't make a mistake."[11] Lenya's story is most interesting as an indication of her emotions at the time. It wasn't enough to hold her own—in this potentially precarious situation, she had to be better than everyone else.

But something even more important took place within Lenya during that high-stakes rehearsal. She confirmed her innate musical talent. Its presence outshone any insecurity she had about her lack of musical education, and it also helped to soothe her worries about the lack of culture in her childhood as a whole. When she first sang with the orchestra, she felt like a "fish in water. I was carried as if on the ocean," she enthused, thoroughly enjoying her first ride on "the wave of that marvelous sound."[12] Weill and Brecht saw and felt Lenya's strong stage presence as well as her powerful dramatic instincts. Brecht saw something else as well—Lenya's familiarity with the habits and language of whores, or *Weiberfleisch* (literally: women's flesh), that are invoked in the lyrics of the first song that introduces the town of Mahagonny:

"Good whores and good horseflesh," as the English version reads, are two of its main attractions. Brecht was delighted that Lenya could help him explore a world that he had so far only written about from a distance. "Lenya," he asked during rehearsal, "what does one of *those* girls say? . . . What does such a girl ask her customer, when she meets him? . . . Do you wear panties under your dress?" If Lenya didn't go out of her way to share the stories of her difficult youth, she was nevertheless far too proud, and too straightforward, to lie about her past. Brecht's instinct had been correct. When she was barely twelve years old, Lenya briefly became a child prostitute.[13] Weill would probably not have appreciated this conversation with Brecht, but fortunately, he often observed rehearsals far from the stage and perhaps didn't witness this particularly personal encounter. "Kurt never sat (during rehearsals). He always walked. Especially when he listened—he walked with his back to the stage." Weill wanted to avoid looking at or listening to an actor's gestures or comments so that he could focus on the effect of the music.[14]

But although Weill was intensely concentrated on his music during rehearsals, that didn't stop him from protecting Lenya when Brecht suggested that both she and Irene (Jessie and Bessie) perform their first song in the nude. Quite apart from his objections to literally undressing his wife in public, Weill believed that the music, the lyrics, and Neher's daring stage design should provoke the audience, not Brecht's crudely conceived prank. The metaphorical lyric about *Weiberfleisch* would be weakened by a cheap flash of actual skin. In any case, the municipal authorities of Baden-Baden rejected the lewd proposal on the spot. And of course Lenya was hardly a passive presence in the matter. She had taken her clothes off for money before, and those days were over.

Nudity would have shocked the well-dressed audience, but once the show began, it was more than obvious that *Mahagonny* would be shocking enough for the patrons of this politely modern festival. Brecht and Weill's opera had been placed third on the program, and the first two had done little to prepare the spectators for what was coming. The audience had enjoyed the opening pieces, which included Ernst Toch's musical fairy tale *The Princess and the Pea,* and Milhaud's eight-minute work *Europa.* These operas were devoutly modernist works that

Lenya described as "the most austere forms of modern chamber music, mostly atonal."[15] During the intermission, as the complacent audience casually turned its attention to the program for *Mahagonny*, they were startled to see the stagehands assembling a boxing ring. Behind the ring, a large backdrop for Neher's enormous rear-screen projections was quickly hung. The first hand-drawn picture that was projected depicted archetypal figures in broad expressionistic strokes. Neher's mythological landscape loomed ominously and also incongruously over the roped-off wooden arena. Would there actually be a boxing match on the concert stage?

If the audience tore their eyes away from the stage in order to seek guidance in the program, they would have been even more confused. Instead of calling *Mahagonny* an opera, Weill had described it as a *Songspiel*. Was it a misprint, this "play of songs"—did they mean to write "*Singspiel*," a recognized form of German-language musical drama, employed most famously by Mozart's *Magic Flute*? As everyone would soon realize, the word "song" was no accident—the American word was intentionally used to distinguish Weill's popular songs from the more exclusive German *Lied*. The *Songspiel* was an entirely new genre, one that simultaneously recalled the once bawdy and popular *Singspiele* of old, as well as incorporating the popular American tunes that were bewitching most of Europe.

Weill added a note to the end of the program that was meant to contextualize the opera's down-to-earth setting and seamy lyrics: "In his more recent works, Weill is moving in the direction of those artists of all forms who predict the liquidation of arts engendered by established society. The small epic piece 'Mahagonny' merely takes the logical step from the inexorable decline of existing social structures. It already addresses an audience that naively demands its fun in the theater."[16] The proudly modern audience at Baden-Baden certainly didn't identify themselves as so-called "established society." But as educated listeners, they were almost more uncomfortable with the notion of *naïve* enjoyment. To whom was Weill addressing this program note? Before they could contemplate it further, the audience was stunned by the sound of a pistol shot.

A boxing ring? A gunshot? What was going on? In just a few minutes, the set for the *Mahagonny Songspiel* had transformed the formal

concert hall into a sporting arena. And that, of course, was the point. The boxing ring was a direct assault on the location itself. It invoked the sport that had become a mass sensation in recent years and sent a powerful message to the audience. Brecht was a great fan of boxing and had recently become friends with Paul Samson-Körner, the light-heavyweight champion of Germany. Brecht believed that theater and opera must look to sports to understand how to entertain a contemporary crowd: "When people in sporting establishments buy their tickets they know exactly what is going to take place," Brecht wrote with envy. "Highly trained persons developing their peculiar powers in the way most suited to them, with the greatest sense of responsibility yet in such a way as to make one feel that they are doing it primarily for their own fun. Against that the traditional theater is nowadays quite lacking in character . . . If only someone could take those buildings designed for theatrical purposes . . . and treat them as more or less empty spaces for the successful pursuit of 'sport.' "[17] The boxing ring demanded attention as a purely metaphorical set, one that had nothing to do with the content of the *Songspiel*. It simply fulfilled Weill and Brecht's insistence that the festival was not nearly as daring as it believed. It was July 17, 1927, and the boxing ring made it clear that music claiming to be modern had no business being played in a concert hall.

Six people climbed through the ropes—the women were wearing straw hats, and the men wore bowlers. They were dressed for a jaunty evening out and had no intention of boxing. Along with Jessie and Bessie, there were four men: Charlie, Billie, Bobby, and Jimmy. The names were never spoken out loud, but simply listed on the program, establishing the American setting before a note was even heard. When the orchestra began, the most shocking thing of all, as Lenya put it, was that it played a "real, unmistakable tune!"[18] Nudity could not have been more astounding to this audience than the sound of an actual melody. This was yet another assault on the festival milieu. Weill and Brecht were brashly insisting that the latest phenomenon of atonal music had itself become a tradition against which all truly modern composers had to rebel.

And as the melodic music continued, it became apparent that Weill had achieved far more than a tuneful rebellion against the atonal movement. He made his point in the very first song, "Off to Mahag-

onny," with the kind of sharp humor that proved to the audience of musical experts that he was beating them at their own game. In that lighthearted and hummable song, the men sang in merry voices as they praised the town of Mahagonny. The lyrics described a paradise filled with whores and whiskey, where the moon is the color of dollar bills and of envy. It is in just these lyrics about the "green and glowing moon of Alabama" that a critical aspect of Weill's musical prowess was demonstrated. The music that accompanied these lyrics distinctly referenced the first important German romantic opera: Carl Maria von Weber's *Der Freischütz* (The Marksman). The educated audience would have recognized Weill's brief but precisely quoted musical phrase, one which evoked the rhythm of a famous passage in Weber's opera. They would also have realized that the content of Brecht's lyrics offered a pointed contrast to those of *Der Freischütz*. In Weber's opera, the women sing a song celebrating a virgin bride. In *Mahagonny,* the men sang a song that celebrated the town's promise of good whores. They are, in fact, joyously headed for a place where "fresh meat (is) for sale on every street."[19]

Within the first five minutes of the *Songspiel,* Weill and Brecht's musical and textual inside joke gnawed at the foundations of the wall between grand opera and popular music, between European and American style, and, finally, between high and low music. An elite scholar who might have been ready to dismiss the boxing ring and jazzy opening bars of music as a shallow prank by a young composer, would be quickly tripped up by Weill's pointed reference to Weber. The sophisticated blend of musical forms quickly admonishes the expert to be patient; the composer clearly knows what he is doing. And if a tourist wandered in (perhaps by accident) after bathing in the hot springs and before a three-course meal, he wouldn't have to know anything about Weber to be entertained by the pleasant music. But perhaps even the uneducated listener would notice the contrast between the sharply rude lyrics and the cheerful melody. Despite how much he enjoyed the songs, even he would be threatened with the possibility of having to think about what he is observing. Everyone in the audience had an equal opportunity to be provoked.

After the opening song that described the illicit town of Mahagonny and also established the arrival of six characters, Lenya gave her debut

performance with the "Alabama Song." In her striking voice, which was "sweet, high, light, dangerous, cool, with the radiance of the crescent moon," the composer's wife captured the attention of everyone in the audience.[20] With its high notes and trills, the song intentionally evoked the classical diva's entrance aria. But in such arias, a maiden usually dreams of her prince or yearns for romance. Lenya's character, Jessie—already anything but a typical ingenue—is looking for a shot of whiskey. Her rendition of the "Alabama Song" thus continued the parody of grand opera—as well as the popular and saccharine operettas of the day—that had begun with the send-up of Weber's virgin bride.

At twenty-seven, Weill had matured beyond the need to call attention to his virtuosity. When Jessie takes the trip to the whiskey bar, she sings what sounds like a popular song, demonstrating Weill's best attempt yet to write music that sounded simple but simultaneously contained all the complexity of his former compositions. On the surface, the "Alabama Song" was a lighthearted, melodic romp to the next whiskey bar. But in actuality, the song was anything but a simple melody. In addition to its clear references to classical arias, Weill also mixed conventional chords with the occasional "non-chord." In this song, and in the others that followed, the typical journey over the keys of a piano sometimes veered off the harmonic pathway in unexpected directions. The individual chords aren't abrasive in themselves—it is just that they often have an extra note or two that no traditional composer would have added, giving them a special tanginess that had never been heard before. Weill's music surprised the audience especially because it neither obeyed the rules of the austerely modern Schoenberg school nor was it always conventionally melodic. Weill had in fact discovered an entirely new country between tonal and atonal music.[21] The music fused with the lyrics to signal the future, simultaneously waving a clear and conscious goodbye to the past. Whether they were tourists or scholars, reviewers or musicologists, it was obvious to everyone who heard Lenya sing the "Alabama Song" that this style had entered the world to stay.[22]

In Mahagonny, money defines morality. This translates to a society in which everything that can be purchased is allowed. The most attractive commodities are the usual sins of drinking, whoring, and gam-

bling. When there is no more whiskey to be had, and no more money to be found, the inhabitants decide it is time to leave. The "Benares Song"—also written by Hauptmann in English—marked the pivotal moment when the characters announced their intentions to abandon Mahagonny for a place called Benares. But they soon learn that an earthquake has destroyed Benares, and they are forced to remain in the hell they have created in Mahagonny. "Is here no telephone?" they cry. Is there no way to communicate with another place—that is, to discover a different way to live? In the resounding answer, "Oh, sir, God damn me: No!," the impossibility of man's journey to enlightenment is confirmed.

Like "Alabama," the word "Benares" had an attractive sound and rhythm. But unlike the way in which the word "Alabama" was chosen, the name "Benares" was anything but arbitrary. In fact, Benares is another name for Varanasi, the birthplace of Eastern religion and thus the most important pilgrimage site for Hindus.[23] Since Brecht's original poetry collection was an obvious parody of Martin Luther's *Book of Piety*, the reference to Benares was probably intended to invoke the Eastern equivalent of Jerusalem. The move from Mahagonny to Benares is symbolic of the move from West to East—from one religious perspective to another. But the characters cannot escape their sins, and they are thus unable to change their destiny. In the penultimate song, God arrives in Mahagonny and furiously orders all the sinners to go to hell. They answer cheekily that since they are in hell already, God has no power over them. They refuse to be sent to God's version of the inferno and threaten to call a strike.

Seventeen years before Sartre declared that "Hell is other people," the *Mahagonny Songspiel* proclaimed that God's ultimate punishment is no more, and no less, than a man-made phenomenon. It doesn't matter whether it is the Eastern religion of Benares or the Judeo-Christian values of the West, God's moral influence is only as good as the people who claim to follow his principles. In the final lyrics of the last song, a resounding blow is delivered: "Mahagonny does not exist . . . for Mahagonny is only a made-up word." Thus, the hell of Mahagonny is also invented by man.

The man-made nature of religious authority is also exposed by the *Songspiel*'s additional attack on conventional bourgeois society.

The values of any given society are constantly shifting and the definition of sin depends upon the society in which one lives. "Lots of people have no pride," the lyrics insist. "To pay their way they sell their hide." All principles are relative and interchangeable, and in the case of Mahagonny, for example, they are determined by money and not Christian values. In order to be a good citizen, all you need is "five bucks a day."[24] This is a world governed by financial status, and it is logical that the sinners resort to a strike when God attempts to control them. The notion of a strike is appropriate in a society governed by money; but the strike also invokes the metaphorical power of the workers to rebel against the authority of their boss. God has no power in the atheist utopia and therefore no right to punish or forgive their behavior. This is a reminder that all authority—whether religious or social—is created by those who choose to obey. Mahagonny begins as a godless city where men are given permission to enjoy forbidden sin, but it eventually becomes a symbol of the corrupt nature of authority itself. When God visits the godless town, his will has been nullified by man's recognition of his own role in the creation of hell—perhaps also in the corollary definition of heaven.

Heresy, of course. But even the starkly satirical parody of religion was simply a layer to be unpeeled. Underneath the surface send-up of God, the piece climaxed with an even more ferocious critique of the bourgeoisie. At the end of the show, the performers held up placards that mocked the morality of the middle class. The first sign, which decried the religious claim to the immortality of the soul, read: "For the mortality of the soul." The second sign dismissed the heavens and praised earthly rewards. Another sign dismissed bourgeois conventions and celebrated free love: "For natural fornication." Only Lenya held up a sign that referred to the authors themselves. Hers said simply, "For Weill."

The thirty-five-minute, six-song opera was dense with literary and musical meaning. Very few members of the audience comprehended its many layers by the time the performers were holding up their signs. But one thing was clear: The enfants terribles, Brecht and Weill, were making fun not only of the politely rebellious tenor of the festival but also of its cultured audience. This audience was not yet prepared to accept a simple melody as an equal citizen in their world of modern

music, and many of them were rankled. But there was at least one man who was brilliant enough to understand the importance of what had taken place, and that was Klemperer, a conductor who was no stranger to musical scandal. His dramaturg, Hans Curjel, sat beside him at Baden-Baden, astounded to see that the highly discerning Klemperer couldn't stop singing "Oh Moon of Alabama," even after the opera had ended.[25] Nicknamed the "Volcano" for his conducting style, Klemperer was not a man to keep his likes and dislikes to himself, and his towering figure and booming voice would have been hard to miss. Weill was more than a foot shorter than the enormous conductor, but as he leaned back to gauge Klemperer's reaction, the strain on the composer's neck muscles would have been well worth the reward of the conductor's enthusiastic applause. The *Songspiel* had infuriated many, but as Lenya and Weill would soon discover, it had impressed the most impressive person there.

Weill was not the first composer to blend classical, jazz, and popular melodies. He was, after all, on the program with Hindemith and Milhaud, who had both worked enthusiastically in the jazz idiom. Milhaud's 1922 jazz piece *La création du monde* had in fact predated George Gershwin's *Rhapsody in Blue*. Hindemith had also famously written a jazz piece titled Suite "1922" for piano. But it was Weill's particular way of combining these elements—and allowing them to speak with each other—that distinguished him from his peers. Weill was also unique in the way his music deliberately reflected the German and Austrian operetta style in a "fun-house mirror." This cultural parody was naturally not the goal of the French composers, but it also differentiated Weill from his German counterparts, such as Hindemith.[26]

Weill had created a particularly articulate dialogue between different forms of music. By evoking a diva's aria in the "Alabama Song" or Weber's *Der Freischütz* in "Off to Mahagonny," he was allowing the present to make an ironic commentary on the past. Most of all, it was a conversation and not a judgment. If atonal music was a form of rebellion that utterly defied the traditional rules of composition, Weill had found a way to make his music both speak to and poke fun at its ancestors, and yet also be entertaining for his "naïve audience." *Mahagonny* had, in effect, managed to destroy the facile distinction between high and low music in less than an hour.

"The public had a double reaction," Curjel noted. "With horror and anger on the one hand, with frenetic appreciation on the other."[27] Lenya remembered that Brecht had been expecting, and certainly hoping for, an explosive reaction. "The demonstration started as we were singing the last song, and waving placards . . . The whole audience was on its feet cheering and booing and whistling. Brecht had thoughtfully provided us with whistles of our own . . . so we stood there whistling defiantly back."[28] In Germany, whistling is the most forceful expression of audience disapproval. The performers reveled in demonstrating their own disapproval of the spectators' rudeness.

Mahagonny proved how difficult it was to remain modern in those turbulent times. Audiences were changing as quickly as the cultural venues that were being invented to draw them in. Music had been irrevocably influenced by recording devices, home radios, and cinema, and it was hard to keep up with the constant interchange between audience and technical innovation. But, finally, it was the relationship between the spectator and the artist that had changed most of all. When Brecht suggested that his performers whistle back, it was more than a prank. It was the logical follow-up to the preface he had written for his original collection of poetry, where he had asked the reader to take control of his poems by making "use" of them in different situations. In the concert hall, he was asking the performer to acknowledge the new powers bestowed upon the audience. Artistic activity, Brecht was pointing out, could no longer be controlled by the artist alone—it only existed by virtue of its dialogue with the audience. The sound of the whistles pierced the ears of their whistling spectators and convincingly shattered the pretense of the fourth wall that divided the stage from the house.

This radical redefinition of the artistic process took place alongside another seismic change in German philosophy. Less than two hundred miles to the north, Martin Heidegger had recently thrown an intellectual grenade into 2,500 years of philosophy with the publication of *Being and Time*. His treatise condemned Plato's and Aristotle's quest to discover the "ideal" truths and claimed that they had committed a fundamental error, one which subsequent philosophers continued to uphold in their approach to the meaning of life. The error, Heidegger insisted, was to try to discern the actual facts of physical reality, and to

distinguish them from the so-called imprecision of human perception. Heidegger believed that man could only discover the meaning of his life by understanding the way in which our perceptions give meaning to the world we inhabit. Only in the complex act of perceiving—of remembering, of seeing—can we find the truth of what he called "Being," of existence. To label subjectivity as an "error" is to negate the very condition that defines our humanity—we are defined by our way of experiencing the world.

Heidegger's dismissal of entrenched philosophical wisdom, published just a few months before the music festival in Baden-Baden, related directly to the six performers in a boxing ring singing about the town of Mahagonny. The philosopher redefined traditional perceptions about observer and object just as profoundly as Brecht and Weill had begun to alter the relationship between stage presentations and the audience.[29] Just as Heidegger was convinced that an object only derived meaning from being observed, so the whistling performers were acknowledging an audience whose presence created the meaning of their performance. And in the case of *Mahagonny*, the roaring audience seemed quite eager to share their opinions of the *Songspiel*'s "meaning."

The crowd, just as the artists had hoped, was ferociously divided about the value of *Mahagonny*. Many of the elite listeners would have preferred an opera that called upon the exclusivity of their knowledge. They enjoyed having special access to the intellectual triumphs of atonal music. Melodies that were accessible to all were to be scoffed at precisely because everyone could enjoy them. If they found themselves next to a cheering tourist from the spa, their confusion might have turned to anger. There were others who were devoted to democratic art—the festival leaders were among them—but this had gone too far. It was hard to tell who was the butt of the joke. Who were the sinners, and what was sin? What were the wages of sin in a town where men had no one to blame but themselves? *Mahagonny* ravaged established religion and bourgeois morality as brutally as it rejected the purely atonal school of music, but it didn't replace them with yet another strict category. The music was too intelligent to ignore but too outwardly popular to fully accept. Like Heidegger, Brecht and Weill replaced answers with questions that could not be easily answered. Like Hei-

degger, they had moved beyond rebellion, beyond even reinvention, to create an entirely new quest. Truth, they declared, was in the space between the artist and the audience. The more versions of the truth, the better. The indignation this generated was made abundantly clear when one well-dressed gentleman hurled a rotten apple at the boxing ring.[30]

Did anyone even hear Hindemith's piece, which had the misfortune of following the explosive reaction to the *Mahagonny Songspiel*? What would have bothered Hindemith more: that his former reputation as a musical enfant terrible had been taken from him in just thirty-five minutes, instantly conferring the honor on the even younger Weill, or that he and his festival had been so quickly transformed into yet another authority against which the true innovators were proud to rebel? When Hindemith's far more polite piece began, the audience members were barely back in their seats, hoarse from shouting, ears ringing from the whistling onstage and off, and perhaps just beginning to process the power of the boxing ring that had been so hastily deconstructed. For it was not only the definition of modern opera and music that had changed; it was also the audience itself. Once polite and respectful, they might have been embarrassed to find themselves on their feet and sharing their views with such wild enthusiasm. Brecht and Weill had successfully transformed the concertgoing audience into a crowd more expressive, perhaps even more vulgar, than the most lowbrow sporting fans. Thanks to them, the concert hall had actually taken on, however briefly, the proletarian atmosphere of the stadium.

Even before the reviews hit the newsstands, the verdict was being discussed in the hotel bar. "I walked into the lobby of the fashionable hotel where most of the audience went for drinks after the performance," Lenya remembered. "Suddenly, I felt a slap on the back, accompanied by a booming laugh: 'Is here no telephone?' It was Otto Klemperer. With that, the whole room was singing the 'Benares Song,' and I knew that the battle was won."[31] Klemperer's loud vote of confidence jump-started the singing just as powerfully as the pistol shot in the performance. And it sent an important signal to impresarios all over Germany.

Mahagonny was a mythical Western town that evoked America at every turn, and it must have gratified Brecht and Weill when so

many Americans were soon reading about it in a *New York Times* review: "A . . . songspiel, by a bold and bad young man, Kurt Weill of Berlin . . . 'Mahagonny' (is) a clever and savage skit on the degeneration of society, the triumph of sensualism, the decay of art. It is done by a composer who knows his business . . . His was the triumph of the festival, and it is a pity that the others could not be as witty, as accomplished . . . even . . . as cognizant of the line between farce and satire."[32] An influential critic for a Berlin newspaper was equally enthusiastic: "Gradually a social and political message makes its way into what starts out as a purely musical play . . . The last song, a protest against the existing world order in the guise of a revue, rears itself up in a steep dramatic curve . . . One is swept away by it. It once again betrays Weill's eminent gift for theater, his capacity for dramatic concentration."[33] Not every review was positive. Aaron Copland, an American composer the same age as Weill, was savage: "Weill is the new *enfant terrible* of Germany. But it is not so easy to be an *enfant terrible* as it used to be, and nothing is more painful than the spectacle of a composer trying too hard to be revolutionary. Weill . . . cannot escape the accusation."[34] Copland was as in love with European culture as the Germans were entranced by America, and he perhaps resented Weill's playfully ironic retort to the austere modernist composers. Instead of embracing the populist influences of radio and film, Copland had worried a great deal about how composers would "make contact with this enormously enlarged potential audience without sacrificing in any way the highest musical standards."[35] But Copland's biting tone actually underscored the magnitude of Brecht and Weill's triumph. It was indeed difficult to rebel against a rebellion, but the bold and bad young men had obviously prevailed.

Since this was a music festival, it was natural that most of the conversation and reviews emphasized the contribution of the composer more than the poet. Curjel was the most definite on this point: After praising the discovery of Lenya, he insisted that "it was most of all Weill's hour. The fire came from him, he had taken Brecht with him."[36] Not surprisingly, Brecht described the event quite differently when he wrote to Weigel on stationery from the Hotel Gunzenbach-Hof in Baden-Baden: "Dear Helli, I've recovered the car just in time, the papers had been sent to the wrong address. Big 'regieerfolg' ['director's

success'] here. 15 minutes uproar! When are you coming back? Bert." With a P.S.: "What news of Steff? Going back to Augsburg today."[37] Everything about this brief letter, not only his egocentric description of it as a "director's success," indicates Brecht's dismissal of this event as anything other than a small victory that nevertheless belonged in his corner of the boxing ring. He tried hard to appear more concerned with the details of his domestic life than about a performance at an elite music festival. And although he undoubtedly enjoyed the uproar, he probably felt uncomfortable standing in the background while most of the attention was paid to the composer. Weill must have been quite busy right after the show making the rounds of the musical luminaries, most especially trying to build on Klemperer's positive reaction. This was, for the moment, no place for Brecht.

Lenya was sharply attuned to Brecht's manipulations, and she noticed that he was trying to take control of the situation. In return, Brecht enjoyed needling his composer's talented, sensuous, and loyal wife. He whispered a brief, but significant, warning about his future collaborations with her husband: "Weill has to get used to the fact that his name will not appear on the program." It was a casual retort, but one that Lenya never forgot.[38]

Despite the poet's sense of being marginalized, the event had certainly reinforced Weill's and Brecht's belief in their future collaborations. Both recognized that the combination of their talents had been inevitable—after *Mahagonny*, they also felt invincible. But in the months following the Baden-Baden festival, they needed to retreat briefly from each other in order to allow the success to strengthen their individual artistic identities. The sense of competition was continually adding to the power of their partnership.

Weill went back to Berlin and immediately began working on a full-length opera of *Mahagonny*. He was in constant correspondence with his publishers, prodding them to promote the success of the *Songspiel* and to pave the way for a commission for the expanded version. Brecht drove in the other direction toward his hometown of Augsburg. He often retreated there in order to focus intensely on his work. The presence of Weigel in Berlin had made these retreats even easier. In

addition to her own career and looking after Stefan, she attended to every detail of his domestic life, and Brecht's rather demanding letters were replete with inquiries about all of his children, but mostly Stefan: "Don't leave Stef too long in the sun and don't smoke cigarettes . . . and send me all the Marxist literature you can lay your hands on . . . If in addition to all that you take Stef's picture (in the sun 1/25 exposure, lens half closed), you'll be right as rain."[39] In Brecht's letters, his intellectual and personal respect is as clear as his total dependence on Weigel as a woman. As domineering as these letters sound, they actually proved that Weigel had bound Brecht to her as no other woman ever had. The strongest tie was her role as mother to all his children. Brecht believed that his love for Frank, Hanne, and Stefan translated directly into Weigel's duty to take care of them. She agreed.

The combination of domestic and artistic roles that Weigel played in Brecht's life occasionally veered toward the ironic. A good example took place shortly after he returned to Berlin and offered Weigel a part in his radio adaptation of Shakespeare's *Macbeth*. The maternal and supportive Weigel might well have relished the departure from her daily reality in order to inhabit the murderously ambitious Lady Macbeth.

Hauptmann continued to live on Spichernstrasse, where Brecht worked and sometimes slept. She was involved in all of his projects in the fall of 1927, including the *Macbeth* in which Weigel starred. The director of the radio broadcast was fascinated by their working relationship: "I know exactly how Brecht wrote. There was a lady at the typewriter that helped. First she put a record on and played music, and Brecht ran up and down the room with his 'eruptive' ideas . . . (If) the secretary doesn't like it, she says 'nein.' And her opinions prevailed. The secretary's contributions were essential, Brecht listened to her carefully, and that's how the adaptation was achieved."[40] Hauptmann was not only helping Brecht research and develop his own ideas; she also functioned as a talent scout and was constantly on the lookout for interesting material to adapt. She fueled their fascination with the English language and culture by reading American and British magazines and newspapers. In November, she found something especially intriguing in London. A seventeenth-century play called *The Beggar's Opera* had been revived to great success. She sent for a copy right away.

Weill had eagerly awaited Brecht's return to Berlin so that they could begin to work in earnest on the libretto for the expanded version of *Mahagonny*. The sizzling creativity of their partnership with Brecht was never far from his mind. He ardently believed, as he wrote his publisher, that in writing a modern opera with Brecht, they would create a "new genre, which gives appropriate expression to the completely transformed manifestation of life in our time."[41] Weill's publisher was an admirer of Brecht and was impressed by the success in Baden-Baden, but he sounded a cautionary note about the full-length opera of *Mahagonny* that the passionate composer was determined to ignore: "An opera libretto is not like a prose play . . . Naturally, these remarks are not in any way directed against Mr. Brecht, but are only intended to urge you, as an opera composer, to exercise the greatest caution, whereby one should keep in mind that to date Herr Brecht has never written a libretto and none of his plays have been set to music."[42] Weill wrote back quickly: "The reason I am drawn to Brecht is, first of all, the strong interaction of my music with his poetry, which surprised all those in Baden-Baden who were competent to judge . . . There can certainly be no doubt that at present a completely new form of stage work is evolving, one that is directed to a different and much larger audience and whose appeal will be unusually broad. This movement, whose strongest force in the spoken drama is Brecht, hasn't had any effect upon opera to date (except in 'Mahagonny') although music is one of its most essential elements."[43] Weill's publisher was understandably wary of expecting a playwright like Brecht to function in the subordinate role of librettist. But Weill was already convinced that in order to define the modern opera of the future, he needed Brecht in his corner. And even if Brecht wasn't as excited about the opera as Weill, the poet was enthusiastic enough. They worked together nearly every day for several months during the fall of 1927.

Weill certainly wasn't the only person to notice the influence of Brecht's original voice. Erwin Piscator, the most important producer of political theater in Germany, was also eager to welcome the talented playwright into his collective of radical artists. Piscator's huge productions had attracted a working-class audience in numbers that rivaled the cinema. He was obsessed with technology and made abundant use of projections, still photography, and film, as well as elaborate scaf-

folding on revolving stages. A confirmed Communist, Piscator had declared that all artistic aims must be subordinated to the "revolutionary goal," and he had tangled with even the most left-wing of theaters in Berlin.[44] By the time Brecht began to work with him, the director had managed to finance his own theater, called the Piscatorbühne, with the help of the wealthy husband of a devoted actress. The financier was the manager of a brewery, and his capitalist cash allowed the Communist Piscator not only to afford a large theater but also to hire many of the left-wing writers who had gathered around him. His circle included Felix Gasbarra, Léo Lania, Kurt Tucholsky, Ernst Toller, Walter Mehring, and Erich Mühsam. The radical artist George Grosz also worked there as a scenic designer. This was a natural habitat for Brecht.

Like Brecht, Piscator's politics and his style of working required a devoted collective that could fulfill the needs of his theater. Unlike Brecht, Piscator did not write his own plays, and the director was actually known for ravaging the text in order to heighten its revolutionary impact at every turn.[45] Piscator's way of working could have been a great match for the playwright, also a serial reviser who had always demanded that his actors keep up with his frequent changes. But Brecht already had planets orbiting around him, and he wasn't about to have his constellation disturbed just so that he could be drawn into the gravitational pull of Piscator's universe. Despite their common goals, the Communist producer and the budding Marxist writer ran into problems of hierarchy almost immediately. When Brecht's eyes landed on a newspaper article reporting that he had joined a group of writers to be led by Gasbarra, he wrote Piscator an irate letter: "I am not prepared to work under Gasbarra's *literary* direction, but under his political leadership I would be. I may be your comrade, but I am definitely not your dramaturg."[46]

Piscator's Communist theater brought out Brecht's passion for and his problem with cooperative endeavors. Artistically, Brecht had to be in total command. Conversely, he would always work with others in order to achieve a common political goal. Once again, Brecht believed in an ideal that his personality made it impossible for him to attain. He wanted to overturn bourgeois conventions of monogamy, but he couldn't stop himself from being possessive of his women. He believed

in the structure of a group-run theater and was committed to certain aspects of political theater, but he was not a team player. Artistic subordination was impossible for him; even equal footing was hard for him to bear.

Brecht nevertheless realized that Piscator had created the ideal theater for his plays and his developing theories of political drama, and it was in the playwright's best interests to remain a part of the group. Brecht instinctively assigned himself a rather more than equal part and behaved as though he was co-captain of Piscator's ship. Imperiously, he invited a number of his close comrades to become members of Piscator's collective. These included his favorite critic, Herbert Jhering, as well as many of his other allies, such as the painter Rudolf Schlichter, the sociologist Fritz Sternberg, and of course "his" new composer, Kurt Weill.

By suggesting the composer to Piscator, Brecht was actively pulling Weill into his theatrical domain. Brecht likely noticed, with his uncontrollable jealousy, that "his" composer was still working long hours with Kaiser, as they finished *The Czar Has His Photograph Taken,* in the months that followed the Baden-Baden festival. And even though the composer worked more often on *Mahagonny,* and even though he had also set another poem from Brecht's collection—"Vom Tod in Wald" ("Death in the Forest")—the poet was perhaps beginning to feel uncomfortable with Weill's independence. Weill had dared to write the ballad from Brecht's poem entirely on his own. It was a classical piece whose formal character harked back to the composer's pre-*Mahagonny* days and it premiered at the Berlin Philharmonic. Technically a collaboration with Brecht, it was truly Weill's song. Brecht didn't mind another commission falling into his lap—cash was always short—but he preferred to accompany his words out into the world. He was the overprotective chaperone of his work.

Brecht needn't have worried about how much attention he was receiving from his composer. All throughout the autumn, Weill cared about their opera most of all, and he continued to write his publisher letters insisting that Emil Hertzka's worries were in vain. The composer claimed that their inspired collaboration on the full-length *Mahagonny* proved that Brecht had come to understand the difference between writing for an opera and creating a play. "After much effort,

I've been so successful with Brecht that he's quite fascinated by the idea of writing a text for musical purposes. Day by day for three solid months I've worked with him on this libretto . . . and I've examined every word in terms of operatic requirements. Not for many years has there been a libretto so rigorously designed for music—and, what's more, for *my* music."[47] Weill's passion for the full-length *Mahagonny* forced him to turn a deaf ear to his publisher's warnings about the difference between a playwright and a librettist. The creative excitement between Brecht and Weill was soaring, and the composer's active role in the text mixed harmoniously with Brecht's enthusiasm about the music. It was a joint work, and neither of them noticed, or cared, how much of the libretto was being written individually or together.[48]

During the few months of separation after Baden-Baden, each artist demonstrated his determination to include the other in his world. Weill needed Brecht for the opera, Brecht needed Weill in his—and Piscator's—theater collective. Their effort on each other's behalf allowed each artist to believe that he was the primary engine of the collaboration. It was an unspoken, perhaps still unconscious, but decidedly inspiring tug-of-war that both men enjoyed.

The cool distance between Brecht and Weill made it possible for them to judge each other's character with the kind of clarity and perspective a closer friendship might have prevented. Brecht recognized Weill's quiet power and steely confidence; Weill understood the dramatic impact of Brecht's energetic and temperamental personality. They both observed that, despite the difference of style, they were each equally good at getting their way. But if they acknowledged each other's evident determination, how could the spirit of competition and need for control have remained unconscious for even a moment? The answer lies in the absolute priority each man gave to his artistic ambitions. Brecht's and Weill's commitment to the idea of democratic art blinded them to any issues of hierarchy that could potentially come between them. Neither believed in hierarchy, and so they both convinced themselves that, in the context of their partnership, it didn't exist. What did it matter if composers and playwrights in the past had traditionally presided over their respective creative territories? The two artists were transforming opera and musical theater, and, if neces-

sary, Weill and Brecht were certain they could reinvent the fundamentals of collaboration as well.

In any case, if they both were used to dominating, they might have believed that together they could dominate twice as much. There were many challenges ahead and they looked forward to facing them together.

As the year came to a close, Brecht and Weill were still harboring hopes for the increasingly challenging project of the industrial opera in the Ruhr district. Along with the photographer Carl Koch, they believed that all the financial issues had been solved, but suddenly new objections having nothing to do with money had arisen. During the summer, the culture minister had sent an oddly worded letter to the head dramaturg of the Essen theater, saying that he was disturbed to discover that news of Brecht and Weill's *Ruhrepos* had been leaked to both the local press and the newspapers in Berlin. The information, he said, "awoke an enormous amount of opposition to the project, not only in the press but also among our citizens." The minister neither described the nature of the indiscretion nor what the public had found so distasteful, but despite all attempts, he continually insisted on postponing *Ruhrepos* until further notice. Curiously, the indiscreet press and leaks to the newspapers were nowhere to be found in either Berlin or Essen. The trio of artists, along with the director and dramaturg of the Essen theater, had waited months in the hopes that the vague hesitations expressed in the initial letter would eventually dissolve. But the silence continued and their optimism finally began to fade.

Unbeknownst to Brecht and Weill, there was one quite powerful objection to *Ruhrepos* sitting on the shelves of the Essen library. Although it's unclear who wrote it, or how many people had the opportunity to read it, an angry leaflet had been circulated and was officially filed and stamped by the librarian. The document began with an objection that the minister did not mention in his letter. After listing all the high-ranking theater personnel who were of Jewish origin, the leaflet continued with the fear that "if the State theater is also placed in Jewish hands, that would mean nearly all the public stages will be virtually overwhelmed by Jewish influence . . . The latest plan for the State Theater is for a winner—a Ruhr Review—a big theater spectacle with

lavish set decoration, song and dance . . . The backers have chosen the two Jews Brecht and Weill to execute this plan and they have gone so far as to offer them a contract. Brecht (who should really be called Baruch) is a trashy, decadent author of perverse plays . . . and Weill is an insignificant and petty fabricator of operettas." It went on to say, in large bold letters that underscored the nasty and ironic tone: "These two Jews should bring the 'great art' from Berlin to Essen." The Jewish opera director is blamed for hiring so many other Jews, and the leaflet concludes with the warning that the "Culture of Essen is in danger of being contaminated by Jews."[49] The flyer was received six days before the culture minister wrote his letter about the unpleasant rumors in the press. Since he failed to specify what articles he had read, and none have ever been found, the significance of this anonymous circular is as unclear as it is disturbing.

Because the theater and music directors of Essen continued to sincerely express their enthusiasm about Brecht and Weill's *Ruhrepos* (and were perhaps also unaware of the reasons for its endless postponement), the "trashy" playwright and Jewish composer would not have had any way of knowing just how sinister the reasons might have been for the project's dissolution. But even if the specifically anti-Semitic prejudices expressed in the leaflet were not shared publicly, the artists were in fact Berliners, were in fact left-leaning—and there was actually one Jew among them. It is therefore perhaps not altogether surprising that the industrialists and politicians had come to understand, if late in the game, that *Ruhrepos* was likely to engage the sympathies of their workers in a dangerous way. It was unclear to these officials whether the "Berlin artists" would inspire loyalty or rebellion, and it was not a risk they were willing to take. The anti-Semitic leaflet is no more, and no less, than an indication of the most extreme version of the nationalistic prejudices that were in the air. As it turned out, the civil authorities avoided the subject and a formal letter of cancellation was only sent long after it was clear that the project had been abandoned. Brecht was left with the unpleasant task of recouping expenses from the opera director, whose sworn allegiance to *Ruhrepos* had been unable to counter the murky protestations from on high.

Cultural works are often canceled because of money or artistic differences, or both. Brecht and Weill tried valiantly to make it work but

were perhaps not overly surprised by yet another unrealized project in their hectic and fertile creative lives. It is impossible to know just how much they analyzed the sudden indifference of the local Essen authorities. But Brecht and Weill were sharply attuned to the tenor of the times, and they likely sensed that something critical was left unsaid.

Given the time and place, it was not only the magnetic pull of each other's gifts, or the ferocity of their mutual goals, pushing Brecht and Weill together; it was the opposition from the outside world—whether overt or covert—that made their collaboration necessary to them both. The simmering competition between these two very different and strong-willed men was insignificant compared to the political, social, and cultural forces they were both determined to fight. Even if the issue of creative control was slowly seeping into their partnership, this was still far less toxic than the poisonous undercurrents plaguing Germany in 1927.

Since Brecht and Weill's work together so far had taken place in a concert hall, and they were hoping *Mahagonny* would be accepted by an opera house, it was provident for their tenuous balance of power that an opportunity for a theatrical production was the next thing to come their way. It was Brecht's turn to offer Weill a job, and although both of them were far more serious about their current projects, there would be a long road ahead before Weill would be able to mount the ambitious opera, or Brecht would be finished with his more serious play. A quick job, with the promise of some quick cash, was very tempting for them both.

The Beggar's Opera

In the beginning of 1928, the entire city of Berlin seemed to exhale with a collective sigh of relief. Money was retaining its value, and the violent passions on the extreme right and left had receded into the background of a rational, peace-loving, and, above all, stable country. The German parliament—while still a volatile blend of six major and eight minor parties—was calmly settling just a bit left of center. Culture was valued and supported in the increasingly vibrant metropolis, and there were more roving dramatic troupes than independent militias, more artists and writers than soldiers, and two million people went to the cinema every day.[1] The belief in art was illustrated by the evident passion not only for the movies but also for radio, photography, literature, music, and theater. There were, in fact, far more theaters than neighborhoods in Berlin.

Brecht and Weill had both been swept up by the optimistic breeze. Brecht was particularly light on his feet after finally agreeing to a divorce from Marianne Zoff at the end of 1927. After years of bitter recriminations and mutual accusations of infidelity, Brecht accepted her lover, Theo Lingen, and stopped denying his own relationship with Weigel and their son, Stefan. This had not come easily, and it was not until Brecht and Mar had each sued each other and both were found guilty that the divorce finally went through.[2] The struggle, as both

Weigel and Hauptmann had witnessed, took up an enormous amount of energy and nerves, even for the seemingly inexhaustible Brecht. But once he forced himself to do what was most difficult for him—end a relationship with a woman—he was finally able to say a proper farewell to his life in Munich. Perhaps it was not until this moment, despite Hauptmann, Weigel, Stefan, and his active professional engagement, that he could fully accept Berlin as his hometown. In return, the city rose to greet him.

Brecht had two triumphant openings in January alone. The first was for the Berlin premiere of *A Man's a Man,* the play that had first brought him to Weill's attention. The production reunited him with acclaimed director Erich Engel for the first time since his Munich production of *In the Jungle of Cities* five years earlier. Together with Neher, Brecht was further defining and refining his original and highly visual approach to the theater. His sharp language and satirical style had triumphed on the mass medium of the radio, but now for the first time one of his plays had been an unqualified success on the stage. The efforts of many independent Berlin theaters to broaden their scope and appeal, and especially the prominence of socially relevant plays produced by Erwin Piscator, had all contributed to the popularity of *A Man's a Man.* But the successful reception was also due to Brecht's rising reputation as a poet and playwright who spoke in a language, as Herbert Jhering had pointed out years earlier, "you feel in your tongue, your palate, your ears, your spine."[3] Brecht had taken a critical step from being merely scandalous to genuinely stimulating, and he was gratified to see that after so many revisions, his political and social satire had managed to entertain as much as it edified.

The shifting ground of new German drama was also confirmed by the simultaneous success of Piscator's groundbreaking antiwar triumph *The Adventures of the Good Soldier Schweik.*[4] Along with Piscator's collective of prominent left-wing writers, Brecht had worked passionately on the adaptation of the already famous Czech novel. At this time, he also formed a close professional relationship with George Grosz, who was the scenic designer. They had a mutual bond from their respective depictions of a dead soldier and a skeleton being drafted into the war—and the ironic *Schweik* was a perfect place for them to join their talents. With *Schweik,* Brecht had proven himself

alongside the best left-wing writers and artists in Germany. His confidence soared.

Since Weigel was an integral part of Brecht's more settled domestic life in Berlin, as well as an increasingly important part of his reformation of German theater, she also began the year in a state of exhilaration. Just as she had for the radio broadcast, Weigel once again played the leading female role in *A Man's a Man* and received the best reviews of her career: "Never before was her interpretation so strong, her performance so precise, or her tone so steely." One review proclaimed that she was largely responsible for conveying the power of Brecht's message.[5] The playwright himself had come to believe in not only her talent in general but also her particular ability to enhance his theatrical vision. But during the rehearsals for the play, she had experienced, for better and worse, the full brunt of his faith in her importance. Perhaps sensing that he had a chance to reach his biggest audience yet, he rode Weigel hard. She could not fail to be perfect. "Brecht . . . intervened more with [Weigel] than the others, and he wasn't nice," observed one of the other actresses. "Despite that, I never saw her cry . . . It wasn't easy for Helli, because even when they were in agreement about the basic approach, Brecht still wasn't satisfied."[6] Naturally, Weigel did not cry—her devotion to him thrived equally in love for the man and in belief in his genius. Once she had woven her way into the center of Brecht's creativity, she would have done anything to stay there. The more he believed in her as an actress, the more demanding he would be, but she was tough enough to take it.

Weigel had, after all, been tough enough even in her early twenties to venture down the theatrical path without the support of her family. She had struggled on her own, and she was proud that she had earned her father's support by proving her abilities as an actress. And yet, as hard-won as his financial support had been, she was still brave enough to risk yet another rift by taking up with an unreliable and only recently divorced poet, let alone having his son out of wedlock. But once Stefan was born, Weigel's priorities began to shift. She could no longer afford to dismiss financial help and instead focused intensely on preserving her father's approval at all costs. Although Stefan was already well over three by early 1928, she still hadn't told her family about their grandson or her relationship with Brecht. When her

father came from Vienna to pay a surprise visit to her apartment in Berlin, the crafty Weigel asked an actress friend to play the role of Stefan's mother. Under Weigel's "direction," the performance was a triumph.[7] Weigel had therefore risked much, both on and off the stage, to remain at Brecht's side; she certainly wouldn't have backed down when he focused his brilliant, if severely harsh, attention on her work as an actress. She was still enjoying the challenge.

Hauptmann's role in the success of *A Man's a Man* had always been acknowledged by Brecht, and she was thrilled by the success of a play they had revised so many times. After almost four years of steady work at Spichernstrasse, Hauptmann was more certain than ever that her devotion to Brecht had been the right choice for her. Their achievements not only would serve her political goals but would also catapult her into professional independence. She continued to hide behind the mask of anonymity most of the time, but she was slowly beginning to try out a variety of other costumes. The story "Juliet Without Romeo," which had been printed in a journal under the pseudonym of Catherine Ux, was to be published in a book that same year. She still used the name Ux, but at precisely the same time, she also placed yet another story in a prominent magazine.[8] The story was "Bessie So and So" (the first name being the same as Hauptmann's nickname), and in this case, she signed her own name and centered the story on Bessie, a Salvation Army soldier. The story is set during the 1906 earthquake in San Francisco. As the inhabitants of the city flee the falling buildings, one of Bessie's fellow Salvationists begins to give a raging penitential sermon. He convinces the frightened crowd that the earthquake is a sign from God, and everyone freezes in place, joining him in a rousing religious song. Bessie is the only one who doesn't succumb, and realizing that everyone will die if they remain where they are, she shouts until she is heard above the singing: "Stop that nonsense! . . . Get out of town!"[9] The sound of her practical advice breaks the spell, and everyone runs to safety. Hauptmann's farcical critique of the Salvation Army offers a lighthearted but definitively Marxist stance on the narcotic role of religion in society.

Carl Koch, the photographer who had worked on the aborted Essen project with Brecht and Weill, took a photo of Hauptmann in Bessie's stern gray uniform, buttoned up to the top of her graceful neck, and it

was published alongside the story. It seemed that the flip side of Haupt-mann's serial modesty was an eagerness for the entire spotlight. When not hiding behind a false name, she was dressing up as the leading lady. The title itself pokes fun at her double-sided nature, for although she gives the title character her own first name, the "So and So" refers to the fact that the narrator of the story, who remembers Bessie's hero-ism very well, cannot recall the heroine's last name.

Despite these self-conscious devices, it is still hard to know if Haupt-mann was playing the various roles according to her own whims or if she had trouble navigating the border between herself and her fictional creations. Each and every day, her actual schedule of activities embod-ied this enigmatic blend of characteristics. She was still working full time for Brecht—by her own account she often spent eighteen hours a day with him—and yet she was also writing, publishing, and doing radio broadcasts of her own work.[10] Although she earned little or noth-ing from her labors for Brecht, her letters from this time certainly dem-onstrate her determination to be financially independent. In asking a colleague to help her complete a theatrical transaction, she boldly and humorously laid bare her need for cash: "I would get 25 percent of the royalties and for several reasons, right now I have a chance to make much more money. Then I could take a trip to Honolulu or rent an apartment in Westend.[11] I also have a very important theater play in mind, and if that goes, I would be financially secure for the next three years. It would be wonderful if that would happen."[12] Haupt-mann's desire for her own apartment and professional independence was directly contradicted by her behavior. She still spent most of her time working on Brecht's many unpaid projects—especially their play *Joe Fleischhacker*—and still prioritized his needs over her own.

Along with Hauptmann's usual duties as talent scout, secretary, researcher, and dramaturg, she had also translated John Gay's 1728 play *The Beggar's Opera*, whose recent success in London had sparked her curiosity. After Brecht read the first rough version in German, they were both persuaded by its obvious suitability for an updated adapta-tion. And since Hauptmann had been discovering and eagerly translat-ing Rudyard Kipling's poetry, she and Brecht began to use parts of his poems as lyrics for the songs they envisioned for their update of Gay's play. This fluid use of poetry—whether it was Brecht's, Hauptmann's,

Kipling's, or occasionally François Villon's—was standard practice at Spichernstrasse. In their limited spare time, Brecht and Hauptmann playfully reinvented the characters and their relationships, as well as creating new song texts from a variety of sources. Many borrowed lyrics would come and go, be shortened and lengthened, and some were altered in translation beyond recognition.

With regard to Hauptmann's efforts on Brecht's behalf, it was by no means a one-way street in those energetic early months of 1928. The original manuscript of "Bessie So and So" is covered with handwritten notes from Brecht. He simplified her style and sharpened her speech. As a brilliant writer of dialogue, he not only recognized but also helped to improve the way her characters spoke.[13] There was a symbiosis there—and it is evident that Brecht was, as Hauptmann herself always insisted, an important teacher and influence on her own fiction. He was reaping great rewards from Hauptmann's labor, but from time to time, he returned the favor.

If Brecht's collective beehive was humming that winter, Weill's year also had quite a promising start. The buzz from Baden-Baden had expanded his reputation well beyond that of an esoteric classical composer, and even before Brecht presumed to invite Weill to join Piscator's theater, the excitement about his music had already attracted the attention of many left-wing playwrights in Berlin. Dramatists began to approach the composer to provide incidental music and songs for their plays, hopeful that his music would enhance the power and the popular appeal of their work. Weill reveled in his versatility as he moved fluidly between the left-wing theaters of Piscator and Brecht and the major opera houses in Germany.

Despite his increasing popularity among modern playwrights, Weill still cared a great deal, perhaps most of all, about his reputation as a modern opera composer. Soon after the successful opening in February of *The Czar Has His Photograph Taken*, his short opera with Georg Kaiser, another opera house featured a double bill with *The Protagonist*, which was also met with great acclaim. Weill actively promoted his operas while simultaneously scoring a political play for Léo Lania, one of Piscator's main writers. The play was called *Konjunktur*,

the German word for an economic boom. Just as Brecht's developing play *Joe Fleischhacker* was concerned with the wheat market, Lania's story was about the struggle between the Standard Oil Company and Royal Dutch Shell over petroleum in Albania. "The hero of this play," Lania wrote, "is petroleum," and Weill's song was appropriately titled "Petroleum Song."[14] Weill also composed incidental music for two of Brecht's close associates, his former mentor, Lion Feuchtwanger, and Arnolt Bronnen, a friend and fellow playwright.[15] "Brecht's composer" was in high demand, and although Weill would never have referred to himself in this way, it was clear that their worlds were intersecting more than ever in the wake of the scandalous *Songspiel*. This artistic confluence was reflected in the very geography of Berlin, for the composer would literally pass by Brecht's studio on the way from his rooms to Piscator's theater on Nollendorfplatz.

Weill had known almost from the beginning of his career that his music would be most powerful when it joined hands with drama. When his father's unemployment obligated him to leave school and take a job in a small town, the young Weill had the privilege of conducting everything from *Die Fledermaus* to *Cavalleria rusticana* to *The Flying Dutchman*. In a letter to his brother, he rapturously predicted that his "special field of activity would be the theater."[16] By the age of nineteen, Weill knew that the theatrical stage had captured his imagination in a way that the concert hall never would. At twenty-eight, his career had begun to fulfill his prediction more than his confident teenage self might have dared to dream.

Throughout the early months of the year, Weill was still most ardently devoted to the full-length version of *Mahagonny*. His collaboration with Brecht was as inspired as ever, and on his way to Piscator's theater, he often stopped at Spichernstrasse to continue developing the opera. Weill was thus able to witness Brecht's rather self-centered way of doing business. He took careful note of the playwright's penchant for developing a large number of projects with the help of many people— and then pursuing the ones that ultimately put his career forward more swiftly. Weill was equally ambitious, and knew that he had to maneuver carefully in order to get what he needed from his partner. As orderly about the management of his career as he was with his composing habits, Weill was determined to mount the *Mahagonny* opera as quickly

as possible and he dreaded being put on one of Brecht's crowded back burners. The wariness that had set in by March 1928 is evident in a letter he wrote to his publisher about the terms for the full-length version: "Incidentally, the question of an advance for Brecht is now pressing. He asked me to enter into negotiations with you about it since he has a need for the money. Personally, I would be very pleased if Brecht could be paid a certain sum now and postpone signing a contract until later. For it is quite possible that he might make some kind of impossible demands which one could easily reject if he were already bound by an advance . . . If you do agree to an advance for Brecht, then insist upon the delivery of the final version of the libretto . . . before making the final payment."[17] Weill's caution at this point was probably prompted not only by his awareness of his partner's habit of developing many projects at once but also because he had become familiar with Brecht's hatred for deadlines. Weill knew that cash upon delivery would be the most effective incentive—far more influential than the writer's desire to fulfill his promises or deliver in a timely fashion. Weill was also no stranger to the need for money, and even if the disciplined composer valued his reputation as a keeper of promises, he also bore no grudge to an artist who was inspired by a paycheck. By then, however, Weill was undoubtedly aware that Brecht's hesitation to complete the libretto wasn't due only to his busy schedule. For although Brecht's cooperation in the fall had been encouraging, his lack of availability by the spring confirmed that the opera was by no means a priority for the busy playwright. Without Weill's passion to create a modern opera, *Mahagonny* might well have fallen by the wayside. Knowing that, the composer was determined to extract as much as possible from their increasingly intermittent meetings.

Brecht's genius was certainly in demand, and his attic *Kraal* became just the sort of corral for Berlin's theatrical talent that the playwright had craved ever since his arrival. Looking out over the rooftops of the city, he no longer saw an anonymous landscape but instead a creative territory that he was conquering. As Weill noticed on his sporadic visits to Brecht's studio, the playwright had become emblematic of a popular and accessible, and yet politically meaningful, theater and there were many important directors and theaters working or trying to work with him. It had been only two years since Brecht had written that "once

one has a wind one can naturally sail against it; the only impossibility is to sail with no wind at all." Brecht had finally caught that wind, and his possibilities were increasing daily.

Weill was wary of Brecht on a practical level, but he liked the playwright's energy and enthusiasm and continued to admire his talent and his like-minded ambitions for the future of musical drama. They were both determined to address important ideas in the opera and in the theater and to invent an altogether new approach to these forms. Having begun life as an "attic composer," Weill also enjoyed the climb to Brecht's humming beehive. His creativity was still closely associated with several flights of stairs.

Brecht and Weill were both enjoying their fledgling fame and were adamantly pursuing their individual careers, but underlying everything was their mutually strong desire to transform the theatrical arts of their time. That's why Hauptmann's British discovery, *The Beggar's Opera,* remained on just the kind of back burner Weill was determined to avoid for *Mahagonny.* The piece was interesting and amusing, but there was no time for a lighthearted distraction in those volatile and ambitious months of 1928.

So when the eager young producer and actor Ernst Josef Aufricht came their way, he hardly seemed the type to distract Brecht and Weill from their resolute goals. He was no Otto Klemperer and certainly no match for Piscator or Max Reinhardt. Aufricht had spent years working in a threadbare theater company where everyone was paid from the box-office receipts—that is, when there were any profits to divide—and they had suffered especially during the inflation years.[18] As a producer who was determined to build an ensemble that didn't make any concessions to big business, Aufricht had the same idealism that Brecht and Weill possessed, but as an actor, he did not have anywhere near the same kind of talent. He was honest enough to admit this, and made the decision to depart from the stage and work behind the scenes. By the time he encountered Brecht, he had produced a fair amount, but only small, underfunded plays where he had rarely made artistic decisions on his own. And although his name might have been slightly familiar as the leader of a theater group that had once presented an early play of Kaiser's, or from his performances in character roles alongside some of Berlin's famous actors, neither the composer

nor the playwright could have imagined putting aside their important projects for such a green producer.[19] Unless, as Brecht was soon made to understand, the young man had enough money to outweigh his inexperience.

As it turned out, 1928 had begun most auspiciously for Aufricht. To his astonishment, the young producer's father had sent him 100,000 marks for the express purpose of leasing a theater in Berlin. Having worked for years with an acting troupe that, like so many small companies in the city, had no permanent building, Aufricht now had a large theater at his disposal but no particular play with which to fill it. By the time he approached Brecht, he was unappealingly desperate, but his newly flush bank account was certainly quite attractive.

Aufricht was exactly the same age as Brecht and came from a wealthy Jewish family in Silesia. But although he shared Weill's religious affiliation, his background was actually far more similar to Brecht's. Where Brecht Sr. had earned his money from paper, Aufricht's father dealt with a commodity on the opposite end of the industrial supply chain—he was a lumber magnate with sizable holdings. Aufricht Sr. was also a self-made man and a strict disciplinarian, but his son was a lazy and badly behaved student who fought with his stern father constantly. And yet, despite Aufricht's rejection of traditional mores, he was nevertheless swept up by the patriotic wave of World War I, and, utterly unlike Brecht or Weill, he actually volunteered to serve in the army. The war ended before he saw active duty, and his determination to study theater had only intensified during his military training. Aufricht's father, like Brecht's, had also tried to push his eldest son into medical school, but to no avail. Typical of the rebellious postwar sons of his generation, Aufricht thoroughly rejected not only a life measured by money but also any traditional career paths his father might have approved. He was a young man determined to make a new and better world through the arts.[20]

Since Aufricht had enlisted voluntarily, he suffered acutely from the disillusionment caused by the war. He despised the hypocritical betrayals of both Kaiser Wilhelm II and the military powers. Like many young artists in Berlin, his postwar anger had been transformed into hope for the future. "It was a wonderful time," he wrote. "Our optimism knew no boundaries. The long and bloody war was over,

it had become a ghost of the past. Its victims hadn't died for nothing, their pain wasn't for nothing, it had taught us pacifism. Now, there would never be another war! We became aware of poverty and we knew the cure: Socialism."[21] What he brought to Brecht besides cash was steely determination. Like Brecht, he wanted to meet, and also to surpass, his father's expectations. Even more important, he wanted to leave the world of his father behind forever.

And yet Aufricht was much luckier than most of the angry sons who had rejected the rigid class-based society of their disciplinarian fathers. For although Aufricht Sr. was adamantly against the theatrical profession, he possessed a genuine affection for his children that always managed to soften his sternly judgmental nature. More than once he had bailed out his son's bankrupt theater troupe, and in the early months of that optimistic year 1928, the lumber magnate had taken his most generous step so far toward underwriting the ambitions of his eldest son. He would have preferred him to be a doctor, but he forgave his rebellion nonetheless. The cash had come with an agreement to co-sign a one-year lease, and Aufricht had only nine months left to find, develop, and produce a play.

Brecht hadn't heard of Aufricht, but the young producer certainly knew about the renegade poet and playwright, and he was initially not interested in working with such a risky artist. Instead, Aufricht approached Kaiser, Toller, and Feuchtwanger, along with several other prominent writers, but no one was ready or willing to provide him with a play. After weeks of searching, Aufricht claimed, with characteristic drama: "If I don't find anything, I'll die."[22] To stave off an untimely if metaphorical death, he decided to search for a playwright in the cafés and restaurants of Berlin, and he knew that Schlichter's was one of the most bountiful hunting grounds.

When Aufricht came charging through the door with his dramaturg in tow, his eyes scavenged the crowded room. He took in the walls covered with paintings and the patrons at their tables, hoping for a miracle. Unlike Weill's steady approach to Brecht's table on the occasion of their first meeting, the hungry producer probably scanned the entire restaurant several times before pouncing on Brecht's table to ensnare his prey. After all, he "didn't know him personally, though [he] did know his literary experiments for the stage, and thought highly of

his poetry. Brecht's long face," Aufricht noticed, "often had the ascetic expression of a monk, occasionally the slyness of a gallows bird . . . He was scrawny, with drooping shoulders . . . Although his exterior tended to be repellent, he himself was pleasant."[23] It was hardly a coincidence to have found Brecht at his favorite eatery. Since it was located directly on the walk between his studio and Piscator's theater, where the playwright was spending a good deal of time, Brecht was likely to be dining there even more often than usual. Accustomed to doing business underneath Schlichter's portrait of him, Brecht would certainly have been pleasant to a young producer who had a large, well-appointed theater and nice budget for his opening play. He quickly offered up *Joe Fleischhacker,* the play for which he and Hauptmann had such high hopes.

As far as Brecht was concerned, *Joe Fleischhacker* was more than just a single play. He saw it as the forerunner of the new German theater he was determined to create. The background of war in *A Man's a Man* had been highly effective, but this was not a particularly unusual subject matter for the time. In this next work, he was utilizing the far more modern idea of the commodities market as the driving force behind his play. He believed *Joe Fleischhacker* would illuminate, in a dramatic way, how man is defined by social and economic conditions.

Brecht and Hauptmann therefore burdened their next play with weighty responsibilities. And ever since 1926, they both had been struggling to meet their own high expectations. Their research for the play had begun in the usual way—extensive reading and consultation with experts. But even after interviewing brokers, they still hadn't found the information Brecht required to comprehend, and thus dramatize, modern global economics. Not until reading Karl Marx's *Das Kapital* did he achieve the profound understanding he was seeking, and the encounter changed his life. For the past year and a half, he had been studying Marxism, and this led him to begin thinking more precisely about the kind of theater that would reflect the Marxist vision for a more just society. His reading changed his perspective on everything he had previously written, but *Joe Fleischhacker* was Brecht's first play to be written directly under the influence of a Marxist point of view.[24] This was in no sense a Communist play, or one that supported any particular system of government. It was Marxist in that it sought to

understand men in terms of their position in the economic structure. The improvement of social conditions, Brecht had begun to hope, would come through the kind of understanding he wanted his plays to provide. His play had become the repository of Brecht's vision not only for the theater but also for a better world.

It would have been a great stroke of luck to find a producer with such deep pockets for a play written under the spell of Marx, but it was not to be. Despite Brecht's sincere enthusiasm, the background of the "wheat market" likely came too early in the description. Aufricht was quickly bored, and he remembers asking hurriedly for the bill. He was risking a great deal of his father's money, and he was certain never to receive more if he produced a total flop the first time around. He wanted to be socially provocative, but it was far more important that his first production be popular. And as to entertainment, the dry background of the wheat market wasn't too promising. Brecht could have attempted to further convince Aufricht. After all, with *A Man's a Man* he had proven that a play could be simultaneously entertaining and elucidating, but the playwright was astute enough to see that he was frightening off a good catch. He took a gamble by spontaneously offering Hauptmann's discovery, the far less developed adaptation of *The Beggar's Opera*. Although the German version of the play was still in an embryonic state, it's indicative of Brecht's powers of persuasion that his description instantly sparked the producer's enthusiasm. After a brief and broad outline, Aufricht declared that the piece "smelled of theater."[25] Was it the description alone that was so alluring? Was Aufricht's sense of smell so highly developed? Or could it be that Aufricht's enthusiastic nose had been overwhelmed by the scent of the revival's huge success in London? One thing is certain: The producer promised to send his dramaturg to Brecht's studio the very next day.

It must have been exciting for Hauptmann to hear that Brecht had offered the adaptation she had suggested, a play whose content was known to him only through her translation. Although she and Brecht had enjoyed working on it from time to time, she thus far had no reason to think it was anywhere near the top of his list of projects. It was simply good fun, and when they had fun working on a project, Hauptmann insisted, the lack of a theatrical contract never stopped them from pursuing it.[26] Heinrich Fischer, Aufricht's close colleague, came

to Spichernstrasse the following morning. It was raining very hard, and he was soaked by the time he climbed the stairs and pulled open the heavy steel door of Brecht's studio. Hauptmann barely had time to assemble the work in progress, and she handed over the pile of pages without so much as a folder to protect them. It was all Fischer could do to keep them dry as he made his way through the stormy streets to the nearby apartment of Aufricht's in-laws. The producer was waiting with great anticipation and nearly snatched the fledgling play out of Fischer's hands. The pages were damp and beginning to tear, and the ink was partly running down the page, but most of it was legible. Aufricht remembers being gripped by its "dry wit" and "cheekiness" from the very first page.[27]

Hauptmann's translation—along with the revisions that were already in place by that point—had managed to capture the humorous and universal tale of social injustice that had made Gay's *Beggar's Opera* so ripe for revival. The story line was simple, but its social implications were complex. It reveals a world in which a ruthless fence named Peachum does business with the criminals in London. He shares in their profits, and in turn he influences their fate. His authority stems from a partnership with Lockit, the prison warden. They share the spoils of the criminals' stolen goods, as well as the bribes they pay to stay out of prison. Together, Peachum and Lockit decide who is punished and for how long. As far as they are concerned, the system benefits everyone: Criminals are caught with the help of informants, and criminals who can reap further profits are released. Freedom is a purchasable commodity. Their mutually beneficial relationship is disrupted, however, when the bandit Macheath marries Peachum's only daughter, Polly. Among his many adventures with women, Macheath has also already impregnated Lucy, the daughter of Lockit. Both men want to eliminate Macheath, but since their daughters have a claim to the bandit's inheritance, the fathers nearly come to blows as they argue over the proper distribution of his fortune. They both realize that it is in their better interests to reconcile and agree that their emotions must take a backseat to profit. The story reveals that a prison warden and a crime boss share the same hypocritical system of morality, and both inhabit a world where everyone betrays everyone else. Peachum declares such betrayal to be the natural condition of man, but one that man refuses

to properly accept. "Lions, Wolves, and Vultures don't live together in Herds, Droves or Flocks," Peachum declares. "Of all Animals of Prey, Man is the only sociable one. Every one of us preys upon his Neighbour, and yet we herd together." In *The Beggar's Opera,* Mr. and Mrs. Peachum mock both the human emotion of love and the social institution of marriage with particularly ferocious abandon. In a world devoid of morality, they agree that "Money well tim-d, and properly apply'd, will do anything."[28] The power of money and the hypocrisy of bourgeois values that Gay's "opera" portrayed was the precise territory that Brecht had mined in his *Mahagonny* poems, and which the *Songspiel* had expanded with its music. In both *The Beggar's Opera* and *Mahagonny,* everything worth having could be purchased with money.

When Hauptmann first read *The Beggar's Opera,* she quickly realized that it was an acerbic portrayal of a society devoted to money, one in which everyone—whether lord or thief—was equally corrupt. The line "The lower Sort of People have their Vices in a degree as well as the Rich" must have stood out in particular.[29] It was a tale, as Brecht was quick to realize, that also exposed the fact that most bandits are bourgeois in nature. And conversely, a bourgeois man is also a bandit.[30] It is impossible, Brecht believed, to desire and achieve material wealth without some form of theft. *The Beggar's Opera* revealed the dangers of a society that valued money over equality and justice. This was done in a lighthearted way, but nonetheless held the potential to illustrate the very themes that Brecht and Hauptmann were expounding in their more directly Marxist *Joe Fleischhacker.*

In addition to its satirical vision of society, *The Beggar's Opera* also functioned as a parody of the Italian operas that were in vogue at the time in which Gay was writing.[31] The music for the opera was intentionally popular, combining Handel's most accessible melodies with simple ballads. This send-up of the operatic genre is most humorously displayed in the story's arbitrary happy ending—where a Beggar and a Player turn to the audience (in the style of Shakespeare) and announce the operatic need for romance to triumph over all. (In Macheath's case, several romances.) "'Tis no matter how absurdly things are brought about—So—you Rabble there—run and cry, A Reprieve!—let the Prisoner be brought back to his Wives in triumph."[32] Thus, Macheath is rescued from the gallows. Another artistic parallel that would

have caught Brecht's eyes and ears was the distinct contrast between the words and the music. Weill's melodic music had contrasted with Brecht's harsh and cynical lyrics. Conversely, Gay made use of sleazy erotic tunes to set off his naïve and innocent lyrics. He wrote new lyrics for sixty-nine airs, all of which are based on popular melodies of the time. These melodies were arranged by Johann Christoph Pepusch, a German-born composer who spent most of his professional career in England. Gay's opera, which also used spoken dialogue instead of recitative, was one of the earliest forms of modern British musical comedy.

This eighteenth-century opera was indeed quite similar to the kind of theater Brecht and Hauptmann had been developing for the new mass audience of the twentieth century. The satire was social, political, and artistic, and it gained further power from its particular use of musical ballads that were both seamy and sweet. The success of the adaptation would depend on updating the social and political milieu in a precise way. Rather than a parody of Handel, their version had to lampoon the melodramatic excesses of the operettas that were currently popular in Berlin. Most important, as Brecht pointed out, would be the revelation of how little had changed in the fundamental composition of man's material nature.

The London revival of Gay's opera was far more loyal to the original than Brecht or Weill planned to be. The contemporary composer assigned to the update, Frederic Austin, was essentially faithful to Pepusch's original score, but he did cut several of the more daring airs in the third act. He also created new settings for most of the remaining songs and contributed some additional music required by the new staging. The parody of Handel was still relevant to a twentieth-century British audience, and the musical changes were primarily practical in nature, accommodating the theatrical blocking, the particular singers, and the composition of the contemporary orchestra, but the timeless qualities of Gay's opera remained. Brecht and Weill would of course go well beyond adaptation in their reinvented version.

The decision to reimagine *The Beggar's Opera* was very much in keeping with Brecht's habitual way of working. He was always inspired by a variety of sources, and he was particularly attuned to making use of plays and novels that had a lasting place in history. His penchant for updating and adapting had been most directly employed with his play

Edward II, but his first play, *Baal*, based on Hanns Johst's *The Lonely One*, and his second play, *In the Jungle of Cities*, based on Upton Sinclair's novel *The Jungle* and Johannes V. Jensen's Danish novel *Hjulet* (The Wheel), also reveal his desire to write in direct response to what has been already written.[33] Brecht believed that if a work was truly a classic, it would be possible to portray its underlying themes in another time and place. Adapting *The Beggar's Opera* was yet another example of his ability to recognize when a fictional work had managed to say something significant and lasting about the human condition. A society might change, but a play that exposed the hypocrisy of its social structure would always be illuminating. Hauptmann rightly saw the potential of placing *The Beggar's Opera* in Brecht's hands.

While an update of *The Beggar's Opera* could certainly make a meaningful social statement for Germany in 1928, it was also quite appealing right on the surface. With its humorous blend of dialogue and ditties and its colorful cast of black-hearted characters, it could certainly be taken for a lighthearted comedy broad enough to attract a large audience. This combination of social satire and lusty entertainment was familiar ground for Brecht and Hauptmann. For them, adapting *The Beggar's Opera* was akin to a virtuoso practicing scales on a piano—relaxing and edifying at the same time. But up until Aufricht's offer, Brecht had merely enjoyed the exercise and had not yet taken it seriously. It simply didn't measure up to *Joe Fleischhacker* as a means to expose the financial realities of contemporary society. If Marx was Brecht's ideal audience, an entertaining musical about a colorful gangster and a corrupt society was hardly tailored for him. At best, it would simply make Marx laugh out loud.

It was precisely this rather light tone that attracted Aufricht. He saw that it was "a humorous literary operetta with intermittent flashes of social criticism" and believed this would be a winning combination in the left-leaning yet optimistic Berlin circles.[34] Since he had directed an independent theater company for several years—attempting all the while to do the kind of cutting-edge theater that sophisticated Berliners loved—the producer knew that a successful play had to contain an impressive satirical bite. But the work would do well to reveal the flaws of society in a pleasant way, and in songs people could hum on their way out the door.

The corners of those soggy pages curled up as they slowly dried in the heat of the apartment where Aufricht read with increasing enthusiasm. As soon as he was done, the producer phoned Brecht to make an offer for the uneven pile of paper that he cradled in his lap. Brecht brought up "his" composer, Kurt Weill, right away. Most of the old-fashioned music, Brecht insisted, would have to be replaced. Brecht liked the idea of parodying older art forms, but there was no sense in satirizing the kind of music that was no longer prevalent. Since they would be changing the period in which the opera had been set, the music must change as well.

Aufricht might have been surprised by Brecht's instant assumption of power. It was, after all, the producer who was offering a job to a writer—moreover, a writer who despite his burgeoning reputation for brilliance had only scored one true success of his own. And although *A Man's a Man* had been at the large and impressive Volksbühne (People's Theater), his greatest achievement was still in only one Berlin theater.[35] But Brecht had become accustomed to calling the shots long before his latest triumph, and he wasn't about to stop for the eager young producer. Happy to have a play, and not wanting to challenge his playwright too soon, Aufricht agreed without being sure he would fulfill his verbal promise. He secretly hired Theo Mackeben, a musical director, as a backup and then decided to do some further research. Aufricht first went to see the Weill/Kaiser short opera double bill, but his worries were not put to rest by *The Protagonist* or *The Czar Has His Photograph Taken*. "I . . . found Weill's music too atonal for a theater piece," Aufricht remembered, and he secretly instructed Mackeben "to get hold of the original music of 'The Beggar's Opera' so as to have a replacement ready."[36]

Aufricht was understandably hesitant to hire a composer who was mostly known in the opera and concert world, and who hadn't yet made a name for himself in musical theater. But "atonal" was a mischaracterization of Weill's music at this point in his development. The producer's mistake makes it clear that despite the modernity of Weill's opera work, despite his compositions for Piscator's left-wing theater, and despite the scandal caused in Baden-Baden, it was still possible for a theater enthusiast to have this perception of the composer.[37]

Aufricht's duplicity regarding Weill was accomplished diplomati-

cally, but the producer became increasingly worried that the balance of power was tilting too heavily in Brecht's direction. He had eagerly accepted Neher, whose reputation in the Berlin theater was stellar— since his arrival four years earlier, the designer had worked not only with Brecht but also with Reinhardt at the Deutsches Theater and Leopold Jessner at the State Theater. Aufricht just as eagerly sought out one of the most successful directors in Germany, Erich Engel, but he and Brecht formed a daunting team whose joint authority might trump the producer's. Engel was certainly worth that risk, but Aufricht was nowhere near as thrilled about the prospect of Brecht's favorite composer.

Fischer, the stage manager who had picked up the play from Spichernstrasse, was far more worried about the combination of such an outspoken writer and the dignified director. He warned Aufricht: "Engel and Brecht together in the rehearsals? All hell will break loose!" Perhaps Fischer, fresh from Munich, remembered Brecht's youthful reputation for disrupting play rehearsals. Or perhaps he had heard something about the Berlin production of *A Man's a Man*, although no rumors of unpleasantness between Brecht and Engel in those rehearsals are documented. But Aufricht didn't heed Fischer's warning. As far as he was concerned, Engel was a box-office draw, and was the one prominent director who had proven himself able to secure the cooperation and loyalty of the outspoken playwright. They had after all done two plays and one film together already, and Engel still seemed eager to work with Brecht again. So when Fischer worried about "all hell breaking loose," Aufricht countered vehemently that pairing Brecht with someone else would be "the end of the world."[38] Aufricht was certainly worried about the personal politics of the production, but he clearly felt that Engel's steady hand and strong personality would be an asset to this adventurous production.[39]

But the fact remained that with Engel's participation, Brecht was coming on board with not only his favorite director but also his designer and potentially his composer in tow. As happy as Aufricht was to have secured such a talented team, his youthful enthusiasm couldn't have blinded him to the potential power struggles ahead. He feared that despite having his hands on the purse strings, he would have trouble controlling these tough and talented artists. The producer must have

wondered, from the very beginning, whether even his bountiful budget was enough to guarantee the respectful cooperation of the notoriously demanding Brecht.

Weill was intrigued by Brecht's invitation to work on *The Beggar's Opera,* and Aufricht's worries, had he known about them, would have seemed patently absurd to the composer who was running from the opera house to the theater and back again. The man who had startled the snobs in Baden-Baden by his assault on the reigning atonal school could only have laughed at a theater producer who had been unable to understand the complex blend of modern and classical elements in his collaborations with Kaiser. Blissfully unaware of the producer's hesitation, he enthusiastically began work on *The Beggar's Opera.* With its satirical views of society, religion, and love, the piece offered many opportunities for the composer to employ his signature variety of musical genres; and with its ballad structure, it also was the perfect place to further develop his song style. It seemed, most of all, an excellent way to enhance his partnership with Brecht. They had conquered the elite audience at the music festival, and he was sure the full-length *Mahagonny* would triumph in the opera house. *The Beggar's Opera* would be a fun and simple way to prove their mettle on the theatrical stage. Perhaps the composer even hoped that working on a musical play with Brecht would serve to reignite the playwright's enthusiasm for the opera project.

Even if Aufricht hadn't been worried about the commercial appeal of Weill's music, his anxiety about Brecht's desire to dominate the production would have been rightly exacerbated by the sticky nature of the contractual transaction involving the playwright, the composer, and Hauptmann. The contract was drafted in April, and Weill had only been working on the music for a few weeks. But prior to signing, the composer had clearly already decided that it was "out of the question" to define *The Beggar's Opera* as an opera. It was instead a "farce with music, which cannot be considered for opera houses because of the preponderance of dialogue." In this rather uncharacteristic letter to his publishers, Weill continued: "Herr Brecht, who is heavily involved in the project, would . . . prefer it if the work were not given to a straight music publisher but rather to a theater agency that liaises with the theaters and operetta houses for whom our work is

intended."[40] For this reason, Weill agreed to sign a contract with a theatrical agency. The composer viewed the job as Brecht's theatrical engagement, and this attitude was made abundantly clear in the contractual agreement, where Weill sacrificed his customary financial advantage. In his contracts with the far more established and successful Kaiser, he had received an opera composer's usual two-thirds of all royalties.[41] But those works were operas and had been initiated by Weill. The adaptation of *The Beggar's Opera* was a play with music, and Weill must have initially believed that his role as a composer would be more in line with his other theatrical works, involving the composition of incidental music, perhaps a few songs, or the reorchestration of existing music.[42] That is the only way to explain why Weill accepted 25 percent of the royalties when he signed with the theatrical agency Felix Bloch Erben. Brecht received 62.5 percent, and Hauptmann, who was listed as the "translator" but who was not a signatory of the contract, received 12.5 percent.[43]

This legal document describes the atmosphere surrounding the initial work on *The Beggar's Opera* as richly as any work of fiction ever could. It reveals Brecht's need for artistic control and financial advantage, as well as Hauptmann's maddening modesty in both of these areas. But Weill was straightforward and practical about money matters, and he certainly never relegated his music to the backseat in any context. His agreement to 25 percent indicates, it is fair to guess, his belief that this job was little more than an amusing sideshow to the real work at hand. His zealous pursuit of a commission for the full-length opera version of *Mahagonny*, and the attendant importance of having Brecht's commitment to providing the libretto, was the overriding priority in his musical life. If Brecht wanted him to participate in this "literary operetta" for an eager producer with a nicely appointed theater, he was more than happy to oblige. But he could not have expected his share of the royalties to amount to much, or he might have fought for a higher percentage. As for Brecht, he also viewed *The Beggar's Opera* as a job to keep him flush while he worked out the far more meaningful *Joe Fleischhacker*, but he hedged his bets nonetheless. His world, just like that of the bandit Macheath's, was a place where "Money well tim-d, and properly apply'd, will do anything."

Brecht's studio was busier than ever in that particularly cold winter

of 1928. The icy wind would have rattled the large glass windowpanes, but he and his collective were on fire with creativity. Everyone wanted a part of him, and more and more young people were eager to join the collective where Hauptmann was a permanent and increasingly influential presence. There was almost too much going on, and Brecht often found it hard to concentrate on *Mahagonny* or *The Beggar's Opera* amid the chaos swirling around him. The composer would arrive punctually at Spichernstrasse to work, but he didn't have time to spare and wouldn't wait if Brecht got preoccupied with something else. Weill was also pulled between opera and theater, taking advantage of every opportunity he could.

In Brecht's eyes, Aufricht's offer had one real drawback: an inflexible delivery date. For all his diplomacy and polite demeanor, Aufricht needed to open within nine months, and he further insisted on opening the show precisely on his thirtieth birthday, August 31, 1928. Brecht quickly decided that his Berlin *Kraal* was not secluded enough to protect him from other distractions.[44] In addition to all that he had learned from Piscator about the creation of a proletarian theater, Brecht could credit the powerful producer with one of the most important techniques of his career: Piscator always took his writers to a handsome villa perched on a picturesque lake just outside Berlin where they could devote themselves fully to a revolutionary theater for the working class. Even revolutionaries need comfortable chairs in order to create, Piscator insisted, not to mention good food, a refreshing swim, and a healthy dose of fresh air.

Brecht would go even further than Piscator to sequester his creative partners. After the long and cold winter, the playwright was in the mood for something warmer and more beautiful than any place Germany had to offer. A lake near the city wasn't going to suffice.

When Brecht suggested that he, Weigel, Lenya, and Weill take a trip to the South of France—for the sole purpose of writing the music and text for their version of *The Beggar's Opera* as quickly as possible—no one objected. The optimism blowing through Berlin transported them to the Mediterranean, where the weather was sublime, the cuisine was exquisite, and the fireworks between Brecht and Weill were certain to light up the entire beach.

Le Lavandou

After a dark and freezing winter in northern Europe, the bright sun glinting on the azure Mediterranean must have blinded Weill, Lenya, Weigel, and Brecht. When the pupils of these pale Berlin artists adjusted, their eyes feasted on the sight of the pure white sand and gentle waves as they luxuriated in the aroma of oleander, lavender, and rosemary. It's likely that this was the first time Lenya had ever seen the ocean—there had been no seaside holidays in her impoverished Viennese childhood. She was an avid swimmer and would have reveled in that warm and silky water, so different from the chilly Berlin lakes. Their accommodations were not luxurious, but the modest room at the Hôtel de Provence where she and Weill stayed was flooded with light and cooled by the fresh ocean breeze. Brecht, Weigel, and Stefan came down as a family, and because they needed more space and a kitchen, they rented a house near the beach.

Weill emerged onto the promenade of Le Lavandou as if the sun and salt air were enemies against which he had to protect his sensitive skin. He suffered from psoriasis all his life, and although he enjoyed lounging on the beach, he did so in a long striped robe and leather slippers with a buttoned strap. When he carefully removed his thick glasses and plunged into the water, the vigorous stroke of this small

and seemingly delicate man was a surprise. He and Lenya were both enthusiastic and quite capable swimmers, and they shared a passion for water.

Not so Brecht. As Lenya observed, "Brecht didn't like water very much, and I'll never forget the picture of him standing in the Mediterranean, with his seersucker pants rolled up and a cigar in his mouth. He never got wet, he just stood there."[1] Brecht's fraught relationship with the water is rooted in his childhood illness. He was often treated with hydrotherapy, and despite his love for swimming in the river in Augsburg, he usually associated water with recuperation rather than enjoyment. He was not only prone to chills because of his weak heart; he perhaps also feared that his vulnerable kidneys would become infected by the bacteria swirling in the warm French sea. His casual pose didn't manage to fool the astute Lenya for an instant. When she watched him wading in so cautiously, she caught the scent of his fear.

Weigel and Stefan loved to swim, but as much as they enjoyed the Mediterranean, they were most excited about the chance to finally spend a vacation with Brecht. For Weigel, it was the best of both worlds: She could build sand castles with Stefan like any happy mother, but she also had the professional excitement of knowing that Brecht was creating a part for her in his adaptation of *The Beggar's Opera*. Lenya was also there as a "wife," but after her triumph in Baden-Baden, she too could relax on the beach with the sure knowledge that a great role for her was being written by Brecht and Weill—one that suited her newly discovered talent for singing their songs.

Brecht was very pleased with his outdoor *Kraal*—it was more soothing than his hectic Berlin studio, and it was even more beautiful than his riverbank strolls back in Augsburg. In Le Lavandou, he had replaced the sound of falling chestnuts with the lilting rhythm of the waves, and he appreciated the convenience of an entire ocean in which to flick the ashes of his cigar. But even though Brecht found time to calmly observe the view and Weill enjoyed his daily plunge into the sea, it was still definitely a working trip. As Lenya assures us, "The two men wrote and rewrote furiously, night and day, with only hurried swims in between."[2] Brecht and Weill sat on the beach and discussed the adaptation for hours on end. The only lengthy interruptions were

the delicious French meals. With the composer's ardent appreciation for food, he would have enjoyed the menus more than Brecht's sensitive stomach allowed him to do.

Although Brecht had already begun rearranging the original story with Hauptmann back in Berlin, the new characters and relationships had to be further fleshed out before he and Weill could begin to work on the musical concept and the songs.[3] To Brecht's delight, the literary and sophisticated composer was profoundly engaged in every detail of the dramaturgical decisions. Weill was equally delighted to discover that Brecht was such an astute and experienced adapter. Turning a work inside out, cutting here and adding there, was familiar territory for the playwright. Brecht spread all the new elements metaphorically on the beach, and like a painter working from a palette of preexisting colors, he revealed an altogether new picture of Gay's work. The themes were the same, and while several characters remained close to the original, Brecht's version was more modern and more dramatic. It would, of course, require new music before coming fully to life. Most challenging of all was the task of reinventing the genre of musical theater, and that was a goal both men were determined to achieve.

The Beggar's Opera was designed as a play with music, but its very title raised the question of genre. Gay's "opera" was neither an opera nor was it *about* beggars. It was a musical play created *for* beggars, and the title was meant to poke fun at the opera's typically elite audience. The story delivered handsomely on the operatic parody the title promised, particularly at the end when Macheath is sentenced to death for his crimes. His intentionally implausible reprieve is wryly explained by Gay's Player, who insists that "an opera must end happily." When the Beggar famously adds "In this kind of Drama, 'tis no matter how absurdly things are brought about,"[4] he gives voice to the play's most blatant satirical maneuver. In arbitrarily rescuing Macheath from the gallows, and justifying this deus ex machina on the basis of the absurd rules of operatic storytelling, the very "concept of opera is used . . . to resolve the conflict," Weill observed with delight.[5] The aesthetic parody attracted Weill just as much as the caricature of a greedy and hypocritical society. Like Brecht and Weill, Gay clearly believed that one could not level charges at society without exposing the hypocrisy of its cultural institutions at the same time. To the extent that culture

supports society, it must be indicted along with it. Lenya's rendition of a mock diva in the *Songspiel* was a perfect example: She sang a parody of a classic aria where she longed for whiskey rather than true love—and the satirical lyrics were emphasized when she hit the high notes of the conventional heroine. Brecht and Weill's songs for their *Beggar's Opera* would tackle the conventions of modern opera and operetta just as savagely as Gay attacked the romantic Handelian operas of his time.

However determined Brecht and Weill were to transform existing genres, there were certain requirements that came with the job. Aufricht was offering a theatrical venue, so they had to deliver a musical play and not an opera. That meant the music would have to be written for singing actors rather than professional opera singers. Weill knew that he had to render "a far-reaching simplification of musical language" in order to facilitate these requirements. But far from considering this a limitation, Weill believed that the need for "an identifiable melodic line" was precisely what allowed them to create a "new type of musical theater."[6] Specifically, the complex ideas usually associated with advanced music would now be communicated through accessible melodies. Brecht and Weill had already shocked the elite music crowd by introducing prostitutes, drinkers, and gamblers into an opera at an esoteric festival. By offering sophisticated social satire in the context of a popular and entertaining musical, they were just as fiercely challenging the conventional expectations of the popular theater. This original mixture of high and low elements was fast becoming their signature. Since existing genres of musical drama no longer related to the modern world, boundaries and borders had to be blended, redrawn, and, quite often, simply erased.

The southern coast of France was the perfect place for Weill to think about redrawing the map of musical theater. He had never been to Le Lavandou, and he was almost as excited about the natural beauty and fresh air of coastal Provence as he was to discover new artistic vistas. Creating a concept for a full-length musical play was certainly new territory for Weill. Although he had already written incidental music for several plays at Piscator's theater, and had begun composing for singing actors with his very own Lenya, Weill had only begun to discover his new style in the six songs he composed for the *Mahagonny Songspiel*. Now he had to employ his song style in the context of a dra-

matic play. Because there would be dialogue in their *Beggar's Opera,* the music would not predominate in the same way that it had in the short opera. But with Weill as the composer, the music would still play an influential role in the drama itself. In stark contrast to Weill's prior theater experiences, the music would be far from incidental. By determining that the work would be broadly defined as a "play with music," the two men had an opportunity to define the role and extent of the music in their own way. The decision to create an exceptionally musical form of theater therefore created a convergence of their interests and experiences. Weill was moving closer to writing music for the theater; Brecht was moving closer to a theater that allowed music to play as important a role as the text. The atmosphere of mutual respect is not to be taken for granted. A year earlier, Brecht had been uncomfortable at the Baden-Baden music festival where the composer naturally garnered most of the attention. But since stage music was his passion, Weill was far more comfortable holding his own as a composer in the theater. This meant that their partnership would be able to blossom in an atmosphere that suited them both. Given their different backgrounds when it came to the hierarchy of words and music, this union of equals continued to be as unusual as it was electrifying. And it was this equality of elements, of words and music, that was critical to their reinvention of musical theater.

Their creative union blossomed luxuriously under the bright, warm sun. Their talks continued throughout the pleasantly cool nights, and they both came to believe that this particular coastal setting played an important role in their prodigious artistic productivity. Brecht and Weill knew after only a few days that this was a place where they would return again and again.

Having come to an understanding of the transformed genre of the "musical play" they intended to pursue, Brecht and Weill thoroughly digested the key dramatic alterations that constituted the Brechtian version of *The Beggar's Opera.* Many of these changes had already been put in place by Hauptmann and Brecht in Berlin; others were invented, or reshaped, as the drama became absorbed and interpreted through the music. The first and most obvious transformation was changing the time frame from the mid-eighteenth to the mid-nineteenth century. The date is never mentioned in the play, but by adding the background

action of Queen Victoria's coronation, Brecht and Hauptmann were clearly referencing 1837. Brecht believed that if the events took place in the 1700s, a modern audience could dismiss the society as too old-fashioned to be relevant for them to understand. By placing it less than a hundred years in the past, it was close enough to impart the familiarity of the themes but distant enough to offer an objective perspective as well. The astute critic Walter Benjamin recognized Brecht's gift for illuminating the universal themes of the work: "Brecht grasped . . . that 200 years had not been able to loosen the alliance that poverty had sealed with vice, but rather that this alliance is as enduring as a social order whose consequence is poverty . . . The counter-morality of the beggars and rogues is bound up with the official morality . . . Thus, [Brecht's *Beggar's Opera*] which on account of its picturesque setting appeared distant, became at a stroke something of considerable relevance."[7]

The Queen's coronation served as an extremely effective finale for the play. Significantly, it is the Queen, and not the Beggar and the Player of Gay's original, who decides to arbitrarily forgive Macheath for his crimes. Thanks to her, the bandit is also awarded a castle and a pension. The irrational power of the monarchy still resonated ten years after the cataclysmic end of World War I, a catastrophe that led directly to the Kaiser's chaotic abdication. Invoking a queen's unquestioned authority sharpened the witty blade of the play's climax in a way the European audience of 1928 could easily understand. Brecht preserved the "arbitrary ending" that was offered as a parody of opera in Gay's version, but his alteration gave the finale the power to pierce the consciousness of the German population. Brecht made it possible for the spectator to learn something about their own culture and history while watching a play about Victorian England.[8]

Once the time frame was in place, Brecht and Hauptmann made the brilliant realization that the suggestive title *The Beggar's Opera* not only offered a statement about genre but also could inspire the key to transforming the story itself. The character of Peachum—originally a rather typical fence who profited from the sale of stolen goods, as well as peddling his influence with the law—became something much more interesting. In Brecht's version, Peachum became the king of the beggars. That is, his business consisted of renting ragged clothes and

other paraphernalia to people so that they could masquerade as paraplegics, blind men, and other pitiable and unfortunate men. He also controlled the practice of begging in all of London, beating those who tried to ply this trade without purchasing his "protection." Instead of profiting from stolen goods, Brecht's Peachum trafficked in a far more valuable commodity: human misery—something worth more than all the stolen wallets and jewels in the world. This new Peachum figures out that there are "five basic types of misery . . . most likely to touch the human heart. The sight of such types puts a man into the unnatural state where he is willing to part with money."[9] In a profit-driven world, misery has indeed been transformed into a commodity. Thus Brecht turned Gay's opera *for* beggars into an opera that was *about* the art, and the artifice, of begging. By portraying man's fate as a function of economic and social structures, Brecht displayed a quintessentially twentieth-century perspective.

As the king of the beggars, Peachum is trading in souls. His beggars sell their souls when they lie about their poverty or physical handicaps; those who give away their pennies are, conversely, trying to purchase a soul. Rather than creating a more just and equal society, the wealthy can soothe their collective conscience by tossing a few unneeded coins to the poor. As a statement about society, the dramatic significance of Brecht's redefinition of Peachum was a masterstroke.

Brecht also dramatically altered the illicit partnership between the play's criminal and hypocritically "lawful" characters. He first replaces the prison warden, Lockit, with a chief of police named Tiger Brown. And while Lockit is in cahoots with Peachum, Brown is allied with the bandit Macheath. Since the antagonistic connection between a breaker of the law (Macheath) and enforcer of the law (Tiger Brown) is even more direct than that between a fence and a prison warden, this new Brechtian alliance is a more striking statement about the corruption of social institutions. Brecht also further strengthened Macheath and Tiger Brown's relationship by portraying them as friends who bonded when they were soldiers during the war. This cemented the relationship between bandit and policeman far more powerfully than Gay's version. The wounds of war united the disillusioned youth of the country far more than any laws of society ever could, and Macheath and Tiger Brown's shared military service heightened the resonance of

the play for twentieth-century Germans. In this way, Brecht brought Gay's searing social statement to life for his contemporary audience.

All the changes made to the story revealed not only Brecht's ability to parse out the social message and make it even more powerful for a modern audience; they also demonstrated his stunning dramatic gifts. He restructured and enhanced all of Macheath's important relationships—with Tiger Brown; with his wife, Polly; and with his lover, the prostitute Jenny—and this allowed the play to lampoon the emotions of love and the institution of marriage even more vigorously than in the original *Beggar's Opera*. The love story between Macheath and Polly was, for example, far more complex and convincing. Brecht's Polly evolves from an innocent bride into Mac's savvy wife and business partner. Forced to take over his crooked business, Polly has the chance to become a powerful professional and proves herself to be quite capable of running his gang of criminals. Gay's heroine is, in contrast, innocent until the end—she never loses her belief in the romantic plays and novels she has read, and despite his betrayals, she begs Macheath for "a token of love" when he is on the gallows.[10] In Gay's play, it is the author who offers the audience a parody of the conventional ingenue; Brecht's Polly parodies herself right on the stage. And since she is hardly a love-struck maiden, she refuses to give Macheath money to buy his freedom and leaves him, shouting, "Take care of yourself! Never forget me!" When Macheath is rescued, she reverts to the love-struck heroine, crying, "My dearest Mackie has been rescued. I am so happy."[11] As a hypocritical member of the bourgeoisie, she can overlook his sins of lying, stealing, and murdering, as long as she wins and keeps his love—rendering his love into a commodity of which she demands sole ownership. Thus she simultaneously embodies feminine innocence and wicked cynicism. When a conventional character removes her own disguise, the moment is particularly illuminating. The audience is thoroughly entertained while being educated as to how they have been hoodwinked by the artifice of theater.

Given how pivotal Hauptmann had been in the creation of so many of these essential alterations to the work, it is remarkable that she wasn't present for the Mediterranean retreat. But if Brecht was missing her voice, it likely went unnoticed by Weill. The men were working too rapidly and too enthusiastically for the composer to imagine there

being room for another important partner. Despite the time Weill had spent in the Berlin studio, he might not yet have realized how unusual it was for Hauptmann not to be there, nor how hard it had been to engineer her absence. As for Brecht, since it had been impossible to bring Hauptmann along, he refused, as always, to dwell on things that were out of his control. If it crept into his consciousness as he stared out at the horizon during one of the brief breaks, he kept it to himself.

As this sojourn was the most purely instinctive phase of their collaboration, it was probably best that they had a chance to tackle the songs on their own. While the literary and aesthetic decisions required a great deal of discussion, their ability to generate sensational songs thrived on an atmosphere of spontaneity. Since Weill composed in his head and there were, in any case, no instruments on the beach, their ability to imagine the songs together was a further indication of the profound trust between them. Because Brecht respected Weill's comprehensive understanding of drama, the playwright knew he could rely on the composer's musical choices to enhance the multilayered meanings of the text and lyrics. The *Mahagonny* songs had already revealed Weill's impressive ability to construct "an overly languid and 'emotional' melodic line . . . [for] the unromantic, almost aggressive words in such a way that . . . one responds both to the effectiveness of the melody and to the implied ironic comment on its banality."[12] The composer's sensitivity to the lyrics' tone, rhythm, and meaning had impressed Brecht right from the start, and it was in fact the poet who most precisely articulated the dynamic quality of the unique song style they were developing. The power of a song, he wrote, "depends on whether it contains 'yes' and 'no' in it and whether the 'yes' or 'no' is sufficiently established in it."[13] The equal balance of "yes" and "no" refers to the ability to represent a phenomenon fully in one way, and yet see it from a contrasting perspective at the same time.

The most literal example of this technique came into play with the "Barbara Song," where the lyrics describe the act of saying first no, and then yes, to a suitor. Polly sings of her innocent youth: "And if he'd got money / And seemed a nice chap / And his workday shirts were white as snow / And if he knew how to treat a girl with due respect / I'd have to tell him: No." But after saying no to all the "nice chaps," she finally meets someone who is not at all nice (Macheath) and declares, "In the

end you have to let your feelings show . . . Ah, then's no time for saying:
No."[14] The irony of the lyrics—a girl pretending to yearn for pure love
and then flamboyantly giving way to reckless and lusty passion—is
echoed in the music in a sophisticated way. The song embodies Weill's
classic "emotional melodic line," and is punctuated alternately with the
pure high notes of an innocent soprano and the more bluntly outspo-
ken, and lower, register of an experienced woman.[15] The song travels
smoothly, melodically, and thus unpredictably toward Polly's cynical
rejection of an ingenue's pretensions of purity.

Brecht had already written the text for the "Barbara Song" more
than a year earlier, but his recycling instincts helped him find a home
for it in their *Beggar's Opera*.[16] The song effectively illustrated Polly's
"amoral" love and lust for the bandit Macheath, as well as allowing her
character to simultaneously inhabit and parody a conventionally naïve
heroine. Brecht could enhance universal themes in Gay's work as well
as embolden elements that had always been of interest to him in his
poetry and plays. In this case, Brecht saw that the character of Polly,
as a pure woman who has given way to desire, could go far to expose
the kind of hypocritical bourgeois morality that he had been satirizing
for as long as he had been writing.

The "Barbara Song" came to life in Weill's setting because it high-
lighted the song's textual contradictions in musical terms. It was not
only the usual contrast of melodic music and acid wit but also yet
another example of the composer's ability to employ musical refer-
ences in an extremely effective way. Just as he did in *Mahagonny*, where
he invoked Weber's opera in the opening song, he also made sure
that the music for the faux-naïve "Barbara Song" clearly reminded
the listener of a popular and saccharine operetta song called "Ich
bin nur ein armer Wandergesell" (I'm Just a Poor Wayfarer). As with
Mahagonny, the satire was again textual as well as musical. The oper-
etta song is about a "degenerate" rascal who pretends to be someone
else and wins the unsuspecting heart of the heroine. In contrast, in the
"Barbara Song," Polly gives herself to Macheath not only knowing
that he is a scoundrel, but even reveling in his scandalous reputation.[17]
The absorption of Brecht's lyrics into Weill's music functioned well
because they both understood the value of representing and comment-
ing simultaneously, and together they could fulfill Brecht's demand for

a resounding and equally powerful "yes" and "no" that constituted the magic of the songs he and Weill created. This technique permeated the whole of their collaboration on *The Beggar's Opera*.

Brecht not only made new use of the "Barbara Song" but also found places for two more works that had originally been written for other purposes. He was always a supreme recycler—not simply reusing, adapting, or actually taking the work of others, but most especially reusing his own. Since Weill was a like-minded composer, who always attempted to make use of music he had composed for projects that had been canceled, Brecht's artistic husbandry was yet another technique he shared with the composer.

The second set of recycled lyrics was for the "Cannon Song." The text was from an antiwar poem in Brecht's first poetry collection and was ideally suited to fleshing out the relationship between Macheath and Tiger Brown. It established their prior and predominant relationship as loyal war buddies, a facet of their friendship that dramatically strengthened the importance of the affection between the policeman and gangster. This is another brilliant example of recycling with intent: Brecht was consistently concerned with antiwar themes, and by merging one of his early poems with the material in *The Beggar's Opera*, he was able to keep this universal theme alive in a way that also improved the particular social and dramatic message of the play.[18]

The same was to be true for the third recycling candidate, the "Pirate Jenny" song, which had been performed in another form on the radio two years earlier.[19] This song describes a servant girl wreaking revenge on her oppressors, and both men were eager to find a place for such a powerful ballad in a piece about social hypocrisy and injustice. Weill had already heard and admired the radio version, although he naturally had ideas of his own for the music. The rhythm of Brecht's lyric style permeated the original song in the same way that it infused all of his poetry and early ballads. When it came to Brecht's other ballads, Weill had dismissed the poet's musical suggestions as "nothing more than a notation of the speech-rhythm and completely useless as music."[20] In the case of the original "Pirate Jenny" song, Weill also realized that its melody reflected the strong Brechtian literary rhythm, but hardly more than what the composer could already have heard in the lyrics alone. The beauty of the cadence influenced him far more

than the way in which the song's original composer had chosen to render it. So if Weill was not the "first musician to board Brecht's 'ship with eight sails' . . . it was Weill who took it to sea and steered it to its destination with all its cannons blazing."[21] The composer was in the perfect place to catch the Brechtian wind. After all, he was forming the melody in his mind as he gazed out at the Mediterranean, which spread luxuriously before him, as his wife, Lenya, swam intrepidly toward the horizon.[22]

This free and easy exchange of artistic ideas is further proof of the atmosphere of mutual trust and respect between the men. Not every writer, and most especially not Brecht, would hand over a finished song to a composer to do with as he wished. And few fiercely individualistic composers would revise a song that already existed in another form. In Le Lavandou, the synchronicity that had been building gradually since their first meeting had become a true force of nature. There was a glorious lack of territorial concerns between the artists as they collaborated under the large umbrella, digging their feet into the sand and focusing intently on the result they wished to achieve. For a few bright weeks, the circle of shade they inhabited was the only territory they knew, and it belonged to both of them.

Their sense of equality and their equally competitive natures were working in their favor. Not to mention their shared need to work quickly. If Weill took a few "hurried swims" in between, as Brecht puffed his cigar at the water's edge, it was only to take a brief respite from the breathless and energized collaboration taking place on the hot sand. Weill, with his striped robe neatly belted, and Brecht, with his brimmed hat pulled low on his face, each respectfully addressed the other with *Sie,* and each tried hard not to interrupt the other. Weill wrote excitedly to his publishers about their process: "I'm working at full steam on the composition of the 'Beggar's Opera,' which I'm enjoying . . . it is being written in a very easily singable style since it is supposed to be performed by actors."[23] Brecht and Weill were eager to call specific attention to the fact that actors, rather than singers, were performing the songs. The actor's "aim is not so much to bring out the emotional content of his song," Brecht wrote. "If he drops into the melody it must be an event; the actor can emphasize it by plainly showing the pleasure which the melody gives him . . . Particularly in

the songs it is important that 'he who is showing should himself be shown.' "[24] Brecht and Weill's ideas about music and theater spilled out with the rapidity of gunfire and, when they combined, exploded like fireworks into songs.

The key to understanding the magic of their songs in *Mahagonny* and the ones they were creating on the beach is that the clash of music and lyrics—the melodic, even romantic, rhythms underscoring the harshly unromantic text—was the product of two men with a profoundly shared goal. It was not just that Weill was more romantic and Brecht more cynical, so that the natural contrast between them created an interesting effect. They both wanted to expose the hypocrisy of society and its institutions, they both wanted to reflect mankind in a satirical mirror, and they both consciously used textual and musical means to heighten the power of their work. The contrast between them was consciously maintained and exploited. Despite the differences in appearance and personality, the bespectacled, erudite composer who was making melodies respectable again and the cigar-chewing writer of acid poetry were equally ironic and romantically minded by turns. Their work reflected their intentions, not their demeanors.

With the two men working so enthusiastically, and their talented lovers enjoying the abundant sunshine, the idyllic scene of artistic inspiration and domestic harmony was almost perfect. But the picture was incomplete, and everyone had to have known it on some level, even if no one was willing to ask the question aloud: Why wasn't Elisabeth Hauptmann there? *The Beggar's Opera* was unthinkable without her, and it would have been less surprising to see her lugging the heavy black typewriter onto the beach than not to have seen her at all.

But she wasn't invited. More accurately, it's quite likely that she was specifically uninvited, despite Brecht's desire to have his secretary and dramaturg join him and Weill in their Mediterranean *Kraal*. But if Weigel had objected just this once, it's hard to blame her. She and Stefan usually traveled to far more modest places, and she often included Brecht's daughter, Hanne, in their plans. Even if this was a working holiday, it was nevertheless a chance for them to spend time as a family in a beautiful place—a place where Brecht was likely to come home to their rented house for dinner every evening, which certainly

wasn't always the case in Berlin. But although it is understandable that Weigel probably forbade Hauptmann to join them, it is rather surprising that Brecht agreed to this demand. It says much about the importance of Weigel in his life.[25] It says even more about what he was sure the essential but modest Hauptmann would tolerate.

Hauptmann never documented her discontent with this situation—a complaint didn't even make its way into one of her quasifictional, heavily autobiographical short stories. Since she would be responsible for making sure all the changes to *The Beggar's Opera* were properly incorporated on the technical and dramaturgical level, not to mention the actual typing, she was hardly worried about being left out of the process. But the chance to escape that chilly if inspiring attic on Spichernstrasse would surely have been enviable, and as the discoverer and translator of *The Beggar's Opera,* it's fair to assume that Hauptmann was quite sorry to be left behind. But she was, as always, more focused on the work than on her personal situation. And since she knew that it would be necessary to spend a lot of time transcribing Brecht's handwritten changes, Hauptmann was at least able to insist upon an early meeting to give her a head start on the work. To this end, Brecht left Le Lavandou before Weigel and Stefan, and went to meet Hauptmann in Marseille. From there, they traveled north together, so she had her time in France with Brecht after all. Even if it was hardly a paid working vacation on the beach, she had the honor of being needed and respected by Brecht. This was still enough for her.[26]

For those two weeks on the beach, Weill was more than enough company for Brecht. If the playwright was reliant upon intense collaboration, the composer was equally gratified by the chance to develop and interweave the music and literary elements simultaneously. It was far more satisfying to make decisions with the writer than it was to set the finished work of a poet or playwright. In Weill's measured way, he expressed just how excited both of them were to have found each other: "Without a doubt . . . the great ideas of our time can result initially only from the collaboration of a musician with one of the representatives of literature who is at least equivalent in standard." As the tourists passed by, they could little have imagined that this pale, balding man, sitting in his chair with his striped robe, speaking eagerly to his skinny

companion with cropped hair, deep-set dark eyes, and a cigar in his mouth, was transforming the relationship between music and drama on the stage. It was even less imaginable that the shorter one with thick glasses, who carefully placed himself under the umbrella so that the shadow covered every inch of his fair skin, could write melodies that made people feel like dancing. Brecht, who was rarely photographed on the beach in anything other than long pants, a long-sleeved shirt, and often a jacket, hardly seemed like a man who could catch the rhythm of fairground barkers, carpenters, and laundresses. Although the project had begun as a lighthearted distraction, Weill was increasingly convinced of the importance of their partnership: "The often-expressed apprehension that such a collaboration with worthy literary figures could bring music into a dependent subservient, or only equal relationship to the text is completely unfounded. For the more powerful the writer, the more he is able to adapt himself to music, and so much the more is he stimulated to create genuine poetry for music."[27] A less cautious composer might even have risked a bad sunburn for the chance to get his hands on genuine poetry. But Brecht and Weill were as cautious physically as they were utterly courageous as artists. They had that in common as well.

By the time Weill left on June 4, he was ready to promise his publishers a finished work by the end of the month.[28] The promise alone is the most staggering evidence of the speed with which they both could work. They had envisioned not less than twenty songs for the new version, and considering that only one of them was from the original, and only three others already had complete lyrics written by Brecht, the composer's promise was impressive. Brecht was equally confident of what they had accomplished. He wrote Weigel just a week after leaving the beach and announced that he had finished *The Beggar's Opera*.[29] They surely accomplished a lot in between "hurried swims," and since Brecht left the beach to attend a production of *In the Jungle of Cities* and also to meet his Marxist teacher, Fritz Sternberg, in Hamburg, we can assume that he didn't spend much more time on it directly after his work with Weill. When Brecht met Hauptmann in Marseille, she likely received a hefty truckload of the usual details to work out. As far as the playwright was concerned, the important masterstrokes were in place.

One essential element was still missing: a new title. Since Gay's ver-

sion had been so recently successful in England, and because Brecht's adaptation was both too close to and too far from the original, confusion with the British source had to be avoided. He and Hauptmann had somewhat mockingly referred to their first version as "The Pimps' Opera," but this neither described Macheath's true profession nor illuminated the essence of the play. But since he believed that there was nothing as inspiring as seeing a work up on the stage, Brecht was confident that the title would be found during the rehearsals.

But if the working holiday was over, why did Weigel and Stefan remain behind? Perhaps because it was lovely and the house had been rented for the month, but it was also because Mar and Hanne were coming to join them. This emotionally complex situation seemed quite normal to Brecht, and in a letter to Weigel, he cheerfully sent his greetings to Hanne and Mar on one line, and warns Weigel on another: "Don't go in the water too much!"[30] As far as Brecht was concerned, water seemed far more dangerous than the thought of Weigel spending time with his volatile ex-wife. And he had, after all, agreed to leaving Hauptmann behind. In return, perhaps Weigel wryly understood that an empty room in a house on the Provençal beach would soon be filled by one or more of Brecht's dependents.

Although Weill and Lenya had struck a rather modern deal—Lenya tolerated Weill's obsessive workaholic schedule, and he accepted her sexual infidelity—they were still the relatively stable married couple in this constellation. Unlike the complex chess moves of Brecht's extended family, Weill and Lenya simply took the train back to Berlin together and, with the kind of domestic simplicity that Brecht had yet to achieve, resumed their city schedule in the apartment they shared. No children and no steady lovers or ex-spouses to be managed.

Predictably, Weill went straight to work on the music as Lenya waited impatiently to receive her new songs. And although the composer had optimistically predicted a completed work by the end of June, this was not to be. By July 22, he told his publishers not to print anything yet because the arrangement was not complete.[31] Despite the fact that rehearsals were to begin in only a few weeks, he reported with apparent calm that there were still two "numbers" that were missing. The use of the word "number" is intriguing, because Weill didn't specify whether or not the concept for the songs had been decided and,

more pointedly, if he was in fact waiting for lyrics. It is highly unlikely that Weill, who had been working nonstop on the music, would have been the cause of delay, and though he had frequently warned his publishers about Brecht's penchant for late deliveries, he used intentionally protective language in this case. The composer was extremely careful about the printed versions of his music, and working with a writer like Brecht meant he had to wait until the very last minute to reproduce the piano music for the rehearsals. He had to make sure his publishers would be ready to wait as well.

Brecht had been right to insist on a beachside *Kraal* in order to keep him from the distractions of his other projects and obligations. But once that time was over, the writer found it hard to sit still and complete the task. Even if Hauptmann could pull together the new draft from Brecht's notes and her likely additions, only he could finalize the necessary lyrics for the new songs. The closer the deadline, the more distractions he found to occupy him.

August was unusually warm for Berlin, and at first the weather reminded Brecht and Weill pleasantly of the French beach where their musical play had burst into being. But a sultry summer in the city is far harder to tolerate, especially under the poorly insulated roof of Brecht's roasting attic studio, and in Weill's sweltering, sunbaked rooms. But even the burning asphalt and those long, sticky nights couldn't quell the enduring optimism of that great year. There had been an election at the end of May, and the left-of-center Social Democrats won 30 percent of the vote. This gave them the opportunity to form a grand, or at least a "great," coalition with four other parties in Germany.[32] Everyone seemed determined to work together and maintain the peace. Everyone was eager to believe that the horrific scars of World War I, and the bloody revolutions that followed, had finally begun to fade.

In this atmosphere of peace and prosperity, what did it matter if the play wasn't quite finished as they headed into rehearsals? The playwright and composer were doing this for fun, to earn some money, and because the chemistry of their interlocking talents was the most compelling artistic phenomenon of their careers so far. Brecht relished the chaos of rewriting on the spot, and the disciplined Weill certainly didn't fear the idea of composing on his feet. They not only embraced spontaneity; speed had in fact come to be an essential part of their

magic. It would be an adventure on every level—a chance to create a new genre of musical drama, a far bigger budget than either had known before, and their first partnership on a full-length work. They had a large theater and all their favorite artists working alongside them. What could possibly go wrong?

The Bourgeois Bandit

The bourgeoisie's fascination with bandits rests on a misconception: that a bandit is not a bourgeois. This misconception is the child of another misconception: that a bourgeois is not a bandit.

—Bertolt Brecht[1]

The Schiffbauerdamm Theater was the perfect place to present Brecht and Weill's "opera for beggars." Perched on the bank of the Spree River, the elegant, baroque building was wedged between one of the greatest stages in Berlin and the city's most desperate inhabitants.[2] On one side was Max Reinhardt's Grosses Schauspielhaus (Grand Playhouse); on the other were the rather unsavory visitors who looked for trouble along the dark and damp pathways of the abandoned ship-builder's quay. Just across the river was the Friedrichstrasse train station, in a neighborhood known for its shady clubs, abundant cocaine, nude dancers, and cheap wine. Although most of the wealthy patrons who came to see Reinhardt's spectacles knew little of the underground life in the alleys behind his theater, they had no choice but to share the narrow sidewalks with seedy clubbers, famous actors, and beggars alike. If Brecht and Weill had their way, their "opera for beggars" at the Schiffbauerdamm would have something for all of them—high, low, and in between.

Rehearsals for their *Beggar's Opera* began on August 10, 1928. Brecht and Weill, along with Weigel, Lenya, and Hauptmann, most likely took the newly electrified S-Bahn across the city to the modern glass-and-steel double-arched terminal of the Friedrichstrasse station. Just as Weill had reveled in his airplane flight to the Ruhr, both men would have particularly enjoyed the startling speed of the elevated train as they watched the city flashing by outside the windows. As they walked across the bridge leading from the station toward the quay, they could see the theater on the other side of the wide Spree. The Schiffbauer-damm's very name was a reminder of the technological progress that had been made since the days of ships (*Schiffe*) and their builders (*Bauer*)—seen from a distance, the building looked small and quaint.

The theater loomed far larger once the young artists stood directly in front of the imposing columns framing the entrance. As they looked up toward the tower crowning the Schiffbauerdamm, their eyes would have also landed on the broad-shouldered director, Erich Engel. He was very skinny, and his large, bald head looked out of place on his slender frame. He spoke carefully and slowly, as if even the pronunciation of his name had been thoroughly considered before saying it out loud. As Brecht introduced him to Weill and Lenya, it was clear how much the usually irreverent playwright respected the stately and imposing Engel. Caspar Neher was there, too, and greeted all his colleagues warmly.

Ernst Josef Aufricht, who was waiting nervously just inside the building, was already ruminating over the two intersecting trios facing the theater on that hot morning. Neher and Brecht had been "brothers in arte" since they were sixteen, and they were a fixed unit within the production. Neher's quick friendship with Weill and the successful collaboration in Baden-Baden had formed a solid professional bond between the three men. Likewise, Neher had worked on the two Brecht productions that Engel had directed, and this trio was equally strong. Given the complex network of relationships, Aufricht was curious to see who would first come through the heavy doors of the impressive entrance and what that would signify for the politics of the rehearsals to come. Brecht had already behaved as though he were in charge, but perhaps he hung back as they approached, expecting the door to be opened for him. Weill was probably not thinking about the door at

all—he was far too concerned about the acoustics of the theater they were about to enter.

Once inside, it would be the wry Neher who looked over Aufricht's anxious head and smiled at the hundred-year-old theater "plastered with nymphs, tritons and cherubs," with eight hundred red velvet seats.[3] Although the varied neighborhood outside the theater was the perfect environment for Macheath's shadowy activities, the exaggerated, if faded, elegance of the interior was truly an ironic setting for a beggar's opera. The theater hadn't been used for many years, and while Neher was pleased to see the shabby condition of the house, he realized that his design would have to clash with the opulent architecture of the Schiffbauerdamm.

There was anxiety and excitement all around, but Aufricht had the most on the line. Brecht had weathered failures before, Weill's operatic reputation was doing nicely enough to allow him this theatrical experiment, and Neher was in demand all over Berlin.[4] Most certain of all, Engel's status as a star director was untouchable. It was Aufricht who needed a success in order to avoid losing all the money his father had given him; this was his last chance to establish himself as a capable producer instead of a dreamy and foolish son. He had therefore engaged several important actors, including a famous operetta star for the role of Macheath. He couldn't imagine that there would be objections to these known quantities, but with a powerhouse like Engel and an opinionated playwright like Brecht, he was nevertheless eager to receive their approval. And, of course, he still hadn't revealed his concerns about Weill's esoteric reputation nor his backup plan of using the music from the original *Beggar's Opera*.

It didn't take long for Weill to connect with the quiet and thoughtful Engel. A man of many diverse interests, Engel shared Brecht's fascination with boxing and had an equal passion for music. "As a chess player and devotee of mathematics [Engel] was fascinated with the structural exactness of a musical composition and the mathematical precision of an orchestral score," observed Felix Joachimson, a friend of the composer's who often observed the rehearsals. "Kurt Weill, the Busoni pupil, understood and valued this approach. It was honest, and not obscured by foggy romanticism. He himself relished the logical design of a musical phrase, the painstaking architecture of an orches-

tral score. Weill's mind was analytical like Engel's."[5] Aufricht observed the alliances forming quickly and was grateful that his wife, Margot, was working as Engel's assistant. The sooner he knew about problems erupting among the cast and crew, the better.

Fortunately for Aufricht, his first offer of Harald Paulsen for Macheath was easily accepted. Paulsen had a good voice and was known for his acrobatic dancing style. As a star of operetta, he could handle the musical and dramatic requirements, and, just as important, his name and style strongly evoked the very form they were planning to parody. Paulsen had no idea that the genre in which he had been so successful was to be satirized so savagely, and he had eagerly agreed to play the role.

Aufricht had also brought in a very talented actor from Dresden, who was still unknown in Berlin. With his worn face, huge nose, and cunning eyes, Erich Ponto was perfect for the role of Peachum. For Mrs. Peachum, Aufricht had cast Rosa Valetti, a large woman known for her loud voice and whose style was typical of the Berlin cabaret. Another cabaret actor, the fat comic Kurt Gerron, was chosen for Tiger Brown.[6] The blend of an operetta star, a dramatic actor, and authentic cabaret performers pleased Engel, Brecht, and Weill. When they were welcomed into the play, Aufricht must have breathed his first sigh of relief.

Brecht had two critical casting demands, the first being the part he had written for Weigel. It was a small but colorful role—that of a brothel madam—which didn't exist in the original. The second was the crucial, and greatly enlarged, part of Polly. Brecht wanted the stunning and ambitious actress Carola Neher (no relation to Caspar), who also was known for her lovely voice.[7] She was neither a cabaret nor an operetta star; instead, she was just the kind of singing actress that ideally suited both Brecht and Weill. She was a professionally experienced and beautiful version of Lenya, her equal in talent yet her opposite in both style and upbringing. Playing Polly and Jenny—as the good girl who was not so good, and the bad girl who was not so bad—Carola Neher and Lenya represented two complementary versions of the classic romantic heroine. Together, Polly and Jenny demolished the cliché of the ingenue.

During the first few days of work, everyone revealed their distinct

rehearsal styles. Brecht sat in the house and shouted his orders to the actors on the stage. Engel preferred to approach an actor when he had something important to say. He went up the stairs to the stage "slowly and deliberately, looking down as if he was lost in thought until the last moment; and then he spoke with the actors in such a way that everyone in the ensemble could hear him; it was amazing what a strong voice could come from his lanky body."[8] Weill rarely sat down. When he wasn't rehearsing the actors at the piano, he preferred to walk up and down the aisles, often with his back to the stage, so he could focus on how the music sounded. Neher was used to the chaos of Brecht's rehearsals, and in an almost ironic contrast to the hectic atmosphere, he moved more slowly than anyone as he supervised the construction of the set. The astute Lenya enjoyed watching Neher navigate through the playwright's storm: "Neher was blond, always with a straight lock over his forehead, tall, a little stooped . . . with squinting, scrutinizing eyes, never losing his temper, savoring all the battles around Brecht but never entering into them."[9] Aufricht anxiously wandered in and out of the house many times a day. Of all the players in this production, Brecht was the only one who spent most of his time sitting. He liked it that way.

The significance of the physical position they each inhabited off-stage would not have been missed by the composer or the playwright. They had, after all, already spent much time discussing the precise ways in which an actor's posture onstage would support or conflict with the meaning of the words or the emotional thrust of the music. Weill and Brecht had each defined this physical precision independently with a term called *Gestus* or, in Weill's case, *Gestic* music. It was a concept they had both begun to develop around the time that they first met. The composer believed that *Gestic* music "could articulate that which the text does not make explicit," while Brecht's idea of *Gestus* claimed that the way in which a song was performed—down to the smallest detail—was as critical as the music and the text itself.[10] With regard to the role of body language in musical and dramatic performance, they asked many critical questions: Where would Polly stand, and how would she move as she sang the not-so-sweet "Barbara Song"? Would she bat her eyelashes demurely or gaze fiercely out at the audience? When should her posture be as defiant as the words,

and should it ever be as seductive as the melody? The essential aim of *Gestus,* as the drama professor and Brecht expert Peter Thomson points out, was to create "a disorientating conflict between what is seen and . . . heard" on the stage.[11]

As each person walked, ran, and paced around the house, Brecht sat still, observing that the gestic character of director, composer, scenic designer, and producer was being firmly established by the way that they moved and from which positions they observed the stage. Brecht was pointedly sitting where he could see everything, on the stage and off. While others attended to their spheres of expertise— directing, music, design—Brecht believed that he, and not the director, must be the one to have an eye on the whole. His one "inflexible rule" of theater was "that the proof of the pudding is in the eating."[12] That "eating" was the performance itself, and Brecht sat in the house so that he was constantly confronted with the truth of his play. If he was rushed, and sometimes rude, it was because he was certain that he was right and had to communicate the need for an adjustment right away. Lenya, not always his strongest supporter, extolled his ability to work with performers. "He could teach a horse to act," she insisted.[13] Such "teaching" might have been viewed as the job of the director, but Brecht was too concerned with the outcome of his play to bother with diplomacy. It was quite hard for Engel "to cope with Brecht's constant interruptions and with his habit to give instructions to actors over the director's head," but Brecht was determined to ignore conventional hierarchy in the pursuit of the best ideas.[14]

If volume was the chief indicator of power, Brecht would have been the clear winner from day one. But volume alone was unlikely to be enough in this talented and stubborn mélange of artists.

Weill still had no idea that Aufricht's musical arranger was waiting in the wings with orchestrations of the original music. But he was acutely aware that Lenya did not yet have the official approval from the producer. The composer politely waited a few days before he silently headed for the exit at the back of the house, subtly gesturing to his wife along the way. It was time to pop the question to Aufricht. They tiptoed up the aisle, unnoticed by Brecht whose voice was echoing off the stucco as he barked an order a bit too loudly for Engel's taste. Weill preferred to make his demands quietly and in the privacy of Aufricht's

office. The composer's signature *Gestus* was the contrast of his modest demeanor and his intractable tone—Weill spoke softly because he expected people to lean forward in order to hear him.

The composer and his wife went through the back door of the lobby, crossed the courtyard outside, entered the rear building of the theater, and climbed a narrow flight of stairs to Aufricht's office. The producer was surprised to see the couple enter so boldly and state their demands with such confidence. "I'd like to play my music for you tomorrow," Weill politely informed him. Without waiting to see if the schedule worked for Aufricht, he casually added: "And I have another request, I want my wife to play Jenny, one of the whores." Aufricht was not pleased with this double assault. He had not yet approved of Weill's music, and yet this cheeky composer was requesting a part for his wife. The producer was somewhat intrigued by Lenya's unusual looks and even briefly wondered how the bespectacled Weill had ensnared such a conspicuously sensuous wife. Just as he was warming up to the idea that she might be a new discovery, Lenya brazenly told Aufricht that her husband would write a special song for her.[15] The producer had worried about commanding authority with egos like Brecht and Engel—but it was a true slap in the face to be treated so disrespectfully by a commercially unproven composer and his inexperienced wife who claimed to be an actress.

Not surprisingly, it was with a certain amount of ill will that Aufricht came into the theater the next day to hear Weill's music. Aufricht would have called it an "audition," but other than his loyal staff—Theo Mackeben, the musical arranger; Robert Vambery, the dramaturg he had engaged for his new theater; Heinrich Fischer, his stage manager; and his wife, Margot—he was the only one who was aware of the composer's precarious position. Had Brecht known, he wouldn't have given it a second thought—he would have scoffed rudely and informed the producer that he couldn't dictate their musical choices. Had the composer realized he was auditioning, he would have been simply astounded. On the beach in France, he and Brecht had taken possession of *The Beggar's Opera*—their version simply didn't exist without the new music—thus the unspoken objections from the producer were unimaginable.

Weill asked for the piano to be rolled out on the still-bare stage.

The composer sat down, and unassumingly began to sing some of the songs while accompanying himself on the piano. The distinct melody emanating from the piano was the first surprise. Weill easily revealed his ability to make his music "speak directly to the audience, to find the most immediate, the most direct way to say what I want it to say, and to say it as simply as possible."[16] The songs he chose to play stood on their own, and even without singing actors, Neher's powerful sets and lighting, and Engel's direction, the quality and power of the music were clear. It was a risk that only the most confident of composers would have dared to take. "Oh my, he was really a bad player, and his voice, he really couldn't sing either," Margot Aufricht said, confirming Weill's own estimation of his piano skills.[17] Aufricht was surprised and relieved to hear an actual melody. The "small soft, bespectacled composer with his light, somewhat metallic voice," as Aufricht described him, stunned the producer and everyone else into an appreciative silence. "And then Vambery whispered in my ear," Aufricht continued. " 'The music has at least as big a chance of success as the play.' The longer Weill played, the more my prejudice was worn down. In spite of the strangeness, the music had something both naïve and sophisticated and exciting, and it moved me."[18] One thing was certain: Weill's music was far better than the original. Mackeben would stay on as the arranger for Weill's music. And now the producer could turn his attention, a bit more kindly, toward the audition for Weill's actress wife.

The "Pimp's Ballad" was a song that had been written as a duet for Lenya's Jenny and Paulsen's Macheath, and it showcased Lenya's unusual talent, as well as revealing the power of Brecht and Weill's song style.[19] A bitterly ironic tale of a pimp and his prostitute girlfriend, it was a song of true love and truly shocking abuse—a haunting song that warmly portrayed tragic lovers and mocked them at the same time. Aufricht would have known nothing about Lenya's brief experiences as a twelve-year-old prostitute, but he couldn't have missed the submerged despair behind her audacious façade. Only she could fully realize what Weill called "the charm of the piece [which] rests precisely in the fact that a rather risqué text . . . is set to music in a gentle, pleasant way."[20] Brecht elaborated on the illuminating quality of the contrast: "The tenderest and most moving love-song in the play described the eternal, indestructible mutual attachment of a procurer

and his girl. The lovers sang, not without nostalgia, of their little home, the brothel. In such ways the music, just because it took up a purely emotional attitude and spurned none of the stock narcotic attractions, became an active collaborator in the stripping bare of the middle-class corpus of ideas."[21] If Paulsen was struggling to depart from the straightforwardly romantic performance style of most operettas, and if he was unable as yet to put his saccharine skills in the service of satire, he must have learned a great deal from Lenya's ability to project such strong emotion despite her cool, unwavering demeanor. She understood how to reveal pain as strongly as the need to conceal it—that is, she instinctively knew how to perform Brecht and Weill's provocative songs with an edge as sharp as the blade of Macheath's knife. Aufricht warmly approved of Lenya, and he was relieved that he did not have to engage in an argument with the quiet but resolute Weill, or the equally stubborn and noisier Brecht.

The quiet Weill was indeed surprised by Brecht's loud voice during the rehearsals, a quality that, for him, was far more irritating than it was intimidating. It seemed so unnecessary to a composer whose soft-spoken manner rarely failed to convince. When it was just the two of them, Brecht was always soft-spoken and respectful. During Lenya's "Alabama Song" audition in their apartment, she had remarked on Brecht's "deep courtesy." And apart from one brief conflict over Lenya's suggested nudity, the two men had been in complete agreement during the brief rehearsals for the music festival in Baden-Baden. Although the composer had seen Brecht's dominant position among the collaborators in his attic studio, he had been unprepared for the extremely aggressive public persona that evidently exploded in the theater. It was not a side that Weill or Lenya had ever seen in full force before.

Since the playwright had behaved this way from his early days in Munich, Neher had often witnessed Brecht's temper in action. But because Brecht rarely directed his thunder at Neher, the calm scenic designer had the privilege of enjoying his friend's passionate arguments from a safe distance. Having achieved their most sophisticated design yet with *A Man's a Man* that same year, they were more in league than ever regarding their ambitious theatrical goals. Everything about the stage design, they had concluded, must actively force the audience to be aware of the technical components of the theater. In *A Man's a Man,* for

example, they had discarded the traditional red velvet drapes that concealed the backstage mechanics and used a half curtain instead. This allowed the machine of illusion to be visible to the audience, revealing everything from changes of scenery to the backstage mechanics. If opera and operetta sought to suspend disbelief, then Neher did everything he could to provoke it. The curtain wouldn't conceal, the light sources would be exposed, and the sets were aggressively plain. The audience for *The Beggar's Opera* must never be permitted, even for a moment, to forget they were in a theater.

Brecht and Neher were also passionate about the use of the printed word, and they took this to a new extreme by using large hanging signs in the background of nearly every scene. In the *Mahagonny Songspiel* the actors held up signs at the end. This time the placards would play an even larger role in the drama, not only by displaying the titles of the songs but also by offering snatches of the story that often gave away the suspense. Brecht scoffed at the conventional disdain for titles: "The orthodox playwright's objection to the titles is that the dramatist ought to say everything that has to be said in the action, that the text must express everything within its own confines. The corresponding attitude for the spectator is that he should not think about a subject except within the confines of the subject. But this . . . passion for propelling the spectator along a single track where he can look neither right nor left, up nor down, is something that the new school of playwriting must reject."[22] Neher used a variety of lettering styles, including modern typefaces from newspapers and magazines, as well as painting them with an old-fashioned brush or simply writing with a thick piece of charcoal.

In the scene where Macheath was to be betrayed by his whores, a sign gave away this information long before the audience could have been certain that he would be caught. Suspense was a tool of illusion, and illusion was the enemy. By heightening the audience's consciousness of the theatrical tools of the trade, Brecht forced them to view the story, and its underlying social assumptions, from all angles. Especially because these elements often contradicted each other, no "single track" was available. This was a play that was as much about the artifice of theater and opera as it was about Macheath.

This new form of musical drama was difficult for the actors to

understand. They were accustomed to sincerity and satire as separate entities—operetta was saccharine, Berlin cabaret was scathing—and the mixture of tones was confusing. Weigel and Lenya were the only ones in the cast who had experienced Brecht and Weill's technique of portraying and commenting simultaneously. Paulsen spent a lot of time in his dressing room, "alone and miserable . . . This is the first time in my life that I don't know what I am doing," he said to Joachimson, Weill's sympathetic friend. "They're all maniacs. I have no idea what the whole thing is about. All I know is that it's a disaster."[23] Valetti and Gerron, the cabaret stars, were equally disoriented. What kind of a play gave away the plot in advance by writing it on signs that were lowered into the background? Why wasn't the play ready to rehearse instead of being constantly revised?

The more experienced theater actress, Carola Neher, would have demanded to know the answers to all of these questions, but she hadn't shown up yet. Her husband, a famous poet known as Klabund, was dying, and shortly after accepting the leading role, she had rushed to his bedside.

The music, lyrics, and set design that intentionally contradicted one another up on the stage were like an aesthetic mirror of the chaos of conflicting opinions raging down in the house. This confusion was exacerbated by the constantly revolving group of visitors that Brecht encouraged not only to observe but also to voice their thoughts and offer suggestions. Brecht had brought his collective inside, effectively declaring the Schiffbauerdamm as yet another one of his *Kraal*s. "Brecht knew that if one writes a play for modern times, they have to understand a lot about the world," Hauptmann explained. The expertise and opinions of intelligent people had been part of his writing process since he was a teenager in Augsburg—it wasn't going to stop for his biggest production yet. The pervasive presence of so many perspectives was irritating to many, but Hauptmann saw it as one of Brecht's most admirable traits. She proudly quoted his simple metaphor for his working philosophy: "'Most people can't build anything larger than a doghouse, and that's mainly because they want to build it alone.' It wasn't possible for Brecht [to work] in any other way. For that, he was too ambitious."[24] Engel was accustomed to Brecht's strong presence,

but this was the first time such a large group of people had taken up permanent residence during rehearsals.

Brecht's colleagues were quite a prodigious group. They embodied the best of the literary and artistic elite of Berlin, including Elias Canetti, Karl Kraus, and Brecht's former mentor, Lion Feuchtwanger, along with his wife, Marta.[25] Weill had visitors, too—his friend Joachimson and his publisher, Hans Heinsheimer—but he didn't encourage them to participate in the discussions. Because of the open-door policy, however, artists, critics, writers, and gossips at every café table, atelier, and theater in Berlin eagerly discussed tales of the exuberant and increasingly combative rehearsals. As Joachimson observed, "people dropped in at rehearsals and came out with horror stories of shouting matches and hysterics . . . It was hard enough for Engel to deal with Brecht's constant interruptions, but far worse to endure the suggestions and opinions of his seemingly endless cadre of intellectuals and artists."[26]

On one particularly rough day, Brecht sat imperiously in the house and openly entertained suggestions for a new title from anyone who cared to contribute. "It was the writer Lion Feuchtwanger—among the distinguished kibitzers who wandered in and out of the stalls," Lenya remembered, "who suggested a new title for the work: *Die Dreigroschenoper*."[27] *Drei* means "three," and *Groschen* was the word used for a ten-cent coin. The word *Groschen*, however, was used as "penny" in English. Feuchtwanger's title was a clear reference to an inexpensive type of book known as "penny novels" that were quite popular in the 1920s, and Brecht was quickly convinced that the title captured the play's essence. "Since this opera was intended to be as splendid as only beggars can imagine," Brecht wrote, "and yet cheap enough for beggars to be able to watch, it is called 'The Threepenny Opera.'"[28] The title had particular relevance in the summer of 1928. The government had recently passed a controversial measure—the Law to Protect Youth from Trashy and Filthy Writings—which attempted to ban penny novels and other forms of cheap literature.[29] The idea of a "Threepenny Opera" poked fun at the conservative hatred for inexpensive mass-market books that purportedly encouraged the bad values of modern urban life.

Everyone agreed that it was a great title; nevertheless it was extraordinary that anyone, even an esteemed man of letters like Feuchtwanger, could walk into rehearsals and become a part of the decision-making process. The extremely well-read Engel would have been graciously willing to discuss the play with Feuchtwanger in private, and yet no director, let alone one as established as he was, would enjoy the freewheeling environment that Brecht had unleashed. Joachimson remarked that "the production of a show is not an exercise in democracy. Unless conception and execution are determined by one person, and one person only, chaos will reign. And that is exactly what happened."[30]

Brecht's enormous respect for Engel was unabated, and he likely assumed not only that the director was up to the challenge of hearing suggestions from Berlin's literary and political celebrities, but also that he enjoyed the stimulation. Brecht's enthusiasm for the collaborative process blinded him to the frustration it caused, as well as the obvious insult to Engel's ego. Brecht even praised Engel for having what he thought was his like-minded and painstaking approach: Engel "rarely brought a fixed conception to the rehearsals," Brecht wrote with admiration. "At most, [Engel] suggested some temporary attitudes or positions for a scene, then he studied it carefully, going deep into its center . . . and then he put his finger on the point of the scene and its interpretation . . . skillfully overcoming any difficulties that got in his way."[31] Brecht described Engel as the prototype for the "urban, intelligent director, who directs not only with great artistic responsibility and imagination, but also with a scientific method."[32] The playwright believed that this "scientific method" entailed seeking the opinions of intelligent colleagues as often as possible. Engel was open-minded, but like any director, he could not tolerate the infinite process of revision that Brecht so adored.

It was not only Engel's role as the final decision maker that was being challenged by Brecht. The very style of the play itself created more than enough obstacles for even the most modern of directors. The signs gave away the suspense, the scenic design exposed the backstage mechanics, and surprising story twists and character revelations were jettisoned. Any director, no matter how brilliant, would be struggling to implement the usual tools of his trade. It didn't help to feel

ignored and constantly overridden by Brecht. Engel finally got everyone's attention when he tried to insist upon getting rid of all the music.

Was he serious? Probably not. He certainly didn't dislike the music and had found in Weill a very pleasant and cooperative partner. So why would he propose such an outlandish idea? Most likely because no one was listening to his objections about the way in which the music was being presented. Engel had agreed to several unconventional ideas already—just as he had been with *A Man's a Man*, he was as excited as everyone else about exposing the conventions of theatrical illusion. Thus he had enthusiastically abandoned the use of an orchestra pit, whose function is to permit music to emanate magically from an unseen place, and embraced the plan to replace a large orchestra with a small jazz band, whose members would be highly visible when they played. The musicians were to be positioned on the steps of a mock fairground organ, placed upstage center, which Neher had designed and built. But other lighting and design elements had been introduced without Engel's participation, and he worried about the extent to which the songs would interrupt the drama.

When a song was performed, all the lights would go out except a single spotlight for the singer and three colored lamps to illuminate the musicians. On either side of the mock organ were large screens, which were framed in red satin, where the title of the song would be projected in large letters. Since many of the songs not only didn't advance the plot but actually stopped the action of the play in order to tell an entirely different story, the visual design italicized the interruption caused by the words and music. "Nothing is more revolting than when the actor pretends not to notice that he has left the level of plain speech and started to sing," Brecht wrote.[33] And he insisted that the step from speaking to singing be made as abruptly as possible.

This technique of interruption was most literally employed with "Pirate Jenny," which was to be sung by Polly at her illicit wedding to Macheath. This occurs in scene two of the play. Although the audience would likely be focused on several aspects of the story—the dubious wisdom of Polly's choice of husbands, for one—they are suddenly asked to focus on Polly's entirely disparate song about a servant girl who stands up for herself against oppression. Since the song had been written years earlier, it was its thematic underpinnings, and not its

relationship to the plot, that had inspired both men to find a place for it in *Threepenny*. As such, the song offers a "side" story that has no direct function in the central drama, and whose only relevance can be found in its tacit comment on the dominant themes within the play.[34] Pirate Jenny's plight underlines the issues of class and power, and as such, her predicament indirectly criticizes a society where businessmen, policemen, and gangsters are deemed morally equivalent.

The way in which Polly performs the song adds another layer to her character: It shows that the "sweet" girl knows quite a bit about the seamy side of life. Macheath proclaims her singing as "art," thus calling attention to the fact that the song has been offered as a self-conscious performance—and not an integrated part of the opera—and his remarks go one step further in separating out the song from the rest of the drama. When he tells Polly not to perform again because he doesn't like "playacting," he is wryly commenting on the artifice of theater itself. The song thus created a complex network of interruptions to the musical play.

Significantly, Polly was not singing about her own pleasure and pain but instead reporting on the condition of another character. This revealed Brecht's as-yet embryonic idea of creating distance between an actor and the character he or she is playing. Brecht believed that "the actor must not only sing but show a man singing. His aim is not so much to bring out the emotional content of his song (has one the right to offer others a dish that one has already eaten oneself?) but to show gestures that are . . . the habits and usage of the body."[35]

But where did this leave Engel? The traditional function of a song or aria is to allow a performer to impart the emotional sensibility of their character—their feelings of love, hate, revenge, and mercy. A song allows them to bare their soul. Brecht and Weill's songs were, conversely, the moment to stand back and analyze or satirize—often to provoke a contradictory impression. They portray a pimp who felt true love for a woman he has been beating and selling, an ingenue who is anything but innocent, a blushing bride who sings of a servant girl who dreams of murder. If the audience hadn't yet been pulled off the "single track" that Brecht disdained, the songs and the music would surely activate the switch. But Engel wasn't sure it would be possible to engage an audience in this multilayered musical play—one

that portrayed a literal story and an icy parody all at once—without some purely emotional moments. The actors had to reach the audience on that visceral level before they jumped back and exposed an equally strong satirical perspective. Engel was all for subverting the traditional suspension of disbelief, but did it have to be so relentless? Shouldn't they be sure that the rug was properly laid, and comfortable to walk on, before pulling it out from under the audience? Shouldn't the songs provide some of that comfort?

Finally, Engel had to ask the question of how far one could stray from psychological elements before a work becomes cold and alienating. This was a difficult judgment to make in this new form of entertainment, and it is not surprising that it caused profound conflicts. A director must be engaged with the inner psychological motivations of his actors, and Engel had to make sure an actor's performance dominated the song and not the other way around. This came into conflict with Brecht and Weill's strict ideas of *Gestus,* where the contrast between the lyrics and the music invoked analysis over emotion—where the psychological involvement of a single performer was replaced by multiple perspectives. Caught in the grip of the composer and playwright's musical and dramatic innovation, perhaps Engel thought that everyone was losing track of the roles of the directors and the actors. According to Aufricht, when the director was presented with the ideas for lighting and staging to accompany the songs, "Engel didn't want to accept this arrangement under any circumstances. Since Brecht didn't want to make any concessions, Engel suggested striking the music. Of course, no one agreed to that."[36]

Engel's suggestion had surely been a provocative gesture—he was demanding that his voice be heard; he was insisting that they include him in the plan for their artistic revolution. And it was probably Weill who approached the angry and beleaguered director and began to discuss the role of the songs in a polite and diplomatic way. As Joachimson observed, "Weill was always willing to make changes, to cut and to adjust. That was to him an essential part of the job. He loved the theater and even though he himself was extremely fastidious and tidy and very methodical in his habits, he liked the dazzling punch-drunk hours of the night rehearsals . . . the sight of the empty rows in the dark theater punctuated by a few faces he knew and trusted."[37] Weill knew

that their innovative approach wouldn't work without the strong direction of Engel, a man he had come to trust very much. Brecht knew it as well, but if Engel's suggestion was indeed a ploy, it had the reverse effect on the playwright. Brecht actually listened to anyone who made a good suggestion—the constant presence of his illustrious friends in the theater was proof of that—but he didn't ever let himself be baited. Brecht was not only concerned with the presentation of this particular play; everything he did was a step toward a style of theater he was urgently constructing for the future. Unlike Weill, he didn't have the time or inclination to soothe Engel's ego. While both men were ultimately eager to prove the power of their song style to the director, Weill was the only one who made sure to do so.

Fortunately, Weill was thrilled with the band he had found and knew they would help his cause. The seven uninhibited jazz musicians were known as the Lewis Ruth Band, and each was able to play three or four instruments apiece—the music required them to play a total of twenty-three instruments between them.[38] They enthusiastically fulfilled the promise of Weill's songs, and the composer's music was once again more convincing than any verbal argument. Engel had been distressed and perhaps distracted by the way in which the songs were separated out from the rest of the action, but he quickly realized that the strong melodies overcame the abruptness of the lights and setting. The songs created an equally emotional drama of their own. Weill knew that "in the theater at least, melody is such an important element because it speaks directly to the heart—and what good is music if it cannot move people."[39] The composer did not intend for his music to have only an emotional effect, but rather to be able to invoke both levels—high and low, bitter and sweet—at will. After hearing the songs, Engel understood that the intensity of the drama was doubled rather than diluted. The chess-playing director was convinced.

In Brecht, Weill, and Neher, Engel faced a trio he respected and admired. Once the "situation" regarding the concept for the songs was solved, they became a quartet. Only Aufricht had yet to become integrated into this tightly woven group of artists.

While the egos in the theater were clashing, Aufricht was increasingly concerned by the continued absence of Carola Neher, the leading lady. By the time her sick husband died, there were only four days left

until the premiere. She made a dramatic entrance in her long black dress, only to find her part drastically revised. To her fury, much of her role as Polly had been deleted. The other performers had long since given up trying to control the constant revisions and reductions of their roles, and they doubted that Carola's demands would be met. She thought differently. If the play was too long, she announced that it would not be shortened at Polly's expense.

A day or two after the explosive arrival of the grieving widow, the first full run-through took place. For Aufricht, it was the worst moment yet: "Soon a chaotic situation broke out . . . text was written, blocking changed, there was shouting and soothing, until suddenly [Carola] made it clear that she wouldn't do the part, it was too small. Brecht jumped in: 'I'll fix it, please, bring the curtain down!' He put a small table on the stage, Carola sat next to him, and he began to write. In the house, the exhausted actors waited patiently . . . [but] at five o'clock in the morning, their patience came to an end . . . When I suggested to [Brecht and Carola] to continue their work in my office," Aufricht reported, "she stood up, threw the manuscript at my feet, and said: 'Perform this crap yourself!' and left the theater."[40]

Weigel often watched rehearsals from the house, and if she was irritated by Brecht's attention to the temperamental star—a woman and actress so different from her in every way—she didn't have the chance to express it. She suddenly came down with an acute case of appendicitis and had to be rushed to the hospital for surgery. There was no chance she would recover in time to be in the play. Now one actress was ill and another had walked out. And there were only three days to go.

Weigel had quickly noticed the erotic sparks flying between Brecht and the beautiful Carola, but for once she needn't have worried. He likely had ideas about what might happen between him and Carola in the future, but his devotion to her during the busy rehearsals was purely professional. He refused to go after her when she walked out of the theater and instead suggested that Engel and Aufricht go to her house the next day, bringing flowers and the beautiful wedding dress she would wear in the play. She refused to come to the door. The search began to replace the leading lady.

The unusually hot summer in Berlin had continued unabated. As

Aufricht made phone calls from his steamy office and Fischer went from theater to theater, their suits were soaked through with sweat. Every theater in town seemed to be rehearsing a play of their own and no one was available. It was a stroke of good fortune, the kind that *Threepenny* had yet to experience, that Roma Bahn happened to be free. A regular at Reinhardt's theater, this actress with a lovely singing voice had been right next door all along. With her blond hair and beautiful blue eyes, she was perfect for Polly.

Since they were having length problems, and Weigel's role had been designed exclusively for her, Brecht decided to cut it out altogether. Margot Aufricht had been in any case horrified by Weigel's decision to play the brothel madam as an amputee without legs, one who pushed herself around the stage on a wheeled platform. "Thank god she got sick," Margot Aufricht said. "She was getting stranger and stranger during rehearsals."[41] A raw and edgy actress, Weigel was best suited to representing the more brutal side of Brecht's work. If *Threepenny* was intended as a blend of styles—from bitter to sweet—Weigel was at the decidedly pungent end of the spectrum. As the producer's wife, Margot Aufricht was far more concerned about the surface appeal of the work, and she would have worried about any decisions that limited its chances for a popular success. She knew how much it meant to her husband.

As for the rest of the weary cast, Brecht's enormous efforts to please Carola had not gone unnoticed. Paulsen had been desperate from the start, and without Engel's support he, too, might have quit. Valetti had been ignored when she voiced her complaints about the song "Ballad of Sexual Dependency," whose vulgar lyrics disturbed her. Both Weill and Brecht would have smiled wryly at this rough-edged cabaret performer objecting to their sophisticated version of a "vulgar" song, but she stepped up her complaints after the long and offensive evening of watching the playwright kowtow to the delicate flower Carola. Even though they finally agreed to strike the song, Valetti's husband nevertheless took the liberty of booking another job for her that began only two days after the premiere of *Threepenny*.[42] He and Rosa were so convinced of its failure that they signed a binding legal contract for a new role.[43]

Because the first run-through had resulted in Carola quitting,

the second attempt at a full-dress rehearsal—with two days to go—
began in an atmosphere of desperation. The brewing tension between
Brecht and Engel, momentarily soothed by the agreement over the
songs, was boiling over once again. As Mackeben rehearsed the band,
Weill was pale but calm throughout, and managed to make himself
heard even over the din of Brecht and Engel's shouting and the music.
Everyone was waiting for Paulsen to show up so that the rehearsal
could begin. They hoped that his presence would be like an umpire
blowing his whistle to stop the forbidden contact between players, but
Paulsen refused to respond to repeated requests for his entrance. He
even ignored the loud knocks on his door.[44] It was his turn to com-
mand some attention.

When Paulsen, "vain even for an actor," as Lenya described him,
finally arrived onstage, his appearance instantly quelled the storm
between Engel and Brecht, if for unexpected reasons.[45] Paulsen had
long been asking for a more dramatic entrance, and no one had lis-
tened. He had taken it upon himself to fix that by designing his own
costume. "He bounced across the stage in a double-breasted jacket . . .
tight-fitting trousers with straps, patent leather shoes with white spats,
in his hand a slender sword stick and a bowler hat on his head . . . He
completed the outfit, according to his own taste, with a large flutter-
ing bow made of light-blue silk. The blue bow to match the color of
his eyes was indispensable . . . He clung to it with both hands, pre-
ferring to part with his role rather than with his blue bow. A fright-
ful uproar began which soon assumed catastrophic proportions, since
Paulsen was already becoming hoarse and thus putting the show at
risk."[46] Paulsen clung to his costume and even went a step further:
He demanded an opening song that would be all about Macheath.
He specifically requested lyrics about his blue bow tie. Aufricht must
have thought all was lost—surely Brecht would never agree to the dic-
tates of the operetta star; and just as surely, the play had no chance
if the leading man quit a day before the opening. Engel, a director
who was beloved by actors, and who had gained Paulsen's trust, must
have been racking his brain for a compromise. It was a surprise to
all when it was Brecht who came up with the solution. He smiled his
most charming smile, and with a pointedly mischievous glance toward
Weill, offered: "Let's leave him as he is, oversweet and charming . . .

Weill and I will introduce him with a 'Moritat; that tells of his grue-some and disgraceful deeds.'"[47] *Moritat* combines the German words *Mord* (murder) and *Tat* (deed).

The very next morning, Brecht came in with the lyrics for the "Mori-tat of Mack the Knife." Weill wrote the music almost on the spot—and even requested a particular brand of barrel organ for the performer to play as he sang. The song was about the murderous behavior of the well-dressed gangster and it would offer quite the grand entrance for Macheath after all. Paulsen would have been deliriously happy, but the writer and composer saved their final surprise for last. A *Moritat*, Brecht and Weill cheerfully informed Paulsen, is never sung by the subject of the song. It is always sung *about* someone else. They had therefore cre-ated the role of a street singer to be played by Gerron, who was also cast as Tiger Brown. Gerron was to sing the song as Macheath made his entrance in his fancy suit and holding his cane, a vision of the proper gentleman, while the lyrics exposed his less than elegant character. Again, the signature contrast—between the lyrics, music, costume, and performance—is invoked. Macheath's surface appearance is a hoax—the song reveals the truth behind his mask.

Everyone who heard the song knew it was something special. The sound of the barrel organ provided the authenticity of the fairground, but the hypnotic melody burst through the gritty trappings, elevating it to the heavens while evoking rhythms from the street. The entire song was created in twenty-four hours.

There was that incredible speed again—as much a part of Brecht and Weill's creative process as their instinctive understanding of what a song can be, what it can do, and how. Their velocity was as uncanny as it was necessary. Brecht was especially addicted to it—the less time he had, the greater the ratio of brilliance to bravado.

If Paulsen understood almost nothing about the kind of play he was rehearsing, he instantly realized the power of the new song. He had inspired its creation, and now it was going to someone who was not even a professional singer. He was more offended than ever and threat-ened to quit once more. Aufricht, whose spirits had been momentarily lifted by the new song, surrendered his hopes once again. He told Fischer they should be prepared to cancel the opening, close the the-ater, and find another play as quickly as possible. They spent another

hot and sunny day running all over Berlin, this time in search of a play instead of a leading lady, but no one in the cast found out about it. Nor did Brecht, Weill, Engel, or Neher. They were too busy trying to make everything work.

Engel knew that it would be difficult to coax Paulsen back into rehearsals. His pride had been wounded twice over, and this would have been difficult for any actor to handle. The sensitive director knocked politely on his door and entered quietly. Engel saw that his lead actor was completely distressed and softly asked him to come back to rehearsals. Paulsen informed Engel that since he had learned to walk when he was three years old, there was nothing for him to rehearse.[48] Engel wisely sat down and lit a cigarette, his way of showing Paulsen that he would take as much time as was needed to soothe the actor's nerves. Everyone could wait while they talked and smoked. Engel did his best to make Paulsen feel that the song, no matter who sang it, still managed to highlight his role in an important way. Engel extolled the power of silence in a musical drama. Engel, in short, did everything he could to keep Paulsen from leaving. And he succeeded, a true confirmation of his renowned ability with actors.

Paulsen had one other coping mechanism that he would not have shared with Engel, and which possibly played a role in getting him back onto the stage. There was a dark side to the lively acrobatic operetta star. Like many other artists at that time, he was a habitual drug user and injected heroin, a drug he referred to as "energy," to keep him going through bad times.[49]

Since this was the final evening before the premiere, no one had actually waited for Engel and Paulsen to return. By the time they finally appeared, Bahn was singing the "Barbara Song," and the director, angered to find that the rehearsal had gone on without him, stopped her, insisting they go back to the beginning of the play. Bahn was stunned by the interruption. She had learned all the music in just two days, and this was the first time she'd had the chance to sing with the jazz band. She burst into tears and said "she'd be damned if she'd go on tomorrow night and make an ass of herself. Why didn't they get Carola Neher," she fumed. "She'd be great in the part." As Engel began to placate Bahn, he overheard an actor saying, in far too loud a voice, that this would be the "flop of the century." It was high time for the

director to assert his authority over the unruly and discontented cast, and he knew it. He raised his mighty voice, which as always erupted incongruously from his lean figure, and the room went silent for the first time in two weeks. Everyone turned to Engel, and they listened.[50] At least for that particular moment, even Brecht gave the director the space he needed to salvage the final dress rehearsal.

Right up to the end, friends and colleagues of Brecht and Weill populated the house. Heinsheimer arrived at midnight just as the run-through was about to begin. Joachimson was there, as well as many Berlin actors. The famous stage and screen actor Fritz Kortner, known for his booming voice, made a grand entrance by shouting across the theater for all to hear: "You're making a big mistake, Aufricht, and you know it!" Heinsheimer remarked that "pandemonium was not limited to the stage. I saw excited groups debating in the orchestra and in the boxes. Smoke filled the air; crumpled papers, empty bottles, and broken coffee cups littered the floor. Aufricht, the producer, rushed from the stage to the orchestra to the debating groups, trying to pour oil on the waves. But he seemed to put the oil in the fire instead."[51]

Regardless of all the loud predictors of doom, Weill was certain that everything would fall into place. He even seemed to relish his serene disposition, observing the "pandemonium" as if it had nothing to do with him. The composer was under just as much pressure as anyone, perhaps even a bit more, since this was to be his wife's first important role on a Berlin stage. His enviable calm was fueled by lifelong love of the theater—he was thrilled and inspired by the overwhelming crush of emotion and urgent creativity.

Another more hidden contributor to Weill's quiet confidence was his ability to protect his interests at all costs. Just before the final dress rehearsal, he had already written confidentially to his publishers "it is absolutely necessary that the music be given its due in all the promotional activity surrounding the premiere. Theater people (like all literary types) seem to be a bit frightened by the power of music, and I fear that in the announcements and notices in the press, etc., the score will be treated more as incidental music, although with its twenty numbers it goes far beyond the scope of the usual theater music. I'd like to ask that you categorically insist that the Theater am Schiffbauer-damm . . . give advertisements, that my picture be printed in the pro-

gram, etc. . . . You know that I myself don't set any great store by such things, but if it isn't given enough attention at the premiere we may well lose all commercial potential for this music."[52] If *Threepenny* was to be successful, Weill was taking steps to ensure that he participated in that success in every way, and at least in equal measure to Brecht. If it was unsuccessful, the composer could increase the popularity of his music through records and song performances. A hit is always preferable, and yet a flop wasn't the end of the road for his music. Brecht would have been quite surprised to learn that Weill's diplomatic demeanor was possible because he looked out for himself, and just as fiercely as the playwright, behind the scenes.

The dress rehearsal hurtled toward an end—an end that was hardly conclusive since the play was still an hour too long by the time the exhausted cast went home at five in the morning. After the performers left, Brecht, Weill, and Engel began cutting wherever they could. Unfortunately, Lenya's only solo was cut.[53] Mr. Peachum's role had also been drastically reduced, and no one looked forward to breaking the news to Ponto in a few hours' time.

As dawn broke, Aufricht secretly called Fischer and Vambery to his office, and they worked out a rehearsal schedule for a new play. If the first night of *Threepenny* was also its last, they would be ready to open another production five days later.[54] Aufricht was still working things out at noon when Ponto walked in with two suitcases. The actor had been informed of the cuts made to his part, and he announced that he was leaving for Dresden on the next train.[55] Aufricht tried to persuade him to stay, but perhaps the producer's own hopelessness shone through his lukewarm defense of the play, and the unconvinced Ponto left in a rage. In the haze of his exhaustion, it took Aufricht several minutes before he realized that he had let one of the leading actors get away. Perhaps it was the trustworthy Fischer who managed to rouse his weary boss, and minutes later they were running down the Friedrichstrasse toward the train station. Producers have probably never run so often, and in such blistering heat, as Aufricht and Fischer had during the rehearsals for *The Threepenny Opera*. This time, at least, it was worth the sprint. Ponto had already boarded the train, but they pulled him off just before it left the station. He agreed, against his wishes, to go on that evening.[56] As the three men walked back to the Schiffbauer-

damm, they passed by the overflowing newsstands so common in Berlin. Aufricht might have stopped to buy the important papers if only to check the advertisements for his premiere. If he allowed himself a brief pause before going back into the theater and lingered by the Spree to skim the day's news, who could blame him? The evening was to decide his fate, and he needed a moment to gather his strength for the final throes of the catastrophic preparations. Even with another play ready to rehearse, the losses from a failed production would likely break him.

He would have been cheered by headlines he read. Not because there was cheerful news to be had, but because the play he was about to open spoke directly to the disturbing tenor of the times. As Mr. Peachum proclaims, greed was indeed winning out over morality, and all over the country. The national paper reported that one of the world's wealthiest industrialists had been caught flagrantly misusing government bonds in order to enrich himself even more.[57] Unions complained that industrialization brought huge profits for the businessmen and only the misery of unemployment to the workers. The League of Nations was losing the battle to control the munitions industry, and the Communist newspaper *Die Rote Fahne* (The Red Flag) reported that government funding for school lunches had been reduced in order to subsidize a battleship. Finally, the price of bread was suspiciously increasing even as the price of wheat was sinking.[58] Brecht had been right after all to see the economics of the wheat market as a barometer of the social and political times. And if Macheath seemed in any way like an exaggerated version of a violent criminal, his crimes actually paled beside the amount of daily murders routinely listed on the front pages. Most murders in Berlin that week had been crimes of passion, and they were described in vivid detail. No single *Moritat* could do proper justice to the husbands and wives, daughters and aunts, lovers and innkeepers whose lives had been ended by violence in the previous twenty-four hours. If Neher had gotten hold of the newspapers on August 31, 1928, he might have glued them to a placard and used them as prominent backdrops while Polly sang about love and lust, Macheath and Tiger Brown sang about war, and the "Pirate Jenny" song promised vengeance. *The Threepenny Opera* was a play that took place in Victorian England eighty years earlier, and yet it was as if Brecht and Weill had set the local headlines to music.

Aufricht dearly wanted a commercial and popular success, but he was an idealist, too. He had, after all, entered the theatrical profession to create a better world through the arts. The newspaper headlines confirmed the social relevance of his play, and that helped him face the next set of battles awaiting him inside. The sky darkened and a distant clap of thunder augured the additional burden of a heavy storm on opening night. But Aufricht took hold of the large brass handle of the door to his picturesque baroque theater and strode inside with determination. He remembered why he was doing this in the first place.

The Threepenny Opera

After two weeks of commanding the rehearsals from the center of the house, Brecht had worn down the faded red velvet of his customary seat to a threadbare shine. Although opening night was only a few hours away, he had spent the morning urging Neher to build a last-minute addition to the finale that was as ambitious as it was impractical. As the triumphant Ernst Josef Aufricht came rushing into the house with Erich Ponto in tow, his recent surge of optimism was quickly destroyed by the resounding crash of wood and metal.

When the dust cleared, the producer watched as Caspar Neher and his stagehands disentangled the wreckage from the front row of seats where it had landed. As they put the pieces back together on the stage, Aufricht saw, to his horror, that the new addition was a "life-size replica of a galloping . . . horse . . . with fiery nostrils." Brecht had decided that when Macheath's reprieve was delivered, the messenger had to be mounted, and he had demanded the construction of a steed that very morning. In order for the horse to ride across the stage, Neher had built two rails that came from the wings and arched over the highest part of the mock organ where the band was to be placed. "Unfortunately the angle of the tracks had been incorrectly calculated and the [whole contraption] landed in the house." It was clear to everyone except Brecht that they couldn't get the horse ready in time for the

premiere, but he refused to surrender. He shouted up to the stage-hands to put four wheels under the horse so an extra could lead it by the reins with Kurt Gerron in the saddle. Neher watched this attempt with a raised eyebrow—the horse looked like a child's huge pull toy—and Brecht instantly realized that as well. They glanced at each other and shook their heads in silence, but before anyone suggested losing it altogether, Brecht announced firmly that the horse would simply be placed on the stage just prior to the finale. At that point, the newly energized Aufricht objected: "This ugly hulk will not be on the stage in the final scene!" Brecht was surprised by the producer's tone and retorted: "If the horse doesn't come, there will be no play!" But before Aufricht could answer, the technical director arrived with demands of his own: "Several of the projections haven't been tried out. If you want to start at 7:30 . . ." His voice trailed off ominously. Aufricht looked at his watch. It was six o'clock, and along with the technical crew, the cleaning women had arrived with their brooms, complaining that they barely had enough time to clean the house. Aufricht relished the growing number of people eager to throw the playwright out of the theater, and he boldly declared that the time for artistic changes was over. Brecht screamed at Aufricht: "I have entered this theater for the last time!" Weill and Neher stood by him, insisting they would leave as well. Heinrich Fischer, utterly worn down by the difficult production, turned to them all with a smile and asked, "Would you give that in writing?"[1]

Brecht was domineering, but never petty. So why did he insist that the messenger be mounted? Why did he suddenly demand that the message be delivered "with total seriousness and dignity"?[2] Seemingly from nowhere, he had become convinced that the pomp and splendor of the monarchy had to be exaggerated—that the contrast between noble appearances and base motivations must climax at the play's end. Something was irking him, pushing him to an utterly literal presentation of the messenger—pushing him to remove the irony from what had always been a definitively ironic finale, one that simultaneously mocked both the monarchy and opera.[3] Usually supremely confident as he walked the line between satire and sincerity, Brecht was uncharacteristically wobbly.

The rattling, malfunctioning, enormous horse was likely a mani-

festation of Brecht's underlying fear that the entertaining surface of *The Threepenny Opera* would overwhelm the dark critique of society that lay underneath. By forcing the messenger to reward Macheath for his crimes with overstated elegance and ceremony, he was infusing the ironic finale with an inflated sincerity—one he hoped would ensure that this darker perspective could not be overlooked. This had, after all, been the choice for the style of the final music. "The last '*Dreigroschenfinale*' is in no way a parody," Weill wrote. "Rather, the idea of opera was directly exploited as a means of resolving a conflict. Consequently it had to be presented in its purest, most pristine form."[4] Brecht might have worried that this was one place where the *Gestus* must match rather than conflict with the traditional music; that the messenger's arrival must be equally as operatic as the music itself. Aufricht was right to insist that it was too late to change it for opening night but wrong about the reasons for Brecht's insistence. His eleventh-hour demand was rooted in his zeal for stylistic precision. The horse fiasco wasn't a display of power—it was a case of last-minute nerves.[5]

Aufricht went limping back to his office, dodging the large brooms wielded by the impatient women sweeping the dirty aisles, ignoring the groans of the crew trying to sort out the projections, and wondering which disgruntled actor was awaiting him outside. He turned to take a last glance at the stage and saw something he once again could not ignore: Neher had chosen a red-and-green silk curtain, still half the height of a normal one, which was embroidered with colored parrots. As he began to install it on the thin black wire, Aufricht choked out his objection to the laughably garish material: "This is the burial cloth of the premiere," he shouted over the tops of the red velvet seats.[6] Neher didn't respond, but just then his eyes lit on a pile of plain burlap in the corner. The raw and ragged material was in direct contrast to the traditionally luxurious red velvet, and he grabbed it enthusiastically. As he held up the drab burlap to Aufricht, it seemed like a dare. Too much color or none? Aufricht didn't know which was worse, the fanciful parrots or the wrinkled sackcloth, and it took all his strength to suppress the fury that was rising in his throat. Both were bad, but it was becoming increasingly hard to say which of the many potential disasters would ring the death knell for his fraught production. As Neher quickly installed the burlap and pulled it taut across the wire,

the weary Aufricht departed without another word. He missed the broad smile on Neher's face as he viewed the replacement with delight.

Still chafing under the failure to alter the tone of the finale, Brecht had to face yet another painful task: The play was much too long, and he had to figure out what to cut. He pointed his scissors at the epilogue he had written. Brecht had dramatically revised John Gay's final scene in which the Beggar and the Player discuss Macheath's "absurd" operatic reprieve, but in both versions, the epilogue was unnecessary to the story. As his scissors hovered in the air, Brecht asked himself if the ending dialogue was essential to the audience's understanding of the play. He didn't like the idea of explaining the meaning to the spectators—a good play would provoke them to figure it out on their own—but deleting the epilogue would force him to face the test of his theatrical convictions. He took hold of the final pages and summoned his courage.

In Brecht's version, the dialogue between the Beggar and the Player is replaced by a conversation between the "Author" and the three "Actors" playing Macheath and Mr. and Mrs. Peachum. They stop playing their roles and engage in an argument with the playwright. It begins with the "Actor" playing Macheath objecting to being hanged. But the "Author" insists, saying, "It's the plain truth: the man's hanged . . . if that's how it is in real life, then that's how it is on the stage." The "Actor" playing Macheath retorts: "Plain truth. That's a load of rubbish in the theater. Plain truth is what happens when people run out of ideas. Do you suppose the audience here have paid eight marks to see plain truth? They paid their money *not* to see plain truth."[7]

Brecht's hope was that the audience would engage in just the kind of critical commentary he had written into the epilogue. But in those final hours, the prospect of losing it invoked the very same fears that had inspired the mechanical horse. Did he respect the audience enough to cut the ending? *Threepenny*'s story of love, betrayal, and crime had intentionally activated the usual theatergoing senses, but would the precise tension between sincerity and irony—especially in the songs Brecht had created with Weill—force the spectators to synthesize the disparate elements in an entirely new way? What if they walked out humming those seductive melodies instead of analyzing the play's actual meaning? Finally Brecht was forced to admit that if he needed

the epilogue, he had failed. It had to go. With this decision he challenged *The Threepenny Opera* to confirm his deepest belief: that the audience doesn't have to hang up "its brains in the cloakroom along with its coat" when they come to enjoy an evening in the theater.[8]

Once Brecht cut the ending, he, Erich Engel, Weill, and Neher were as ready as they would ever be. In any case, it was already so late that they had barely enough time to go home and change clothes before curtain time. Engel slowly and quietly lumbered up the aisle behind the composer and playwright. He shared their exhaustion but not necessarily their optimism. He could only reassure himself that despite Brecht's domineering behavior and the myriad problems that had arisen daily, he had done his best to stave off a disaster.

Neher, a man of few words, provided the final flourish before they left the theater. He picked up a large brush and dipped it into a can of thick black paint. Casually, as if the idea had struck him only a moment before, he painted the title of the play—*Die Dreigroschenoper*—across the width of the burlap half curtain. The shape of the letters was swirly and old-fashioned, and they filled the curtain from left to right as precisely as if they had been measured out in advance. And yet the brushstrokes were hasty and the black paint was as crude as the curtain itself. It may have looked as though Neher painted the title spontaneously, but such a theatrical gesture was more than likely planned. This "performance" was the exclamation point proclaiming the blend of "shabbiness and opulence" that characterized the entire design of *Threepenny*. Neher had his dramatic side, too.

Weill entered his rooms wearily, but he was too excited to sleep. He tiptoed from the front door to the piece of hanging tapestry that divided his room and pushed it a few inches to the side. He quietly gazed at Lenya, who was in the single bed squeezed in behind the wardrobe. Since she had rehearsed until six in the morning, he was happy to see his wife still slumbering deeply into the early evening. Even a powerhouse like Lenya would need all the energy she could muster to surprise the Berliners with her spirited Jenny. He hoped she wouldn't be too disappointed that one of her two songs had been cut. As he sat down on the piano bench and wondered how to tell her, the rain—which had long been threatening to burst through the heat and humidity—began to fall. The heavy drops landed on the roof and in

the courtyard below, and he watched Lenya curl into herself as if to shut out the rhythmic sound of the beating rain. Just two years earlier, Weill had written Lenya a letter saying that his longing for her was "most of all for the sound of your voice, which I love like a very force of nature."[9] Listening to the storm, he might well have marveled that the powerful voice he had so instantly, and so intimately, loved had since been praised by the public in Baden-Baden, and that this very evening it would be shared with all of Berlin. He was thrilled, burning with anticipation, and yet anxious all at once. It was their biggest debut yet.

So practical a woman was Lenya that, when she awoke, even the news of the song's deletion couldn't mitigate her joyful anticipation of her first performance in an important theater. If her strong character and defiant air made her the perfect vessel for the Brecht and Weill song style, it also made her the perfect actress to handle the ups and downs of such violent rehearsals and last-minute changes. She had never felt safe as a child, and unlike most of her fellow cast members, it took more than a reduced part to threaten her as an adult. Weill loved his wife's pragmatic, earthy attitude as much as her sensuality. She didn't have a petty bone in her body. As the sky broke open, she was far more concerned with the actual problem at hand—which was how to get to the theater in their fine clothes without being soaked through by the rain. There was no umbrella large enough to cover them completely for the ten-minute walk to the S-Bahn that would speed them toward their first opening night together.

Brecht didn't like getting wet, and in any case, he loved to drive his beautiful new Austrian car—the Steyr was a gift from the company in exchange for a poem he had written about the automobile. And since Weigel was still weak, and Hauptmann had been typing in the final changes up until the last minute, they were also in a hurry. Driving would be the quickest way to the Schiffbauerdamm.

The rumor of disaster had spread through the town, and Aufricht worried about not having a full house. The lightning and thunder surely made the prospects even gloomier. Who would wade through such a heavy storm to see a show everyone had already declared to be a catastrophe? Since Rosa Valetti already had her next job in place, perhaps she considered not showing up for the guarantee of humiliation that awaited them all.

Nonetheless, the cast and crew all arrived in good time. They came through the doors shaking their soaked umbrellas and raced to their dressing rooms to dry off and change. Aufricht moved between the lobby and the stage, both of which were still being prepared only minutes before the patrons were to arrive. But whether they were backstage or out in the house, no one missed the unfamiliar sound of the soft-spoken composer shouting louder than Brecht ever had. Had he finally cracked under the pressure? What could possibly have provoked a man who had weathered the most arduous rehearsals in a state of almost preternatural calm?

It was the program. Weill was furious when he discovered that his wife's name, as well as the part she played, had been left out. Everyone else, from John Gay to François Villon, whether living or dead, had been named, and the insult was unbearable to Weill. *Die Dreigroschenoper* was still subtitled *The Beggar's Opera* and was called a "Play with Music in a prologue and 8 scenes after the English of John Gay. Interpolated ballads by François Villon and Rudyard Kipling. Translated by Elisabeth Hauptmann. German adaptation by Brecht. Music by Kurt Weill." All of the named roles except Jenny's were listed. Insisting that it was an innocent oversight, Aufricht apologized profusely and promised to fix the error as soon as possible. But Weill was inconsolable. Having once lost his temper, he couldn't get it back. He hurled the program at the producer. "This pigsty! My wife will not perform! I forbid it!" Weill shrieked at Aufricht.[10] Lenya was the only one who could calm him down. This was her big chance, and she didn't want anyone to stop her, not in the name of honor or any other trifles. "For the first and last time in his whole theater career Kurt completely lost control," she noted with satisfaction, happy that his explosion of loyalty was on her behalf. "Perhaps it was a blessing that I was the one who had to quiet him and assure him that, billing or no billing, nothing could keep me from going on."[11] "Darling," she said to him, "tomorrow they'll know who I am."[12] If Valetti had walked by in this moment, she would have told Lenya she was lucky, since now no one would have to know she'd been part of this "pigsty." Brecht had likely enjoyed the spectacle of Weill losing his temper—at long last his irritatingly guarded partner was as loud and disagreeable as the playwright had been every day.

Weill ultimately recovered his nerves enough to attend to the many last-minute musical issues. Most important, he rehearsed the opening number with Gerron, who was still figuring out how to sing along with the barrel organ. The sound of the instrument is made by turning a crank that rotates a mechanical roll—a mechanism similar to that of a player piano. Gerron had to turn the crank steadily and sing the song exactly as the organ played it. Such rhythmic precision required more practice than had been available for the recently composed opening number. Gerron was not a professional singer, as Paulsen had so bitterly observed, and he had every reason to be nervous.

With only minutes to go until curtain time, it was hard to believe that so many missing pieces could fall into place. Hauptmann, the woman in charge of all the details, sat down anxiously in the house, wondering if the play—her discovery—would make any sense at all. Brecht was used to flying by the seat of his pants, but she was not. Up above in the director's loggia, Aufricht and Fischer took their places, their hearts beating rapidly and their anxious faces pale in contrast to their dark tuxedos. They watched the audience arrive and saw the immediate confusion caused by the empty orchestra pit. Given all the rumors swirling about town, the audience might have wondered if some last-minute conflict had caused the musicians to quit. In addition to the bad press, the stormy weather had ensured that the theater was not particularly crowded. Those who were there either couldn't resist their curiosity or, worse, were eager to feel the thrill of Schadenfreude. No one loved to witness an artistic disaster more than a typical Berliner, and "columnists had reported with faintly disguised malicious joy about the gloomy outlook of some of the actors."[13] Most of the people who did come to the opening night were ones who savored the atmosphere of doom. They licked their chops.

Most bloodthirsty of all were the Berlin drama and music critics, and when Aufricht looked below him, he was miserable to discover that yet another dreadful mistake had been made. Two sworn enemies had been seated side by side: Alfred Kerr, Berlin's own Addison DeWitt and a consistent critic of Brecht, was rubbing shoulders with the playwright's champion, Herbert Jhering.[14] Kerr, a brilliant Jewish intellectual, dubbed by Aufricht as "the pope of critics," was a potent foe who held enormous sway over the German theatrical world.[15] His

uniquely constructed reviews, with numbered paragraphs, were written for the *Berliner Tageblatt* and constituted an art form of their own. He had condescendingly quipped that Brecht's first play, *Baal,* was no more than "chaos with possibilities."[16] And although he admitted in 1923 that *Drums in the Night* was fresh, the critic had mainly emphasized its poor construction. He insisted that the play was "a brick for a building that's not yet built. Brecht must remain a hope."[17] Only someone of Jhering's caliber could have countered Kerr's derision. Where Jhering had credited Brecht with changing Germany's literary landscape forever, Kerr had relentlessly harped on the young playwright's unrealized potential. It must have been gratifying for a young writer—and a boxing fan—to push these two critical heavyweights into such a prolonged and passionate conflict.

Kerr barely deigned to acknowledge Jhering's presence by his side. He pulled out the program with great ceremony and began to read it with exaggerated concentration. Fischer had designed and edited the unconventional playbill, and in a nod to the contemporary spirit of the musical play, it looked like a small newspaper. This paper was called *The Catchword*[18] and included articles about theater and literature. There were two poems by the Austrian satirist Karl Kraus, who had been in attendance during rehearsals and was yet another victim of Kerr's scathing public derision. Once his eyes landed on Kraus's name, the venerable critic's eyes turned dark, and he stuffed the program into the pocket of the seat in front of him. It was as if they were trying to goad him into writing a bad review.

The house went dark. For the opening, the traditional red velvet curtain was closed and the stage concealed. The unseen musicians played an overture that briefly sounded quite traditional. But the musical style soon rushed forward in time as a saxophone, a trumpet, a trombone, a timpani, a harmonium, and a banjo chimed in. It "was meant to resemble an eighteenth-century baroque overture but with wind instruments so it would sound cheap and tawdry and not authentic."[19] For the sophisticated members of the Berlin audience—who had already heard Schoenberg's atonal works and Stravinsky's boldly neoclassical creations—a playful tampering with musical conventions was hardly a revolution. Surely this much-anticipated flop would be braver and more outrageous than this?

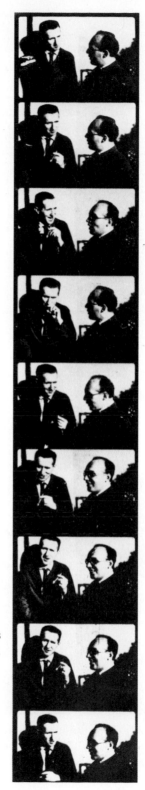

Bertolt Brecht and Kurt Weill in rehearsals
for *The Threepenny Opera*, 1928.

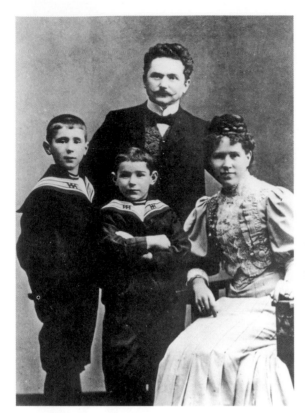

Brecht, left, at age ten in 1908, already suffering from health problems and diagnosed as a "nervous child." With him are his sturdy brother, Walter; his authoritarian father, Berthold; and his beloved, ailing mother, Sophie.

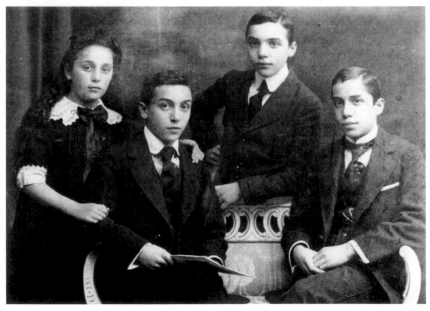

Weill's sister, Ruth; his brother Hans; Kurt, age eight; and his brother Nathan in 1908. By this time Kurt had already been dubbed "the attic composer." The siblings were close and often performed concerts and theater for their parents.

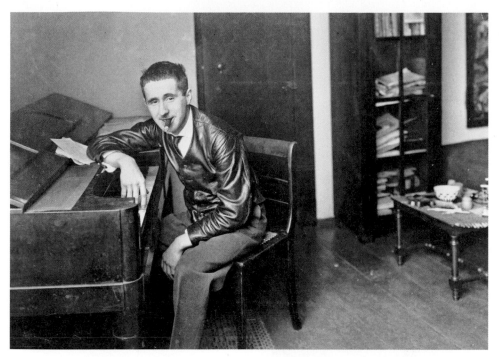

The twenty-eight-year-old Brecht in Berlin, c. 1926. He always removed his glasses and often smoked a cigar when being photographed.

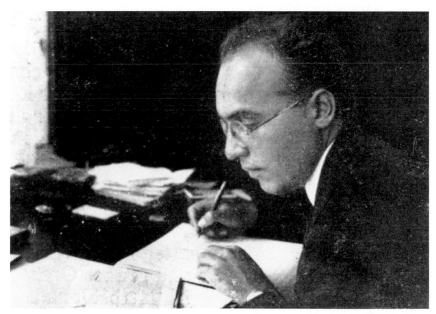

Weill always composed at his desk. A friend once remarked that Weill used his piano only as a place to put his pipes. Berlin, c. 1926.

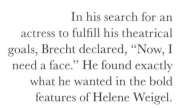

Lotte Lenya and Kurt
Weill on their wedding day,
January 28, 1926. Kurt holds
a package of celebratory
herring under his arm.

In his search for an
actress to fulfill his theatrical
goals, Brecht declared, "Now, I
need a face." He found exactly
what he wanted in the bold
features of Helene Weigel.

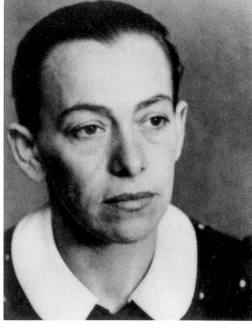

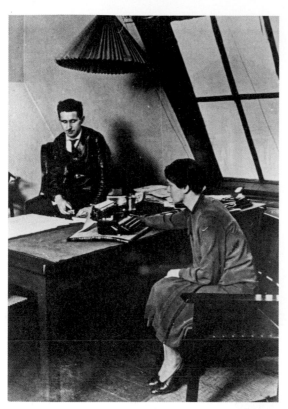

Brecht and the twenty-six-year-old Elisabeth Hauptmann in his Berlin studio on the Spichernstrasse in 1926. Hauptmann seemed permanently installed behind the black typewriter, prompting Lenya to dub her Brecht's "devoted shadow."

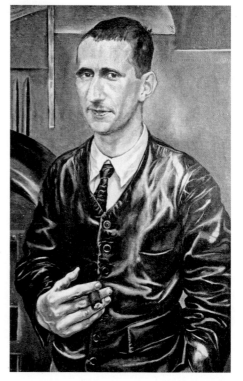

A 1926 painting of Brecht by Rudolf Schlichter, the leader of the November Group. This picture—a political and cultural badge of honor for the young poet and playwright—was hung on a wall of Schlichter's restaurant.

The scandalous finale of the *Mahagonny Songspiel*, Brecht and Weill's first collaboration, at the 1927 German Chamber Music Festival. Weill observes from the far left, while Lenya holds up a sign saying "for Weill" on the far right of the boxing ring. Next to her is Brecht, in a white suit at the rear, watching with one foot in the ring. Lenya's sign was a direct answer to Brecht's comment about future work together: "Weill has to get used to the fact that his name will not appear on the program."

Kurt Weill in Le Lavandou, where he and Brecht completed *The Threepenny Opera* in 1928. As Lenya wrote: "The two men wrote and rewrote furiously, night and day, with only hurried swims in between."

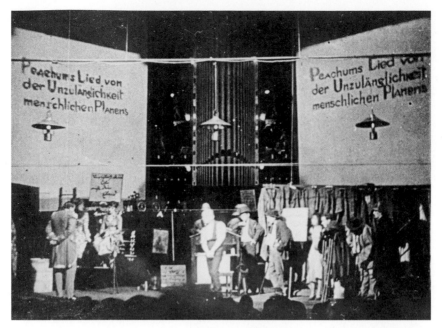

A scene from the 1928 production of *The Threepenny Opera*. The signs in the background announce Peachums's song, "The Insufficiency of the Human Endeavor." The background titles and special lighting insured that the songs interrupted rather than continued the story being told.

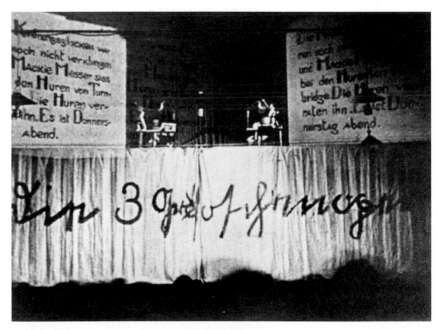

Caspar Neher's famous half curtain for the 1928 *The Threepenny Opera* (*Die 3 Groschenoper*). The spray-painted title was added just hours before the audience arrived.

By 1929 Brecht and Weill's alliance had produced artistic and financial triumph, but they had curiously little affection for one another. Brecht's signature leather jacket and cap and Weill's dapper hat and tie illustrate their profoundly incompatible personalities.

There was a palpable sense of expectation in the air as the red curtain rose.[20] The audience held their breath when the spare stage and the tiny jazz band standing on the mock organ were revealed. They quickly shifted their gaze to Gerron, who stood alone downstage. He was dressed as the organ grinder, and, sensing the resistant crowd, he fixed his eyes on the back of the house as he began to turn the crank. No sound came out. He kept on turning it again and again, hoping for a miracle, and the sighs of disappointment in the house were almost as loud as the grinding and useless handle. Would all the tales about explosive rehearsals come down to this minimalist skeleton of a play?

The audience didn't know that the silence was anything but deliberate, and the increasingly desperate Gerron finally decided to sing the opening verse without any accompaniment at all. As he sang "And the shark, he has teeth" straight through the second verse, only the sound of his voice was heard.[21] Finally the Lewis Ruth Band came to the rescue and put the lone singer out of his misery. But even with their help, the audience was utterly unmoved for the duration of the song. They were not disgusted, only disappointed by the imitation of a fairground barker's flat rhythm; unimpressed by the contrast between the violent description of Macheath and his elegant appearance because, after all, they had yet to see what the bandit actually looked like. Only when the song ended did Macheath come onstage and walk past Gerron with his hat and cane. He was followed by Lenya's Jenny, who was leading several other prostitutes. She stopped to look out at the audience and said, "That was Mack the Knife." No one clapped. "The audience was icy," Margot Aufricht lamented. The *Moritat* of Mack the Knife, Heinsheimer concurred, "fell like a stone in water."[22]

How could such an entrancing song, even without accompaniment, leave the audience so cold? Part of it can be explained by the monotonous rhythm of the original setting to which Gerron had slavishly adhered. Despite the barrel organ's malfunction, its rhythm still controlled the way in which he performed the song. The overall effect was not haunting at all but simply deadening.[23] The audience hungrily awaited something that would at least be bad enough to make them angry.

By the time Polly Peachum and Macheath arrived at the stable where their forbidden marriage was to take place in scene two, the

audience presumed that the plot would revolve around a sweet woman who, in order to escape her cynical parents, has unwittingly fled into the arms of a man even worse than her scoundrel of a father. If anyone remembered the lyrics to the "Moritat of Mack the Knife," they might have begun to appreciate the satirical depiction of a cruel but elegant gangster who surveys the stolen furnishings of the stable and insists on announcing the difference between Chippendale and Louis Quatorze. As Macheath chastises his crude gang of thieves, he complains about their lack of breeding in every respect. The implied similarities between the high bourgeoisie and the underworld were wickedly defined, and Brecht's sarcasm began to penetrate the minds of the spectators. In this world of money-grubbing, Polly seems to be the lone innocent presence—a naïve soul swept off her feet by the charming Macheath. But the surface layer of her innocence is systematically peeled away throughout the scene. The unraveling of her "simple" character begins when she sings the "Pirate Jenny" song, thus revealing a familiarity with a servant from a different stratum of society, a woman far less innocent than Polly seems to be. Since the song has nothing to do with the rest of the story, Polly must step "out of character to 'adopt an attitude' in . . . 'Seeräuberjenny' ['Pirate Jenny'] and [offers] . . . a kind of anarchic *cri de cœur* on behalf of womankind—with a view to political emancipation in the former and for the cause of amatory autonomy in the latter."[24] As a "side" song, it accomplished two functions at once: It exposed the dubious assumption of Polly's innocence; and it heightened the themes of gender and oppression in the play.

As the Marxist philosopher and influential cultural critic Ernst Bloch wrote in his astute analysis: "An unspeakable theology was contained in the sentimental mush" of this highly unconventional wedding scene. The antibourgeois sentiment of the "Pirate Jenny" song allowed "a new folk moon [to] break through all the tearjerkers in the skies of servant girls and picture postcards."[25] The complex layers of the play inspired the critics, but the audience wasn't always as quick to decipher this rich blend of serious and satirical elements. By the end of the "Pirate Jenny" song there had been so many and such radical shifts of tone that they still didn't know what kind of musical play they were watching. So far, the dialogue was unusually funny and the music was pleasant enough, but as Polly became less innocent, and Macheath

increasingly witty, it was hard to know for whom they should be rooting or why.

When Gerron reappeared as Tiger Brown, and it became clear that the chief of police and Macheath were close friends, the audience finally began to recognize the play as a scathing reflection of their own society. The corruptibility of government and its municipal authorities—inspired by either friendship or profit—was comprehensible to most Berliners. The shameless jockeying for political power had continued unabated since the abdication of the monarch, and in the ensuing decade there were few public figures who had wholly gained the public trust. When a legal authority like Tiger Brown overlooked the crimes of his good friend Macheath, the crowd could laugh with bitter sincerity.

And that's when the "Cannon Song" exploded on the stage. For not only were the ties between social institutions and gangsters paraded with pride but the war was even more shockingly invoked as a plausible motive for the alliance of policeman and criminal. With a rhythmic ragtime beat—ending with a vaudeville kick step that lampooned its marching-song ancestors—Tiger Brown and Macheath paraded their soldiers' bond with gusto. After the war, they proclaimed, soldiers had more loyalty to each other than to God and country. More loyalty to their friendship than to the law. Aufricht had been suffering through the first two scenes and couldn't believe his eyes and ears when the audience started clapping, shouting, and demanding an encore for the war song. "From this moment on, every sentence and note was a success."[26] Macheath and Tiger Brown chopped the "uncongenial races" into "beefsteak tartar," and suddenly a decade of tension was defused by the chance to laugh about the war.[27] Brecht's youthful antiwar poem, which had inspired the song, had come full circle nearly a decade after its creation.

The Threepenny Opera presented a savagely humorous invocation of war on the stage. This was, like all of Brecht's poetry and plays about the Great War, in direct contrast to the highly emotional response of the expressionist dramatists. Their plays had been full of soulful anger about the most destructive war in history, but the advent of New Objectivity—which offered a cooler and more practical reflection of society in all the arts—had paved the way for the kind of satirical blade

exemplified by the "Cannon Song." Brecht was particularly adept at taking a comical approach to the misery of war and, significantly, had written the two other important examples that had been performed in that same year. *A Man's a Man* had been a witty send-up of the hypocrisy that turned young boys into killers, and *The Adventures of the Good Soldier Schweik* was a parody in a similar vein. But they had both been set entirely in the landscape of war, and neither of them employed more than incidental music. In contrast, the "Cannon Song" allowed two characters to sing about the war that created their friendship, but only as a context for another story altogether. A song that made fun of the war and a story that placed war in the background were both strikingly original innovations. It dared to suggest that Germany had begun to recover from the wounds of war—at least enough to play the Hawaiian guitar while singing satirical lyrics about chopping black and yellow people to bits.[28]

There was good reason to hope for a peaceful future. Just four days earlier, on August 27, 1928, fourteen countries had come together with Germany to renounce the use of war to resolve conflicts. It was called the Kellogg-Briand Pact, and had been created in the "spirit of Locarno," referring to the peace treaty that had been signed in 1925 by Germany, France, and Belgium.[29] But if overcoming the tragedy of Germany's recent past was one part of the song's resonance, Hauptmann also rightly understood another important reason for the sudden enthusiasm of the audience: "Probably it was the time," she said. "The army was then again coming around."[30] The public was as yet unaware of just how much rearmament was under way, but the stories of funding battleships over bread, and the persistent machinations of the vengeful former imperial army officers, loomed like a dark cloud over the cautiously optimistic mood of the country. By exposing the folly of war with unbridled derision, the "Cannon Song" forced the suppressed fears of the audience to finally burst out into the open. When Macheath and Tiger Brown performed it on opening night, they were lampooning the past and, in the final verse, also sending a warning for the future: "Young men's blood goes on being red / And the army goes on recruiting."[31] The audience clapped and roared for an encore—as if the song could help their cause.

There were lighthearted comedies playing all over Berlin, but it

was rare for an audience to laugh so hard at a play with such a serious underlying vision. Those who had not chosen to see *The Threepenny Opera* that evening might have been watching Marlene Dietrich in the popular revue *It's in the Air,* or perhaps they were being titillated by Hans Albers's nude models in the comic opera *Take Off Your Clothes.* Up until they roared for an encore of the "Cannon Song," the patrons of the Schiffbauerdamm were certain their money had been wasted. After the war song ended, they were already impatient to tell their friends how mistaken they had been to miss the most important opening night of the season.

Once the audience had begun to comprehend the caustic yet comic tone of *Threepenny,* their appreciation grew with every scene. They swayed to the music of the "Pimp's Ballad" as they savored the horror of the tale it told.[32] The song was a nostalgic elegy to the brothel Jenny and her pimp had once called home. As Lenya sang of being beaten by Macheath, the man she loved, to the seductive melody of a tango, her performance only strengthened the play's bewitching effect. Lenya was hardly a method actress, but it must have been impossible for her to sing this song without remembering her childhood. Not only had she actually, if briefly, been a prostitute at the age of twelve but, perhaps even more poignantly, the very act of singing had been her first attempt to gain the approval of a drunken father who was impossible to please. Brecht and Weill had given her a precise *Gestus*—but they couldn't and wouldn't be able to contain the burning behind her eyes, the fixed line of her mouth, or the unspoken tension of her performance. Onstage, she recaptured the desperation of a four-year-old girl singing in the vain hope of preventing her father from hurting her. Would it be possible, her expression seemed to ask, to delight the audience as she had never delighted her father? As Jenny, she infused her performance with her inner spirit, but Lenya never lost the physical and musical precision that the song demanded. She exuded the sensation of a volcano that is about to erupt any second but never does. The song ends before the explosion occurs.

In contrast to Jenny's portrayal of a victim who refuses all pity, Paulsen's Macheath is the unrepentant oppressor who offers no apologies. He sees no conflict between the elegance of his appearance and the violence of his behavior toward Jenny. The sincerity of the

experienced, smooth operetta star—as he sang of selling the charms of his true love and of drinking schnapps while she turned a trick—enhanced the eeriness of the lovely music. As lover and pimp, he tangos with a woman whose defiant plans are unknown to him. Thanks to the construction of the plot and the revealing signs, it is instead the audience who knows that Jenny will betray him. The suspense builds as the song becomes increasingly amorous and melodic. Jenny sings with affectionate longing, and unlike the audience, Macheath believes that she still hopes to renew their life together. And so she once did, but his behavior with Polly has caused her to give up all hope of a future with him. It is her hopelessness that motivates her to betray him, not her recognition that his treatment of her was vile. Paulsen and Lenya were a vivid example of the "yes" and "no" inherent in the song, one polished and one raw, and yet, like the evocative melody itself, both performers felt true nostalgia for their shared past. To them, this was a sincerely romantic tango.

When Macheath and Jenny sing about the brutal past, they don't comprehend its brutality. Jenny betrays Macheath not because he was cruel to her but because she is jealous of Polly. After all he has done to her, Jenny still loves Macheath. Both lovers believe their story is romantic, and the music is a staunch ally in this delusion. And since the lovely melody threatened to delude the audience as well, the spectator has to resist its intoxication in order to remain aware of the tragedy of Jenny's plight that the lyrics describe. It was quite original to use songs—and the tension between words and music—to create an emotionally driven moment of dramatic irony. It is the audience, and not the characters, whose feelings are provoked by the beguiling songs.

The tension between words and music heightened the suspense for the change that was coming. Directly after the song, Jenny dances Macheath into the arms of the constable as Mrs. Peachum watches in triumph. Jenny hands him over without fanfare, without a shout of vengeance, but the tension built by the song caused a powerful sense of satisfaction in the audience when Jenny—renouncing her victimhood—finally turns him in.

Even the calculating Kerr might have been moved to pull the offending program out of the pocket in front of him and to search for the name of this unknown actress who had the audience in the palm

of her hand. He would have been surprised not to find it there, and it made him observe her all the more. If Weill had witnessed Kerr's struggle to identify his wife in her first Berlin performance, his fury would have been both stoked and soothed. The insult was public, but the mystery also doubly seared Lenya's performance into the critic's memory.

By the time the "Pimp's Ballad" was sung, the audience was completely overwhelmed by the brilliantly layered composition of the songs. Each number had progressively cleared the dramaturgical path and led them confidently to the height of comprehension. They had come to realize that the nineteenth-century story of a highly polite, schnapps-drinking gangster offered an incisive portrait of their own society in all its bourgeois glory. It may have been Jenny who informed on his whereabouts, but it was Macheath's bourgeois habits that betrayed him most of all. The reason that Macheath could be found at the brothel on Thursdays was because that was his regular day. And sure enough, he was caught because he was a slave to his established routine. Just like most of the bourgeoisie, the gangster Macheath was proper on the outside and corrupt within.

In addition to the social satire, the religious parody is crafted as deliberately in *Threepenny* as it was in Brecht's first book of poetry, the *Manual of Piety*. The story of the play begins with Mr. Peachum singing "You ramshackle Christian, awake!" to the music of a morning hymn.[33] He goes on to explain his business as king of the beggars, and the difficulty of profiting from the complex commodity of human misery. He then shamelessly elaborates on his dependence on the Bible to help him stir the human heart: "There are four or five sayings in the Bible that really touch the heart. But when they're used up, one's daily bread's just gone."[34] Thus, the biblical satire is launched in scene one, ensuring that no one could miss the significance of locating Macheath and Polly's illicit marriage in that most venerable Christian symbol of all: the stable.[35] The day of the week chosen for Macheath's capture was also anything but an arbitrary choice, for it calls to mind Maundy Thursday, the holiest day of the Paschal week. This was also the day that Christ celebrated Passover with his disciples and was betrayed by Judas. When a whore betrays a gangster on Thursday, the sacred was being quite obviously and most wickedly profaned.

Macheath is an immoral representative of an amoral world, and the ambiguous nature of morality itself forms the essential core of the play's thematic landscape. This was best expressed by one of Brecht's most staggering explosions of poetic genius: the line "First comes food, then comes morality." The most obvious interpretation of this phrase is that in a world where people are hungry, they are entitled to break the law, or any moral code, in order to eat. The only cure is social justice. And yet, as the play made clear, crime is not limited to the hungry or to the lower classes.[36] If anything, corruption is more rampant, and certainly more hypocritical, among the wealthy. The poor steal to stave off poverty, the rich steal to remain rich. Pointedly, it is Macheath and Mrs. Peachum who sing the lyrics—two characters who are distinguished by their greed and bourgeois ambitions—proving that Brecht was not claiming that stealing is only a consequence of poverty.[37]

A key factor in understanding Brecht's phrase is the use of the word *Fressen* for "food." The German phrase is *"Erst kommt das Fressen, dann kommt die Moral."*[38] The word *Fressen* refers specifically to animals. The German maxim *"Tiere fressen, Menschen essen"* means "Animals feed, humans eat."[39] *Fressen* connotes a predatory form of consumption, devoid of any social component such as polite dinner conversation or the use of utensils. The character of Macheath—with the contrast of his pretensions to high-class culture alongside his murderous deeds— personifies the significance of Brecht's precise vocabulary. Macheath is a man who pretends to be human because he "eats" like one—but in fact he is an animal of prey, who "feeds" on his fellow man.

The line *"Erst kommt das Fressen, dann kommt die Moral"* resonated through all strata of society, and its enigmatic meaning was interpreted differently at each level. Hannah Arendt insisted that the phrase was essentially misunderstood by "the bourgeoisie [who] applauded because . . . it had grown tired of the tension and found deep wisdom in the expression of the banality by which it lived." Conversely, she added, "the elite applauded because the unveiling of hypocrisy [of the bourgeoisie] was such superior and such wonderful fun."[40] Brecht managed, in eight words, to justify the crimes of the truly poor, as well as indicting the criminally rich, and he did so in a phrase that embla-

zoned a critique of modern civilization on the foreheads of an entire nation.

The second-act finale in which these eight words appear is asking the most elemental question of all: "What keeps mankind alive?" The answer is frightening: "The fact that millions are daily tortured, stifled, punished, silenced, oppressed . . . Mankind is kept alive by bestial acts."[41] The song erupted from Brecht's belief that human society can best be seen when viewed as a jungle. The musical finale punctuates the grim view with a dark and monotonous rhythm that suddenly begins to soar into a pleasing melody but stops before it reaches a satisfying crescendo. The song offers a faint recognition of hope, but one that fades as quickly as it came. Men live, the song concludes, by forgetting they are men.

By the end of the play, the audience was sitting raptly as the Queen's messenger, who turned out to be Tiger Brown himself, came on foot and stood on a small piece of grass that was the simple replacement for the dysfunctional horse and tracks. Brown informs his friend Macheath that all is forgiven, and that he is to receive a castle and pension. Macheath promptly declares his "true" love for Polly, the woman who has been running his business in his absence. His other less useful "wives" are rejected.[42] Since Macheath need not learn from his mistakes, he is free to begin robbing, lying, and betraying again. Peachum's proclamation after Macheath is freed, "Messengers come from the Queen far too seldom, and if you kick a man he kicks you back again," was met with resounding laughter and applause.[43] The triumph of a delightful cad had pleased everyone.

Such a dark vision in such a witty and pleasant play. If Macheath is a murderer in gentlemen's clothes, *The Threepenny Opera* is a scathing indictment of society that was shockingly fun to watch. Just as Weill had hoped, the play was transported into the audience's hearts by the music, but it also nestled in their brains. The production was an embryonic example of Brecht's theatrical activism, and he was still discovering the role that theater could play in laying bare the ills of society. Pointedly, the play does not judge the individually corrupt natures of Peachum, Tiger Brown, and Macheath; it instead provokes the audience to judge the structures of power. And once corruption

is exposed, the audience can yearn for change. A central element of the dramatic experience, Brecht realized, was to reveal a world that was not only imperfect but also changeable. The ability to recognize the flaws of society offered the possibility for improvement. Only plays that delivered the harshest critique could inspire the spectator's hope for the future.

But most of all, *Threepenny* established that it was possible to be simultaneously entertaining and intelligent, and to deliver hit tunes as well. Kerr had to admit that Brecht's "chaos" had gone well beyond possibilities. The playwright's promise had been unequivocally proven. Seated next to his rival Jhering, Kerr most likely didn't speak to him during the performance. But the audience was so completely engaged that any dissenting spirit would have been felt. Surely Jhering knew that even his skeptical colleague must acknowledge not only Brecht's enormous talent but also the achievement of *The Threepenny Opera*. Together with Weill, Brecht had created a work that, in Jhering's words, erased "the barriers between tragedy and humor."[44] In creating a form of musical theater that was as at home in popular culture as it was socially astute, they had also abolished the even more important boundary between high and low art.

For those who had witnessed the fractious rehearsals, the successful opening night was the biggest shock of all. The state of wonder in the Schiffbauerdamm wasn't lost on Carola Neher, who was sorry to be sitting in the audience instead of sharing in the glory onstage. As soon as the applause died down, she went straight up to Aufricht and demanded to know the details of Roma Bahn's contract. She wanted to reclaim the role of Polly the moment it was legally possible to get rid of the leading lady. Never mind that Bahn had so bravely taken on the role that Carola had so capriciously abandoned.[45]

Aufricht likely smiled at her desperation—now she was waiting for an answer, just as he had waited in vain at her front door only a week ago. He didn't rush to respond. The overwhelming reception led to the correction of many slights—not least the problem of Lenya's name in the program. Aufricht raced to the phone and called his printer's night laborers. An insert was needed in time for the following show. It would read: "The role of 'Jenny' is played by Lotte Lenya." Aufricht might have noticed the pride on Weill's face as Lenya conquered the audi-

ence, and the producer looked forward to bringing the first copy to the happy composer. Weill had been certain of Lenya's talent, but perhaps even he had been surprised by just how commanding her presence had been on opening night. She became a different person when she performed, never more so than in the large Schiffbauerdamm. "As soon as my feet hit the stage," Lenya pronounced, "I feel safe."[46] And since Weill had made it part of his life's mission to ensure Lenya's sense of security, nothing was more satisfying than seeing her courageously displaying her talent to the rest of the world.

Elias Canetti, who had been present for many of the rehearsals, was among the most delighted, and the most astonished, of all the people in the house. He agreed with Arendt's impression that the bourgeois members of the audience were "forced to confront on stage their own unchristian, villainous traits. They were not repelled however. They liked it . . . The people cheered themselves, they saw themselves and were pleased. First came *their* food, then came their morality, no one could have put it better, they took it literally." Along with the creators of *The Threepenny Opera,* Canetti also recognized that the parody was not only of society but also of its popular cultural institutions: "What one had done was to take the saccharine form of Viennese operetta, in which people found their wishes undisturbed, and oppose it with a Berlin form, with its hardness, meanness and banal justifications, which people wanted no less, probably even more, than all that sweetness."[47]

Canetti recognized that the power of the play was in the impossibility of figuring out who is good and who is bad. In a harshly satirical style, this absence of morality precisely mirrored the continuing crisis of post–World War I Germany. Their confusion was captured, distilled, and set to music. And in keeping with Weill's wishes, the music was scrappy and energetic, and simple enough to be whistled as you went out the door.

The enthusiasm ignited by *The Threepenny Opera* cut through all levels of class, education, and wealth. It realized Brecht and Weill's dream of reaching a large audience without sacrificing intelligence, wit, or sophistication. And while they had enjoyed shocking the spectators at an elite musical festival, that had been the mischievous feat of talented and rebellious young men. Conquering the patrons of the Schiffbauerdamm—from the elite connoisseurs to the everyday fan

of light operetta—was an unqualified triumph. They soaked up the applause on opening night, but these two ambitious artists were even more excited about a future they were now certain to define. If opportunity was sure to beckon from many corners, they were certain of only one thing: Their next work would be created together.

It was their first full-length production, but their stunning originality and popular appeal proved they had the kind of passionate synergy it took most famous duos years to develop and refine. After the premiere, the twenty-eight-year-old Weill and the thirty-year-old Brecht instantly took their place in the pantheon of legendary partnerships of musical theater.

Grotesque and Protest

[*The Threepenny Opera* creates] something new that is all things at once: irony and symbol, grotesque and protest, opera and popular melody . . .

Der Tag[1]

The thunderstorms that drenched the premiere had persisted throughout the night. But even the sound of heavy rain on the rooftops of Berlin couldn't compete with the loud and enthusiastic applause for *The Threepenny Opera*. But when the early-morning light revealed a cloudless blue sky, and the winds had stopped shaking the trees and rattling windowpanes, the sudden silence seemed ominous to Ernst Josef Aufricht as he waited nervously for the thud of the newspapers hitting the sidewalks. Despite the wonderful premiere, he still feared the early reviews that might well decide the play's fate. As he kept his ear to the door of the theater, Brecht, Weill, Caspar Neher, Hauptmann, Lenya, and Erich Engel were arriving at the S-Bahn station across the river. They were also up early, ready to smooth out the play's rough edges and double-check the barrel organ. They hesitated on the bridge near the train station, trying hard to make out the outline of the Schiffbauerdamm through the cool mist still hovering over the Spree. The audience had been thrilled the night before—at

least by the middle of act two—but Hauptmann had heard rumors that Aufricht was still considering the backup play he'd sought in the darkest hours of the final rehearsal.[2] As the euphoria of the premiere began to wear off, they also wondered if the show had been successful enough to survive the possible onslaught of bad reviews. The theater had hardly been full, and an excited Berlin critic in the house was no guarantee of a rave the following day.

From their perch on the bridge, the artists noticed that the streets in front of the theater looked unusually crowded. They wondered if the technicians had been called in early to strike the set, or if patrons were demanding their money back. As the sun rose—burning off the obscuring mist and bathing the quay in light—they saw instead that the people were standing in line in front of the box office. And the line was very long.

Word of mouth had flooded through the city, and when the papers finally arrived, the reviews were overflowing with praise. Brecht snatched the *Berliner Tageblatt* to read what his enemy, the critic Alfred Kerr, had to say, and he was stunned to see the phrase "unquestionable success" staring back at him.[3] Aufricht, thirty years and a day old, came outside in the bright glare and thought he was hallucinating from exhaustion when he saw people clamoring for tickets. He celebrated the reviews alongside Brecht and Weill, and once the numbers were in, he was just as delighted to hear he had 12,000 marks in the bank. Since he now had good reason to believe that the play's run might last until winter, he would use the money to fix the boiler in order to heat the building.[4]

By the time the composer and playwright entered the Schiffbauerdamm, the box office had only been open for half an hour and the show was already sold out for the next three weeks.[5] One week later, *Threepenny* had been booked in nearly every major theater in Germany and Austria. It was instantly "all the rage, permanently sold out," remembered Harry Kessler, a diplomat and one of the most significant patrons of modern art in Germany. "We bumped into the Prittwitzens (the ambassador and wife), the Herbert Gutmanns (members of the board of the Dresdner Bank and his wife) . . . One simply has to have been there."[6]

After three years of accepting Georg Kaiser's hospitality, Weill and

Lenya were thrilled to move into a large apartment in the comfortable residential neighborhood of Westend.[7] Not only were their new bedroom and living room separated by an actual wall, instead of a hanging tapestry, but even Weill's piano could have a room of its own. Due to his newfound fame, a lovely grand piano had been loaned to him free of charge.[8] Success didn't change Weill's disciplined habits or his desire to transform musical theater and opera, but he did allow himself a burst of youthful joy when he bought a beautiful and brand-new car. It was made in America, a Graham-Page model, and his editor, Hans Heinsheimer, was delighted to observe the playful side of this serious composer: "I have never seen a man enjoy his first automobile . . . more than Kurt Weill, and I will not forget the exuberant, relaxed, boyish pleasure with which he drove the car, with Lenya . . . singing [a made-up song] with his famous veiled voice: '*Ja, so ein Sträßchen / Ja, das macht Späßchen!*' ('It's such a treat / to drive down this street!')"[9] Weill's exuberance about his first car was probably in part spurred by competition with Brecht, who had been driving an enviable Austrian Steyr since April. The composer's talent had garnered him a piano, just as the playwright's poem for the Steyr's advertising campaign had earned him a car. Left-wing friends had criticized Brecht for accepting gifts from a large corporation, but he didn't mind receiving money or goods in exchange for plying his trade.[10] His father's scornful question, posed years earlier, still irked the rebellious son: "What's a poem worth?" "Four shirts, a loaf of bread, half a cow?" Brecht had answered mockingly in the privacy of his journal.[11] How gratifying it must have been to make a single poem worth an expensive car.

The success of *Threepenny* allowed Weill to live more luxuriously than ever before, but having been poor for so long, it was hard for him to truly relax about money. One month after the premiere, he complained to his publishers that the advance they had sent was 200 marks short.[12] His letter reads more like the struggling composer he had been before *Threepenny* rather than the toast of the town: "I was amazed that you once again sent me a monthly installment of only 400 marks since last month you agreed to leave it at 600. My move has been extremely expensive and I ask you to guarantee me the 600 mark payments for several months since I would otherwise have to accept composition commissions again, which would keep me from

working on *Mahagonny*. I . . . am in a real predicament because of the missing 200 marks."[13] Despite the clear promise of financial success to come, the loss of a month's rent still made him tremble. For the ambitious composer, money meant not only affording the fine foods he had craved throughout his wartime youth—the "snow white butter and Swiss cheese"[14]—but also the far more important commodity of artistic freedom. The possibility of such freedom was tantalizing, and he couldn't yet believe it was within his grasp.

If Weill had trouble feeling secure financially, Brecht couldn't believe he had a scandal-free success. Completely at home amid controversial reviews, or as the target of audience hostility, he didn't yet know how to handle so much effusive praise. This time, he couldn't even fire off one of his passionate letters to the newspaper where he customarily attacked critics like Kerr. Perhaps he was somewhat frightened by having the approval of the eminent "pope."

With the exception of moving into a newly furnished apartment, Brecht's response to the fanfare could not have been more different than Weill's. While the composer tried to enlarge their success by marketing the songs, Brecht fled to his hometown of Augsburg and went straight back to his study of dialectical materialism. He continued reading Hegel, Marx, and Engels—and began work on another serious play, *Fatzer*, about young soldiers who had deserted.[15] It was a return to the subject matter of *Drums in the Night*, and in that sense, he was specifically not responding to the genre he and Weill had created with *The Threepenny Opera*. Deeply invested in his identity as a rebellious and provocative writer, Brecht was embarrassed by the commercial triumph that Weill so openly enjoyed.[16] He willfully ignored the press and all his new fans in Berlin and retreated to the familiarity of his first attic *Kraal*.

Brecht's plunge into intellectual seriousness was also made possible by delegating his material needs to the reliable Weigel. She was in charge of finding and furnishing an attractive apartment, one that was nevertheless to be for Brecht alone so that he could be free to pursue his work in peace. "Dear Helli, I can work very well now," he wrote from Augsburg. "I'm very excited about the apartment. (The chairs must be black . . . I'm confirming that!) . . . Please give Radtke [his cleaning woman] a key when the apartment is finished."[17] Brecht

cared about the kinds of chairs he sat in—he believed that comfortable chairs had a great deal to do with the ability to write and think—but he considered his time too valuable to waste on the logistics of finding and purchasing them. Every day of his life was devoted to artistic and intellectual concerns; domestic chores were for others. This enabled Brecht to enjoy the comforts of his improved finances without admitting that such things mattered to him. While he was studying Marx or Hegel, or writing an antiwar play such as *Fatzer,* he allowed himself to imagine that his nice chairs, or the box-office royalties his very favorable contract awarded him, had appeared as if by magic.

Weigel provided a large portion of that "magic." She met all of Brecht's demands, as well as taking care of Stefan, but she also managed to pursue her career with equal ferocity. Having recovered from appendicitis by early September, she was once again in rehearsals in a Theodore Dreiser play,[18] and by the end of the year she had performed in a cabaret show with Rosa Valetti, as well as in two other plays.[19] A less independent woman might have relied on Brecht's professional admiration to bring all the stage roles she required, but Weigel had fought hard to build an impressive career of her own. She wanted to work with many directors and in a larger variety of plays than Brecht would have been able to provide. And unlike Brecht, she was able to handle a hefty domestic load alongside her devotion to the theater. Perhaps Brecht—who could not conceive of dealing with Weigel's complicated daily logistics—was unaware of just how hectic her schedule must have been when he complained to her in October 1928: "Dear Helli . . . it's desperately boring here and work! This fatzer is hard," he wrote of his latest play. And even though Weigel likely didn't have a second to spare, he continued: "What do the two of you do when it rains? . . . send me döblin's address (from the phone book) and write me more often, don't be so lazy."[20] Since he was fully aware of Weigel's industrious nature, it's also possible that calling her "lazy" was just his wry humor—maybe this illogical accusation was to be taken ironically, and knowing him as she did, Weigel most likely would have recognized it as a joke.

Weigel did take the time to make one very important decision: She went to the official government office in Berlin and legally withdrew herself and the nearly four-year-old Stefan from the Jewish commu-

nity.[21] German citizens were required to register their religion on their identity papers in Germany—this had always been the formal means by which the Catholic and Protestant churches collected taxes. Under the Weimar Republic, the Jewish community had also been granted the legal right to collect taxes from its members for its communal and ritual affairs. Because the official status of the community had been difficult for the Jews to obtain, and had only recently been awarded, a formal withdrawal was a significant step for even the nonobservant Weigel. It was a step she likely took in order to be closer to the non-Jewish father of her son. And since they were not going to raise their son in the Jewish faith, moreover, she felt it was wrong to specify this religion on Stefan's legal documents. And if she and Brecht were to live a life consistent with their social and political goals, she would have no reason to pay taxes to a religious community in which she played no active role. But while her decision has often been assumed to be a rejection of religion in favor of her devotion to Communism, this rings false given her political development at that point. Under the influence of her school director, Eugenie Schwarzwald, her belief in social justice had certainly begun at a young age, and she had been actively committed to serving and fighting for the poor ever since. But Weigel's growing interest in Communism was not yet official, and it's far more likely that this principled woman wanted to match her legal status to her private beliefs. She was not a practicing Jew, and in 1928 she was still able to maintain that she had no official connection to its community.

In Brecht's letter to Weigel about the apartment, he also delegated the privileged distribution of keys—not only to the cleaning woman but also to Hauptmann, "so she can find room for all the papers," he explained.[22] For him, there was no reason to think that the success of Hauptmann's discovery and translation of *The Threepenny Opera* would change her professional status in any way. And although *Threepenny* was as good a launching pad as any writer could hope for, and her small 12.5 percent share of the profits would bring her the financial security for which she had been longing, she continued not only to organize Brecht's business but also attended to jobs that came about because of his growing fame. He attracted artists and writers and opportunities from all over the world, and it was up to Hauptmann to

help judge which of these projects were worthwhile, and to make use of her linguistic and dramaturgical skills to translate and revise the ones they selected.[23] Hauptmann said, "Brecht was very economical with his time. If he could win time to work on something else, and also to read . . . then he was happy to make use of something that was already written . . . That's why we never threw anything away."[24] What had worked so beautifully with *The Threepenny Opera*, Hauptmann reasoned, would continue to flourish. She saved him quite a bit of time and his confidence in her talent provided the validation she craved. Her strengthened bond with Brecht was more gratifying to her than money.

Lenya was legally married to and living with Weill, but in every other way this audacious newcomer was a far less conventional "wife" than Weigel, and far more independent than Hauptmann. Her working-class instincts didn't permit her to become dependent on either Brecht or Weill, or any one man. And after *The Threepenny Opera*, she had very good reason to be confident of her professional independence in the future. For although it had taken years for the playwright to hear a kind word from his enemy Kerr, Lenya gained the critic's approval the first time he saw her on the stage. In his review, which had called *Threepenny* a "magnificent and pioneering work," he described a scene with the "whores." "Four actresses take part—and one of them seems to come from Munich. She was very good, very good indeed . . . Yes, her enunciation was excellent. Let this be recorded here permanently with my powerful pen."[25] Lenya had been trying to work on the stage since she went to Zurich at the age of fourteen. She was thirty by the time she triumphed in *Threepenny*. This was her moment, and she knew it.

Lenya continued acting in the long run of *Threepenny*, playing both Jenny and Lucy, and she was soon offered many important roles all over Berlin. These included Georg Büchner's *Danton's Death*, Frank Wedekind's *Spring Awakening* (with Peter Lorre), and Lion Feuchtwanger's *Die Petroleuminsel*. Her reputation led to a role, along with Weigel, in *Oedipus* at Leopold Jessner's State Theater. This may have felt like an encroachment on Weigel's stomping ground—she was a regular with Jessner and had been a professional actress far longer than Lenya—but their careers suddenly seemed to be converging, a fact that can't have

gone unnoticed by either of these ambitious and competitive women. Lenya perhaps downplayed how much success meant to her as a way of camouflaging just how much she did enjoy overtaking her peers. "After *Threepenny* we had a little bit more money, and, of course, that made a difference. We could go to the opera more often and sit in better seats, but our life didn't change very much." She did admit, however, "At that time I couldn't live without the theater—it was my life."[26] Lenya's overarching modesty was probably somewhat insincere, but as someone who had fought her way to a new life, she had very good instincts about what truly changes one's destiny. A large apartment, a nice car, and fancy meals were all wonderful, but they didn't hold a candle to being offered an esteemed place in Berlin's cultural royalty. In this sense, theater *was* her ticket to a better life.

If Lenya was happy to be accepted by established directors and theaters, Weill was thrilled to be recognized by a broad and mostly unsophisticated audience, one that is "simple, naïve, unassuming and [has a] healthy sense of fun and seriousness, good and bad, old and new."[27] *Threepenny*, he exclaimed, had allowed him to reach "an audience which either did not know us at all, or . . . never considered us capable of interesting a circle of listeners much wider than the average concert-and-opera-going public." The critic Ernst Bloch believed that Weill's "hit tune ammunition . . . wearing a popular, even vulgar mask, managed to affect those whom progressive music couldn't even reach."[28] The genre of opera had finally been lifted out of its splendid isolation and this achievement was not lost on the modern and brilliant impresario, the giant Otto Klemperer. Weill was thrilled to hear that he had seen *Threepenny* ten times in a matter of weeks.

Brecht was also pleased to have reached a larger audience, but he was far more cautious about celebrating a "popular" success. And he certainly hadn't set his sights on transforming the elite form of opera. Even if *Threepenny* had managed to be relevant and entertaining for a broad audience, he still wasn't convinced that the spectators had engaged in the admirably critical reaction that he had been determined to provoke. Many of Kessler's banker and diplomat friends, along with much of the audience, were probably humming Weill's melodic tunes, as Brecht had feared, rather than reflecting on society. The play had appealed to many different kinds of people but—and for

Brecht this was a big but—only "the smallest proportion of these many were proletarians."[29]

Did the popular appeal of *Threepenny* heighten or dilute the social satire? Had Brecht and Weill's intentions triumphed or simply been misunderstood? What was Brecht to think when he noticed, with dismay, that in Berlin it quickly became fashionable to dress like a pimp? It was not only Macheath's clothes that were imitated but also his swagger and his cane.[30] The gangster was being co-opted as a masculine hero instead of becoming an unflattering metaphor for the bourgeoisie. Hannah Arendt shared Brecht's disappointment: "The effect of the work was exactly the opposite of what Brecht had sought by it. The bourgeoisie could no longer be shocked; it welcomed the exposure of its hidden philosophy, whose popularity proved they had been right all along."[31] Theodor Adorno agreed with Arendt that the meaning of *Threepenny* could be misconstrued. It could appear to offer "the comfortably educated man a pretext to like in public what he had hitherto secretly played to himself on the gramophone."[32] "The work captures the little ghosts of the bourgeois world," Adorno continued, "and reduces them to ashes by exposing them to the glaring light of an alert memory . . . The parodistic surface is deep, sparkling and color-ful enough to make all those who don't observe sharply enough believe that it's all fun."[33] Adorno's solution was to "defend it against that suc-cess."[34] The possibility of misunderstanding *Threepenny* was, however, part of its charm. As Jhering said, it "neither opposes nor negates morality."[35] Instead, it forces everyone to make up their own mind. The bourgeoisie could find and seek approval if they so chose, but a sharp criticism of their hypocrisy was available as well. The message was defined by the recipient's ability, and desire, to reconcile the play's contradictory elements. But of course, as Brecht had realized, no one could be forced to reconcile anything at all. Thus the play's conten-tious blend of art, politics, and commercial appeal were hotly debated in every club, café, and art studio in Berlin. In the weeks and months after the premiere, arguments about the relationship between art and popular success raged throughout the night and were recharged with strong coffee the very next day.

But no matter how piercing and opinionated the artists and critics could be, their aesthetic concerns were polite chatter compared to the

politically driven hostility that *The Threepenny Opera* provoked. These negative responses were especially vicious, as if they had to be louder and crueler in order to drown out the cheering crowds. Brecht was most rankled by the review in the Communist *Die Rote Fahne:* "If one's attitude to the present is more or less one of incomprehension, then one seeks refuge in the past; if one does not know how to organize the revolutionary movement of the working class, then one experiments with the aimless and dull rebellious moods of the *Lumpenproletariat.*" The reviewer concluded by confirming Brecht's greatest fear, saying that *The Threepenny Opera* doesn't have "a trace of modern social or political satire. All in all, a varied, entertaining mishmash."[36]

Brecht had worried all along that despite his efforts to provide a layered and complex vision, many would unfortunately take the love story literally. He was determined to prevent this kind of misunderstanding from happening in the future. He conducted a mock interview with himself to press home the point, and it began with his own leading question: "What accounted for the success of *Die Dreigroschenoper?* I'm afraid it was everything that didn't matter to me: the romantic plot, the love story, the music." "And what," he asks himself, "would have mattered to you?" Brecht answers with utmost sincerity: "The critique of society."[37]

If criticism from the left was a disappointment, hostility from the far right was to be expected. The right-wing *Neue Preussische Kreuzzeitung* deemed *Threepenny* an example of "literary necrophilia" and recommended it to anyone who suffers from "chronic sleeplessness."[38] The *Deutsche Zeitung* called it a "political horror ballad."[39] By far the most angry review came from the staunch organ of the National Socialist German Workers' Party, the *Völkischer Beobachter* (The People's Observer): "Some especially noxious cesspool they find in a corner of any big city is barely good enough for the celluloid romance of this two bit culture and is otherwise really just a matter for the police to take care of as part of street cleaning."[40]

Brecht and Weill may not have been worried by the overwrought response of the *Völkischer Beobachter,* but they must have noticed that this was the first time they were directly attacked by the National Socialists, whose association with Hitler was increasingly disturbing. Although the Nazis had done poorly in the spring elections—they had

won only 14 seats in comparison to 153 for the Social Democrats and 54 for the Communists—the divisions within the many parties were extreme. That year in particular, the elections were hotly contested. In this turbulent environment, thirty-one-year-old Joseph Goebbels had managed to be elected as a deputy to the parliament. It had only been two years since he had been appointed the district leader for the Nazi Party in Berlin, and he had come a long way in terms of inciting unrest and violence between the National Socialists and the Communists. In his zeal to appropriate the loyalty of the working class, he worked hard to lure them away from the Communists. Goebbels gave speeches, staged public events, and, typical for Berlin, started his own newspaper, *Der Angriff* (The attack). Above all, he understood the role of mass opinion in achieving political power, and it was the popularity of *The Threepenny Opera* that frightened him and other Nazi Party members, far more than the humorous display of decadence. *Threepenny* was beloved by all, regardless of class, wealth, or political views—it had the mesmerizing appeal of just the kind of propaganda Goebbels was beginning to perfect. The vitriol came as much from professional jealousy as it did from attempts to claim the moral high ground.[41]

The Nazis needn't have troubled themselves over the success of *The Threepenny Opera.* Its saucy satirical spirit hardly formed an attack on the right-wing elements alone—Macheath's amoral universe had proven its ability to mock nearly everyone. At that point, as John Willett says, Brecht "was full of fighting spirit, but he fought mainly in the literary ring and on behalf of his own works. That distinctive aggressivity which we have already seen persists recognizably enough into 1928; yet in 'Threepenny,' the hatred of the bourgeoisie which he so pungently expresses is the hatred felt by an artist and intellectual, ultimately by somebody from a bourgeois background . . . And certainly that is what the Communist Party critics found at the time."[42] The Nazis might have done better to dismiss the work, as *Die Rote Fahne* had done, as possessing no trace of social or political significance. *Threepenny* had pointed out universal truths about human greed and the perennial partnership of power and corruption—it had not singled out any particular political party or movement.

In the months following *Threepenny*'s spreading success, Weill was far more concerned with the marketing of his songs than with the

occasional political criticism the work had received. He pushed his publishers constantly: "I'm really afraid that by under-exploiting these popular numbers I may miss a good opportunity to assure my financial well-being for years to come." Record sales would perhaps outweigh his royalties, which were, pointedly, less than half of Brecht's. Weill had always disagreed with Schoenberg's insistence that "art and success will have to part company" and had no qualms about promoting the songs that were so adored.[43] He permitted himself to bask in his success because of his enduring belief in the democratic appeal of art. "We would be falling back into our old mistakes," the composer insisted, "if we were to deny certain music its importance and artistic value simply because it found its way to the masses."[44]

Weill had no idea how long the affection of the masses would last, however, and he urged his publishers to do all that they could to market the songs as soon as possible. "In any event it seems to me the most important thing is to see to it that in two weeks at the latest, the popular numbers are being played in the cafés."[45] When Universal Edition didn't move quickly enough, Weill sent telegrams to increase the pressure. His urgency was about money and the artistic freedom he could gain from a steady income, but it was also truly about the importance of his music. "My gift for writing a completely new kind of popular melody is absolutely unrivaled today. If this were ingeniously promoted on a large scale there is no doubt that my popular compositions could take the place of American jazz."[46] But although Weill sincerely believed in the quality of his popular music, in the end he was forced to make artistic compromises when it came to selling the songs on their own. The "Pimp's Ballad," for example, was ultimately published without the risqué lyrics.[47] Transforming satirical songs into popular numbers often made it necessary to dish up the melody without the message. As commercial records, therefore, the songs served a different purpose than they did in the satirical play. It's hard to dance to irony.

If Brecht was concerned about the accusation that *The Threepenny Opera* had no social significance, he might well have been irked by Weill's forthright insistence on marketing. The play had undoubtedly fulfilled the goal of democratic art—it was "art for the people" in every sense of the word. But the line between creating a culture that is acces-

sible to the masses, which both of them wanted, and sheer commer-
cial appeal, which was problematic for Brecht, had been permanently
blurred. Even more ironic, Brecht and Weill were becoming rich
because of their devotion to art for the common man. Their parody of
greed had quickly become a valuable commodity in purely capitalistic
terms. This was a dilemma that one of Berlin's rather astute beggars—
even though he purported to be blind—saw most clearly of all. Shortly
after the play had opened, Lenya went for a walk in the Tiergarten
and she recalled: "I unthinkingly passed a blind beggar who called
after me, 'Fräulein Lenya, is it only on the stage that you notice a
blind beggar?'"[48] Brecht would have smiled wryly at the supposedly
blind beggar, pleased to find a real man who behaved like a character
in his play and whose wit crystallized his own burning question: How
can a drama be both entertaining for all and still inspire meaningful
changes in the society it exposes on the stage?

Brecht was not the only one who felt uneasy about the commercial
appeal of Weill's music—it also led to the assault by the composer's
peers. As his friend and former student Maurice Abravanel remem-
bered: "Serious musicians thought he was a traitor. He was not rec-
ognized by operetta composers because he wrote wrong notes, and he
was given up by the avant-garde because he wrote successful things.
So, he was in a no man's land except that he knew he was doing good
work."[49] In the meantime, Weill was proving himself on both fronts
simultaneously. A month after the premiere of *Threepenny* and amid its
continuing success, Weill and Kaiser's operatic double bill—*The Pro-
tagonist* and *The Czar Has His Photograph Taken*—opened in Berlin. They
fared extremely well, both in terms of box office and critical recep-
tion. As the sophisticated critic Oskar Bie commented: "Kurt Weill is
now showing a special gift, independent, serious, and developed into
a firmer discipline."[50] With the success of his operas, and the support
of critics like Bie, Weill was doubly free to enjoy the popular appeal
of his songs. He was convinced that the snobs would come to realize
the deeper layers of his compositions, just as the mass audience would
slowly have their tastes expanded. Weill knew that erasing the line
between high and low music would be difficult, but he was certain it
would happen. The composer understood that social and cultural tran-
sitions take time, even and especially if Brecht was far more impatient.

When Weill was requested by a prominent Berlin newspaper to explain his work "as if to a class of intelligent urban twelve-year-olds," he addressed the issues that had been raised by the success of *Three-penny:* "You want to hear music you can comprehend without special explanation, music you can readily absorb and sing with relative ease . . . if music cannot be placed in the service of society as a whole, it forfeits its right to exist in today's world. WRITE THIS DOWN! Music is no longer a matter of the few." To state his case as strongly as possible, Weill parodied the tone of a "Prussian schoolmaster."[51] He made his point while mocking the traditions that sought to keep popular and serious music in separate categories.

Threepenny was certainly a work for the many. Within the year, it had 250 consecutive performances at the Schiffbauerdamm and had been performed 4,200 times in 50 cities outside Germany, including Italy, France, Russia, Switzerland, Czechoslovakia, Austria, and Scandinavia.[52] It had touched a particular nerve in German culture and society, and the reverberations were seen and felt all over the country: "*Dreigroschen* wallpaper was manufactured depicting and naming the work's principal characters. And a 'Dreigroschen-Keller' opened in Berlin's Kantstrasse . . . [And] this pub was the rage in Berlin. It was the done thing, after the theater to end up in a group in the 'Dreigroschen-Keller' . . . soon the society snobs also turned up—whoever considered themselves part of the culture, the diplomats and the crooks of the strong-man and pimp type, journalists and police informers."[53] Weill would hear his tunes whistled not only by the Berlin cab drivers but also by shopgirls, bankers, university professors, and street cleaners. No wonder he worked to exploit their popularity in the promotion of his song music, record sales, and dance-band versions.

And Weill's publishers were naturally delighted by the unexpected success of their outspoken young composer: "We had witnessed the greatest of nature's miracles: the transformation of the drab larva of a prestige composer into the golden-winged beauty of a commercial butterfly." Heinsheimer proudly reported that "the vocal score of *The Three Penny Opera* sold many more copies in the first few months of its existence than all other works by Weill combined."[54] But as happy as Weill felt about such statistics, he, like Lenya, had the good personal instinct to play down his celebrity status. He wrote to Abravanel: "I'm

getting sick and tired of this fame of mine . . . All at once I have gotten the kind of things I had expected to achieve, at the earliest perhaps in another ten years or so. Of course, this offers lots of advantages—not only of a material kind, but also because of my name (which right now is worth a lot of money!). I'll now be able to do all kinds of other things. I can assure you that I'll be taking full advantage of all possibilities."[55]

But the more Weill enjoyed the success of *Threepenny*, the more Brecht became embarrassed by it. Shortly after the opening, the playwright even found the need to justify himself to the staunchly political Erwin Piscator—careful to camouflage his own doubts with wry humor and confidence: "Thanks for your letter. I hope the *3-Penny Opera* doesn't sound too provocative at a distance. She hasn't an ounce of falsehood in her, she's a good honest soul. Her success is most gratifying. It refutes the widespread view that the public is incapable of being satisfied— which comes as something of a disappointment to me."[56]

The raging "Threepennyfever" gave Brecht and Weill more faith in their talents, and even more faith in their collaboration, but it also began to push them in opposite artistic directions. Brecht wanted to use their breakthrough as a hammer to smash the operatic form to bits—in fact, to smash all elite forms of culture to bits; Weill wanted to continue transforming the opera to reinvigorate its popular appeal. Brecht yearned to create a theater that would have a significant effect on society; Weill believed that creating a form of musical theater that engages with the modern audience was a significant achievement on its own, proof that all culture can and must belong to the people. The composer was therefore determined to complete and mount the full-length opera of *Mahagonny*, and Brecht was most concerned about writing a serious play. But despite their emerging artistic differences, they were still creatively joined at the hip. Everyone wanted a piece of this exciting new partnership.

In addition to their continuing work on the *Mahagonny* libretto, several joint commissions came pouring in, including one from a four-day festival called *Berlin im Licht*, with displays of lights and fireworks to celebrate the city's architecture and industry. Weill composed a work, based on Brecht's text, which had both a song version and, ironically, one scored for a military band.[57] Working with speed and intensity, the composer also wrote *Das Berliner Requiem* for the radio—a cantata with

a male chorus that was based on a poem Brecht had already written. The requiem was created on the tenth anniversary of the end of the Great War, but because it offered a politically charged anti-military message, including the story of Rosa Luxemburg, the radio station had objections to the piece. It was part of the live concerts at the festival, but it wasn't aired on the radio until May 1929, and even then only reluctantly. Weill was so displeased with the station's cowardice that he quit writing for the radio journal once and for all. This protest was proof that he felt as strongly about cultural freedom as Brecht did about the political role of theater. In essence, however, "the two collaborators had different motives for engaging in the work. Brecht saw a chance to disseminate his political convictions, and Weill wanted to reach as large an audience as possible with his experimentation in musical form."[58]

The advent of early, rapid, and overwhelming success began to unravel the fabric that held Brecht and Weill so fiercely together—a material made out of talent, passion, and experience so far beyond their years. But fame brought obligations that also bound them to each other as well—causing these astute men to miss the first dropped stitch of their partnership. They had both yearned to reach a large audience, and they had succeeded, but what was the most principled way to expand upon that triumph? The answers to this question would begin to haunt them in the coming year.

The Beginning of the End

Five months after the opening of *The Threepenny Opera*, Weill was standing before the grand Kroll Opera House, score in hand, taking in the sight of its lavish gardens, relishing the opportunity to hear his music presented under the virtuoso baton of Otto Klemperer. Invoking a tradition going back to Mozart, Weill had composed an instrumental suite based on *Threepenny*'s original score. For although he had enjoyed the dance-band and hit-tune versions of his songs—he was always delighted to hear that his music could live and breathe in an amateur's whistle—Weill also wanted to establish its classical prowess. It was one thing to be popular and another to be "only" popular.

Brecht, meanwhile, was still struggling to justify his popular success. He came quietly back to Berlin, his extensive period of Marxist study nearly complete, and wondered how to lure his newly acquired broad audience into a politically engaged theater. His future plays, he hoped, would combine the excitement of a boxing match with the insights of *Das Kapital*. But he had yet to finish *Fatzer*, his antiwar play, and was impatient to leap back into action. Upon his return to the city, he was therefore delighted to hear that Ernst Josef Aufricht was planning to mount several politically explicit works.[1] Having moved the successful *Threepenny* to another theater for several months, the recently flush producer was able to afford a few intrepid and risky projects.

Brecht suggested a very left-wing play he had encouraged his ex-lover Marieluise Fleisser to write, *Pioneers of Ingolstadt,* a follow-up to *Purgatory in Ingolstadt,* which Brecht had directed three years earlier. When Aufricht agreed to mount it, Brecht quickly invited himself into the production. Fleisser welcomed his participation, for although her affair with him had ended shortly after they worked on her first play, there was still a great deal of mutual professional respect between them.[2]

Brecht was most adventurous when he felt secure in his surroundings. He quickly treated the Schiffbauerdamm as his theatrical *Kraal*—an extension of his attic on Spichernstrasse. He reveled in his return to a familiar space, an old lover, a good play, and the chance to work with his regular colleagues, including Lenya, Caspar Neher, and the actress Carola Neher. He completely dominated the production, rewriting and interfering in the direction as well. He ended up with a co-director credit.

Pioneers was a strong antiestablishment play that would have been provocative enough even without Brecht's influence. But eager to create the kind of uproar he so enjoyed, Brecht pushed Fleisser to write several daring new scenes, including one where three schoolboys explicitly discuss the female anatomy. He also directed the actors to be quite graphic in their depiction of the already sexually frank scenes. One notably shocking encounter took place in the bushes. Since one of the main characters is a soldier who enjoys several liaisons with the servant girls around the town of Ingolstadt, and the army in general is portrayed in a harshly critical light, military officials objected ferociously to the play. Many people were offended by the looseness of the girls—one main character becomes a prostitute and other girls enjoy casual encounters with the men. The residents of Ingolstadt, Fleisser's hometown, were particularly outraged.[3] The protests were long and loud, until finally the police threatened to close the play. When Aufricht attempted—with Brecht and Fleisser's ultimate cooperation—to tone down the overt sexuality of the work, another section of the public rose up in protest. They were furious to see a theatrical production acquiesce to such shameless censorship.[4] Brecht enjoyed the scandals up until the end. The angry reaction still felt more familiar than the runaway commercial success of *Threepenny,* whose social critique had been so often ignored.

On the surface, Germany was thriving, recovering financially and culturally from the painful postwar era—even the ruinous inflation was practically a dim memory. But it was nevertheless a country surviving on borrowed money, and the government would be repaying American loans until 1987. The debt was a constant and humiliating presence in the national psyche, creating an undertow of dread that lurked ominously below the surface. If the police could still threaten to close down a play, all was not entirely well.

And although Brecht was finally feeling rooted in Berlin, he sensed the persistent tingling in the air, the disturbing tension in the streets and in parliament. When he decided to legally marry Weigel in April 1929, he was seeking the feeling of home and belonging so essential to his work. He needed to feel utterly stable in order to shake up the rest of the increasingly shaky world.

Weigel surely demanded his steadfast commitment as well. She had agreed to a modern relationship, free of all bourgeois requirements, but she was also, as Lenya sharply observed, a natural-born mother. Regardless of her political, artistic, and feminist goals, she wanted a permanent relationship with her son's father—to establish a version of a "normal" family, however she chose to define it. She didn't ask for sexual fidelity, and she accepted that Hauptmann was still in the picture. She also knew and tolerated Brecht's most recent affair with Carola Neher, which had begun shortly after she became the leading lady in the second cast of *Threepenny*.[5] Nor did Weigel ask to be financially supported. But she did want Brecht's acknowledgment of paternity for Stefan, and a legal marriage was the easiest way to bring this about.[6] Her son would soon go to school and, no longer attached to the Jewish community to which Weigel's family belonged, she wanted him to begin his official life bearing his father's name. Brecht agreed.

Weigel fully accepted the price of winning a man like Brecht: "When a woman wants to have a normal marriage, she should marry a normal man," Weigel stated unequivocally. "When she marries a genius, she must be ready to sacrifice a lot."[7] In turn, Brecht prided himself on being a husband who made no false promises.

Which is why he went straight to Carola Neher and promised her that the marriage was "unavoidable, but doesn't mean anything."[8] But as Lenya observed, Carola always "had a banker in the background to

surround her with great luxury," and she therefore wasn't accustomed to being the second priority for any man.[9] She reacted with fury but didn't call off the affair. As a woman, Carola was adored by men—but as an actress, she desired the affection of a great playwright. She would take as much of him as she could get.

How did Hauptmann receive the news that her lover, mentor, collaborator, and, most significantly, politically committed comrade had decided to let the state sanction his private relationship? Did she, as nearly everyone has insisted, give way to despair and try to commit suicide?[10] Although her attempt is often cited as a fact, there is no simple answer to this question. Any light that can be shed on this puzzle is to be found in the clues she left behind. One thing is certain: In this moment, the equation between her fiction and her life became more literal than ever before. And she certainly invited people to ponder whether or not she was imitating the heroine of her story "Juliet Without Romeo," who attempted suicide in order to get the attention of the man she loved. In that story, the heroine loves but loses the man because he is frightened by her erratic behavior. The message is that a suicidal woman would frighten most men. Did Hauptmann only want to frighten Brecht? Or did she sincerely want to die?

Another story she wrote just before the marriage took place certainly underscored the irony of her position with Brecht. Especially its mock-biblical title—"Er soll dein Herr sein" (He shall be thy master). The self-deprecating Hauptmann was surely making fun of herself when she derided her own title: "Many stupid men agree with this sentence—and so do nearly all the clever women."[11] It is noteworthy that Hauptmann signed her real name to this story, a rare event, and one that further implicated her as one of those clever women who so foolishly served her master. But perhaps after Brecht's marriage to Weigel, she was hoping not to serve him anymore.

In order to understand how Hauptmann reacted to the news of Brecht's marriage to Weigel, it is necessary to depart from 1929 and leap ahead, following the paper trail she herself left. If we read her work for clues, the trail offers beguiling hints about what might have been her darkest hour. In 1951, Hauptmann wrote a story that was not published in her lifetime, "Gedanken am Sonntagmorgen" (Thoughts on a Sunday morning). It describes a woman who sounds much like

Hauptmann: She is a lonely translator who has been living in a city for three years. "That was at least 150 Sundays. For 150 Sundays she was alone the whole day, and sometimes she thought, I can't bear it any longer . . . there was another time she'd also been unable to bear [the loneliness] . . . that was in a small hole of a room, there she had a misfortune: someone was working in the building that night and heard her moaning. And then the doctor came and three days later, she was back to herself."[12] This same story refers to an article about Brecht, using his real name. Thus the story floats, with Hauptmann's customary freedom, between the facts of her life and the fiction of her character. The story is fragmented, unfinished, but has been used— based on the opaque phrase "there was another time . . . she had a misfortune"—as "proof" of Hauptmann's suicide attempt in 1929.[13] It is far more convincing as proof that the precise Hauptmann—who had spent much of her life organizing, publishing, and creating an archive for Brecht's papers—intentionally left the story to be found and discussed by people in the future. She knew best of all how to leave such dazzling archival discoveries in plain view. There are also rumors that she spoke about this attempt to a few people during her lifetime, and these whispered confidences also ensured that her archival hints were not overlooked.[14]

It is entirely unclear if Hauptmann attempted suicide nor not—but it is far more interesting to realize that she was, later in life, determined to make people believe that she did.[15] Twenty-two years would pass before she began to create—perhaps even with an air of mischief—her enigmatic legacy. Hauptmann was above all not without humor, especially about herself, and the spirited and lively writer surely wanted to influence the future versions of herself as much as possible. She might well have wanted to heighten the somewhat bland description of herself as the unrecognized and lovelorn assistant to Brecht by throwing in the suggestion—if not exposing the fact—of a romantic suicide attempt of a brokenhearted woman. Like Brecht, she didn't deliver answers; she provoked questions.

Her future writings did make it clear, however, that Hauptmann was unhappy about Brecht's marriage in 1929. But she was outwardly defiant and declared some measure of independence by working with his former colleague Emil Hesse-Burri, with whom she wrote many

radio adaptations, including stories by Arthur Conan Doyle and Edgar Allan Poe.[16] With regard to Brecht, her independence was also based on the ambiguous honor of becoming the official editor of the new literary journal that was devoted to his collective works. It was to be known as the *Versuche* (Experiments).[17]

Several weeks after his marriage, Brecht wrote Hauptmann a letter proving that she was his most essential *Mitarbeiter*, and that his professional devotion to her was as important as his domestic commitment to Weigel. "Dear Bess, Today it struck me that you might like to . . . hammer out a little play, something very loose and sloppy, you could do it piecemeal if you like. Something heartrending and at the same time funny, for about 10,000 marks. You'd have to put your name to it, but it would do you a lot of good . . . Here, roughly, is the plot. Setting: Salvation Army and gangsters' dive. Content: Battle between good and evil." Brecht goes on to define the plot in some detail, including suggestions for dialogue and several songs.[18] This "little play" was, as it turned out, Brecht's answer to a commission that Aufricht had already offered him and Weill. The producer had enticed them with the idea of writing another musical that would be ready in time to celebrate the one-year anniversary of *Threepenny*.

The offer was Brechtian "kindness" in all its maddening complexity. Coming in the wake of his marriage, the "it would do you a lot of good" had to be a reference to the personal pain he had caused Hauptmann. But knowing her as he did, and understanding her desire to be successful as a writer, Brecht disguised his apology in professional clothing. Hauptmann was not a woman to be comforted—as Carola Neher was—with flowers and flattery; she desired his intellectual recognition. But although his offer was to write a story about the Salvation Army, he didn't even bother to acknowledge that this was a subject Hauptmann had addressed a year earlier in her short story "Bessie So and So," which had been published alongside the memorable photo of her dressed as a Salvation Army girl. Both Hauptmann's story and Brecht's "suggested" plot share the idea of an alliance between business and religion, and both center on a woman who must confront hypocrisy and disillusionment in her efforts to do good works.[19] Much of the plot that Brecht "gave" to Hauptmann stemmed from her original ideas. If Hauptmann subsumed her professional identity by con-

tributing to Brecht's work without credit, perhaps he had also come to believe that her ideas could only take root in his imagination. From Brecht, this invitation to remain in his collective identity was an act of generosity and love. She agreed.

It was quite the opportunity. The subject matter was especially timely, since 1929 marked the hundredth anniversary of the birthday of the founder of the Salvation Army, an event that was being celebrated all over Europe; they had an eager producer with ready cash; and Aufricht had engaged not only Brecht, the best poet of his generation, who promised he would write the song lyrics, but also Weill, the best composer for the stage in Germany. What more could Hauptmann ask for her first solo gig?

Hauptmann had long been fascinated by the Salvation Army, and she plunged herself into the task with gusto. She had recently made a new friend, Bianca Minotti, a left-wing journalist and budding Communist, and together they dressed up as homeless women and went around Berlin seeking help in various Salvation Army headquarters.[20] They had so much fun that Brecht insisted on joining Hauptmann for several of their escapades.[21] The play would revolve around an encounter between Chicago gangsters—who were not as hardened as they pretended to be—and Christian soldiers whose motivations were not as pure as they so loudly professed. The satirical play was to be called *Happy End*, a title that promised the pleasures of a Hollywood story and simultaneously mocked the clichés of the genre.

And Hauptmann would get the sole credit for it. That is, if she chose to sign her real name to the play—which was by no means guaranteed.

Once again, the competition to be the "essential one" returned in full force. In March, Weigel seemed to have won with the marriage. With the prospect of being the sole author of a play that had been offered to Brecht, Hauptmann might have felt as though she had a second chance to gain the upper hand. Brecht was a man who knew exactly how to capture the heart of each of his women.

Weill and Lenya were just as disobedient as Brecht when it came to upholding the traditional conventions of marriage. But as far as they were concerned, Lenya's infidelity struck a balance with the composer's zealous devotion to his work. "I sit in my study all day and work," Weill said by way of explaining Lenya's behavior to a friend. "And I'm

perfectly happy. I don't need anybody and I don't miss anybody."[22] What Weill meant by not "needing" anybody was an admission of his celibacy while he was working on something very intensely, even if the project went on for months.[23] And although his friends often insisted that the composer was hurt by Lenya's affairs, Weill seemed content with the bargain they had made. "There is no one like Lenya," he insisted. It was a way to keep the woman he loved, even if he was often neglectful of her needs. He wrote wittily about his wife's behavior: "She is a terrible housewife but a very good actress. She can't read music, but when she sings, people listen as if they were hearing Caruso. (For that matter, I pity any composer whose wife can read music.) . . . She always has a couple of male friends, which she explains by saying that she doesn't get along with women. (But perhaps she doesn't get along so with women precisely because she always has a couple of male friends.)"[24] In her own succinct way, Lenya responded to the accusation that she cheated on Weill with indignation: "I don't cheat! He knows."[25]

Like their marriages, the working partnership between Brecht and Weill was as passionate as it was steadily becoming creatively promiscuous. With the composer still most devoted to the full-length opera of *Mahagonny* and the playwright far more interested in realizing the potential of political theater, what was keeping them together? As artists, it was the astonishing interaction of their talents, especially the song style they had discovered, which never ceased to amaze them both. As career-minded men, *Happy End* was a chance to continue holding the attention of the *Threepenny* audience, one that was larger than either of them could attract on their own. If both men were wondering where to take this audience next, and were in fact coming up with conflicting destinations, neither of them spoke openly about it yet. They were frozen in the spotlight, and they could only remain there with the kind of musical play they had invented. That's what they hoped *Happy End* could be for both of them—a chance to continue the glorious present. Neither of them yet admitted how little it meant to their plans for the future.

The work on *Mahagonny* continued to be fraught. The conductor Maurice Abravanel remembered that Weill often complained openly about Brecht's distracted behavior: "Here, I need lines. I want to com-

pose . . . And that idiot is taking Marxist classes every afternoon instead of writing his stuff."[26] But despite his frequent frustration with Brecht, Weill was nevertheless always happy with the results of their collaboration on the opera. Brecht's poetry was inextricably intertwined with Weill's musical conception, and since Brecht couldn't imagine working with another composer, he continued to respond, if sporadically, to Weill's ardent requests. Their mutual respect was in full force. What had changed was their vision of how art should interact with their increasingly turbulent world.

That spring, Brecht witnessed events that exposed the brutal political realities that were once again emerging in Germany. He had an epiphany, one that made him feel the need, more strongly than ever, to write plays that shaped the political world in which he lived.

On May 1, 1929—May Day—the Communists and Social Democrats each had organized demonstrations to protest the plight of the unemployed. To avoid a violent clash between the parties, the chief of police formally banned all public gatherings. The Communists demonstrated against this ban and the police were called in to disperse them. Brecht watched the May Day demonstrations with Fritz Sternberg, whose course in Marxism he had attended, and they were both shocked to witness the police opening fire on the unarmed demonstrators. "At that time, as far as I remember, there were more than twenty dead among the demonstrators in Berlin," Sternberg wrote. "When Brecht heard the shots and saw that people were being hit, he went whiter in the face than I had ever seen him before in my life. I believe it was not least this experience which drove him ever more strongly towards the Communists."[27] The Communists were, Brecht believed, the strongest forces against the reactionary parties on the right. They were also the most valiant supporters of the working class. As Sternberg wrote, Brecht "had hoped for 'leadership of the German left from below.'"[28]

Brecht's already pressing desire to connect his Communist leanings with the theater was made even more imperative by an ironic combination of articles in the newspaper just two days after the "Bloody May Day" he had witnessed. On the front page of the *Berliner Tageblatt,* there were two reports side by side: one about the violent riots in the working-class neighborhoods of Berlin; the other a prominent piece by Alfred

Kerr, who was attacking Brecht for plagiarizing the German transla-
tions of François Villon for the song lyrics in *The Threepenny Opera*.[29]
For Brecht, it was incredible that Kerr—whom he quickly dubbed the
"leading critic of this bourgeois epoch"—would be petty enough to
accuse the playwright of stealing intellectual property while unarmed
Communist sympathizers became victims of illegal violence.[30] It was
even more pathetic that so many of Brecht's enemies were equally
delighted by the implication that the playwright was nearly as much
of a bandit as Macheath himself. Brecht predictably didn't agree. He
had openly credited Kipling and Villon for some of the song lyrics,
but since Hauptmann had long been Brecht's gateway to works in
English, he was simply not in the habit of remembering the presence
of a translator at all. This was the reason he failed to acknowledge
K. L. Ammer, the man who translated Villon's French into German.
Brecht defended himself by admitting he had a "fundamental laxity
in the matter of intellectual property." But he went on to justify this
"laxity" to his enemies by insisting, with marked condescension, that
"it is the grand line of the drama that counted and that could never be
borrowed." Many prominent writers and critics were eager to weigh
in on the plagiarism controversy. Brecht's friend, the Viennese satirist
Karl Kraus, declared, "In his little finger with which he took some
twenty-five verses of Ammer's translation of Villon, this fellow Brecht
has more originality than that man Kerr who is stalking him." In con-
trast, Kurt Tucholsky quipped: "Who wrote that piece? It's by Bertolt
Brecht. Well, who wrote that piece?"[31] Brecht enjoyed his scandals but
wouldn't let anyone have the last laugh either. He soon silenced his crit-
ics by offering Ammer 2.5 percent of the royalties for all performances
of *Threepenny*. Even this small percentage amounted to a great deal of
money, and Ammer used it to buy a vineyard in Austria. He produced
a wine called Threepenny Drops (*Dreigroschentropfen*), which sold as well
as Ammer's suddenly popular translations of Villon. Brecht also con-
tributed a witty sonnet that served as the introduction to the new edi-
tion of Ammer's translations.

In Brecht's opinion, the critics' bourgeois concerns about the dis-
tribution of profits and rights were the by-product of a theater that
was cut off from the concerns of the modern world. Brecht hoped for a

time when it would be considered disgraceful to discuss the ownership of lyrics while policemen murdered citizens in the streets of Germany.

The violence Brecht witnessed put pressure on him to move more quickly on his path toward political theater. During that same week, however, even the more moderate Weill was clashing with right-wing politicians. To his horror, after the single and hard-won performance of *Das Berliner Requiem,* the radio station refused to schedule further broadcasts. In addition to quitting the radio journal, he also published a furious essay in a German newspaper protesting the narrow-minded behavior of the broadcasters: "The victorious spread of stupidity encounters . . . a dullness, an indecision, an apprehensiveness that also seem to be unique," he wrote. "This is the pleasant situation in which creative intellectuals are supposed to work in Germany today."[32]

Although they both wanted to address social and political themes in their work, Weill, unlike Brecht, did not believe his music could or should influence contemporary political events. Cultural transitions took time to establish, as Weill had always insisted, and when it came to the influence of culture on politics, even more patience was required. But if culture couldn't influence daily politics, then politics shouldn't exert power over culture. The only critical point, Weill maintained, was for the arts to flourish without censorship. He was therefore outraged that politicians who were disturbed by a pacifist song could influence the arts with such shameless measures. It was frightening enough to learn that air rearmament had been going on secretly since 1921, but it was even more disturbing that the hidden military build-up was permitted while a musical invocation of peace was forbidden. Germany was in danger of turning once again, and ominously, toward violent solutions to its problems. And because artistic freedom was both the cause and the effect of a healthy democracy, Brecht and Weill knew their work was more important than ever.

In this political climate, Brecht became increasingly uncertain about his plans for the rest of the year. He and Weill had long since planned another trip to Le Lavandou to work on the songs for *Happy End* and the as yet unfinished libretto for *Mahagonny.* These projects would be artistically rewarding, but ever since May, mere aesthetic satisfaction was by no means enough to satisfy the playwright's politi-

cal ambitions. As Brecht was speeding south from Germany to France in his beloved automobile, and metaphorically contemplating which path to pursue, he failed to see a large truck that was coming toward him. Brecht slammed on the brakes and swerved off the road, avoiding the truck but crashing into a tree. He broke his kneecap and the car was destroyed. If he had any reservations about either the commercial musical or the elite nature of opera, he was able to avoid both obligations in order to return to Berlin to see a doctor about his knee.

Brecht's Marxist beliefs, however, didn't alter his love for the Steyr. He promptly had himself photographed with the wrecked car and, with Hauptmann's assistance, wrote a story praising it as the safest possible vehicle in which to have an accident. Once this was published in the well-known magazine *UHU*, he was given another car. With the work on the song lyrics for *Happy End* and the libretto for *Mahagonny* postponed indefinitely, it can't have gone unnoticed by the composer that a story that garnered Brecht a new car was written immediately. By the summer of 1929, Weill decided he had gotten all he could out of Brecht, and the composer pulled together what he had and declared the *Mahagonny* libretto to be finished. His next step was submitting it to his publishers in the hopes of gaining Klemperer's acceptance.

The shifting priorities of Brecht and Weill were becoming increasingly difficult to overcome, but fortunately, there was one commission that could serve as a lightning rod for their higher artistic goals. They had been invited once again to Baden-Baden for the 1929 music festival. The theme was the influence of technology on mass media, specifically film and radio music. As a tool that brought culture into the everyday lives of regular people, the radio had always been significant to them both. And although the elite festival in Baden-Baden was perhaps not the ideal venue for Brecht's ultimate political goals, it provided him with the means to continue exploring the advantages of radio as a mass medium.

Weill wrote passionately about the radio: "Only radio can replace those more superficial formal concerts, which have become superfluous, by a worthwhile and really fruitful mass art: it alone can guarantee that widest dissemination which will produce the artistic public of the future."[33] In its earliest days, as Brecht had noticed right away, the radio encouraged more artistic freedom. There had been several

occasions where he was able to broadcast a play that theaters had initially refused to present. *A Man's a Man* was a case in point. But once politicians had recognized the power of the radio, the government did everything they could to control it, as the censorship of *Das Berliner Requiem* had unfortunately proven. What better time to defend the integrity of this revolutionary form?

Happy End perpetuated the magic they had begun to take for granted, but Baden-Baden provided the challenge that kept their relationship interesting.

For this particular commission, it was once again Hauptmann who offered the perfect subject matter for the task at hand. Her brief biography of the aviator Charles Lindbergh—whose flight across the ocean in 1927 symbolized the fusion of the human spirit with twentieth-century technology—became the basis for their piece. *Der Lindberghflug*, as it came to be known, honored the brave character of Lindbergh, as well as being "a celebration not only of the technological feat of the first airplane crossing the Atlantic, but also of the new technological media and their communicative potential."[34]

The story of Lindbergh reveals a courageous man who, plagued by bad weather and other misfortunes, perseveres through personal strength and ultimately survives by the grace of good luck. He battles nature with his belief in technology—his voice contrasts with the choir, which symbolizes many of his obstacles, including the fog that threatens to doom his flight. Brecht and Weill's play was, most of all, about the experience of listening to the radio, and it called attention to the machine itself in every aspect of its presentation. On the left side of the stage, there was a full orchestra and the singers in the setting of the radio station. On the right side there was a single character at home, listening to the music on an actual radio. The listener had his own score and performed the part of the aviator, singing to the broadcasted music from his living room. Thus the audience becomes a performer as the radio infiltrates his private space.

Der Lindberghflug made no judgment about the relative good or evil inherent in technology, nor was the aviator presented as a storybook hero. The work was meant to inspire a discussion of all these themes, and it led to a conceptual breakthrough for both Brecht and Weill. They called this new genre a "learning play" (*Lehrstück*), a form of the-

ater to which both men were instantly devoted. Such plays, Brecht insisted, were "valueless unless learned from. It has no value as art which would justify any performance not intended for learning." The *Lehrstück* fulfilled Brecht and Weill's desire, as Walter Benjamin phrased it, "to free the audience from its passive role."[35] Since Weill wanted to educate students to be the audience of the future, it was particularly important that the learning plays were not "recipes for political action" but were instead designed to introduce a critical way of thinking.[36] The composer was determined to perform *Der Lindberghflug* in as many schools as possible.

Brecht and Weill both saw the *Lehrstück* as a welcome antidote to the commercial success of *Threepenny* and thus renewed their idealistic artistic vows in Baden-Baden—the place where their partnership began. However cerebral their intentions, neither of them lost sight of the need to inspire learning in an entertaining way. The "lesson" embedded in *Der Lindberghflug* was cleverly placed within a witty and highly accessible tale of adventure and triumph. If *Mahagonny* had proven that popular music could entertain and even satisfy the erudite audience, two years later, the learning play about Lindbergh proved an even more important point: that popular entertainment can educate the masses.

Given that this step was so important for their partnership, how was it possible that another composer, Paul Hindemith—who was still one of the directors of the festival—was allowed to share the commission and actually compose almost half of the songs in the play? There was no doubt that the two composers were very competitive with each other—Hindemith was older and had been more prominent up until the resounding success of *Threepenny*. There was also no doubt that Brecht was aware of this rivalry and probably enjoyed the prospect of having them compete for his attention.

It's therefore likely that Brecht approached Hindemith, in part to irk Weill. And Weill also probably welcomed the opportunity to show he was not only the better composer in general but also unquestionably the only composer for Brecht.[37] Hindemith would have been surprised to see a letter Weill wrote to his publishers a full month before the festival: "The sections I have done (more than half) are so successful that I will [eventually] compose the whole piece, that is, including the

sections Hindemith is doing now."[38] Weill had dismissed Hindemith's contributions long before he even heard them.

Even the mathematical division of the compositions reeked of hostility. Hindemith composed five and a half numbers, and Weill did seven and a half for *Der Lindberghflug*.[39] In a tense tug-of-war over the entire piece, one song actually had to be split in half, and their very different musical styles rankled throughout. As the noted musicologist and Weill expert Stephen Hinton says, "Hindemith had 'abandoned' popular dance music, whereas Weill had assimilated it as an idiom . . . Weill was a man of the theater, Hindemith was not."[40] One famous reviewer compared "Weill's songlike, clearly declamatory compositions" to the "more descriptive, heavy music of Hindemith."[41] When it came to transporting the "learning" within the *Lehrstück*, Weill's dramatic sensibility clearly won the day.

Weill did his best to ignore Hindemith's participation during the festival and did everything he could to erase his role in the future. He staked his ground as Brecht's partner by quickly replacing all of his rival's songs with his own, and then convincing Klemperer to present his exclusive version at the Kroll Opera House by the end of the year. In a letter to his publisher, he wrote, "Baden-Baden was really shitty. Hindemith's work on *Lindberghflug* . . . was of a superficiality that will be hard to beat. It has clearly been proven that his music is too tame for Brecht's texts. What's amazing is that the press has discovered this as well, and they now present me as the shining example of how Brecht should be composed."[42] If Brecht had been asking for confirmation of Weill's devotion, he found it in the composer's ardent desire to reclaim all of the Lindbergh work. In return, Weill was gratified when the critics agreed he was the best possible composer for Brecht.

As the deadline to finish *Happy End* approached, both men were certain that they needed each other creatively and professionally. But they couldn't ignore the fact that this time they both felt very differently about doing a fun little play for Aufricht. Although it portrayed a dramatic encounter between the criminal underworld and the Salvation Army, and therefore gave Weill yet another chance to compose songs with his signature blend of musical styles—this time, popular melodies alongside religious hymns and marches—it still wasn't a step forward for the ambitious composer's plans to transform the opera.

Nor was it able to satisfy Brecht's post–May Day urgency to create a play that would make a penetrating social and political difference.

They never did get back to Le Lavandou after Brecht crashed his car. Instead, everyone assembled at Brecht's place in southern Germany a few weeks after the music festival ended. But very little was accomplished there. An increasingly impatient Erich Engel was waiting in Berlin and he sent angry letters to Brecht, demanding a complete play. The director seemed to ignore the fact that Hauptmann was the author of record and behaved as though her presence was just another one of the troublesome playwright's ways of avoiding Engel's demands. Hauptmann pointedly wrote Engel back on her own, answering his questions about the play—and only sending greetings from Brecht and Weill as a postscript. She called further attention to her presence by writing to him with a thick pink pen, its crude line resembling a crayon, an implement that Brecht would never have used.[43] Engel refused to take the hint.

The atmosphere of creative discovery that had energized Brecht and Weill on the beach as they wrote *Threepenny*—not to mention the sheer spirit of fun—was markedly absent on the shores of the cold Bavarian lake. They had once thrived off each other's company as they composed songs together—this time, the difference in their working methods irritated both of them. It was as if they needed an infusion of the Provençal sunshine to keep the magic alive.

Weill got tired of waiting and left Ammersee before Brecht and Hauptmann. Back in Berlin, Lenya observed her husband's impatience, as well as Engel's mounting fury over the missing third act, and was happy she was too busy to be involved with *Happy End*. In addition to playing both Lucy and Jenny in occasional performances of the extended run of *Threepenny,* she was also performing in Georg Büchner's *Danton's Death.* From her safe distance, she was perhaps the first to sense the disaster looming on the horizon.

There was, however, one song she knew she could have sung better than anyone else. That was "Surabaya Johnny," whose haunting music she heard her husband composing day after day. The music was entirely new, but, like "Pirate Jenny," the lyrics came from a song that Brecht had written years earlier for Lion Feuchtwanger's play *Kalkutta, 4. Mai,* which was set in India.[44] Surabaya is the name of a Javanese

city that had enticed Brecht with both its lyrical sound and its meaning. The name recalls an important native legend about a battle between a shark (*sura*) and a crocodile (*baya*). As an important center of trade, the strategically located Surabaya was mired in conflict for centuries—Islamic, Hindu, and ultimately Dutch colonial powers all attempted to dominate the region. By using the name of a Javanese city in a play located in Calcutta, Brecht was harking back to the Hindu Empire that dominated Surabaya for two centuries. The colonial strife invoked by the name was suggestive once again of Kipling's territory, and the lyrics are loosely based on one of his ballads, "Mary, Pity Women!" And of course, where there's Kipling, there's Hauptmann, and this clear homage confirms her participation in its lyrics. Once again, Brecht and Hauptmann pooled their resources to create a song with a rich blend of influences, one whose universal message about scoundrels and wronged women could be plucked from one show and revised to suit another. Brecht had been accused of stealing from others, but the truth is that he stole most often from himself. These particular robberies were often among his most memorable song lyrics. The poet in Brecht had a genius for recognizing the eternal qualities of a work of art—especially in his own creations.

The song tells the story of a betrayed young girl who sings of her love and hatred for Johnny—a sailor who cheated her blind. Brecht had written it in 1925, but it was made to order for Lenya.[45] Weill knew right away that "Surabaya Johnny" was something special, and since weeks had gone by and Brecht still hadn't returned to Berlin, Weill hoped to lift everyone's spirits by playing it for Aufricht and Theo Mackeben. The producer looked forward to hearing Weill play something upon which to pin his hopes. Aufricht was trying to stay calm, daily reminding himself of the success that the Brechtian chaos had delivered a year ago.

As they assembled in the Schiffbauerdamm to hear "Surabaya Johnny," it was reminiscent of the time when Weill first convinced Aufricht with his songs for *Threepenny*. They were on the same stage, with the same piano, and with nearly the same audience. Aufricht was there with his wife, Margot, as well as Heinrich Fischer, and there was great anticipation in the air. Even the first four notes of "Surabaya Johnny" were familiar, because they were the same as those that began

the "Moritat of Mack the Knife." Weill was clearly as great a recycler as Brecht when it suited his purposes.[46] And the mischievous reminder of the legendary Casanova Macheath was a very effective introduction to the plight of the betrayed young girl.

But this time, the composer was not auditioning, and Mackeben was his devoted arranger rather than his competition. And Weill hadn't gotten much farther than those famous four notes when Mackeben shouted for him to stop, snatching the sheet music off the piano. "Give it to me!" he cried. "This music is being shamed by your playing!"[47] Mackeben was a great concert pianist, and Aufricht smiled at his impatience. Weill's playing never could do justice to his own compositions.

The song was for the leading lady, a Salvation Army officer named Lillian Holiday. She is an even more innocent version of Polly—but unlike Polly, Lillian's purity has religious overtones, and therefore she has farther to fall. Brecht planned to use this song in the same way as "Pirate Jenny" in *Threepenny*—that is, as a "side song" that had nothing to do with the plot of the play. The Salvation Army officer would expose her knowledge of seamier worlds when she sings the song, and thus illuminate her personality rather than advance the story. Aufricht was indeed heartened. With songs like that, he could not fail. But still, no Brecht, no third act, and Hauptmann wasn't answering Engel's letters anymore.

It was Weill, so accustomed to Brecht's stalling tactics, who finally figured out a way to bring Brecht back to the Schiffbauerdamm. He told Aufricht and his wife to go with Lenya to a resort on the Baltic Sea. Before leaving, he should send Brecht a cable saying he is canceling the show and going on vacation. The producer did as he was told, and two days later, he received a cable from Brecht. "The third act is ready," Brecht wrote, adding that he was back in Berlin and ready to rehearse. "We sped back," Aufricht remembered. "Lenya and I traded driving every hour."[48] Only when the theater was about to go dark would the playwright leap into action.

On August 19, two weeks before opening night, Brecht had installed himself at the Schiffbauerdamm. Most of the cast was in place, but he had lied about having a completed third act. And his situation was further complicated by his obligations to the various actresses in the

production. Weigel, his wife, was playing the only female gangster, who was also the leader of the gang. Carola Neher, still his lover, was the leading lady, Lillian Holiday. It was officially Hauptmann's play, but very little was in her control. "The atmosphere seethed with jealousy, and Brecht presided over it with superb tact . . . He was careful to see that both mistresses had equal roles in the play," Lenya observed on her infrequent visits to the theater. "There were the three women: Hauptmann the shadow, Neher, sexy and talented, which unquestionably fascinated Brecht, and Weigel, deeply in love with Brecht, knowing him better than anyone ever has, or ever will, determined to wait her turn."[49] But no amount of Communism or bohemian beliefs, Lenya knew, could suppress the jealous passions that were sure to erupt on the stage.

Engel harbored no hopes that the return of the contentious playwright would bring peace or calm to the rehearsals, but he had expected some version of a complete play with which to work. When Brecht began changing the already existing text, the director stormed into Aufricht's office and tried to get out of his contract. Aufricht begged him to be patient, but only two days later, Engel put his ultimatum in writing: "I grant the following concession: In the next days, I will attend the rehearsals. My final decision will depend on how relations will develop during these days . . . This will depend on how the final act and all the other edits turn out, all of which, despite promises made, have still not been sent to me . . . It is your duty as director of the theater to shield me from Mr. Brecht's inappropriate behavior . . . I am not going to be subject to any further outbursts of Mr. Brecht's intolerable and aggressive behavior."[50] Despite Brecht's lack of enthusiasm for the project itself, once he watched *Happy End* onstage, he became obsessed, as he always did, with making the play as good as possible. He didn't care if his constant changes forced everyone else—composer, designer, and director—to revise their own work under extreme time pressure.

When Engel finally quit, Brecht characteristically found motives for the resignation that had nothing to do with his own behavior. He wrote to Engel: "I quickly realized that you'd accept the play as finished, if it would cost you money not to accept it . . . You'd take the text as the right text, you as the right man for the text, as soon as

another opinion (yours, earlier) would mean losing money. I don't consider you greedy for money, but a passive dependence on money (and also maybe prestige) would be enough to make you unqualified for responsible intellectual work." Brecht didn't tolerate betrayal in any form, and although he and Engel had worked together for many years, he ended their collaboration in the same letter, dated only days after the director walked out of the Schiffbauerdamm. Brecht took over the direction—closely consulting, as he always did, with experienced colleagues who were loyal to him.[51]

Although Weill didn't believe, as Aufricht needed to believe, that such mayhem was a precursor of success, he nevertheless remained calm during the ferocious upheaval his partner was causing. The composer had known for some time that *Happy End* was not very important to Brecht and had made his calculations accordingly. This time, he began marketing the songs even before the play premiered. His experience with *Threepenny* had made it clear that there was an entirely separate life for his theatrical numbers—and he was, as always, pushing his publishers to promote them in advance. In this way, Weill felt he was protecting his own interests regardless of what Brecht did to the play itself.[52]

On an artistic level, however, Weill could not be angry with Brecht for treating *Happy End* as a kind of stepchild—because he felt the same way. It was an attempt to repeat the success of *Threepenny,* and few genuine artists wish to repeat themselves, especially when they are at the peak of their creativity. If Brecht was more concerned with bringing his theater in line with his intellectual and political goals, Weill was equally passionate about bringing his new audience into the opera house. During the rehearsals for *Happy End,* Weill was far more concerned about the looming contract with Klemperer at the Kroll Opera. Klemperer had remained a loyal fan of Weill's work—presenting the concert version of *Threepenny* as well as accepting *Lindberghflug*—but official acceptance of the *Mahagonny* opera was oddly stalled. Because *Mahagonny* would establish that Weill was an opera composer through and through, he believed his greatest work with Brecht was yet to come. Weill had pursued the opera's performance possibilities on his own, without Brecht's interest or participation, but he still hoped to pull him back in once he had a contract with Klemperer. Therefore,

even if his partner was irritating everyone else, Weill refused to allow himself to be pulled into the fray.

Hauptmann kept a low profile as Brecht dominated the rehearsals. She had in the meantime decided once again to use a pseudonym and credited the play to a fictional Dorothy Lane. And although this didn't necessarily indicate her lack of faith in the troubled production, it was certainly proof that she wasn't using *Happy End* to launch her theatrical career. She had accepted the challenge of writing the play as a way of accepting Brecht's gesture of faith in their relationship. She did it because she loved him and believed in the theater they would ultimately create. For her, *Happy End* was a symbol of what bound them together.

The actors had the impression that most of the play was written during rehearsals. And even those familiar with Brecht's ways, including Kurt Gerron, who'd played both the organ grinder and Tiger Brown in *Threepenny*, were astounded by the constant revisions that seemingly knew no end. In addition to Brecht's lover and wife, the distinctly Brechtian cast also included Theo Lingen, the actor who had married the playwright's first wife. Brecht had vowed never to forgive Mar for letting their daughter spend time with a man he disdainfully dismissed as a "comic" and who he once feared was a danger to his child, but he had clearly changed his mind.[53] Lingen had quickly become a regular in Brecht's ensemble of actors: He had played a part in one of Brecht's learning plays in Baden-Baden and was also in the second cast of *Threepenny*.[54] According to Lingen, "When Helene Weigel was there, Brecht gave most of the new lines to her; when she was absent, Carola Neher got the bulk of the dialogue. [We] were sitting around most of the time, waiting. We had mounted a large old ball on a wooden stand with strings and whenever a new line was born and distributed, we pulled the strings and raised our ball to show them that we were still alive, hoping for some crumbs from the rich man's desk."[55] Lingen kept his sense of humor, but as the days wore on, Gerron finally exploded. When he demanded more lines, Brecht responded furiously: "'You fat-assed clown. You abortion! If you lost weight, you'd be unemployed!' Gerron shouted back: 'You should have written a play, instead of shitting all over the stage.' Brecht [answered], 'I demand that this man be disciplined immediately. Otherwise I'm leaving.'"[56] At one point,

the actors were so enraged that Aufricht and his assistants feared that Brecht would be physically attacked. "What rescued him from a severe beating was a band of gauze between the footlights and the orchestra pit that would have been torn and rendered useless by the assault. A piece of theater property, sacrosanct even in a moment of frenzy."[57]

What had begun as a lighthearted romp had become almost impossible to finish. And the complexities that arose could not be explained simply by the fact that Brecht and Weill were distracted—after all, a genre piece like this should have been possible even without their full attention. But only Weill was prepared to embrace the chance to practice their unique form of musical theater on its own terms—Brecht was no longer able to do so. He could not accept that *Happy End* might also attract those stinging words that the Communist Party newspaper had used to describe *Threepenny:* "not a trace of modern social or political satire."[58] He was twisting and turning in rehearsals, still hoping to catch the audience mid-laughter and triumphantly activate their critical senses.

The ingredients for social satire were all there. By the end of the story, the greedy, murderous gangsters and the cash-strapped Salvation Army officers form an alliance based on stolen money. This union is first ignited when the leading lady, the purest of all Christian soldiers, falls in love with the worst of all the gangsters. Their implausible pairing was followed by others, until several members of the criminal gang end up being engaged to the religious zealots. Probing beneath this comical surface, Brecht was determined to show that the Salvation Army soldiers and the gangsters were allied not only as profit-seekers but also as powerless entities in capitalist society. During rehearsals, he realized that this anticapitalist point wasn't proclaimed loudly enough. The same kind of indecision that had plagued him on *Threepenny*, when he was shouting for a horse, had reached a crisis point. And much to everyone's chagrin, he and Hauptmann came up with a solution at the last minute. Since the secret text was given to Weigel, she was the only one who had been told in advance.

On the evening of September 2, the Schiffbauerdamm was full to bursting with an audience that had adored *Threepenny*. As the audience reveled in the first two acts—swooning especially to "Surabaya Johnny" and delighting in the satirical story about gangsters and

Christian soldiers falling in love with each other—they enjoyed them-
selves once again in a way that made them feel sophisticated and smart.
But by the time the embattled third act arrived, the smiling spectators
quickly understood that Brecht had lured them into the theater with
the full intention of holding them hostage to his political message.

And being held hostage is precisely how many in the audience felt
when Weigel, in the role of head gangster, pulled a piece of paper out of
her pocket and began to read the speech that had been hastily written
by Brecht and Hauptmann, and that had very little to do with the rest
of the play. No sooner had the gangsters fallen into the arms of the Sal-
vation Army officers, than the Fly, as Weigel's gangster character was
called, turned all too serious: "Our two groups have been fighting the
same enemy all along," she proclaimed. "It's time to forget our little
quarrels and stand together. Blasting open a safe is nothing—we've
got to blast open the big gang that keeps the safe locked . . . Robbing a
bank's no crime compared to owning one! The world belongs to all of
us."[59] The blatantly Communist slant of the speech was a paraphrase
of Karl Marx and instantly altered the character of the play, as musi-
cologist Stephen Hinton writes, "from light entertainment to political
rally . . . The play had abruptly turned into a vehicle for a hard-hitting
point of materialist social critique; the truly successful criminals are
the big corporations . . . three of whom the finale celebrates in person
as 'saints.' "[60] Large portraits in stained-glass windows, which came
down for the final act, revealed those saints as Henry Ford, John D.
Rockefeller, and J. P. Morgan. The final number was "Hosannah
Rockefeller," whose melody conjured up American dance music. Even
without the speech, the stained-glass windows of these entrenched cap-
italists, combined with the popular American music, would have been
a strong indictment of corporate greed, but Brecht, Hauptmann, and
Weigel clearly didn't think it was harsh enough.[61]

The Berlin audience shouted and whistled their displeasure. They
had caught Brecht cheating with a last-minute political pretension—a
pretension far more shallow than the entertainment that had at least
delivered what it promised for the first two acts. Unlike the expected
scandal in Baden-Baden, this time Brecht didn't give whistles to his
performers. Not least because, other than Weigel, all the actors had
been blindsided by the speech as well.

The critics were as displeased as the audience. Kerr, always ready to lead the pack, declared, "In this play, which comes from Brecht's workshop and from the workshop of a lady who may or may not exist, Brecht copied from himself. A few nice ideas. Some charming music. But sometimes the height of stupidity . . . The brilliantly articulate Frau Weigel was declaring, no: reading from a piece of paper, at the very end of a dwindling evening, a quick note of social critique. Carelessly stuck together . . . That was the worst. That was the absolute worst."[62] Even Brecht's champion Herbert Jhering couldn't defend him. He clarified the problem best of all: "Repetitions don't work. One can either elaborate a certain position, or transcend it. Doing both at the same time is impossible."[63] Jhering believed that *Der Lindberghflug* signified Brecht's artistic future. Brecht no longer needed to camouflage his serious intentions behind the façade of light entertainment.

Brecht once again had to suffer the humiliation of a bad review in *Die Rote Fahne:* "Everything in this 'witty' and ethically propped-up mush is fake . . . Whoever wants to find the cheapest rhymes and most trite sentimentalities, should look no further than Brecht. You can be dead sure that nut (*Nuß*) rhymes with kiss (*Kuß*) and '*Kuß*' with pleasure (*Genuß*)."[64]

After the disastrous run of *Happy End,* Weill quickly defended his own part. "We must not be misled into trivializing what was achieved through *Die Dreigroschenoper,*" he wrote his publishers, "achieved not only for my music, but for musical life in general—just because some of my new works happen to be badly mounted in a bad play."[65] But Weill wasn't sorry when the play only had twenty-four performances—four weeks total.[66] He did feel sorry for Aufricht, who lost 130,000 marks, but the sooner *Happy End* disappeared, the better for the composer. He feared it would give the "snobs" yet another opportunity to label him as a popular songwriter, and he was having a hard enough time convincing Klemperer to accept the unusual *Mahagonny* for the Kroll Opera House.

Happy End was a hiccup. Both composer and playwright were eager to see it go.

Brecht had been in too much of a hurry. He rushed because Germany was changing and he feared the rapid shift toward violence that he had witnessed earlier in the year. His fears were realized. In the

weeks following the premiere of *Happy End*, the entire world began to fall apart. It began on October 3, with the death of the brilliant foreign minister Gustav Stresemann. With his passing, "Germany . . . lost the statesman who, single-handedly, had been doing the most to restore peace among the nations."[67] Two weeks later, the U.S. stock market crashed. This of course had a direct impact on Germany, whose post-war financial recovery was entirely dependent on loans from America. And since the United States immediately recalled any money they had in Europe, the continuation of future loans was impossible to maintain.[68] In short order, the collapse had a catastrophic effect on world trade, and an additional 2.5 million Germans rapidly joined the roster of the unemployed. For those on the right who had despised the humiliation Germany had suffered in the wake of their military defeat, these tragic events reinvigorated their political cause. The National Socialists were especially capable of exploiting hard times in order to recruit the masses. As Weill had already experienced with the radio, the rightward slant of parliament had begun to cause artistic censorship and the situation rapidly became worse. From one day to the next, financial support for cultural expcriments was greatly reduced. Berlin's fevered creativity was the first to suffer from the sudden eruption of intolerance. The impact was felt everywhere, especially the theater and the opera house.

By the time Emil Hertzka read the completed version of *Mahagonny*, his personal misgivings were compounded by the increasingly conservative sentiment in the country. He implored Weill to tone down the more salacious elements of the opera. A particularly offensive scene took place in a brothel, where three men would go together to enjoy the services of one prostitute. Erotic pictures were to be projected in the background as the madam issued instructions: "Let the tips of your fingers / Stroke the tips of her breasts / And wait for the quivering of her flesh."[69] This was simply not acceptable even for Klemperer's progressive opera house. Weill agreed to revise the scene so that only one customer was served at a time, and to omit the most offensive dialogue. He also enlisted Brecht's help, one last time, to compose lyrics for a new song.

It was titled "Cranes' Duet," and it was a sincere love song that attempted to soften the sexually explicit portrayal of prostitution. The

song portrays a romantic relationship between the main characters, who first meet at the brothel, and offers at least the possibility of true emotion underlying a clear business transaction. The music and lyrics are beautiful and unabashedly romantic, and this time the signature contrast between Brecht's words and Weill's music is not present. The song compares lovers to birds, and as they soar through sun and moon, "In one another lost, they find their power." In one another lost, prostitute and customer can, perhaps, fall in love.[70] The song succeeded in making one of the most provocative scenes more palatable, and the beauty of the song was once again proof of the invincible power of Brecht and Weill's combined talents. Even when writing a song that was infused with just the kind of compromise that Brecht despised, the alchemy still thrived. For although Weill believed that the "Cranes' Duet" was a creative solution rather than a compromise, Brecht was still wary of love stories. He had been dismayed when the so-called romance in *Threepenny* had distracted the audience from its social message, and the addition of the song was yet another decision that made Brecht wary of the opera as a whole.[71] The composer's zeal convinced Brecht to make this last contribution in the fall of 1929, but from then on, Weill would once again be alone in fighting for *Mahagonny*.

Once *Happy End* closed, Brecht was more determined than ever to create plays whose political depth and impact were clear beyond a shadow of a doubt—whose call to action was not sullied by commercial trappings or diluted by conservative pressures. His social conscience, and his ability to work on less profitable plays, was made possible by the fact that both his and Weill's wealth was rising in direct opposition to the sudden downward shift of the times. Their advances and *Threepenny* profits were increasing as millions of Germans were losing their jobs.

Hauptmann's devotion to political theater was equal to Brecht's, and since the failure of *Happy End* was partly due to the explicitly Marxist message delivered at the end, she had not seemed disappointed that her first play had been a commercial and critical flop. Given Hauptmann's signature modesty—as well as her sense of humor—she wanted neither credit for the play's success nor blame for its failure, and might even have been gratified to read that Kerr questioned her very existence. Shortly after the play closed, she began to pull *Happy End* apart

and used its parts for another "Brechtian" project: *Saint Joan of the Stock-yards*. This was to be another learning play, a form she believed would truly unite her political and theatrical goals. In order for Hauptmann to fulfill her best vision of herself—as a woman who cared more about society and politics than her own personal gain—she was willing to ravage her failed play for another one that would bear Brecht's name.[72] She continued to spend just as many hours in his studio on Spichern-strasse, but she did decide to separate her personal life from her work in one significant way: She finally moved to an apartment of her own.[73] By the end of the year, only Weigel was still living in the same place as before the success of *Threepenny*.

Weill's and Brecht's reactions to the success of *Threepenny* had begun to reveal the distance between them. The failure of *Happy End* made those differences even harder to ignore. Weill was eager to transform the opera so that it appealed to a modern audience, while Brecht was only interested in a theater that provoked rapid political action. There was a place in between—the place the learning play fulfilled—where they could happily meet. And since another such project was already in the works, the value of their artistic collaboration still outweighed the tensions that had been brought to the surface. But not for long. For as the world around them was heading for darkness, so was their peaceful coexistence. They had to rush, and rush they did—as if they knew what was coming, from within and without.

Weill knew his partner was the best playwright and poet in the country—as long as he could control him.

Brecht knew that Weill was the best composer he had ever known. But as a man who was highly attuned to professional domination, the playwright already knew he couldn't control his partner for much longer.

If Someone's Getting Kicked, It'll Be You

Brecht came rushing into the town of Leipzig in a state of aggravation. He was far too busy to be dealing with *Mahagonny* once again, a project that had already cost him so much time. But although Brecht had never been as enthusiastic as Weill about turning their short *Songspiel* into a full-length opera, the playwright was incensed to hear that his composer was treating *Mahagonny* as if it were his own. This sideshow of Weill's was getting far too much of the wrong kind of attention—it was only an opera after all.

Brecht stormed past the nineteenth-century building whose columns soared skyward over the majestic town square. He tore open the door of the Leipzig Neues Theater and glanced disdainfully at the imposing array of paned glass windows. For the defiant Berliner who had dared to hang a piece of spray-painted burlap on a wire and call it a curtain, entering this stodgy opera house was like stepping back in time. Had Weill forgotten who they were?

When Brecht entered the theater, the first thing he saw was Weill's distinctively broad forehead just barely clearing the top of the orchestra pit in the distance. The composer was deep in conversation with the conductor, Gustav Brecher, and the director, Walter Brügmann, as the musicians took up their instruments and began to play. Brecht

assumed an aura of command as he walked down the broad aisle toward his partner, and he was struck not only by the enormousness of the 1,700-seat house but by the fact that so many classical musicians were playing what sounded like far too grand a version of the music he once knew so well. Although Weill's orchestra of thirty musicians was small by comparison to most operas, Brecht still felt that their bravely simple beginnings in a boxing ring in Baden-Baden were very far away.

When Brecht looked up toward the stage, he was further stricken to see his oldest friend, Caspar Neher, cheerfully building the set on his own for *Rise and Fall of the City of Mahagonny*.

Brecht was most pained to observe the pronounced respect the conductor and director both had for the composer. Acutely sensitive to body language, the playwright noted the thoughtful nods and the approving smiles that flashed between the three men and immediately understood that the chain of command would make it impossible for him to interrupt or intimidate in his usual way. In an opera house, Brecht was reduced to a mere librettist, and Weill was, for the first time in their partnership, in complete control. When Brecht reached the lip of the orchestra pit, the composer, who had surely noticed Brecht's arrival, greeted his partner with an exuberant expression. This time, Weill clearly rejoiced, Brecht wouldn't be able to add a last-minute speech without gaining the composer's permission. After all the months of hounding Brecht about the libretto, suddenly Weill didn't seem to be craving the poet's input at all.

Brecht knew that Weill's conquest of *Mahagonny* had nothing to do with the petty desire for revenge over the ruined musical play. It was far more serious than that. In realizing his dream of creating a grand opera, Weill was dismissing his playwright altogether. It was a stinging rejection, especially since the composer was claiming custody of the work that first brought them together, a work that had once belonged so distinctly to Brecht. With that dismissal, a partnership once defined by mutual artistic goals and equality had suddenly and retroactively become a series of separate collaborations geared toward Weill's interests alone. Brecht was now one of the composer's writers.

In fact, once the impatient Weill had finally given up on getting more work out of Brecht, he had even written the occasional lyric on

his own. The story of the city of Mahagonny, for example, had been elaborated to include a hurricane that threatens to destroy everyone.[1] In the end, it passes them by but ravages other cities. Weill remembers: "When the hurricane was coming [in *Mahagonny*], I got out a map and looked for places for it to hit. I found Pensacola. It was a marvelous name for a city to be called by a hurricane in an opera. I built up the whole chant around it—Pensacola, Pensacola, Pensacola, *wham!*"[2] Weill had learned much from Brecht's (and Hauptmann's) techniques, most especially the way they picked the name "Alabama" for the beauty of its sound.

"Music has more impact than words," Weill confided to a fellow composer. "Brecht knows it, and he knows that I know. But we never talk about it. If it came out in the open, we couldn't work with each other any more. Brecht asks for complete submission. He doesn't get it from me but he knows that I'm good and that I understand him artistically, so he pretends that I'm utterly under his spell. I don't have to do anything to create that impression. He does it all himself. And I don't care. He's still a brilliant guy."[3]

Brecht would have fiercely denied knowing anything about the superior power of music. But he was most incensed by the presumption that his contributions would be subservient to the artistic goals of another person. This was a characteristically Brechtian point of view, one that permeated all his professional and private relationships. Despite his own inability to be loyal, he never could tolerate infidelity in any of his women; in the same way, Brecht would not have understood if Weill objected to his occasional interest in another composer.[4] Brecht freely admitted to defining equality on his own terms, but it was a surprise to discover that Weill had been doing the same thing all along.

Ever since Weill began to adapt the *Songspiel* into a full-length opera, he had assumed that Brecht's poetic gifts would ultimately serve his musical goals. When Emil Hertzka, his publisher, had warned him about the difficulty of transforming a domineering writer into a librettist, Weill had discounted the threat. He assured him that the opera he wrote with Brecht "is the first libretto in years that is fully dependent upon music, and what's more, for *my* music!"[5] If Brecht had spent the last three years assuming that Weill was working for him, the com-

poser had also convinced himself of something equally implausible: that he had Brecht's agreement to adjust the text for Weill's musical specifications. "There are no grounds whatsoever for the frequently voiced fear that any collaboration with literary figures of real stature must make the relationship between music and text into one of dependence, subordination or at best parity," Weill had written confidently for a music magazine that Brecht clearly never read. "The more powerful the writer, the greater his ability to adjust himself to the music."[6] They were three years into their partnership and Brecht had only just learned that Weill allowed himself to believe that the writer was "adjusting" his text to suit the composer's needs. Brecht knew, and had been certain that his composer knew, that he was not only unwilling but was also incapable of such adjustments. Until this moment, Brecht had never given a second thought to what had happened after he continued to delay their meetings about the opera. He had never quite admitted that after his car crash in France, they had barely discussed it until Weill requested lyrics for the "Cranes' Duet." As soon as he entered the opera house, however, Brecht realized that Weill had continued on his own, adjusting the libretto for his own musical purposes.

When Brecht's and Weill's eyes met in the opera house, there was no longer any doubt that the composer's true feelings about the power of music had "come into the open" at last.

Weill had every reason to feel triumphant as he rehearsed the orchestra in Leipzig. He had fought long and hard, and alone, to get the opera mounted, and he had certainly noticed that in the many months that elapsed since the opera had been completed, Brecht had never inquired once about its progress. Weill, in the meantime, had written hundreds of letters to his publisher and made constant revisions in the hopes of garnering Otto Klemperer's approval. But the long-promised deal had never actually worked out. After Weill played the third act for the eminent conductor, and despite the fact that the music impressed the other officials at the Kroll Opera House, things took a surprising turn. Weill described the scene to his publishers with biting sarcasm: "Two hours later Klemperer called me at my apartment to say that he wanted to come by to see me right away. He arrived in a state of absolute despair and declared with tears in his eyes that he had now spent two hours wrestling with himself, but that it was impos-

sible; he acknowledged the importance of the whole thing, he recognized the musical beauties, but the whole thing was foreign to him and incomprehensible."[7] For Klemperer, its message was too savage, and the story was too unrelentingly tragic. Weill had been first devastated and then furious over his wasted efforts. The composer worked unstintingly until the Leipzig Neues Theater finally accepted the piece.

The *Songspiel*, which balanced the scandalous with the entertaining, had delighted Klemperer in Baden-Baden. But where the shorter piece hinted at the folly of a society consumed by hedonistic pleasures, the full-length opera portrayed, far more graphically, the horrors of life in the city. The *Songspiel* ended when the inhabitants of Mahagonny were condemned to remain in the hell that they had created; the opera would force the audience to endure a lengthy and visceral stay in hell.[8] It was the prolonged and detailed nature of that experience, so different from the first thirty-five-minute version, which was daunting to Klemperer and others.

In the opera, the main character was still the city of Mahagonny, but the anonymous people in the shorter work became clearly delineated in the full-length version. Three founders of the city are introduced as fugitives on the run from the law.[9] They create the city of Mahagonny, and with the help of four prostitutes who are eager for work, hope to become rich by ensnaring sinners who come their way. Four lumberjacks soon arrive, fresh from seven years in freezing Alaska, with their pockets full of money. They are happy to spend it all on sex, gambling, and whiskey. According to the reinvented laws of Mahagonny, the only real sin is running out of money, and anything that can be paid for is permitted. The characters are driven by their most primitive desires and lack any sense of morality or principle. They simply experience one pleasure after another—eating, fornicating, fighting—until they arc destroyed by them. Crime, sex, and violence occur regularly and realistically on the stage. The characters have no power over their own fate, and they have no fate separate from that of the city as a whole. Although the possibility of love is offered in the "Cranes' Duet," no true emotion can thrive for long in this harsh territory. The opera was intended as a parody of contemporary life, one that portrays the weaknesses of men against a backdrop of modern society. In the full-length *Mahagonny*, hell on earth was no longer a metaphor about the future.

Instead, the materialism and hedonism it exposed was a crushing fact of the infinite present. For Weill, *Mahagonny*, with its raw depiction of the underside of the human condition and its experimental storytelling structure, exemplified what a modern opera could be.

Weill's editor, Hans Heinsheimer, was one of his few colleagues who had been genuinely thrilled with the opera: "Here, dear friend Weill, is what I've been waiting and frequently calling for, namely, the synthesis between the melodic and rhythmic wealth of your fantasy . . . now that . . . successful popular works have freed you from literary and artistic thickets, you must once again create works of lasting value that aren't written just for the moment to accompany plays, but which once again adhere to the grand path."[10]

It was fortunate that Brecht was not part of this conversation, since he would have been offended by Heinsheimer's distinction between the lasting value of Weill's opera music and the ephemeral quality of music written "just" for plays. But even more important, Brecht's definition of the "grand path" would have been entirely different, and would certainly not have included the opera.

Since its provocative content had made it almost impossible to get *Mahagonny* produced, Weill thought it was absurd that Brecht would view it as an elitist opera in danger of supporting, rather than bluntly criticizing, the values of bourgeois society. And if Brecht nevertheless objected to the grand venue in Leipzig, Weill would have countered that *Mahagonny* would stir up enough controversy to capture the interest of the "people" who would formerly never have dreamed of entering an opera house. "Only opera still persists in its 'splendid isolation,'" Weill had once written so passionately to his publisher. "The operagoing public still represents a closed group seemingly removed from the large theatergoing public . . . there is no other artistic form in the entire world whose bearing is so unabashedly engendered by established society . . . If the bounds of opera cannot accommodate such a rapprochement with the theater of the times, then its bounds must be broken."[11] *Mahagonny* was breaking those bounds. And wasn't that the point of democratic art: the accessibility of all genres to everyone?

Mahagonny, Weill insisted, was concerned with universal themes. It exposed the consequences of uninhibited greed and lust, and it did so without apology or forgiveness. But although the opera was not

intended as a political statement of any kind, the composer still had good reason to fear a political reaction. Not long before the premiere, Weill happened upon a Brownshirt rally and was surprised to hear his own name mentioned, along with Albert Einstein and Thomas Mann, as being "among the dire forces threatening the country."[12] So Weill was aware that the hostile Brownshirts would likely believe the sins in *Mahagonny* were being promoted rather than parodied, and that their attack on the opera would be fierce. This was only further proof, Weill insisted, that the freedom of the arts and of artists was vulnerable to the increasingly powerful conservative presence in Germany.

A howling mob of Brownshirts was frightening enough, but the behavior of government officials further exemplified the nation's rush toward ignorance and intolerance. In January 1930, as the economic crisis spiraled out of control, the authorities became increasingly alarmed by the strikes, demonstrations, and street fighting all over the country. "A decree against radicals . . . ensured that state employees deemed unreliable could not become civil servants."[13] The vague definition of "unreliable" gave politicians a chance to deny work to anyone of whom they did not approve. It also set the precedent for more stringent decrees, including the frequent prohibition of "immoral" theatrical performances and increased censorship of works even before they hit the stage. In this new climate, Marieluise Fleisser's *Pioneers of Ingolstadt* would probably not have made it past its first performance.

A right-wing campaign against *Mahagonny* began directly after the Neues Theater announced its decision to accept the opera. Given the response, it is hard to believe that Brecht didn't think the opera was political enough. "Irate letters protesting the performance of a communist propaganda play came pouring in. Threatening phone calls accused the administration of giving in to the pressure of the international Jewry . . . Anti-Semitism and anti-communism were the two great vote-getting issues of the ultra-Right and any work with liberal tendencies was immediately labeled Jewish or communist."[14] This blatant display of prejudice was yet another result of the economic turmoil wreaking havoc all over Germany. The violent demonstrations of the unemployed and underpaid inflamed the right and inspired a ferocious nationalism, the likes of which hadn't been seen since before the First World War. Identifying a threat as being Jewish or Communist—that

is, un-German—became the knee-jerk conservative response to anything that frightened them. They used any means possible to categorize their enemies, and all modern artists were quickly labeled as Jews or Bolsheviks, or both. No one was "just" a rebel anymore.

Weill made several additional revisions in order to ensure that the opera house wouldn't capitulate to the hostile campaign and cancel the production. As with the "Cranes' Duet," the composer was once again vulnerable to the accusation of compromising the work, but he staunchly defended the artistic value of every change he made. There was, for example, the decision to change the names of the characters in the opera. The original use of American names, such as Jimmy, Jack, and Fatty, had been done in a spirit of fun—a nod to the melodic and popular style of the *Songspiel*—but were never, according to Weill, intended as a specific reference to American society nor did they offer a symbolic critique of capitalism.[15] But in 1930, the charged nature of the times created a situation where anything that could be vaguely construed as anti-American was quickly assumed to be anticapitalist. By further distortion, anything that was anticapitalist was defined as Communist propaganda. Thus, the mere existence of a man named Jimmy engaging in immoral activity on the stage could lead to the entire opera being labeled a Bolshevik conspiracy. The speed with which these absurd accusations flew was the strongest indicator of the civil unrest that was igniting the country. The National Socialists exploited that fear as best they could. But Weill's decision to make the change had nothing to do with politics, he insisted. Changing the names was something he had considered doing months before the opera had been accepted: "Since the human pleasures which are to be had for money are everywhere and at all times the same," Weill wrote, "and since the pleasure city Mahagonny is international in the widest sense, the names of the protagonists can be altered to suit the appropriate land."[16] Thus, Jimmy became Johann, Jack became Jakob, and Fatty became Willy.

To spare those who were offended by the name of Trinity Moses, one of Begbick's fellow fugitives, he was renamed Virginia Moses. The more American name was still preferable to one that risked mocking Christian symbols.

By the time *Rise and Fall of the City of Mahagonny* opened on March 9,

1930, the mythical city had already become a symbol, both ironic and literal, of decadence and depravity. It was despised by the right-wingers as the perverse product of Jews and Communists, and savored by the left as a parody of bourgeois society. The Brownshirts, spoiling for a fight, demonstrated all afternoon on the day of the premiere, carrying banners and placards that insulted the work. When Lenya arrived with Weill's parents, who still lived in Leipzig, she was stunned to find the young men chanting in front of the Neues Theater. She didn't yet know that the local office of the National Socialist Party had bought tickets for their members and paid them to make a scene. This explained "the strange and ugly tension" Lenya felt as they took their seats in the house.[17] Heinsheimer was there as well. He asked, "Was it really only nineteen months and nine days from the happy, carefree fireworks of the opening of *The Three Penny Opera* in Berlin to the dark, frightening events surrounding the . . . operatic premiere in Leipzig?"[18] Even Brecht was surprised by the suspenseful air in the house. It was as if people were waiting for a bomb to explode rather than for the curtain to rise.

Since Lenya knew that *Mahagonny* was guaranteed to shock even the most sympathetic of spectators, she feared the extreme reaction of such a hostile audience. But what would Weill's parents have thought as the first scene unfolded? Three fugitives on the run from the law decide to establish a town that will be a paradise for pleasure-seekers. "It's easier to get gold out of men than out of rivers," Begbick, the fugitive in charge, declares to her cohorts.[19] Begbick soon welcomes four prostitutes into her web. They arrive singing the "Alabama Song," boldly declaring, "Oh we must have whiskey, oh you know why." Weill's parents were sophisticated and cultured—familiar with passionate stories in opera and literature—and the beauty of their son's music would have been moving to them both. But they were religious as well, and perhaps found it difficult to understand the ways in which their son had changed since becoming a Berliner. He had married a non-Jewish woman, had no children, and now he was writing an opera that offered such a cruel and provocative perspective on human nature. They had seen *Threepenny*, of course, but that had been a far more playful satire of society. The foibles of men and women were seen with humor and affection: its characters still loved, as Polly, Jenny, and

Lucy loved Macheath; its villains nearly met their comeuppance, as Macheath is nearly hanged. And even if Macheath's reprieve exposes the way in which villains are rewarded in a corrupt society, the social critique is softened by blaming the operatic genre as well. In *Threepenny*, the parody of the deus ex machina creates a sophisticated sense of comic relief.

Mahagonny offered no such relief. The city that centered around the "As-You-Like-It Tavern" exposed a world based on soulless materialism where there is no rescue to be found. People are sinners made to live and die in hell, incapable of love or charity. For Weill's parents, as for his publisher, Hertzka, the unforgiving nature of the opera was hard to bear. To his parents, *Mahagonny* perhaps seemed similar to that permissive city up north where their son was living. His music was impressive and moving, but his soul was confronting the most frightening features of modern life.

If Weill's parents had their own misgivings, they would have been even more worried by the increasing anxiety in the audience. There were those who were determined (and paid) to hate it, and those who were just as desperate to love it, but the approaching hurricane at the end of act one heightened the cryptic meaning of the opera. It confused everyone. For when the hurricane passes, hitting Pensacola instead, the inhabitants of Mahagonny are wild with joy. Their joy seems sinister in light of the news that eleven thousand people died in Pensacola, making it cruelly clear that the citizens of Mahagonny only cared about themselves. Was this an indecent proclamation in favor of human selfishness? Or was it a critique of the law of the jungle? Was it to be interpreted as a critique or a defense of capitalism? Even before act one was over, the opera had become a lightning rod for the passion and anger that had so rapidly been polarizing Germany.

More than a third of the audience was composed of the usual Leipzig operagoers who attended the entire season year after year. Unlike the Berlin theater and opera audiences who knew what to expect from Brecht and Weill, these patrons were stunned by the harshly modern slant of the first act. They were alarmed by the language of the crude whores and lumberjacks and didn't immediately understand the satirical tone. And even the more cosmopolitan among them were jarred by the way in which *Mahagonny* discarded every single defining aspect

of the operatic genre, where all "beauty, illusion, nobility, pathos and idealism are thrown overboard" in one fell swoop.[20]

The astonishingly self-serving joy displayed by the unharmed inhabitants of *Mahagonny* was unnerving, and so was the music that accompanied this tale of corruption and depravity. In contrast to *Threepenny*, Weill's score was far more operatic: Instead of seven musicians, he had thirty and the songs were performed by professional opera singers. The score, with its references to Bach and Mozart, revealed its mastery of traditional opera and classical orchestration, but true to Weill's signature blend of styles, his orchestra also included such unconventional instruments as a banjo, zither, and Hawaiian guitar. The grand music was frequently laced with something subversive, and always with dramaturgical consequences. The neobaroque passages offered a timeless reflection on the rise and fall of the city; the rhythms and sounds of dance music revealed the corruption and debauchery of Mahagonny's citizens. Many of the arias still recalled their balladlike origins—"Alabama Song" most of all. Unlike the ultimately lighthearted tone of *Threepenny*, the orchestra, the operatic voices, and the gravity of parts of the *Mahagonny* score heightened its portrait of doomed humanity. The music enhanced the disturbing amorality of the story and its characters, never allowing the audience to settle into the predictable pattern of traditional opera. The score was grand, but not always grand.

Act two did little to defuse the rising tension in the house. Once the sinners of Mahagonny are protected from rather than punished by the hurricane—once they have been spared God's wrath—they decide they can truly do anything they please. That is, they can commit any sin without guilt or fear of punishment. The first pleasure to be exploited invoked a saucy reminder of *Threepenny*—a sign comes down that says "And first, don't forget, comes eating." The homage turned sinister when one of the four principal men ate until he exploded and died. What began as a clownish prank ended up as a ghoulish nightmare. Once the pretense of comic relief ceased, the spectators couldn't relax again. The next sign introduced the second pleasure, love. And although the opera was originally written with that untamed brothel scene, it was softened by the "Cranes' Duet," which strengthened the love story between Johann (formerly Jimmy) and the prostitute Jenny.

But even the cooperative composer couldn't, finally, accept a literal performance of the song.

On opening night, the duet was not sung by the main lovers in the story but instead by an anonymous couple. These lovers were not given names, and thus the song functioned as a kind of emotional *Moritat*. Where "Mack the Knife" described the actions of Macheath, the "Cranes' Duet" described the emotions of Johann and Jenny. And as with the "Pirate Jenny" song and "Surabaya Johnny," characters once again sing about someone else. The "Cranes' Duet" differed from earlier songs that reported the actions of others in that it suggested an alternative fate for characters within the work. As such, it offered an even more modern narrative approach than *Threepenny* or *Happy End*. But the song's alternate emotional reality was, ultimately, an unsuccessful attempt to dilute the harshness of the pleasures that could be purchased in Mahagonny. It was meant to infuse a business transaction with a hint of romance, but the reminder of true love ultimately emphasized the cold cruelty of Johann and Jenny's world. The song hinted that the whore and her customer might perhaps become real lovers, but when it becomes clear that they are incapable of true emotion, the disappointment is even more sharply felt.

The third pleasure is fighting, and it is in this final sequence that the story comes to a climax. Johann bets all his money on his friend in a boxing match. The friend loses and Johann is penniless. He drinks to drown his sorrows, and he is arrested because he cannot pay for three bottles of whiskey. Act three begins with Johann's trial where he is sentenced to death. "In the whole human race," Begbick declares, "there's no greater criminal than a man without Money." Jenny refuses to lend Johann the money that would save his life. When pressed, she sings "As You Make Your Bed," which pronounces the piercing "moral" of the city: "So lie down and get kicked if you want to. As for me I will stand up and kick!"[21] As Jürgen Schebera, Weill's biographer, has written, "The misanthropic brutality of the text is juxtaposed with a relaxed melodic line, and the music drives the sense of oppressiveness to an extreme."[22] Like the "Cranes' Duet," the soft melody evokes a warmer world where love exists, but that is a world Jenny has never experienced.

The Jenny of *Mahagonny* is as far as possible from the Jenny of *Three-*

penny. In *Threepenny,* Jenny still loves Macheath despite his constant betrayal. She feels guilty about turning him in and is relieved when he lives. No such empathy can be found in the Jenny of *Mahagonny*. She is incapable of the human yearning to be good, and she is unable to love. As with the other characters, all she can do is mirror the cruelty of her world. The audience, as Hertzka had feared, was quite worn down by the time Jenny, the one feeble hope for a spark of humanity in the opera, refuses to save her lover.

When Johann is put to death, the citizens of Mahagonny, much like the audience, can no longer enjoy the city where anything is allowed. Instead, they finally despair over the hopelessness of their empty lives. But rather than attempting to transform themselves and society, they simply surrender to their hopelessness. They cannot save themselves or their city.

In *Mahagonny,* the human pleasures of food, love, and industry are transformed by extremity into the sins of a corrupt society: gluttony, lust, and greed. The profound despair that permeated Brecht's poems about the city of Mahagonny, and the ironic vision of modern life they offered, had remained intact. As one critic observed: "It was the text, chiefly, which caused indignation, for it is materialistic, cynical, and, beyond everything, profoundly pessimistic. Life appears not rose-colored, as is usual in opera, but naked and brutal."[23]

The final scene offers the most literal rendition of hell thus far: Images projected on the screens in the background show Mahagonny on fire, while on the stage, the inhabitants of the city carry signs with slogans like "For freedom of the rich," "For brute stupidity," and "For the buying and selling of love." They cry out as they carry the signs: "Why, though, do we need a Mahagonny? Because this world is rotten . . . Because there's nothing to depend upon."[24] It ends with their tragic wail: They can't help Johann, they can't help any dead man, they can't help anyone. As the opera's scathing critique of human nature came to a crescendo, the audience was infected by its message of despair. Weill's loyal friend Felix Joachimson sat in the audience and observed, "As the meaning . . . became more and more apparent, the climate changed. They got scared."[25]

It was a triumph of musical, literary, and theatrical sophistication. It was beautiful, edgy, and raw—it racked the spectators' brains and

broke their hearts—it never soothed the pain with the kind of light and entertaining moments that had punctuated *Threepenny*. *Mahagonny*, the audience quickly understood, was much meaner and much more significant. "In 'Mahagonny,' there is no love; there is only money . . . ultimate desolation, ultimate soullessness."[26] The cold, cruel parody of human nature is the subject of the opera, and the audience must confront and decipher its message. Whether *Mahagonny* was interpreted as a parable of human greed or a critique of capitalism depended upon the viewers themselves. The opera reflected and even heightened the fearful mood that was taking over Germany. In their real lives, the deluge of economic and political misfortunes threatened the audience's well-being. *Mahagonny* transformed their fears into a palpable reality on the stage. Yet another sign aptly read "For the chaotic state of our cities." And another featured the prophetic slogan "For the honor of murderers."[27]

The critics had felt the anxiety in the audience, but they were among the few who remained calm enough to notice the music. Despite the harsh subject matter, they understood immediately that Weill had fulfilled his dream of both transforming and yet honoring the highest level the operatic genre could attain. But they had no time to think about it as the third act came to a close. The city it portrayed had burst through the fourth wall and pulled the audience into the fray. As Mahagonny went down in flames, and the inhabitants turned against one another, there was a simultaneous outburst of rage and conflict in the house. The audience was in a frenzy. "By the time the last scene was reached the riot had spread to the stage," Lenya saw to her dismay.[28] Heinsheimer, Weill's editor who had so loudly praised and encouraged him to compose this grand opera, must have wondered if he had given the composer the right advice. Heinsheimer described the "shouts, at last screams and roars of protest. Some of the actors stepped out of their parts, rushed to the apron of the stage, shouted back."[29] And although the distinguished critic Hans Heinz Stuckenschmidt realized immediately that "The work form[ed] a climax in the operatic history of the age," he, too, witnessed the ugliness of that equally historic premiere. "Brecher [the conductor] barely managed to bring the performance to a close."[30] Alfred Polgar, another famous critic, remained calm enough to observe the events in great detail:

"The woman on my left was seized by a heart spasm and wanted to get out; only the suggestion that she might miss an historic event kept her from leaving . . . Belligerent shouts, hand-to-hand fighting in some places, hissing, applauding that sounded grimly as if the hissing people had been symbolically slapped in the face, enthusiastic fury mixed with furious enthusiasm . . . A dignified gentleman with a lobster red face had taken out a bunch of keys and . . . held the fifth one pressed to his lower lip, dispatching air streams of the highest vibration frequency . . . There was something merciless in the sound of this instrument, something that cut into your stomach . . . His wife didn't desert him at the moment of truth. A hefty Valkyrie, with a bun on top . . . With her eyes shut, her cheeks blown up and two fat fingers in her mouth . . . she out-screeched the key . . . A dreadful, sordid sight."[31]

What had provoked the riot? First and foremost, there was the staged reaction of the National Socialists. Then there was the bourgeois reaction of the regular opera patrons to the portrayal of vulgar men, brash prostitutes, and the explicit sex scenes. At another time, they might have been more accepting of the harsh portrayal of human weakness; they might not have liked it, but they would have tolerated its bleak message. A few bad reviews, poor tickets sales, and it would have left Leipzig forever. But their fears about the future of Germany were stoked onstage by the opera and offstage by the rioting Brownshirts, and they were unable to bear the pressure from both sides. The times were hopeless enough. An opera that underscored the hopelessness of their society, rather than insisting—as the conservatives were trying to insist—that a return to good German values would save the day, was dangerous and radical. There were a few sophisticated spectators who opposed the staged opposition of the extreme right; the Brownshirts in turn opposed the approval of those who comprehended and appreciated the brilliance of the opera. When the citizens of the city of Mahagonny cried out the final line, "Nothing will help him or us or you now!," they were proclaiming the death knell for any society that can no longer find a common humanity.[32] The raging audience tried to protest the message of despair, but their own behavior proved that the accusation was truer than ever before.

The difference between 1928 and 1930 was ominously revealed by the contrasting reactions to *Threepenny* and *Mahagonny.* The premiere

of *Threepenny* had taken the audience on a journey that went from an expectation of total failure to the experience of joyful approbation; conversely, the opera *Mahagonny* began in an atmosphere of hope— not only the expectation of a great work of art but also the belief that it was still possible to present such daring subject matter on a German stage—but the evening ended in violence and a heightened sense of fear. The audience was thus a mirror of the times, signifying the descent from hope to despair, a sign that the brief golden years of the Weimar Republic had come to an end.

The opera, the elitist form Brecht wanted to destroy, had provoked the audience far more than *Threepenny*. In fact, it had been far more provocative than any political play Brecht had ever written or directed. It had stirred social and political fury, while simultaneously proving itself on artistic grounds. Weill was gratified by the artistic success but concerned about the violence in the house, not least for his wife and his parents. He was also dismayed to become the target of National Socialist abuse. In contrast, Brecht was highly impressed by the response and quickly reconsidered his indifferent attitude toward the work. Watching the prolonged pandemonium in the house, he knew he had to figure out a way to claim ownership of the theatrical event of the season.

Weill had hoped that the audience would understand the universal nature of the opera's vision, that it was about human nature not politics. Brecht was pleasantly surprised that the opera was seen as a fierce critique of society as well as a Marxist assault on capitalism. Brecht and Weill had quibbled about the role of music in this modern opera, and Brecht had bristled at adhering to any operatic conventions, but their artistic disagreements paled beside their utterly contrasting responses to the reception of the work. The composer had wanted the opera to be thought-provoking; the playwright was thrilled to discover that it could provoke meaningful action.

What was most clear on that tumultuous opening night was that *Rise and Fall of the City of Mahagonny* had arrived on the stage far too late. It could no longer play in the same context in which it had been created. Politics and society had swung too far to the right, and censorship was too readily invoked. The conservatives had, as Weill predicted, stubbornly insisted that *Mahagonny* promoted the hedonism it was

clearly using as a metaphor. That was the only way in which it could be used as an example of the moral depravity of Communists and Jews. Had the composer succeeded in mounting the opera a year earlier, he might have been able to fend off the politically motivated assaults. But by 1930, the National Socialists were a force to be reckoned with.

Both Brecht and Weill were accustomed to, and even welcomed, the aesthetic objections of a bourgeois audience. Artistic battles were ones that they enjoyed and could usually win, but it was the insidious hatred not just of the creation but of the men themselves as a Communist and a Jew that cut deep. This was an irrational battle, and one that could not be won.

Weill was not ready to surrender. In order to keep the opera on the stage, he tried to listen to any criticism that was remotely reasonable. And he took comfort in the fact that "the second performance was reluctantly permitted under police protection with the house lights on," because it proved that the authorities still protected the freedom of the arts. He made several changes and was encouraged by a successful performance in Kassel, which took place only three days after Leipzig. In the absence of a deliberate and arbitrary campaign against the artists themselves, the value of the opera was recognized. Indeed, "the Nazis had concentrated on Leipzig in their campaign against the opera. They had forgotten to inform the citizens of Kassel that the work was a Communist-Jewish plot. And the citizens of Kassel loved it."[33] This one victory gave Weill reason to believe, against all odds, that he could triumph over the unreasonable forces of evil that were against him. It was far harder to convince Brecht, who instantly came to believe that the most important aspect of the opera was its power to incite controversy.

Having spent years pushing his publishers to promote the difficult opera, Weill feared that the outcry would discourage them once again. He tried to infuse his letters to them with as much optimism as he could muster. A week after the opening in Leipzig, he wrote: "It might be a good idea this time to arrange the reviews according to the political tendencies of the papers in order to show that it isn't a political work at all, since there have been positive reviews from papers of all political persuasions . . . I have just spent two days working with Brecht [and]

we now have a version to which even the pope can't object. It is now absolutely clear that the closing demonstration is not at all communistic, but rather, like Sodom and Gomorrah, Mahagonny perishes because of the crimes of its inhabitants, the wantonness and the general chaos."[34]

There were, of course, other Leipzig reviews that Weill chose not to mention. One insisted the opera was "baldly Communist propaganda of the most evil sort." Another went even further: "Hark, my clean Misters Brecht and Weill, your days may be just as numbered as the days of your scum city Mahagonny!"[35]

Every time the optimistic composer recovered, yet another blow came his way. His monumental resources for denial were put to the test a few months after the brief success in Kassel. When the opera was performed in Frankfurt, "hundreds of storm troopers forced their way into the opera house to hurl stink bombs. Only a courageous vote by the City Council allowed the remaining performances to continue, with police lining the auditorium."[36] The leader of the mob who disrupted the premiere was arrested, but not because of his behavior during the opera. It turned out that he was a train robber the police had been trying to arrest for some time.[37]

It was increasingly clear that *Mahagonny* had become a rallying point for the National Socialists, one that had little to do with the opera itself. "Naturally it was a real stroke of bad luck that the second performance in Frankfurt was disturbed by the Nazis," Weill wrote his publishers. But "this scandal was naturally not in any way directed against the work."[38] The composer was trying to believe the virulent opposition would exhaust itself, that the power of a good work of art would overpower the manipulated political censorship. But when he heard that several cities were trying to postpone their performances of *Mahagonny,* he made a passionate plea to his publishers: "We must do everything we can to fight this plan . . . if permitted, [it] would mean lasting damage for every modern theatrical endeavor."[39]

This battle, too, was lost. As a direct reaction to the uproar, the opera houses in Essen, Oldenburg, and Dortmund all withdrew from their contracts. If the Nazis couldn't yet stop a performance in a large city like Leipzig, where the rule of law was still in place, they had far

better luck in the provinces. They consciously focused on their power and popularity in rural areas, and the wisdom of this strategy was increasingly apparent.

It had been three years since Weill had decided to compose a full-length opera based on the *Songspiel,* and nearly all his professional decisions had been in order to realize this cherished goal. Even in the face of such massive resistance, he was determined that he could find a place for his opera in the most progressive city of all, Berlin. He still believed in his artistic rights, and he still believed that *Mahagonny* fulfilled his creative ambitions to transform the opera. He wanted to honor Heinsheimer's glowing appraisal of what Weill's opera had achieved: "The new sound of the coming years becomes audible . . . a new longing, a new search for the 'unattainable.'" Weill had expected a dramatic reaction to his opera, but in the months that followed the Leipzig premiere, the "sound of the coming years" turned out to be the resounding thud of the Brownshirts' boots on the asphalt, their loud protest drowning out the composer's quest to "create works of lasting value."[40]

As Weill fought for the survival of *Mahagonny,* Brecht was himself preparing to wage a territorial battle with the composer. The writer not only wanted recognition for inventing the concept of the sinner's paradise city but also to claim some credit for the uproar it caused all over Germany.[41]

Brecht had been unusually isolated amid the initial chaos in Leipzig. Neher had collaborated harmoniously with the composer. Hauptmann had been spending a good deal of time with Emil Hesse-Burri, and the two *Mitarbeiter* were forming a warm professional and personal relationship. Weigel was two months pregnant with their second child and decided not to work until after the birth in October. Since she already had a signed offer for a Berlin production of *A Man's a Man* in the following year, and *Threepenny* continued to bring in hefty royalties, she could afford some time off. But now that Stefan was in school, she couldn't be running down to Leipzig on a whim. If Brecht decided to do battle with Weill over the opera, he was uncharacteristically on his own.

Brecht and Weill fought a duel over *Mahagonny* in three key publications, using pens as their chosen weapons. The composer began

by laying down not one but two gauntlets with his introduction to the *Regiebuch* (promptbook) for the opera, which he published just before the premiere. The first slap asserted a composer's ownership over a joint work by using the provocative pronoun in his title, "Notes to My Opera *Mahagonny*."[42] The second slap was formally labeling it an opera. And Weill wasn't using the word "opera" ironically, as he and Brecht had with *Threepenny*, but rather with utmost sincerity. The title calmly asserts, to Brecht's alarm, that their *Mahagonny* had become an opera that belonged to the composer. It was likely the sheer nerve of this introduction that compelled Brecht to show up in Leipzig at the last minute.[43]

Brecht accepted Weill's challenge with gusto, but he paced slowly away from his adversary as the scandals took place in Leipzig and other cities. When these events had run their course, Brecht made use of his personalized literary platform, the journal *Versuche*, where he had begun to publish the approved versions of his plays, and returned fire.[44] He attacked the egregious pronoun directly by publishing his "Notes to the Opera, *Rise and Fall of the City of Mahagonny*," and he also included a revised version of the libretto, one that had specifically not been approved by Weill.[45] Thus, he took the liberty of firing two shots at the same time too. First, by making it clear that the tale of this city and all that it represents began with his book of poems and wouldn't exist without him, Brecht wrested the opera from Weill's possessive hands. By publishing an altered version of his own, he was further insisting that the *Mahagonny* of the future might well exist without Weill's control or participation.

Brecht's second shot was even more significant. He not only reclaimed and revised the work itself; his "Notes" also took charge of its future identity. For although it had been months since the opera had been completed and performed, and Brecht had been involved only intermittently in its final stages, he had the audacity to assert that *Mahagonny* had been created purely as an experiment to prove the absurdity of the genre. Thus Brecht's "Notes" allowed him to claim his participation in the elite form of opera while simultaneously taking credit for its destruction. "Even if one wanted to start a discussion of opera—and of its function!" Brecht wrote, "one would have to write an actual opera."[46] In these "Notes," Brecht insisted that the

opera was simply "a piece of fun . . . [it] pays conscious tribute to the senselessness of the operatic form."[47] By claiming that *Mahagonny* was a satire, as opposed to an actual opera, Brecht was attempting to put it in the same category as *The Threepenny Opera*. This was a category over which the writer had enjoyed far more control.

Brecht's explanation of *Mahagonny* as an experiment was a direct answer to the distinction Weill had made in the introduction to *his* opera: "In *The Threepenny Opera* the plot had to be advanced in the intervals between the musical numbers. This led to something like a form of 'dialogue opera,' a cross between opera and play. With *Rise and Fall of the City of Mahagonny*, the material permits of construction strictly according to the laws of music."[48] It was precisely these "laws of music" that Brecht refused to acknowledge or obey.

Brecht refused to accept the very concept of an ideal opera. In order to delineate his disdain for the form itself, he created the concept of "culinary" art, one he defined as a work designed for pleasure alone. One that feeds the emotions but not the intellect. He believed that opera was particularly susceptible to this tendency to soothe and satiate. Wagnerian opera was the pinnacle of this form, a place where all the elements blended to offer the same taste, like a rich soup— hence the word "culinary"—and the desired effect worked like a drug. "Perhaps 'Mahagonny' is as culinary as ever," Brecht admitted, "just as culinary as an opera ought to be—but one of its functions is to change society; it brings the culinary principle under discussion." That is, if *Mahagonny* is guilty of being an opera, it is only in order to attack "the society that needs operas of such a sort . . . The process of fusion extends to the spectator, who gets thrown into the melting pot too and becomes a passive (suffering) part of the total work of art. Witchcraft of this sort must of course be fought against. Whatever is intended to produce hypnosis, is likely to induce sordid intoxication, or creates fog, has got to be given up." Brecht recognized that *Mahagonny* "still perches happily on the old bough, perhaps, but at least it has started . . . to saw it through . . . Real innovations attack the roots."[49]

The metaphorical bough that Brecht wanted to destroy was the one upon which Weill was standing. And as far as the composer was concerned, a truly modern opera can attack society just as effectively as,

if not more powerfully than, Brecht's modern theater. *Mahagonny* had not only eradicated the noble hero; it had removed the fate of an individual from the center of the story. "The play's protagonist is the city," Weill wrote pointedly. "The fate of the individual is depicted in passing only where it exemplifies the fate of the city."[50] Significantly, the music strongly supports this break with tradition since "all the opera's songs are an expression of the masses."[51] With these words, Weill pushed Brecht to recognize and accept that transforming the opera was no less revolutionary than transforming the spoken drama. Between the lines, the composer was challenging Brecht to confess that his only problem with the opera was his loss of control over the final product.

Brecht's accusation that *Mahagonny* was culinary could have been directed at his own analysis as well. The "Notes" were clearly "cooked up" after the fact, and pointedly after the explosion the work caused all over the country. The pretense of the "experiment" was created to take back some measure of control and therefore to save face. It was also an attempt to destroy Weill's work—as if the opera, like the town of Mahagonny itself, should burst into flames after being performed.[52] By presenting *Mahagonny* as a laboratory experiment, Brecht was able not only to deny the value of Weill's work but also to claim a new level of scientific authority for his theories about the modern theater and opera.[53] He believed in the results he eventually published, but his initial motivation was to reclaim the territory Weill had taken from him.

Their battle proved that even the equality of their work, even the power of their combined talents, had failed to settle the great struggle for supremacy between words and music that has permeated opera and musical theater from the beginning.[54] By the winter of 1930, three years after they first met and proclaimed their desire to dispense with the traditional artistic hierarchies, each believed more than ever that their individual contribution spoke loudest and most effectively of all.

Given the outcry over the opera, Weill could justifiably have insisted that creating a work that exposed human greed and lust in such a harsh light had been provocative enough. "The path I've chosen is correct," Weill announced to his publishers. And "it is out of the question to give up this path just because its beginnings happen to run into a strand of the fiercest cultural reaction and, like all great innova-

tions, encounter violent opposition."[55] Weill's opera, he insisted, had brought the battle for artistic freedom into the spotlight. Nothing was more important for a democracy.

But Brecht was losing faith in the hope held out by merely fighting for the arts. He was alarmed by the increasing dominance and violence of the right-wing parties in Germany, and the fight for modern opera paled beside the pressing concerns of the day. The social welfare system was dissolving rapidly, and unemployment insurance had gone bankrupt. By the end of September 1930, the divided parliament was still unable to come to an agreement about how to handle the financial crisis, and Chancellor Heinrich Brüning called for new elections in the hopes of restoring some unity. It was the political miscalculation of his career. To everyone's surprise, the Nazi Party won 17 percent of the vote and 107 seats, and despite gains in the Communist Party seats, this made the Nazis the second-largest group to be represented in the Reichstag. Brüning was now facing an utterly dysfunctional parliament. He declared a national emergency and continued to rule by decree. Although he was unable to prevent severe wage reductions or an overwhelming rise in unemployment, he nevertheless made devastating cuts in the social welfare programs. The increasingly austere and nationalistic Brüning thus governed with a radically free hand during the first presidential dictatorship of the Weimar Republic. Like the furious response to *Mahagonny,* Brüning's dictatorship confirmed that the golden years were truly over.[56]

It is therefore understandable that Brecht maintained his radical disposition against the operatic genre. If opera had a firm foothold in elite society, and the elite German society was becoming quite frightening, he believed it was far more effective to symbolically and literally destroy it. The situation was too urgent for Brecht to engage with any form of theater that didn't offer some hope for the political future of Germany. If the opera had stirred up more of a fuss than his plays so far, it still didn't directly address the urgent issues of the day. It didn't answer his most burning question: "How can the unfree, ignorant man of our century, with his thirst for freedom and his hunger for knowledge; how can the tortured and the heroic, abused and ingenious, changeable and world-changing man of this great and ghastly century

obtain his own theatre which will help him to master the world and himself?"[57]

Weill was equally aware of the dangerous political climate. As a Jew, he was especially vulnerable to the anti-Semitism that infused the right. But unlike Brecht, he did not believe that the theater or the opera could have an immediate influence on contemporary politics in Germany. As early as 1927, Weill had written to his publishers about his plans for *Mahagonny:* "The piece we are going to create won't exploit topical themes, which will be dated in a year, but rather will reflect the true tenor of our times. For that reason it will have an impact far beyond its own age."[58]

Both Weill and Brecht were high-minded, ambitious, and brilliant. If the composer thought more about the future impact of his work and the playwright was trying to make his mark every single day, they were both resolute in their belief that art can and must make the world a better place. But by the fall of 1930, and despite the precarious state of their country, they were wasting far too much of their creative energy quarreling over petty personal slights. "Word got to Brecht that Weill had called him a 'Parlor Communist,'" Joachimson remembered. "The story made the rounds and found its way into a reporter's column. Weill denied the remark and complained to the editor. A retraction was printed that read worse than the original item. The whole affair was ridiculous."[59] Weill had achieved an artistic milestone with *Rise and Fall of the City of Mahagonny.* For Brecht, it was a symbol of everything he wanted to leave behind. This could have been, and perhaps should have been, the end of their partnership, but it wasn't. To their dismay, and to their credit, they both knew that their work together was not yet done.

Last Time in Germany

The irrevocable moment between Brecht and Weill had finally come to pass. Once they engaged in an angry dispute about the hierarchy of words and music, their egalitarian pact dissolved. Working together became an unpleasant obligation rather than a joyful privilege.

There was one factor that still held them together even after such fundamental, long-suppressed creative differences had been voiced, one force powerful enough to push them together again and again, even when both knew the gulf between them was expanding every day.

It was the opposition from the outside world. By 1930, that force, especially the onslaught of right-wing aggression toward the freedom of the arts, was worse than ever. They knew that only together could they win the politically charged cultural battles that lay before them. They didn't have to like each other in order to conquer their common enemies. They just had to tolerate their differences long enough to triumph.

Given their discord over the role of opera and musical theater, the only venue that fulfilled them both equally was the classroom; however much their specific politics were diverging—Brecht was increasingly attached to the Communists, and Weill remained a liberal democrat—an audience of students still gave them the most pleasure.

Just as *Der Lindberghflug* was a harmonious creative refuge from the troubles of *Happy End,* so their new learning play, which they had been developing for the first half of the year, sustained their artistic relationship throughout the months of prolonged tension over the interpretation of *Mahagonny.* The new play, or "school opera," as Weill called it, was titled *The Yes-Sayer (Der Jasager).*

Weill had been teaching since he was a teenager and was devoted to educating the audience of the future.[1] He was also excited by the challenge of composing for an audience of teenagers. "If I want to write for pupils and be intelligible to them . . . I must remain rigorous in my simplicity . . . I subject myself above all to the most intense self-control."[2] For Brecht, who often lectured about the connection between his plays and reality at the Marxist Workers School, the classroom was the place where popularity and integrity could happily meet. When entertainment inspired critical thinking, the celebrity status that had been so problematic for him with *Threepenny* was transformed into an asset.

It was once again the remarkable Hauptmann, whose fertile imagination was rivaled only by her intellectual generosity, who provided the foundation for their next work. Fascinated by the potential of the Asian Noh ("talent" or "skill") genre as a basis for future learning plays, she translated an English version of the traditional fifteenth-century Japanese parable *Taniko* into German.[3] The Noh form of theater is one of the oldest dramatic traditions. In this genre, much like Brecht's own emerging concept of theater, actors describe and report the stories of the characters they play, relying heavily on their appearance and gestures. When Weill read one of Hauptmann's early translations, he was immediately enthusiastic, and Brecht came on board shortly afterward.[4]

Brecht relied even more extensively on Hauptmann's adaptation than he had on her version of John Gay's *Beggar's Opera.*[5] But despite her increased professional independence, she continued to ignore the issue of credit or money when it came to working with Brecht, and she received neither for her hefty role in the creation of *The Yes-Sayer.* Hauptmann's modest public presence was nevertheless beneficial for her career. It paid off that very spring when she was singled out in the magazine *Tempo* as one of the two most important new women

in literature.[6] Although she was chiefly described as the translator and co-worker of Brecht and Weill, she was well aware that this kind of attention made it easier to publish future stories of her own. For Hauptmann, who was devoted to the collective process, the occasional glimmer of individual fame was enough.

It had been less than a year since Brecht's marriage to Weigel, but Hauptmann had firmly settled into what she hoped would be her permanent role. With occasional exceptions, she and Brecht were no longer lovers, but she was as essential to his work as she was in the background of his personal life.

The Yes-Sayer is a parable about a boy whose mother is ill. His teacher comes for a visit and says that he is taking three older students on a journey to a city where they can benefit from the knowledge of the wise professors who live there. The boy asks if he can come too in order to consult the great doctors in the city, in the hopes that they will give him medicine to cure his mother. The boy is told he is not strong enough to hike and climb over the steep hills, but he nevertheless manages to convince the teacher to take him along. When he falls ill at the most dangerous point, thus preventing the others from reaching their destination, the other students insist that an ancient law be invoked. The custom demands that if one member of a group is unable to finish the journey, he must be thrown into the valley where he will die. The boy must consent to obey this law, and when the question is put to him, he accepts his tragic destiny. The students sing: "He said Yes," the phrase that gave rise to the title. The boy acquiesces to the customs and needs of his community.

The skeletal story is as simple as it is haunting. The arbitrariness of the custom that demands the death of the boy goes unquestioned. Although many other possibilities come to mind, only the boy's death or everyone turning back are considered. Their literal interpretation of the custom therefore offers an implicit criticism of the acquiescence it claims to support. As with everything Brecht and Weill created, no single attitude is wholly supported. The boy's acquiescence can be seen as heroic or passive; the behavior of the teacher and his students can be seen as emblematic of the needs of a community or as an act of arbitrary cruelty. In the theater, and especially in a learning play, as Brecht put it, "the puzzles of the world are not solved but shown."[7]

The school music movement, as it was known in 1930, was widespread in Germany. Most schools had excellent choirs and student orchestras, and musical performances were an important component of their education. The rising significance of the movement was acknowledged by Paul Hindemith and his peers, who chose the theme of school music for their annual summer festival. Having contributed so successfully to the themes of short operas in 1927 and the mass media technology of film and radio music in 1929, Weill and Brecht were invited for a third time.

As it turned out, *The Yes-Sayer* not only embodied the strongest aspect of Brecht and Weill's shared artistic intentions; it also became a perfect example of how their bond strengthened when faced with outside opposition. In this case, the unifying antagonism came not from right-wing forces but directly from Hindemith and the festival leaders. It was not directed toward *The Yes-Sayer* itself but instead, and ironically, toward a work that Brecht had begun with another composer, Hanns Eisler. As the political differences between Brecht and Weill mounted, the playwright had become especially attracted to Eisler's commitment to Communism. Brecht and Eisler had been working for months on *The Measures Taken (Die Maßnahme)*, another learning play with music, which had also been invited to be part of the festival.[8] The overtly Communist play encouraged workers to engage in the class struggle in China. Its songs boasted blunt titles like "Praise of the USSR."[9] The festival directors decided it was far too controversial and canceled the performance. Brecht was furious to see Hindemith buckling under the pressure from the anti-Communist conservatives in charge of government funding for the festival.[10] In an open letter, he wrote: "If you want to continue your ever-so-important programs, in which you present new ways of using music for discussion, then you must by no means make yourself financially dependent upon people or institutions which, for quite other than artistic reasons, forbid you so and so many ways of using music . . . Let us remove these important presentations from all dependencies."[11]

As a party member, Eisler's commitment to Communism was even stronger than Brecht's, and unlike Weill, he wholly encouraged the playwright's increasingly political slant. Weill might have taken some pleasure from watching Brecht's difficulties when working with

someone else, but the composer nevertheless agreed immediately to the playwright's suggestion that they withdraw *The Yes-Sayer* from the festival in protest over the rejection of *The Measures Taken*. Weill publicly concurred with Brecht's open letter: "The prerequisite condition of any artistic institution is *complete independence*."[12] This was no doubt a display of loyalty to Brecht, but it also indicated the composer's unwavering support for the freedom of the arts.

Instead, *The Yes-Sayer* premiered at the Berlin Central Institute for Education and Teaching on June 23, 1930. It was extremely well received by the students and provoked just the kind of heated debate its creators had hoped for. It inspired the audience to examine the concept of acquiescence rather than simply accepting its inherent moral value. They argued over whether the boy should have said "yes" under those conditions, and if any conditions could ever warrant obedience to such an arbitrary custom.

As a sign of just how important the school music movement had become, all the prominent newspapers in Berlin reviewed the performance. But although the press was mostly positive, the play was attacked by several critics on the left for what they saw as its unqualified support of all forms of obedience. One particularly harsh review denounced its "reactionary way of thinking based on senseless authority. This yes-sayer is strikingly reminiscent of the cadaverlike obedience of the yes-sayers during the war." Even more disturbing was the praise the work received from one source on the right. A conservative Catholic paper was thrilled: "We have not heard basic Christian truth sung more plainly and clearly than in . . . this gripping, even devastating play. Consent, consensus, and the offering up even of life for the suffering of the world."[13]

The students understood that the school opera was meant to provoke a debate about acquiescence, but professional critics on the right and left wrongly presumed that Brecht and Weill were advocating a single point of view. These reviewers were unfortunately behaving just like the Nazis who had insisted upon a literal interpretation of the sins of *Mahagonny*. The rapidly polarizing political climate clearly diminished the possibility for a nuanced response to any creative work, even one presented for the explicit purposes of education.

The students asked the best questions of all. An especially criti-

cal audience was made up of students at the working-class institution pointedly named the Karl Marx School. After their response, Brecht decided that the discussion could be sharpened if he wrote a companion play in which the boy does not accept the edict that would cause his death. Instead, he would ask everyone to turn back for his sake. It was bluntly titled *The No-Sayer* (*Der Neinsager*), and Brecht wanted it to be performed with *The Yes-Sayer* whenever possible. This would provoke a debate about the concept of obedience, forcing the audience to ask when and whether acquiescence is the proper moral choice.

But Weill believed *The No-Sayer* was performing a function that his music already achieved. Consequently, he worried that its addition would prevent the students from learning how to read the contrast inherent in the words and music of the original play, as well as how to interpret the distinct musical choices: The music is restrained and unemotional even when the boy's life is threatened; when the chorus describes the boy being thrown to his death, their voices are high, sweet, and calm. Finally, as the consequence of the boy's cooperation becomes clear, the melody becomes steadily more ironic, creating a chilling sense of doom. As far as Weill was concerned, this dismissal of the music's equal and contrasting role attacked the very foundation of all his collaborations with Brecht so far. True to their goal of engaging the intelligence of their audience, the composer insisted, "If the *Jasager* is studied and performed with true understanding, the original text requires no 'corrections' beyond those which the music itself so eloquently supplies."[14] Weill declined Brecht's request to compose an additional score for *The No-Sayer.*

But the impatient Brecht wanted to confront the students' reactions right away. As the unemployed flooded the streets, and Chancellor Brüning imposed increasingly autocratic policies, the danger of obeying authority—any authority—was painfully clear to the playwright. He wanted to undercut the instinct to obey as quickly and as forcefully as possible. There was no time to waste when it came to prodding young people into a deeper understanding of acquiescence—learning to properly interpret the aesthetic balance of words and music, as Weill suggested, could wait.

The enormous success of *The Yes-Sayer* on its own made it unnecessary for Weill to worry about the interference of *The No-Sayer* in the

immediate future. For despite its provocative qualities, *The Yes-Sayer* was warmly received by the Ministry of Education and was performed on its own in more than three hundred German schools.[15] Because it had such an enormous impact in its original form, the composer was able to ignore the playwright's constant need to revise. Because Weill didn't necessarily object to future performances of both plays, Brecht was able to ignore what he perceived as his composer's refusal to alter a finished work. By focusing on the success of *The Yes-Sayer*, which once again confirmed the seeming guarantee of success for everything they did together, Brecht and Weill agreed to disagree.

But far beyond the nature of the difference itself, the school opera indicated something far more devastating about their future. It proved that even in the classroom, even when passionately pursuing mutual goals, Brecht and Weill could no longer find a harmonious solution. In his urgent fight against the right-wing conservatives, Brecht favored provocation over education. In his equally urgent pursuit of cultural freedom, Weill was certain that education trumped agitation every time. For the first time, the pressure from without was losing its power to unite them.

There was perhaps only one work that could rekindle the flame, at least temporarily, before it went out for good. It was the favorite child, the still-successful *Threepenny Opera*.

There had been a film director in the audience on the night of that jubilant 1928 premiere. It was G. W. Pabst, one of the most prominent film directors in Germany, who was heard clapping loudest and most enthusiastically of all. At the end of the show, Pabst turned to his equally impressed colleague, the American producer Seymour Nebenzahl, and said, "That would make a great movie."[16] Eighteen months later, Pabst had sent a contract to Brecht and Weill offering 40,000 marks to secure the film rights to the longest-running show in German theater history.

Brecht and Weill were both fascinated by the cinematic medium. Brecht had already written several short screenplays during his early days in Munich, and he was excited about exploring the potential of the most modern of twentieth-century technologies.[17] Like radio, film had the ability to bring culture to the masses in an immediate and powerful way. Its popularity in Germany had also skyrocketed. By the

middle of the 1920s, two million people went to the movies every day. By 1929, there were 5,600 movie theaters in the country.

Pabst's backers were the Tobis Syndicate—a European firm that had cleverly purchased all the patents on the technology of sound films, creating a monopoly—and Nero Films, which was owned by Nebenzahl.[18] For his first sound film, Nebenzahl, in turn, asked for the support of Warner Bros., "and the result was the largest pool of funds for a single project in the history of the German cinema."[19] The involvement of American businessmen in the German film industry was a direct result of the Dawes Plan, which had relied heavily on U.S. investment banks to help Germany recover its postwar economic prosperity. The film version of Brecht and Weill's satire of the bourgeoisie was thus made possible by a conglomerate of businessmen who represented the very essence of capitalism.

As artists, Brecht and Weill were therefore very careful about the terms of their contract. They hoped the proper wording would protect the integrity of their work when it was adapted for the screen. Specifically, the contract read: "The production company accords the authors the right of participation in adapting the material for the screen . . . the screenplay [will be] adapted in consultation with the authors. The composition of additional music and the arrangement of existing music may only be carried out by the composer Kurt Weill."[20] Brecht was hired to write the treatment for the film adaptation. Caspar Neher was hired to do the costumes. The cast included Carola Neher as Polly, Lotte Lenya as Jenny, and the well-known actor Rudolf Forster to play Macheath.[21] Pabst had already directed the acclaimed *Pandora's Box* and *Diary of a Lost Girl*, both with Louise Brooks, as well as *The Joyless Street* with Greta Garbo, and there was every reason to expect a sophisticated and highly professional screen adaptation.

Weill hoped that his contractually guaranteed participation would protect his music. Brecht, however, had entirely different plans for exercising his creative control. Having been embarrassed by the commercial appeal of the stage version, he was determined to make the film clarify and heighten the social and political significance of *The Threepenny Opera*. Brecht's irritation over the reception of the work had only increased in the twenty months since the premiere, especially now that his close circle of colleagues and friends included the left-wing

intellectual Walter Benjamin and his other composer, Eisler. Brecht took on Léo Lania, another staunchly left-wing playwright from Erwin Piscator's circle, to help him write the treatment for what he hoped would be a controversial film.[22]

Brecht's treatment underscored the theme of class warfare and the evils of big business and the banks. In this version, the scene from the play where Peachum threatens Tiger Brown that his beggars will disrupt the coronation if Macheath isn't arrested is expanded into an extended sequence depicting the rage of the exploited poor in general. To this end, Brecht added a dream in which a terrified Tiger Brown envisions a revolt of the masses who flood the streets of London. Another pivotal change is that the Queen no longer delivers a pardon to the bandit. Instead, with Jenny's help Macheath escapes from prison and discovers that Polly has founded a bank in his absence. Tiger Brown and Peachum, both realizing that the rebellious poor are their true enemies, join forces with Macheath and Polly as bankers and businessmen. The treatment not only discarded the playful parody of the opera, where mounted messengers come to the rescue, but even more significant, it abandoned its critique of mankind in general. Brecht no longer proclaimed a world in which all men are equally corrupt; instead he populated it with good guys and bad guys. The wealthy upper classes are the oppressors who victimize the poor and other largely innocent victims. The new version retained its caustic wit but was a far more pointed attack on capitalism.

Brecht and Lania set up shop in his outdoor *Kraal* in Le Lavandou. As he gazed out at the blue Mediterranean and enjoyed the warmth of the hot white sand, Brecht cheerfully took advantage of two second chances to turn his earlier plays into stronger political statements. In addition to *Threepenny*, he was continuing the dissection of *Happy End* and, with Hauptmann's and Emil Hesse-Burri's help, using it as source material for his anticapitalist learning play, *Saint Joan of the Stockyards*.[23]

Brecht was very much in his element on the familiar beach, with the regular members of his collective working in the way that suited him best. He was therefore unpleasantly surprised when Pabst, with a lawyer from Nero Films in tow, came rushing down to the French Riviera after getting wind of the changes that Brecht was proposing. As the director, Pabst saw himself as the highest authority, and he had

no interest in Brecht's collective style of working. Pabst was also not intimidated by Brecht's aura of artistic and political integrity. Hardly a timid director himself, Pabst had bravely shocked the bourgeoisie with his overtly sexual *Pandora's Box,* a film that portrayed a prostitute who felt no remorse and exposed a society steeped in hypocrisy. There could have been much common ground between Brecht and Pabst, but their desire for dominance precluded that possibility from the moment the film director set foot on the beach. Brecht treated him as if he were a rival gang member trespassing on his turf.

The one area of actual disagreement between Pabst and Brecht concerned their attitude toward a mass audience and how best to reach them. Brecht publicly complained that "from Pabst's side came the repeated advice that one must take into account the backwardness and stupidity of the film audience."[24] Brecht naturally disagreed with this assumption of the stupidity of the masses. He believed, and had already proven on the stage and in the schools, that it was possible to simultaneously entertain and educate.[25] But Pabst wasn't convinced that this idealistic young playwright, with only one theatrical hit so far, had anything to teach him about the movies. They argued in circles until a furious and discouraged Pabst stormed off the beach. He grudgingly agreed to let Lania and Brecht submit a revised treatment before making up his mind about what to do.

Brecht soon went off to his hometown of Augsburg and continued working on the screenplay with Lania. Perhaps to spite the authoritarian Pabst, he was more determined than ever to invoke his collective style of working, and he also brought in Neher and another writer, the Communist sympathizer Slatan Dudow, to help revise the script.[26] As the producers fumed in Berlin, Brecht provoked them further by taking time off to go to yet another waterside *Kraal,* the house on the Ammersee, where the pregnant Weigel and six-year-old Stefan were waiting for him.[27]

That was the moment for Weill to arrive on the Ammersee. The predictable friction between the imperious Brecht and the producers did not surprise the composer, but since he was also disappointed by what he saw as the vulgar direction the film was taking, he sided entirely with his partner. He wrote his publishers: "Nero, purely commercial in orientation and curiously disorganized, apparently wanted

to make a harmless operetta film out of the *Dreigroschenoper*. We have to use every means at our disposal to guard against that."[28]

The composer also knew that Brecht's politicized revision would ignore the needs of the music altogether, and Weill likely came to work on the adaptation with a variety of motives. First, and in complete sync with Brecht, to protect their contractual artistic rights; second, to protect his work from a literary structure, be it Brecht's or the director's, that would be damaging to the musical foundation; and third, because he thought he could broker an agreement between the uncompromising Brecht and the mighty egos fuming in Berlin.

Weill did not prevail in any of these goals. Brecht sent off yet another rebellious treatment to Pabst and Nebenzahl, with the rude new title *Die Beule* (The Bruise).[29] Lania came back to the Ammersee and tried to reason with Brecht, who in turn refused to write anything more for the project. Nero Films, insisting that Brecht was entirely unprofessional, asked him to resign and collect his fee. Brecht refused, and the script was subsequently revised by Pabst's team of writers in Berlin. The filming commenced without any further input from Brecht.[30] Brecht sued Nero Films immediately, claiming breach of contract and demanding a halt to the production. Weill supported him wholeheartedly and decided to join the lawsuit as well.

Weill had been pushed over the edge by the decision to insert music into the film that had been composed by someone else.[31] This was in violation of his contract and, he felt, entirely unnecessary. The composer had already been very tolerant of the needs of the cinematic version; he had accepted the reordering of the songs, the deletion of certain songs, and the loss of most of his actual score. While there had been fifty-five minutes of music in the play, the film only planned to use twenty-eight.[32] The severe reduction of his score made using the work of another composer all the more outrageous. He expressed his fury once again to his publishers: "The Nero people don't understand that they would be better off just letting us work in peace . . . rather than being in a constant state of confrontation with us. An awful industry!"[33] As Brecht and Weill prepared to go to court to stop the filming, the differences between them were for once overwhelmed by their shared interests. The power accorded to the producers and the direc-

tor made the film industry unbearable for these two very controlling artists.

The revisions to the original songs and score were not based only on Pabst's artistic preferences. The ever-increasing influence of conservative powers meant that many aspects of the 1928 play were deemed objectionable for the 1930 film. Pabst had undergone much scrutiny for the licentiousness of *Pandora's Box* and was understandably hoping to avoid problems with the strict censors whenever possible. For this reason, the "Pimp's Ballad" was performed in the film in an instrumental version—just as it had been for its popular recording—without the scandalous lyrics.[34]

While the two creators prepared to do battle in court, Lenya was working for their adversaries. For the recently famous star of the Berlin stage, this was yet another opportunity to boost her career, and she was greatly enjoying the cinematic version of her role as the prostitute Jenny. Since the character of Lucy (Tiger Brown's daughter) had been removed, her role was enlarged to become a combination of both women.[35] In a further stroke of luck, because her solo, "Pimp's Ballad," was now only going to be heard in an instrumental version, she was offered the "Pirate Jenny" song instead. With a chance like this, it is understandable that she (along with the diplomatic Caspar Neher) stayed out of all the arguments going on between her husband, Brecht, and the producers.

Lenya's role of Jenny occasioned some of the bigger changes to the story. In taking on some aspects of Lucy, her character was softened. She still attempts to betray Macheath but is ultimately too in love with him to go through with it. This creates both a more sympathetic and a more sentimental Jenny. When she sings the "Pirate Jenny" song, it is simultaneously a shout of protest for the sad circumstances of her life and a defense against her guilt about betraying her lover. Her moving rendition of the vengeful song ironically draws Mackie back to her, briefly reigniting their affection. She relents and helps him get away.[36]

The "Pirate Jenny" song in the film therefore plays an entirely different role than it did in the play. In the stage version, as sung by Polly, it had been used as a classic Brecht/Weill side song, irrelevant to the plot or characters. It instead illuminated another and grittier side of

Polly's seemingly "innocent" character. For the film's more conventional storytelling style, it made far more sense to have Jenny use the song to directly lament and then triumph over her position of powerlessness.[37] When Weill saw his wife standing in front of the paned glass window, singing the "Pirate Jenny" song with the precise rhythm and gesture he and Brecht had envisioned, it must have made the whole unpleasant film debacle suddenly seem worthwhile.

But not even Lenya's stinging performance could make up for what Brecht and Weill saw as an egregious artistic and contractual betrayal by Nero Films. The press agreed, and the trial became a cause célèbre all over the country. Receiving as much publicity as if it were a play or a film, the trial promised to be a dramatic public confrontation between artists and big business.

As creative people fighting for their artistic rights, the partners were very much in sync. When it came to the details, however, their issues were very different. Brecht objected to the tone and content of the adaptation, and he contended that the producers refused to accept his contractually guaranteed input. But because the producers formally requested another draft, and he refused to do it, he had officially failed to fulfill his duties as a writer. Weill, on the other hand, had gone on working for Nero Films until they fired him without just cause. "It is unbelievable the way these people have behaved," Weill wrote to his publishers. "After the latest events there is no doubt that our every attempt to protest against the kitsch which is manufactured there will be suppressed by use of deliberate force and methods one only thought possible in the wild west novels. When I tried for the first time to make use of my contractual right of co-determination and objected to a scene that seemed especially harmful, my employment contract was cancelled for no reason at all."[38]

By the time the trial commenced on October 17, the filming had been under way for three weeks. Since Brecht's and Weill's concerns and situations were entirely different, the judge's first action was to separate the lawsuits. The next step was for the court to attend a performance of *The Threepenny Opera* at the theater so the judges could better assess the differences between the stage and film versions. The seriousness with which the case was addressed, and the level of attention it received from the public and the press, was a sign that even in

the fall of 1930—as conservative powers curtailed and condemned the role of art in society—the Weimar Republic was still a system in which artists were highly valued. Germany was still a country that believed a true democracy ensured the right to cultural freedom.

The trial lasted four days, and the courtroom was a noisy, crowded venue exploding with conflicting passions. The judge often had to call for quiet and threatened more than once to clear the courtroom. As Lotte Eisner, a renowned film critic of the time, remembers, "All Berlin high society had tried to attend and the Court had to move into a larger courthouse for plenary hearings . . . Journalists from all over the country tirelessly took notes . . . Brecht's friends and his Nazi enemies were all present in force . . . The literary elite of the day sided with Brecht, realizing that the outcome would establish a precedent affecting all German authors."[39] The Nazis in the audience who opposed Brecht were nevertheless in a quandary—how could they support a Jewish producer like Nebenzahl? For Brecht, the high drama confirmed his particular love for the theatrical nature of a courtroom. The *Threepenny* trial could well have been a scene from one of his plays.[40]

Brecht was quick to emphasize the unethical role of big business in its association with creative ideas. He wrote: "'The protection of the authors' rights is denied because the producer is 'burdened with an exorbitant financial risk.' Intellectual interests may be protected as long as this protection does not cost too much. . . . The businessman, in this case as everywhere, prevails over the worker."[41] The lawyer for Nero Films was, however, quick to point out that Brecht had been known to disregard the supposedly sacrosanct nature of artistic rights. It had been Brecht who used K. L. Ammer's translations of François Villon's ballads, and his justification had been that he didn't believe in intellectual property. In citing the plagiarism case, the lawyer hoped to puncture what he saw as Brecht's hypocritical charges against the filmmakers. But Brecht returned fire. Not only had he come to an agreement with Ammer, including him in the revenues for *Threepenny* and contributing a preface to a new edition of Ammer's translations—showing he was not concerned with financial gain—but he also insisted that the issue in the courtroom was fundamentally different from the accusation of plagiarism. "In the present instance," Brecht declared, "he was in no way defending his copyright, his lit-

erary property, but"—and this is very significant to Brecht's attitude toward his audiences—"the property of the spectator, who had the right to demand that a work be transmitted intact and according to the author's intentions."[42]

Brecht's highly principled intellectual defense was applauded in the press. The *Kölnische Zeitung* wrote: "There is hardly any decency and backbone left in matters of art and art deals . . . There is no trust and no consideration for the work itself." The *Deutsche Allgemeine Zeitung* concurred: "Filmmakers have no right . . . to distort a stage play in any way they please. For the primacy of art . . . must unconditionally . . . be preserved."[43] With the support of the press, the literary intelligentsia, and much of the public, Brecht charged triumphantly out of the courtroom, treating the court as if it were his collective. He had listened to everyone's points of view and subsequently arrived at his own conclusions. He assumed his interpretation would prevail.

Several weeks went by before a verdict was delivered. In the meantime, on October 28, 1930, Brecht and Weigel's daughter Barbara Maria Brecht was born in Berlin. Since Weigel and Brecht still lived in separate apartments, the more hectic home life had little effect on his constant stream of professional activity. Not so for Weigel, who ended her engagement at the State Theater and became, for the first time, financially dependent on Brecht. He was busier than ever, but still not a reliable earner. In addition to the chaos of his risky lawsuit, Brecht, together with Benjamin, was also consumed by the creation of a left-wing journal that would publish protests against the government's increasingly authoritarian behavior. The journal, which was never published, was designed to prove that intellectual activity could have an influence on politics. He also worked with Eisler on *The Measures Taken*.[44] Brecht's persistent efforts in so many areas—theater, criticism, education—confirmed that his passionate courtroom defense of art's role in society was backed up by his intense personal commitment to the cause. He adored his children, but Weigel was the only parent who put them above and before her equally strong interest in theater and politics.

The verdict was ultimately decided without paying much attention to Brecht's heartfelt proclamations about the relationship between art and commerce. His plea was rejected because he hadn't fulfilled the

terms of his contract. The judges concluded that Brecht, by refusing to discuss the screenplay with Pabst or the producers, or to do further revisions, had voluntarily ended his collaboration. Although Weill also had strong objections to the filmed version, he continued working until Nero Films fired him without just cause. For this reason, the more diplomatic, and perhaps craftier, composer won. This gave him the right to block the distribution of the film, and he used this power to force not only the removal of any music not composed by him but also the right to supervise the final soundtrack. Although his score was ultimately abandoned in favor of an arbitrary selection of songs, Weill had gained as much control as was practically possible.

Both men received compensation. Weill was paid 50,000 marks for the use of his work, along with a contract that promised future employment on three films. And although Brecht lost rather decisively, he still threatened to appeal. Since the film was nearly done shooting and its producers hoped to release it as quickly as possible, Nero Films found it expedient to pay for Brecht's future silence. In exchange for withdrawing his objections to the film, they covered his legal fees in the amount of 25,000 marks. They also agreed to return the film rights to him earlier than the initial contract had stipulated.[45] The production of the film continued without further legal obstacles.

Both men were attacked, by the press and by the artists and friends who had supported them, for accepting money from Nero Films. Some even accused them of using the trial to gain greater profits. Both men needed the money to cover their legal fees, but characteristically, each of them attempted to explain their decisions in a different way. Brecht wrote an essay titled "The *Threepenny* Process: A Sociological Experiment" in which he claimed "the lawsuit was to be viewed as a sociological experiment, organized for the purpose of seeing certain ideas at work."[46] He continued: "The aim of the trial was to publicly demonstrate the impossibility of a collaboration with the film industry, even given contractual protection. This aim was achieved—it was achieved when I lost the trial."[47] As he had demonstrated in his "Notes" to *Rise and Fall of the City of Mahagonny*, Brecht was fond of reclaiming control by portraying his disappointing professional experiences as "experiments." A year later, he wrote his most damning pronouncement about the whole experience: "We have often been told and the court held

the same opinion, that when we sold our work to the film industry, we gave up all our rights; the buyers acquired through purchase the right also to destroy what they had bought; the money satisfied all further claims. These people felt that, by agreeing to deal with the film industry, we put ourselves in the position of someone who brings his laundry to a dirty ditch for washing and later complains that it is ruined."[48]

Weill's explanation was also true to his long-held ideals about the importance of artistic freedom. "I have not settled for the sake of a monetary reward. I went to trial to keep the film production free of methods that are harmful to art and to individuals, and I settled because [Nero Films] agreed to consult me in the future for direction of the production . . . Up to now, all film authors . . . have fought in vain for these concessions . . . Anyone who knows me knows that I agreed to the settlement not for material reasons but because I had attained the principal goal of the trial."[49] The composer also called attention to the practical necessity of his deal. The costs of his suit were well beyond his means, and the suit had been necessary since the damage to his name could have done irreparable harm: "I have to live from my work and from the material value of my name as a composer."[50]

While the composer technically won, the music in the film was far more different from the stage version than he would have liked—there was less music overall, the songs were rearranged, and the lyrics of the "Pimp's Ballad" had been cut. And although Brecht technically lost, the film ultimately took more of his new ideas than anyone who heard his violent objections could have imagined. In fact, Tiger Brown's dream about the beggar's revolt actually became a climactic sequence in the film: Peachum loses control of the beggars, who ultimately disrupt the coronation of their own free will. And although the romance between Macheath and Polly was more in the foreground than Brecht would have liked, their roles as bankers, the alliance of the capitalists against the poor, and the ending where Macheath escapes and thrives were all left intact. The film still functions as a profound assault on the capitalist system. As the musicologist Stephen Hinton accurately writes, "Despite Brecht's condemnation of the film as a 'shameless botch,' there is no denying that it sticks more closely to his own outline for the screenplay . . . than it does to his original stage version of *Die Dreigroschenoper*."[51]

Elisabeth Hauptmann dressed up as the main character in her short story "Bessie Soundso" ("Bessie So and So"). The modest Hauptmann often hid behind a pen name, but occasionally she dared to bask in the spotlight.

Carola Neher as Lillian Holiday in Brecht's *Happy End*, a play that unexpectedly climaxed with an anticapitalist message that caused a riot in the theater. Neher became a passionate Communist and fled to Moscow in 1936. She was imprisoned during Stalin's Great Terror and died in Russia.

Caspar Neher's sketch of prostitutes for the 1930 premiere of *Rise and Fall of the City of Mahagonny*. The scandalous brothel scene almost stopped the production. Weill and Brecht softened its crude sexuality with the love song "Cranes' Duet."

Caspar Neher in 1930. The cheerful and diplomatic Neher often found himself in the middle of the creative and personal disputes between his good friends Brecht and Weill.

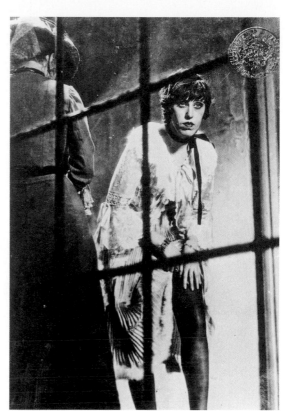

Lotte Lenya as Jenny in
G. W. Pabst's controversial film
version of *The Threepenny Opera*.
Script and musical changes
compelled Brecht and Weill to
sue the production company.

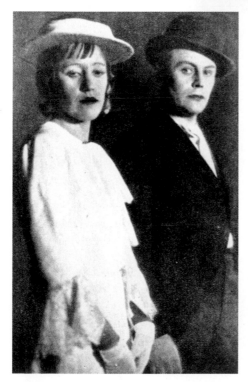

Lotte Lenya and Harald Paulsen
(the original Macheath) in the
1931 *Rise and Fall of the City of
Mahagonny*. As Jim and Jenny,
their romantic relationship
cruelly depicted the uselessness
of love in a society that cares
only about money.

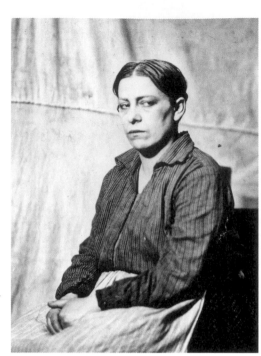

Helene Weigel in *The Mother*, 1932. Brecht rehearsed this Marxist play in the basement of the Berlin theater where Weill was staging the opera *Rise and Fall of the City of Mahagonny*.

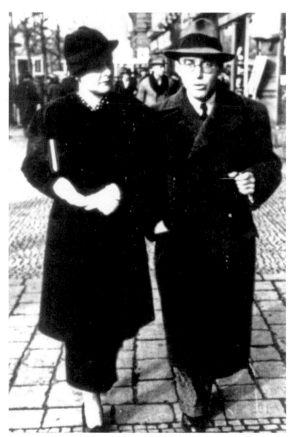

Erika Neher, wife of Caspar, with Kurt Weill. Their love affair began in 1932, when this photo was taken. Weill continued to write her passionate letters from France and the United States until the end of 1936.

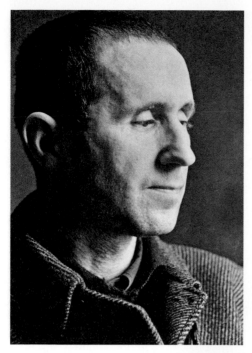

Brecht in Paris, 1935; Kurt Weill in Paris, 1933. Although their partnership was over by the time both men fled Nazi Germany, exile forced them together one last time. Their brief collaboration on *The Seven Deadly Sins* in Paris prompted Weill to call Brecht "one of the most repulsive, unpleasant fellows running around on this earth."

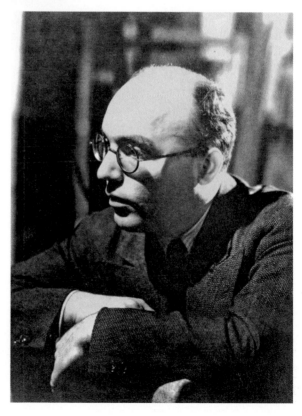

Tilly Losch and Lotte Lenya in *The Seven Deadly Sins*. Weill invited Lenya to be in the play in the hope of restarting her career in exile. He also wanted to distract her and her lover, Otto Pasetti, from the gambling casinos in the South of France, where they were losing a lot of money.

Helene Weigel's Danish passport photo, 1939. Thanks to Weigel's connections, Brecht and her children were able to able to live, work, and go to school in Denmark for six years. They fled in 1939, when the Nazis occupied the country.

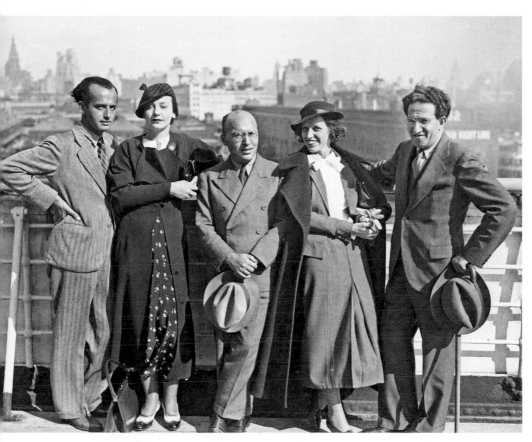

Francesco von Mendelssohn, Eleanora von Mendelssohn, Kurt Weill, Lotte
Lenya, and Meyer Weisgal on board the *Majestic* as they arrive in New York
City in 1935. Weill's friends were astonished when he and Lenya reunited in
Paris and decided to begin a new life togther in America. They remarried in
New York in 1937.

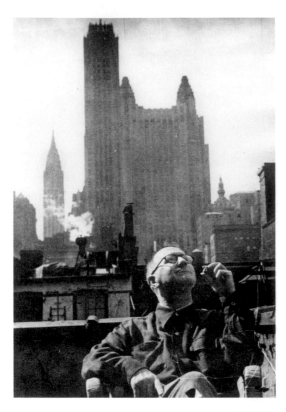

Bertolt Brecht in New York City, c. 1941; Kurt Weill at his house in New City, c. 1941. Brecht never felt at home artistically or personally in the United States, where his work still remained largely unknown. Weill enjoyed creative and financial success on Broadway and adored America.

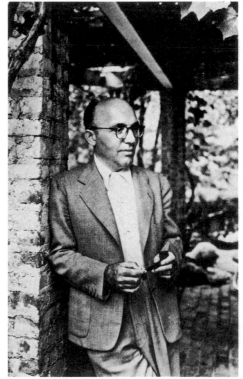

One point was proven above all others: There's no such thing as bad publicity. The notoriety of the trial led to a phenomenally successful revival of *Threepenny* at the Schiffbauerdamm. In addition, Brecht was able to present an even more radical version of *A Man's a Man*—one where the soldiers were transformed into monsters on stilts—and which opened on February 6, 1931. It was a critical and commercial failure, and was closed down after just four performances, but nevertheless generated the kind of public controversy that Brecht craved. Weigel craved it as well, and although it had been less than four months since the birth of Barbara, she once again played the role of Begbick in a production that also featured Peter Lorre as Galy Gay.[52] The faithful Neher designed the sets. *A Man's a Man*, the play that had first brought Brecht and Weill together after its radio broadcast in 1927, was also being performed with new incidental music by the composer. By the time Pabst's film opened on February 19, 1931, both Brecht and Weill were enjoying a particularly prominent presence in the theater.

The premiere of *The 3 Penny Opera* was heralded with so much fanfare and publicity, it was as if Nero Films was trying to surpass the excitement that had surrounded Brecht and Weill's lawsuit.[53] The one small nod to its stormy journey to the screen could be detected in the description of the film as being "freely adapted from Brecht" (*frei nach Brecht*). The press and the public received it warmly, and Pabst could rightfully lay claim to having heightened the love story without sacrificing the film's attendant political and social satire. The success of the film further promoted the popularity of the songs that were released on a new album featuring photos of the movie's stars. Both Brecht and Weill would reap financial benefits from the commercial film that had disappointed them both so much.[54]

Where did all this spent passion leave their troubled partnership? As they had indicated at the trial, they were in complete agreement about the importance of their work and the cause of artistic freedom. But the ultimate division of their joint lawsuit was also emblematic of the fact that they continued to be in utter disagreement about how to further their individual goals. For the first time since they met four years earlier, they were not planning any new projects together. In that cold winter of 1931, they pursued separate plans that predictably went in entirely different directions.

After his disappointment with the film, Brecht still hoped to realize the true potential of *The Threepenny Opera*. To that end, the "master of the work-in-progress" turned once again to his literary journal, *Versuche*.[55] These slender gray volumes, with their cheap paper and intentionally provisional appearance, epitomized Brecht's desire to keep his works in continual flux while reverentially documenting every step of his artistic experimentation. As he had already done with *Mahagonny* in the second *Versuche*, he planned to publish a revised version of *The Threepenny Opera* in the third edition, along with yet another set of notes that would offer a far more Marxist interpretation than had been intended when it was first written.[56]

The editions of *Versuche* joined two conflicting impulses. The modest style of the journal, designed to look like something that could be thrown away, emphasized its commitment to the freedom of everchanging ideas and attitudes. But at the same time, Brecht used his journal to canonize his own work. Thus it refuted the notion of literary authority and claimed it at the same time. And although the names of many authors were listed on the first page in true collective fashion, the cover still labeled the journal as "Brecht's *Versuche*." The complex web of contradictory impulses was much like Brecht himself—profoundly committed to the collective creation of socially provocative theater, yet unable to control his powerful ego and individual need for control.

The revised version of *Threepenny* was a work in progress throughout much of 1931. Hauptmann had been in charge of the journal ever since the debacle of *Happy End*, and in addition to inspiring much of *Saint Joan of the Stockyards*, her ruined play also provided specific scenes and lines of dialogue for the new *Threepenny*. Specifically, Hauptmann and Brecht took Fly's famously climactic speech in *Happy End*—the politically charged monologue added by Brecht and Weigel at the last minute—and gave it to Macheath to declaim after he has been sentenced to death. The speech ends with a directly polemical call to action: "Robbing a bank's no crime compared to owning one!" and "What's murdering a man compared with employing a man?"[57] Earlier in the new version, Macheath's attraction to banking is previewed with yet another new line spoken when he first takes leave of Polly: "'Between ourselves,' he confides to Polly in the 1931 version of scene IV, 'it's only a matter of weeks before I go over to banking altogether.

It's safer and it's more profitable.' "[58] Macheath's new line introduced the essential thematic thrust of the transformed *Threepenny*—the moral equation between bankers and criminals. In addition to these attempts to create a far more political *Threepenny*, Brecht also published "Notes" that laid out a strictly Marxist interpretation of the play. Weill never approved the changes, but after it was published in the third issue of *Versuche*, Brecht tried to establish the 1931 version as the official *Threepenny Opera*.[59]

Weill was equally concerned about the dangerous reactionaries, but Brecht's serial revising was an anathema to his creative process. The composer rarely revisited a finished work in order to update its relevance; he instead chose to express his new ideas in entirely new compositions. And his overall goal had never wavered: He wanted to redefine the modern opera for the twentieth century. But this did not serve as an excuse to ignore the pressing issues of the day. Weill believed more than ever that the opera—by cloaking contemporary issues in timeless themes—was the most effective way to inspire a critical attitude toward society. So he began to work on another full-length opera: *Die Bürgschaft* (The Pledge). It was to be set on a cattle farm in precolonial Africa and addressed the "role of justice in a primitive society."[60] It takes place in the past but was thematically modern without being pointedly political. Pure Weill.

Since Weill and Brecht's partnership was deteriorating, the composer's decision to work with Neher as a librettist on his next opera could have seemed spiteful—as if he was deliberately taking possession, artistically and personally, of Brecht's best friend. But Weill's choice had more to do with his singularly purposeful character and working style. In choosing Neher, he was able to further the intentions he and Brecht had once shared—intentions that no one could understand better than the designer who had always been an instrumental part of every production. Neher provided a large part of Brecht's intelligence and originality, but because he was quiet and diplomatic, and such a close friend, his skills came in a far more pleasant package. Weill was also increasingly fond of Neher's wife, Erika, and the prospect of a trip together in Spain, where they could work and enjoy a vacation, promised to be far more pleasant than any excursion he had ever taken with Brecht and the various members of his family and collective.

For his part, Neher had worked with Brecht since he was a teen-ager, and more than anyone else he had witnessed his friend's explo-sive creative process and endured his triumphs and failures. It was finally the visual artist's turn to try his hand at writing a libretto. Given all the conflicts he had witnessed, it would have been impossible for even the modest Neher to resist the chance to have more input and control over a production.

In the summer of 1931, before joining the Nehers in Spain, Weill and Lenya took their regular vacation in Le Lavandou. Since Brecht had also come down to this same beach for yet another working holi-day, the composer was once again confronted with the playwright's constantly distracting personal turmoil. Brecht was joined by Benja-min, with whom he discussed a variety of intellectual and theoretical endeavors, as well as Hauptmann, Hesse-Burri, and other regulars. Weigel stayed in Berlin with the children. Along with the second child came Weigel's increasing irritation over Brecht's infidelity, and that summer she was the unfortunate recipient of unpleasant rumors about her husband's beachside love affairs. As an actress who had appeared in three plays since the birth of Barbara, and who was also in charge of all Brecht's domestic affairs, she barely had time to breathe. Brecht, it seemed, had time for several lovers along with many ongoing profes-sional projects. As it turned out, even the invincible Weigel was human.

In response to her angry letters, he wrote: "Here I am at Le Lavan-dou, staying at the Hotel Provence, where the Weills are staying too. Hesse and Hauptmann are staying at a private pension, I don't think there can be any such gossip . . . The weather is bad. Wind and rain . . . What are Steff and Barbara doing? . . . would you care to spend three or four days with me in Paris?"[61] Brecht was clearly trying to appease Weigel's anxiety, but he didn't balk at lying to do so. He was in fact stay-ing with friends at a villa where Hauptmann also had a room. When Hauptmann left, Carola Neher, yet another old flame, took her room as well as her place as his lover.[62] In his subsequent letters to Weigel, he kept up the pretense of living in the hotel and felt sufficiently assured of her gullibility to ask her to send books, and to take care of his other daughter, Hanne, from time to time.[63] He seems to have misgauged even the resilient Weigel's tolerance, however, because she declined to write back. Noticing her silence, Brecht wrote to her on a menu

from the hotel restaurant, presumably to prove his residence there. He even asked Lenya and Weill to write their greetings on the menu, but Weigel's silence persisted. Several weeks later, Brecht learned from his father that Weigel had taken a vacation with the children in their usual place on the Ammersee. She hadn't informed him of her plans.

It wouldn't be long before Brecht would join his family by the Bavarian lake. His passionate affection for his wife and children never waned, even if he refused to acknowledge the toll his unfaithfulness took on them. Whenever Weigel's patience was tried to the breaking point, he always showed up at the eleventh hour. She always took him back. Seen from Brecht's perspective, his conscience was clear by virtue of the sincerity of his emotions—all of his emotions. In a letter to his father, who was suffering from a bad cold, Brecht's fondness for his children is warmly displayed: "Steff goes to school in a few days and found a knapsack that he's very proud of. Little Barbara is fat and rosy-cheeked and can shout very loudly. Helli sends her greetings and hopes you feel better soon, also Steff, who suggests that you should put a hot water bottle on your stomach (although he himself can't bear hot water bottles). I myself hope, as I said, to be there soon and hope that you soon get over this. Yours, Eugen."[64]

The women who loved Brecht—and who chose to stand by him personally or professionally, or both—had to figure out their own way of handling the complexity of this unrepentant and unchangeable man. Hauptmann had decided, in March 1931, that one way to right the balance of Brecht's legal relationship with Weigel was to get married as well. She chose a radio producer named Friedrich Wilhelm Werner Kurt Hacke, a man whose name is as long as Hauptmann's mention of him is scarce. Hacke doesn't appear as a close friend or lover in any of her journals or correspondence, and there is good reason to believe that she was living with Bianca Minotti before and after her marriage to him. Minotti had been Hauptmann's comrade during her Salvation Army research for *Happy End* and was by then a committed Communist as well as a lesbian. There is no evidence of a lesbian relationship between Minotti and Hauptmann, but the closeness of their friendship is well documented in letters and photos taken during the late twenties and early thirties.[65] If not for the official marriage certificate, it would be hard to believe that Hacke actually existed. For

the time being, however, Hauptmann required not only independent professional activities but also a husband in order to remain close to Brecht.

Weill and Brecht, however, had not found a way to correct the problems in their creative relationship, and their differences continued to separate them as they headed back to Germany in the fall. In addition to the plays he was developing, Brecht had plunged headlong into the screenplay for yet another film, *Kuhle Wampe oder: Wem gehört die Welt?* (Cool belly or: to whom does the world belong?), to be produced by Promethus, a Comintern-sponsored company.[66] Working with his Communist collaborators Dudow and Eisler, he was determined to use the film "apparatus" for anticapitalist purposes. Along with his *Versuche* version of *Threepenny*, this was yet another way in which he tried to compensate for his disappointment over Pabst's commercial film. *Kuhle Wampe* was about the life of unemployed workers in Berlin—an ever-present and daily growing crisis in Germany—and it openly supported a Communist solution to the country's problems.

Weill continued to work on his new opera with Neher, as well as devoting much of his time to finding a place to produce the full-length *Mahagonny* in Berlin. If much of the rest of the country had fallen sway to right-wing censorship, his home city held out the only hope for the future of freedom of the arts. Weill needed to believe that he and his work would always be welcome in Berlin.

The year 1931 ushered in a crisis of enormous proportions. The number of operas performed in Berlin was slashed from thirty per year to eight, and by July, right-wingers had succeeded in shutting down Otto Klemperer's Kroll Opera House.[67] As cautious as Klemperer had been in refusing to stage *Mahagonny*, he was nevertheless modern enough to be labeled a "cultural Bolshevik" by the conservative government officials in charge of funding the arts.[68] Piscator had also been forced to give up his bankrupt theater, and Ernst Josef Aufricht could no longer afford the lease on the Schiffbauerdamm. Even Max Reinhardt had closed his five theaters and returned to Vienna. At a time of massive unemployment and savage cuts in wages, Chancellor Brüning had declared his sixth emergency decree in an attempt to control the bloody clashes between demonstrators and the police. By the middle of the year "the state of emergency had become the rule."[69]

Under these desperate economic circumstances, it was hard to mobilize the masses against the extreme cultural censorship, or to object to the slashed funding for the arts. Most people were concerned with the ability to afford food and shelter.

Artists like Piscator tried to ignite a nationwide protest. He wrote an impassioned piece for a full-page appeal published by the Berlin Press Service. It was titled "Germany, Awake! On Occasion of the Berlin Rallies Against the Abuse of Intellectual and Artistic Freedom—Call for a Unified Front in the Battle Against the Cultural Reaction." In the very same week it was published, the Nazis tried to stop the release of the film *All Quiet on the Western Front*. Their protests were ultimately unsuccessful, but the Nazi storm troopers, led by Joseph Goebbels, disrupted the premiere by bringing mice into the theater.[70]

Along with other noted cultural celebrities such as Alfred Döblin, Carl Zuckmayer, and Harry Kessler, Weill also contributed an article in which he detailed the Nazi disruptions of *Mahagonny* all over Germany. He lamented the lack of government leadership to control the forces of "stupidity and narrow-mindedness" that were demoralizing artists all over the country. These artists, he decried, are "fully exposed to an opponent who cannot be affected by the intellectual defense mechanisms at our disposal, and against whom only governmental power can succeed." Only a spirit of irrational and infantile cowardice, Weill declared furiously, prevented the government from controlling the forces of ignorance that were holding sway over the cultural fate of Germany.[71]

Given Weill's public courage and his insistence upon artistic freedom as a guarantee of all freedoms, why did he and Brecht feel so very far apart? Even if Brecht had long ago dismissed opera as an elitist form, "an old mismanaged, broken-down circus robbed of its magic, with its effeminate tenors and masculine prima donnas, its rinsed-out lingerie and bellowing pipes," why didn't he give *Mahagonny* credit for the kind of provocation it clearly incited?[72] Couldn't Brecht see that Weill's fight to mount a Berlin production of *Mahagonny* was as profound a cultural battle against the extreme right as his desire to produce an overtly Communist film?

The truth is that Brecht was not quite as done with the operatic form as he proclaimed himself to be. Otherwise he would have

completely ignored the production that Aufricht finally managed to finance at the luxurious Kurfürstendamm Theater. But Brecht was instead inexorably drawn back into his debate with Weill; he could not resist yet another chance to recast *Mahagonny* in a more radical mold.

The opera was to be presented in a theater and not an opera house, and this choice was entirely reflective of the times. For despite the tightening of Prussian control from above, a Berlin audience still craved socially provocative drama. Aufricht, who would never have been able to receive government funds for an opera like *Mahagonny,* could still count on selling tickets to a controversial show. This alone might not have been enough to convince a backer, but the ultimate source of funding was as ironic as the story of the opera itself.

Rise and Fall of the City of Mahagonny—an opera about a town where the only sin is running out of money—was financed by a banker named Fritz Schönherr. Schönherr was a social democrat, but his motivation for underwriting the opera was just the kind of romantic love that didn't exist in the paradise city. He opened his wallet mainly because he adored the actress Trude Hesterberg, who desperately wanted to play the role of Begbick, one of the founding fugitives. Hesterberg introduced her besotted boyfriend to Aufricht, and after months of struggling, a production was under way immediately after their first conversation.[73] Since the orchestra size would have to be reduced and singing actors would be engaged, Weill was especially thrilled to hear that Aufricht could afford a first-class conductor, Alexander von Zemlinsky. The composer was even more pleased to hear that in order to ensure *Mahagonny*'s box-office appeal, Aufricht insisted that Lenya play the other leading role of Jenny. The very same actress whose name had been left out of the *Threepenny* program three years ago, whose unknown status had worried Aufricht a great deal, was now being called in as a star who could attract a large audience.

Weill, who had originally written the music for trained opera singers, agreed to alter the musical demands of Jenny's songs so that Lenya could sing them. If he had to work with singing actors, there was no one better than his wife. But Lenya had been away for several months, and although he was thrilled to welcome her into the opera, he would have a lot of explaining to do upon her return.

Even the loyal Weill was not immune to the effects of the grow-

ing unrest and uncertainty of his position—as a Jew and artist—in Germany. The thirty-one-year-old composer was working harder than ever, but his emotions were raw, and by the end of 1931, his habitual denial became impossible to maintain. He had taken the precaution of opening a Swiss bank account just in case the troubled times endangered his assets, but even admitting the potential of such an event was very painful for him. In midsummer, when Lenya went to Russia to do a film with Piscator, *The Revolt of the Fishermen of Santa Barbara*, he was left to his own devices for many desperate months of personal and political turmoil. Without Lenya's practical presence to stop him, he fell sway to his growing affection for the twenty-eight-year-old Erika Neher. The fact that Erika returned his feelings did not make things any easier. Weill, who tried hard to keep his life simple and devoted to work, succumbed to an affair with the wife of his best friend and creative partner. The composer was once again headed into dangerously Brechtian waters, but he was unable to leave his powerful conscience behind.

Weill seemed as loyal as ever when he called Lenya in October, in Russia, and announced: "Darling, I've bought you a house for your birthday."[74] The house was in an elegant suburb of Berlin called Kleinmachnow, and the composer was very proud of his ability to afford such an elegant residence. But although Erika's husband had already been informed, Weill didn't say a word to Lenya about his new relationship. This was extraordinary behavior for the forthright composer—the clearest sign that despite his outwardly courageous stance toward the right-wing extremists, he was deeply unsettled and frightened by the extraordinary times.

By the time an exhausted Lenya returned from Russia, she barely recognized the life she had left behind. Several theaters and operas had closed; a long-established Berlin bank that had guaranteed some additional loans for Aufricht's production had collapsed overnight; and most surprising of all, her reliable, predictable husband, the most faithful and kind man she had ever known, was having an affair.[75] Even worse, he seemed to be very much in love. But this demoralizing news didn't prevent her from moving into the house that he had, after all, bought for her and put in her name. It didn't stop her from beginning rehearsals on time and prepared, and reveling in yet another role

of a lifetime. She noticed that Weill's beloved opera music had been changed for her, and without an operatic voice, she would have to work very hard to please him.[76]

Lenya also knew Weill would never stop loving her even if he loved another as well. And she was realistic enough to accept that since he had tolerated all of her affairs, it was now her turn to be understanding. Or as understanding as she could be. She both dismissed and acknowledged Erika by describing her as "a sexy little pony, one of those blonds, sturdy and witty. I could see why he would fall for somebody like that."[77] Weill lived for his work, as she knew too well, and in playing the role of Jenny, she was to be part of his work for the next month. She may even have gotten more attention from him than when she was "only" his wife.

Since Brecht had dismissed *Mahagonny* as an experiment designed to destroy the operatic genre, he was delighted to have the opportunity to prove its mettle on the theatrical stage. Now that it had been liberated from the opera house, Brecht also hoped to have a better chance of getting his way in the theater. He began interfering in rehearsals right away.

On the composer's recommendation, Aufricht had agreed to let Neher direct as well as design the work. The producer probably hoped that Neher's relationship with Brecht would help to form a bridge to the composer, but Weill of course had other reasons for promoting Neher's artistic prowess. He was perhaps trying to indicate how much he valued Neher as a friend and colleague, even and especially when he was betraying him in other ways.

It is impossible to imagine an atmosphere more charged than that at the Kurfürstendamm Theater in December 1931. Outside, the streets were seething with tensions among the Communists and the National Socialists, the angry unemployed, and the battle-weary and frightened government. Inside, the composer, married to one of the leading ladies, was sleeping with the director's wife; and the conductor and the producer were doing everything they could to keep the writer from sabotaging the production. Perhaps hoping that their noisy confrontation could drown out the far more terrifying situation going on just beyond the theater walls, Brecht and Weill were once again dueling over *Mahagonny* as if their lives depended on it.

There was only one dramatic revision that both Weill and Brecht could agree upon. They changed the names of the doomed lumberjacks yet again, this time to Paul, Heinrich, and Joseph. This was a direct reference to the three directors of the German Music Festival who had rejected *The Measures Taken* the year before. The composer and the playwright had both been angered by the behavior of Paul Hindemith, Heinrich Burkard, and Joseph Haas, and this was their playful revenge.

Everything else between Weill and Brecht was a battle that knew no end. According to Weill's observant friend Felix Joachimson, Brecht "claimed that the . . . sound of Weill's score was working against the concept of [his] theater. It was covering his hard-core anti-capitalist drama with a carpet of saccharine bourgeois melodies. Kurt Weill reacted sharply and fast. He instructed his lawyer to obtain an injunction to restrain Brecht from entering the theater. Brecht filed a similar action."[78] The battle over words and music was out in the open again, and neither Brecht nor Weill would surrender. Neher was called in to negotiate, but since he was equally loyal to both men, he was the least qualified to effect a truce. The news of their fights spread throughout Berlin and "reporters descended on the theater. One enterprising photographer managed to take a picture of Brecht and Weill together as they were emerging from a meeting with their lawyers in Aufricht's office. Brecht got furious, knocked the camera out of the photographer's hands and yelled after Weill who was on his way out: 'I'm going to kick that phony Richard Strauss down the stairs!'"[79] For the third time in a row, Aufricht was faced with a catastrophic rehearsal of Brecht and Weill proportions. Given the endangered economic and political times, creative differences had become a luxury that no Berlin artist could afford and the producer knew it.

Of course it was Brecht who had to be ejected. Not only because Zemlinsky insisted upon Weill's presence but also because it was impossible to allow Brecht to make *Mahagonny* any more controversial than it already was. Desperate for a solution, the producer finally made the angry playwright an offer he couldn't refuse: to mount a small production of Brecht's newest play, *The Mother.* This was a blatantly Communist work and would have been very difficult to produce anywhere else in Germany by that time. Brecht and his actors quickly accepted and

began rehearsing in a small room in the basement of the same theater where *Mahagonny* would be performed.

Loosely based on Maxim Gorky's novel of the same name, *The Mother* was about a woman who is radicalized by the death of her activist son.[80] The cast included Weigel in the lead role, Theo Lingen, and Margarete Steffin. Steffin was the daughter of seamstress and a construction worker and a member of a Communist youth group, whom Weigel had taught in her acting class at the Marxist Workers School. Steffin was a symbol of Brecht's ideal union between the theater and the working class, and he was especially pleased by her presence in his play. Neher was designing the show and made many trips up and down the stairs of the theater—directing above and designing below and, as always, refusing to take sides in the conflict between Brecht and Weill. Eisler composed the songs for the play, and Brecht declared his work to be the most effective stage music he had ever heard. He likely shouted this loudly enough for Weill to hear it upstairs.

Brecht also came upstairs from time to time. Hearing the siren call of the orchestra as it reverberated through the ceiling of his rehearsal room, it was impossible for him to resist objecting to what he saw as Weill's operatic bullying. Brecht's disruptions were soon quelled, not least because his passion for *The Mother* was growing every day. This play was his most convincing example of political theater so far, and its integrity gave him the strength to leave his earlier attempt in peace. At the end of the rehearsals, Brecht and Weill left the theater by separate entrances in order to avoid accidental encounters.

The Mother left the basement to play exclusively for workers at first, but went on to have short runs at more commercial theaters, as well as in schools and community centers. The play had been designed so that all the props and scenery could fit into a small truck and be transported to a variety of venues. The goal was in keeping with the Communist Party's desire to mobilize the working class, a cause that was furthered by frequent performances in accessible places. The Communists continued to be the only other political entity capable of garnering the kind of mass appeal—one that fueled parades and demonstrations—that the Nazis had achieved.

Despite the ill will between Brecht and Weill, and the prolonged tension of the rehearsals, the Berlin premiere of *Rise and Fall of the City*

of Mahagonny on December 21, 1931, was a success. Joachimson, who was faithfully present at all of Weill's premieres, remembered that "it was as brilliant and as festive an opening as Berlin had ever seen. Minks and sables and black and white ties sat shoulder to shoulder with crew-neck sweaters ... There were no protests. There was no opposition. As the evening progressed, the enthusiasm grew. The sheer theatrical power of the Weill-Brecht work wiped out the controversies right and left."[81] And when more than a hundred Nazis managed to create an uproar on the second night, the police threw them out and the performance continued undisturbed.

This theatrical opera, or operatic work of musical theater, had managed to fulfill the goals of both Brecht and Weill: True to the composer's wishes, it was a powerful portrayal of universal sin, free from any specific political affiliation; true to the writer's demands, it offered a critical perspective of bourgeois society. The combination of their talents had progressed to a point where the explosive results occurred even without their agreement—even with their passionate disagreement. Together, they created what Marc Blitzstein would praise as "a poetic paean of rage; and with the rage, it has said its say. It is also shot through with personal tenderness, solemnity, and ribald garish poetry."[82]

Mahagonny played for fifty sold-out performances before closing in Berlin. In her role of yet another prostitute named Jenny, Lenya sang the most powerful song of all: "How You Make Your Bed." Her tragic proclamation moved the audience as profoundly as it pierced Lenya's own heart. With all the defiance she could muster, she sang, "So lie down and get kicked if you want to. As for me I will stand up and kick!"[83] She sang it to her unfaithful husband, and yet knowing she had gotten what she deserved, she also sang it to herself. But perhaps her shout of protest was aimed most of all at the tyranny erupting outside the theater. Venturing well beyond her private pain, Lenya's Jenny not only mirrors the cruelty of the world but also fights against it. When Lenya sang "We're humans, not brutes!," it was on behalf of all the persecuted artists and intellectuals.[84]

Lenya brought the house down one last time in Berlin, and then, tired of watching Weill's intense passion for Erika, she accepted the leading role in a smaller production of *Mahagonny* that was to be

mounted in her hometown of Vienna. Weigel might have envied Lenya's ability to come and go as she pleased. For despite her solidarity with Brecht, as *The Mother* fulfilled their greatest hopes of activist political theater, and despite the role her publicly acclaimed performance played in that success, she saw Brecht's eye roving once again.[85] This time, perhaps for the first time, she sensed real danger.

At the end of 1931, hardly anyone was left unscathed by the palpable foreboding in the air. Once Brecht and Weill were unable to reconcile how their work should battle the outside opposition, the fragile balance of their creative partnership was destroyed. With or without the end of the world as they knew it, one thing was clear: On a personal level, they couldn't stand each other anymore. The explosive rehearsals for *Rise and Fall of the City of Mahagonny* destroyed what was left of their partnership. They would never work together in Germany again.

Exile

Kurt Weill was defined by the precise habits that structured his day and soothed his mind. Whether he was living and working in one small room divided in half by a hanging tapestry or, as he was in the beginning of 1932, in a large, elegant home in the Kleinmachnow suburb of Berlin, he was always at his desk early in the morning. Although he certainly enjoyed luxurious surroundings, Weill didn't need them in order to work. The piano was bigger and better than it had been at the Pension Hassforth, the rooms were larger and brighter, and he did not miss the solemn paintings of the hunting dogs. Weill's long hours of composing were punctuated by his enthusiastic labor in the garden surrounding his redbrick house. He loved flowers and anticipated spring as keenly as an opening night for one of his operas. Where he once had to stroll through public parks to delight in the first bulbs poking up through the earth, he could now enjoy the early blooms right in front of his house. He lived better and had more money than he ever imagined possible, but the predictable nature of his days was still essential to his soaring creative spirit. He needed both feet on the ground in order to capture "the roaring hymns of the stars."[1]

So many of his dreams had come true, at least when it came to his music. But almost everything else in his life had taken an unexpected turn.

The successful composer had continued his intense love affair with Erika Neher as he worked almost daily with his good friend and her husband, Caspar. Lenya had understood the depth of Weill's passion for Erika and remained in Vienna even after *Mahagonny* closed. "I'll tell you what it was with Kurt," Lenya confided to a friend. "He had affairs which were rather serious because Kurt was . . . very emotional and honest in his love . . . that was a lovely affair. She loved him . . . there was a wall I didn't touch."[2]

Back in her hometown, Lenya was immediately attracted to her young and handsome co-star. He called himself Otto Pasetti, or upon occasion *von* Pasetti to acknowledge his aristocratic heritage. Pasetti was from the kind of Austrian family Lenya would never have encountered, let alone attracted, when she was an impoverished girl from the wrong side of the tracks. But with the confidence caused by both her celebrity status and her encouraging husband, Lenya pulled Pasetti in quickly. She needed to compete with the intensity of Weill's feelings for Erika. This surprised Weill. It was his first affair, and he probably hadn't expected Lenya to prolong her stay in Vienna because she couldn't bear to be around him and Erika. The composer worked even harder than usual in order to distract himself from the complexities of his personal life.

But on the day Weill walked through his snow-covered garden, passing by his brightly polished car on the way to his mailbox, where he found a note inside asking, "What's a Jew like you doing in a community like Kleinmachnow?," even he couldn't ignore the truth about the political situation in Germany.[3] His increasingly urgent efforts to lay down roots—to buy a house, plant a garden, and fall newly in love—had been a brave attempt to ignore the daily uprooting that was taking place in his native land. But the wrought-iron fence and graceful hedge in front of his house could not protect him for much longer.

Weill was not the only one who tried to calm his nerves by purchasing property in that tumultuous year. With substantial help from his father, Brecht also bought a house in Utting am Ammersee, a small town perched on his favorite lake near his boyhood home. For although Brecht wrote that he was at home in the "asphalt city," it never comforted him like the sound of falling chestnuts in the countryside of his youth. His modest cottage was set in the middle of a park

that had been beautifully landscaped, and Brecht reveled in the color and texture of every tree and blade of grass. Weigel adored swimming in the lake. Ultimately bound by his background and geography, the reputedly unconventional and rebellious poet wanted to own a house in the only place he thought of as home: the Bavaria in which he was born and raised. As the country he loved fell apart, Brecht craved a sense of belonging more than ever.

Brecht enjoyed the harmony of his life in the Bavarian country-side, but back in Berlin, he wreaked his usual havoc in his domestic life. When Weigel realized that Brecht had begun yet another affair, this time with her former acting student Margarete Steffin, Brecht's strong and tolerant wife finally threatened to divorce him. Grete, as Brecht affectionately called Steffin, was ten years younger than Weigel, and although she was attractive enough, it was her working-class background that appealed to Brecht most of all. It was as if he believed an intensely romantic relationship with a construction worker's daughter would finally absolve him of his upper-class trappings—as if Grete could be the gateway to a perspective that all his genius and education hadn't yet provided. And despite Steffin's impoverished background, she had extraordinary literary talent and a remarkable gift for languages that could rival even Hauptmann's abilities. Brecht was truly smitten, and Weigel knew instantly that Steffin was far more threatening than Hauptmann and the others had ever been. Brecht lost control of his emotions, as he hadn't done since his marriage to Marianne Zoff.

Steffin was chronically ill with tuberculosis, and her frail health was a sad reminder of Brecht's mother. For the second time in his life, he formed a deep and loving relationship with a woman who was unlikely to live for very long. From Weigel's more pragmatic perspective, Steffin also posed a real threat to herself, Brecht, and to their children. When Brecht temporarily took his sick lover into his Hardenberg-strasse apartment, exposing himself and his children to the disease, Weigel issued her first ultimatum. Brecht answered with his customary protestation of innocence: "I've told you in all sincerity putting up Grete was a purely practical matter . . . I'd have very much preferred it, and it would have been much more practical if you had put her up somewhere . . . as you know, I'd like to help her (as long as it doesn't

cost too much) . . . Dear Helli, you mustn't make a big thing of this . . . I am as fond of you as ever."[4] Weigel was still Jewish in the eyes of the increasingly powerful Nazis, and openly committed to the Communist cause, and such personal upheaval in her life couldn't have come at a worse time. She had two young children to protect, and this understandably weakened her habitual fortitude when it came to Brecht's infidelity. It was the first truly severe crisis in their marriage.

Steffin was finally sent to a sanatorium in Switzerland, an expense that was partially, if inexplicably, paid by Brecht's father.[5] Brecht engaged in a passionate correspondence with her that often included plans for the future, but characteristically, he also entreated Weigel not to leave him. He promised to finally move in with his wife, a promise he soon broke, but Brecht nevertheless managed to convince Weigel of his enduring "fondness."

Although Brecht and Weill didn't work together and were hardly speaking to each other for all of 1932, they were behaving in strikingly similar ways. While Albert Einstein, Oskar Kokoschka, Erich Maria Remarque, and George Grosz fled Germany as fast as they could, the Communist playwright and his Jewish wife bought an idyllic house in the country and the Jewish composer was looking forward to the flowers that would soon burst into bloom outside his elegant suburban home. Weill wrote and mounted a controversial opera. Brecht devoted himself to a highly polemical theater for the working class. New houses and new lovers gave them the personal strength to carry on in the face of an increasingly impossible professional battle against the brewing terror. They were acting as if owning land meant they had a future in their country; they were acting as if love had any power at all.

As Brecht and Weill attempted to wage separate cultural battles, unemployment skyrocketed and thousands rapidly descended into poverty.[6] It was time to make choices and take sides. And the choice was coming down to one between the Communists and the National Socialists. Both the National Socialists and the Communists were adept at mass demonstrations and at manipulating the unrest caused by Germany's economic turmoil, but the Nazis also had an increasing influence in the government. In contrast, the Communists had achieved only a small minority in parliament, garnering just 10 percent of the popular vote. In the second presidential election of the

Weimar Republic, in March 1932, Paul von Hindenburg, running as an Independent, outpolled Hitler by seven million votes, and yet it was still not enough to win a majority in parliament. There was a run-off election in April, and Hindenburg officially won but with an even slimmer margin. With thirteen million votes (36 percent of the total), Hitler was gaining, and fast. There was a tug-of-war for support, and ultimately the wealthy industrialists threw their weight behind Hitler. They didn't like him very much, but the Nazis seemed most capable of defeating the Communists, whom they hated even more. With the support of many disenfranchised workers, as well as the richest men in Germany, Hitler would soon be impossible to stop.

Neither Brecht nor Weill could have expected to go on expressing his views with impunity, but they fought on because their work was the weapon they could each wield the most strongly. Since they needed to be true to their artistic beliefs in order to keep that nearly impossible faith, it meant, for the first time, that they would be stronger if they were not together. Weill desperately needed to believe in the timeless aspect of opera as time was running out. Brecht desperately needed to believe in the rational influence of political theater as irrational forces won the day. Whether or not their new partners—Hanns Eisler for Brecht and Caspar Neher for Weill—were as brilliant, whether or not the combination was as electric as theirs had been, they had to follow their separate yet parallel paths in order to believe there was still hope for Germany.

They were far apart artistically, but the social and political import of their work was not as different as both men seemed to believe. Weill's opera *Die Bürgschaft* was set in a mythical precolonial town that is suddenly invaded by a "Great Power," one that rules by the "Law of Money and Power."[7] The protagonists, who once valued their friendship and believed in justice, succumb to the selfishness and greed of their new society. They betray themselves and each other. The opera is complex, but its overpowering message is clear: An individual has a moral responsibility when confronted with an immoral government or ruler. The metaphorical comparison to the Nazis was hardly subtle. Weill's language about the obligation of art to society remained as close to Brecht's as his preferred operatic genre was distant from the playwright's theater. "I believe that the task of opera today is to move

beyond the fate of private individuals toward universal social issues," he declared. With the exception of the word "universal," it was hard to tell whether it was Brecht or Weill speaking.

Brecht was quick to mock *Die Bürgschaft*, lampooning it with terms like *Avantgartenlaube:* a crude play on a popular bourgeois home magazine called *Gartenlaube* (garden arbor) and what he saw as the opera's pretensions to being avant-garde. As always, Brecht disdained Weill's elite opera houses, and instead struggled to perform *The Mother* in as many working-class venues as possible. He clung to the hope that an understanding of Marxist principles would enable the masses to resist Hitler's hypnotic lure. The conservatives recognized the danger of his play's appeal to the many angry and impoverished citizens, and tried to stop him wherever possible. Brecht and his actors made do with any space that could hold an interesting crowd, and they snuck in one last performance of *The Mother* at a brewery.

The Communists were thrilled with *The Mother.* In *Die Rote Post* it was called "the best propaganda for the revolutionary idea. Because what could be a more convincing advertisement than to reveal the principles of Marxism and Leninism in such a clear, lively, and interesting way. Even the least educated person will understand and be captivated by the play."[8] To Brecht's delight, the Communist press had finally acknowledged him as a poet for the working class.[9]

Die Rote Fahne, the newspaper that had once ridiculed his efforts, specifically credited Brecht's break from Weill, and his collaboration with a Communist composer, as the cause of the playwright's newfound political significance. Their review of *The Mother* declared, "Here there's no monstrous orchestra as on the Kurfürstendamm for Weill's score for Brecht's *Mahagonny;* no intoxicating violins, bloated wind sonorities . . . but rather a very small ensemble of a couple of brass players, percussion, and piano. But here there is sharp, clear voice—leading brittle march rhythms, proletarian songs that grip you tensely from the first to the last note."[10] The critic's words were naturally music to Brecht's ears.

Weill was dismissed as too "intoxicating" by the Communists, a charge he could have easily handled if not for the simultaneous and venomous criticism by the Nazis. They accused him of "intentionally

bringing Negro rhythms into German art music ... [as if] a trans-
fusion of Negro blood could not hurt us ... [As if] the people that
brought forth a Bach, Mozart, Beethoven, and Wagner need to be
rejuvenated with Negro blood."[11] And yet, in spite of attacks from the
right and the left, Weill finally managed to open his opera on March
10, 1932. It received mixed reviews, but one important critic dubbed
him "the only real opera composer in Germany"—the compliment
he wanted most of all.[12] Given Hitler's increasing political power, and
the opera's clear reference to the dangers of a tyrannical and violent
regime, the opera's relatively successful run in three cities was a testa-
ment to its artistic value. But it was only a brief moment of delay. The
Nazis would soon be able to suppress any form of art they found threat-
ening, and within months of the premiere, they managed to frighten
all the opera houses into canceling their contracts for *Die Bürgschaft*.

As Weill's opera was being canceled, the Film Inspection Board
was simultaneously prohibiting Brecht's Communist film, *Kuhle Wampe
oder: Wem gehört die Welt?* It was deemed a work of disturbing propa-
ganda likely to incite class warfare. There were massive public protests
in support of the film and against the board's unbridled use of censor-
ship to curtail artistic freedom. On May 30, 1932, and due specifically
to the public outcry, the film was briefly released and, in part because
of the uproar, it was also well received. But the cultural battles were
becoming more difficult by the hour. Very few film or theater produc-
ers had the courage or the power to insist on artistic freedom.

As he struggled to find a place that was still safe from the irratio-
nal and unjust forces spreading so rapidly across the country, Weill
returned to the lakeside house where his Berlin life had been so hap-
pily launched. He went back to work with his good friend Georg Kai-
ser, one of the few artists who still dared to be controversial. They
began work on a play with music to be titled *Der Silbersee* (*Silverlake*).
It was a winter's tale in keeping with the darkest winter in German
history. Like Brecht's film, the play portrayed a society devastated by
unemployment, hunger, and social upheaval. It was to be Weill's final
and unimaginably bravest shout of protest, as well as his disheartened
whisper of hope—but most of all, it gave him a sense of belonging that
nothing else could provide. He came back to Grünheide to work with

Kaiser, and as he gazed across the lake, he remembered his romantic encounter with Lenya in the rowboat. He hadn't seen her in months and had no idea when their next meeting would be.

At the end of the year, in yet another election, Hitler again received a solid third of the popular vote. He still didn't have the majority he needed in parliament, but the writing was on the wall. Even the doggedly optimistic Weill knew he must begin capitalizing on his good reputation in other countries. He jumped at an invitation from Paris to present *The Yes-Sayer* and the *Mahagonny Songspiel* in Paris. He even managed to secure parts for both Lenya and her lover, Pasetti, which gave him a chance to lure them both away from the roulette tables to which they had become increasingly attracted. Since money was getting tight, and Weill still felt responsible for his wife's financial security, this professional distraction from gambling was as much for him as it was for Lenya. He was happy to see her after such a long separation, and just as eager to be sure that the performance went well. He could always rely on Lenya's talent.

The audience, which included Igor Stravinsky, Jean Cocteau, and André Gide, was captivated by the concert, most especially by Lenya, who was "the toast of the critics."[13] The evening had been hosted by the Vicomte and Vicomtesse de Noailles, and shortly afterward, the composer received a commission from the prominent musical patron Princess Edmond de Polignac. Born Winnaretta Singer, she had inherited a fortune from her father, who invented the American sewing machine, and earned her title by marrying Prince Edmond de Polignac. Together, the Polignacs hosted one of the most famous salons in Paris. Just as he had done as a young boy impressing the Duke in Dessau, Weill was once again performing for royalty. Forced to accept that his days in Germany might be numbered, he performed with a mixture of pleasure and desperation.

The performance in Paris might well have given Weill professional options, but it didn't manage to revive his relationship with Lenya. They agreed to pursue a friendly divorce, and Lenya went back to Vienna with Pasetti. Weill returned to Erika, whom he still loved deeply, but she wasn't planning to leave Caspar or her son. The chances of a permanent relationship seemed dim.

In the final days leading up to Hitler's triumph, Brecht was equally

enmeshed in his fraught personal affairs. He managed to send Steffin to Switzerland and finally had more time to soothe Weigel's hurt feelings, and to see his children. For the first time since they had met, Brecht had only one lover in Berlin, and that was his wife. This situation was as unusual as the composer's affair with Erika. Everyone's identity was shaken as the country faced the inevitable rise of the Nazi Party.

Since the elections had failed to produce a solid majority in parliament and no two parties agreed to form a ruling coalition, Hitler finally convinced an aging Hindenburg to let him form the "Hitler cabinet." The radical academic Theodor Lessing had described the Hindenburg years with what turned out to be prophetic accuracy: "a Zero paving the way for Nero."[14] Hitler, who had still never won more than a third of the popular vote, was appointed chancellor on January 30, 1933. The end was no longer nigh—it had arrived.

On the day Hitler was appointed chancellor of Germany, Weill was in rehearsals with Kaiser for *Der Silbersee*. Neher, who was designing the sets, was also there. "We're ghosts," a friend of Weill's remarked after Hitler won his bid for power. The composer looked at him and answered: "I've never felt more real in my life. And what we're doing and what we're talking about is real. They are the ghosts."[15] But by then, this was only Weill's public face, the one he would keep until *Der Silbersee* made it successfully onto the stage. Privately, he was very worried, and he put pressure on his publishers: "What is going on here is so sickening that I cannot imagine it lasting more than a couple of months. But one could be very wrong and it wouldn't hurt to secure for oneself all the employment possibilities that lay outside Germany's official theater life."[16] The publisher's answer was gloomier, and weaker, than Weill had hoped: "I cannot agree that the course in Germany might only be a nightmare lasting a few months. I am filled with the deepest pessimism . . . we should be prepared for anything and just let fate take its course."[17] Weill refused to let anything "take its course." He wanted to fight, to hope, and at the very least, to plan for the worst. His editor, Hans Heinsheimer, was sounding alarmingly passive at a time when action was most needed.

Brecht also faced the immediate consequences of the Nazis' rise to power. On the day of Hitler's appointment, he was in Darmstadt,

unsuccessfully fighting the sudden, Nazi-influenced cancellation of the first stage performance of *Saint Joan of the Stockyards*. Soon another theater was savaged for performing *The Measures Taken,* the play rejected by Paul Hindemith a year earlier. Because of its Communist content, the police arrested the producers and charged them with treason. Naturally, no one else was interested in taking similar risks. Two weeks after Hitler was appointed, it became all but impossible for any of Brecht's plays to be performed in public.

Hermann Göring, the Prussian minister of the interior, quickly subordinated the police to the authority of the SS and the SA. This meant that the police would no longer be protecting the artistic rights of theaters and opera houses that were thought to have "Bolshevik" intentions. After this decree, local politicians soon threatened to penalize Detlef Sierck, the director of *Der Silbersee,* if he dared to open Weill and Kaiser's play with music. Sierck retorted bravely, proclaiming, "It was a time when it would be disastrous not to stand by one's opinion and give in."[18] The director, one of the most courageous men in German theater at that time, still had just enough power to follow through on his convictions.

What was most threatening about *Der Silbersee* was not only its story about unemployment leading to crime—a man is shot for stealing a loaf of bread—but also its blunt portrayal of a society torn asunder by class struggle. In the mythical villa by the silver lake, a policeman, a hungry thief, two deposed aristocrats, and a servant girl experience a variety of unexpected and disturbing alliances and divisions. The Nazis condemned it as "un-German propaganda," a play that "preaches the idea of class hate" and has "veiled invitations to violence."[19] The play exhibited Kaiser and Weill's social and political commitment in no uncertain terms—they were risking their necks in the most public possible way.

The play had no chance of being mounted in Berlin, but Sierck's Leipzig premiere was as well received by the general public as it was despised by the Nazis, who insisted on its immediate withdrawal. "Everyone who counted in German theater met together for the last time," proclaimed one of Max Reinhardt's prominent dramaturgs. "It was the last day of the greatest decade of German culture in the twentieth century. The Nazis barracking and yelling were somewhat

disturbing. But in spite of that it was a great evening, certainly the most impressive theatrical evening I have ever been present at."[20] Since everyone knew time was short, *Der Silbersee* opened on February 18, 1933, in three cities at once. But although Leipzig managed thirty performances, violent Nazi riots exploded in one of the other theaters. The *Völkischer Beobachter* wrote most venomously about Weill: "A so-called artist who concerns himself with such subjects, who writes 'music' for such licentious texts that consciously undermine any sense of genuine art . . . must be treated with great suspicion, all the more so since he, as a Jew, has taken the liberty of using the German operatic stage for his own anti-national [*unvölkische*] purposes!"[21] After the Nazis issued a manifesto denouncing the work, Weill's publisher urged him to begin thinking of emigrating voluntarily. "What will you be missing in Berlin except bullets and abuse? . . . 'The Silver Lake' success . . . has demonstrated quite clearly the worthlessness of artistic successes in this fully corrupt and ravaged atmosphere."[22] Shortly afterward, Weill was asked to "withdraw" from his contract with the producers who had hired him to compose a score for a major film.[23] Ever since Hitler's appointment, doors all over the country had begun rapidly shutting on the Jewish composer.

While Universal Edition encouraged Weill to leave the country, Brecht's publisher, Felix Bloch Erben, took him to task in quite a different fashion. The owner, Fritz Wreede, wrote Brecht a letter in late February, saying that due to his failure to deliver a new work, in addition to the unlikely performance possibilities for his "peculiar" play *Saint Joan,* and finally because he had ignored the requested revisions for his politically unacceptable *The Measures Taken,* they refused to pay his monthly advance of 1,000 marks for the foreseeable future.[24] Brecht's publishers had often been aggravated by his refusal to make deadlines or cooperate with outside requests for revisions, but because he was a successful and celebrated writer, they had never revoked his advance. The ascent of the Nazis gave them the nerve, and the occasion, to punish Brecht for behavior he had always displayed—especially since it was clear that his works would no longer have any chance of making a profit.

On February 27, 1933, the same day that Brecht's publishers cut him off and just nine days after the premiere of Weill's *Der Silbersee,* the

Reichstag burned to the ground. Hitler blamed the Communists and used that false accusation as an excuse to institute martial law. Civil liberties, including freedom of the press, were suspended immediately. Homes were searched, stores ransacked, and four thousand Communists were arrested, along with many writers and intellectuals who had been openly opposed to the Nazis. The rule of law had ended, and the Third Reich had begun.

Also on that day, Brecht was recovering from a hernia operation in a Berlin hospital, and he was therefore especially frail when he heard the news from a breathless Weigel. He insisted they leave Germany as quickly as possible to avoid being arrested.[25] Afraid to return to their apartment, they spent the night at the publisher Peter Suhrkamp's house. Believing it would be safest if they left the country separately from their children, they sent Stefan and Barbara to the most reliable person they knew: Elisabeth Hauptmann.

One day later, Brecht and Weigel fled to Prague and from there to her family home in Vienna. Stefan was able to fly a few days later to Prague and took a train to meet his parents. Barbara was only three years old, and Hauptmann took her to Brecht's father in Augsburg until they could figure out a safe way to bring her over the border. It was their housekeeper, Mari Hold, with the help of a Quaker Weigel had entreated, who managed to bring Barbara safely to Vienna.

When Brecht and Weigel came to her for help in their darkest hour, Hauptmann was far more concerned with their safety, and the safety of their children, than she was for her own welfare. And although she was also in danger because of her association with Brecht and her official commitment to the Communist Party, she chose to stay in Berlin to continue helping the man she loved and respected. In the months to come, she sorted and packed Brecht's papers and his family's possessions in lieu of her own. During this time, she endured several house searches from the Gestapo, but they ended up finding very little other than her typewriter. When they accused her of typing leaflets, she claimed to never have used the machine at all. This lie inspired one of the Gestapo men to take it for himself. Her close friend Bianca Minotti was sometimes frustrated by Hauptmann's saintly behavior and would beg her to stop packing up Brecht's belongings and flee to safety. "I

was mad with rage at the idea of you acting as a nursemaid when you needed looking after so much."[26]

Hauptmann may have needed looking after, but in this moment of emergency, Brecht's faithful *Mitarbeiter* understood the freedom and the responsibility of being a single woman with no children. However badly Weigel had wanted a divorce from her husband during the painful early months of 1932, it was the quiet but resolute Hauptmann who had actually achieved one from Hacke in March of that same year. It came through just days away from their first anniversary.[27] With this divorce, Hauptmann once again defined herself as a member of a collective in every aspect of her life—personal and professional. In lieu of a husband or other family members, her allegiance was to Brecht and, in this moment, to his entire family.

Brecht didn't have time to say goodbye to many people in Germany—he certainly never had the chance to say farewell to Weill. And although *Der Silbersee* was shut down in the days following the burning of the Reichstag, and all of Weill's and Kaiser's works were immediately forbidden, the Jewish composer did not flee as quickly as Brecht. It was as if he went into a state of shock instead. A week after the Reichstag fire, he wrote to his publishers about various business matters as if nothing extraordinary had taken place.

Brecht's quick escape and Weill's maddening need to linger were direct expressions of their distinct personalities. Weill was the more hopeful of the two, and until the last possible moment, he believed that justice would prevail. But that wasn't the only reason he had the nerve to stay. The soft-spoken composer was less realistic than Brecht but also more courageous. He would risk much to fight for his rights. The fearful playwright, whose association with the German Communist Party put him directly in touch with the violent tenor of their political opponents, always avoided personal danger whenever possible.[28] This was true for himself, but also of course for his children and his Jewish wife.

It wasn't until a friend warned Weill that he was on the Gestapo's list of people to be arrested that the composer finally surrendered to his fate. It helped that Lenya happened to be in Berlin. She had attended the Leipzig premiere of *Der Silbersee,* and in a heroic display of loyalty,

she came back to Berlin to record several songs from the play that already had been shut down. The records were pressed but forbidden only moments after the vinyl had cooled. Seeing how quickly things were happening, Lenya forcefully steered her husband out of town. At her insistence, Weill agreed to wait at a café while Lenya and a friend went to the house and packed as much as she thought they could carry. She drove with Weill straight through the night to Munich, and they checked into the Four Seasons Hotel "where nearly the entire Berlin intelligentsia seemed to have assembled."[29]

The strictly disciplined composer whose regular habits were as necessary to him as air had left at a moment's notice with only the bare essentials in hand. But he could no sooner tear himself away from his life and his work than he could have stopped composing a song or score once it began pulsing inside his head. Seething in Munich, he could not reconcile himself to leaving his lovely home, his scores, and his friends in such a chaotic haste. He went back to Berlin a week later. It was a reckless decision, but he couldn't control himself.

And Lenya couldn't talk him out of it. Perhaps she assumed he went back to say goodbye to Erika, or to try to convince her to leave with him. As well as she knew her husband's compulsive ways, it was still hard for her to imagine anyone risking his life to "arrange his affairs," as he insisted he must.[30] His career in Germany was over, and if he couldn't see that, he really had gone mad. Did they fight before parting? It's hard to imagine that they didn't. She returned to Pasetti in Vienna as her impulsive and stubborn husband answered the siren call of Berlin one last time.

Once back, Weill wrote a series of furious letters to his publishers in the vain hope that even if they couldn't help him turn the tide in Germany, they would at least pave the way for a dignified escape route. It was difficult enough to accept his forced departure from his native land, but he couldn't yet accept that his fame was worth nothing tangible in other lands. "I get the impression that you have now thrown in the towel and, probably influenced by the numerous Berlin alarmists . . . [you] have fallen into a lethargy which is unwarranted, especially now . . . go abroad and . . . explore all the possibilities for finding new markets . . . Why aren't you in Paris now, dear Dr. Heinsheimer? You have seen how the giant success I had there hasn't been exploited

at all . . . I am doing what I can. For months now I have been carrying on negotiations instead of saving my nerves for my work."[31] Sensing that America would one day become a part of his future, he became increasingly concerned with the fate of the New York production of *Threepenny*. Even though shattered glass from Jewish store windows littered the streets, and innocent people were being arrested and brutalized every day, Weill couldn't stop himself from writing a letter on March 14 as if nothing else was going on in the world: "We must do everything to assure a first-class performance of the music [in New York] . . . Give him a description of the musical idiosyncrasies of the piece—that it is not jazz-music in the American sense, but rather a quite special, new sound, which can result only by a meticulous realization of the original full score."[32] Although Weill was right to expect his publisher's help during this crisis, the composer's obsession with such details as Germany descended into darkness exposed his profoundly devastated frame of mind.

It was his beloved Erika, and Caspar, who finally convinced Weill to leave for good on March 21, 1933. It was Potsdam Day, when Hindenburg officially transferred power to Hitler. Weill and the Nehers crossed the French border at Lunéville. The composer had 500 francs in his pocket, the maximum allowed for foreign travel. He arrived two days later in Paris and soon rented a room at the Hôtel Splendide.[33] The Nehers didn't like what was happening in Germany, but they had a teenage son and decided not to voluntarily leave their country. They returned to Berlin.

As Weill put his suitcase down in his first small hotel room in exile, still smarting from the pain of leaving everything behind, Brecht, Weigel, and Stefan were in Vienna with family still awaiting the arrival of their daughter. Lenya was also in Vienna, with Pasetti, as yet unsure, and likely terrified, about Weill's whereabouts. Less than five years after creating one of the most successful theater sensations in European history, these five formidable artists were banished from Berlin or, in Hauptmann's case, in danger of arrest. By then *The Threepenny Opera* had been performed 4,000 times in 120 theaters in Germany alone. It had been translated into eighteen languages and had played in more than twelve countries, but the Nazis were as eager to obliterate the memory of *Threepenny* as they were to silence its creators.[34] Even

Mahagonny seemed like a fairy-tale city compared to what was going on in Germany.

In a different world, Weill's move to France would have been the culmination of careful calculations—contacts made, concerts booked, perhaps a commission in hand. But such luxuries were over. He arrived in Paris with very little beyond his good name, and even his enviable reputation in France, however useful, could only comfort him up to a point. It was based on only a fraction of his works, mainly the French film and stage versions of *The Threepenny Opera*, and on his successful concert performance three months earlier. His other cherished achievements, especially his operas and his final work with Kaiser, were all but unknown. Weill's response to the extraordinary times was, however, not very different from his response to ordinary life. He was, and always had been, a workaholic. He turned to it in times of joy and pain, whether he was celebrating life or avoiding unpleasant emotions. Even at seventeen, his greatest dream was to "work until I drop."[35] Sixteen years later, during the initial horrors of 1933, Weill wrote to Lenya that "I completely fall apart when I'm not working," and that staying busy was the only way he could avoid "bouts of depression."[36] The composer needed to work to make his heart beat, to avoid the kinds of truths that made life unbearable. And he went straight to work in Paris. Composing kept him alive in the darkest time of his life.

The exiled professional class from Germany had been very capable in the context of their own culture and society. But few transplanted themselves so well, and so quickly, as Weill. As Ernst Josef Aufricht observed shortly after his arrival in Paris that same year, most émigrés "escaped with very little money and a few suitcases with their best clothes. They sat, perfectly groomed, in groups on the Champs-Élysées—on the terraces drinking coffee, or in the Montparnasse. They irritated the café owners by drinking coffee and eating croissants, and pushing out the regulars who ordered much more expensive aperitifs. No one wanted to admit that they no longer had their lives."[37] Too impatient to linger in cafés, Weill met George Balanchine and his Russian dancers only weeks after arriving, and they began to discuss the idea of creating a ballet together. Happily for both of them, the extremely rich Edward James, rumored to be the illegitimate grandson of King Edward VII, was a man very much in need of a ballet.[38]

A lover of poetry and art, James's sensitive heart had been broken by his young Austrian wife, the dancer Tilly Losch, who had married him under the false impression that he was gay, assuming that their union was an intentional sham providing him with respectability and her with great wealth.

Although James's sexuality was in question, Losch discovered that his passion for her was not. Disturbed by the shock of his sincere devotion, she soon abandoned him. In the hopes of winning her love, or at least tempting her to return to him, he financed a full season of Balanchine ballets in Paris. They were to have music by Mozart and Schubert, as well as original scores by Darius Milhaud and, soon, by Weill. James's commission came with the sole request of a leading role for his lovely wife. This was yet another chance for Weill to play the part of court composer. Even if James's royal origins had never been legally acknowledged, he indulged his artistic tastes as passionately as any monarch.

Weill's fevered need to reestablish his professional stature was fortunately matched by James's personal desperation. They both agreed to the ambitious idea of a singing ballet (*ballet chanté*), and they wanted to find the best possible librettist. Weill asked for Cocteau, but the celebrated writer was put off by the shortage of time. James quickly suggested Weill's famous partner: Brecht. Hiring the most celebrated duo in European theater would only further impress his errant wife.

It was hardly a surprise when James asked Weill if he could bring Brecht into the ballet project, but it was nevertheless irritating for the composer to find himself starting all over again in a country where his fame was inextricably tied to his difficult ex-partner. Weill wasn't sure he had enough nerves left to tolerate the most difficult person he knew. But refusing to extend a generous hand to a fellow artist, and his entire family, all of whom were surely in need, would have taken more hatred and cruelty than the kind composer could allow himself to indulge. With these thoughts in mind, Weill agreed to invite Brecht to Paris to work on one more project together. One last time.

Weill hoped the ballet commission would convince his publishers to stand by him until his financial situation was in order. But when Weill met with a representative from Universal Edition in Paris, he was disappointed to hear that they expected him to sign a new contract with

a radically reduced advance.[39] Even Heinsheimer, with whom Weill had corresponded almost daily for several years, was brusquer than expected: "We are naturally quite aware of your difficult position and will not leave you high and dry. But you must also understand the catastrophic situation in which we find ourselves."[40] Universal Edition's support diminished as rapidly as their sympathy. Two months later, Heinsheimer wrote: "With the complete collapse of the German market for your works . . . we would have been very happy if, in spite of your current situation . . . you had shown some understanding for the publisher, which the whole time has been going to the limit for you."[41] The reduced advances soon ended altogether.

As he awaited Brecht's arrival, Weill had to work hard to keep his despair at bay. He needed all his strength for the first professional encounter with Brecht in more than a year. The composer kept up a brave face for everyone, for his publishers, in his letters to Lenya, and on the streets of Paris. Only with Erika did he describe his attacks of dizziness and his despair over the chaos and disappointments of everyday life. All of German society had turned their backs on him: his bank, his divorce lawyers, his publishers, and many former fans and employers.

Brecht was looking for a place to live in Carona, Switzerland, a village near the Italian border, when the offer from James and Weill arrived. Many of Brecht's close friends had fled to this ancient hamlet nestled between two mountain ranges, including Alfred Döblin, Bernard von Brentano, and Lion Feuchtwanger. The playwright was eager to convene a collective in exile—the presence of his colleagues provided the sense of home that was so important to him and that had been so brutally taken away. Carona's proximity to a lovely lake made it all the more appealing to the nostalgic Bavarian poet. Steffin was also nearby in her Swiss sanatorium, and he visited her in between searching for a house to rent. Weigel was in Vienna with the family, waiting to see what he could find. She knew that Switzerland was likely too expensive for them, and she already had another plan brewing in the background. A friend had invited their family to Denmark, where living was pleasant and remarkably cheap.[42]

Money was foremost in everyone's mind, and the professional betrayals in Germany worsened by the day. Brecht, like Weill, con-

tinued to fight with his German publisher. When they again warned that his plays could no longer be performed, he wrote back with furious indignation. "There's no doubt that the times are very hard for a writer like me, but for that very reason you should stop yourself from behaving like unscrupulous businessmen. A contract is still a contract; I think that you are perhaps misunderstanding the intentions of the new government."[43] Brecht also pleaded directly with Wreede to stand by him during this crisis, but to no avail. Felix Bloch Erben took no moral position about why Brecht's works were suddenly deemed unprofitable; they only made it clear that given the facts, the playwright could hardly expect his advances to continue. Brecht naturally accepted James's offer right away. His negative feelings about Weill were insignificant compared to his financial distress.

And so, like their very first project together for the Baden-Baden music festival, Brecht agreed to take part in a commission that had been offered to Weill. But this time, the inspiration was not Brecht's poetry, nor anything even remotely connected to the playwright's interests. It was ballet, an elite form of art that he disliked even more than the opera. He left Switzerland and arrived promptly in Paris on April 10, 1933.

Brecht entered the Hôtel Splendide where Weill awaited him. The exchange of polite greetings must have been tense, fraught with withheld emotions, infused with a mutual desire, even desperation, to make this commission work. Even with their souls pierced and livelihoods threatened, nothing was more alienating than the pretense of harmony. The handshake would be brief, the personal information they exchanged limited to essentials. They got to work as soon as possible, because that was the one place where they could temporarily rekindle a connection.

Brecht might have been happy to benefit from Weill's new contacts in Paris, but he was also rankled to see that their reputations were still joined at the hip in France. The rise of the Third Reich had forced them back together just as they were beginning to enjoy independent careers. No matter how forcibly, or how often, Brecht tried to revise *Threepenny*, its original form continued to haunt him. First, it was the embarrassing commercial success, and now it linked Brecht inextricably to a composer whose values he claimed to reject. Both of their

egos were bruised by the impression, promulgated by *The Threepenny Opera*, that they needed each other to achieve artistic heights. This insult infused the room in which they had to create a successful ballet. The unspoken hostility is confirmed in an interview Weill gave to a Parisian magazine at the time. The composer assured the journalist that the popularity of his music pleased him. Without mentioning Brecht, he talked about continuing his development with *Threepenny*, *Mahagonny Songspiel*, and the opera of *Mahagonny*. Walter Benjamin tore the interview out of the magazine and wrote a sarcastic note across the top: "*Der Starke ist am mächtigsten allein*"—"The strength is doing it all on your own." And then he sent it directly to Brecht.[44]

But Brecht was not in the mood to fight with Weill. He was in Paris for the money, to look for more work, and to check out yet another possible place to live. He wrote to Weigel upon his arrival: "I arrived here safely and am already in the middle of work with Weill. I hope this will go quickly . . . Apartments are cheap, but unfurnished, tomorrow I am going to look at a few . . . How are you all? . . . Steff should learn French! I kiss you! B."[45]

Although Brecht was eager to leave the original *Threepenny* behind, it still can't have been welcome news that despite the enthusiasm of two young American producers, his and Weill's most famous musical play was a complete flop across the ocean. John Krimsky and Gifford Cochran had worked hard to duplicate *Threepenny*'s European success. They had flown to Germany in the beginning of 1933, met with Felix Bloch Erben, and learned all they could about the original production. While there, they hired as director Francesco von Mendelssohn, an accomplished cellist who had been a production assistant under Erich Engel at the Schiffbauerdamm. But the choice of translator hadn't gone as well, and Weill came to believe that the English version, by Cochran and Jerrold Krimsky (John Krimsky's younger brother), made the mistake of doing "a literal translation instead of an adaptation geared for the American theater." The cast was also fairly inexperienced: Robert Chisholm, an Australian operetta baritone, played Macheath; Steffi Duna, a Hungarian dancer, was Polly; and Rex Weber played Peachum. The one actor in the cast who would eventually become quite famous, Burgess Meredith, played the small role of Crooked Finger Jack. The preview survived relatively unscathed in

Philadelphia, but the opening in New York was a disaster. On April 13, 1933, only three days after Brecht arrived to work with Weill, Robert Garland of the *New York World-Telegram* reviewed the piece, calling it "as humorless as Hitler." The audience in Brecht and Weill's beloved America, with its Wild West, Chicago stockyards, and Pensacola hurricanes, had failed to understand *The Threepenny Opera*. Its poor reception was summarized by Stephen Rathbun in the *New York Sun:* "The fact that Bert Brecht's modernization of 'The Beggar's Opera' is somber and depressing is no doubt the reason why it was unsuccessful on Broadway. In these days, if people want to be depressed, they can be depressed at home! . . . When gloom on the stage meets gloom in the audience, the result is failure for any play. At least that's what happens in America."[46] Weill's music was almost universally praised, but the composer's especially high hopes for a successful American production were nevertheless dashed. He once again repressed his disappointment and forged ahead with the project at hand.

The underlying theme of the *ballet chanté* was expressed in its title, *The Seven Deadly Sins*. It was familiar territory for Brecht and Weill, who had explored greed, lust, and gluttony in *Mahagonny*. Returning once again to their imagined America, the tale begins as a family in Louisiana sends their daughters, Anna I and Anna II, out into the big cities to earn money so that they can build a house. Anna I plays the role of guardian to her sister, Anna II, whose dancing will earn the money their family needs. In her first job, the dancer has too much pride to strip during a dance, but her sister cures her of that. Later, when she is a star, the dancer must control her weight, and her sister keeps her from succumbing to gluttony. When the dancer enjoys relationships with both a rich boyfriend and a poor lover, her sister forces her return to the wealthy suitor. But the dancer doesn't want to stop having lovers, and she falls sway to both greed and lust. Once again, Anna I rescues Anna II from herself. The ballet ends when the sisters return home, having survived the seven deadly sins that had tempted Anna II. Her physical desires were overcome in order to earn money. The story is portrayed on two levels: Anna I, the singer, tells the story in words, and Anna II dances it. Giving them the same name also suggests that they represent two sides of the same person: the logical and the emotional, the rational and the irrational pursuit of pleasure. In Freudian

terms, they represent the ego (Anna I) and the id (Anna II). Anna I sings about Anna II: "She's just a little mad, my head is on straight. But we're really one divided being, even though you see two of us."[47]

The story resided in Brecht and Weill's habitually provocative territory: It displayed the conflict between earning money in a bourgeois society and pursuing one's natural human desires. It highlights the materialistic basis of middle-class values that disapprove of such sins as sloth, pride, and lust.[48] But there are other more personal aspects to the story, ones that invoke the highly emotional state of the two men in exile. The ballet begins with the two women being forced to leave home in order to help their family survive. They are full of fear and expectation and short on cash. They must face the practical realities of their unfortunate situation by accomplishing unpleasant tasks. As Brecht and Weill wrote, they could hardly separate themselves from the subject of being forced out of their own country, or the idea of working together out of necessity and not desire. The image of Anna I holding a suitcase and singing "In seven years our fortune will be made and then we can go back" must have moved them both. The themes of leaving home, surviving hardship, and giving up one's values to make money—all were woven into the fabric of the ballet. And as removed as they were from each other, the pain expressed in the piece was as personal to Brecht and Weill as it was an abstract critique of society.

Weill and Brecht only worked together for about seven days, but it was more than enough time for their differences to grate. The composer worked hard on the score—not only because he was a perfectionist who always demanded the most from himself but also because he believed that the Paris performance might be decisive for the coming years. Brecht maintained his pride in the opposite way. He made no attempt to hide his contempt for the job that Weill had given him, and it was important for him to demonstrate his contempt for the form itself. Being forced to do it for money was an excuse he accepted, but his artistic passion could not be purchased. The libretto would be intelligent and respectable, as everything he wrote had to be, but he would not pretend that it engaged his heart. "Of all the art forms," Brecht wrote in a sarcastically phrased foreword for the program, "ballet is the silliest. They are forever fairytales and the most stupid stories and the whole thing . . . stinks to high heaven." These two opposing

styles—Weill giving his all and Brecht coolly giving the minimum—quickly eroded the atmosphere of forced politeness that both men had hoped to maintain. Maurice Abravanel, Weill's friend and also the conductor for the ballet in Paris, was furious when he learned of Brecht's attempt to write a dismissive piece, never used, for the ballet's program. Brecht's remarks publicly disdained both the project and the composer's generosity. "He was rescued by that money, thanks to Kurt, and immediately he bit the hand that fed him."[49]

Brecht became quite sick in Paris. It was shortly after his hernia operation, and his kidneys were acting up. He was exhausted and spent all of his free time in bed, and this certainly contributed to his uncooperative mood. Given all the factors, it was a miracle that Brecht and Weill got along for a week, and even more miraculous that their artistic chemistry could still trump their dislike for each other. They finished the work as quickly as possible, and the composer was certain it contained passages of "great individual beauty" that would provide him the chance to compose a mesmerizing score. Even when he barely made an effort, Brecht was still better than most. Weill wrote a letter to Erika soon after Brecht's departure: "After having worked with B. for a week I am of an even stronger opinion that he is one of the most repulsive, unpleasant fellows running around on this earth. But I am able to separate this completely from his work."[50]

Weill breathed a sigh of relief when Brecht left town. The composer happily left the hotel and moved into Marie-Laure de Noailles's home in order, he claimed, to work "undisturbed." He did finish the score in just a few weeks, but Lenya was certain that there were other reasons for his residence in the luxurious palace on the Place des États-Unis. In one of her letters to Weill, she jokingly suggested she change her name to sound more like that of his rumored lover: L. Marie Lenja. Even in Vienna, Lenya heard the rumors about Weill's romance with the vicomtesse, and she couldn't resist a playful, but jealous, remark.[51] Erika, to whom Weill was also being unfaithful, certainly wouldn't have been as lighthearted or as funny.[52]

Weill continued to express his love for Erika with a passion that equaled his earliest letters to Lenya, but she was never as intertwined with his inner being as his wife had been from the start. Weill and Lenya's special closeness was based on an irreplaceable artistic con-

nection. His music came first, and Lenya was the only woman who had ever touched that essential part of him.

The composer hadn't realized how critical this difference between Erika and Lenya was until Caspar Neher refused to be the designer for *The Seven Deadly Sins*. He objected to the libretto, describing it as "literary trash." This was disappointing enough, but when Erika wrote to Weill and supported her husband's opinion, the composer's temper erupted in pain, grief, and fury. He wrote to Erika: "When C.'s terribly embarrassing letter arrived here yesterday, I was immediately in the grip of a feeling which didn't leave me for one truly miserable night: I was horribly afraid of your next letter. Now it's here. And the sentence I was so afraid of is in it: 'I can't blame Cas, he's right . . .' I had so wished that you would assume an attitude in this matter that would have made it possible for me to sort out the whole affair with C. alone, so that I could have written you a very sweet love letter. You unequivocally side with C. and that which is between the lines in C.'s letter, you make explicit: a deep contempt for me . . . And so on top of everything else I am forced to defend myself to you."[53] This was a situation, Weill well knew, that would never have arisen with Lenya. She was not a faithful wife, but she was a staunch defender of Weill and his music. She was, in this sense, faith incarnate.

There were two things that Weill could not admit: first, that Neher was truly refusing to work on *The Seven Deadly Sins* because it was artistically inferior. He insisted to Erika that "everyone who knows something about me, is aware that a text is merely a starting point for me—that every text I have composed looks entirely different once it has been swept through my music . . . I swear to you, my little angel, what I have created from this text belongs to the very best I have been able to achieve up to now; it contains a wealth of inventiveness, a greatness in expression and unity such as I have not achieved since the *Jasager*."[54]

The second point that Weill obstinately refused to see was the role of his affair with Erika in her husband's refusal. Surely Neher didn't want to spend time with the man who was writing such passionate letters to his wife, let alone a best friend who had decided that Erika was the only woman for him.

Neher's refusal cut deep. Especially since he was one of the few close colleagues who had been able to remain in Germany. The dis-

traught composer interpreted Neher's reproach in an extremely sinister light: "Darling, let us be honest: the reasons lie elsewhere," he wrote Erika. "He has inhibitions about working with B. and myself . . . and if he had really told me, everything would have been very simple. But he didn't have the guts . . . now that B. is gone and is no longer playing an important role, [he] indulges in the most furious abominations. There's something awfully wrong here!"[55]

Neher was right to notice that the text of *The Seven Deadly Sins* was hardly Brecht's best work. But he was wrong to ignore the elevating effect that Weill's music would have on the ballet. He was wrong again to invoke artistic objections at all, however sincere, given the difficult times. Brecht and Weill were desperately in need not only of a job but also of a sense of loyalty from such a close friend and colleague. The kind and diplomatic Neher's tactless behavior therefore surely stemmed from a combination of fear of the Nazis and, just as surely, some irritation with his best friend's boundless passion for his wife.[56] Whatever combination of motives Neher had in his early refusal, he was ultimately too loyal to both Brecht and Weill to refuse them. To the composer's relief, Neher arrived in Paris after all.

It had been far easier to convince Lenya to play Anna I in the ballet. A role was also found for Pasetti as an extra enticement. To James, who was spending a fortune on a season of ballets in order to keep his wife, it seemed perfectly normal for Weill to cast both his soon-to-be ex-wife and her lover. With Brecht, Weill, Neher, and Lenya all involved in the ballet, *The Seven Deadly Sins* turned into a reunion of the best theater artists in Germany. The addition of a celebrated Russian choreographer added a humorous touch to this creative hothouse. As Lenya described it, "Rehearsals were very funny because Balanchine didn't speak French very well and didn't know a word of German. He didn't understand what the goddamn thing was all about. So everything was translated for him: from German into French, then from French into Russian. Still he did a beautiful job."[57]

The premiere was on June 7, 1933. Despite the tension of their week in April, Weill gallantly invited Brecht to the opening and entreated James to pay for his travel from Switzerland. Since Brecht had made good contacts in Paris, he once again accepted the favor. His assistant and lover, Steffin, had by then left the sanatorium in Switzerland and

was already there, helping to arrange his professional affairs. Among many projects, Brecht began negotiations for a political novel based on *Threepenny*, his third version of the work. He also tried to convince Aufricht to help him produce a play for the French theater. Brecht was unusually confident, despite regular disappointments, that he would be treated well by all his colleagues, regardless of their working history. As an artist who, in his view, never sacrificed his integrity, he saw no reason to apologize for his troublesome past behavior—instead, he was proud of it.

While Brecht traveled back to Paris for the premiere, Weigel moved to Denmark with the children. Although he still dreamed of living in Switzerland or perhaps Paris, Brecht knew that only the resourceful Weigel could get their family comfortably settled amid the hardship of exile. If she decided that Scandinavia was the only practical solution, he would certainly follow. Weigel probably knew that Steffin was with him in Paris, and before her decision to move north, she contemplated divorcing him once again. Weigel told her daughter, "Zurich would have been my chance to be independent, and to support my children. But then I was [in Denmark], financially dependent on your father . . . How could I earn a living when I couldn't speak the language?"[58]

The premiere of *The Seven Deadly Sins* was well received by the homesick émigrés in Paris, but the French were frustrated by the German lyrics that made it impossible for them to understand the story. The production traveled to London, this time in a hasty English translation, but it didn't fare any better. James's efforts failed in every way, including the most important. A full season of leading roles in Parisian ballets wasn't enough to keep his wife by his side. Losch left him after the London performance and never came back.

Brecht described the ballet to Weigel, already in Denmark, as "pretty enough but not very important." Weill was as determined as ever to see it as a step in his artistic development, and he declared it to be the "finest score I've written up to now." If this was hyperbole, it's nevertheless true that the composer put more of himself into the music than Brecht had put into the text. Only after the premiere did the composer finally give way to his exhaustion. He had a severe outbreak of psoriasis, a condition that continued to plague him, and on the "brink of nervous collapse," he took a vacation in Italy with Caspar

and Erika Neher in order to soothe his ragged skin and soul.[59] He and Neher had reconciled, professionally and personally—at least enough to travel together again. The Nehers helped Weill regain his strength for the hard times ahead.

Lenya and Pasetti were a far less soothing influence on the composer's mood. They left Paris together and continued their gambling streak in the French Riviera. Whereas Weill turned to work for comfort, his wife, who had also lost everything, needed to risk losing even more. Lenya's hard childhood had made her brave and reckless. The luckier and more ambitious Weill was experiencing injustice for the very first time.

In late June, Brecht went to the house Weigel had found on Thurø, a Danish island. For the time being, he left Steffin behind in Paris to keep his French contacts alive. Hauptmann was in Berlin, sorting his papers and possessions. This was all the more critical since by May 1933 the Nazis had burned his published books and plays in public fires. Hauptmann had agreed to bring as much as possible to Denmark as soon as it was safe to travel. Exiled from his country, robbed of his career, more broke than ever before, Brecht's need for many women in his life continued unabated. But after ten years together, one critical change did take place in Brecht and Weigel's relationship: they finally moved in together.

In Berlin, Neher's work permit had been revoked by the Nazis. Whether this was a direct result of his participation in *The Seven Deadly Sins* or if it was due to his long professional relationship with Brecht and Weill is unclear. He waited out the storm, and by the end of the year, his permit was reinstated.[60] Cautious, patient, and, most important, not a member of the Communist Party, the quiet Neher was one of the few in their inner circle who was not only able, but who also wanted, to stay in Germany. Engel, who had directed so many of Brecht's plays before they parted angrily on *Happy End,* chose to remain in Germany as well. He developed a specialty for comedies as quickly as possible in order to avoid making propaganda films for the Nazis. He lived, as so many did, under the rule of the Third Reich without sympathizing but without making his objections known.

The rise of the Third Reich endangered lives and livelihoods, forcing the five exceptional artists—Brecht, Weigel, Hauptmann, Weill,

and Lenya—to become even more extreme versions of themselves. Brecht clung to his needs with force: to his lover, to his ingrained deceit about his affairs, and as always to his dependence on the sturdy Weigel. He would not give up his family, who were the center of his adventurous amorous and professional life. For Weigel, the exile was particularly cruel. Her career, her political activity, and her personal freedom all disappeared in a matter of weeks. Keeping her difficult family together in exile would require more sacrifice than ever before.

The submissive but brave and reliable Hauptmann went beyond the boundaries of selflessness, perhaps even of sanity. In her zeal to help Brecht, she entirely neglected herself, her belongings, and her financial straits. In this most dramatic of times, the line between her identity and Brecht's was once again blurred.

Finally, there was Lenya and Weill's illogical but inescapable dependence. He was unable to feel angry with her, and ultimately she ceased her efforts to infuriate him. Their passions—hers for Pasetti and his for Erika—were real, but their bond was also absolute and unquestioned by either of them. He kept her solvent despite her refusal to stop gambling. She took the dangerous step of returning to Berlin in order to rescue his possessions, especially his scores—which were being destroyed by the Nazis in public venues. She also sold the expensive house he had put in her name. Because their divorce had been finalized in September 1933, and she was no longer the wife of an outlawed Jewish composer, she was able to sell the property he had put in her name. But she made the mistake of asking Pasetti and his father, Florian von Pasetti, to help her transfer funds out of Germany to Austria, in the hope that it would then be easier to send to France. Weill agreed to this plan, and both he and Lenya were surprised when Pasetti, by then a bitter ex-lover, stole the money along with their car. As exiles, they had no legal recourse, and in any case, they couldn't locate Pasetti or his father after the bank wire went through. Lenya felt very guilty, and ever after described Pasetti as "a crook . . . He was nothing, he was just shit."[61] But Weill never blamed her for the situation. He admired her courage in returning to Berlin in the most dangerous of times, and her devotion to rescuing as much of his music as possible meant far more to him than the loss of money. For him, she was the quintessence of loyalty in a way that no lover could ever rival.

Exile forced forgiveness on all of them. Compared to the sins of the Nazis, even the largest of personal sins seemed to disappear. When it came to women, 1924 sealed the fate of both Brecht and Weill: despite everything, their relationships—Brecht's with Weigel and Haupt-mann, Weill's with Lenya—survived and became even stronger. Weill and Lenya would reconcile and leave for America together. Weigel remained with Brecht despite the increasingly painful nature of his infidelities in Denmark. Hauptmann would remain devoted to Brecht's work for her entire life. As strained as these relationships were before Hitler came to power, it was ironically the bonds of exile that made them impossible to sever.

The bond between Brecht and Weill was of an entirely different nature. Although the crisis of exile made them far more dependent on their shared fame, the time in Paris clearly proved that this forced connection did not engender forgiveness or reconciliation. For despite the fact that their partnership had been essential to each man's artistic development, they both had come to see the other as a hindrance to their future goals. And exile made their future more urgent than ever.

They had come of age during the devastation of the First World War. They became partners as young men in Germany's first republic without a monarchy. The kingless country had been transformed into a true democracy, and they both understood that theater, music, and musical theater had to engage the people. Brecht and Weill weren't just inspired by the advent of democracy—together they actually helped to sow its seeds. What they made in Germany had defined them as art-ists, and it was all being obliterated by the Nazis. The spark between them, begun six years earlier, had flashed once more in Paris before being extinguished. That light illuminated the loss of all they had built together. It was possible that none of their achievements would survive in their native land.

They said their goodbyes coolly and quickly. Not as friends but as two respectful yet distant professionals. Although friendship mattered deeply to them both, their work, their creativity meant much more. In parting, they relieved themselves of the personal irritation they pro-voked in each other, but they simultaneously said farewell to the kind of mutual artistic provocation they might never find again.

They shook hands, still using the formal *Sie* that had persisted dur-

ing their worst fights and most intimate creative moments. They were foreigners in France and would be foreigners in many other countries to come. Saying goodbye on the streets of Paris, with their futures equally uncertain, they were suddenly more like each other than different: They shared a devotion to work, a need for a stable home, and a fervent attachment to Germany's language, landscape, and culture. When their eyes met one last time, Brecht's impish smile briefly ignited Weill's boyish grin. They were too smart not to know what they were losing, and once again too much alike to be the one to speak this truth aloud. The poet and the composer agreed, as they had so rarely agreed of late, that silence offered the most eloquent farewell of all.

When the Shark Bites

Three months before Weill died, he wrote an angry letter to Brecht, insisting, without a trace of irony, that "the entire legal situation of *The Threepenny Opera* remains unresolved . . . we cannot let this situation drag on any longer." Understanding that Brecht's recent silence in no way signaled acquiescence, Weill eliminated the slightest possibility of ambiguity: "Any further performances of this work are illegal."[1]

Weill was especially confident as he sent these lines from his seventeen-acre estate in Rockland County in upstate New York. After years of struggle in France, England, and America, the composer's success on Broadway made it possible for him to live in a charming 150-year-old farmhouse, where he could work accompanied by the sound of a brook flowing through the woods and meadows of his property. He once again had a flower and vegetable garden, with a special plot devoted to his beloved potatoes. Weill had changed a great deal since he was a teenager, but potatoes had remained his favorite food since his hungry days during the First World War.

The composer had steadfastly refused to let the despair of exile overpower his iron will or his optimism. After *The Seven Deadly Sins,* Weill worked diligently on several other shows, including *Der Kuhhandel* (*A Kingdom for a Cow*) and *Marie Galante,* until an offer to collaborate with Max Reinhardt and Franz Werfel came his way. The commission

for a Jewish pageant titled *The Eternal Road* gave him an opportunity to go to America. Although legally divorced, Weill had reconciled with Lenya and, to the astonishment of many of his friends, decided to take her with him to America. In September 1935, they embarked on the *Majestic* for New York.

Lenya was the woman he needed in order to start all over again. They were both hardworking, resilient, and determined to succeed in America—the country that had lived for so long in their imaginations. Lenya and Weill insisted on speaking English to each other shortly after their arrival, and both of them made friends on their own and quickly. Despite their solidarity during this difficult transition, Weill's correspondence with Erika Neher continued until the end of 1936, when they both agreed to end the relationship. In parting ways, Weill declared, "You will never lose me, because I belong to you and will love and adore you from afar as I did when I was allowed to be your lover."[2] Six months after this passionate declaration, Weill remarried Lenya. And although his professional life in America was quickly set in motion, they waited many years before he began earning much money. They were once again nearly as broke as they had been on the day of their first wedding and celebrated their vows just as modestly.

The Group Theatre had given Weill a warm welcome in New York. His first show with them, *Johnny Johnson*, was produced less than a year after his arrival. That was soon followed by a collaboration with one of the most successful American playwrights of the era, Maxwell Anderson. The show was *Knickerbocker Holiday*, and it contained Weill's first American hit, "September Song."[3] After that came *Lady in the Dark*, with a book by Moss Hart and lyrics by Ira Gershwin. The success of this show placed Weill in the highest ranks of Broadway composers—his share of the film rights alone made it possible for him to buy the peaceful country home where he wrote his angry letter to Brecht.[4] His ability to retain his sense of integrity as a composer while adapting to the cultural milieu of America was a source of great pride for Weill. If Brecht's shenanigans with *Threepenny* implied that Weill had anything for which to apologize—whether it was making money or writing music that appealed to a large audience—the composer let him know that if anyone should apologize, it was the playwright.

When Brecht received Weill's final letter, he had only recently rec-

onciled himself to the necessity of living and working in the eastern sector of Berlin. The performance of *Threepenny* that had ignited their final dispute was a 1949 production in Munich. And since Brecht was determined to keep his presence alive in West Germany as well, he was willing to fight very hard to make sure that his most famous work was performed there as soon and as often as possible. Brecht insisted privately to Weigel, "I can't settle in one part of Germany and be dead for the other part."[5]

Brecht's confidence hadn't diminished, but his seventeen years in exile had been more arduous than Weill's. He and his family had lived in Denmark, Sweden, and Finland, constantly forced to flee just one step ahead of the Nazis' march across Scandinavia. Life had been very difficult, and Weigel knew that their family's survival depended on Brecht's ability to keep writing. As she set up house in each of these countries, she made sure that Brecht's *Kraal* was intact—his long desk, his Chinese scrolls, and as many of his familiar books and pictures as he had been able to take with him. Because of Hauptmann's bravery and devotion, he had a fair number of his possessions by his side. But since Brecht's royalties and advances had virtually vanished during this time, he had constantly sought new theaters and publishers in other countries, with works old and new, to support himself, his family, and, as it turned out, his assistant and lover, Grete Steffin.

Although Brecht had promised Weigel that Steffin would not follow them into exile, he couldn't bear to leave her behind. Yet Brecht felt bad enough about Weigel's feelings to try to hide Steffin's presence in Denmark. She had been there several months before he confessed to his family that Steffin was in the country. Weigel accepted her presence but demanded that she live separately, so her children wouldn't be exposed to Steffin's tuberculosis.

By the time Steffin arrived, Brecht had already captured the heart of yet another woman. Actress, writer, and photographer Ruth Berlau was involved in creating a theater for the Danish working class, and was particularly useful to Brecht because she could speak the language and knew the culture. As a result, Steffin was dismayed to see that her personal and professional life in exile would be even more complicated than she had predicted. Weigel's disappointment about Brecht's behavior was even more extreme, but as always, she found a way to

keep the family together despite the presence of his two mistresses in Denmark.

While in Scandinavia, and with Steffin's assistance, Brecht wrote seven plays: *Mother Courage and Her Children, The Roundheads and the Peakheads, Fear and Misery of the Third Reich* (later called *The Private Life of the Master Race*), *Señora Carrara's Rifles, The Good Person of Szechwan, The Trial of Lucullus,* and *Mr. Puntila and His Man Matti.* He also began two more important plays: *Life of Galileo* and *The Resistible Rise of Arturo Ui.* In addition, he published a French translation of his *Threepenny* novel, *Dreigroschenroman,* his third version of the same concept, as well as a great deal of his most famous poetry. Brecht had managed to be very productive in exile, but by 1940 it was clear that surviving the war in Europe would soon be impossible.

Once most of Scandinavia had been occupied by the Nazis, Brecht decided to seek refuge in America. Although his political beliefs would once have steered him toward the Soviet Union, the violence of Stalin's Great Terror had long since dissuaded him from considering a move to Moscow. Even prior to Stalin's purges, the hardline Communists had often been suspicious of Brecht. His ironic style and acid wit were at odds with the Socialist Realism they demanded—where every work of art served to praise the revolutionary cause—and they had no use for his artistic independence. Despite the Party's approval of Brecht's politically explicit plays, such as *The Mother* and *The Measures Taken,* he had still never been enough of a Communist for the Soviet leadership. For these reasons, Brecht didn't think he would be treated any differently than his friends, the German Communists who had fled Hitler and taken refuge in the Soviet Union, and whom Stalin had accused of treason in the late thirties. Several of them had already been imprisoned or executed, including Carola Neher, who had been sentenced to ten years in a prison camp, where she would ultimately die.[6]

Given Brecht's fear of the Soviet Communists, it was ironic that his Marxist beliefs delayed his United States visa for nearly a year. In 1941, Brecht finally received the precious American permission for himself, Weigel, their two children, and, as the documents read, a "secretary" named Grete Steffin. Indeed, despite Brecht's desperation to leave before it was too late, he had found the time to organize Steffin's papers as well. With his wife, his lover, and his two children,

Brecht's modern family traveled through Moscow to catch a ship in Vladivostok. Along the way Steffin became too ill to travel, and with the pressure of the ship's imminent departure, Brecht was compelled to put her in a hospital where several friends promised to look after her. He hoped she would follow them at a later date. But after all the difficult years of illness and hardship, she finally succumbed to tuberculosis a few days after the family left. She was thirty-three years old. Brecht was heartbroken for the entire journey. Just before their ship docked in Los Angeles, the grieving Brecht threw his Lenin books overboard. He was too exhausted to risk any immediate trouble in America.

After having been on the run for so long, "changing countries more often than our shoes," Brecht felt safer in Los Angeles but also more alienated.[7] "Even in the backwoods of Finland," he wrote, "I never felt so out of the world as here."[8] The Wild West was nowhere near as wonderful, or even as wild, as he had hoped. It was instead far more cynical and even more obsessed by greed than Brecht, in his fictional parodies, had ever imagined. Hollywood was a place, as he described it, where "you even sell your piss to the urinal."[9] Navigating the business of American film and theater was difficult for him in every way, not least because he lost his most valuable gift: his language. His reputation as a genius had not followed him to America, and his English wasn't good enough to reveal his enormous talents to those who hadn't heard of him. Very few of his plays had been translated into English, and few publishers seemed eager to do so. In 1942, Brecht met Eric Bentley, who was to become one of his first champions and translators into the English language, but it was by no means a rapid process. Brecht memorialized his anonymity in a famous poem: "Wherever I go they ask me: 'Spell your name!' / And oh, that name was once accounted great."[10]

But because Brecht had been continually tracked by the FBI, the House Un-American Activities Committee (HUAC) was indeed quite familiar with his reputation as a Marxist writer. Since they were unaware of Brecht's difficult relationship with the Soviet Communists, he was high on their list of suspicious émigrés by the time they called him in to testify in 1947. He returned to Europe the day after his appearance in court, deeply shaken by his turbulent experiences in exile.

He hoped to settle first in Switzerland, where his plays were performed as soon as the war ended, but after two years the Swiss government refused to offer him permanent residency. He tried Austria next—where his plays also enjoyed an immediate postwar renaissance—with the optimistic assumption that Weigel's original nationality might guarantee their right to become citizens once again. But even there, no guarantees could be made.[11]

When Erich Engel offered Brecht a job as dramatic advisor at the very first theater to ever present his plays, the Munich Kammerspiele, Brecht jumped at the chance. At the last moment, however, the U.S. secretary of state personally intervened and banned the Marxist playwright from entering the U.S. zone of Germany. Brecht was thus too Marxist for America, and not enough of a Communist to commit easily to life in East Germany. The political leadership and the ministers of culture in the Soviet zone of Berlin were nevertheless eager to claim Germany's most prominent playwright, and they tempted him with promises of a theater and a variety of publishing platforms. But even if Brecht favored the East's revolutionary socialism over what he considered to be the West's bourgeois liberal democracy, he was decidedly too independent to fulfill the role of cultural spokesman the Berlin Communists envisioned for him.

By 1950, as Brecht was arguing with Weill about *Threepenny*, the playwright had finally accepted the best role he had been offered, even though it was not the one he most wanted: the national poet of East Germany. But he was still reckoning with the disappointment of his banishment from Western Europe. Given no choice but to deal with the complexity of working in East Berlin, he was determined to remain a presence in the West. Since Munich was the place he would have preferred to locate his postwar theater, it was of particular importance to have his plays performed there.

Meanwhile, Weill was still soaring in America, the country of his dreams. After *Lady in the Dark,* he worked on *One Touch of Venus* with Ogden Nash and S. J. Perelman, *The Firebrand of Florence* with Ira Gershwin, *Street Scene* with Elmer Rice and Langston Hughes, *Love Life* with Alan Jay Lerner,[12] and *Lost in the Stars* with Anderson. As Brecht and Weill were achieving very different but equally acclaimed status in their respective countries, their joint custody of the coveted *Threepenny*

Opera continued to provoke their possessive souls and inflamed their never-quite-dormant competition. At fifty and fifty-two, Weill and Brecht were still haunted by their early success.

Given Brecht's and Weill's contrasting professional goals and circumstances, it isn't surprising that the 1949 Munich production of *The Threepenny Opera* had been problematic from the start. Brecht had instigated the troubles with his usual blend of financial acumen and artistic passion. When the theater offered to mount a production, he decided that a new version was required for a post–World War II audience. He believed this as ardently as he had believed in all the new versions he had created since the premiere twenty years earlier. But there was another motive as well: These revisions would make it possible for them to get out of their original contract with Felix Bloch Erben—the agency that had abandoned Brecht during his difficult years in exile.[13] Since Felix Bloch Erben also failed to pay Weill royalties for *Threepenny* during the war years, he was in complete agreement with Brecht's preference for switching publishers to Suhrkamp, but he wanted to sign a separate contract of his own. And, knowing Brecht, he was wary of what he meant by a few "small" changes. He wanted to read them first, and then make certain that they didn't necessitate an unauthorized alteration of music. Despite his initially cooperative spirit, the composer would be disappointed by the subsequent events.

When Weill heard that there had been a Munich performance of *Threepenny* in which his music had been "substantially altered," he wrote to Brecht immediately: "I commissioned Universal Edition to forbid any further performances of this version as far as my music is concerned. I have also asked the theater department of the American military authorities to undertake the necessary steps to prevent any further infringements of my music's copyright."[14] He ended the letter politely, saying that he was sure—even if he was far from it—that these musical changes might have been unknown to the playwright as well.

But when Weill finally had a chance to read the altered play, his anxieties were not soothed. Peachum's phony cripple enterprise had been replaced with a more topical background story. This had necessitated new text and lyrics, which in turn required new music. Two song lyrics in particular were also revised to make specific mention of the Nazis. Weill wrote Brecht: "I must honestly confess that I don't

understand what your intention is with these changes. It's possible that I can't judge the situation in Germany sufficiently from over here, but it seems clear to me that . . . this cabaret-style political satire of current events . . . [is] simply not on the level of the *Dreigroschenoper* . . . the whole philosophy of the *Dreigroschenoper* transcends these current events [and] is much more incisive and aggressive."[15]

Brecht agreed wholeheartedly that Weill couldn't judge the situation from so far away. Living and working in Germany, Brecht was confronted daily not only with his personal residency issues, but also with the physical and moral devastation of Europe. He suffered this most acutely when he discovered that his eldest son, Frank, along with Caspar Neher's son, Georg, had died on the Russian front in 1943.

Brecht's next letter emphasized the composer's distance from the horrors: "I made the changes for very simple reasons. Mr. Peachum's phony cripples wouldn't go down in Germany just now, there are too many authentic (war) cripples or relatives of cripples in the audience. Something had to be found to take their place . . . Believe me that I shall do nothing contrary to your interests, nothing whatever."[16] Brecht's respect for Weill was sincere, but he was also surprised that the composer would quibble over his score when it came to producing a version of *Threepenny* that made sense in the war-torn landscape of Germany.

Weill was not surprised that Brecht would say anything to get his way. But Weill also didn't know much about Brecht's frustrated attempts to live in Switzerland and in Munich, nor about his prolonged reluctance to settle in the East. And since the composer didn't know how worried Brecht was about remaining visible in Western Europe, he also couldn't understand the playwright's particular urgency about the Munich performance of *Threepenny*. Because of his past experiences, Weill assumed that his troublesome ex-partner was simply taking advantage of the fact that the composer was far away in America.

Weill therefore had no intention of allowing Brecht to do what he wished with *Threepenny* in Germany or anywhere else. Weill soon heard that in order to include the musical changes that he had refused to authorize, a jazz arranger had been hired to reorchestrate the entire score. Weill quickly contacted the U.S. theater officer in Munich and asked him to stop the production.[17] Brecht continued to claim his

innocence in the matter, and the Munich Kammerspiele also wrote a touching letter, imploring the composer to understand that the popular *Threepenny* would rescue them from financial collapse. If Weill stopped the performance, they would have to fold.[18] Given the catastrophic difficulties for theaters in Germany, it was unthinkable to them that a successful composer working in America would care that much about their small production.

But they didn't know Weill. And they didn't know about the history of Weill's relationship with Brecht. This argument went beyond their theater in particular, and beyond the fate of German theater in general. It was a moment that would either honor or sully that spontaneous work of genius that exposed and illuminated bourgeois German society. As a landmark of the Weimar Republic, *Threepenny* was a mirror of a lost civilization, and it belonged to both of them.

The importance of *Threepenny* had been ironically highlighted by the musical follow-up to Joseph Goebbels and Adolf Ziegler's 1937 Degenerate Art exhibition. First presented in Munich, it displayed paintings by George Grosz, Max Beckmann, Oskar Kokoschka, Paul Klee, and Emil Nolde, among others, as examples of moral depravity. One year later, in Düsseldorf, there was a Degenerate Music exhibit and an entire room was devoted to *The Threepenny Opera*. As soon as it became clear that the ever-increasing crowd was enjoying rather than condemning the music, the Nazis stopped playing the songs immediately. Although *Threepenny* was written years before Hitler came to power, and was therefore a satirical portrait of Germany prior to the Third Reich, the subsequent Nazi attack on all forms of modern art and music transformed the historical significance of the piece. In the postwar years, *Threepenny* had come to symbolize a shout of protest against National Socialism, which had not been part of its conception. Just as important, the work was a symbol of the artists and intellectuals who had been exiled or murdered by the Nazis.

Weill believed the power of *Threepenny* was in its original form and wanted to preserve it; Brecht believed its power was in its infinite ability to expand and reshape itself according to his evolving response to contemporary conditions. It was the same fight they'd always had—about art, about politics, and about how best to control the legacy of their shared creation. They had grown a great deal as men and as artists,

but in 1950 their passionate disagreements remained intact. The unauthorized version of *Threepenny* was performed again in April 1949, and in addition to having his objections ignored, Weill never received any royalties.[19] And despite Weill's many requests, Suhrkamp only signed an agreement with Brecht for the stage rights to *Threepenny*, which created contractual problems that would outlive them all.

This was Brecht and Weill's final, but by no means first, dispute over *Threepenny*. Nine years earlier, in 1941, Brecht hardly had time to inhale what he called the "tasteless" air of Los Angeles before he began trying to mount a new production. Just six months after arriving, he had already wooed Paul Robeson and Katherine Dunham with the suggestion of doing an "all-Negro" version of the play, and with an uncannily prophetic twist, he wanted to set it during an American presidential inauguration. A stranger to the business of American theater, Brecht not only needed Weill's permission to make the necessary changes to the music but also his help in mounting a production. Since Weill had been one of the many friends who sent Brecht money when he was desperate in Finland, it had been reasonable to expect a friendly renewal of their relationship. Brecht wrote humbly to Weill and with high hopes: "I would be very grateful to you, if you support the issue [about *Threepenny*] I really need it a lot. Please write to me immediately."[20]

Weill was certain that the disastrous American reception of *Threepenny* in 1933 had been caused by its poor adaptation, and he therefore wanted to protect them from making the same mistake twice: "The idea of letting American Negroes perform a German adaptation of an English ballad opera from the seventeenth century is so 'sophisticated' that it would completely confuse the public."[21] Realizing that the composer really did intend to stop him from producing his new *Threepenny*, Brecht's letters became increasingly emotional: "I would like to propose to you to take up our collaboration again and to simply liquidate all misunderstandings and semi-disputes which so easily come up due to the disadvantage of the time, the distance and so on. So far I have actually not lost any of my friends and in our work, there was so much fun and so much progress."[22] Weill was moved to allow a limited local run, but there were ultimately several reasons the production didn't make it to the stage—not least that Brecht was unable and unwilling

to exercise the kind of professional caution with regard to rights and contracts that the well-established Weill knew was crucial in America. Brecht hoped that *Threepenny* would help him jump-start his career in America, but Weill needed to defend the career he had. The composer was nevertheless sympathetic to Brecht's plight and when the project failed, he contemplated giving him $50 a month until he found his way.

It was Lenya who absolved Weill from his feelings of guilt: "If it makes you feel better, send Brecht $100 but don't send him anything monthly . . . I don't trust him at all. I never believe that he ever can change his character which is a selfish one and always will be . . . Of course he wants to collaborate with you again. Nothing better could happen to him."[23] Lenya more than likely realized that the most dangerous aspect of this renewed relationship would be the cost to her husband's physical health. Brecht and Weill couldn't be in the same room for very long—they couldn't even correspond for very long—without raising each other's blood pressure. Lenya had no idea that both men would die of heart problems, and her intuition about the danger was more prescient than she could have known.

Even so, in between their initial disagreements over the "all-Negro *Threepenny*" in 1941 and the final troubles in Munich in 1949, the magnetic force between Brecht and Weill never ceased to exert its power. During Brecht's six years in America, they attempted to collaborate on two subsequent projects. There was still some sense of unfinished business, still some hope that their once hallowed combination of talent could be resurrected in another country.

When they met in Los Angeles—where Brecht lived and Weill often visited when he was scoring a film—their surface politeness didn't change, nor their use of the formal *Sie* when addressing each other. Their cool personal relationship had always been in contrast to the heat of their artistic collaboration, and this wouldn't change under the warm California sun. It was even more appropriate in a country where both understood that the appearance of friendship often had nothing to do with real feelings. Brecht disliked American superficiality; Weill, though witty and sharp about his colleagues in private, enjoyed their pleasant manners in public.

When they shook hands, the sleeve of Weill's expensive American suit would briefly graze Brecht's old leather jacket. Weill wrote to

Lenya that Brecht was "just as dirty and unshaved as ever, but some- how much nicer and rather pathetic."[24] It was 1942, and the two men were yearning to feel the creative surge of that first meeting in Ber- lin in 1927. They were certainly both excited by the idea of doing an American adaptation of *The Adventures of the Good Soldier Schweik,* the antiwar Czech novel that Brecht had already helped turn into a play for a 1928 production in Berlin. The conversation went well enough for Brecht and Weill to plan a week of work together the following spring. Neither knew if working in America would pacify or exacerbate their seemingly inexorable tensions, but both wanted to try.

Although Brecht lived in Los Angeles, he often came to New York for both personal and professional reasons. His Danish lover, Ruth Berlau, who had followed him to America, was living there, and since she was working with him as closely as Hauptmann and Steffin had, Brecht felt as though he had an East Coast office.[25] When Brecht vis- ited Weill's Rockland County house in New City in May 1943, Ber- lau came with him. In addition to an American version of *Schweik,* they also discussed a musical version of Brecht's play *The Good Person of Szechwan.* They enjoyed the week together and agreed to approach Ernst Josef Aufricht, who was also in New York by then, as a potential producer for *Schweik.* Although the creative collaboration was pleasant, there were soon questions about translators, contracts, and rights. And there the harmony ended.

A month later, Brecht wrote to Weill about his objections to the contract for *Schweik.* He complained that it "brands me for all time as a pure librettist, without any author's rights . . . As you know, I'm quite willing to be guided by your advice in matters concerning an Ameri- can production. On the strength of our recent collaboration, which I very much enjoyed, I don't believe there will be any serious differences between us."[26] Brecht's politeness, however hypocritical, was evidence of his understanding that he needed Weill to navigate the difficult waters of an American theater production. But he didn't try to cover up his true feelings when he wrote, the very same day, to Berlau about the situation: "Why should Weill get such unreasonable rights? I'm not a librettist. It's got to be my play . . . I wouldn't dream of interfering with Weill's conduct of the business end, but I must have a reasonably 'influ- ential position,' I'm not just the bottle washer."[27] Brecht was behaving

as though nothing had changed—not his country nor his professional position—since the 1930 production of *Mahagonny*. By using the word "librettist," he behaved as though he was back in Leipzig fighting the elite form of opera. But he was no longer battling anything of the kind. Had Brecht been able to write in English, and had he understood the Broadway system, the hierarchical structure of musical theater would actually have offered the playwright just the kind of power denied an opera librettist. The true source of Brecht's rage was his own inability to master the language and culture of America, and his consequent dependence on Weill's preferences regarding the translator. Brecht knew that Weill would thus have a great deal of influence not only over the text, but also the entire production. Despite, or perhaps because of, his altered circumstances, this was a situation the playwright was still unable to tolerate—most especially when it came to working with Weill.

Since Weill was working harmoniously with some of America's leading literary icons, he was not interested in these old arguments. Brecht's power play bored and frustrated him, and Weill ultimately decided that despite his enduring affection for the story of *Schweik*, the project wouldn't be feasible. The composer was also influenced by his discovery that Brecht had simultaneously offered the project to Erwin Piscator, who was also in New York and teaching at The New School. The situation came to light when Piscator found out about Aufricht's involvement and publicly decried the "Brechtian swinishness."[28] Surrounded by Berliners, Brecht behaved as he had in Berlin, hedging his bets and working on both fronts at once without telling Weill. The deception put the composer over the edge.[29]

Despite the composer's serial disappointments with Brecht, he continued valiantly to try and develop *The Good Person of Szechwan* for the Broadway stage. He even sent Brecht $100 a month for six months as payment for an option on the play. But despite his forgiving nature, Weill finally lost faith in overcoming the Brechtian obstacles. Brecht "is playing his old tricks again," the composer wrote to his lawyer, "and I just don't feel like going through all this again. Life is too short."[30] By October of that year, Weill walked away from both projects and never sent Brecht money again. As Lenya had predicted, their partnership was impossible to revive.[31]

Brecht's particular failures with Weill exemplified his alienation from America in general. The playwright continually tried to dominate an industry that refused to accept his prowess or his rudeness. He made far more enemies than friends, brashly accusing Christopher Isherwood of selling out, rejecting Orson Welles in favor of someone he could better control, and, finally, clashing with the poet W. H. Auden. Auden had translated several of Brecht's plays, but even the two men's great regard for each other's work did not help them overcome their quick personal hatred for each other.[32] Brecht routinely expected far more devotion from writers and directors than they were prepared to offer, but his worst blunder was failing to understand the power of a Hollywood star. When Luise Rainer dared to challenge his authority during the development of Brecht's play *The Caucasian Chalk Circle,* he made it clear that no actress could ever have that kind of authority over his work. He refused to listen to her, and she withdrew from the project. It once again surprised the naïve Brecht that an actress could force the producer to cancel the project. He also tried to write a screenplay for Fritz Lang, but unlike his fellow émigré, the playwright couldn't accept the compromises that Hollywood required.[33]

Brecht's problem functioning in the American cultural scene was not only a matter of his personal style. His artistic interests had also definitively shifted in the direction of the epic theater, a form that emphasized historical events and abandoned the central role of the individual in drama. Nothing could have been more at odds with the character-driven Hollywood films and Broadway plays of the era. Brecht was deeply discouraged that Hollywood was cultivating just the sort of narcotic influence on the audience that he had fought so hard against in Germany. Anything that sold tickets was approved, and Brecht bemoaned a country in which culture was treated "as a commodity rather than a utility."[34]

Even less compatible with American theater was Brecht's refusal to invoke the Aristotelian concept of empathy with the main character and the attendant comfort of catharsis. In Aristotelian theater, the hero's ability or inability to overcome his weaknesses determines his fate. In Brecht's epic theater, man is not defined by his psychological or spiritual condition but instead is elevated or defeated by his society. In order to change the fate of men, men must change the society

that determines their fate. The epic theater provokes action, Brecht contended, while Aristotelian theater encouraged passivity. Attendant upon this redefinition of the building blocks of drama is a transformation of the dramatic experience. Rather than suspending the audience's disbelief, Brecht made sure that as they became aware of the social structure, they simultaneously became aware of the apparatus of the theater itself. They had to be able to judge the events onstage with the full recognition that these events are being consciously performed for them. They had to judge the presentation and the presenter simultaneously.

Brecht's approach had been a response to very specific circumstances of the Weimar Republic. Early in his career, he had announced that the epic theater must reject a dramatic structure based on the journey of a hero. It began as a revolt against the noble heroes that had become associated with the theater prior to the very unheroic World War I, and it had gone on to embody the role of art in a democratic society. The fight against rigid class distinctions, the revolt against bourgeois hypocrisy, and ultimately Brecht's belief that social justice could be brought about by elucidating the Marxist analysis of society had all informed the playwright's theories about the epic theater. During and after the Second World War, Brecht was speaking entirely the wrong language to Americans, many of whom despised and feared Communism, and who also desperately needed their heroes. Their infatuation with antiheroes had yet to come.

Brecht, Weigel, and their two children lived in Los Angeles from 1941 until 1947. In comparison to his enormous burst of creativity in Scandinavia, Brecht's six years in America were painfully unproductive. He wrote only two plays, *The Caucasian Chalk Circle* and his final version of *Life of Galileo*.[35] A few of his plays were produced, but they all flopped. With the exception of Bentley, one of the early English translators of his work, and his dynamic relationship with Charles Laughton, who played the leading role in *Galileo* and with whom he developed the final version of the play, Brecht made few lasting creative relationships in the United States.[36]

Brecht found it impossible to dominate his American colleagues, but he did manage to keep his imperious behavior with women surprisingly intact. Weigel remained his wife and took care of the children in

Los Angeles, where she used her characteristic resourcefulness to survive. She even managed to send many packages to friends and family who were suffering in postwar Germany. For a time, Berlau replaced Steffin and Hauptmann as Brecht's colleague and lover, although once she came to America her mental and physical health deteriorated. She railed against him and her subservient role as his mistress and was often unable to take care of herself, or to render her professional duties. In the increasingly frequent times when Berlau became dysfunctional, Brecht called upon Hauptmann, also in the United States at that time, to help him. Hauptmann not only began to translate his work into English; she also attended to Berlau's health problems when necessary.

Hauptmann's time in America had also been very difficult. After managing to send Brecht many of his manuscripts and possessions, she finally boarded a ship to America with little more than the clothes on her back. She stayed with one of Brecht's cousins in New York before moving to St. Louis, where her sister had been living for many years. Working as a teacher and translator and earning very little money, she often suffered from both psychological and financial duress. As a committed Communist, she considered immigrating to Russia, but like so many Germans, she changed her mind after Stalin's purges.

In 1945, Hauptmann went to New York to help Brecht with the troubled Theatre Union's production of *The Mother,* for which he had made a special trip from Europe. Although her letters from St. Louis had made clear that she no longer wanted an intimate relationship with Brecht, a romantic poem he wrote about their time in New York gives the impression that they briefly renewed their love affair. She continued to work on and off with Brecht after his arrival in America in 1941, but it seems that this romantic encounter was truly their last. Although helping Brecht rarely provided much money or potential for her professional advancement, Hauptmann nevertheless decided, by 1946, to devote herself once again to his work. The satisfaction this provided far outweighed her many disappointments in America. She moved to Los Angeles and stayed with Peter Lorre while she collaborated with Bentley on a translation for Brecht's collected works. Lorre's ranch had become a gathering place for Brecht devotees, including the composer Paul Dessau, who was working as a gardener in Los Angeles. Like many who hadn't adjusted to American life, Dessau was awaiting

a chance to return to Germany. He and Hauptmann fell in love and married in 1948, and they waited out their time in the West together. That is, once Brecht returned to Europe, they waited for him to re-establish a theater where both of them would be able to work.

Weigel had only been onstage once during her entire period of exile. It had been in 1937, when she briefly left Scandinavia to play the lead in a French production of Brecht's play *Señora Carrara's Rifles*. Her accented English and Germanic acting style made it impossible to have a career in Hollywood, and she had only one silent role in a film. As a talented actress who had once been financially independent, she found it increasingly difficult to lead the life that exile had forced upon her. In one of her extremely rare moments of open despair, she wrote to Piscator, "I am sick and tired of my idiotic existence. I have always been a useful person and the hibernation is lasting too long."[37] Weigel couldn't wait to return to Europe, and she and Barbara boarded a ship a few weeks after Brecht's hurried departure following the HUAC hearings in 1947. Stefan remained behind. A graduate of the University of California, Los Angeles, and a PhD student at Harvard University, Stefan was, like Weill, pleased to make his permanent home in America.

Weill's ability to adjust to the American cultural scene was only partly due to the fact that, as a composer, he worked with the universal language of music. His enthusiastic acculturation also came about because he was captivated by the many talented people in the musical theater he had been fortunate to meet so early on. Upon his arrival, he heard Ira and George Gershwin's *Porgy and Bess*, a musical that fulfilled his dream of what popular opera could be. "It's a great country where music like that can be written—and played," he declared.[38] *Porgy* convinced Weill that America was the perfect place to further the experiments he had begun in Berlin to transform the modern opera. In addition to that pivotal experience, his colleagues in the Group Theatre were ambitious, both artistically and politically, and their heated arguments and large personalities made the Berlin composer feel more at home than he perhaps expected. The celebrated Anderson quickly became a friend, and it was his residence in New City that had led to Weill buying a house next door. The composer was surely more determined than Brecht to adapt to American culture, but

it also suited him better. He enjoyed the pleasant manners and what he called the "rules of fair play" on Broadway. He was at home in the world of rights and contracts, especially ones that were usually honored. Weill's devotion to serious subject matter, and his ability to work with first-class writers, along with his quick rise to fame, ultimately convinced him that he was right about Broadway. It was the greatest venue for popular opera he could ever have imagined.

Like Weigel, Lenya's accent and her unconventional appearance had stymied her stage career in America, and part of Weill's motivation for working with Brecht had been to generate good roles for her. Once the composer had given up hope that a Brecht production would ever materialize, he tried to find other ways to help Lenya with her American career. Weill used his influence to have her cast in the Ira Gershwin musical *The Firebrand of Florence*, but it was a critical flop. Lenya's particularly disastrous reviews caused her to retire from the stage for the foreseeable future. She was content to let her husband succeed where both she and Brecht had failed. She was the last person in the world to believe that Brecht and Weill could ever work together again, and certainly not in a country where the playwright was even more uncomfortable than she was. What she found harder to comprehend was the fact that they kept on trying.

Brecht and Weill indeed tried hard to believe that their desire to collaborate was based on either the playwright's opportunism or the composer's kindness. But the continuing attempts at a creative reunion cannot be fully explained without acknowledging their passionate, if somewhat irrational, compulsion to work together again. They could not stop believing in the chemistry that had existed between them—it had been even stronger than their disputes, and stronger than either man. But their professional attraction to each other in America, where their union was more hopeless than ever, raises the question of why it had become impossible to maintain their successful partnership even before their exile had entered the equation.

Artistic differences had of course evolved as early as 1929, during the development of *Mahagonny*. Weill wanted to transform the operatic genre, and Brecht wanted to destroy it. Music remained important to the playwright, but it is telling that after departing from Weill, Brecht wrote very few plays in which the music played a dominant role.

These differences were powerful, but hardly impossible to over-come. The composer and playwright had created an altogether new genre, one where traditional lines between musical and literary conventions were successfully transformed, so their disagreements about how to deal with the elite trappings of opera could not have been their sole undoing. Together, Brecht and Weill's shared ability to bend, discard, and create new genres was matchless, and for the duration of their partnership, there was no significant disagreement between them about the essence of the modern musical theater. Artistic differences played a role, but they were not strong enough to undo a partnership that had produced so much, so quickly, and with such astonishing originality.

It is perhaps true that if they had been forced to fight harder for their mutual ideas, it might have added to the longevity of their partnership. But a little more than a year after their initial meeting, the groundbreaking style of *The Threepenny Opera* was instantly accepted and imitated. For Weill, this success encouraged him to continue his struggle to erase the distinction between high and low culture. This no longer satisfied Brecht, who wanted to use his popularity to appeal to workers and advance Marxist principles. It was ultimately a difference of opinion about how to make use of their triumph, more than their actual artistic differences, that first initiated the rift.

Although Brecht and Weill had begun with a mutual belief in promoting a love of justice through art, the evolution of their political differences also played a role in their parting. They had met during the heyday of the November Group and came of age as artists committed to the central role of art in society. But the political turbulence of the Weimar Republic, as it hurtled toward the reign of the Third Reich, forced Brecht and Weill to be far more specific about their idealistic aims. And it was this pressure that brought their political differences into sharp relief. Brecht believed that the theater could fight the Nazis by serving Marxist goals; Weill believed that art could only create meaningful change over the course of time.

The troubled circumstances in Germany forced Brecht and Weill to redefine their attitude toward the political role of art in society, as well as their definition of the broad audience they hoped to attract. Weill upheld his belief that operas and musical plays should be

thought-provoking for the "people," meaning people from all social classes. Access to culture was the best route to eradicating the rigid class distinctions of the past, and democracy, he insisted, was defined and confirmed by cultural freedom. For Brecht, the commercial success of *Threepenny* tainted the concept of popular appeal with the stench of capitalism, and he began to equate "popular" with "bourgeois." In dire times, Brecht insisted, provoking thought was not enough—the theater had to provoke the "people," defined by him as the working class, to action. As he wrote in one of his most famous poems, Nazi Germany made it impossible to create any form of art that is not engaged with its political and social context: "A talk about trees is almost a crime / Because it implies silence about so many horrors."[39]

It was this difference between provoking thought and provoking action that shook the foundation of Weill and Brecht's earliest and most cherished goal of "mass appeal." They could no longer even agree on the definition of the "people" themselves.

Brecht's and Weill's divergent postwar careers have deepened the misconception that their angry split in Germany was the inevitable result of the radical and irreconcilable differences between Brecht's Marxism and Weill's inherently commercial priorities. Even the sharp Lenya insisted that "the reason the collaboration eventually broke up was very logical—Kurt simply wasn't interested in composing Karl Marx."[40] This flippant quip has only furthered the misunderstanding of both the artists and their legacies.

For although Brecht was devoted to works that illuminated politics and society, he was ultimately too concerned with artistic matters, with creating good theater, to write plays that existed only to toe the Party line. For that reason, the East German ministers of culture and education often interfered in Brecht's productions, and the playwright was subjected to persistent and scathing criticism from above. He never truly felt settled in East Berlin and expressed this in a private poem: "Even now / On top of the cupboard containing my manuscripts / My suitcase lies."[41] That feeling would never quite go away.

Weill's postwar reputation as a composer has often been equally as misleading as Brecht's. With shows like *Lady in the Dark* and *One Touch of Venus*, and especially the songs "Speak Low" and "September Song," his music has earned an indelible place in America's popular

imagination. This achievement has led to the mistaken assumption that Weill abandoned serious drama and succumbed to the purely commercial rewards of Broadway. But the composer's determination to reach a broad audience did not require the dilution of the serious subject matter he was determined to address. "Looking back on many of my own compositions," Weill said, "I find that I seem to react very strongly to the suffering of underprivileged people, of the oppressed, the persecuted. When my music involves human suffering, it is, for better or worse, pure Weill."[42] Weill used his adaptability to the American idiom to introduce his own original version of what a Broadway musical could be. One of his favorite examples was *Street Scene,* and he wrote a moving letter to the cast: "Dear Friends, the show we are giving tonight is to me the fulfillment of an old dream—the dream of a serious, dramatic musical for the Broadway stage."[43]

The misunderstandings about Weill's commercial concerns, or Brecht's dogmatic political agenda, persist until the present day. In 2011, when the director Brian Kulick proposed a stage production of Brecht's *Life of Galileo,* he noticed the dismayed look on a colleague's face. He asked what he had against it: "*Galileo* is one of those 'eat your vegetable plays' . . . it's supposed to be good for you," the colleague replied. "And anything that's good for you," Kulick understood, "can't possibly be entertaining." Nothing would have disappointed Brecht more than that type of response. Kulick believes that at his best "Brecht is a smuggler. He knows that if he tells a joke, or has a song, in between the joke and the song, a message can come through . . . That, to me, is black-market dramaturgy."[44]

Brecht had declared early on, and never stopped believing, that "a theatre which makes no contact with the public is a nonsense."[45] He was certain that theater could simultaneously provoke a critical response and inspire emotion. The epic theater "in no way renounces emotion. Least of all emotions like the love of justice, the urge to freedom or justified anger: So little does it renounce these emotions, that it does not rely on their being there, but tries to strengthen or to evoke them."[46] Although Brecht's Marxist passion was at its height as the Nazis came to power, and his political commitment evolved further during his pivotal development in East Germany, he never stopped trying to move people, intellectually and emotionally, with his work.

Even if he spent the early 1930s believing that commercial success had to be sacrificed in order to achieve political awareness, even if he narrowed his audience to the workers during those dark times, he ultimately returned to his belief in the broad appeal of his plays. The poet who first brought the authentic speech style of the German people to the stage was too witty and too sharply ironic to be satisfied with a small audience forever. Kulick believes the ability to understand the tenor of Brecht's plays continues to evolve: "America didn't fully understand Brecht's black humor until Vietnam and Watergate, and in a way we've caught up with his humor. It was always there, but we couldn't hear it. His ironic, one might say cynical, outlook just didn't fit with a Rodgers and Hammerstein world. And now, post all these horrible things that have happened in the twentieth century, we've learned how to laugh the way Brecht laughed."

After his period of understandable political engagement in Nazi Germany, Brecht's commitment to eternal themes returned, and indelibly, during his exile in Scandinavia and America. It was during these difficult times that he wrote his best-known plays. And in these works, Brecht's genius for illuminating the human significance of historical events burns exceptionally bright. Tony Kushner points out: "When Brecht lost contact with the German-speaking audience as a playwright . . . he decided to create a group of plays between 1935 and 1940 that were intended to last forever and have."[47] In Brecht's return to the eternal in his work, in Weill's lifelong commitment to serious drama, and in their mutual desire to entertain a big audience, the two men maintained similar artistic goals all their lives.

Thus the truly insurmountable obstacle between Brecht and Weill was not caused by their artistic or even their political differences. However significant these differences were, they paled beside their personal dislike for each other. They provoked each other in different ways, but they were finally undone by their equally powerful need to control. For although they had succeeded in shattering the distinctions between high and low culture—and they had succeeded in smashing the old hierarchies and creating a new genre that defined and delivered democratic art—they could not avoid the curse of hierarchy as far as the two of them were concerned. No room, no creative space was big enough

for two such large egos, and the primal personal battle between them was ultimately impossible to resolve.

During the brief era of the Weimar Republic, Brecht and Weill's struggle against outside forces in Germany, in both art and politics, created a connection that bound them together, and for the few short years of their partnership, their common enemies proved far stronger than the force of their artistic and political differences. These forces were even, for a time, stronger than their incompatible egos and personalities. But as the Third Reich steadily ascended, and provoked a different response in each of them, these outside forces began to gnaw at rather than embolden their partnership. Once the unique environment of Berlin between the wars dissolved, the artistic revolution that brought Brecht and Weill together ceased to exist. The mutual passion that united them, that led to the groundbreaking *Threepenny Opera*, evaporated along with the Weimar Republic.

Kushner has noted that *The Threepenny Opera* is a perfect example of the evolving legacy of Brecht and Weill's signature work.[48] "It is so timeless, [*Threepenny*] doesn't date at all. The world that [Brecht is] describing and . . . every act of aggression against the system, the impossibility of teasing out who's good and who's bad, who's profiting and who's not, the way that morality is completely suffocated by the genius and inexhaustible energy of capitalism, it's so modern, so of the moment, it doesn't feel stale at all." Lenya also summarized the eternal appeal of *Threepenny* in terms that captured the essence of Weill's populism: "The 'Moritat' has been recorded by seventeen different companies. You hear it coming out of bars, jukeboxes, taxis, wherever you go. Kurt would have loved that. A taxi driver whistling his tunes would have pleased him more than winning the Pulitzer Prize."[49] The work's importance functions just as Weill believed it must—over time.

Over time, it was *The Threepenny Opera* that also forced them to be in contact long after their paths had forked, quite literally, toward east and west. Their first work forged a contentious bond, and it was no coincidence that once he was back in Berlin, Brecht reunited with the talented group of artists who worked on the original production. Brecht and every other important member of the *Threepenny* group, including Hauptmann, Neher, and Erich Engel, came together at the

Berliner Ensemble. Only Weill was missing, and perhaps Brecht even reveled in the contentious situation with the postwar productions of their first success. After Brecht's return to Europe, every argument about *Threepenny* gave him the chance to interact with Weill as an equal again, undoing the inferiority he had suffered in Hollywood. As one of the most powerful playwrights in Europe, Brecht felt more than equal to the partner who stayed in America. The competition thus remained strong, even without the collaboration.

The professional rewards in postwar Europe were also lavishly bestowed upon the deserving Weigel. After fourteen years of exile from the stage, she starred, almost upon landing, in a 1948 Swiss performance of *Antigone,* which was followed by her now legendary interpretation in the 1949 production of *Mother Courage* in East Berlin. At the age of forty-eight, her acting career began again with force, on top of which she was also named the leader of the Berliner Ensemble, confirming her importance in Brecht's postwar collective.

Hauptmann left California for Berlin in 1949, eager and ready to work with Brecht again. Her husband, Paul Dessau, however, had left a few months earlier and by the time Hauptmann arrived, he was already having an affair with a young actress. He asked her for a divorce. This was Hauptmann's second marriage to dissolve in less than a year, and there was again a rumor that she tried to commit suicide. The proof is once again anecdotal, having been reported by Dessau's girlfriend, Antje Ruge, who was distressed by Hauptmann's despair.[50] To add to her problems, Weigel, although eager to make use of Hauptmann's skills, was reluctant to accept Brecht's first and most faithful *Mitarbeiterin* as a formal member. Despite her cool welcome on all fronts, Hauptmann nevertheless recovered her strength and stayed on to edit Brecht's collected works and take charge once again of the *Versuche* journals. Working on the publications of his literary works kept her out of the inner circle of the active Berliner Ensemble theater, where she most wanted to be, but the eternally patient Hauptmann waited for Weigel to change her mind.

The troubled and troublesome Berlau also followed Brecht back to Europe, first to Switzerland and then on to Germany. She worked at the Berliner Ensemble as an archivist and photographer, thriving professionally although her romantic relationship with Brecht had come

to an end. She was, however, the only one of Brecht's women to be astonished that back in Berlin, Brecht would continue to take on several younger lovers. His attraction to brilliant and talented women never waned, and his amorous opportunities grew alongside his professional ones.[51]

Brecht's inability to end relationships, either personal or professional, indicates his deep-rooted dependence on the friends and colleagues in his life—he needed their approval. No one who saw him raging in a theater could imagine he was a man who cared very much about being liked, but although he always insisted upon the final word, he clung fiercely to those he considered essential, as in his lifelong collaborations with Neher, Engel, Eisler, and of course Weigel and Hauptmann.

As a young man in the Weimar Republic, Brecht had always maintained a magnetic aura of brilliance based largely on his belief in himself; he now had the help of the East German government to burnish and bolster his reputation. Life in the German Democratic Republic was by no means easy, but after having to spell his name in America, Brecht enjoyed his celebrity.

Weill's career in America continued to ascend until the end of his life. His last two projects were *Love Life* with Lerner and *Lost in the Stars*. The latter was with Anderson, who had discovered Alan Paton's novel *Cry, the Beloved Country* and wrote to Weill immediately, saying he had "found the story we'd been searching for during the last ten years." As with *Street Scene*, Weill thought of the work as a "musical tragedy," and the composer was thrilled to see that the audience accepted it "without hesitation, that they accepted a lot of very serious, tragic, quite un-Broadwayish music of operatic dimensions."[52]

Unlike Brecht who went on to use other composers, such as Eisler and Dessau, whose musical talent and personalities were far less overpowering than his own, Weill took great pride in his desire to work exclusively with literary royalty. This was far more important to him than finding colleagues with whom he could be friends. If friendship naturally took place, as it did with Georg Kaiser and with Anderson, he accepted it warmly. But he didn't need to make friends at work, and he didn't need to work with the same people all the time. In this way, Weill was more independent than Brecht. As a Jew who broke from

Judaism, and as the son of a cantor who was supported by the royalty in his hometown, Weill knew the value of independence as well as the price of dependence. Working with the likes of Hart, Lerner, and Ira Gershwin, Weill clearly sought out professionals who were already as accomplished in their own fields as he was in his.

On the surface, Weill's personal life in America also seemed to resemble his final year in Berlin. He was living with Lenya, and they remained a close couple continually helping each other enjoy their adopted country. As in Europe, Lenya engaged in casual affairs, but it was Weill, once again, who engaged in a deeply committed relationship outside the marriage. In 1944, Weill met Jo Revy, the wife of Lenya's first acting teacher in Switzerland, Richard Revy. Jo lived in California, and Weill's trips to Hollywood to score films gave him frequent opportunities to see her. This continued until nearly the end of his life, and it only stopped when Lenya said he had to make a choice between her and Jo. He chose Lenya. However difficult it might have been to part with Jo, the composer was far more preoccupied with the joy of having attained his most important goal of composing serious musical works for Broadway. He was intensely involved in his adaptation of *Huck Finn*, once again collaborating with Anderson, during the final weeks of his life. As always, his music came first.

On April 3, 1950, Weill died at the age of fifty of heart failure. He is buried high on a hill with a view of the Hudson River. There were no religious rites at the funeral, but his brother-in-law said the Kaddish over his grave. Anderson, his close friend and colleague, wrote the epitaph for his headstone: "This is the life of men on earth / Out of darkness we come at birth / Into a lamp lit world, and then / Go forward into dark again." This was taken from lyrics to a song called "Bird of Passage," which was in their show *Lost in the Stars*. The song is part of a "service for those who die without faith, except in man."[53] Weill's quick death was a shock to everyone. Since his final letter to Brecht had never been answered, the troubled rights situation with *The Threepenny Opera* was on his mind until the very end.

Brecht taped a short newspaper announcement about Weill's death into his journal. In the brief description of Weill's career, the American clip did not mention his collaboration with Brecht.

The Schiffbauerdamm Theater was in the eastern sector of Berlin,

and it became the permanent home of Brecht's Berliner Ensemble in 1954. Thus, in the final years of Brecht's life, every time he opened the front door of the baroque building perched on the Spree River, he was reminded of *Threepenny*. If this daily reminder of Macheath was not enough, the ailing Brecht also spent his last birthday in 1956, in Milan, seeing Giorgio Strehler's Italian production of *The Three-penny Opera*. This production was set in 1914, and the updated design replaced the stable with a garage. Brecht enjoyed Strehler's interpretation immensely and began to wonder how the play would be produced after World War III.[54]

As Brecht well knew, however, there was no need to wait for another world war before *Threepenny* would find an altogether new and even more lasting foothold in the popular imagination. By the time he saw the Italian version, virtually everyone in New York was already raving about a production where the fifty-five-year-old Lenya was playing Jenny. It was already several months into what would be one of the longest-running shows in the history of American theater.[55]

Weill's death had paralyzed a grief-stricken Lenya. She had to find a way, as she had done all her life, to start over again. She was unsure how to go forward, and it was her good friend George Davis, the gifted literary editor at *Harper's Bazaar*, who finally showed her the way out of her deep mourning. A highly cultured man, who had published a successful novel at the age of twenty-four and had first published Christopher Isherwood's story about Sally Bowles, Davis was also well acquainted with the theater and music from the Weimar Republic. He appreciated Weill's legacy and convinced Lenya that the best way to honor her husband's memory was by giving a Town Hall concert in honor of his music. The event was so successful that it strengthened her resolve to "fight for [Weill's] music, to keep it alive, to do everything within my power for it."[56] When she sang Weill's music in America, her profound grief over his death mixed with the pain of exile, and her moving renditions became even more powerful.

Davis was by her side all the time, even coaxing her onto the Town Hall stage when she momentarily lost her nerve. Lenya needed his support to honor Weill, and she married him five months after the Town Hall event. Some friends questioned her decision to marry an openly homosexual man, but she enjoyed their friendship and cared

most about his devotion to Weill's music and his belief in her talents as a performer. With renewed energy, Lenya threw herself into the promotion and preservation of Weill's music, and no one was happier about her success than Marc Blitzstein.

Blitzstein, a left-wing composer and writer, was best known for the pro-union and politically controversial *The Cradle Will Rock*, directed by Orson Welles in 1937. Famous for his play about corporate greed and corruption, Blitzstein had long been burning to translate and adapt *The Threepenny Opera* for the American stage. He pursued Weill until just before his death. In early 1950, right around the time that Weill was warning Brecht that all further Munich performances of *Three-penny* were illegal, the composer's phone was ringing off the hook at his house in New City. It was Blitzstein, who had translated the "Pirate Jenny" song and wanted to show it to Weill right away. Weill, who had not always been a fan of Blitzstein's work, must have cracked a smile as he dared the eager young man to sing it over the phone. But Blitzstein was prepared to do anything, and he waited patiently as Lenya picked up an extension to listen. When Blitzstein finished, Weill responded, "I think you've hit it. After all these years! . . . do it all, why don't you?"[57]

Weill's initial hesitations about Blitzstein were easy to understand, given that the younger composer had begun his career studying with the renowned composer, conductor, and teacher Nadia Boulanger in Paris, and initially believed, like Schoenberg, that art could only be appreciated by the intellectual elite. For that reason, Blitzstein had first denounced the work of Weill, mistakenly considering him to be too commercial. Blitzstein eventually changed his mind, both about the need for art to address social and political subjects, and, of course, about the importance of Weill's music.

It would be two years, however, before Blitzstein had the chance to finish his translation. In the meantime, Weill had died, and Lenya's reinvigorated career had led to a role on Broadway in Anderson's *Bare-foot in Athens* and many opportunities to perform Weill's music in New York. By the age of fifty-four, she had regained enough confidence to accept the role of Jenny in Blitzstein's concert version of *Threepenny*, conducted by Leonard Bernstein. Under his baton, the magic power of the piece that had exploded in Berlin thirty-four years earlier began to

take hold in America. Lenya and Blitzstein were deluged with offers to mount an American production.

When they chose the young theater producers Carmen Capalbo and Stanley Chase, perhaps they were remembering those equally youthful Berliners Brecht and Weill, who had astonished the Berlin audience so many years ago. Capalbo and Chase were not only young; they were also as faithful as possible to the 1928 score and script, choosing, as Blitzstein had, to ignore Brecht's 1931 revised version as well as the altered songs used in Pabst's film. Adjustments were made to accommodate the voices of the American singers, particularly Bea Arthur, who played Polly and was a female baritone, and there were other necessary changes to suit an American theater, the English language, and the particular performers. But because they listened carefully to Lenya's authoritative suggestions, the production was authentic enough to be billed as "Kurt Weill's *The Threepenny Opera*."[58]

There was so much about the New York performance that was reminiscent of the 1928 premiere. It was produced on a very low budget; once again they took the "risk" of casting Lenya as Jenny—this time the risk was of course her age, but both producers insisted she was the only woman alive who could play the part. And once again, no one dared to assume that a run of ninety-six performances, which was the only lease available at the Theater de Lys in Greenwich Village, wouldn't be nearly long enough.

The stars had aligned once again in March 1954. This *Threepenny* had the same blend of courage, economic risk, and youthful, idealistic passion, but it also resonated in America because of Blitzstein's excellent translation. The lyrics had a contemporary sound, and they also captured Brecht's essential combination of vernacular speech and poetry. Most important, the 1954 American audience, especially in New York City, was ready for a humorous stab at hypocrisy and greed. They were finally tired of the rabid intolerance that fueled the conformist culture of postwar America. There was even concern that the show would be picketed by McCarthyites, but fortunately that didn't come to pass.

The audience was ready, but the critics took a few weeks to join the public appreciation. The show initially received mixed reviews, and not until after the first month was it praised by Brooks Atkinson in

the *New York Times* and Virgil Thomson in the *New York Herald Tribune*. Meanwhile, every performance was sold out and every inch of standing room was taken. The production only ended because of a previous booking. By the time it reopened in September 1955, Lenya and Blitzstein had received requests from all over the country. *Threepenny* had 2,611 consecutive performances and played until the end of 1961—six solid years in New York alone. Lenya remained in the cast, with a brief hiatus, until April 1956, the same year she won a Tony for Best Featured Actress in a Musical.

As Kim H. Kowalke, a musicologist and the resident of the Kurt Weill Foundation, explains, "It came at the right time . . . [The premiere] coincided with the date of James Dean's car crash; that year Brando won [one of the eight] Academy Awards for *On the Waterfront;* the rebellious Beat generation could identify with certain anti-Establishment aspects of *The Threepenny Opera*."[59] It is also significant that the show was in rehearsals during those very HUAC hearings that had already driven Brecht and so many others out of the country. Blitzstein was a former Communist Party member, and in 1958, halfway through the run, the committee subpoenaed him as well.

In 1961, Bob Dylan saw Lenya in the revue *Brecht on Brecht,* also at the Theater de Lys, and he proclaimed the "raw intensity of the songs." He was particularly taken with her "Pirate Jenny" song, describing its power in dramatic terms: "Each phrase comes at you from a 10-foot drop, scuttles across the road and then another comes like a punch on the chin."[60] Brecht and Weill's influence on Dylan's songs is well known, but it didn't stop there.[61] Another clearly impressed member of the audience was the American composer of *Cabaret,* John Kander (of Kander and Ebb). With its broad appeal, the *Threepenny* fever that had swept through Berlin in 1928 had taken hold in New York at last. It offered a musical and theatrical howl to the Beats; it was an incisive gateway to the rebellious culture of the 1960s; it skewered the very bourgeoisie that was about to come under fire in America. To Lenya's great joy, the play "guaranteed for Weill what his Broadway works had not: a posthumous impact on the course of American musical theater."[62] The success of the show also secured the kind of American reputation for Brecht that he had been unable to attain during his six years in Los Angeles.

It was only when *Threepenny* began to conquer the country that Brecht finally showed an interest in the American production. Characteristically, he had never returned the copy of the contracts sent by Lenya before the premiere, where they had specified equal shares for Weill, Blitzstein, and Brecht. Once news of its triumph reached him in Germany, Lenya received a letter written by Hauptmann, on Berliner Ensemble stationery, stipulating Brecht's terms. He was willing to give Blitzstein the requested 30 percent of the profits, but he refused to give Weill more than the 25 percent that had been agreed upon in the original contract. Lenya tried to argue, but ultimately came to an agreement with Blitzstein instead. She and the American composer shared the combined royalties of 55 percent equally, the remaining 45 percent going to Brecht and Hauptmann, who continued to receive her original 12.5 percent from the 1928 contract.[63] As to his creative engagement, Brecht did tell Blitzstein that he found his translation to be "magnificent."

Brecht was aware of the financial rewards of the New York production, but his personal and professional focus was decidedly elsewhere. During the pause in *Threepenny*'s theatrical run, he was intensely engaged in his work at the Berliner Ensemble, the publication of his collected works, and the role of his theater in Europe. In May 1955, as *Threepenny* was waiting to reopen in the capitalist center of the world, Brecht was giving an acceptance speech in Russia, where he received the Stalin Peace Prize. "The desire for freedom among simple men is deep," he announced. "Our best hope of peace rests with the workers and the farmers in their individual nations."[64] Brecht would not surrender his rights to *The Threepenny Opera*, but he had long since ceased to care about a commercial American career. His life and work was in East Germany, and since he received visitors from all over the world, and his plays were performed in many different countries, he had finally garnered the international reputation he'd always expected to achieve. He was not interested in crossing the Atlantic Ocean ever again. By that time, his health was also suffering.

Six months after his birthday trip to see Strehler's *Threepenny* in Milan, and one year into the six-year run that made the tale of Macheath known all over America, Brecht's perennially weak heart failed, and he died on August 14, 1956. He was fifty-eight years old and in

the process of directing a production of *Galileo*. Engel, the director with whom Brecht had begun his career, faithfully took the helm.[65] According to his daughter, Barbara, his final words were, "Leave me in peace!"[66] He was buried in the Dorotheenstadt cemetery, where Hegel and other prominent people are also buried, next door to his apartment in East Berlin. At his request, no ceremony and no speeches took place during his burial.

Brecht's last will and testament was as complicated as his relationships with women had been throughout his life. He left Käthe Reichel, his ex-lover, a house in the country; another ex-lover, Isot Kilian, received the royalties from Brecht songs she performed; and in the hopes that Berlau would return to her native country, he left her money to buy a house in Denmark. He left nearly everything else to Weigel, including the rights to all his other works, the leadership of the theater, their main country house, and their residence in Berlin. Weigel was also named as the executor. Hauptmann was, finally, incensed, since the royalties she was to receive from the international productions of *Threepenny* were not properly articulated in the will. Hauptmann fought with Weigel, but had no confidence she could win against one of the most famous families in the country. She appealed to Peter Suhrkamp, for whom she was editing the collected works of Brecht, and he intervened on Hauptmann's behalf. Weigel respected Hauptmann and knew her value to her husband's legacy, and she ultimately relented.[67]

Weigel worked hard to protect Brecht's legacy, which was of a piece with her own prominent career as a stage actress and the leader of the Berliner Ensemble. Her trajectory from almost total obscurity in exile to her celebrated status in Germany had been accomplished with astonishing speed. She had become the face of the most revered poet and playwright in all of Europe, and she was going to keep it that way.

Like Weigel in Europe, Lenya began a new life on the American stage in her mid-fifties. Her career, also like Weigel's, continued to soar long after her husband's death. During and after playing Jenny in the long run in New York, Lenya went on to perform as well as supervise Weill's music on the stage and for recordings. She was especially thrilled to witness the spectacular reception for the 1955 recording of "Mack the Knife" made by Louis Armstrong, but her efforts perpetu-

ated Weill's fame beyond America. Because her many recordings of Weill's music were made in Germany, for the prominent Philips label in Hamburg, she also brought the composer back to life in the country that had forgotten about him and many of his compositions. In the space of five years, from 1955 to 1960, Lenya recorded *The Yes-Sayer, Berlin Theater Songs of Kurt Weill, The Seven Deadly Sins, Rise and Fall of the City of Mahagonny, Happy End,* and, of course, *The Threepenny Opera.* She gleefully taught the Germans how to spell Weill's name again, and this was a source of great irritation to Weigel.

It was the combined ascendance of both Weill and Lenya that provoked Weigel in particular. When Weigel realized that Lenya's long-dormant career was taking off, even outside of America, her competitive nature went into high gear. It must have reminded her of that time in 1928 when Lenya skyrocketed to fame as Jenny, while Weigel, sick with appendicitis, was forced to relinquish her part in the hugely successful *Threepenny.* History seemed to be repeating itself, and the battle between the two women, often referred to as the "war of the widows," was as personal as it was professional.[68] The two competed as actresses and as wives, and although the legal mess left behind offered a lot of room for financial disputes, money was nowhere near as important as the struggle for power.

When Lenya received rave reviews in a New York City Ballet production of *The Seven Deadly Sins,* she was soon invited to present it in Germany. Weigel complained that Brecht had never wanted the ballet to be performed again, but as with so many other issues, the widows had to define the terms that had never been contractually settled in the past. Although Weigel managed to stop a 1957 production in Hamburg, Lenya succeeded in playing Anna I in the German premiere of the ballet at the State Theater in Frankfurt in 1960. This time, Weigel not only found it impossible to stop the show, she also failed in her subsequent efforts to insist on using the politically suggestive title under which Brecht had later published the piece in German: *The Seven Deadly Sins of the Bourgeoisie.* The "bourgeoisie" addition was never used in English, and never in any German-language production with which Lenya was involved.

Whatever conflicts had taken place between Brecht and Weill were certainly inherited by their ferociously loyal widows. And as both

Lenya and Weigel achieved fame and financial security, they were able to fight longer and harder, with both lawyers and publishers, than either of their husbands had been able to do. Brecht and Weill had always put these two strong women in second place in their lives: For both men, their work came first. By fighting these professional battles, Lenya and Weigel were able to merge with their husband's top priority, and this also fueled their ardor.

Many arguments were caused by the fact that when Brecht transferred the *Threepenny* rights from Felix Bloch Erben to Suhrkamp, the new agent failed to sign a separate contract with Weill. This had been part of what upset the composer toward the end of his life. Since Brecht was the only one who had signed, this gave him, and later Weigel and her heirs, the impression they could license the work without the permission of Weill's estate. Lenya and Weigel, and quite often Stefan, who was still living in America, fought over this situation again and again. This particular contractual struggle over *Threepenny* continued until long after both widows had died and was only resolved in the 1990s.[69] But the antagonism seeped into every joint work, and there are conflicts that persist to this day. As so often happens when a family controls an artist's estate, the personal tensions are passed on from generation to generation.

No single work was in as much demand and therefore caused as many disputes as *Threepenny*. It is continually performed to the present day and in a seemingly infinite variety of interpretations. In 1976, Richard Foreman staged a new translation at Joseph Papp's New York Shakespeare Festival, starring Raul Julia as Macheath. It received mixed reviews but enjoyed a long and successful run. Yet another translation by Michael Feingold in 1989 was produced on Broadway and starred Sting as Macheath, but this far more expensive production was a huge flop. There were many performances and recordings, and several new translations, over the following decades, and 2006 brought another English version to New York. This one was by Wallace Shawn and starred Alan Cumming as Macheath. And finally, in 2008, Robert Wilson went back to the original German and designed a stunning production using a cast of German actors, most of them veterans of the Berliner Ensemble. He was supremely faithful to the original 1928 text and music, and his visual genius added a contrasting and illumi-

nating element, one that captures the spirit of Brecht and Weill's and, just as important, Neher's, original intentions. The eternal popularity of *Threepenny* isn't limited to an American or German audience. It has been translated into at least twenty languages and performed all over the world.[70]

Lenya's professional renaissance brought her the role of Frau Schneider in Harold Prince's *Cabaret,* as well as a career in film: She was in *The Roman Spring of Mrs. Stone, From Russia with Love,* and *Semi-Tough.* Lenya even dared to invade Weigel's territory by doing *Mother Courage* in Europe and was made to suffer many not very favorable comparisons to Weigel's landmark role. The German critics sided with their legendary dramatist's widow.[71] Thus, the "war" between the women continued to thrive in Germany.

Weigel's personal devotion to Brecht's legacy was no less fierce than Lenya's to Weill's. She was the powerful and responsible leader of the increasingly famous Berliner Ensemble, as well as continuing to perform many of the greatest roles in Brecht's plays. And unlike Lenya, she never married again. If she had romantic liaisons, she kept them to herself.

Weigel's last role was in *The Mother* in a 1971 French production, which she performed even as she was dying of cancer. In the final embrace at the end of the play, she broke two ribs and kept on acting. She died, at the age of seventy-one, on May 6, 1971. She is buried next to Brecht, who had rightly understood that the small, sturdy woman he met in 1923 was the one who would last. His Hellitier was indeed a rare animal, strong and smart and, most important, she was the only woman who truly understood the maddening genius with whom she had chosen to share her life.

Lenya's American career had been a direct result of a devotion to her husband's music, but she understood that taking possession of his legacy had been made possible by his death. That lent a bitter-sweet sense of triumph to her life as the widow Weill, and the pain of those years are in part reflected by the men with whom she chose to spend her life after he was gone. Although Lenya's kind husband, George Davis, had been a great source of comfort to her—as well as an adamant promoter of her talents and Weill's legacy—he was nevertheless a troubled and often reckless man. His pursuit of adventurous

homosexual liaisons often got him into trouble that made Lenya's life difficult. Davis died in 1957—like Weill, of a heart attack. He was fifty-one years old. Lenya was once again shocked and grieved. Five years later, she married a painter named Russell Detwiler. He turned out to be a volatile drunk and her life with him was extremely difficult. When she toured in *Mother Courage,* she had to send him back to the United States because he made it impossible for her to work. He died in 1969 from a fall caused by an alcoholic seizure. Despite her depression after this event, she married one more time, impulsively and in secret, but she and her husband, the documentary filmmaker Richard Siemanowski, never lived together and she ended up divorcing him for abandonment.[72] Lenya was diagnosed with ovarian cancer in 1977 and died in 1981 at the age of eighty-three. She is buried next to Weill, the only man who truly understood her, the man whom it had been impossible to replace. The most consistent part of her life as a widow was his music—in singing his songs, she brought him back to life for herself and for the world.

Brecht and Weill had both formed lifelong relationships with the women they met in their early twenties. The composer was stable enough to be Lenya's anchor, brilliant enough to earn her respect, and confident enough to tolerate her affairs. Lenya's life after Weill gives some hint of what her life might have been without him. From the beginning, Weigel had demonstrated in no uncertain terms her ability to put up with everything being with Brecht entailed. As a woman, she wanted an unconventional and independent life, and she wanted to be at the forefront of theater and politics. She certainly achieved her goals.

But what about Elisabeth Hauptmann? She never found a partner who would be devoted to her alone, and although Brecht was the most important man in her life, she surely wasn't the most important woman in his. Was she satisfied just by remaining important to his work until the end? Did her frustration about her own writing overwhelm that achievement?

As always with Hauptmann, there are several correct answers to any single question about her character. She was a hardworking and disciplined dramaturg and translator, and the author of her own fiction; a frustrated woman who mourned her inability to stand up for

herself; and a depressed woman who even after following Brecht to East Germany was kept in the background of the Berliner Ensemble until she threatened to leave. Only then did she, the first person in Brecht's early collective, achieve formal membership. There is, finally, the Hauptmann who may or may not have twice attempted suicide, but who certainly seemed eager to give the impression that she did.

And yet. She had many close friends and the Berliner Ensemble members admired and adored her. She came to life in the collective, personally and professionally, and in this sense, she achieved her goal of leading a modern, artistic life. She was not a very happy woman, but she was perhaps as happy as she could have been.

Hauptmann died two years after Weigel, in 1973, at the age of seventy-six. She is buried in the same cemetery as Brecht and Weigel. Her plot, however, is in a row among many others, including Berlau, who lived on in very poor health until 1974. Both women are buried on the other side of the Dorotheenstadt cemetery, as far from the shared grave of the married couple as possible. All three women are connected by their devotion to Brecht and his work.

Brecht and Weill, whose graves have an ocean between them, also remained connected because of the work they did together. The eternal success of *The Threepenny Opera* forged their permanent bond, one that haunted their final days and outlived them both. Only death could unify them. The public legacy has kept them together in a way that they couldn't manage in life. *Threepenny* is the most frequently performed work that Weill or Brecht, together or separately, ever created. It is perennially in the top five most performed plays in Germany.[73] The popularity of *Threepenny* has made their names live on together, not only for the musical play itself but also as the two artists who redefined and influenced the future course of musical theater all over the world.

Their partnership reflected the very best of the explosive creativity that flourished in the Weimar Republic during that brief sliver of freedom between the reign of kings and the terror of a dictator. From the singspiel to a songspiel, from heroes to antiheroes, from atonal to melodic, from Mozart to fox-trot and back again. Ultimately Weill's utopian ideas about the power of cultural freedom and Brecht's idealistic hopes for what a Marxist theater could achieve were equally unable

to rescue Germany from the impending darkness. Their attempts were as unrealistic as they were noble and heroic. And as they had tossed aside the noble hero of expressionist drama, so the National Socialists would, and with a good deal more violence, discard the ideals of both Brecht and Weill. The rise of the Third Reich demanded the people's unthinking and uncritical obedience, and Brecht and Weill's thinking audience was dangerous for them. Hitler knew he must force the curtain to come crashing down on the profoundly provocative artists of that remarkable epoch. He had to end the revolution that Brecht and Weill defined and defended for as long as they could.

Brecht and Weill were cut from the same cloth of historical and geographical circumstances—shaped by the fabulous and monstrous events that changed the entire world. Their auspicious encounter ignited a conversation about art, and politics, and society, one that would never stop. Neither ever found a better partner, and neither of them, despite their hugely fertile artistic lives, created a work that occupies as important a place in the cultural pantheon as *The Threepenny Opera*.

Long after they ceased working together, the unavoidable and bittersweet dialogue between them remained in their heads. Each was a silent partner for the other, but even then, their voices must have been metaphorically raised. They answered each other, and answered for each other, knowing that if they were actually in the same room again, they would soon be immersed in an insoluble argument. But they also knew that regardless of how well they worked with others, regardless of how monumental their separate accomplishments might be, it would never be more original or inspiring than that afternoon at Schlichter's, or the two weeks on the beach in France, or those chaotic, impassioned, unruly rehearsals at the Schiffbauerdamm. The shark bit both of them, with his teeth, dear, and Brecht and Weill, and audiences all over the world, were changed forever.

Acknowledgments

I had the privilege of writing this book with the guidance of the brilliant editor Gerald Howard, whose rare combination of exactitude and encouragement had me running to my desk every day for the last three years. Gerry's passion for the time in which Brecht and Weill lived—a time, as he put it, "when art and artists seek to both reflect and literally change the world"—always pushed me to do justice to the astonishing creativity of the artists in the Weimar Republic. His exuberance is electrifying and infuses every page of this book.

My heartfelt thanks to my energetic and intelligent agent, Sydelle Kramer, who has been with this project from conception to completion, and who offered unflagging support every step of the way.

I wrote this book because I believed that a close examination of Bertolt Brecht and Kurt Weill's partnership would reveal not only a fascinating story of artistic collaboration and creative genius but also the ways in which their relationship illuminated the social, political, and cultural era of the Weimar Republic. In order to portray this belief convincingly, I conducted research in a variety of disciplines—theater, music, cultural history, and political theory to name a few—and without the generosity of the many experts who helped me to understand the dazzling and complex artistic revolution of Germany between the two world wars, this book would have been impossible to write.

The Kurt Weill Foundation for Music sets the gold standard for what such institutions should be, and I thank Dave Stein, the intelligent, painstakingly thorough, and eternally helpful head archivist; Elmar Juchem, the associate director for research, has my thanks for

his insightful comments and guidance. And, of course, I am indebted to the foundation's inspired president, Dr. Kim H. Kowalke, whose genius and generosity were essential to the writing of this book; indeed, a glance at the bibliography will confirm Dr. Kowalke's scholarly achievements in the literature, and I am also grateful for our many thoughtful conversations.

Across the ocean, the Bertolt Brecht Archiv in Berlin, Germany, also proved an invaluable resource. My thanks go to Iliane Thiemann for her thoughtful replies to my many queries, to Dorothee Friederike Aders for her daily help at the archive, and to Anett Schubotz for her guidance in choosing the photographs for the book. Dr. Erdmut Wisizla, the director of the archive, not only runs an impeccable institution but also provided valuable sources of insight and information through his books and through our conversations and correspondence. I am grateful for his expertise.

For additional expertise, it is with great pleasure that I thank the following scholars and artists: the charming Jürgen Schebera, one of Weill's principal biographers; the elegant Werner Hecht, Brecht's most important German biographer and Helene Weigel's *Mitarbeiter* at the Berliner Ensemble for twelve years; Hermann Beil, the dramaturg for the Berliner Ensemble; Tony Kushner, whose insights about Brecht were illuminating; the talented and erudite composer John Musto and gifted soprano Amy Burton, for their patient explanations of musical language and history, and their ability, as consummate performers, to offer me a greater understanding of life on the stage and in the wings; William Bolcolm, one of our greatest living composers, for elucidating Weill's early experiments with the "jazz idiom"; Brian Kulick, the director of the Classic Stage Company and a Brecht enthusiast and expert; Vera Tenschert, the longtime photographer at the Berliner Ensemble, for her perceptions about both Brecht and Weigel, whom she knew personally; Elke Pfeil, the director of the Brecht-Weigel Memorial; Sabine Wolf, the director of the literature archive at the German Akademie der Künste; Steven Blier, the director of the New York Festival of Song and an expert on Weill's music; Sanda Weigel, for her insights about her aunt Helene Weigel, as well as for sharing her knowledge about the theater and music of Brecht and Weill; Klaus Pohl, for his expert knowledge about Brecht's life and theater; Jerome

Kohn, for pointing out Hannah Arendt's valuable perspective on *The Threepenny Opera;* Volker Schlöndorff, for his enthusiastic support; Barbara Sukowa, who graciously shared her profound understanding of theater and music; Margarethe von Trotta, whose vast knowledge of German history, culture, theater, and music was a constant source of information and inspiration—as well as the constant stream of articles she mailed me from all over the world and the experts she helped me to meet.

Brecht and Weill devoted themselves to the goal of entertaining and educating simultaneously, and I was determined that my portrait of them would accomplish the same daunting task. Without the advice from the experts listed above, I could not have done justice to the genius of the people I was trying to portray, but it was equally essential to present this complex world in a way that was accessible to readers who were encountering these two artists for the first time. I am fortunate to have colleagues who not only are gifted critical readers but also were kind enough to give my manuscript their valuable time and attention. My first thanks go to one of the best writers I know, Gina Barreca, for her penetrating commentary, her precision, and her passion; to Louise Crawford, for holding me to her own very high poetic standards; to Anja Marquardt and Carina Riethmüller, for their assistance with the research and translation; to Jeremy Medina, Gerald Howard's energetic and thoughtful assistant; to Bette Alexander, for her meticulous attention to every detail; to my husband, Florian Ballhaus, for helping me to better understand the German theater and culture; to my daughters, Rebecca and Louisa Ballhaus, for making sure I was meeting the unstinting demands of the bright young audience I hope to interest in the work of Brecht and Weill.

Beyond their intellectual support, I want to thank my family for cheering me on with so much good humor, amazing patience, and love. They permitted me to have a room of my own, where I could close the door, but even more important, they were full of support and understanding, and often an excellent meal, when I finally emerged. As both Brecht and Weill have so vividly proven, a happy domestic life is not always the province of writers and artists, and I am grateful for my good fortune.

Notes

All translations of letters or text from German-language sources are the author's unless otherwise noted.

ARCHIVES CITED

BBA: Bertolt Brecht Archiv, Akademie der Künste, Pariser Platz 4, 10117 Berlin, Germany.
EEA: Erich Engel Archiv, Akademie der Künste, Pariser Platz 4, 10117 Berlin, Germany.
EHA: Elisabeth Hauptmann Archiv, Akademie der Künste, Pariser Platz 4, 10117 Berlin, Germany.
HWA: Helene Weigel Archiv, Akademie der Künste, Pariser Platz 4, 10117 Berlin, Germany.
WLRC: Weill-Lenya Research Center, Kurt Weill Foundation for Music, 7 East Twentieth Street, New York, NY 10003.

CHAPTER 1 THE FIRST ENCOUNTER

1. Weill to his sister Ruth, spring of 1920, Series 45, WLRC. Also quoted in Kurt Weill and Lotte Lenya, *Speak Low (When You Speak Love): The Letters of Kurt Weill and Lotte Lenya,* edited and translated by Lys Symonette and Kim H. Kowalke (Berkeley and Los Angeles: University of California Press, 1996), 31–32, where it says "murmuring" instead of "roaring."

2. Weill to his brother Hans, June 27, 1919, quoted in Weill and Lenya, *Speak Low,* 30.

3. Ibid., Weill to Lenya, March 24, 1927, 51–52.

4. Ernst Toller, another expressionist playwright, also lived in the pension from time to time. He was famous not only for his plays (*Hoppla, We're Alive!* was performed in 1927) but also for his six-day term as the president of the short-lived Bavarian Soviet Republic that emerged from the rubble of World War I.

5. Weill and Lenya, *Speak Low,* footnote to letter 17, 51.

6. Universal Edition to Weill, January 29, 1927, Series 41, WLRC.

7. Weill to his family, November 1925, letter 183, in Kurt Weill, *Briefe an die Familie (1914–1950),* edited by Lys Symonette and Elmar Juchem with Jürgen Schebera (Stuttgart-Weimar: J. B. Metzler Verlag. 2000), 306–7.

8. Weill had also written two works—a short opera and a cantata—based on the poetry of Ivan Goll, a French-German surrealist poet.

9. *Mann ist Mann* was Brecht's fourth original play and had its Berlin premiere on the radio. Translations of this play vary from *Man Is Man* to *Man Equals Man* and *A Man's a Man* (which I use throughout).

10. Eric D. Weitz, *Weimar Germany: Promise and Tragedy* (Princeton, NJ: Princeton University Press, 2007), 8–9.

11. "Die Programme der Sender," *Der Deutsche Rundfunk* 5, no. 11 (March 13, 1927): 732; and Series 31, box 6, folder 11, a, WLRC.

12. Herbert Jhering quoted in Kim H. Kowalke, "Brecht and Music: Theory and Practice," in *The Cambridge Companion to Brecht,* edited by Peter Thomson and Glendyr Sacks (Cambridge: Cambridge University Press, 1994), 219–20.

13. "Die Programme der Sender," and Series 31, box 6, folder 11a, WLRC.

14. Jhering quoted in Ronald Hayman, *Brecht: A Biography* (New York: Oxford University Press, 1983), 91.

15. Bertolt Brecht, *Diaries 1920–1922,* edited by Herta Ramthun and translated by John Willett (New York: St. Martin's Press, 1979), 120. See also entry of February 26, 1920, on page 62: "And I can't get married. I must have elbowroom, be able to spit as I want, to sleep alone, be unscrupulous."

16. Martin Esslin, *Brecht: A Choice of Evils* (London: Methuen London Ltd, 1984), 50.

17. Quoted in his boyhood friend's memoir; see Hanns Otto Münsterer, "Recollections of Brecht in 1919 in Augsburg," in Hubert Witt, ed., *Brecht: As They Knew Him* (New York: International Publishers, 1974), 23. Christian Friedrich Hebbel was a prominent and admired nineteenth-century German poet and playwright who became famous for his tragedy *Judith* in 1841. He also wrote *Maria Magdalena* (1844) and won the Schiller prize for *Die Nibelungen* in 1862. Brecht was very critical of Hebbel and described *Judith* as "one of the weakest and most stupid plays in our classical German repertoire." Brecht is quoted in Stephen Parker, *Bertolt Brecht: A Literary Life* (London: Bloomsbury Methuen Drama, 2014), 159.

18. Bertolt Brecht, "Of Poor B.B.," in *Poems 1913–1956,* edited by John Willett and Ralph Manheim (New York: Routledge Theater Arts Books, 1979), 107.

19. Ibid. The first stanza of "Of Poor B.B." reads as follows: "I, Bertolt Brecht came out of the black forests. / My mother moved me into the cities as I lay / Inside her body. And the coldness of the forests / Will be inside me till my dying day."

20. Ibid., September 16, 1921, 107n15.

21. This quote is from Carl Zuckmayer, a playwright from Austria who worked with Brecht at Max Reinhardt's theater in the early twenties, where both men were dramaturges. This description is quoted in Ronald Hayman, *Brecht: A Biography* (New York: Oxford University Press, 1983), 85–86.

22. Heinrich Strobel writing about Weill for *Melos* in October 1927; quoted in Jürgen Schebera, *Kurt Weill: An Illustrated Life,* translated by Caroline Murphy (New Haven, CT: Yale University Press, 1995), 66.

23. David Drew, *Kurt Weill: A Handbook* (Berkeley and Los Angeles: University of California Press, 1987), 18.

24. Bertolt Brecht, *Brecht on Theater,* edited and translated by John Willett (New York: Hill and Wang, 1964), 5–7. The quote is from "Mehr guten Sport," written for the newspaper *Berliner Börsen-Courier,* February 6, 1926. The use of the word "stadiums" is my own translation. The actual German word is *Zementtöpfe,* which literally

means "cement pots" or "pans." Willett translated this simply as "pan" but Brecht is clearly making up a humorous name for sporting stadiums with their concrete floors.

25. Kim H. Kowalke, "Accounting for Success: Misunderstanding *Die Dreigroschenoper*," *The Opera Quarterly* 6, no. 3 (Spring 1989): 35. Kowalke is quoting Weill from "Verschiebungen in der musikalischen Produktion," written for the newspaper *Berliner Tageblatt*, October 1, 1927.

26. Peter Gay describes this split very eloquently: "Weimar also came to symbolize a prediction, or at least a hope, for a new start: it was a tacit acknowledgment of the charge . . . that there were really two Germanys: the Germany of military swagger, abject submission to authority, aggressive foreign adventure, and obsessive preoccupation with form, and the Germany of lyrical poetry, Humanist philosophy, and pacific cosmopolitanism." See Gay's *Weimar Culture: The Outsider as Insider* (London: Penguin Books, 1969), 1.

27. Elisabeth Hauptmann, "Notes on Brecht's Work," in Witt, *Brecht: As They Knew Him,* 52–53.

28. Weill to Hans Heinsheimer, in Universal Edition's journal, *Anbruch,* in 1928, reprinted in Stephen Hinton, ed., *Kurt Weill: The Threepenny Opera* (Cambridge: Cambridge University Press, 1990), 124.

29. Jürgen Schebera and Bärbel Schrader, eds., *The Golden Twenties,* translated by Katherin Vanovitch (New Haven, CT: Yale University Press, 1990), 120.

30. Weill writing in the German radio publication in 1925 and quoted in Ronald Sanders, *The Days Grow Short: The Life and Music of Kurt Weill* (Los Angeles: Silman-James Press, 1980), 66–67.

31. *Große Berliner Frankfurter Ausgabe* 21 (January 2, 1927), cited in Bertolt Brecht, *Brecht on Film and Radio,* edited and translated by Marc Silberman (London: A & C Black, 2001), 189–90.

32. Lion Feuchtwanger, "Bertolt Brecht Presented to the British," in Witt, *Brecht: As they Knew Him,* 18.

33. Hans W. Heinsheimer, *Best Regards to Aida* (New York: Alfred A. Knopf, 1968), 17.

34. Stephen Hinton, in his book *Weill's Musical Theater: Stages of Reform* (Berkeley and Los Angeles: University of California Press, 2012), quotes an article on page 98, clearly indicating that Weill was aware of Brecht's work as early as 1925. Weill wrote for the radio journal and reviewed an evening hosted by the November Group, and in that context, Weill mentions Brecht's name. But only with regard to his work, and with no further indication that they had already met. This was published in *Der Deutsche Rundfunk* 3, no 21 (May 24, 1925). Given the electric nature of Weill and Brecht's instant partnership after the composer heard *A Man's a Man* on the radio, as well as his letter to Lenya where "B" was very likely Brecht, I believe that the first encounter was in March 1927.

35. Heinsheimer, *Best Regards to Aida,* 18.

36. For information regarding Weill's German accent, I am indebted to Jürgen Schebera, who described the only document of Weill speaking in German: a one-minute, forty-second newsreel for WDR (Germany's main public television station) from 1948.

37. Abravanel, an early composition student of Weill's, became a well-known conductor in Germany and, after 1936, in America. This quote is from Alan Rich, Kim Kowalke, and Lys Symonette's interview with Abvranel, Series 60, WLRC.

38. Walter Israel, on Rundfunk-Rundschau, *The Golden Twenties,* March 27, 1927, Vorl 5528, Theaterdoku, BBA.

CHAPTER 2 **COMING OF AGE**

1. Werner Hecht, *Brecht Chronik* (Frankfurt am Main: Suhrkamp Verlag, 1997), 15.

2. Recently, Brecht's medical records have been reexamined and it's now believed that he suffered from rheumatic fever as a boy. BBC News, Entertainment and Arts, November 11, 2010.

3. Brecht, "Driven Out with Good Reason" (1936–38), in Frederic Ewen, *Bertolt Brecht: His Life, His Art, and His Times* (New York: Carol Publishing Group, 1992), 55; also in Bertolt Brecht, *Poems 1913–1956,* edited by John Willett and Ralph Manheim (New York: Routledge Theater Arts Books, 1979), 316.

4. Hecht, *Brecht Chronik,* 11–12.

5. Entry of February 18–19, 1921, in Bertolt Brecht, *Diaries 1920–1922,* edited by Herta Ramthun and translated by John Willett (New York: St. Martin's Press, 1979), 61n5.

6. Brecht to Neher, letter 5, November 10, 1914, in Bertolt Brecht, *Briefe 1: Große kommentierte Berliner und Frankfurter Ausgabe,* Band 28 (Berlin: Aufbau-Verlag, 1998), 17.

7. Kurt Weill and Lotte Lenya, *Speak Low (When You Speak Love): The Letters of Kurt Weill and Lotte Lenya,* edited and translated by Lys Symonette and Kim H. Kowalke (Berkeley and Los Angeles: University of California Press, 1996), 24.

8. Ibid.; according to the brief biography given here, Emma's "father descended . . . from a distinguished line of rabbis. Emma's brother Aaron [who became a rabbi in Brandenburg in 1908] was also widely recognized as the leading authority on Jewish liturgical music."

9. A German high school, traditionally ending after the thirteenth year, is called a *Gymnasium.* This is the highest level of pre-college education available and the only one that prepares students for university entrance.

10. Lenya learned these details from Weill's family. Weill and Lenya, *Speak Low,* 25.

11. Jürgen Schebera, *Kurt Weill: An Illustrated Life,* translated by Caroline Murphy (New Haven, CT: Yale University Press, 1995), 7.

12. David Farneth with Elmar Juchem and Dave Stein, eds., *Kurt Weill: A Life in Pictures and Documents* (Woodstock, NY: The Overlook Press, 2000), 8.

13. Weill joined a national organization called the Dessauer Feldkorps (Dessau Military Corps); Schebera, *Kurt Weill: An Illustrated Life,* 10.

14. Letter 32, April 20, 1918, in Brecht, *Briefe 1,* 47. "My brother has been promoted to the infantry. That raises him above me. He's swimming in bliss."

15. For an excellent summary of the events of 1871 in Germany, see Alexandra Richie, *Faust's Metropolis: A History of Berlin* (New York: Carroll & Graf Publishers, Inc., 1998), chapter 6. Richie also elucidates the buildup to World War I in chapter 7.

16. Ewen, *Bertolt Brecht: His Life, His Art, and His Times,* 60.

17. Letter 21, March 1918, in Bertolt Brecht, *Letters 1913–1956,* edited by John Willett and translated by Ralph Manheim (New York: Routledge, 1990), 38.

18. Ibid., letter 28, May 11, 1918, 43.

19. Letter 35, April 20, 1918, in Brecht, *Briefe 1,* 49.

20. Letter 13, November 11, 1917, in Brecht, *Letters 1913–1956,* 31.

21. This famous poem is often quoted. I first encountered an excerpt in Ewen, *Bertolt Brecht: His Life, His Art, and His Times,* 62.

22. *Brecht-Lexikon,* edited by Ana Kugli and Michael Opitz (Stuttgart: J. B. Metzler Verlag, 2006), 173. I am indebted to Iliane Thiemann of the BBA for bringing this information about the relationship between "The Legend of the Dead Soldier" and Neher to my attention.

23. Andreas Skrziepiet, "Medical Student Bertolt Brecht (1898–1956)," *Journal of Medical Biography* 17 (August 2009): 179.

24. Bertolt Brecht, *Baal, A Man's a Man, and The Elephant Calf,* edited by Eric Bentley (New York: Grove Press, 1964), 12.

25. This analysis of *Baal* is inspired by Peter Thomson, "Brecht's Lives," in Peter Thomson and Glendyr Sacks, eds., *The Cambridge Companion to Brecht* (Cambridge: Cambridge University Press, 1994), 25.

26. Brecht, *Baal, A Man's a Man, and The Elephant Calf,* 53, 78, and 71.

27. Letter 58, February 13, 1919, in Brecht, *Briefe 1,* 73.

28. Weill and Lenya, *Speak Low,* 26.

29. Weill to Hans, June 11, 1917, Series 45, WLRC.

30. Weill and Lenya, *Speak Low,* 26.

31. Ibid., 26.

32. Weill to his family, September 6, 1917, Series 45, WLRC.

33. Ibid., letter from mid-July 1917.

34. Weill and Lenya, *Speak Low,* 26. For a complete account, see George Davis Papers, Notes and Transcriptions, Series 37, Box 1, WLRC.

35. Weill to Hans, November 12, 1918, Series 45, WLRC. This letter is also mostly quoted in Weill and Lenya, *Speak Low,* 27, and I deferred to this translation until the two final sentences—"I could fill volumes. But I'm too tired!"—which were not included in the excerpt but were in the original.

36. The Freikorps (Volunteer Corps) wrought a powerful influence on post–World War I politics in Germany. This right-wing paramilitary group had a membership of more than four thousand men and helped the Social Democrats to power. They also crushed Communists and far-left Socialists (such as the Spartacists) who attempted to seize power in Berlin and Munich.

37. Weill to Hans, August 20, 1917, Series 45, WLRC.

38. The end of the war was apparent long before Kaiser Wilhelm II or the German military generals were willing to admit defeat. The "cataclysmic ending" to which I refer began with the famous uprising of the sailors in Kiel. They refused to go to their unnecessary and inevitable deaths merely for the lost cause of saving the "honor" of the German army. The sailors' rebellion forced their superiors to negotiate a surrender.

39. Hanns Otto Münsterer, "Recollections of Brecht in 1919 in Augsburg," in Hubert Witt, ed., *Brecht: As They Knew Him* (New York: International Publishers, 1974), 24–25. The Socialist organization led by Luxemburg and Liebknecht was known as the Spartacist League in honor of Spartacus, the man who led a revolt of the slaves against the Romans in 73 B.C.

40. "Every man for himself" from *Drums in the Night,* which was the ultimate title of *Spartacus,* in Bertolt Brecht, *Jungle of Cities: And Other Plays,* edited by Eric Bentley and translated by Anslem Hollo, Frank Jones, and N. Goold-Verschoyle (New York: Grove Press, 1966), 157. "I am a swine" is from Martin Esslin, *Brecht: A Choice of Evils* (London: Methuen London Ltd, 1984), 139.

41. Feuchtwanger was the author of *Jud Süß,* among many other novels and plays.

42. Lion Feuchtwanger, "Bertolt Brecht Presented to the British," in Witt, *Brecht: As They Knew Him,* 17.

43. Stephen Parker, Bertolt Brecht: A Literary Life (London: Bloomsbury Methuen Drama, 2014), 124.

44. Letter 62, April 4, 1919, in Brecht, *Briefe 1,* 77.

45. Feuchtwanger, "Bertolt Brecht Presented to the British," 18.

46. John Willett, introduction for Brecht, *Diaries 1920–1922,* ix.

47. Weill to Hans, November 15, 1918, Series 45, WLRC.

48. *Risches* is a Yiddish word for anti-Semitism. It comes from the Hebrew word *rish'ut,* meaning wickedness or malice; letter to the editor, *Association of Jewish Refugees Journal* (November 2010).

49. Weill and Lenya, *Speak Low,* 31.

50. Quoted in the introduction to Brecht, *Diaries 1920–1922,* xiii.

51. Letter 107, May 1921, Brecht, *Briefe 1,* 114.

52. Ibid., letter 108, May 1921, 116.

53. Entry of September 15, 1920, in Brecht, *Diaries 1920–1922,* 49.

54. Letter 16, December 29, 1917, in Brecht, *Letters 1913–1956,* 33.

55. Valentin was a legendary minstrel, clown, and cabaret performer in Munich, who's credited with inventing the "unheroic hero" on the cabaret stage. His style exerted an enormous influence on the kind of humor Brecht displayed in future plays, especially *A Man's a Man.*

56. Entry of September 4, 1921, in Brecht, *Diaries 1920–1922,* 119.

57. There is an often-quoted anecdote about this particularly trying time in Brecht's young life. Sources include an interview with Hans Bunge—the dramaturg and director at the Berliner Ensemble and a noted Brecht scholar—which is quoted in Ronald Hayman, *Brecht: A Biography* (New York: Oxford University Press, 1983), as well as quotations in Paula Banholzer, *So viel wie eine Liebe* (Munich: Universitas, 1981), which is quoted in Sabine Kebir, *Ein akzeptabler Mann?* (Berlin: Aufbau Taschenbuch Verlag, 1998). The story told is that Zoff and Banholzer actually joined forces to confront Brecht. He said he wanted to be with both of them. He offered to marry Zoff in order to make their baby legitimate. Then he promised Banholzer that he would soon divorce Zoff and marry her in order to legitimize their son. In Banholzer's version, the story ends with her deciding she doesn't want to marry Brecht anymore. It is difficult to delineate between rumor and fact—although I have no substantiated reason to doubt either Bunge's or Banholzer's version.

58. Jhering quoted in Ewen, *Bertolt Brecht: His Life, His Art, and His Times,* 104 and 91.

59. Zoff quoted in Kebir, *Ein akzeptabler Mann?,* 193.

60. Weill wrote about his clothes to his father in December 1920; see Schebera, *Kurt Weill: An Illustrated Life,* 37.

61. Busoni was a brilliant pianist and composer of modern music. He wrote many operas, including *Turandot* and *Arlecchino,* as well as a version of *Doktor Faust* that was unfinished at the time of his death at the age of fifty-eight.

62. Weill to Busoni, January 20, 1921, Series 45, WLRC.

63. Weill and Lenya, *Speak Low,* 32.

64. As described in Kim H. Kowalke, *Kurt Weill in Europe* (Ann Arbor: University of Michigan Research Press, 1979), 25, Weill's orchestral piece had two titles: *Berliner Sinfonie* or *Sinfonie in einem Satz* (Symphony in one sentence). On the title page it had a motto from Johannes R. Becher's *Workers, Farmers, Soldiers: A Community's Awakening to God,* an expressionist play with a Socialist and pacifist worldview. Weill met Becher in 1920 and called him "a prodigious young talent . . . on the way to transforming the political ideals of a young generation into a new artistic form." Becher later became a Communist in East Germany. Becher and Brecht remained close friends until the end of Brecht's life.

65. Lenya quoted in Kim Kowalke, Joanna Lee, and Edward Harsh, eds. *Mahagonny: A Sourcebook* (New York: Kurt Weill Foundation for Music, 1995), 12.

66. Schebera, *Kurt Weill: An Illustrated Life,* 38.

67. Brecht's statement excerpted from "Mehr guten Sport," *Berliner Börsen-Courier,* February 6, 1926, quoted in Bertolt Brecht, *Brecht on Theatre: The Development of an Aesthetic,* edited and translated by John Willett (New York: Hill and Wang, 1964), 7.

68. Weill to Hans, June 27, 1919, in Weill and Lenya, *Speak Low*, 28.

69. Ibid., Weill to Ruth, June 1919, 29.

70. Brecht to Arnolt Bronnen, in Hayman, *Brecht: A Biography*, 93.

71. Engel was seven years older than Brecht and an important director in both Hamburg and Munich by the time they met. The film that Brecht wrote for Valentin, and which Engel directed, was *Mysteries of a Barbershop*.

72. Stephen Parker, *Bertolt Brecht: A Literary Life* (London: Bloomsbury Methuen Drama, 2014), 206.

CHAPTER 3 THE WOMEN

1. Kurt Weill and Lotte Lenya, *Speak Low (When You Speak Love): The Letters of Kurt Weill and Lotte Lenya*, edited and translated by Lys Symonette and Kim H. Kowalke (Berkeley and Los Angeles: University of California Press, 1996), 35.

2. Ibid., 12.

3. Ibid., 16.

4. Ibid., 19. This biographical section describes Revy's influence and Lenya's description of him as "pudgy" and "moonfaced." The original spelling of Lenya's name was Lenja, since in German the *j* is pronounced like an English *y*. She changed the spelling when she came to America.

5. Ibid., 23.

6. Alan Rich interview with Lenya, 1976, Series 60, WLRC.

7. Weill and Lenya, *Speak Low*, 13.

8. Jürgen Schebera, *Kurt Weill: An Illustrated Life*, translated by Caroline Murphy (New Haven, CT: Yale University Press, 1995), 60.

9. This period of Kaiser's life is told in great detail in Sabine Wolf, ed., *Kunst und Leben: Georg Kaiser (1878–1945)* (Berlin: Akademie der Künste, 2011), 55 65. Ironically, one of his most successful early plays was about the ruinous influence of money on a young bank clerk.

10. Felix Jackson, "Portrait of a Quiet Man: Kurt Weill, His Life and His Times," unpublished manuscript, WLRC, 30.

11. Weill to Lenya, letter 8, 1925, in Weill and Lenya, *Speak Low*, 43.

12. Ibid., Weill to Lenya, letter 10, April 1925, 44.

13. Ibid., 8.

14. Ibid., Weill to Lenya, letter 15, July 1926, 48.

15. Ibid., Weill to Lenya, letter 5, December 1924, 41.

16. Jürgen Schebera, "The Extraordinary Life of Lotte Lenya, Part I: Europe 1898–1935" in liner notes for *Hoppla! Die Weill-Lenya Biographie* (Hamburg: Bear Family Records, 2006), 20.

17. Gottfried Wagner interview with Lenya, May 28, 1978, Series 60, WLRC.

18. Weill to his parents, 1925, in Weill and Lenya, *Speak Low*, 2.

19. Bertolt Brecht, *Poems 1913–1956*, edited by John Willett and Ralph Manheim, translated by Michael Hamburger (New York: Routledge Theater Arts Books, 1979), 107.

20. Bertolt Brecht, *Baal, A Man's a Man, and The Elephant Calf*, edited by Eric Bentley (New York: Grove Press, 1964), 45.

21. This letter from Weigel to Brecht was unpublished and undated when I read it at the BBA, Laufnummer 3228, Vorl 41029, BBA4. Since that time it has been published in Stephen Parker's Bertolt Brecht: A Literary Life (2014) and in Erdmut Wizisla's *"Ich lerne: gläser + tassen spülen"—Bertolt Brecht/Helene Weigel: Briefe 1923–1956* (Berlin: Suhrkamp Verlag, 2012), 194. Wizisla has good reason to believe that this undated letter was written in 1944, when Weigel and Brecht had a marital crisis in

exile because of his involvement with Ruth Berlau. I include the letter here, early in Brecht's relationship with Weigel, because it so clearly reveals her initial, and lifelong, attitude toward Brecht.

22. Martin Esslin, *Brecht: A Choice of Evils* (London: Methuen London Ltd, 1984), 4.

23. Herbert Jhering, "Bert Brecht the Dramatist," in Hubert Witt, ed., *Brecht: As They Knew Him* (New York: International Publishers, 1974), 36–37.

24. Brecht's 1929 quote is on the back cover of Werner Hecht, *Helene Weigel* (Frankfurt am Main: Suhrkamp Verlag, 2000).

25. This review was published in the Frankfurt newspaper *Mittagsblatt*, March 8, 1920; quoted in Hiltrud Häntzschel, *Brechts Frauen* (Reinbek bei Hamburg: Rowohlt Verlag, 2002), 100.

26. Ibid., 106. Häntzschel quotes an unpublished portrait of Weigel, written by Marieluise Fleisser, that describes how Weigel found a new apartment.

Despite this atmosphere of free morality—where women had children out of wedlock, pursued independent professions, and many people enjoyed a variety of lovers—Berlin was still a city where residents were legally obliged to register their address with the police. This bureaucratic rule makes it possible to track the movements of even the private Brecht and Weigel. This dual sensibility of freedom and order defined the rebellious lives of so many young artists of the time. The legal document of Weigel's move to Babelsbergerstrasse can be found in Bestandsverzeichnis-Band 4, alte Archiv 20930, Laufnummer 0720/001-002, BBA.

27. When a child is born out of wedlock in Germany it is customary to give it the last name of the mother.

28. Werner Hecht, *Brecht Chronik* (Frankfurt am Main: Suhrkamp Verlag, 1997), 192. Hecht gives a thorough description of the positive reception that Weigel's performance received. Critics such as Walter Steinthal, Manfred Georg, and others gave her rave reviews.

29. Kerr's review is quoted in John Fuegi, *Bertolt Brecht: Chaos, According to Plan* (Cambridge: Cambridge University Press, 1987), 15.

30. Frederic Ewen, *Bertolt Brecht: His Life, His Art, and His Times* (New York: Carol Publishing Group, 1992), 121.

31. Elisabeth Hauptmann, *Lesebuch* (Cologne: Nyland-Stiftung, 2004), 18.

32. This information was confirmed on an application that Hauptmann filled out in 1953 to join German Writer's Union, 1318, EHA.

33. Sabine Kebir, "A Private Student's Portrayal of Elisabeth Hauptmann," in International Brecht Society, *The Brecht Yearbook: Mahagonny.com*, vol. 29, edited by Marc Silberman and Florian Vassen (Madison: University of Wisconsin Press, 2004), 6.

34. Hauptmann, *Lesebuch*, 29.

35. Quote is from the interview with Hautpmann in the film *Die Mitarbeiterin*, directed by Karlheinz Mund (DEFA-Studio für Kurzfilme, 1972). (Translation by Anja Marquardt and the author.)

36. Brecht was frequently accused of plagiarism—partly due to his penchant for writing in reaction to an existing work or works, partly because of his somewhat lax attitude toward intellectual property. But just as frequently, it was used as a way for unfavorable reviewers and writers to attack him. This has been the subject of many essays and requires at least one book to do it justice. In 1924, Brecht was accused of plagiarism for the first time with regard to his play *In the Jungle of Cities*. Apparently, a number of lines were taken from a German translation of Rimbaud's *Une saison en enfer*. Brecht answered this accusation by saying that these lines appeared in quotation marks in the text and were quite clearly being quoted by the character. See Esslin, *Brecht*, 24.

37. *Die Mitarbeiterin.*

38. Ibid. See also Hauptmann, *Lesebuch*, 129.

39. Sabine Kebir, *Ich fragte nicht nach meinem Anteil: Elisabeth Hauptmanns Arbeit mit Bertolt Brecht* (Berlin: Aufbau-Verlag, 1977), 51. Kebir was the first author to publish Hauptmann's diaries.

40. The publications were *Simplicissimus,* a German weekly satirical magazine, and *Das Leben*—both important journals of the time. The poem was "Night Thoughts" and describes, in an almost cheerful singsong voice, a woman desperate for money who becomes a prostitute.

41. Entry of March 24, 1926, in Kebir, *Ich fragte nicht nach meinem Anteil,* 46.

42. Ibid., entry of June 8, 1926, 52.

43. This was Lenya's famous term to describe Hauptmann. See George Davis Papers, Notes and Transcriptions, "Kurt Weill/Working Methods," Series 37, box 1, folder 24, 3, WLRC.

44. It was prophetic to talk about the "adaptability of man" in 1926. The Nazis were only beginning their slow ascent and not until about ten years later would the ability of Germans to "adapt" themselves to Nazi ideology begin to be so widespread. The "cooperation" phenomenon, known as *Gleichschaltung*—a term associated with the ugliest aspects of complicity with the Nazis—is a phenomenon still studied today.

45. Entry of September 15, 1920, in Bertolt Brecht, *Diaries 1920–1922,* edited by Herta Ramthun and translated by John Willett (New York: St. Martin's Press, 1979), 49.

46. Sternberg published an important book on imperialism in 1926. He and Brecht often discussed the relationship of art and politics, and Sternberg greatly influenced the playwright's thinking about Marxism. Brecht gave Sternberg the first copy of *A Man's a Man* when it was first published, with the handwritten note: "To my first teacher."

Korsch gave courses on Marxism at the Karl Marx Workers School in Berlin that Brecht attended. They often discussed art and politics during the 1920s and '30s, although Korsch was ultimately expelled from the German Communist Party (KPD) because he was believed to have written too critically about the Communist thinkers in his book *Marxism and Philosophy*. Korsch and Brecht remained in contact for the rest of their lives.

47. Hauptmann, *Lesebuch*, 32.

48. Brecht to Zoff, February 1925, letter 259, in Bertolt Brecht, *Briefe 1: Große kommentierte Berliner und Frankfurter Ausgabe,* Band 28 (Berlin: Aufbau-Verlag, 1998), 221.

49. Ibid., Brecht to Zoff, May 1925, letter 266, 226.

50. Ibid., Brecht to Zoff, October 1923, letter 230, 204.

51. Ibid., Brecht to Zoff, November 1923, letter 231, 204.

52. Ibid., Brecht to Zoff, February 26, 1926, letter 303, 249.

53. Ibid., Brecht to Zoff, March 1926, letter 309, 253.

54. Ibid., Brecht to Zoff, April 1926, letter 315, 255.

55. Brecht to Weigel, letter 99, June 1925, in Bertolt Brecht, *Letters 1913–1956,* edited by John Willett and translated by Ralph Manheim (New York: Routledge, 1990), 99.

56. James K. Lyon is quoting Weigel and Brecht's daughter, Barbara Brecht-Schall, who reports having heard her mother say this in International Brecht Society, *The Brecht Yearbook: Mahagonny.com,* 20.

57. George Davis Papers, Notes and Transcriptions, "Kurt Weill/Working Methods," Series 37, box 1, folder 24, 5, WLRC.

58. Weigel not only took care of Frank from time to time but also asked her sister in Vienna to look after him. At one point, Weigel's father was helping to support Frank. See Sabine Kebir, *Ein akzeptabler Mann?* (Berlin: Aufbau Taschenbuch Verlag, 1998), 56.

59. Women in Germany won the right to vote in 1919, shortly after the Weimar Republic was proclaimed.

60. The only common demographic that bound Lenya, Weigel, and Hauptmann was that they were part of a baby boom, and their liberated behavior became emblematic of the postwar era.

61. Schebera, *Kurt Weill: An Illustrated Life,* 79.

62. Ibid., 66.

63. Joachimson is quoted in Foster Hirsch, *Kurt Weill on Stage: From Berlin to Broadway* (New York: Limelight Editions, 2003), 22.

64. Bie is quoted in Stephen Hinton, *Weill's Musical Theater: Stages of Reform* (Berkeley and Los Angeles: University of California Press, 2012), 73.

65. Weill to Universal Edition, April 6, 1926, Series 41, WLRC.

66. Ibid., April 29, 1926.

67. Jackson, "Portrait of a Quiet Man," 196.

CHAPTER 4 MOON OF ALABAMA

1. In between *The Protagonist* and *The Czar Has His Picture Taken,* Weill had also worked with Ivan Goll, a bilingual (French-German) Alsatian surrealist poet and playwright to whom Kaiser had introduced him. With Goll, Weill composed the cantata *Der neue Orpheus* and the one-act opera *Royal Palace* that first introduced Weill's use of popular dance forms and jazz, and led directly to the idea of using a tango in *Czar.* Weill's work with Kaiser was more critically successful and satisfying, but it's important to note that Weill had written four short pieces in collaboration with two accomplished writers before beginning to work with Brecht.

2. Jürgen Schebera, *Kurt Weill: An Illustrated Life,* translated by Caroline Murphy (New Haven, CT: Yale University Press, 1995), 83–84.

3. Bertolt Brecht, *Manual of Piety (Die Hauspostille),* translated by Eric Bentley (New York: Grove Press, 1966), 9 and 11.

4. James K. Lyon and Hans-Peter Breuer, eds., *Brecht Unbound* (Newark: University of Delaware Press, 1995), 227–40. I am also indebted to the very helpful chapter by Reinhold Grimm titled "Luther's Bible in Brecht's Poetry."

5. Weill's distinctive way of touching his nose when he was pacing in an absorbed state was observed by Lenya; see George Davis Papers, Notes and Transcriptions, "Kurt Weill/Physical Characteristics," Series 37, box 1, folder 23, WLRC.

6. Brecht's musical notation published in the *Manual of Piety* was written with the help of the young Berlin cabaret composer Franz S. Bruinier. After meeting Weill, Brecht never worked with Bruinier again. Brunier died at the age of twenty-three in 1928.

7. Stephen Hinton, *Weill's Musical Theater: Stages of Reform* (Berkeley and Los Angeles: University of California Press, 2012), 105. Hinton writes: "The similarities with Weill's own setting, such as they are, are purely rhythmic, however. The melodies are quite different."

8. Kim H. Kowalke, "Singing Brecht vs. Brecht Singing: Performance in Theory and Practice," *Cambridge Opera Journal* 5, no. 1: 70. I am indebted to Kowalke for his discussion of Weill's attitude toward Brecht's musical efforts.

9. Weill is quoted in Felix Jackson, "Portrait of a Quiet Man: Kurt Weill, His Life and His Times," unpublished manuscript, WLRC, 84.

10. Letter 33, July 10–11, 1935, in Kurt Weill and Lotte Lenya, *Speak Low (When You Speak Love): The Letters of Kurt Weill and Lotte Lenya,* edited and translated by Lys Symonette and Kim H. Kowalke (Berkeley and Los Angeles: University of California Press, 1996), 180.

11. Ibid., letter 15, July 1926, 48.

12. Brecht, *Manual of Piety*, 199. The original poem was in English, a language that Lenya did not speak very well.

13. Bertolt Brecht, *Letters 1913–1956*, edited by John Willett and translated by Ralph Manheim (New York: Routledge, 1990), 90.

14. The new publisher was Ullstein, in a division called the Propylaen Verlag. Further details about this change of publisher and the two editions can be found in Ronald K. Shull, PhD dissertation, "Music and the Works of Bertolt Brecht: A Documentation" (New York: Weill-Lenya Research Center, 1976).

15. Kim H. Kowalke, *Kurt Weill in Europe* (Ann Arbor: University of Michigan Research Press, 1979), 57.

16. Hinton, *Weill's Musical Theater*, 184.

17. Martin Esslin, *Brecht: A Choice of Evils* (London: Methuen London Ltd, 1984), 103.

18. Brecht's article describing Baal's fictional biography was published in the German sports magazine *Die Szene* in 1926. Josef K. is also the name of the main character in Franz Kafka's *The Trial*, which had appeared the previous year. Therefore, Brecht's fictional biography had both proletarian and literary trappings.

19. Brecht, *Manual of Piety*, 199.

20. "Brecht and I: Lotte Lenya Talks to Irving Wardle," *The Observer*, September 9, 1962.

21. Foster Hirsch, *Kurt Weill on Stage: From Berlin to Broadway* (New York: Limelight Editions, 2003), 30.

22. Kim H. Kowalke, Joanna Lee, and Edward Harsh, eds., *Mahagonny: A Sourcebook* (New York: Kurt Weill Foundation for Music, 1995), 12.

23. In Lenya's foreword (originally published in *Theatre Arts* in May 1956 as "That Was a Time!") to Bertolt Brecht, *The Threepenny Opera*, translated by Desmond Vesey and Eric Bentley (New York: Grove Press, 1949, 1955, 1960), she claimed that the Austrian singer Grete Keller taught her how to sing the "Alabama Song" phonetically. Since Keller only began studying English in 1928, it's more likely that she coached Lenya for a future performance of *Rise and Fall of the City of Mahagonny* in Berlin, in 1931. Lenya and Keller probably met in 1930 in connection with a play at the Volksbühne.

24. Kowalke, *Kurt Weill in Europe*, 57.

25. Kowalke, Lee, and Harsh, *Mahagonny: A Sourcebook*, 4.

26. The "friend" in Munich was Arnolt Bronnen, a fellow writer (his works include the play *Vatermord*) whose relationship with Brecht was complex and fascinating. This anecdote is also mentioned in every biography of Brecht that is listed in the bibliography. This story about watching the Brownshirts in Munich is often cited as the source of the name "Mahagonny."

27. Schebera, *Kurt Weill: An Illustrated Life*, 93.

28. Hinton, *Weill's Musical Theater*, 104.

29. David Farneth with Elmar Juchem and Dave Stein, eds., *Kurt Weill: A Life in Pictures and Documents* (Woodstock, NY: The Overlook Press, 2000), 59.

30. Hinton, *Weill's Musical Theater*, 104.

31. Brecht, *Manual of Piety*, 187.

32. In contrast to Brecht's poem, Weill's fox-trot music for "Off to Mahagonny" bore no resemblance whatsoever to the melody of the hit song. See Hinton, *Weill's Musical Theater*, 104.

33. Letter 130, December 1927, in Bertolt Brecht, *Letters 1913–1956*, edited by John Willett and translated by Ralph Manheim (New York: Routledge, 1990), 114.

34. Weill to Universal Edition, April 4, 1927, Series 41, WLRC.

35. Weill to Hertzka, April 4, 1927, Series 41, WLRC. It is interesting to note that he wrote Universal Editions twice in one day about financial matters.

36. *Metropolis* was concerned not only with divisions of class and wealth but also with technology and a broad mix of other issues, including religion and the occult. According to Lang, the film was also a visceral reaction to his first glimpse of New York City in 1924. The film was produced in 1925 but not released until January 1927.

37. One of the most important officials to be murdered during this violent period was Walther Rathenau, the foreign minister. A Jewish industrialist, politician, and statesman, Rathenau was gunned down in 1922 by right-wing military officers while he was driving to work.

38. Frederic Ewen, *Bertolt Brecht: His Life, His Art, and His Times* (New York: Carol Publishing Group, 1992), 164.

39. Weill and Lenya, *Speak Low*, 50.

40. Eric D. Weitz, *Weimar Germany: Promise and Tragedy* (Princeton, NJ: Princeton University Press, 2007), 135.

41. *Ruhrepos* does literally mean "Ruhr Epic," but the use of the Greek *epos* instead of the more commonly used German *episch* is interesting because it specifically refers to a collection of poems that treat an epic theme and are not formally unified by a traditional dramatic plot. This is probably how Brecht would define his *Manual* and speaks to his future concept of epic theater—which would also be driven more by theme than by a conventional plot.

42. Letter 20, June 3, 1927, in Weill and Lenya, *Speak Low*, 53.

43. Letter 366, July 1, 1927, in Bertolt Brecht, *Briefe 1: Große kommentierte Berliner und Frankfurter Ausgabe*, Band 28 (Berlin: Aufbau-Verlag, 1998), 288.

44. Lenya's observations in George Davis Papers, Notes and Transcriptions, "Kurt Weill/Working Methods," Series 37, box 1, folder 24, 3, WLRC.

45. Ibid.

46. Paula Hanssen, *Elisabeth Hauptmann: Brecht's Silent Collaborator* (Bern: Peter Lang, Inc., 1995), 21. Hanssen has looked at the original typescript for the *Manual of Piety* and discovered that "at least two poems . . . (are) here: . . . Despite the handwritten note on the typescript for the 'Alabama Song,' 'Gedicht von Hauptmann' (BBA 451/84) and 'v. Hauptmann' at the top of the typescript for 'Benares-Song' (BBA 451/60), these have never been officially recognized as her work." This was written in 1995, and since that time there has been some acknowledgment of Hauptmann's role in writing the poems. But this documentation proves that although their author was known and accepted by Brecht, he published them under his own name. Clearly Hauptmann was also in agreement with this plan. The credit situation remained in place for more than seventy years.

47. Hauptmann interview in *Die Mitarbeiterin*, directed by Karlheinz Mund (DEFA-Studio für Kurzfilme, 1972). (Translated by Anja Marquardt.)

48. Lenya, in "Kurt Weill/Working Methods."

49. Hauptmann, *Die Mitarbeiterin.*

50. David Drew, "Kurt Weill and His Critics," *The Times Literary Supplement*, October 3, 1975. I am grateful to Jürgen Schebera's *Kurt Weill: An Illustrated Life* for bringing my attention to this great article.

51. In the twenties, as today, many young artists dispensed with this grammatical formality in favor of the more relaxed and friendly *du*. Therefore, it was somewhat unusual for two young artists like Brecht and Weill to be strict with this mode of address.

CHAPTER 5 **OFF TO MAHAGONNY**

1. Bertolt Brecht, *Briefe 1: Große kommentierte Berliner und Frankfurter Ausgabe,* Band 28 (Berlin: Aufbau-Verlag, 1998), 10–13. In a letter dated July 24, 1913, Brecht makes specific mention of these composers. In several letters during this stay he mentions music.

2. Hans W. Heinsheimer, *Best Regards to Aida* (New York: Alfred A. Knopf, 1968), 105.

3. In addition to Schoenberg, the other composers invited to the Donaueschingen Festival in 1924 included Anton Webern and Josef Matthias Hauer. Paul Hindemith, Alban Berg, Ernst Krenek, and Philipp Jarnach were invited to the inaugural event.

4. Schoenberg's letter is often quoted. Among other sources, it is quoted in Ronald Sanders, *The Days Grow Short: The Life and Music of Kurt Weill* (Hollywood: Silman-James Press, 1991), 82.

5. Stephen Hinton, *Weill's Musical Theater: Stages of Reform* (Berkeley and Los Angeles: University of California Press, 2012), 18.

6. For further details about the cross-fertilization between French and American music, see Sanders, *The Days Grow Short,* 82.

7. Heinsheimer, *Best Regards to Aida,* 105.

8. George Davis Papers, Notes and Transcriptions, Series 37, box 1, folder 24, 20, WLRC.

9. Klemperer was a conductor and also a composer. Born to a Jewish family in 1885, he had met and impressed Mahler by the age of twenty. His reputation as a champion of modern music was just beginning in 1927 with his position at the influential Kroll Opera.

10. Weill to Universal Edition, April 4, 1927, Series 41, WLRC.

11. Kurt Weill and Lotte Lenya, *Speak Low (When You Speak Love): The Letters of Kurt Weill and Lotte Lenya,* edited and translated by Lys Symonette and Kim H. Kowalke (Berkeley and Los Angeles: University of California Press, 1996), 50.

12. Gottfried Wagner interview with Lenya, May 28, 1978, Series 60, WLRC.

13. Donald Spoto, *Lenya: A Life* (Boston: Little, Brown and Company, 1989), 25.

14. Wagner interview with Lenya.

15. Kim H. Kowalke, Joanna Lee, and Edward Harsh, eds., *Mahagonny: A Sourcebook* (New York: Kurt Weill Foundation for Music, 1995), 12. It's important to add a note regarding Lenya's musical assessment. Although all the critics confirm that the *Mahagonny Songspiel* was by far the most radical work, partly because of its popular and melodic music, it's not clear that Milhaud's piece, for example, could or should be classified as "austere." In the words of the esteemed contemporary composer William Bolcom, "Milhaud might have written something polytonal—in many keys at once—but Milhaud also did a number of pop-oriented pieces. His jazz piece *La création du monde,* from 1922, predated *Rhapsody in Blue*." (Bolcom in conversation with the author.)

16. The translation of the program note is from Hinton, *Weill's Musical Theater,* 102. The original German version of the program is shown in full in David Farneth with Elmar Juchem and Dave Stein, eds., *Kurt Weill: A Life in Pictures and Documents* (Woodstock, NY: The Overlook Press, 2000), 60.

17. Bertolt Brecht, *Brecht on Theatre: The Development of an Aesthetic,* edited and translated by John Willett (New York: Hill and Wang, 1964), 6. The quote is from an article that Brecht wrote titled "Mehr guten Sport," which was published in the *Berliner Börsen-Courier* in February 1926.

18. Kowalke, Lee, and Harsh, *Mahagonny: A Sourcebook,* 12.

19. More information concerning the Weber reference is available in Hinton, *Weill's Musical Theater*. The English lyrics are from the translation on the Capriccio recording from the 1993 WDR radio presentation (Delta Music).

20. Kim H. Kowalke, "Singing Brecht vs. Brecht Singing: Performance in Theory and Practice," *Cambridge Opera Journal* 5, no. 1: 74. Kowalke is quoting Ernst Bloch, whose 1935 essay about *The Threepenny Opera* is reprinted in Stephen Hinton, ed., *Kurt Weill: The Threepenny Opera* (Cambridge: Cambridge University Press, 1990), 136. This description of Lenya's voice is particularly noteworthy since it is proof of the high, sweet quality of her voice at that time. Her singing voice in America was quite different and those who heard her later recordings or concerts are often unaware of the "sweet" and "high" elements of her young singing range.

21. The musical and historical context for the "Alabama Song" was provided by Stephen Blier, a famous coach who is aptly dubbed a "guru of song." He is also one of the founders of the New York Festival of Song. Blier's erudite and entertaining interpretation of Weill's composing style was essential to the writing of this chapter.

22. The "Alabama Song" has since been performed by the Doors, Bette Midler, David Bowie, Nina Simone, Marianne Faithfull, and many others.

23. In the commentary about *A Man's a Man* in Brecht, *Briefe 1*, mention is made of Kipling's story "The Incarnation of Krishna Mulvaney," in which the drunken soldier in Palankin is sent off by train to Benares. This was used as a point of comparison with the plot of *A Man's a Man*, but nevertheless indicates Brecht and Hauptmann's familiarity with the significance of the town of Benares.

It is also important to note that since Hauptmann was the one who read Kipling in English, and then translated it for Brecht, this mention of Benares from the Krishna story is further proof of her authorship of the song. She also translated another Kipling story into German for publication in a magazine in 1927, but she typically credited Brecht for the translation.

24. English translation of lyrics from the Capriccio recording.

25. Fritz Hennenberg and Jan Knopf, eds., *Brecht/Weill Mahagonny* (Frankfurt am Main: Suhrkamp Verlag, 2006), 201.

26. I am grateful to William Bolcom for speaking with me about the different uses of jazz in both French and German music during the 1920s. I am further indebted to Stephen Blier for explaining the relationship between Weill's music and the German and Austrian culture of operetta.

27. Hennenberg and Knopf, *Brecht/Weill Mahagonny*, 210–11.

28. Kowalke, Lee, and Harsh, *Mahagonny: A Sourcebook*, 12.

29. Brecht was not a fan of Heidegger. As early as 1930, Brecht and Walter Benjamin planned to inveigh against Heidegger—both his philosophy and his "leadership cult." For an excellent description of their plans, never realized, see Erdmut Wizisla, *Walter Benjamin and Bertolt Brecht: The Story of a Friendship* (New Haven, CT: Yale University Press, 2009). Wizisla quotes Günther Anders, a colleague of Brecht's, as saying that Brecht had never read Heidegger's books nor heard him speak. Therefore Anders discouraged Brecht from starting an anti-Heidegger journal.

30. The eyewitness for this account of the rotten apple was the influential critic Heinrich Strobel. See Kim H. Kowalke, *Kurt Weill in Europe* (Ann Arbor: University of Michigan Research Press, 1979), 59.

31. Kowalke, Lee, and Harsh, *Mahagonny: A Sourcebook*, 12.

32. The complete review from Olin Downes is reprinted in Farneth, Juchem, and Stein, *Kurt Weill: A Life in Pictures and Documents*, 62.

33. Jürgen Schebera, *Kurt Weill: An Illustrated Life*, translated by Caroline Murphy (New Haven, CT: Yale University Press, 1995), 99. This quote is from a review in the *Berliner Börsen-Courier* by Heinrich Strobel.

34. Kowalke, Lee, and Harsh, *Mahagonny: A Sourcebook,* 15. Copland's review was originally printed in the journal *Modern Music* (November/December 1927).

35. Carol J. Oja, *Making Music Modern: New York in the 1920s* (Oxford: Oxford University Press, 2003), 61.

36. Hennenberg and Knopf, *Brecht/Weill Mahagonny,* 210–11.

37. Letter 122, in Bertolt Brecht, *Letters 1913–1956,* edited by John Willett and translated by Ralph Manheim (New York: Routledge, 1990), 108.

38. Wagner interview with Lenya. Lenya often repeated Brecht's remarks, and this one is quoted in a variety of sources. I first read about it in the interview with Wagner.

Brecht's comment about the program can be further contextualized by noting that the program for the *Mahagonny Songspiel* only included a biography of the composer. This was standard practice at music festivals, but it was hardly usual for Brecht to participate in a work where he received less space on a program than his partners. This might have sparked his remark and could have meant that often in the theater, the writer would be more prominently featured than the composer. For Weill's part, he actually heightened his prominence on the page by adding that famous note about the audience going to the theater "naively and for fun."

39. Brecht to Weigel, letter 126, August 1927, in Brecht, *Letters 1913–1956,* 111.

40. Sabine Kebir, *Ich fragte nicht nach meinem Anteil: Elisabeth Hauptmanns Arbeit mit Bertolt Brecht* (Berlin: Aufbau-Verlag, 1977), 63–64.

41. Weill to Universal Edition, August 25, 1927, in Farneth, Juchem, and Stein, *Kurt Weill: A Life in Pictures and Documents,* 63.

42. Universal Edition to Weill, August 15, 1927, Series 41, WLRC.

43. Farneth, Juchem, and Stein, *Kurt Weill: A Life in Pictures and Documents,* 63.

44. Erwin Piscator, *The Political Theater: A History 1914–1929* (New York: Avon Books, 1978), 45.

45. Ibid., 111.

46. Letter 124, August 1927, in Brecht, *Letters 1913-1956,* 110. According to Willett's editorial notes (to letter 123 on page 578): "Gasbarra had been appointed by the KPD (the German Communist Party) as Piscator's literary collaborator or dramaturg . . . in 1927, Gasbarra organized a 'dramaturgical collective' of Brecht, Döblin, Toller and half a dozen other writers." As a committed Communist writer, Gasbarra participated in some of Piscator's most important productions. Brecht liked Gasbarra as a person and liked his politics, but it is understandable that he could not take a subordinate position *as a writer* to Gasbarra, who was nowhere near as accomplished.

47. This letter from Weill to Hertzka is often quoted in the literature about the composer. It is put in a particularly fascinating context in David Drew, "Struggling for Supremacy: The Libretto of *Mahagonny,*" *Kurt Weill Newsletter* 27, no. 2 (Fall 2009): 6. This volume was dedicated to the great Weill scholar David Drew after his death in 2009. I am grateful to Elmar Juchem for pointing it out.

48. Ibid. Drew has made an extensive study of the writing of the libretto for *Mahagonny,* and on page 6, he writes: "How much of [the libretto] came from Brecht and how much from Weill cannot be exactly determined."

49. Part of this anti-Semitic leaflet is in Werner Hecht, *Brecht Chronik* (Frankfurt am Main: Suhrkamp Verlag, 1997), 235. However, the initial report about the discovery of the Essen document was made by D. Stephan Bock, in connection with discoveries made by Bernhard Schapitz. The story was reported on a radio show for Westdeutscher Rundfunk in 1992; this was rebroadcast in 2006 on the fiftieth anniversary of Brecht's death. Bock wrote about the story in great detail in an article in *Neue Deutsche Literatur* 42, no. 3 (May/June 1994).

CHAPTER 6 **THE BEGGAR'S OPERA**

1. Eric D. Weitz, *Weimar Germany: Promise and Tragedy* (Princeton, NJ: Princeton University Press, 2007), 236.

2. Werner Hecht, *Brecht Chronik* (Frankfurt am Main: Suhrkamp Verlag, 1997), 232 and 239.

3. Herbert Jhering, "Bert Brecht the Dramatist," in Hubert Witt, ed., *Brecht: As They Knew Him* (New York: International Publishers, 1974), 36.

4. *The Adventures of the Good Soldier Schweik* was based on the antiwar novel of the same name by the Czech author Jaroslav Hašek. The character of Schweik was the "'unheroic' hero of the Austrian army . . . who in his naïve, fumbling, shrewdly inept ways exposes both wars and armies." See Frederic Ewen, *Bertolt Brecht: His Life, His Art, and His Times* (New York: Carol Publishing Group, 1992), 154.

5. Hecht, *Brecht Chronik*, 241–42. Among others, Hecht quotes a 1928 review by Monty Jacobs, published in *Vossiche Zeitung.*

6. Sabine Kebir, quoting Steffie Spira in International Brecht Society, *The Brecht Yearbook: Helene Weigel 100*, vol. 25, edited by Judith Wilke (Madison: University of Wisconsin Press, 2000), 153.

7. Hiltrud Häntzschel, *Brechts Frauen* (Reinbek bei Hamburg: Rowohlt Verlag, 2002), 110.

8. The magazine was *UHU*, one of the first photo-illustrated journals in Germany. It was published by the well-known Ullstein Verlag in Berlin.

9. Elisabeth Hauptmann, *Julia ohne Romeo* (Berlin and Weimar: Aufbau-Verlag, 1977), 25.

10. Hauptmann's calculation of working eighteen hours a day with Brecht is mentioned in her 1935 letter to Walter Benjamin; see Elisabeth Hauptmann, *Lesebuch* (Cologne: Nyland-Stiftung, 2004), 114. At a radio engagement on April 1, 1928, the program was announced as follows: "Elisabeth Hauptmann reads from several of her stories." This reveals her growing reputation as a short-story writer.

11. Westend was and is a nice residential neighborhood in Berlin.

12. Hauptmann to Hannes Küpper, December 4, 1927, Z31/61, BBA. The editor of the magazine *Scheinwerfer*, Küpper was also the dramaturg for the theater in Essen where *Ruhrepos* had originally been commissioned.

13. Sabine Kebir, *Ich fragte nicht nach meinem Anteil: Elisabeth Hauptmanns Arbeit mit Bertolt Brecht* (Berlin: Aufbau-Verlag, 1977), 100.

14. David Drew, *Kurt Weill: A Handbook* (Berkeley and Los Angeles: University of California Press, 1987), 190.

15. Bronnen was a prominent playwright and important early friend to Brecht. He wrote a play called *Vatermord,* which Brecht tried to direct in 1922, but he was thrown out of the production after arguing with the cast and producer. It was Bronnen who first told Brecht about Weigel.

16. Weill to Hans, April 26, 1920, in Jürgen Schebera, *Kurt Weill: An Illustrated Life,* translated by Caroline Murphy (New Haven, CT: Yale University Press, 1995), 26.

17. Weill to Universal Edition, March 20, 1928, Series 41, WLRC.

18. Ernst Josef Aufricht, *Erzähle, damit du dein Recht erweist* (Munich: Deutscher Taschenbuch Verlag, 1969), 43–44.

19. Ibid., 48. Aufricht had produced Kaiser's well-known play *Nebeneinander.*

20. Ibid., 37.

21. Ibid.

22. Ibid., 55.

23. Ibid.

24. James K. Lyon and Hans-Peter Breuer, eds., *Brecht Unbound* (Newark: University of Delaware Press, 1995). In the chapter by Carl Weber titled "Brecht and Communism—Clear-sighted Ambiguity or Blurred Vision?," a cogent account of Brecht's research for *Joe Fleischhacker* and subsequent acquaintance with Marx is detailed on page 20.

25. Aufricht, *Erzähle, damit du dein Recht erweist*, 56.

26. Kebir, *Ich fragte nicht nach meinem Anteil*, 103.

27. Aufricht, *Erzähle, damit du dein Recht erweist*, 56.

28. John Gay, *The Beggar's Opera* (Bungay, UK: Richard Clay & Sons, Ltd, 1921; text from 1765 edition), 46 and 40.

29. Ibid., 61.

30. Bertolt Brecht, *The Threepenny Opera*, translated and edited by Ralph Manheim and John Willett (New York: Arcade Publishing, 1994), 92. In Brecht's "Notes to *The Threepenny Opera*," he wrote: "The bandit MACHEATH must be played as a bourgeois phenomenon. The bourgeoisie's fascination with bandits rests on a misconception: that a bandit is not a bourgeois. This misconception is the child of another misconception: that a bourgeois is not a bandit."

31. Ibid., 90. In his notes, Brecht also wrote: "*The Beggar's Opera* was a parody of Handel, and it is said to have had a splendid result in that Handel's theater became ruined." Jürgen Schebera, in *Kurt Weill: An Illustrated Life*, 105, adds: "With their *Beggar's Opera* of 1728, Gay and Pepusch had founded the new genre of 'ballad opera' in sharp opposition to the fossilized Italian courtly opera, and also to Handel's operas. Along with its profane contents, it brought street songs [and] ballads . . . to the opera stage."

32. Gay, *The Beggar's Opera*, 61.

33. In *Baal* and *In the Jungle of Cities*, Brecht's versions were a reaction that was in direct conflict with the visions offered by the authors who had inspired him.

34. Aufricht, *Erzähle, damit du dein Recht erweist*, 57.

35. Brecht's uncanny ability to appear successful is described by John Fuegi in "Most Unpleasant Things with *The Threepenny Opera*: Weill, Brecht, and Money," in Kim H. Kowalke, ed., *A New Orpheus: Essays on Kurt Weill* (New Haven, CT: Yale University Press, 1986), 163. Fuegi writes: "As Brecht's friend Arnolt Bronnen was to observe with some puzzlement: his own plays had *succeeded* in theaters but he had been *defeated*, while Brecht's plays had *failed*, but Brecht had *won* . . . Brecht managed to project an image of extraordinary success."

36. Stephen Hinton, ed., *Kurt Weill: The Threepenny Opera* (Cambridge: Cambridge University Press, 1990), 17.

37. There is another wrinkle in Aufricht's account. He claims to have seen the double bill in Berlin, but Weill's two short operas had been performed as a double bill only three times that spring, twice in April and once in June, and both times were in opera houses outside Berlin. The double bill was not performed in Berlin until after the opening of *The Threepenny Opera* in October 1928. So either Aufricht remembers seeing the operas in the wrong place (likely, since they were performed fairly close to Berlin) or he didn't see the double bill at all.

38. Thea Lenk, ed., *Erich Engel: Schriften. Über Theater und Film* (Berlin: Veröffentlichung der Akademie der Künste, Henschel Verlag Berlin, 1971), 207. (Translation Carina Reithmüller.)

39. It is interesting to note that Aufricht's and Fischer's accounts about hiring Engel differ in one important way: Aufricht insists that he hired Engel prior to selecting Brecht as the playwright. Because Aufricht's memoir is one of the most complete accounts of the genesis of *The Threepenny Opera*, this has usually been the

accepted version. Aufricht goes so far as to talk about Engel's first suggestions for plays.

Because this account doesn't acknowledge the strong relationship that already existed between Brecht and Engel, it rings false. It doesn't seem likely that Aufricht would have "stumbled" upon Brecht in a café if Engel was already the director of choice. Surely Brecht's name would have come up, given the success of *A Man's a Man*—helmed by Engel—only a few months earlier. Based on the strong relationship between Brecht and Engel, Fischer's account makes far more sense. It is still unclear as to why Fischer was worried about Brecht and Engel getting along, but his detailed story about his discussion with Aufricht lends a further sense of authenticity.

It is therefore a judgment call to state that Engel was hired after Brecht, rather than before. Aufricht's memoir (*Erzähle, damit du dein Recht erweist*) and Fischer's essay (in Lenk, *Erich Engel: Schriften*) are the sources on record. No legal contract from either Aufricht or the Schiffbauerdamm, which could confirm these dates, has been discovered.

40. Weill to Universal Edition in Hinton, *Kurt Weill: The Threepenny Opera*, 18.

41. Fuegi, "Most Unpleasant Things with *The Threepenny Opera*," 166.

42. Weill's most recent theatrical works had been with Feuchtwanger and Lania. In a conversation I had with Kim H. Kowalke, the president of the Kurt Weill Foundation, he said: "The first number he was asked to do was an arrangement from the first number of [the original] *Beggar's Opera*. I wonder if there wasn't a thought that 'I'll just arrange tunes from *Beggar's Opera*'—it's possible. I don't have any evidence for that, but I don't think they started out thinking that this was going to be the most influential work of musical theater in the twentieth century. So it was, well 25 percent for a few days' work, a few songs, 'It'll be fun, I've tested the style in *Mahagonny*.' Weill might have thought, 'This is going to be a lark,' and his real interest was the big opera, so he chose his battles."

43. A revised draft of *The Beggar's Opera*, titled *The Pimps' Opera*, was published by Felix Bloch Erben in May 1928. According to Jürgen Schebera, this draft shows few signs of any input from Weill, with whom Brecht had only just begun to discuss the project. The new title didn't last long, however, and Weill always referred to it as *The Beggar's Opera* prior to the name change, which was to take place in rehearsals. See Schebera, *Kurt Weill: An Illustrated Life*, 107.

44. George Davis interview with Hauptmann, Series 57, box 1, folder 11, WLRC.

CHAPTER 7 LE LAVANDOU

1. David Farneth, ed., *Lenya, the Legend: A Pictorial Autobiography* (Woodstock, NY: The Overlook Press, 1998), 58. This quote is from the transcript of a BBC radio program, Paul Vaughan interview with Lenya, September 9, 1981, Series 122, folder 2, WLRC.

2. Stephen Hinton, ed., *Kurt Weill: The Threepenny Opera* (Cambridge: Cambridge University Press, 1990), 19.

3. The adaptation that Brecht and Hauptmann worked on was published by Felix Bloch Erben as *Die Ludenoper* (The Pimps' Opera) in May 1928; ibid. According to Jürgen Schebera, *Kurt Weill: An Illustrated Life*, translated by Caroline Murphy (New Haven, CT: Yale University Press, 1995), 107, this version showed no trace of Weill's participation.

4. John Gay, *The Beggar's Opera* (Bungay, UK: Richard Clay & Sons, Ltd, 1921; text from 1765 edition), 61.

5. Stephen Hinton, *Weill's Musical Theater: Stages of Reform* (Berkeley and Los Angeles: University of California Press, 2012), 116.

6. Hinton, *Kurt Weill: The Threepenny Opera*, 125.

7. Ibid., 144–45. Benjamin's quote comes from his essay "L'opéra de quat'sous" (the French title of *The Threepenny Opera*). Brecht and Benjamin became very close friends and colleagues in the 1920s. This relationship lasted until the end of Benjamin's life in 1940.

8. In Willett's introduction for Brecht, *Diaries 1920–1922*, xix, he writes: "By such means Brecht arrived at what he later termed a 'poetic conception': that is, an imaginary setting for dramatic action such as he also found in the Indian garrison town of Kilkoa (for *Man Equals Man*) or the pullulating slums of Victorian London (for *The Threepenny Opera* in 1928). Such creations could be justified in terms of his later doctrine of alienation, according to which the strangeness of the setting helps us to see the actual events in a more critical light."

Brecht's use of the Victorian era was anything but pedantically accurate. According to Lotte Eisner, *The Haunted Screen* (Berkeley and Los Angeles: University of California Press, 1969), 317: "Though Queen Victoria came to the throne in 1837, Brecht, who had already transplanted the eighteenth-century *Beggar's Opera* to a more recent period, again chose for his *mise-en-scene* the stiffened gowns, feathered hats, starched collars and stiff frock-coats of *the end of the Victorian period* because they accentuated the sham middle-class appearance of his low-life men and women." Eisner is referring here to G. W. Pabst's film of *The Threepenny Opera*, but her statement holds true for Brecht's approach to the historical accuracy of the year presented in the stage version. Victorian London was a broad metaphor that he used rather freely. Despite the presence of the coronation, people often refer to *The Threepenny Opera* as taking place in an Edwardian rather than a Victorian setting.

9. Bertolt Brecht, *The Threepenny Opera*, translated and edited by John Willett and Ralph Manheim (New York: Arcade Publishing, 1994), 8.

10. Gay, *The Beggar's Opera*, 24–25 and 60.

11. Bertolt Brecht, *The Threepenny Opera*, translated by Desmond Vesey and Eric Bentley (New York: Grove Press, 1949, 1955, 1960), 88 and 95.

12. Michael Morley, "Suiting the Action to the Word: Some Observations on *Gestus* and *Gestische Musik*," in Kim H. Kowalke, ed., *A New Orpheus: Essays on Kurt Weill* (New Haven, CT: Yale University Press, 1986), 192–93.

13. Ibid., 193. Morley is quoting Brecht from an essay titled "Das Ja-Nein" reprinted in *Gesammelte Werke* 15: 411.

14. Brecht, *The Threepenny Opera*, Willett and Manheim translation, 27–28.

15. Morley, "Suiting the Action to the Word," 193–94.

16. The "Barbara Song" was transcribed and arranged by Brecht's former collaborator, the cabaret composer Franz S. Bruinier. As Schebera notes in *Kurt Weill: An Illustrated Life*, 93: "Once he met Weill, 'Franz S. Bruinier disappeared from Brecht's field of vision.'"

17. Hinton, in *Kurt Weill: The Threepenny Opera*, 36, identifies the operetta as Eduard Künneke's *Der Vetter aus Dingsda* (1921). The operetta, along with its song "Ich bin nur ein armer Wandergesell," was popular at the time and Weill was certainly familiar with the music. Hinton quotes Weill as calling the suitor in Künneke's opera "degenerate."

18. John Willett, *Brecht in Context* (London: Methuen London Ltd, 1998), 71–72. Willett notes that there was already a song in Brecht's play *A Man's a Man* called "Song of the Three Soldiers" that is a reference to the poem from his collection *Soldiers Three*, upon which the "Cannon Song" was based. The setting of colonial wars in general revealed the distinct influence of Kipling, whose work was in turn translated for Brecht by Hauptmann. The original poem for the much revised "Cannon Song" was originally derived, if loosely, from Kipling's ballad "Screw-Guns." For

more specific information about the origins of the "Cannon Song," see Fritz Hennenberg, ed., *Brecht-Liederbuch* (Frankfurt am Main: Suhrkamp Verlag, 1984), 391–93. This complex network of influences, combined with Brecht's tendency to recycle his own work, offers an insightful example of his creative process.

19. Hinton, *Kurt Weill: The Threepenny Opera*, 38–39. The first settings for both the "Barbara Song" and the "Pirate Jenny" song were originally transcribed and arranged by Franz S. Bruinier.

20. Weill's statement is quoted in Kim H. Kowalke, "Singing Brecht vs. Brecht Singing: Performance in Theory and Practice," *Cambridge Opera Journal* 5, no. 1: 70.

Hinton, in *Kurt Weill: The Threepenny Opera*, 38, also notes that Carola Neher performed the Bruinier version of the song on December 31, 1926, on the radio. Weill reviewed it and called the song "Splendid!"

21. Hinton, *Kurt Weill: The Threepenny Opera*, 40. Hinton is quoting David Drew, the well-known Weill expert and musicologist.

22. Since the "Pirate Jenny" song became so successful and such a profoundly iconic song, the fact that there was a version predating Weill's has naturally led to some prolonged debates over who, precisely, was responsible for its pungency and popularity. Those who want to believe in Brecht's overarching musical influence over Weill have argued one way; those who want to establish not only Weill's independence from Brecht's musical influence but also his genius for song have argued in the opposite direction, as Drew so emphatically does when he gives Weill credit for "taking the song to sea."

23. Weill to Universal Edition in Hinton, *Kurt Weill: The Threepenny Opera*, 20.

24. Bertolt Brecht, "The Literarization of the Theater," in *Brecht on Theatre: The Development of an Aesthetic*, edited and translated by John Willett (New York: Hill and Wang, 1964), 45.

25. Information about Weigel's role in preventing Hauptmann's presence in Le Lavandou was provided by Klaus Pohl, in an interview with the author.

26. Hauptmann's whereabouts toward the end of the Le Lavandou trip and afterward come from an interview with George Davis, Series 37, box 1, folder 11, WLRC. Davis's third-person summary of Hauptmann's words are as follows: "Up to the time of Fischer's interest [Aufricht's assistant] it had been for their own fun, but now came the deadline—August 28th, Monday—and they had to buckle down—especially terrifying for Brecht, not a deadline man—with reworkings and rewritings—maybe twenty of them—day and night—then to Lavandou in June—Brecht and Weigel and the boy drove down—and Lenya and Kurt took the train—Kurt at the Hotel de Provence, Brecht had a house on the beach . . . Les Lecques sur Plage . . . Kurt and Lenya came back by train to Berlin—Hauptmann met Brecht in Marseilles and drove back—Weigel came back by train—first saw the new version of Threepenny in Aix."

27. Kurt Weill, "Zeitoper," *Melos* 7 (March 1928): 106–8. This article is quoted in: Kim H. Kowalke, *Kurt Weill in Europe* (Ann Arbor: University of Michigan Research Press, 1979), 482.

28. Weill to Universal Edition, June 6, 1928, Series 41, WLRC.

29. Letter 396 in Bertolt Brecht, *Briefe 1: Große kommentierte Berliner und Frankfurter Ausgabe*, Band 28 (Berlin: Aufbau-Verlag, 1998), 306.

30. Ibid., letters 394 and 395.

31. Schebera, *Kurt Weill: An Illustrated Life*, 107.

32. In May 1928, Hermann Müller, a Social Democrat, won a second term. The Social Democratic Party (SPD) also received nearly 30 percent of the vote in parliament. Because of this, they were able to form a coalition to unify the parliament to a certain extent. Technically, a grand coalition occurs when the top two parties in a parliamentary system form a ruling coalition together. In this case, four of the top

six parties formed what was called the Great Coalition. It marked the return of the SPD to some form of ruling coalition after a four-year absence. The seat allotment among the major parties in parliament in May 1928 was 153 Social Democrats, 54 Communists, 61 Center Party, 73 German National People's Party (30 fewer than the previous election), and 12 Nazis (National Socialist German Workers Party).

CHAPTER 8 **THE BOURGEOIS BANDIT**

1. Bertolt Brecht, "Notes to the Threepenny Opera," in *The Threepenny Opera*, translated and edited by Ralph Manheim and John Willett (New York: Arcade Publishing, 1994), 92.

2. The Schiffbauerdamm Theater had been Reinhardt's venue from 1903 until 1906. At that time, it was known as the Neues Theater (the New Theater).

3. Felix Jackson, "Portrait of a Quiet Man: Kurt Weill, His Life and His Times," unpublished manuscript, WLRC, 54. Jackson attended rehearsals for *The Threepenny Opera* and offered a detailed description in his unpublished book.

4. In 1928, Neher had a three-year contract with Leopold Jessner's State Theater, one of the most prominent theaters in Berlin, devoted to staging productions of the classics, from Shakespeare to Schiller, which were also relevant for a modern-day audience. Weigel had also been a regular there from 1923 until 1926. In March 1926, she had played Salome in Friedrich Hebbel's *Herodes und Mariamne*, which was a critical success.

5. Jackson, "Portrait of a Quiet Man," 143.

6. Ernst Josef Aufricht, *Erzähle, damit du dein Recht erweist* (Munich: Deutscher Taschenbuch Verlag, 1969), 57–58.

7. Carola Neher had already begun a successful acting career in southern Germany. Lion Feuchtwanger introduced her to Brecht.

8. Heinrich Fischer's description of Engel in Thea Lenk, ed., *Erich Engel: Schriften. Über Theater und Film* (Berlin: Veröffentlichung der Akademie der Künste, Henschel Verlag Berlin, 1971), 208.

9. George Davis Papers, Notes and Transcriptions, "Kurt Weill/Working Methods," Series 37, box 1, 6–7, WLRC.

10. Kim H. Kowalke, "Brecht and Music: Theory and Practice," in *The Cambridge Companion to Brecht*, edited by Peter Thomson and Glendyr Sacks (Cambridge: Cambridge University Press, 1994), 226–27.

11. Peter Thomson, "Dismantling the *Gesamtkunstwerk:* Weill, Neher and Brecht in Collaboration," *Studies in Theater and Performance* 22, no. 1 (2002): 39.

12. Bertolt Brecht, *Brecht on Theatre: The Development of an Aesthetic*, edited and translated by John Willett (New York: Hill and Wang, 1964), cover page quote.

13. Gottfried Wagner interview with Lenya, May 28, 1978, Series 60, WLRC.

14. Jackson, "Portrait of a Quiet Man," 60.

15. Aufricht, *Erzähle, damit du dein Recht erweist*, 59.

16. Stephen Hinton, *Weill's Musical Theater: Stages of Reform* (Berkeley and Los Angeles: University of California Press, 2012), 20.

17. Alan Rich and Kim Kowalke interview with Margot Aufricht, Series 60, WLRC.

18. Aufricht, *Erzähle, damit du dein Recht erweist*, 59.

19. Part of the "power" of Brecht's lyrics for the "Pimp's Ballad" came from his judicious borrowing of lyrics from a French ballad by François Villon. He also used Villon's lyrics for portions of several other songs, including "Call from the Grave," "Ballad in Which Macheath Begs All Men for Forgiveness," and "Ballad of the Pleasant Life." He also made use of Villon's lyrics for part of the "Solomon Song," which

was cut on opening night but reinstated in later productions. As for his borrowings from Kipling, most of them were ultimately cut. The only remaining Kipling lyrics were in the "Cannon Song." As Hinton details in *Weill's Musical Theater*, 112, these lyrics were "derived loosely from a German translation of Kipling's ballad 'Screw-Guns.'"

Brecht's liberal use of lyrics written by others was an example of how he could bring in the work of another writer in order to strengthen his own artistic and thematic beliefs. By adapting and combining the work of Kipling, Villon, and Gay, and relying on the music of Weill, the brazen poet created a uniquely Brechtian landscape.

20. Stephen Hinton, ed., *Kurt Weill: The Threepenny Opera* (Cambridge: Cambridge University Press, 1990), 6.

21. Brecht, *Brecht on Theater*, 85–86.

22. Ibid., 44. The full quote reads: "But this way of subordinating everything to a single idea, this passion for propelling the spectator along a single track where he can look neither right nor left, up nor down, is something that the new school of playwriting must reject. Footnotes, and the habit of turning back in order to check a point, need to be introduced into play-writing too." This was written by Brecht in volume 3 of his *Versuche* series in 1931.

23. Jackson, "Portrait of a Quiet Man," 64.

24. Hauptmann is quoted in Sabine Kebir, *Ich fragte nicht nach meinem Anteil: Elisabeth Hauptmanns Arbeit mit Bertolt Brecht* (Berlin: Aufbau-Verlag, 1977), 139. This description invoking a "doghouse" is in fact Hauptmann's paraphrase for an idea expressed in Brecht's short stories about Herr Keuner. The actual quote is: "And without any help, only with spare materials that one person can produce himself, the only thing they can build is a small hut. A large building cannot be built by one person!" Kebir, on note 12 of page 262, explains that Hauptmann added the "doghouse" notion to Brecht's "hut" metaphor.

25. Canetti was a Spanish-speaking, Swiss-educated Jewish playwright and novelist. He wrote in German, which was his third language, and was raised by Spanish Sephardic Jews. He won the 1981 Nobel Prize in Literature.

Kraus, twenty-four years Brecht's senior, was a Viennese satirist. He founded the well-known and enormously successful magazine *Die Fackle*, which he published from 1899 until just before his death in 1936, writing nearly all the essays himself.

Given Feuchtwanger's suggestions for the new title of *The Beggar's Opera*, it is noteworthy that his wife, Marta, had been the one to suggest to Brecht the new title for his second play, *Spartacus*. It was she who thought of *Drums in the Night*.

26. Jackson, "Portrait of a Quiet Man," 60.

27. Bertolt Brecht, *The Threepenny Opera*, translated by Desmond Vesey and Eric Bentley (New York: Grove Press, 1949, 1955, 1960), xii.

28. Brecht's narration for the concert version of *The Threepenny Opera*, in Hinton, *Kurt Weill: The Threepenny Opera*, 1.

29. Eric D. Weitz, *Weimar Germany: Promise and Tragedy* (Princeton, NJ: Princeton University Press, 2007), 106. Weitz points out that the government censorship was an attempt to inhibit foreign and Jewish authors in particular.

30. Jackson, "Portrait of a Quiet Man," 60.

31. Lenk, *Erich Engel*, 203–4.

32. Ibid., 221. Lenk is quoting Hauptmann, who in turn is quoting Brecht from memory.

33. Brecht, *Brecht on Theater*, 44.

34. According to Kowalke in "Brecht and Music," 234n29: "Because often the performer is 'reporting' rather than experiencing first-hand, many of Brecht's songs may be sung interchangeably by various characters . . . Thus, at different times in

the run of the original production of *The Threepenny Opera,* Polly and Lucy each sang the 'Barbara-Song.'"

35. Brecht, *Brecht on Theater,* 44–45.

36. Aufricht, *Erzähle, damit du dein Recht erweist,* 62.

37. Jackson, "Portrait of a Quiet Man," 129.

38. The bandleader's name was actually Ludwig Rüth. He changed his band's name to sound more American.

39. Hinton, *Weill's Musical Theater: Stages of Reform,* 20.

40. Aufricht, *Erzähle, damit du dein Recht erweist,* 60–61.

41. Foster Hirsch, *Kurt Weill on Stage: From Berlin to Broadway* (New York: Limelight Editions, 2003), 39.

42. "Ballad of Sexual Dependency" was reinstated in future productions. It was, for example, included in Robert Wilson's version.

43. Aufricht, *Erzähle, damit du dein Recht erweist,* 64.

44. Jackson, "Portrait of a Quiet Man," 63–64.

45. Hinton, *Kurt Weill: The Threepenny Opera,* 23.

46. Ibid.

47. Ibid.

48. Jackson, "Portrait of a Quiet Man," 64.

49. Information about Paulsen's drug habit comes from an interview conducted by David Farneth with Norbert Gingold. Gingold was a conductor and composer who worked for Universal Edition. He was responsible for the piano and vocal scores for *The Threepenny Opera.* See *Kurt Weill Newsletter* 14, no. 1 (Spring 1996): 4–5.

50. Jackson, "Portrait of a Quiet Man," 65.

51. Ibid., 66–67. Kortner had been a leading man at Reinhardt's Deutsches Theater, as well as at Jessner's State Theater. His first film role was in 1916, and among his most famous roles is that of Dreyfus in 1930. Since he was Jewish, he fled Germany in 1933 but returned in 1949 and became known as a great director of Shakespeare.

52. Weill to Universal Edition, August 21, 1928, excerpted in David Farneth with Elmar Juchem and Dave Stein, *Kurt Weill: A Life in Pictures and Documents* (Woodstock, NY: The Overlook Press, 2000), 75. The full letter is in Universal Edition correspondence, Series 41, WLRC.

53. Lenya's solo song was "Solomon Song." It would have been performed just after Jenny betrays Macheath for the second time. The song describes the fall of great men like Caesar and Macbeth. The waltz melody equates gangsters with history's "great men." Like the "Ballad of Sexual Dependency," it was also reinstated in future productions. And like several of the other songs, it too incorporated some lyrics from François Villon.

54. Jackson, "Portrait of a Quiet Man," 68.

55. Aufricht, *Erzähle, damit du dein Recht erweist,* 65.

56. C. R. Martin, "Die Dreigroschenoper," August 9, 1959, BBA985.

57. The story of the industrialist Hugo Stinnes Jr. was reported in, among others, the national newspaper of Germany, *Vossische Zeitung,* August 31, 1928.

58. *Die Rote Fahne* reported on the price of wheat on August 26, 1928. A follow-up about the government's financial priorities, which referenced the situation of wheat, reported the story about school lunches and battleships on the day of the premiere, August 31, 1928.

CHAPTER 9 **THE THREEPENNY OPERA**

1. Ernst Josef Aufricht, *Erzähle, damit du dein Recht erweist* (Munich: Deutscher Taschenbuch Verlag, 1969), 65–66.

2. Bertolt Brecht, "Notes to *The Threepenny Opera*," in *The Threepenny Opera*, translated and edited by Ralph Manheim and John Willett (New York: Arcade Publishing, 1994), 97.

3. Eric Bentley, *Bentley on Brecht* (Evanston, IL: Northwestern University Press, 2008), 324.

4. Weill to Hans Heinsheimer, the editor of *Anbruch;* see Stephen Hinton, ed., *Kurt Weill: The Threepenny Opera* (Cambridge: Cambridge University Press, 1990), 125.

5. Although I believe that Brecht came up with the suggestion in an effort to create the most effective blend of satire and sincerity—and that on opening night he feared that the balance was off—he never gave up his belief that the messenger had to be mounted. He wrote about it years later and documented his often-repeated opinion in "Notes to *The Threepenny Opera*," where he offers a more political motivation for the mounted messenger.

6. Aufricht, *Erzähle, damit du dein Recht erweist*, 65.

7. Hinton, *Kurt Weill: The Threepenny Opera*, 24.

8. Bertolt Brecht, *Brecht on Theater: The Development of an Aesthetic*, edited and translated by John Willett (New York: Hill and Wang, 1964), 27.

9. Letter 15 in Kurt Weill and Lotte Lenya, *Speak Low (When You Speak Love): The Letters of Kurt Weill and Lotte Lenya*, edited and translated by Lys Symonette and Kim H. Kowalke (Berkeley and Los Angeles: University of California Press, 1996), 48.

10. Aufricht, *Erzähle, damit du dein Recht erweist*, 68.

11. Bertolt Brecht, *The Threepenny Opera*, translated by Desmond Vesey and Eric Bentley (New York: Grove Press, 1949, 1955, 1960), xiii.

12. Felix Jackson, "Portrait of a Quiet Man: Kurt Weill, His Life and His Times," unpublished manuscript, WLRC, New York, 72.

13. Jackson, "Portrait of a Quiet Man," 69.

14. Addison DeWitt is the cruel drama critic, played by George Sanders, in *All About Eve*.

15. Aufricht, *Erzähle, damit du dein Recht erweist*, 67.

16. Frederic Ewen, *Bertolt Brecht: His Life, His Art, and His Times* (New York: Carol Publishing Group, 1992), 98.

17. Alfred Kerr, *Die Welt im Drama* (Cologne and Berlin: Kiepenheuer & Witsch, 1954), 166.

18. The German title of the "newspaper" program was *Das Stichwort*, which translates to "Catchword." A catchword is a word or phrase made temporarily popular—often used to define a particular age group or trend. It is also a kind of headline.

19. This quote is from Kim H. Kowalke, the president of the Kurt Weill Foundation for Music. He was interviewed for the documentary accompanying the 1931 film of *The Threepenny Opera*, directed by G. W. Pabst (Criterion Collection, 2007).

20. The red velvet curtain was used to begin and end the show, and to punctuate the acts. At all other times, only the half curtain was used. This served to reinforce the contrast between the velvet and the burlap.

21. The barrel organ failed to function, Gerron would later discover, because they had forgotten to engage some vital mechanical link between the roller and the crank. See Aufricht, *Erzähle, damit du dein Recht erweist*, 67.

22. Foster Hirsch, *Kurt Weill on Stage: From Berlin to Broadway* (New York: Limelight Editions, 2003), 40.

23. I am grateful to Jürgen Schebera for his precise description of how the song might have sounded on opening night. He did extensive research into the sound of the barrel organ that was used in 1928.

24. Hinton, *Kurt Weill: The Threepenny Opera*, 37.

25. Bloch wrote this for *Anbruch* in 1929; see Jürgen Schebera, *Kurt Weill: An Illustrated Life,* translated by Caroline Murphy (New Haven, CT: Yale University Press, 1995), 115.

26. Aufricht, *Erzähle, damit du dein Recht erweist,* 68. The incredible change in the audience after the performance of the "Cannon Song" has been documented in many sources.

27. Brecht, *The Threepenny Opera,* Vesey and Bentley translation, 29.

28. The lyrics are typically translated into English as "Black" and Yellow" when referring to the color of skin. In German, however, the lyrics are *"Braune"* (brown) and *"Blasse"* (pale). The use of different colors was likely meant to put them into the expressions typically used in English for dark-skinned and Asian peoples.

29. This treaty ended the occupation of the Ruhr by the French and Belgians. This was the region where Brecht and Weill had developed *Ruhrepos,* their first project together.

Gustav Stresemann, the foreign minister at the time, was one of the few German leaders who had gained the trust of the people. He was instrumental in the Pact of Locarno and in the success of the Kellogg-Briand Pact. Stresemann received the Nobel Peace Prize along with Aristide Briand. Stresemann was also responsible for instituting the currency known as the *Rentenmark,* which helped to relieve the rampant inflation in 1923.

30. Sabine Kebir, *Ich fragte nicht nach meinem Anteil: Elisabeth Hauptmanns Arbeit mit Bertolt Brecht* (Berlin: Aufbau-Verlag, 1977), 107. The quote comes from the film *Die Mitarbeiterin,* directed by Karlheinz Mund (DEFA–Studio für Kurzfilme, 1972).

31. Brecht, *The Threepenny Opera,* Manheim and Willett translation, 24.

32. According to Hinton (as well as John Fuegi in another essay), "large chunks" of Villon (in someone else's German translation) were "more or less freely adapted" in the "Pimp's Ballad"; see Hinton, *Kurt Weill: The Threepenny Opera,* 9.

33. The translation of "ramshackle Christian" comes from Brecht, *The Threepenny Opera,* Manheim and Willett translation, 5. German line is actually "verrotteter Christ." *Verrottet* means dilapidated. *Christ* can mean Christ himself or Christian. Bentley translated it as "Wake up, you old Image of Gawd!"

34. Brecht, *The Threepenny Opera,* Vesey and Bentley translation, 6.

35. I am grateful to Hinton's cogent analysis of the religious parody in *The Threepenny Opera.* For more details, see "Misunderstanding *The Threepenny Opera,*" in Hinton, *Kurt Weill: The Threepenny Opera,* 187.

36. In the original play, Gay also made the same point: "The lower Sort of People have their Vices in a degree as well as the Rich"; see John Gay, *The Beggar's Opera* (Bungay, UK: Richard Clay & Sons, Ltd, 1921, text from 1765 edition), 61.

37. Significantly, the second-act finale was also sung by Jenny in future productions. As a true victim of injustice (unlike Macheath or Mrs. Peachum), a betrayed prostitute singing the song clearly added another layer to the famous lyrics. The ability of the phrase to either indict the bourgeoisie or defend the poor was indicated by this frequent substitution.

38. Bertolt Brecht, *Die Dreigroschenoper* (Frankfurt am Main: Suhrkamp Verlag Berlin, 2004), 67.

39. Gay also invoked the comparison between men and animals on page 46 of *The Beggar's Opera.* The line is: "Of all Animals of Prey, Man is the only sociable one. Every one of us preys upon his Neighbour, and yet we herd together."

40. Hannah Arendt, *The Origins of Totalitarianism* (New York: Harcourt, Inc., 1968, originally published in 1950), 335.

41. Brecht, *The Threepenny Opera,* Manheim and Willett translation, 55.

42. "Wives" is in quotes, because the legality of all of Macheath's marriages was rather suspect.

43. Brecht, *The Threepenny Opera*, Vesey and Bentley translation, 96.

44. Hinton, *Kurt Weill: The Threepenny Opera*, 56.

45. Alan Rich and Kim Kowalke interview with Margot Aufraicht, Series 60, 7, WLRC.

46. Weill and Lenya, *Speak Low*, 2, and letter 318, 381.

47. Hinton, *Kurt Weill: The Threepenny Opera*, 191–92. Hinton is quoting from Canetti's book *Die Fackel im Ohr: Lebensgeschichte 1921–1931*.

CHAPTER 10 GROTESQUE AND PROTEST

1. This quote was from an article in the German newspaper *Der Tag;* see Stephen Hinton, ed., *Kurt Weill: The Threepenny Opera* (Cambridge: Cambridge University Press, 1990), 56.

2. George Davis interview with Hauptmann, Series 37, box 1, folder 11, WLRC.

3. Hinton, *Kurt Weill: The Threepenny Opera*, 56.

4. Ernst Josef Aufricht, *Erzähle, damit du dein Recht erweist* (Munich: Deutscher Taschenbuch Verlag, 1969), 69.

5. Fischer wrote a newspaper article (newspaper name is undocumented) that can be found at the BBA 985.

6. Harry Clément Ulrich Kessler's articulate diaries have provided a wealth of information about the artistic and theatrical life during the Weimar Republic. See Hinton, *Kurt Weill: The Threepenny Opera*, 56.

7. Their new address was Bayernallee 14.

8. Weill wrote to his publishers about the piano on October 2, 1928. Elmar Juchem, the associate director for publications and research at the Kurt Weill Foundation for Music, confirmed that the offer came from a piano store in Berlin.

9. Hans W. Heinsheimer, *Best Regards to Aida* (New York: Alfred A. Knopf, 1968), 139. The lyrics and tune for Weill's little ditty were made up as he was enjoying his new car.

10. Eva Rosenhaft, "Brecht's Germany: 1898–1933," in Peter Thomson and Glendyr Sacks, eds., *The Cambridge Companion to Brecht* (Cambridge: Cambridge University Press, 1994), 3. In this essay, Rosenhaft quotes Canetti, who was one of the left-wing friends who criticized Brecht's association with the advertising industry.

11. Entry of September 15, 1920, in Bertolt Brecht, *Diaries 1920–1922*, edited by Herta Ramthun and translated by John Willett (New York: St. Martin's Press, 1979), 49.

12. In 1928, 200 marks was worth about $50.

13. Weill to Universal Edition, October 2, 1928, Series 41, WLRC.

14. Weill rhapsodized about food in a letter to his brother Hans in mid-July 1917, Series 45, WLRC.

15. Brecht to Bernard von Brentano, letter 402, in Bertolt Brecht, *Briefe 1: Große kommentierte Berliner und Frankfurter Ausgabe*, Band 28 (Berlin: Aufbau-Verlag, 1998), 310. In this letter, Brecht discusses his reading plans with Brentano and asks for advice about how to educate himself about dialectical materialism. For the plot of the unfinished play *Fatzer*, see Frederic Ewen, *Bertolt Brecht: His Life, His Art, and His Times* (New York: Carol Publishing Group, 1992), 187.

16. I am grateful to Kim H. Kowalke, the president of the Kurt Weill Foundation for Music, for sharing his perceptions about Brecht's and Weill's reactions to success. I was inspired by his well-phrased description of the contrast as one between embarrassment and joy.

17. Letter 404 in Brecht, *Briefe 1*, 311. This letter is also at BBA E12/116.

18. The Dreiser play was *The Hand of the Potter*.

19. The two other plays were Johann Nestroy's *The Lass from the Suburb, or Honesty Is the Best Policy*, at the Renaissance Theater, directed by Jürgen Fehling; and *Oedipus* at the State Theater, directed by Leopold Jessner.

20. Letter 407 in Brecht, *Briefe 1*, 313. Also at the BBA E12/120.

21. An official document was filed to register her withdrawal. It is called an *Austrittserklärung* (withdrawal document) and was submitted to the Jewish community on September 26, 1928. The document is on file at the HWA, Laufnummer 155, Vorl 5209.

22. Brecht to Weigel, letter 404, end of September 1928, in Brecht, *Briefe 1*, 311.

23. In particular, Hauptmann translated Ferdinand Reyher's play *Don't Bet on Fights*.

24. Sabine Kebir, *Ich fragte nicht nach meinem Anteil: Elisabeth Hauptmanns Arbeit mit Bertolt Brecht* (Berlin: Aufbau-Verlag, 1977), 106.

25. Alfred Kerr, *Die Welt im Drama* (Cologne and Berlin: Kiepenheuer & Witsch, 1954), 172. Kerr's review was perceptive in noticing Lenya's talent, but by placing her accent in Munich, rather than Vienna, he mistook her origin by about 270 miles.

26. David Farneth, ed., *Lenya, the Legend: A Pictorial Autobiography* (Woodstock, NY: The Overlook Press, 1998), 62.

27. Kim H. Kowalke, Joanna Lee, and Edward Harsh, eds., *Mahagonny: A Sourcebook* (New York: Kurt Weill Foundation for Music, 1995), 26. Weill's quote was first published in "Zeitoper," *Melos* 7 (March 1928).

28. Ernst Bloch, "The Threepenny Opera," in Hinton, *Kurt Weill: The Threepenny Opera*, 137.

29. Ibid., 135.

30. Foster Hirsch, *Kurt Weill on Stage: From Berlin to Broadway* (New York: Limelight Editions, 2003), 51. Hirsch is quoting John Oser, the sound engineer for the film version of *The Threepenny Opera*.

31. Hannah Arendt, *Men in Dark Times* (Orlando, FL: Harcourt Brace Jovanovich, 1968), 335.

32. Theodor Wiesengrund-Adorno, "The Threepenny Opera," in Hinton, *Kurt Weill: The Threepenny Opera*, 130.

33. Kim H. Kowalke, "Accounting for Success: Misunderstanding *Die Dreigroschenoper*," *The Opera Quarterly* 6, no. 3 (Spring 1989): 27.

34. Adorno, "The Threepenny Opera," 129.

35. Hinton, *Kurt Weill: The Threepenny Opera*, 56. Jhering's often-quoted remark was originally published in his newspaper, the *Berliner Börsen-Courier*.

36. Ibid., 57.

37. This often-cited "interview" Brecht conducted with himself is quoted in Kim H. Kowalke, "*The Threepenny Opera* in America," in ibid., 78.

38. Vorl 985, BBA.

39. Jürgen Schebera, *Kurt Weill: An Illustrated Life*, translated by Caroline Murphy (New Haven, CT: Yale University Press, 1995), 117.

40. Ibid., 118.

41. One month after the premiere, there was just the sort of bloody public clash that Goebbels supported. A National Socialist convention had taken place in the enormous Sportpalast (which could hold up to fourteen thousand) and it had been disrupted by the Communists. Twenty-two people were injured and ninety-three people were arrested.

42. John Willett, *Brecht in Context* (London: Methuen London Ltd, 1998), 91.

43. Kowalke, "Accounting for Success": 31 and 34.

44. Weill to Universal Edition, October 14, 1929, Series 41, WLRC.

45. Ibid., September 8, 1928.

46. Ibid., October 1928.

47. In chapter 8, it is made clear that Weill was quite aware that the power of the song was in the contrast between the text and the lyrics: According to Weill, "the charm of the piece rests precisely in the fact that a rather risqué text . . . is set to music in a gentle, pleasant way" (Hinton, *Kurt Weill: The Threepenny Opera*, 6).

48. Lenya, in her foreword to Bertolt Brecht, *The Threepenny Opera*, translated by Desmond Vesey and Eric Bentley (New York: Grove Press, 1949, 1955, 1960), xiv.

49. Alan Rich interview with Abravanel, 1981, Series 60, 19, WLRC.

50. Schebera, *Kurt Weill: An Illustrated Life*, 87. Bie was an influential music critic in Germany who wrote reviews for the *Berliner Börsen-Courier*, as well as for *Die Welt*.

51. Weill's article was published in the *Berliner Tageblatt* on Christmas Day of 1928; see Kim H. Kowalke, "Singing Brecht vs. Brecht Singing: Performance in Theory and Practice," *Cambridge Opera Journal* 5, no. 1: 55–56.

52. Kim H. Kowalke, *Kurt Weill in Europe* (Ann Arbor: University of Michigan Research Press, 1979), 67.

53. "The Premiere and After," in Hinton, *Kurt Weill: The Threepenny Opera*, 58.

54. Heinsheimer, *Best Regards to Aida*, 122, and 128–29.

55. Weill to Abravanel, late 1928, Series 30. WLRC. Weill's close relationship with Abravanel is indicated by his use of the familiar *du*. He never, for example, used *du* with Brecht. They remained on the formal *Sie* for their entire working relationship.

56. Letter 141, September or October 1928, in Bertolt Brecht, *Letters 1913–1956*, edited by John Willett and translated by Ralph Manheim (New York: Routledge, 1990),120.

57. Details about the Berlin im Licht festival can be found in David Farneth with Elmar Juchem and Dave Stein, *Kurt Weill: A Life in Pictures and Documents* (Woodstock, NY: The Overlook Press, 2000), 43.

58. Schebera, *Kurt Weill: An Illustrated Life*, 131.

CHAPTER 11　**THE BEGINNING OF THE END**

1. It wasn't only Brecht and Weill who had to figure out their identity in the light of the huge commercial success of *Threepenny*. Aufricht also had his idealistic dreams. He had begun with an experimental theater group and was eager to promote riskier productions. After he moved *Threepenny* to another theater, Aufricht produced, among others, Peter Martin Lampel's *Poison Gas over Berlin*. It had pacifist themes and the chief of police threatened to close the theater. Brecht defended Aufricht at that time. From then on, Aufricht became a valiant fighter against censorship.

2. Fleisser's *Purgatory in Ingolstadt* was produced in Berlin in 1926. It was at this time that Brecht and she had an affair. He was very involved in the production of her play and had even insisted upon a part for Weigel. See chapter 3 for more details.

3. Fleisser was less than happy about the outraged response to her play. In particular, she was dismayed to be cruelly ostracized in her hometown. She revised the play years later. For more details, see the introduction to Marieluise Fleisser, *Pioneers in Ingolstadt*, edited by David Horton (Manchester: Manchester University Press, 1992).

4. Herbert Jhering wrote in the *Berlin Börsen-Courier:* "Already at the second performance several scenes were cut. By what authority did the police demand this? A detective is said to be monitoring the performance tonight. Will there be yet further changes made as a result of his demands? This is Berlin, 1929." See also *Lenya*, the book that accompanies *Lenya*, an 11-CD set (Bear Family Records, 1998), 29.

5. Hiltrud Häntzschel, *Brechts Frauen* (Reinbek bei Hamburg: Rowohlt Verlag, 2002), 110–11.

6. Under German law, if the parents are not legally married, a child is given the last name of its mother. The father's name is given only to children whose parents are married.

7. Weigel's quote was reported by James K. Lyon in an interview with Weigel's daughter, Barbara Brecht-Schall, in International Brecht Society, *The Brecht Yearbook: Helene Weigel 100*, vol. 25, edited by Judith Wilke (Madison: University of Wisconsin Press, 2000), 30–32.

8. Carola Stern, *Männer lieben anders: Helene Weigel und Bertolt Brecht* (Reinbek bei Hamburg: Rowohlt Taschenbuch Verlag, 2000), 31.

9. David Farneth, ed., *Lenya, the Legend: A Pictorial Autobiography* (Woodstock, NY: The Overlook Press, 1998), 65.

10. Hauptmann's attempted "suicide" is stated as fact in, among many publications, Werner Hecht, *Brecht Chronik* (Frankfurt am Main: Suhrkamp Verlag, 1997); John Fuegi, *Brecht & Co.: Sex, Politics, and the Making of the Modern Drama* (New York: Grove Press, 1994); and Elisabeth Hauptmann, *Lesebuch* (Cologne: Nyland-Stiftung, 2004).

11. Hauptmann, *Lesebuch*, 45–54. The title comes from the Bible: Genesis, the first book of Moses, in the section called "The Fall of Man." The story was first published in the magazine *UHU* 5, no. 6 (March 1929).

12. Hauptmann, *Lesebuch*, 121–28. The original German is as follows: "Fast drei Jahre wohnte sie nun schon in dieser Stadt—das waren etwa hundertfünfzig Sonntage. Hundert- fünfundzwanzig Sonntage war sie davon allein gewesen, den ganzen Tag, und manchmal hatte sie gedacht, sie ertrage es nicht mehr. Einmal hatte sie es auch nicht mehr ertragen, es war da noch mehr zusammengekommen, aber das war nicht in dieser Wohnung gewesen, sondern in einem kleinen Loch von einem Zimmer, da hatte sie Pech gehabt: es hatte jemand ausgerechnet in jener Nacht in dem Gebäude gearbeitet und hatte sie anscheinend stöhnen gehört. Und dann war der Arzt gekommen, und in drei Tagen war sie wieder beieinander."

13. A notable exception to the trove of scholars who document Hauptmann's suicide attempt as a fact is Hiltrud Häntzschel. I was delighted to discover her healthy skepticism in her excellent book *Brechts Frauen*, 172–73.

14. This was stated by Werner Hecht in a 2011 interview with the author. He knew Hauptmann, and although she had not mentioned her suicide attempt directly to him, he heard that she had hinted about it to other friends.

15. Hauptmann was in charge of the monumental task of organizing the chronological order of Brecht's poetry. While her zeal for accuracy is legend, there is evidence that she deliberately rearranged the order of at least one poem, perhaps in order to generate one final mystery.

For example, in Brecht's poem "Es war leicht," he wrote about her, and as if from her point of view. One line reads: "I opened the gas oven five minutes before he came. I borrowed money in his name: it didn't help . . . one morning I stood up . . . and said to myself: it is over. The truth is: I still slept with him two more times, but by God and my mother: it was nothing." (For the full text of the poem, see Hauptmann, *Lesebuch*, 130.) Since this poem so clearly references suicidal thoughts, it has sometimes been suggested that Brecht slipped this under her door just after she recovered from her own attempt. To contribute to the mystery, Hauptmann rearranged the poem to make it seem as though it was written in 1932. In the current compilation of Brecht's work—*Briefe 1: Grosse Kommentierte Berliner und Frankfurter Ausgabe*, Band 28 (Berlin: Aufbau-Verlag, 1998)—the poem is dated 1926/1927. Neither

date, 1926/1927 nor 1932, connects the poem to the alleged 1929 suicide attempt. For more details, see Sabine Kebir, *Ich fragte nicht nach meinem Anteil: Elisabeth Hauptmanns Arbeit mit Bertolt Brecht* (Berlin: Aufbau-Verlag, 1977), 261n.

The attention paid to Hauptmann's literary clues is most pronounced by theories that have been attached to her chronological rearrangement of yet another poem by Brecht. With lines like "Don't ask for your part" or "Don't ask if you are popular . . . when you are needed," many believe that "The Essential One" was written to and about her, but because she chose, after his death, to place it among work written in 1932, rather than among his far earlier poems, rumors have flourished. (For the full text of the poem, see Hauptmann, *Lesebuch*, 32.) Although she placed the poem long after the year of her alleged suicide attempt—and it was likely written several years before—this rearrangement is a clue as to how the normally accurate Hauptmann occasionally placed Brecht's poems to camouflage her role in his life. In this case, she claimed that the poem was written to the entire collective in 1932—at a time when his creative *Mitarbeiter* were starting to pull away in the emerging political and artistic chaos of the times. Many believe that the poem was written specifically to her.

16. Hesse-Burri had worked with Brecht in Munich.

17. The *Versuche* was first published by Kiepenheuer, and Brecht continued publishing his works in its simple gray volumes until he left Germany. It was published again, beginning in 1949 when Brecht returned to Germany. Suhrkamp is the publisher of the later volumes.

18. Letter 146, in Bertolt Brecht, *Letters 1913–1956*, edited by John Willett and translated by Ralph Manheim (New York: Routledge, 1990), 123–24.

19. Both Brecht and Hauptmann were enthralled with George Bernard Shaw's *Major Barbara*, which had been published in 1906.

20. Margaret Mynatt arrived in Berlin as Bianca Minotti. She was a journalist, and worked for *Die Rote Fahne* as a junior crime reporter. She became a committed Communist for her entire life. She worked closely with Brecht on several projects, and also became a lifelong friend to Hauptmann, even after moving to England in the 1930s.

The description of the women dressing up and visiting Salvation Army headquarters can be found in Kebir, *Ich fragte nicht nach meinem Anteil,* 109. Kebir is quoting the interview with Hauptmann from the film *Die Mitarbeiterin.*

21. Hauptmann to Hesse-Burri, March 29, 1965, EHA219.

22. Felix Jackson, "Portrait of a Quiet Man: Kurt Weill, His Life and His Times," unpublished manuscript, WLRC, 84.

23. Alan Rich, Kim Kowalke, and Lys Symonette interview with Abravanel, 1979, Series 60, 21, WLRC.

24. Originally published by Weill in the *Münchener Illustrierte Press*, April 14, 1929; reprinted on the cover page of Kurt Weill and Lotte Lenya, *Speak Low (When You Speak Love): The Letters of Kurt Weill and Lotte Lenya*, edited and translated by Lys Symonette and Kim H. Kowalke (Berkeley and Los Angeles: University of California Press, 1996).

25. Rich, Kowalke, and Symonette interview with Abravanel, 21.

26. Ibid., 29.

27. Erdmut Wizisla, *Walter Benjamin and Bertolt Brecht: The Story of a Friendship* (New Haven, CT: Yale University Press, 2009), 6; originally published in Fritz Sternberg, *Der Dichter und die Ratio: Erinnerungen an Bertolt Brecht* (Göttingen: Sachse & Pohl, 1963), 25.

28. Ibid.

29. *Berliner Tageblatt,* May 3, 1929; a copy of the article is in BBA 5/205/24–25.

30. Letter 378, written in 1939, in Brecht, *Letters 1913–1956*, 295.

31. Frederic Ewen, *Bertolt Brecht: His Life, His Art, and His Times* (New York: Carol Publishing Group, 1992), 177–78.

32. Weill, "Deutschland Erwache," *General-Anzeiger für Dortmund*, December 21, 1930, in David Farneth, with Elmar Juchem and Dave Stein, *Kurt Weill: A Life in Pictures and Documents* (Woodstock, NY: The Overlook Press, 2000), 115.

33. Josef Heinzelmann, liner notes for *Kurt Weill: Der Lindberghflug and The Ballad of Magna Carta* (Capriccio, 1990), 18.

34. Roswitha Mueller, "Learning for a New Society: The *Lehrstück*," in Peter Thomson and Glendyr Sacks, eds., *The Cambridge Companion to Brecht* (Cambridge: Cambridge University Press, 1994), 83.

35. Wizisla, *Walter Benjamin and Bertolt Brecht*, 7 and 143.

36. Mueller, "Learning for a New Society: The *Lehrstück*," 85.

37. I am grateful to Elmar Juchem, of the Kurt Weill Foundation for Music, for his insights on the co-composing debacle of Weill and Hindemith.

38. Weill to Universal Edition, in Jürgen Schebera, *Kurt Weill: An Illustrated Life*, translated by Caroline Murphy (New Haven, CT: Yale University Press, 1995), 133.

39. In addition to the uncomfortable division of songs for the Lindbergh play, Brecht also wrote an entirely different *Lehrstück*, titled *Badener Lehrstück vom Einverständnis* (The Baden Learning Play on Consent), with Hindemith as the only composer. The program at the 1929 German music festival concluded with this play.

It was Brecht and Hindemith's separate work that caused the biggest scandal at the festival—not so much because of the music, but because, in this play, Brecht decided to present a gruesome display of airmen who had crashed. They sawed each other's legs off and used a great deal of fake blood, causing one critic to faint during the performance. The famous playwright Gerhard Hauptmann walked out in disgust. Hindemith tried to have the goriest scenes removed, but Brecht refused. The work was ultimately withdrawn.

40. Stephen Hinton, *Weill's Musical Theater: Stages of Reform* (Berkeley and Los Angeles: University of California Press, 2012), 18–19.

41. The critic was Heinrich Strobel, quoted in Schebera, *Kurt Weill: An Illustrated Life*, 136.

42. Weill to Universal Edition, August 2, 1929, Series 41, WLRC.

43. EEA 152.

44. See Schebera, *Kurt Weill: An Illustrated Life*, 142. For further details about the influence of Kipling on the lyrics for this song, or on its placement in *Mother Courage*, see Paula Hanssen, *Elisabeth Hauptmann: Brecht's Silent Collaborator* (Bern: Peter Lang, Inc., 1995), 2.

45. Lenya sang and recorded this song many times over the course of her long career. Her rendition in many ways offers the signature version of the song.

46. Schebera, *Kurt Weill: An Illustrated Life*, 143.

47. Ernst Josef Aufricht, *Erzähle, damit du dein Recht erweist* (Munich: Deutscher Taschenbuch Verlag, 1969), 85.

48. Ibid., 86.

49. Farneth, *Lenya, the Legend*, 65–66.

50. EEA 128.

51. Letter 421, written at the end of August 1929, in Brecht, *Briefe 1*, 324. Brecht and Engel did not work together again until years later, after the playwright's exile during World War II had ended. In the 1950s, they became close colleagues again. After Engel left, Brecht consulted with the director Bernhard Reich, who was a regular in Brecht's collective.

52. The songs from *Happy End* were indeed very successful on their own—especially "Surabaya Johnny," which has been sung by Bette Midler, Marianne Faithfull, Bebe Neuwirth, and Anne Sofie von Otter, among others.

53. Letter 320 in Brecht, *Briefe 1*, 261.

54. Lingen was in the scandalous play that Brecht did with Hindemith alone, *Badener Lehrstück vom Einverständnis*. Given Brecht's initial opposition to Lingen when he became involved with Zoff, this artistic alliance is significant. It highlights Brecht's ability to form relationships with people even after a prolonged period of controversy.

55. Jackson, "Portrait of a Quiet Man," 117. This description is also quoted in Rolf Aurich and Wolfgang Jacobsen, *Theo Lingen: Das Spiel mit der Maske* (Berlin: Aufbau Verlag, 2009), 74. The authors cite a 1970 letter from Lingen to Weigel, in which he describes the rehearsals for *Happy End*.

56. Aufricht, *Erzähle, damit du dein Recht erweist*, 87–88.

57. Jackson, "Portrait of a Quiet Man," 119.

58. Stephen Hinton, ed., *Kurt Weill: The Threepenny Opera* (Cambridge: Cambridge University Press, 1990), 57.

59. Bertolt Brecht and Kurt Weill, *Happy End*, lyrics adapted by Michael Feingold (New York: Samuel French, Inc., 1982), 71. Originally produced in 1929. The translation is advertised as "loose," and since this edition cites the fictional Dorothy Lane, Hauptmann's name is not mentioned. Brecht is credited for the lyrics only.

60. Hinton, *Weill's Musical Theater*, 122–23.

61. Hanssen, in *Elisabeth Hauptmann: Brecht's Silent Collaborator*, 39–40, suggests her reasons for believing that the speech was written by Hauptmann.

62. *Berliner Tageblatt*, September 3, 1929; reprinted in Alfred Kerr, *Die Welt im Drama* (Cologne and Berlin: Kiepenheuer & Witsch, 1954), 175–77.

63. *Berliner Börsen-Courier*, September 3, 1929. (Translation by Anja Marquardt.)

64. *Die Rote Fahne*, September 2, 1929.

65. Weill to Universal Edition, October 14, 1929, in Kim H. Kowalke, Joanna Lee, and Edward Harsh, eds., *Mahagonny: A Sourcebook* (New York: Kurt Weill Foundation for Music, 1995), 22.

66. After a variety of incorrect guesses, Elmar Juchem finally established the precise run of *Happy End*.

67. Ronald Sanders, *The Days Grow Short: The Life and Music of Kurt Weill* (Hollywood: Silman-James Press, 1980), 144.

68. Owen D. Young had presented a plan for Germany's final reparations. The loan was payable over fifty-nine years and was to end in 1987. The Young Plan had reduced the repayment that had become untenable over the years. But Wall Street crashed between the agreement and the adoption of the plan, and the credits that had made the plan possible were canceled.

69. Bertolt Brecht, *The Rise and Fall of the City of Mahagonny*, edited by John Willett and Ralph Manheim, translated by W. H. Auden and Chester Kallman (New York: Arcade Publishing, 1996), 111.

70. Ibid., 37. There is some controversy about the origin of the lyrics for this song and details can be found in Willett's notes on page 112. According to the musicologist David Drew, the lyrics were based on the 1928 Brecht poem "Die Liebenden" (The lovers). Willett believes this is unlikely as no such Brecht poem from that time is known.

71. For further details about the role of the "Cranes' Duet" in the history of the *Mahagonny* opera, see David Drew, *Kurt Weill: A Handbook* (Berkeley and Los Angeles: University of California Press, 1987), 185. "Cranes' Duet" is omitted in produc-

tions, since its role in the opera is controversial. Drew, for example, believes that the "truthfulness" of the opera is greatest when the song is omitted.

72. *Saint Joan of the Stockyards* was not performed during Brecht's lifetime. It was first broadcast as a radio piece in 1932. Its first theatrical performance was in 1959, in which Brecht's daughter Hanne played Joan.

73. Hauptmann's new address was Berlinerstrasse 45; EHA 1276. Häntzschel, in her *Brechts Frauen*, 172, reports that due to the particular arrangement of the telephone company in 1929, Hauptmann and Brecht still shared the same telephone number.

CHAPTER 12 **IF SOMEONE'S GETTING KICKED, IT'LL BE YOU**

1. The hurricane in Pensacola replaced the earthquake in Benares—the latter was a feature of the shorter *Songspiel*.

2. Kim H. Kowalke, *Kurt Weill in Europe* (Ann Arbor: University of Michigan Research Press, 1979), 57.

3. Felix Jackson, "Portrait of a Quiet Man: Kurt Weill, His Life and His Times," unpublished manuscript, WLRC, 110.

4. In addition to Brecht's collaboration with Hindemith on *Der Lindberghflug* and *Badener Lehrstück vom Einverständnis,* Brecht had also just begun to work with another composer, Hanns Eisler, in February of that same year. They were collaborating on a play with music titled *Die Maßnahme (The Measures Taken).*

5. Weill to Emil Hertzka, December 27, 1927, Series 41, WLRC.

6. Quote from Weill's article in *Melos* in Kowalke, *Kurt Weill in Europe,* 482.

7. Quote from Weill's 1929 letter to Universal Edition in Jürgen Schebera, *Kurt Weill: An Illustrated Life,* translated by Caroline Murphy (New Haven, CT: Yale University Press, 1995), 154–55.

8. After the full-length opera was completed and performed, the shorter *Mahagonny Songspiel* was given the title *Das kleine Mahagonny.*

9. The most prominent fugitive in the opera is a woman named Begbick, the same name given to a similar female character in Brecht's *A Man's a Man.*

10. Heinsheimer to Weill, October 10, 1929, Series 41, WLRC.

11. Weill's exchange with Heinsheimer was published in the journal *Anbruch* in 1928; this letter is excerpted in Stephen Hinton, ed., *Kurt Weill: The Threepenny Opera* (Cambridge: Cambridge University Press, 1990), 124.

12. Ronald Sanders, *The Days Grow Short: The Life and Music of Kurt Weill* (Hollywood: Silman-James Press, 1980), 149.

13. Erdmut Wizisla, *Walter Benjamin and Bertolt Brecht: The Story of a Friendship* (New Haven, CT: Yale University Press, 2009), 67.

14. Jackson, "Portrait of a Quiet Man," 150–51.

15. For more details about the changing of the names, see Schebera, *Kurt Weill: An Illustrated Life,* 155.

16. Weill to Universal Edition, December 31, 1929, Series 41, WLRC.

17. Jackson, "Portrait of a Quiet Man," 152.

18. Hans W. Heinsheimer, *Best Regards to Aida* (New York: Alfred A. Knopf, 1968), 130.

19. Michael Feingold translation, *Rise and Fall of the City of Mahagonny,* Los Angeles Opera, recorded in 2007, DVD distributed by EuroArts.

20. From Hans Gutman's 1930 essay for *Modern Music,* reprinted in Kim H. Kowalke, Joanna Lee, and Edward Harsh, eds., *Mahagonny: A Sourcebook* (New York: Kurt Weill Foundation for Music, 1995), 34.

21. Feingold translation, *Rise and Fall of the City of Mahagonny.*

22. Schebera, *Kurt Weill: An Illustrated Life,* 152.

23. Kowalke, Lee, and Harsh, *Mahagonny: A Sourcebook,* 34.

24. Feingold translation, *Rise and Fall of the City of Mahagonny.*

25. Jackson, "Portrait of a Quiet Man," 155.

26. The critic Alfred Einstein quoted in Schebera, *Kurt Weill: An Illustrated Life,* 158.

27. Feingold translation, *Rise and Fall of the City of Mahagonny.*

28. Lenya is quoted in Schebera, *Kurt Weill: An Illustrated Life,* 156.

29. Heinsheimer is quoted in Kowalke, Lee, and Harsh, *Mahagonny: A Sourcebook,* 31.

30. Stuckenschmidt is quoted in Kowalke, *Kurt Weill in Europe,* 61.

31. Polgar's famous, often-quoted account, published on March 22, 1930, can be found in Kowalke, Lee, and Harsh, *Mahagonny: A Sourcebook,* 31.

32. Feingold translation, *Rise and Fall of the City of Mahagonny.*

33. Jackson, "Portrait of a Quiet Man," 156.

34. Weill to Universal Edition, March 14, 1930, Series 41, WLRC. The newspapers "of all political persuasions" that he lists are: "On the right: *Leipziger Neueste Nachrichten, Münchener Neuste Nachrichten, Rheinisch-Westfälische, Kasseler Post, Börsenzeitung, Deutsche Tagezeitung.* In the middle: *B.Z., Tempo, Tageblatt, Börsencourier, 12Uhr-Blatt, Morgenpost,* many provincial papers. Left: *Vorwärts, Welt am Abend, Leipziger Volkszeitung* and many others."

35. These hostile reviews are quoted in Schebera, *Kurt Weill: An Illustrated Life,* 156–57.

36. Kim H. Kowalke, "Reflections on the Silver Lake," liner notes for *Kurt Weill: Silverlake (A Winter's Tale),* New York City Opera, recorded in 1980, Nonesuch Records.

37. The information about the train robber was provided by Elmar Juchem's translation of a full-page appeal published by the Berlin Press Service in the *General-Anzeiger für Dortmund* on December 21, 1930, titled "Germany, Awake! On the Occasion of the Berlin Rallies Against the Abuse of Intellectual and Artistic Freedom—Call for a Unified Front in the Battle Against the Cultural Reaction."

38. Weill to Universal Edition, October 21, 1930, Series 41, WLRC.

39. Ibid., March 20, 1930.

40. Ibid., October 10, 1929.

41. It was Weill who coined the sardonic description of Mahagonny as a "paradise city."

42. Bertolt Brecht, *The Rise and Fall of the City of Mahagonny,* edited by John Willett and Ralph Manheim and translated by W. H. Auden and Chester Kallman (New York: Arcade Publishing, 1996), 91.

43. Weill published his introduction to the promptbook a few weeks before the premiere in Leipzig in the journal *Die Musik* 22, no. 6 (March 1930): 29.

44. See chapter 11 for further details about Brecht's journal, *Versuche.*

45. Brecht published his notes and his revised version of the libretto in August 1930, more than five months after the premiere.

46. Brecht's notes are printed in their entirety in Bertolt Brecht, *Brecht on Theatre: The Development of an Aesthetic,* edited and translated by John Willett (New York: Hill and Wang, 1964), and also quoted at length in David Drew's astute article "Struggling for Supremacy: The Libretto of *Mahagonny*," *Kurt Weill Newsletter* 27, no. 2 (Fall 2009). This particular quote is on page 8, but I am also grateful for, and indebted to, Drew's astute analysis of the change in dynamic that occurred during and after the premiere of *Mahagonny.*

47. Brecht, *Brecht on Theatre,* 35.

48. Brecht, *The Rise and Fall of the City of Mahagonny,* 92.

49. Brecht, *Brecht on Theatre*, 38 and 41.

50. Weill included these remarks in his foreword to the production book for the opera, reprinted in Kowalke, Lee, and Harsh, *Mahagonny: A Sourcebook*.

51. This quote also comes from Weill's foreword to the production book; see Stephen Hinton, *Weill's Musical Theater: Stages of Reform* (Berkeley and Los Angeles: University of California Press, 2012), 149.

52. Once again, I am indebted to Drew's astute analysis in "Struggling for Supremacy" with regard to Brecht's culinary theory about the so-called opera "experiment."

53. Brecht's notes about *Mahagonny* have been read, quite literally, as the virtual Bible about the epic theater, rather than as an attempt to regain creative control. As Drew puts it in "Struggling for Supremacy," in describing Brecht's face-saving attempt to refashion the purpose of the opera in his notes: "It was a shrewd gamble, and for many years it paid off."

54. For an in-depth discussion of this point, see Kim H. Kowalke, "Brecht and Music: Theory and Practice," in *The Cambridge Companion to Brecht,* edited by Peter Thomson and Glendyr Sacks (Cambridge: Cambridge University Press, 1994), 227.

55. Weill to Universal Edition, March 14, 1930, Series 41, WLRC.

56. Eric D. Weitz, *Weimar Germany: Promise and Tragedy* (Princeton, NJ: Princeton University Press, 2007), 123. Weitz offers an in-depth description of Brüning's actions and their significance.

57. Brecht, *Brecht on Theatre*, 135.

58. Weill's famous letter is quoted in David Farneth with Elmar Juchem and Dave Stein, *Kurt Weill: A Life in Pictures and Documents* (Woodstock, NY: The Overlook Press, 2000), 63.

59. Jackson, "Portrait of a Quiet Man," 168.

CHAPTER 13 **LAST TIME IN GERMANY**

1. Weill is quoted in Kim H. Kowalke, *Kurt Weill in Europe* (Ann Arbor: University of Michigan Research Press, 1979), 520, as follows: "When the present generation of school children has grown up, the audience I'm counting on will exist."

2. Jürgen Schebera, liner notes for *Kurt Weill: Der Jasager/Down in the Valley* (Capriccio, 1991), 15–16.

3. Hauptmann translated six classical Japanese Noh plays, using Arthur Waley's English translations, including *Taniko.*

In many ways, Brecht's epic theater owes a great deal to the concept of Japanese Noh theater. For a further discussion of this relationship, see *Brecht and East Asian Theatre: The Proceedings of a Conference on Brecht in East Asian Theatre,* edited by Antony Tatlow and Tak-Wai Wong (Hong Kong: Hong Kong University Press, 1982).

4. Even before Brecht knew about Hauptmann's translation, she published it in the December 1929 issue of *Der Scheinwerfer,* which was run by Johannes Kupper. She was paid 40 marks for her translation, the only money she ever earned for her work on the project.

5. Hauptmann described the process of adapting *Taniko* into *The Yes-Sayer:* "Brecht's biggest contribution was the idea of acquiescence . . . Brecht did another draft and changed the ending . . . it was very fast." See Sabine Kebir, *Ich fragte nicht nach meinem Anteil: Elisabeth Hauptmanns Arbeit mit Bertolt Brecht* (Berlin: Aufbau-Verlag, 1977), 151; Kebir is quoting Hauptmann in *Die Mitarbeiterin.*

6. The other woman was another short-lived colleague of Brecht's, Marieluise Fleisser, the author of *Purgatory in Ingolstadt* and *Pioneers of Ingolstadt.* "New Women in Literature," was published on May 19, 1930, accompanied by two photos, one of Fleisser and one of Hauptmann.

7. Brecht is quoted in Peter Brookner, "Key Words in Brecht's Theory and Practice of Theatre," in *The Cambridge Companion to Brecht*, edited by Peter Thomson and Glendyr Sacks (Cambridge: Cambridge University Press, 1994), 189.

8. *Die Maßnahme* is in the form of a cantata. A "control chorus" addresses four agitators who have returned from a mission and report that one of their men had to be killed in order to complete the mission. They had to take "measures" to protect the mission.

9. Roswitha Müller, "Learning for a New Society: The *Lehrstück*," in *The Cambridge Companion to Brecht*, 90.

10. Funding for the arts in Germany was then, and continues to be, organized according to geographical boundaries. This harks back to the days of the monarchy, when each duke chose the artists they wanted to support in their duchy. The transfer from royalty to a democracy upheld this local approach to cultural subsidies. Therefore, when Hindemith's modern music festival changed venues, from Baden-Baden to Berlin, the sources of government funding changed accordingly. The Prussian authorities in charge of cultural subsidies in Berlin were very conservative, and it was their negative influence to which Brecht was objecting.

11. Brecht's letter is quoted in Ronald K. Shull, "Music and the Works of Bertolt Brecht: A Documentation," unpublished manuscript, WLRC, 562.

12. Kowalke, *Kurt Weill in Europe*, 77.

13. Jürgen Schebera, *Kurt Weill: An Illustrated Life*, translated by Caroline Murphy (New Haven, CT: Yale University Press, 1995), 173–74. The "war" referred to in the review was, of course, World War I.

14. David Drew, *Kurt Weill: A Handbook* (Berkeley and Los Angeles: University of California Press, 1987), 229.

15. Kurt Weill and Lotte Lenya, *Speak Low (When You Speak Love): The Letters of Kurt Weill and Lotte Lenya*, edited and translated by Lys Symonette and Kim H. Kowalke (Berkeley and Los Angeles: University of California Press, 1996), 64.

The Yes-Sayer is no longer very well known in the United States, but there are many people who think it was one of Brecht and Weill's finest collaborations. Among them are John Willett, who wrote: "*He Said Yes* marked the creative peak of the Brecht-Weill collaboration, and indeed perhaps of the whole 1920's musical movement from which it had sprung. For what was changing was not only individuals and their political interests, but also the politico-artistic context of the times . . ." See John Willett, *Brecht in Context* (London: Methuen London Ltd, 1998), 174.

Weill also believed that *The Yes-Sayer* was his most important European work. His opinion is quoted in Jürgen Schebera, liner notes for *Kurt Weill: Der Jasager/Down in the Valley* (Capriccio, 1991), 16.

16. This anecdote was told by Michael Pabst in a documentary about the filmed version of *The Threepenny Opera* (Criterion Collection, 2007).

17. As early as 1923, Brecht had written several scripts, including one for a short film titled *Mysteries of a Barbershop*, that starred Karl Valentin and was directed by Erich Engel.

18. The full name of Tobis Syndicate was the Tonbild Syndicate Ltd. *Ton* means sound and *Bild* means picture.

19. Ronald Sanders, *The Days Grow Short: The Life and Music of Kurt Weill* (Hollywood: Silman-James Press, 1980), 170.

20. Stephen Hinton, ed., *Kurt Weill: The Threepenny Opera* (Cambridge: Cambridge University Press, 1990), 44.

21. Forster was an established Austrian film star by the time he took on the role of Mackie Messer in Pabst's film.

22. Lania was a playwright who had been one of the early members of Piscator's theater collective, where he initially met and worked with Brecht. As detailed in chapter 6, Weill wrote the music for Lania's 1928 play, *Konjunktur,* about the oil industry.

23. *Saint Joan of the Stockyards* was not performed on the stage in Brecht's lifetime. It was first broadcast as a radio piece in 1932, starring Carola Neher as Joan. Its first theatrical performance was in 1959. In that production, Brecht's daughter Hanne played Joan.

The play was a modern-day interpretation of the tale of Joan of Arc. In this telling, the updated Saint Joan, a member of the Black Straw Hats (a version of the Salvation Army), is placed in the brutal stockyards in a mythical Chicago. Joan tries to convince an evil capitalist to be kind to the poor who work in the stockyards. In turn, he tries to convince her that the poor are wicked too—but she insists they are evil because of their poverty. She comes to realize that change is impossible without violence. At the end of the play, Joan dies of starvation.

24. Bertolt Brecht, *Brecht on Film and Radio,* edited and translated by Marc Silberman (London: A & C Black, 2001), 145. Brecht's quote comes from "Meddling with Poetic Substance," an essay he wrote for the lawsuit proceedings.

25. Ibid., 165. Silberman quotes Brecht on the condescending attitude of filmmakers toward their audience: "Many difficulties in the film industry can be traced simply to the illusion of agents and buyers that they are art experts and public opinion researchers. In reality they usually migrate towards the lowest level of public taste—innumerable films substantiate this thesis."

26. Dudow was a Bulgarian screenwriter and director who came to Germany in 1922, at the age of nineteen. He was Fritz Lang's directing assistant on *Metropolis* and also worked with Piscator. He was a member of the Communist Party in Germany and was thus expelled in 1933.

27. Although on holiday, Brecht was soon joined by Hauptmann and Dudow, and they continued work on *Saint Joan.*

28. Weill to Universal Edition, August 6, 1930, Series 41, WLRC.

29. Ewen, in *Bertolt Brecht: His Life, His Art and His Times,* 188, has an explanation for the title of "The Bruise" (which he translates as a "The Welt" following the British rather than American tradition): "One of Peachum's underlings is beaten up and is given a welt on his head when he tries to interfere with Macheath's henchmen, who are pilfering the furnishings for Macheath and Polly's wedding. Peachum vows revenge, and the welt becomes the symbolic standard of battle and of Macheath's villainy."

30. It is somewhat ironic that Pabst went on working with the left-wing Lania and the Marxist screenwriter Bela Balazs—both of whose politics were at least as radical as Brecht's—to finish the script. Balazs was the son of German Jews but was raised in Hungary. He was a film critic, poet, and librettist, and eventually a screenwriter, sharing Brecht's propensity for writing in a variety of forms. He was a committed Marxist who left Hungary for Germany in 1919, and was a professor in Russia from 1931 until 1945.

Given this situation, Pabst would have been right to say that it was not political problems that forced Brecht out of the project, it was rather a clash of personalities and working styles. Pabst was also clearly in need of one true ally on the screenwriting team, and to that end he hired Ladislaus Vajda, a Hungarian writer with whom he had collaborated on *Pandora's Box.*

31. Sanders, *The Days Grow Short,* 172–73.

32. Kim H. Kowalke, the president of the Kurt Weill Foundation for Music, in the documentary about Pabst's *The Threepenny Opera.*

33. Weill to Universal Edition, August 24, 1930, Series 41, WLRC.

34. For further discussion of musical changes, see Hinton, *Kurt Weill: The Three-penny Opera*, 46.

35. During the extended run of *The Threepenny Opera*, Lenya had played her original role of Jenny, as well as playing Lucy from time to time.

36. Hinton, *Kurt Weill: The Threepenny Opera*, 36. I am indebted to Hinton's insights about the significance of having Jenny sing the "Pirate Jenny" song, which he aptly describes as "a reflection on her initial betrayal of Mac."

37. Since Polly's original song was given to Jenny, she sings the "Barbara Song" at her wedding. This was stylistically consistent with the idea that the songs would be used in a far more literal way. Just as Jenny directly laments her situation with the "Pirate Jenny" song, so Polly explains to the wedding guests why she fell in love with Mackie. Rather than singing to her parents—in a way that would infuriate rather than placate them—she sings a song of love on the day of her marriage. The irony of the lyrics remains, but the placement of the song is far more conventional and direct.

38. Weill to Universal Edition, October 6, 1930, Series 41, WLRC. In addition to his sincere complaints about the film and the way it was handled, it's important to point out that Weill was also eager, in any event, to capitalize on the potential success of the film. On October 12, 1930, just one week before the trial began, he also wrote his publishers: "By the way, the film (though it has hardly anything to do with the content and style of our work) is being given tremendous publicity by Tobis . . . with pictures in all the papers and is already being touted as the greatest talking film sensation, which will naturally be very good for business."

39. Lotte Eisner, *The Haunted Screen* (Berkeley and Los Angeles: University of California Press, 1969), 344.

40. Sanders, *The Days Grow Short*, 174. Brecht's most famous courtroom scenes took place in his plays *A Man's a Man* and *Galileo*, and in the opera *Rise and Fall of the City of Mahagonny*.

41. Brecht is quoted and paraphrased in Müller, "Learning for a New Society," 80–81.

42. Eisner, *The Haunted Screen*, 344–45.

43. Both newspapers are quoted in Brecht, *Brecht on Film and Radio*, 152.

44. The left-wing journal was to be called *Krise und Kritik*. Benjamin, Brecht, and Jhering planned to edit a journal about the "social role of intellectuals, to develop educational ideas and devise a catalogue of writing styles." It was to use Marxist categories like "capitalist pedagogics," "proletarian pedagogics," creation of "classless pedagogics." *Krise und Kritik* was never published, but it is a good example of how much Brecht believed that intellectual pursuits could have an immediate practical and political effect—he dared to hope that such a journal could have "an active, interventionist role, with tangible consequences, as opposed to its usual ineffectual arbitrariness." See Erdmut Wizisla, *Walter Benjamin and Bertolt Brecht: The Story of a Friendship* (New Haven, CT: Yale University Press, 2009), x and 66.

45. Werner Hecht, *Brecht Chronik* (Frankfurt am Main: Suhrkamp Verlag, 1997), 296.

46. Brecht, *Brecht on Film and Radio*, 160.

47. Brecht's quote was originally published in *Versuche* 3 (1931), reprinted in Hinton, *Kurt Weill: The Threepenny Opera*, 44–45.

48. Originally published in *Versuche* 3 (1931), reprinted in Brecht, *Brecht on Film and Radio*, 161.

49. Schebera, *Kurt Weill: An Illustrated Life*, 178.

50. Hinton, *Kurt Weill: The Threepenny Opera*, 45.

51. Ibid.

52. This production of *A Man's a Man* also featured Theo Lingen, who continued to be cast frequently in Brecht's plays. In addition to playing Macheath in the second cast of *Threepenny* in 1929, he continued to play Macheath in productions all over Germany.

53. The film used the numeral in its title to distinguish it from the theatrical version.

54. The film was even more successful in France, where the play had also had a remarkable reception. The French version was so important that it was filmed simultaneously with the German one—with a separate cast of French-speaking actors using the same sets and camera positions.

It was released in the United States a few months later, alongside such American hits as *The Public Enemy* with Jean Harlow and James Cagney. The play was as yet unknown in America and garnered a far different interpretation: "An English synopsis printed in the program characterized the film's hero, Mickie (*sic*) Messer, as 'the Al Capone of olde England' . . . and described the 'Barbarasong' as a 'ditty about a girl who says "No!" until the right man comes along.'" See Kim H. Kowalke, "*Threepenny* in America," in Hinton, *Kurt Weill: The Threepenny Opera*, 79.

55. The phrase "master of the work-in-progress" was coined by Hinton, ibid., 28.

56. *Versuche* was initially published between 1930 and 1932 by Kiepenheuer in Berlin. It was not published again until after the war in 1949. A brief summary of the first four editions are as follows:

Versuche 1 (June 1930) included "Der Flug der Lindberghs," "Radio Theories," "Geschichten vom Herrn Keuner," "Fatzer, 3."

Versuche 2 (1930) included the revised *Rise and Fall of the City of Mahagonny*, notes to the opera, parts of "*Lesebuch* for City Dwellers," and *Badener Lehrstück*.

Versuche 3 (January 1932) included Brecht's new version of *The Threepenny Opera*, "The Notes to *Threepenny*," and "The *Threepenny* Trial: A Sociological Experiment."

Versuche 4 (December 1932) included *The Yes-Sayer* and *The No-Sayer*, as well as the protocol from the discussion that took place in the Karl Marx School, and *The Measures Taken*, along with notes and other documents relating to the play.

Perhaps sensing that time was running out, the *Versuche* 5 also came out in December 1932 and included *Saint Joan of the Stockyards* and other stories from Brecht's Herr Keuner collection.

57. The first lines about robbing a bank are from Fly's speech in Bertolt Brecht and Kurt Weill, *Happy End*, lyrics adapted by Michael Feingold (New York: Samuel French, Inc., 1982), 71.

There are some discrepancies between Feingold's translation, which he defines as follows: "The present version is a free adaptation, which treats the 'Dorothy Lane' script as loosely as the collaborators of 1929 treated their mysterious source. Only the lyrics, whose authorship Brecht never denied, have been kept in more or less literal translation."

In Willett's translation of the same speech, which he included in his version of *The Threepenny Opera* (using the 1931 version, rather than the original from 1928, as the definitive one), he renders the same lines as follows: "What's breaking into a bank compared with founding a bank?" Willett also has the line, "What's murdering a man compared with employing a man?," which seems likely to have followed the first. This line does not follow in Feingold's version. This line can be found in Bertolt Brecht, *The Threepenny Opera*, translated and edited by Ralph Manheim and John Willett (New York: Arcade Publishing, 1994), 76.

Because *Happy End* was taken apart over such a prolonged period of time—for both *Saint Joan* and *Threepenny*—it is sometimes hard to be certain as to which version of the play, and which version of Fly's speech, is accurate to its original. It is my guess

that both lines, the one in Feingold and the one in Willett, were included in the 1931 version of Macheath's final speech.

58. Brecht, *The Threepenny Opera,* Manheim and Willett translation, 37.

59. The revised 1931 *Threepenny* was promoted by Brecht and his heirs as the official version for years to come, especially the additional speech taken from *Happy End* and given to Macheath. This is published in the Manheim and Willett translation but was not present, for example, in Robert Wilson's adaptation, which is very faithful to the 1928 original.

60. This description of the opera comes from Lenya in an interview with Charles Osborne, *The London Magazine* 1, no. 2 (May 1961). Part of the opera was based on a 1774 text by Johann Gottfried Herder, *Der afrikanische Rechtsspruch* (The African verdict); the title refers to a ballad by Friedrich Schiller.

61. Letter 158 in Bertolt Brecht, *Letters 1913–1956,* edited by John Willett and translated by Ralph Manheim (New York: Routledge, 1990), 128–29.

62. Wizisla, *Walter Benjamin and Bertolt Brecht,* 34–35. In a footnote, Wizisla states: "Benjamin was privy to Brecht's complicated personal relationships. In Le Lavandou he observed how Elisabeth Hauptmann and Carola Neher succeeded each other as Brecht's lovers, while his wife Helene Weigel . . . stayed behind in Berlin."

63. Letter 439 in Bertolt Brecht, *Briefe 1: Große kommentierte Berliner und Frankfurter Ausgabe,* Band 28 (Berlin: Aufbau-Verlag, 1998), 336.

64. Ibid., letter 436, 334.

65. On November 11, 1973, Minotti (by then known as Margaret Mynatt) wrote to Hauptmann's sister in America. This letter is one of many that confirm Hauptmann and Minotti's close friendship, as well as the fact that they lived together in the late 1920s and early 1930s. "I have known Frau Radke ever since she first came to work for Elisabeth because at that time I was living in Elisabeth's flat." This letter can be found in box 1/7 of the Mynatt/Kapp Archive in the Special Collections of the Senate House Library, London.

66. Kuhle Wampe was the name of a place in the working-class outskirts of Berlin where the unemployed live in shacks. *Wampe* is Berlin dialect for "belly," and the literal translation of the town has been taken to mean "Empty Belly" (using *kuhle,* which means "cool" to indicate the opposite of the warmth a full stomach can provide).

67. On his blog of December 16, 2002, Alex Ross writes: "In 1933, shortly after the Nazis took power, the Reichstag burned, and the new Reich Chancellor, who had longed to direct opera in his youth, moved the Parliament to the Kroll. From that stage, he delivered several of his most horrific speeches, including the announcement of the annihilation of the Jews."

After the Reichstag burned in 1933, the Kroll Opera House became the assembly hall of the Nazi government. It was severely damaged during the war and demolished in 1951.

68. Charles Osborne interview with Klemperer and Lenya, *The London Magazine* 1, no. 2 (May 1961).

69. Wizisla, *Walter Benjamin and Bertolt Brecht,* 38.

70. The article title is from an English translation by Elmar Juchem of the Kurt Weill Foundation for Music. A reproduction of the article titled "Deutschland Erwache!" is in David Farneth with Elmar Juchem and Dave Stein, eds., *Kurt Weill: A Life in Pictures and Documents* (Woodstock, NY: The Overlook Press, 2000), 115. Juchem supplied the background information regarding the Nazi campaign against *All Quiet on the Western Front.*

71. In order to fully understand the impassioned fury that infused Weill's brave contribution to the newspaper, one need only look at the expression he used to illus-

trate the cowardice of the German officials: he used the phrase *volle Hosen,* which literally means "full pants" and specifically refers to the idea of "peeing in your pants" from fear. Juchem used the following sentence in his translation: "It is this spirit of the wetted pants which has allowed the situation to reach its current level"; ibid.

72. Schebera, *Kurt Weill: An Illustrated Life,* 93.

73. Ernst Josef Aufricht, *Erzähle, damit du dein Recht erweist* (Munich: Deutscher Taschenbuch Verlag, 1969), 109–10.

74. Weill and Lenya, *Speak Low (When You Speak Love),* 65.

75. Weill mentions the collapse of the bank in a letter to Universal Edition, October 7, 1931, Series 41, WLRC.

76. Lenya learned the English lyrics for "Alabama Song" phonetically with help from the linguistically gifted chanteuse Grete Keller. In Lenya's foreword (a reprint of the *Theater Arts* article "That Was a Time!") to Bertolt Brecht, *The Threepenny Opera,* translated by Desmond Vesey and Eric Bentley (New York: Grove Press, 1949, 1955, 1960), she indicates that Keller taught her the song in preparation for the 1927 *Songspiel* version of *Mahagonny,* but this seems unlikely given that Keller only began to study English in 1928, and by her own admission didn't gain proficiency in the language until 1930. This makes a 1931 English coaching for Lenya far more plausible. The information about Keller's language ability was provided by Rupert Henning, who wrote and directed a one-woman show about Keller.

77. Quoted from Gottfried Wagner's interview with Lenya in Weill and Lenya, *Speak Low,* 3.

78. Felix Jackson, "Portrait of a Quiet Man: Kurt Weill, His Life and His Times," unpublished manuscript, Weill-Lenya Research Center, New York, 170.

79. Ibid., 170; this colorful story is corroborated in several other sources, including Aufricht, *Erzähle, damit du dein Recht erweist,* 110. According to Kowalke, *Kurt Weill in Europe,* 148, the reference to Strauss was not meant as a specific comparison between the composers but instead as a way to lament Weill's insistence on the operatic identity of *Mahagonny.*

80. This play is not to be confused with Brecht's later and better-known *Mother Courage and Her Children.*

81. Jackson, "Portrait of a Quiet Man," 179–80.

82. Marc Blitzstein, "The Weill-Brecht Collaboration Continued," *Saturday Review* (May 31, 1958), quoted in Kim H. Kowalke, Joanna Lee, and Edward Harsh, Edward, eds., *Mahagonny: A Sourcebook* (New York: Kurt Weill Foundation for Music, 1995), 56.

83. Feingold translation, *Rise and Fall of the City of Mahagonny.*

84. In this one case, I use the translation given in Bertolt Brecht, *The Rise and Fall of the City of Mahagonny,* edited by John Willett and Ralph Manheim, translated by W. H. Auden and Chester Kallman (New York: Arcade Publishing, 1996), 48. Their translation of the line *"Ein Mensch ist kein Tier"* lends clarity not only because it is a directly literal version, but also because as the line was sung in German, this English translation, using the word "human," gives the sense of how it would have had broad resonance in Germany at the time. The authorized singing translation is Feingold's "A *girl's* not a beast" and this is how it is sung in the Los Angeles Opera production of *The Rise and Fall of the City of Mahagonny,* recorded live in 2007 and distributed by EuroArts.

85. Although *The Mother* was a turning point for Weigel and Brecht's professional relationship, it didn't have as much impact on their personal one. For this reason, Weigel's memory of Brecht's appreciation for her role in that play is especially poignant. "During the 1932 rehearsals for 'Mutter,'" she recalled, "Brecht utterly changed his sense of me as an actress: the humor, the warmth, the friendliness, that

was all discovered when I played the role of Wlassowa." Vera Tenschert, *Helene Weigel. In Fotografien von Vera Tenschert* (Munich: Henschel Verlag, 2000), 3A.

CHAPTER 14 **EXILE**

1. Weill to his sister Ruth, spring of 1920, Series 45, WLRC. Also quoted in Kurt Weill and Lotte Lenya, *Speak Low (When You Speak Love): The Letters of Kurt Weill and Lotte Lenya*, edited and translated by Lys Symonette and Kim H. Kowalke (Berkeley and Los Angeles: University of California Press, 1996), 31–32, where it says "murmuring" instead of "roaring."

2. Gottfried Wagner interview with Lenya, May 28, 1978, Series 60, WLRC.

3. Weill and Lenya, *Speak Low*, 65.

4. Letter 163 in Bertolt Brecht, *Letters 1913–1956*, edited by John Willett and translated by Ralph Manheim (New York: Routledge, 1990), 131–32.

5. In a letter that Brecht wrote to Steffin on March 13, 1933, he indicates that his father might also have helped her financially. In letter 461 in Bertolt Brecht, *Briefe 1: Große kommentierte Berliner und Frankfurter Ausgabe*, Band 28 (Berlin: Aufbau-Verlag, 1998), 348–49, he writes: "You must regain your health and then you have to study. Everyone has to do that now. Whatever happens in the coming months, don't worry. My father will send you money . . ."

6. By the end of 1932, the number of unemployed had risen from six to seven million in less than a year.

7. Kim H. Kowalke, "Kurt Weill's *Die Bürgschaft*," liner notes for *Die Bürgschaft*, Spoleto Festival, recorded in 1999, EMI Records, 23.

8. A copy of this January 18, 1932, article is in BBA 404/24.

9. The Communist press was equally pleased by his political film, *Kuhle Wampe*.

10. This quote is cited by Kim H. Kowalke in "Brecht and Music: Theory and Practice," in *The Cambridge Companion to Brecht*, edited by Peter Thomson and Glendyr Sacks (Cambridge: Cambridge University Press, 1994), 228.

11. Jürgen Schebera, *Kurt Weill: An Illustrated Life*, translated by Caroline Murphy (New Haven, CT: Yale University Press, 1995), 204.

12. Kowalke, "Kurt Weill's *Die Bürgschaft*," 14.

13. Weill and Lenya, *Speak Low*, 71.

14. The advanced age and pronounced senility of ex–Field Marshal Hindenburg is often cited as the reason he was susceptible to Hitler's machinations. In Richard Grunberger's *The 12-Year Reich: A Social History of Nazi Germany 1933–1945* (New York: Da Capo Press, 1971), he quotes Lessing on page 3. On page 18, Grunberger offers this description of Hitler's rise to power: "It was a hybrid of popular will and authoritative *fiat:* populist by virtue of Hitler's mass following, and authoritarian because his investiture had been at the hands of Hindenburg."

15. Felix Jackson, "Portrait of a Quiet Man: Kurt Weill, His Life and His Times," unpublished manuscript, Weill-Lenya Research Center, New York, 159.

16. Weill to Universal Edition, February 6, 1933, Series 41, WLRC.

17. Ibid., Heinsheimer to Weill, February 8, 1932.

18. Schebera, *Kurt Weill: An Illustrated Life*, 199–200. Sierck changed his name to Douglas Sirk when he moved to America, where he became a famous film director of such films as *All That Heaven Allows, Magnificent Obsession*, and *A Time to Love and a Time to Die*. His fame was spread by Jean-Luc Godard and Andrew Sarris.

19. Ibid., 203.

20. Ibid., 200. Schebera quotes Hans Rothe who, in addition to being Reinhardt's dramaturg, was also a playwright and novelist in his own right. He ultimately became best known as a translator of Shakespeare.

21. Kim H. Kowalke, "Reflections on the Silver Lake," liner notes for *Kurt Weill: Silverlake (A Winter's Tale)*, New York City Opera, recorded in 1980, Nonesuch Records.

22. Heinsheimer to Weill, February 24, 1933, Series 41, WLRC.

23. Hans Fallada, the famous author of *Little Man, What Now?* and *Every Man Dies Alone*, was slated to direct the film for which Weill was composing the score. For several reasons, not least the content of his latest and most successful novel, Fallada was arrested by the Gestapo in March 1933 and instructed Walter Steinthal to inform Weill. It was this call that prompted Weill's second and permanent departure from Berlin.

24. Werner Hecht, *Brecht Chronik* (Frankfurt am Main: Suhrkamp Verlag, 1997), 345–46.

25. Carola Stern, *Männer lieben anders: Helene Weigel und Bertolt Brecht* (Reinbek bei Hamburg: Rowohlt Taschenbuch Verlag, 2000), 60.

26. Minotti to Hauptmann, January 14, 1960, letter 493, EHA. When this letter was written, Minotti lived in London and had long since changed her name to Margaret Mynatt.

27. The name listed on the legal document, providing the official grounds for divorce, was Bianca Minotti, the lesbian journalist and committed Communist who had been living with Hauptmann on and off for the past few years. As a lesbian it seems unlikely that she had an affair with either of them, but rather that as a good friend of Hauptmann, allowed her name to be used to help expedite the divorce.

28. In 1947, Brecht was called before the House Un-American Activities Committee. He testified bravely and betrayed no one, but was sufficiently frightened and flew back to Europe the very next day. Weigel and Barbara didn't leave until almost three weeks later. Stefan stayed behind to continue his studies in America.

29. Weill and Lenya, *Speak Low*, 77.

30. Weill to Universal Edition, March 14, 1933, Series 41, WLRC.

31. Ibid.

32. Ibid. This part of the letter is also quoted in Kim H. Kowalke, "*The Threepenny Opera* in America," in Stephen Hinton, ed., *Kurt Weill: The Threepenny Opera* (Cambridge: Cambridge University Press, 1990), 82.

33. Weill and Lenya, *Speak Low*, 77–79.

34. Kim H. Kowalke, "Accounting for Success: Misunderstanding *Die Dreigroschenoper*," *The Opera Quarterly* 6, no. 3 (Spring 1989): 19.

35. Weill to his brother Hanns, August 20, 1917, quoted in David Farneth with Elmar Juchem and Dave Stein, eds., *Kurt Weill: A Life in Pictures and Documents* (Woodstock, NY: The Overlook Press, 2000), 14.

36. Letter 36 in Weill and Lenya, *Speak Low*, 73.

37. Ernst Josef Aufricht, *Erzähle, damit du dein Recht erweist* (Munich: Deutscher Taschenbuch Verlag, 1969), 122.

38. James's royal heritage was speculation, whereas his actual wealth came from his American businessman father. James was a collector of surrealist art and a patron of René Magritte, Leonora Carrington, and Salvador Dalí. The Mae West Lips Sofa was originally designed for his house.

39. Weill and Lenya, *Speak Low*, 79.

40. Heinsheimer to Weill, April 3, 1933, Series 41, WLRC.

41. Ibid., June 7, 1933.

42. The friend was Karin Michaelis.

43. Letter 477, May 2, 1933, in Brecht, *Briefe 1*, 358.

44. The interview with the note from Benjamin is image #21 in the German version of Erdmut Wizisla, *Walter Benjamin and Bertolt Brecht: The Story of a Friendship* (New Haven, CT: Yale University Press, 2009).

45. Letter 470, April 1933, in Brecht, *Briefe 1,* 354.

46. The information on the first American production of *The Threepenny Opera* is indebted to Kowalke's well-documented and eloquent essay "*The Threepenny Opera* in America," 81, 85, and 86.

47. Liner notes, *The Seven Deadly Sins/Mahagonny Songspiel* (Capriccio, 1993), 45.

48. In yet another effort to highlight the anticapitalist nature of his work, Brecht would eventually change the title to *The Seven Deadly Sins of the Bourgeoisie.* Weill never officially approved this title.

49. Alan Rich, Kim Kowalke, and Lys Symonette interview with Abravanel, 1979, Series 60, WLRC, 30.

50. Weill to Erika Neher, Series 40, WLRC. According to Weill and Lenya, *Speak Low,* the date of Weill's letter to Erika is sometime in May 1933. Weill uses the word *Geselle,* which I translate as "fellow."

51. Weill and Lenya, *Speak Low,* 81.

52. There was a year-and-a-half window in which Weill engaged at least occasionally in an affair with Lenya outside the legal boundaries of marriage. Their divorce came through on September 18, 1933, although they never lost contact. Despite ongoing relationships with others, their letters indicate an amorous relationship took place often enough during this period. By 1935, they were sufficiently reunited for Weill to take Lenya with him to America. They remarried there on January 19, 1937.

Weill's passionate correspondence with Erika continued through early 1937. She remained in Germany and he often indicated a desire to bring her to America. This never happened, and things cooled off by 1938. By that time, Caspar Neher was involved in a serious affair with the actress Maria Wimmer. Many of Weill's letters to Erika sympathize with her worries about Caspar's devotion to Wimmer.

53. Weill to Erika Neher, Series 40, WLRC.

54. Ibid.

55. Ibid.

56. Some authors have postulated that Neher was a homosexual, and that therefore he was understanding of and perhaps even grateful for Weill's affair with Erika. Attempts to track down the source of this theory most often date to Donald Spoto's *Lenya: A Life* (Boston: Little, Brown and Company, 1989), but he doesn't offer any substantive proof of this assertion. After reading the entire correspondence between Neher and the actress Maria Wimmer, a love affair that was sustained from 1935 until 1950 and documented in a voluminous correspondence, there is no doubt in my mind that he was certainly, if not necessarily exclusively, an enthusiastic lover of women. Given that all evidence points to a warm and loving man, and that he had known Erika for a very long time, I am doubtful, but without any documented proof, that he was either particularly understanding or happy about the romance between his wife and his best friend. Erika and Caspar remained married until 1962, when they died within two months of each other.

57. Lenya is quoted in David Farneth, ed., *Lenya, the Legend: A Pictorial Autobiography* (Woodstock, NY: The Overlook Press, 1998), 80.

58. James K. Lyon interviews Barbara Brecht-Schall, who in turn quotes her mother in The International Brecht Society, *The Brecht Yearbook: Helene Weigel 100,* vol. 25, edited by Judith Wilke (Madison: University of Wisconsin Press, 2000), 30.

59. Weill and Lenya, *Speak Low,* 81, 82.

60. Susanne de Ponte, *Caspar Neher, Bertolt Brecht: Eine Bühne für das epische Theater* (Munich: Henschel Verlag, 2006), 19.

61. Lenya admitted this in her interview with Gottfried Wagner, quoted in Weill and Lenya, *Speak Low,* 154.

CHAPTER 15 **WHEN THE SHARK BITES**

1. This correspondence from Weill is quoted in Foster Hirsch, *Kurt Weill on Stage: From Berlin to Broadway* (New York: Limelight Editions, 2003), 301.

2. Weill to Erika Neher, July 28, 1936, Series 40, WLRC.

3. Anderson was a highly celebrated playwright, and President Roosevelt was in the audience for the Washington, D.C., performance of *Knickerbocker Holiday.* The story was based on the book by Washington Irving and was about Dutch rule in seventeenth-century New York City. The text is laced with references to the New Deal and Roosevelt's politics. The president apparently "roared with laughter" when a character named after him presented a clear parody. See Jürgen Schebera, *Kurt Weill: An Illustrated Life,* translated by Caroline Murphy (New Haven, CT: Yale University Press, 1995), 266.

4. In addition to these Broadway shows, Weill's success was the result of several other projects: a popular school opera, *Down in the Valley;* another collaboration with Hart on the Lunchtime Follies, a series that provided midday entertainment for factory workers; and *We Will Never Die* with Ben Hecht, a pageant play dedicated to the two million Jewish dead of Europe.

5. Stephen Parker, *Bertolt Brecht: A Literary Life* (London: Bloomsbury Methuen Drama, 2014), 529.

6. For an extensive description of Brecht's relationship with the Soviet Communists, including his work on their official journal *Das Wort,* and his famous silence during Stalin's Great Terror, see Stephen Parker's 2014 biography of Bertolt Brecht.

7. Bertolt Brecht, "To Those Born Later," in *Poems 1913–1956,* edited by John Willett and Ralph Manheim (New York: Routledge Theater Arts Books, 1979), 320.

8. Brecht to Karl Korsch, letter 433, September 1941, in Bertolt Brecht, *Letters 1913–1956,* edited by John Willett and translated by Ralph Manheim (New York: Routledge, 1990), 339.

9. Ronald Hayman, *Brecht: A Biography* (New York: Oxford University Press, 1983), 257.

10. Brecht, "Sonnet in Emigration," in *Poems 1913–1956,* translated by Edith Roseveave, 366.

11. Brecht and Weigel did not gain Austrian citizenship until after they had settled in East Germany. Brecht at first chose to enter the German Democratic Republic with an official status of "stateless." But when he became an influential member of the East German Academy of the Arts, he was compelled to accept an East German passport. Amid a good deal of controversy, Brecht and Weigel were eventually also awarded Austrian citizenship in 1950.

12. Lerner is best known for *My Fair Lady, Camelot, Gigi, Brigadoon* (all with the composer Frederick Loewe), and *On a Clear Day You Can See Forever* (with the composer Burton Lane).

13. Brecht to Weill, Series 40, WLRC, June 10, 1949. In this letter, Brecht confirms the intention to leave Felix Bloch Erben and the reasons for it: "I would like to give the theatrical distribution rights [for *Threepenny*] to Suhrkamp Publishers, who are now a large theater distribution company as well, and they have a very reliable director. (It used to be called Fischer Publishers.) He can represent the play, and they are located in Frankfurt and Berlin, in the U.S sector . . . At Bloch Erben, Mr. Spitzner is still there with Procura, the one who, in the Nazi times, gave our royalties from Scandinavia to Hitler's regime."

In addition, Brecht wrote to Weill: "I have written a version of the *Dreigroschenoper* which, from a legal standpoint, can be seen as a *new version,* i.e. we don't need to worry anymore about the publisher Bloch Erben." Series 40, WLRC.

14. Weill to Brecht, December 20, 1948, Series 40, box 1, folder 28, WLRC.

15. Weill to Bertolt Brecht, January 17, 1949, Series 40, box 1, folder 29, WLRC.

16. Letter 578, January 28, 1949, in Brecht, *Letters 1913–1956*, 456–57.

17. Weill's directive is documented in Willett's notes to letter 578 in ibid., 653.

18. The letter of June 7, 1949, from the Munich Theater to Felix Bloch Erben was forwarded to Weill: "The general situation of theater is, as you know best, right now a catastrophe. In contrast to this, our *Dreigroschenoper* premiere has, as of now, 25 sold-out performances. It will be the salvation of our theater, and an interruption of the premiere would mean the financial collapse of our theater. The Munich Theater can be trusted to understand the artistic responsibility of performing a masterwork, and we wouldn't have taken on this difficult project without having the counsel from such distinguished composers as Carl Orff, Karl Amadeus Hartmann. We hope that with this clarification, Kurt Weill's concerns will be resolved." Series 41, box 3, WLRC; the original is at the Sibley Music Library at the Eastman School of Music.

19. Hirsch, *Kurt Weill on Stage*, 301.

20. Brecht to Weill, March 12, 1942, Series 40, box 1, folder 17, WLRC.

21. Weill to Brecht, March 9, 1942, Series 40, box 1, folder 16, WLRC.

22. Brecht to Weill, April 1942, Series 40, box 1, folder 16, WLRC.

23. Letter 275 in Kurt Weill and Lotte Lenya, *Speak Low (When You Speak Love): The Letters of Kurt Weill and Lotte Lenya*, edited and translated by Lys Symonette and Kim H. Kowalke (Berkeley and Los Angeles: University of California Press, 1996), 332–33.

24. Ibid., letter 306, 367.

25. Berlau eventually moved to Los Angeles in order to be closer to Brecht.

26. Letter 455, June 23 1943, in Brecht, *Letters 1913–1956*, 356.

27. Ibid., letter 456, 358.

28. Hayman, *Brecht: A Biography*, 277.

29. In 1947, Brecht asked Weill to collaborate with him on yet another version of *Schweik*, to be performed in the Russian sector of Berlin. Weill responded that he was too busy working on *Love Life* on Broadway.

30. Weill to Maurice Speiser, January 22, 1944, MSS 30, Series IV.A, box 47, folder 14, Weill-Lenya Papers, Yale University Music Library.

31. Weill did speak to Moss Hart about becoming involved in *Szechwan*, but shortly afterward, the composer opened a newspaper and read, to his fury, that another producer was publicly claiming the rights to Brecht's play. Brecht denied any involvement with this producer, and although Weill's suspicions were on high alert, he was nevertheless forgiving enough to sign an option contract obligating him to pay his struggling ex-partner $100 a month for a period of time. For his part, Brecht agreed to sign an unusually lopsided contract, one that gave the composer complete freedom to alter the English adaptation of the play. But Weill was clearly aware that Brecht didn't always play by the rules, with or without a signature. The contract, signed in March 1943, is at the WLRC.

32. Details about Brecht and Auden's relationship can be found in Hayman, *Brecht: A Biography*, 300.

33. The Rainer story was told to me by Brian Kulick. The film that Brecht worked on with Fritz Lang was *Hangmen Also Die*.

34. Stephen Parker, *Bertolt Brecht: A Literary Life* (London: Bloomsbury Methuen Drama, 2014), 445.

35. Brecht also collaborated with Feuchtwanger on a play called *The Visions of Simone Machard*. This was his third work to be inspired by Joan of Arc.

36. By the time *Galileo* made it to the stage, the dark clouds of McCarthyism were looming, and Brecht had already left the country. He was greatly relieved to be back

in Europe where his reputation was once again acknowledged, and he brusquely dismissed the failure of his play in America. He confidently declared that the bourgeois audience couldn't understand a play that required thinking. For further details, see Hayman, *Brecht: A Biography*, 316.

37. Weigel's letter is quoted in Werner Hecht, *Helene Weigel* (Frankfurt am Main: Suhrkamp Verlag, 2000), 303.

38. Weill and Lenya, *Speak Low*, 192.

39. "To Those Born Later" in Brecht, *Poems 1913–1956*, 318.

40. Lenya is quoted in Stephen Wadsworth, "Zeitgeist," *Opera News* (December 1, 1979): 19.

41. Brecht's poem is quoted in Stephen Parker, *Bertolt Brecht: A Literary Life* (London: Bloomsbury Methuen Drama, 2014), 531.

42. Weill interview with Boris Goldovsky that was broadcast from the Metropolitan Opera in 1949, quoted in David Farneth with Elmar Juchem and Dave Stein, eds., *Kurt Weill: A Life in Pictures and Documents* (Woodstock, NY: The Overlook Press, 2000), x.

43. Schebera, *Kurt Weill: An Illustrated Life*, 316–17.

44. The author's 2013 interview with Kulick, the artistic director of the Classic Stage Company and a professor of theater arts at Columbia University.

45. Bertolt Brecht, *Brecht on Theatre: The Development of an Aesthetic*, edited and translated by John Willett (New York: Hill and Wang, 1964), 7.

46. Martin Esslin, *Brecht: A Choice of Evils* (London: Methuen London Ltd, 1984), 130.

47. The author's 2012 interview with the playwright Tony Kushner.

48. Robert Wilson's production of *The Threepenny Opera* premiered at the Berliner Ensemble in 2008 and has been performed all over the world, including the Brooklyn Academy of Music in 2011.

49. Lenya is quoted in Kim H. Kowalke, "*The Threepenny Opera* in America," in Stephen Hinton, ed., *Kurt Weill: The Threepenny Opera* (Cambridge: Cambridge University Press, 1990), 110.

50. Sabine Kebir, *Ich fragte nicht nach meinem Anteil: Elisabeth Hauptmanns Arbeit mit Bertolt Brecht* (Berlin: Aufbau-Verlag, 1977), 200; Kebir says that Ruge, Dessau's lover at the time, told her about Hauptmann's suicide attempt. Kebir goes on to say that Hauptmann's description in her famous story clearly refers to her return to Berlin in the 1950s. And while within the story "Gedanken am Sonntagmorgen" there is also a reference to Hauptmann's attempt in the 1920s, Kebir believes that the one in the 1950s really happened and was motivated by both her divorce with Dessau and her generally difficult time upon her return to the Berliner Ensemble. Based on the story itself, and on her conversation with Ruge, Kebir asserts that the second suicide attempt is far more substantiated than the first.

We are once more up against Hauptmann's mystery-laden story, which clearly, in my opinion, refers to both the 1920s and the 1950s. There is the quote, discussed in chapter 11, where she says: "There was another time she'd also been unable to bear [the loneliness] . . . that was in a small hole of a room, there she had a misfortune." Even if the physical description of the apartment is the one in the 1950s, this "another time" seems to be just as clearly the 1920s. Kebir's secondhand account from Ruge is quite convincing with regard to the reality of the second attempt but does not negate the possibility of an earlier one, and if it indeed took place, her relationship with Brecht would have played a central role.

51. Two important younger lovers during this time were Käthe Reichel and Isot Kilian, who was with Brecht at the very end of his life.

52. Schebera, *Kurt Weill: An Illustrated Life*, 326 and 330.

53. Farneth, Juchem, and Stein, *Kurt Weill: A Life in Pictures and Documents*, 271.

54. Brecht to Berlau, February 11, 1956, letter 856, in Brecht, *Letters 1913–1956*, 556.

55. Kowalke, *"The Threepenny Opera* in America," 79.

56. David Farneth, ed., *Lenya, the Legend: A Pictorial Autobiography* (Woodstock, NY: The Overlook Press, 1998), 238.

57. Weill's relationship with Blitzstein was complex and evolved over the years. Kowalke provides further details about the composer's opinions of Blitzstein's work in *"The Threepenny Opera* in America," 101.

58. Ibid., 108.

59. Ibid., 114.

60. This quote from Dylan's book, *Chronicles: Volume One*, was in Jason Zinoman, "When Bobby met Bertolt, Times Changed," *The New York Times*, October 8, 2006.

61. The title *Brecht on Brecht* influenced Dylan's album name *Blonde on Blonde*.

62. Kowalke, *"The Threepenny Opera* in America," 79.

63. Ibid., 111.

64. Hecht, *Brecht Chronik* (Frankfurt am Main: Suhrkamp Verlag, 1997), 1, 167.

65. Engel had directed Brecht's very early play *In the Jungle of Cities;* his first theatrical success, *A Man's a Man;* and, of course, *The Threepenny Opera*.

66. Hecht, *Brecht Chronik*, 1,253.

67. The details of the will come from Stephen Parker's biography, *Bertolt Brecht: A Literary Life* (London: Bloomsbury Methuen Drama, 2014), 596. In both Ronald Hayman's book, *Brecht: A Biography*, 388, and in Kebir's, *Ich fragte nicht nach meinem Anteil*, 210, there is the assertion that another will was dictated at the last moment, and that since it wasn't notarized, Weigel was able to contest it. Since there is no existing copy of the contested will, I favor Parker's well-documented account.

68. The phrase "war of the widows" came into common usage in the German press in 1957. At that time, there was no contract for the division of royalties between Weill and Brecht for *The Seven Deadly Sins*. A production at the Hamburg State Opera that featured Lenya was canceled because Weigel and Lenya couldn't agree on the terms. Their battle became a popular item in the press and the term "widow wars" (*Witwenkriege*) was coined. Thanks to Kowalke and Juchem for providing this information.

69. Suhrkamp finally relented in the 1990s and agreed to sign a proper contract with Weill's estate. This information came from Kowalke in an interview with the author.

70. According to the Kurt Weill Foundation for Music, *Threepenny* has been translated into Bulgarian, Chinese, Czech, Danish, Dutch, English (many times), French, Greek, Hebrew, Hungarian, Italian, Japanese, Polish, Portuguese, Spanish, Romanian, Russian, Turkish, Yiddish, and, most likely, Korean, Swedish, and Finnish.

71. Negative German reviews for Lenya's performance in *Mother Courage* appeared in, among others, *Frankfurter Rundschau* and *Düsseldorfer Nachrichten*.

72. Farneth, *Lenya, the Legend*, 243.

73. These statistics were confirmed by Kowalke in a 2013 interview with the author.

Bibliography

Arendt, Hannah. *Men in Dark Times*. Orlando, FL: Harcourt Brace Jovanovich, 1968.

Aufricht, Ernst Josef. *Erzähle, damit du dein Recht erweist*. Munich: Deutscher Taschenbuch Verlag, 1969.

Bentley, Eric. *Bentley on Brecht*. Evanston, IL: Northwestern University Press, 2008.

Brecht, Bertolt. *Baal, A Man's a Man, and The Elephant Calf*. Edited by Eric Bentley. New York: Grove Press, 1964.

———. *Brecht on Film and Radio*. Edited and translated by Marc Silberman. London: A & C Black, 2001.

———. *Brecht on Theatre: The Development of an Aesthetic*. Edited and translated by John Willett. New York: Hill and Wang, 1964.

———. *Briefe 1: Große kommentierte Berliner und Frankfurter Ausgabe*. Band 28. Briefe 1. Frankfurt am Main: Suhrkamp Verlag and Berlin: Aufbau-Verlag, 1998.

———. *Diaries 1920–1922*. Edited by Herta Ramthun. Translated by John Willett. New York: St. Martin's Press, 1979.

———. *Die Dreigroschenoper*. Frankfurt am Main: Suhrkamp Verlag Berlin, 2004. First published by Suhrkamp in 1955. This is the 1928 version.

———. *Journals 1934–1955*. Edited by John Willett. Translated by Hugh Rorrison. New York: Routledge, 1993.

———. *Jungle of Cities: And Other Plays*. Edited by Eric Bentley. Translated by Anslem Hollo, Frank Jones, and N. Goold-Verschoyle. New York: Grove Press, 1966.

———. *Letters 1913–1956*. Edited by John Willett. Translated by Ralph Manheim. New York: Routledge, 1990.

———. *Manual of Piety (Die Hauspostille)*. Translated by Eric Bentley. New York: Grove Press, 1966.

———. *Poems 1913–1956*. Edited by John Willett and Ralph Manheim. Various translators. New York: Routledge Theater Arts Books, 1979.

———. *Rise and Fall of the City of Mahagonny*. Edited by John Willett and Ralph Manheim. Translated by W. H. Auden and Chester Kallman. New York: Arcade Publishing, 1996.

———. *The Threepenny Opera*. Translated by Desmond Vesey and Eric Bentley. Foreword by Lotte Lenya. New York: Grove Press, 1949, 1955, 1960.

———. *The Threepenny Opera*. Translated and edited by Ralph Manheim and John Willett. New York: Arcade Publishing, 1994.

Brecht, Bertolt, and Kurt Weill. *Happy End*. Lyrics adapted by Michael Feingold. New York: Samuel French, Inc., 1982. Originally produced in 1929.

de Ponte, Susanne. *Caspar Neher, Bertolt Brecht: Eine Bühne für das epische Theater.* Munich: Henschel Verlag, 2006.

Drew, David. *Kurt Weill: A Handbook.* Berkeley and Los Angeles: University of California Press, 1987.

———. "Struggling for Supremacy: The Libretto of *Mahagonny.*" *Kurt Weill Newsletter* 27, no. 2 (Fall 2009).

Eisner, Lotte. *The Haunted Screen.* Berkeley and Los Angeles: University of California Press, 1969.

Esslin, Martin. *Brecht: A Choice of Evils.* London: Methuen London Ltd, 1984.

Ewen, Frederic. *Bertolt Brecht: His Life, His Art, and His Times.* New York: Carol Publishing Group, 1992.

Farneth, David, ed. *Lenya, the Legend: A Pictorial Autobiography.* Woodstock, NY: The Overlook Press, 1998.

Farneth, David, with Elmar Juchem, and Dave Stein, eds. *Kurt Weill: A Life in Pictures and Documents.* Woodstock, NY: The Overlook Press, 2000.

Fleisser, Marieluise. *Avantgarde: Erzählungen.* Munich: Carl Hanser Verlag, 1963.

Fuegi, John. *Bertolt Brecht: Chaos, According to Plan.* Cambridge: Cambridge University Press, 1987.

Gay, John. *The Beggar's Opera.* Bungay, UK: Richard Clay & Sons, Ltd, 1921. Text from 1765 edition.

Gay, Peter. *Weimar Culture: The Outsider as Insider.* London: Penguin Books Ltd, 1969.

Grosch, Nils, ed. *Kurt Weill: Briefwechsel mit der Universal Edition.* Stuttgart: J. B. Metzler, 2002.

Grunberger, Richard. *The 12-Year Reich: A Social History of Nazi Germany 1933–1945.* New York: Da Capo Press, 1995.

Hanssen, Paula. *Elisabeth Hauptmann: Brecht's Silent Collaborator.* Bern: Peter Lang, Inc., 1995.

Häntzschel, Hiltrud. *Brechts Frauen.* Reinbek bei Hamburg: Rowohlt Verlag, 2002.

Hauptmann, Elisabeth. *Julia ohne Romeo.* Berlin and Weimar: Aufbau-Verlag, 1977.

———. *Lesebuch.* Cologne: Nyland-Stiftung, 2004.

Hayman, Ronald. *Brecht: A Biography.* New York: Oxford University Press, 1983.

Hecht, Werner. *Brecht Chronik.* Frankfurt am Main: Suhrkamp Verlag, 1997.

———. *Helene Weigel.* Frankfurt am Main: Suhrkamp Verlag, 2000.

Heinsheimer, Hans W. *Best Regards to Aida.* New York: Alfred A. Knopf, 1968.

Hinton, Stephen. *Weill's Musical Theater: Stages of Reform.* Berkeley and Los Angeles: University of California Press, 2012.

Hinton, Stephen, ed. *Kurt Weill: The Threepenny Opera.* Cambridge: Cambridge University Press, 1990.

Hirsch, Foster. *Kurt Weill on Stage: From Berlin to Broadway.* New York: Limelight Editions, 2003.

International Brecht Society. *The Brecht Yearbook: Intersections.* Volume 21. Edited by Maarten van Dijk. Madison: University of Wisconsin Press, 1996.

———. *The Brecht Yearbook: Helene Weigel 100.* Volume 25. Edited by Judith Wilke. Madison: University of Wisconsin Press, 2000.

———. *The Brecht Yearbook: Mahagonny.com.* Volume 29. Edited by Marc Silberman and Florian Vassen. Madison: University of Wisconsin Press, 2004.

Jackson, Felix (née Joachimson). "Portrait of a Quiet Man: Kurt Weill, His Life and His Times." Unpublished manuscript. Weill-Lenya Research Center, New York.

Kater, Michael H. *Composers of the Nazi Era.* New York: Oxford University Press, 2000.

Kebir, Sabine. *Ein akzeptabler Mann?* Berlin: Aufbau Taschenbuch Verlag, 1998.

———. *Ich fragte nicht nach meinem Anteil: Elisabeth Hauptmanns Arbeit mit Bertolt Brecht.* Berlin: Aufbau-Verlag, 1977.

Kerr, Alfred. *Die Welt im Drama*. Cologne and Berlin: Kiepenheuer & Witsch, 1954.

Kowalke, Kim H. "Accounting for Success: Misunderstanding *Die Dreigroschenoper*." *The Opera Quarterly* 6, no. 3 (Spring 1989).

————. "Brecht and Music: Theory and Practice." In *The Cambridge Companion to Brecht*. Edited by Peter Thomson and Glendyr Sacks. Cambridge: Cambridge University Press, 1994.

————. *Kurt Weill in Europe*. Ann Arbor: University of Michigan Research Press, 1979.

————. "Reflections on the Silver Lake." Liner notes for *Kurt Weill: Silverlake (A Winter's Tale)*. New York City Opera. Recorded 1980. Nonesuch Records.

————. "Singing Brecht vs. Brecht Singing: Performance in Theory and Practice." *Cambridge Opera Journal* 5, no. 1: 55–78.

Kowalke, Kim H., ed. *A New Orpheus: Essays on Kurt Weill*. New Haven, CT: Yale University Press, 1986.

Kowalke, Kim H., Joanna Lee, and Edward Harsh, eds. *Mahagonny: A Sourcebook*. New York: Kurt Weill Foundation for Music, 1995.

Lenk, Thea, ed. *Erich Engel: Schriften. Über Theater und Film*. Berlin: Veröffentlichung der Akademie der Künste, Henschel Verlag Berlin, 1971.

Lyon, James K., and Hans-Peter Breuer, eds. *Brecht Unbound*. Newark: University of Delaware Press, 1995.

Morley, Michael. *Brecht: A Study*. London: Heinemann Educational Books Ltd, 1977.

Oja, Carol J. *Making Music Modern: New York in the 1920s*. Oxford: Oxford University Press, 2003.

Parker, Stephen. *Bertolt Brecht: A Literary Life*. London: Bloomsbury Methuen Drama, 2014.

Piscator, Erwin. *The Political Theater: A History 1914–1929*. New York: Avon Books, 1978.

Ramthun, Herta, ed. *Bertolt Brecht: Diaries 1920–1922*. Translated by John Willett. New York: St. Martin's Press, 1972.

Richie, Alexandra. *Faust's Metropolis: A History of Berlin*. New York: Carroll & Graf Publishers, Inc., 1998.

Sanders, Ronald. *The Days Grow Short: The Life and Music of Kurt Weill*. Hollywood: Silman-James Press, 1980.

Schebera, Jürgen. *Kurt Weill: An Illustrated Life*. Translated by Caroline Murphy. New Haven, CT: Yale University Press, 1995.

————. Liner notes for *Kurt Weill: Der Jasager/Down in the Valley*. Capriccio, 1991.

Shull, Ronald K. "Music and the Works of Bertolt Brecht: A Documentation." Unpublished manuscript. New York: Weill-Lenya Research Center, 1976.

Skrziepietz, Andreas. "Medical Student Bertolt Brecht (1898–1956)." *Journal of Medical Biography* 17 (2009).

Spoto, Donald. *Lenya: A Life*. Boston: Little, Brown and Company, 1989.

Stern, Carola. *Männer lieben anders: Helene Weigel und Bertolt Brecht*. Reinbek bei Hamburg: Rowohlt Taschenbuch Verlag, 2000.

Tenschert, Vera. *Helene Weigel. In Fotografien von Vera Tenschert*. Munich: Henschel Verlag, 2000.

Thomson, Peter. "Dismantling the *Gesamtkunstwerk:* Weill, Neher and Brecht in Collaboration." *Studies in Theater and Performance* 22, no. 1 (2002).

Thomson, Peter, and Glendyr Sacks, eds. *The Cambridge Companion to Brecht*. Cambridge: Cambridge University Press, 1994.

Weill, Kurt. *Briefe an die Familie (1914–1950)*. Edited by Lys Symonette and Elmar Juchem with Jürgen Schebera. Stuttgart and Weimar: Verlag J. B. Metzler, 2000.

Weill, Kurt, and Lotte Lenya. *Speak Low (When You Speak Love): The Letters of Kurt Weill*

and Lotte Lenya. Edited and translated by Lys Symonette and Kim H. Kowalke. Berkeley and Los Angeles: University of California Press, 1996.

Weitz, Eric D. *Weimar Germany: Promise and Tragedy.* Princeton, NJ: Princeton University Press, 2007.

Willett, John. "Bacon ohne Shakespeare?—The Problem of Mitarbeit." In *The Brecht Yearbook: Brecht, Women and Politics.* Edited by John Fuegi, Gisela Bahr, and John Willett. Detroit: Wayne State University Press, 1985.

———. *Brecht in Context.* London: Methuen London Ltd, 1998.

———. *Caspar Neher: Brecht's Designer.* London: Methuen London Ltd and the Arts Council of Great Britain, 1986.

Witt, Hubert, ed. *Brecht: As They Knew Him.* New York: International Publishers, 1974.

Wizisla, Erdmut. *"Ich lerne gläser + tassen spülen"—Bertolt Brecht / Helene Weigel: Briefe 1923–1956.* Berlin: Suhrkamp Verlag, 2012.

———. *Walter Benjamin and Bertolt Brecht: The Story of a Friendship.* New Haven, CT: Yale University Press, 2009.

Wolf, Sabine, ed. *Kunst und Leben: Georg Kaiser (1878–1945).* Berlin: Akademie der Künste, 2011.

FILMS

Die Mitarbeiterin. Directed by Karlheinz Mund. DEFA-Studio für Kurzfilme, 1972.

The Farewell. Directed by Jan Schütte. Novoskop Film, 2000.

Rise and Fall of the City of Mahagonny. Directed by Gary Halvoarson. EuroArts Music International, 2007.

Theater of War. Directed by John Walter. White Buffalo Entertainment, 2008.

The 3 Penny Opera. Directed by G. W. Pabst. The Criterion Collection, 2007.

Illustration Credits

INSERT 2

Page 1 (top): Akademie der Künste, Elisabeth-Hauptmann-Archiv 705, Berlin. Photographer: Carl Koch.

Page 1 (bottom): Akademie der Künste, Berlin, Bertolt-Brecht-Archiv, Theater Doku 1593-007: *Happy End.* Photo: Joseph Schmidt.

Page 2 (top): Courtesy of the Weill-Lenya Research Center, Kurt Weill Foundation for Music, New York.

Page 2 (bottom): Courtesy of the Theatermuseum, Vienna.

Page 3 (top): Courtesy of the Weill-Lenya Research Center, Kurt Weill Foundation for Music, New York.

Page 3 (bottom): Courtesy of the Weill-Lenya Research Center, Kurt Weill Foundation for Music, New York.

Page 4 (top): Akademie der Künste, Berlin, Bertolt-Brecht-Archiv FA 45/008. Photo: L. Hartung.

Page 4 (bottom): Courtesy of the Weill-Lenya Research Center, Kurt Weill Foundation for Music, New York.

Page 5 (top): Courtesy Fredstein.com.

Page 5 (bottom): Courtesy of the Weill-Lenya Research Center, Kurt Weill Foundation for Music, New York.

Page 6 (top): Courtesy of the Weill-Lenya Research Center, Kurt Weill Foundation for Music, New York.

Page 6 (bottom): Akademie der Künste, Berlin, Bertolt-Brecht-Archiv 2968/3. Photographer unknown.

Page 7: © Bettmann/Corbis.

Page 8 (top): Photo: R. Berlau/ Hoffmann.

Page 8 (bottom): Courtesy of The Granger Collection, #0087264, New York. Photographer: Yousef Karsh.

Index

A NOTE ABOUT THE AUTHOR

PAMELA KATZ is an award-winning screenwriter and author based in Brooklyn and Berlin. In addition to seven dramatic films focused on German culture and history, she has written a biographical novel about Lotte Lenya. She has long been drawn to the brilliant personalities who flourished during the Weimar Republic, and her film *Hannah Arendt*—winner of two German Academy awards—was chosen by the *New York Times* critic A. O. Scott as a Top Ten film of 2013. She teaches screenwriting at the NYU Graduate School of Film, and *The Partnership* is her first nonfiction work.